MONUMENTS & MAIDENS

Books by Marina Warner

FICTION

In a Dark Wood

A Skating Party

The Lost Father

Indigo

The Mermaids In The Basement

NON-FICTION

The Dragon Empress:
Life And Times Of Tz'u-hsi 1835–1908
Empress Dowager Of China

Alone Of All Her Sex:
The Myth And The Cult Of The Virgin Mary

Joan Of Arc:
The Image Of Female Heroism

Monuments And Maidens:
The Allegory Of The Female Form

Managing Monsters: Six Myths Of Our Time
(The Reith Lectures 1994)

Wonder Tales (Editor)

From The Beast To The Blonde:
On Fairy Tales And Their Tellers

MONUMENTS &
MAIDENS

The Allegory of the Female Form

Marina Warner

UNIVERSITY OF CALIFORNIA PRESS

Berkeley · Los Angeles

University of California Press

Berkeley and Los Angeles, California

First U.S. Paperback Printing 2000

Library of Congress Cataloging-in-Publication Data

Warner, Marina, 1946–

 Monuments & maidens : the allegory of the female form / Marina

Warner. — First U.S. paperback printing

 p. cm.

 Previously published: New York : Atheneum, 1985.

 Includes bibliographical references and index.

 ISBN 0-520-22733-6 (pbk. : alk. paper)

 1. Feminine beauty (Aesthetics) 2. Allegories. 3. Arts. I. Title:

Monuments and maidens. II. Title.

NX650-F45 W3 2000

704.9'424—dc21 00-022620

Printed in the United States of America

08 07 06 05 04 03 02 01 00

9 8 7 6 5 4 3 2 1

The paper used in this publication meets the minimum
requirements of ANSI/ NISO Z39.48-1992 (R 1997)
(*Permanence of Paper*). ∞

For JDM
with love

Then I thought of the tribe whose dances never fail
For they keep dancing till they sight the deer.

SEAMUS HEANEY.[1]

In dreams, a writing tablet signifies a woman, since it receives the imprint of all kinds of letters.

<div align="right">Artemidorus.[2]</div>

CONTENTS

Illustrations

ACKNOWLEDGEMENTS

I have been helped, throughout work on this book, by the ideas, advice, criticism and knowledge of many friends and colleagues, whom I cannot really thank adequately with this brief mention. Sir John Hale read parts of the manuscript at an early stage and gave me the benefit of his wide learning; Patricia Morison and Nicholas Penny generously read the finished draft and saved me from all kinds of lapses with their comments, both trenchant and constructive. Ruth Padel's acute observations on several chapters were invaluable and clarified many of my thoughts on the classical material. Caroline Elam prevented many an error in the Renaissance material. My publisher John Curtis gave the undertaking his support when it was most needed. Sally Mapstone's reading of the first draft inspired me to revise with energy and a sense that the enterprise was worth it. Linden Lawson's editing was always perceptive – and tactful too. Without them, the book would not have reached its present form, and I am very grateful. The observations of many others were a constant source of knowledge and inspiration: Anne Hollander, with whom I walked through Paris one day, Shirley Ardener, who shared with me her astute understanding of female symbolic representation, and Anthony Barnett, who commented on the political material, were especially helpful. To Simon Canelle, who researched aspects of the classical texts, I owe particular gratitude. Sir Ernst Gombrich, the late D. P. Walker, Roy Foster, David Kresh, Morton Bloomfield, Elizabeth McGrath, Patricia Harris Stablein, Adey Horton, Eugene Vance, Valerie Lagorio, Averil Cameron, Clodagh O'Reilly, Lisa Appignanesi, Rosalind Coward, Pippa Lewis, David Wiggins, Gina Newson, Francis Haskell, Susan Hiller, Alan Tyson, Edmund Colledge, Ruth Rubinstein, Barbara Taylor and the History Workshop, Oswyn Murray, Richard Ehrlich, Claire Tomalin, Maggie Staats Simmons and Pat Kavanagh all helped me, in varying ways, with discussion, references, observations, encouragement, understanding and interest in the project. To them all, much thanks. Ben Ramos and Giannella Nicol were patient and thorough in their assistance with the bibliography and the footnotes; Audrey Jones and Maria Ellis were fortitude personified typing the manuscript as it went through its different stages. The staffs of the Warburg Institute, the British Library, the Owl Bookshop and the London Library, especially the Librarian Douglas Matthews, who did the index, were unfailing

in their helpfulness. And my husband John Dewe Mathews was, in spite of discrepant gender, an allegory of virtue throughout.

The author and publishers are grateful for permission to quote from the following: 'The Songs We Know Best' from *A Wave* by John Ashbery, © 1984 by John Ashbery, reprinted by permission of Viking Penguin Inc., New York, and Carcanet Press, Manchester; *The Jerusalem Bible*, published and copyright in 1966, 1967 and 1968 by Darton, Longman & Todd Ltd and Doubleday & Co. Inc., used by permission of the publishers; 'Living Doll', by Lionel Bart, from the film *Serious Change*, © 1959 Peter Maurice Music Company Ltd, reproduced by permission of EMI Music Publishing Ltd; 'On the Use of Masculine – Preferred', by kind permission of Tom Disch; *Hadewijch, The Complete Works*, trans. and intro. by Mother Columba Hart OSB, © the Missionary Society of St Paul the Apostle in the State of New York, 1980; *The Venetian Vespers*, by Anthony Hecht, published in 1980 by Oxford University Press, used by permission of the publishers.

All quotations from the following books in the Penguin Classics series are reprinted by permission of Penguin Books Ltd (the dates of first publication by Penguin Books are given in brackets): Aeschylus, *The Oresteia*, trans. by Robert Fagles (1966), © Robert Fagles 1966, 1967, 1975, 1977; Aeschylus, *Prometheus Bound and Other Plays*, trans. by Philip Vellacott (1961), © Philip Vellacott 1961; *The Epic of Gilgamesh*, trans. and intro. by N. K. Sandars (1960, rev. ed. 1964), © N. K. Sandars 1960, 1964; Euripedes, *The Bacchae and Other Plays*, trans. by Philip Vellacott (1954), © Philip Vellacott 1954; Herodotus, *The Histories*, trans. by Aubrey de Selincourt, rev. ed. A. R. Burn (1954), © 1954 to the Estate of Aubrey de Selincourt; and A. R. Burn 1972; Hesiod, *Theogony, Works and Days*, trans. by Dorothea Wender (1973), © Dorothea Wender 1973; Homer, *The Iliad*, trans. by E. V. Rieu (1950), © the Estate of E. V. Rieu 1950; Homer, *The Odyssey*, trans. by E. V. Rieu (1946), © the Estate of E. V. Rieu 1946; Horace, *The Complete Odes and Epodes*, trans. by W. G. Shepherd (1983), © W. G. Shepherd 1983; Ovid, *Metamorphoses*, trans. by Mary M. Innes (1955), © Mary M. Innes 1955; Pindar, *The Odes*, trans. by C. M. Bowra (1969), © C. M. Bowra 1969; Plato, *Giorgias*, trans. and intro. by Walter Hamilton (1960), © Walter Hamilton 1960; Plato, *The Republic*, trans. and intro. by H. D. P. Lee (1955, 2nd ed. 1974), © H. D. P. Lee 1955, 1974; Plato, *Timaeus and Critias*, trans. and intro. by H. D. P. Lee (1965, rev. ed. 1977), © H. D. P. Lee 1965, 1971; Virgil, *The Aeneid*, trans. by W. F. Jackson Knight (1965) © G. R. Jackson Knight 1965.

FOREWORD

The gold seals on gallon cans of olive oil, guaranteeing that since some far-off date the precious contents have been considered worthy of the title, virgin, first pressing, are stamped with girls; female figures lie on the portals of stock exchanges and watch from the entrances of banks; the main doors of Macy's, the biggest department store in the world at the time it opened, carry a quartet of caryatids, holding hands in couples as young women used to do in friendship during the last century; the coins we handle in half the countries of Europe bear the heads and sometimes the full figures of imagined ideal states, of Republics and Empires and Victories, or of real queens who embody in their person the pretended unity of the nation; Justice raises her sword over law courts and the White Rock fairy promises the sparkle of fresh water inside the bottle she identifies.

Every day, in public and private, we exchange goods, both as commodities and as ideas, as shared aspirations, desired proofs of status and badges of identity through the symbolic form of the female figure; and as we do so we are participating in a living allegory whose tap-root runs down deep in classical Christian culture.

Allegory means 'other speech' (*alia oratio*), from *allos*, other, and *agoreuein*, to speak openly, to harangue in the *agora*; it signifies an open declamatory speech which contains another layer of meaning. It thus possesses a double intention: to tell something which conveys one meaning but which also says something else. Irony and enigma are among its constituents, but its category is greater than both, and it commands a richer range of possible moods. It is a species of metaphor, and, as a part of speech, has provided one of the most fertile grounds in human communication.[1]

This book attempts to examine a recurrent motif in allegory, the female form as an expression of desiderata and virtues. I hope, in spite of omissions, ignorance, unwarranted personal likes and dislikes, to throw some light on the plural significations of women's bodies and their volatile connections with changing conceptions of female nature. Justice is not spoken of as a woman, nor does she speak as a woman in mediaeval moralities or appear in the semblance of one above City Hall in New York or the Old Bailey in London because women were thought to be just, any more than they were considered capable of dispensing justice. Liberty is not represented as a woman, from the

colossus in New York to the ubiquitous Marianne, figure of the French Republic, because women were or are free. In the nineteenth century, when so many of these images were made and widely disseminated, the opposite was conspicuously the case; indeed the French Republic was one of the last European countries to give its female citizens the vote. Often the recognition of a difference between the symbolic order, inhabited by ideal, allegorical figures, and the actual order, of judges, statesmen, soldiers, philosophers, inventors, depends on the unlikelihood of women practising the concepts they represent.

Yet the first definition of allegory given by *The Oxford English Dictionary* is 'Description of a subject under the guise of another subject of *aptly suggestive resemblance*' (emphasis added). The female figure's aptly suggestive resemblance to the concepts and claims it has represented historically is the central paradox this book attempts to describe, and by describing, to understand.

Although the absence of female symbols and a preponderance of male in a society frequently indicates a corresponding depreciation of women as a group and as individuals, the presence of female symbolism does not guarantee the opposite, as we can see from classical Athenian culture, with its subtly psychologized pantheon of goddesses and its secluded, unenfranchised women; or contemporary Catholic culture, with its pervasive and loving celebration of the Madonna coexisting alongside deep anxieties and disapproval of female emancipation. But a symbolized female presence both gives and takes value and meaning in relation to actual women, and contains the potential for affirmation not only of women themselves but of the general good they might represent and in which as half of humanity they are deeply implicated.

Longinus, in the third century AD, in *The Art of Rhetoric*, provided a definition of allegory which sets out clearly how female imagery is coloured by the Platonist equivalence between the beautiful, the desirable and the good:

Allegoria adorns speech by changing expression and signifying the same thing through a fresher expression of a different kind. ... For ... it is necessary that from his sense of hearing the judge be enticed ... by appetising and pleasant dressings and allurements, just as by rich and fine cookery, and this ought to be done by means of attentive and flattering expressions. For these are means of persuasion, weapons of delight and of art which is trained for persuasion.[2]

To lure, to delight, to appetize, to please, these confer the power to persuade: as the spur to desire, as the excitement of the senses, as a weapon of delight, the female appears down the years to convince us of the messages she conveys.

'Allegory? But allegory's meaningless today' – this has been the re-action of some people who have asked me about the subject of this book. Prudentius' *Psychomachia* or Lorris and Meung's *Roman de la rose* appear to many to be stiff, pedantic examples of a minor literary genre, now fossilized; it is hard to see the allegorical character of John Ford's *Stage Coach,* or of *Star Wars,* or of *The Graduate,* though it would not be at all hard to demonstrate that these films obey the requirements of hidden meaning and didactic convention about the conflict between good and evil and the true lover's rewards as faithfully as the earlier poems.

In order to reveal how allegory's unassuming vitality and presence suffuse the complexion of our lives today, the book begins with a section about three different places – geographical and conceptual – where al-legory flourishes: in the highly visible cipher of American democracy, the Statue of Liberty, a single, emphatic image; in the exuberant archi-tectural ornament of Paris, where the history of the French past lies enfolded, secret, nearly invisible, but no less telling for that; and thirdly, even less noticeable, because it is so caught up with ordinary life, in some of the political drama of Britain under the first premiership of a woman. As Fletcher says, 'Allegories are far less often the dull systems that they are reputed to be than they are symbolic power struggles.'[3] In the claim the Statue of Liberty makes on behalf of America, in the contradiction between the reality of the guillotine and the charming fountains, nymph-bedecked, which now play upon its site, in the conflict between the belligerence of Margaret Thatcher and the peace cam-paigners' demonstrations against nuclear missiles, we can see different bids to persuade, to produce an *alia oratio* that will finally convince and create a consensual idea of order, in the past and in the present.

The second section of the book examines a principal reason for female allegory, the common relation of abstract nouns of virtue to feminine gender in Indo-European languages, and then goes on to select, among the many possible figures, some of the protagonists of the great allegor-ical dramas familiar in our culture. Athena, goddess of wisdom and of war, is the pattern for the armed maidens, invulnerable epitomes of the nation, like Britannia, as well as the Renaissance's muse of muses, patro-ness of learning and the arts. Her manifold, fascinating Homeric person-ality, changing dramatically between the *Iliad* and the *Odyssey,* and deeply influential on her later popularity, both in humanist Italy and in Victorian Britain, is the subject of the next two chapters. A study follows of the transformations undergone by Nike, the Greek goddess of victory and an aspect of Athena herself. Transmuted into the Roman Victoria,

whose descendants are poised on familiar triumphal arches in the capitals of Europe, she lent her winged ecstatic shape to the Christian archangel.

In mediaeval Christian thought and art, the Virtues were personified, as well as celestial choruses of other allegorical figures, like the Beatitudes and the Liberal Arts. In Chapter 8 I discuss allegories of Justice, a Cardinal Virtue, and the metamorphosis of one of her champions and exemplars, Judith, from a model of probity into a fantasy of castration. But the grievous attenuation of mediaeval imagery and meaning can be appreciated even more keenly in Chapter 9, where I explore the possibilities that the biblical Sophia or Wisdom, as well as the allegorized Virtues, held out to female writers, both mystical and practical, from the tenth century onwards, with especial emphasis on the transfigurations worked by the powerful imagination of Hildegard of Bingen, composer, poet, scientist and visionary.

The third, concluding, part of the book describes the varied formal premises that structure allegorical female figures, and the ideas that underpin their appearance both in text and image. Each chapter takes an aspect of the represented female body and explores its reverberating meanings. In 'The Making of Pandora', I tell the story of the first woman of classical myth, who was created as a beautiful work of art, the prototype passive recipient of divine or male energy, and yet at the same time an agent of calamity, a danger to men. Chapter 11, 'The Sieve of Tuccia', analyses the image of the allegorical body as a perfect vessel, a container of fixed meanings, in contrast to an actual woman's imperfect, permeable and changing body. 'The Slipped Chiton' follows the complex values of the female breast, emblematic of love, motherly and erotic and ardent, and the tension between the connotations of maternal tenderness and Amazonian zeal present in the propaganda of the French Republics. In the last chapter, 'Nuda Veritas' (Naked Truth), I look at 'good nudes', angels, redeemed souls and penitent saints, and naked Truth herself. Ostensibly split from endangering Eros, these conventionally nude figures are still fraught with the conflict between gratification and denial that flourishes so vigorously in our culture. For each chapter, as its title suggests, I have taken a single *figura*, or common imaginative motif, to trace the overall pattern.

Plato, who showed such mixed feelings about the possibilities of the imagination and poetic speech, nevertheless ended *The Republic* with an allegory, the story of Er, which Socrates gently urges us to bear in mind: 'And so, my dear Glaucon, his tale (*mythos*) was preserved from perishing, and, if we remember it, may well preserve us in turn, and we shall cross the river of Lethe safely and shall not defile our souls.'[4] Allegories

of the female form inform and animate many of the myths which have, in constant interplay, enriched and reinforced, maintained and reshaped our present identities as the inheritors of classical and Christian culture; whether they may save us from pollution and from death, we cannot tell. We cannot escape being what they have made us enough to see with such clarity and objectivity. But we may think they can; for we continue to speak them, see them, make them, live with them, almost unwittingly, as if we did trust the order they construct to hold out some promise. This book seeks to unfold how that promise is conveyed by the bodies of women.

PART ONE

The Female Presence Today

The course of history, as it presents itself under the notion of catastrophe, can really claim the thinker's attention no more than the kaleidoscope in the hand of a child, where all the patterns of order collapse into a new order with each turn. The image is profoundly justified. The ideas of those in power have always been the mirrors thanks to which the picture of an 'order' came about – The kaleidoscope must be smashed.

WALTER BENJAMIN[1]

CHAPTER ONE

The Monument (New York)

A sudden burst of sunshine seemed to illumine the Statue of Liberty, so that he saw it in a new light, although he had sighted it long before. The arm with the sword rose up as if newly stretched aloft, and round the figure blew the free winds of heaven.

'So high!' he said to himself.

FRANZ KAFKA[1]

Climb inside her head and look out of one of the jewels in her crown, and you will see a helicopter hovering opposite, and the stargazing bowls of camera lenses staring back at you. The passengers are waving, delighted by human puniness beside the looming face of the colossus. But unlike them, you are inside her and you cannot tell how small you seem. Instead you find yourself in a confined space that resembles the bridge of an old pilot boat, cramped, uneven in shape, and coated in institution-green gloss paint against corrosion. A sequence of grimy panes provide limited visibility, and are so tight-fitting and small that the kind of craft they might most appropriately belong to would be an old diving bell, an altogether inappropriate association in the radiant, exalted and upright head of Liberty Enlightening the World.

The notices at the bottom of the one hundred and seventy-one steps warn that the view is best from Liberty's pedestal, and that far above, inside her seven-pointed crown, vision is restricted. But everyone swarms up to the top inside her, for the voyage obeys imagination's logic and requires ascent into the heart and mind of Liberty. Departure, sailing across an ocean, docking at a small leafy haven, gazing up at the colossus who is benign and approachable, and then, to enter her, to find that she is enfolding, even pregnable: these are the phases of a common dream of bliss.

As the Circle Line ferry rounds the island where the Statue of Liberty stands facing the Atlantic, the children thronging the deck stop taking

snapshots and bopping to their headsets and tossing candy into their still unweaned mouths, and for a moment in unison, they roar Woah, Woah, Woooooah Ah Wah! The sound comes almost from the belly, through the throat, without help of lips or tongue: a visceral response, quite like the sound of a male audience in a strip joint when one of the girls promises to uncover big boobs, but here issuing from the mouths of girls, not just boys, Japanese, Puerto Rican, black, and perhaps too young to intend anything openly dirty-minded. Their roar, which greets the first sight head on of the immense frontal view of the immense statue, fades away quickly. It occurs at the moment when every reproduction of the statue merges with the reality and is belittled by the reality: such scale is one of the few phenomena in the contemporary world that defies replication, that only the original can possess.

The children's spontaneous roar pays tribute to Liberty's recognizability, it is the way an old, famous familiar is greeted, to acknowledge that she surpasses all previous mental images. Even when you have been told and have taken in that her nose alone is four and a half feet long – the height of the children on board – she is still much bigger than you expected. Woooah Wooah Woah! You are at a loss for words.

The statue rings all day to the noise as the visitors climb: the hollow shell turns into a copper tympanum. The children teem in the last coil of the spiral companionway, then collapse on to the metal platform, shrieking their exhaustion at the climb. 'Can I die here?' begs a girl, falling against a friend and then flinging herself into a corner of the head, just above the position of the ear. But those who do not protest against the ordeal of the ascent hardly wait to take in what awaits them in the crown. They throw a quick glance at the whirring helicopter outside, at the bulkhead windows, at the cramped space and call out, 'Is this all there is?' Another shouts, 'It looks like prison up here.' Then they clatter down again, taking the downward spiral of the double stair.

Inside Liberty's crown, standing above her eyes, in her cortex, it can be comforting, even jokey, to be completely disillusioned, to resist the imagery of might and light and hardness and ascent. The kids from the Bronx and the East Village and the Lower East Side and Harlem, even from Yonkers' more salubrious suburbs and the luxury apartments of the Upper East Side need to have their personal experience confirmed as well as the identity they have been given as Americans. They see Liberty from the sea in community; but separated by the single file stairs, they voice an independent understanding that gives each of them distinction, an individual sense of separateness and uniqueness that is

also a very American tradition when they repudiate the claim the Statue of Liberty makes. Through cynicism, through disclaiming the symbol's aptness, especially for them personally, they arrive at another form of self-affirming defence: 'Is this all there is?' 'Looks like prison in here.'

Disparagement is a kind of appropriation, and the Statue of Liberty is appropriated again and again by each of her visitors. The insides of the statue bear some of their names: Helena was here from Jackson, Francisco was here from Honolulu. They are scratched in the pale green, curd-like paint, an imitation of the colour of the outside, the verdigris of oxidized copper. There are plans to strip the paint from the inside and return the shell to its primal metallic gleam for the centenary of Liberty's installation in 1886. The present internal structure might also be changed, so that a safety lift can be operated. A few people have actually died inside the Statue of Liberty, especially in the summer when the temperature can rise into the hundreds and the statue becomes an airtight capsule to frizzle the faint-hearted. But the ordeal of the climb is part of the essential appropriation of the statue – and the statue's meaning – on the part of each visitor. The dizziness of the tight spiral stair, the crush, the heat, the impossibility of deviance once merged with the mass rising up the steps, the steepness and the height help to repro-duce, in miniature, the experience of the first makers of the statue, and to join in their imagination as they inched up the structure, ham-mering the copper sheets to the crane-like pylon of cast-iron struts and girders that Gustave Eiffel constructed for Frédéric-Auguste Bartholdi's sculpture.

In 1984, before restoration, this skeleton made the climb into the crown a unique journey. There is no other monument in the world that presents two such different faces simultaneously, no famous building with an interior so nakedly unadorned: the concealing, clad outer form, and the inner workings revealing the artifice. Seeing the inside recalls those large sixteenth-century northern European Paternoster rosary beads, memento moris, with the smiling dimpled faces of kissing lovers on one side, and the wormy skulls, half-devoured, on the other, or those lay figures of early medicine, when the doll of healthy imitation flesh opened up to reveal the veins and arteries, the organs, and finally the bones. Except that neither of these analogies fits the mood of the Statue of Liberty . There is nothing of mortality about her. Copper itself resists corrosion once the green patina has covered the first warm glitter of the metal. Liberty does not bear the long black streaks of acid rain that give public statues of stone a grief-stricken, careworn sophistication. The

internal structure of criss-crossing iron trusswork, the buckled straps of metal holding the sculpture's outer shell rigid, through which the stairs twist upward and downward, reveal how permanent, how impervious the statue is. To modern eyes, trained to enjoy self-revelation and inner structures, the interior of Liberty is more beautiful than the exterior. She is mechanical, strong, even though, as one engineer working on the restoration pointed out, the structure Eiffel designed was not properly assembled by the workmen who erected the statue three years after it had been crated in France for transport to America. They began attaching the copper sheets to the frame and found, as amateur paper-hangers do, that the drapery did not meet as it should have done, in the region of Liberty's right arm, which she raises to hold her torch. The facing of the statue had shifted round her body. So a few extra struts were added, just under her armpit, to accommodate the fault.

Visitors are no longer allowed to climb up the ladder in her arm to the torch, where twelve people can stand on the rim, and where Hitchcock's villain in *Saboteur* (1942) dangled till he fell to his death, but you can squint up the hollow of her arm towards the beacon, just as you can read her exterior from the interior on the climb, inverted as in a negative or rubber mould, the bunched draperies, the shoulders, the neck, the cheeks. The chief difference is that inside she appears to be made in strata like the earth. The sheets of copper were laid one upon the other in undulating ridges like the marks of tide on the sand, so that internally the sculpture ripples and flows more plastically than her resolute outer form would ever let one guess.

The beauty of the Eiffel Tower has been the subject of argument, but it has its aesthetic partisans; by making no distinction between internal structure and outer appearance, it is startlingly, visionarily modern in construction. The Statue of Liberty shares some characteristics with the Eiffel Tower, besides contemporaneity. Also, although Eiffel, an engineer, proposed many uses for his Paris tower, for observation, communications, meteorology, and although Bartholdi's statue functions as a beacon, the two constructions are both primarily monuments, practically without function. Stripped of use and service, they resist obsolescence. They are in the first place expressions of identity: Paris' sign has become the Eiffel Tower, though the tower's meaning is not precisely defined; but in the case of the Statue of Liberty, we have a monument with an unambiguously ascribed significance.[2]

Proposed by the jurist and historian Edouard de Laboulaye as a gesture of republican fellowship with the United States, the statue was formally accepted as a gift from the French-American Union in France by the

US Congress in 1877. Funds had been raised by public subscription from all over France, on the patriotic basis that as the French *philosophes'* idea of Liberty had been exported to America and inspired the War of Independence, so it would be fittingly commemorated by a French statue. Only Liberty's arm with the beacon was finished in time to be exhibited at the world fair in Philadelphia in 1876, the centenary of independence. Her head followed, shown at the world fair in Paris two years later, but a problem developed about erecting her *in situ* at New York harbour, for the French gift did not include the cost of the pedestal. Joseph Pulitzer, the proprietor of the *World* newspaper, hearing of the hitch in Liberty's move to her island site, started a campaign in his newspaper and raised the necessary money in small donations in a startling 147 days. The pedestal was designed by the eclectic architect Richard Morris Hunt in the style of a classical mausoleum, and in 1885, the statue, which had towered over the roofs of Paris from the workshops of Gaget, Gauthier et Cie., where Bartholdi had assembled it, was shipped to New York in 214 crates (Pl. 3). It was unveiled on 26 October 1886.

Although the political history of the statue, and its French origin, have not been erased from its story, Liberty is no longer La Liberté, but was identified from the start with an American ideal of democracy, now represented as an American gift to the world. Bartholdi created an allegory of the Republic in keeping with moderate rather than radical politics, to suit American taste and respectability in the late nineteenth century. His is a staid and matronly conception of the wild thing who surges across the barricade in Delacroix's *Liberty Guiding the People*, and could be guaranteed not to offend a people who had been dismayed by Horatio Greenough's marble statue of George Washington *all'antica* – naked under a toga.[3] He shifted the allusions of Liberty away from unbridled Nature in favour of an imagery of control and light, influenced by the symbols of the Freemasons, to whom Bartholdi belonged. However, as Gombrich has written, 'The balance of Justice or the torch of Liberty … are not just fortuitous identification marks…. Their choice is rooted in the same psychological tendency to translate or transpose ideas into images which rules the metaphors of language.'[4]

Bartholdi had been working on the idea of a colossus for some years. He had travelled to Thebes with the painter Gérôme and been much impressed by the huge statues in the desert, impassive, mighty, seemingly sovereign over time and history. He had already suggested to the ruler of Egypt, Ismail Pasha, that he build him a tomb with his portrait on a

colossal scale, sitting cross-legged on a lion over the entrance. Nothing came of this project. In 1867, Bartholdi also proposed a gigantic lighthouse for the Suez Canal: 'Egypt Bringing Light to Asia'. The maquettes for this still exist, and resemble Liberty except for their Egyptian dress. The idea of colossi was in the air, inspired by devotion to the buildings of the ancient world which the Ecole des Beaux-Arts had rekindled. In 1851-2 students had produced designs for enormous lighthouses, three of them anthropomorphic, after the famed Pharos of Alexandria crossed with the Colossus of Rhodes, two of the seven Wonders of the World (Pl. 2).[5] In 1878 the colossal *Germania* by J. Schilling, celebrating the foundation of the German Reich and the defeat of France, was completed on its site near Rüdesheim in the Rhineland.[6] But it is a nice irony that if the Pasha of Egypt had yielded to Bartholdi's blandishments, the Statue of Liberty under another name would now stand at the mouth of the Suez Canal.

Few people sail to Liberty Island to picnic there and climb up the statue in order to feast their eyes on its beauty. It is in fact remarkably hideous for a public sculpture of its date. The twist on the figure as she steps forward forcefully to brandish her torch provides the only movement in the statue, but it is visible, given the statue's size, from the right side only, in profile, and there it looks frozen, exaggerated and slightly vulgar, a soubrette's over-emphatic gesture. There can rarely have been so many yards of sculptured drapery that meant so little in terms of the figure they wrap, or conveyed as little sense of the material they imitate. Liberty clearly wears sheets of copper, not fabric. They are bent, rolled and pummelled, folded and tucked, but still unmistakably metallic, no kindred to cotton or linen. The only material they might recall is water proofing, the heavy stuff which cavalry officers wear in storms. Yet the ideals in Bartholdi's mind were classical, goddesses who gently filled clinging tunics, Junos in soft weaves straight from the loom.

Liberty's seven-pointed halo, a reminiscence of Helios, the sun god (a sunburst was the Bartholdi family emblem), has an unfortunate look of knife-like sharpness and rigidity, while the transition to the diadem, with its jewels serving as observatory windows, has been handled awkwardly. It grips Liberty's head like a military visor lifted by a mediaeval knight. Though classical rills have been incised into Liberty's hair, which has been dressed in the main in a loose Greek knot at the nape of her neck, Bartholdi framed the face with two kiss curls by each ear, and a bunch of sausage curls on either side of the neck, the kind of ringlets

achieved in the 1870s with curling papers, and the only tell-tale evidence in the sculpture of the exact date when it was first conceived. The face set off by these Third Republic sausage-curls is the face of a Greek god, without the redeeming sensuousness. Liberty appears here a thunderbolt judge of stern unrelenting character, upright and unmerciful (Pl. 5).

Children's books on sale at the statue describe how 'the classical features of Liberty radiate an exalted beauty as well as strength',[7] but this is a caption to a photograph taken in soft focus through a peach filter and sharply angled from below. In illustrated books, the artists have invariably failed to reproduce Liberty's face at all accurately. They have, consciously or unconsciously, mellowed Bartholdi's vision, either by giving her a more compassionate expression, or by softening the downward curve of her lips and the beetling jut of her brows.

Bartholdi however made up in size for his lack of conviction in artistry: his materialization of the ideal gains its energy entirely from its enormousness, its boggling hugeness. America produces many of its trademark images in the colossal, exclusive mode: the Empire State Building, the World Trade Centre's twin shafts, the Presidents of Mount Rushmore, the Statue of Liberty. Liberty's torch was perfected, after years of difficulty, by Gutzon Borglum, the sculptor who later carved the features of Washington, Jefferson, Lincoln and Theodore Roosevelt in the granite face of a Dakota mountain.[8] The national love of gigantism has been taken to its logical and witty extreme by one of America's finest contemporary artists, Claes Oldenburg. Throughout the sixties and seventies, Oldenburg drew schemes for huge monuments, to celebrate the materialist society's inventions, appliances and domestic wonders: he transformed a lady's panty girdle into the majestic portals of a stock exchange (Pl. 3);[9] he captured London's atmosphere in the sixties with his project *London Knees,* a sketch of a mini-skirted girl's legs, lopped at mid-thigh and slightly knock-kneed, towering over the Thames skyline. Oldenburg's jokes are not frivolous, however funny; with his series of soft sculptures he has recognized metaphors axiomatic to our culture. Hardness and potency, softness and weakness belong together naturally, it seems. By making a typewriter or a kitchen beater limp and flaccid, he empties them of function and purpose, and instead bestows on them a pliant and nonsensical charm, pointing up the traditional view of what is feminine. And with his sequence of imagined colossal monuments, he comments vividly on another fundamental metaphor in the way we conceptualize the good: big and strong is better than small and feeble. Confronted with his gleaming-blue builder's trowel, of Brobdingnagian dimensions, we are thrilled by its scale and

yet uneasy that mere scale can thrill us in this way. Oldenburg celebrates the hyperbolic, but bitingly; he is always aware of the image's internal structure and he knows how to make us aware of it, to our discomfiture.[10]

By altering the sex of the more familiar antique wonders and by conceiving of his monument as a penetrable container, Bartholdi adapted the phallocracy of the ancients to create a symbol of the universal mother, of the bodily vessel as an actual temple. In this, his design recalls the most ancient edifices of the archaic past, the Stone Age temple of Skara Brae in the Orkney Islands, for instance. Arranged in the cinque-foil form of a schematic female body, the entrance lies through the birth passage into the sanctuary within.[11]

Bartholdi also reveals traces of matriarchal tendencies found in utopian socialist fantasies during the earlier years of the century.[12] In 1833, in a utopian plan for Paris, one of the adherents of the visionary Saint-Simon proposed for the capital's centre a colossal settlement in the shape of the 'Female Saviour' of Saint-Simonianism. He described her as so large that the mere globe under her right hand would hold a theatre. In her other hand, she would carry a sceptre and 'from the tip of this sceptre [would rise] a flame, like a drawn-out pyramid, a huge beacon, the light of which would shine out into the distance, revealing her smiling face in the depths of the darkness'.[13]

After his father's death, Frédéric-Auguste, aged two, was taken to Paris by his mother, and brought up by her alone, and he never shook himself entirely free of her, as the statue makes clear. For although Bartholdi's wife posed at length for the maquettes during Liberty's five-year gesta-tion, it is the countenance of Mme Bartholdi, *mère*, which we behold in the statue.[14] She was by all accounts a grim, overbearing character. Their family home in Colmar had been occupied by Prussians after the defeat of France in the war of 1870 and the annexation of Alsace, and Bartholdi experienced the full outrage of his mother at this vio-lation.[15]

The Statue of Liberty soon acquired the character of a mother, the 'Mother of Exiles'. Emma Lazarus, writing in 1883 in the context of US immigration from Russia during the Tsarist pogroms, composed the famous verses which were inscribed on a plaque on the statue's base in 1903. Liberty speaks:

> Give me your tired, your poor,
> Your huddled masses yearning to breathe free,
> The wretched refuse of your teeming shore.

> Send these, the homeless, tempest-tos't to me,
> I lift my lamp beside the golden door![16]

The verses catch the invitation extended by the statue's myth to identify with her, and in so doing to ally ourselves with Liberty and distinguish ourselves from others who do not enjoy her or her fruits. We are all her children, she speaks to us in the voice of a mother, as if responding to the entreaty of the ancient antiphon to the Virgin Mary, the *Salve Regina*: 'Exiled children of Eve, we cry unto thee, wailing and weeping in this vale of tears. So ... turn thy merciful eyes upon us.' Emma Lazarus' famous flight of rhetoric dissolves the harshness of Liberty's countenance, and she becomes a mother of mercy. Her meaning is freedom, it is we who appropriate her, we who are free, or at least, as the children pointed out in the head, free to say we are not free. She is the container of our definitions of ourselves, not for American visitors alone, but for visitors to America who consent to American influence or reject it. Perceived either as a lie, or as a statement of the truth, the claim that the Statue of Liberty makes on behalf of the United States defines the nation's self-image. As a children's book, *Our Statue of Liberty*, says: 'Americans love Miss Liberty because everything about her shows our freedom. The book in her left hand carries the date of our nation's birth, July 4, 1776. The broken chain at her feet means that we became free by breaking away from England. The rays of her torch show how our liberty lights the way for the rest of the world.'[17] Others interpret the statue's attributes with less attention to the historical past: the shackles represent tyranny everywhere at any time.[18] Given the vastness of the statue's claim, and the intensity with which political America identifies with it, it is surprising that so few attempts have been made to occupy or bomb it.[19]

The myth reverberates and the structure incorporates: when we visit the statue, and especially when we enter into her, we are invited to merge with her, to feel at one with her. Beside the entrance to the evangelizing Museum of Immigration installed inside the plinth, there used to stand a painted image of the Statue of Liberty with a hole for a face, like a seaside photographer's booth. You could stick your head through the hole and take home a snapshot of yourself as Liberty, carrying the caption 'My Ideals'. Most visitors did – that was the point. The statue's hollowness, which we occupy literally when we make the ascent to Liberty's equally empty head, is a prerequisite of symbols with infinite powers of endurance and adaptability. She is given meaning by us, and it can change, according to what we see or want. As William Gass has written,

Great memorials are curiously non-committal. Remove Lincoln's statue and put in FDR's. No problem. Greek temples are quite general. Liberty's torch can stand for Victory. Or Fidelity. Or Truth.... The Sphinx says nothing to us; it is blank in its stare as the sky and silent in its posture as the sand – or, if you wish: sky silent/sand blank ... the monumental monument tends to be, in this way, an open emblem. It tends to be

FOR RENT[20]

We can all take up occupation of Liberty, male, female, aged, children, she waits to enfold us in her meaning. But a male symbol like Uncle Sam relates to us in a different way, and the distinction between the two figures who have become emblematic of the United States indicates a common difference between male and female figures conveying ulterior meaning. The female form tends to be perceived as generic and universal, with symbolic overtones; the male as individual, even when it is being used to express a generalized idea.

'Uncle Sam', who appeared in New York State around 1812 as the owner of the initials U.S., stamped on government supplies to the army and other goods and equipment, stands to America as John Bull stands to England, an epitome of the nation's character, a collective caricature. John Bull too, has his humorous side; like Uncle Sam he is not thought to be based on anyone in particular, but was first born in print in Dr John Arbuthnot's pamphlet of 1712: 'Law is a Bottomless Pit, exemplified in the case of Lord Strutt, John Bull, Nicholas Frog, and Lewis Baboon, who spent all they had in a Law Suit.'[21]

John Bull typifies the Englishman; Uncle Sam and Brother Jonathan the US citizen. But Liberty can hardly be said to represent the typical American woman, or Britannia the Englishwoman of collective consciousness. Men are individual, they appear to be in command of their own characters and their own identity, to live inside their own skins, and they do not include women in their symbolic embrace: John Bull, however comic, can never be a cow. But the female form does not refer to particular women, does not describe women as a group, and often does not even presume to evoke their natures. We can all live inside Britannia or Liberty's skin, they stand for us regardless of sex, yet we cannot identify with them as characters. Uncle Sam and John Bull are popular figures; they can be grim, sly, feisty, pathetic, absurd, for they have personality. Liberty, like many abstract concepts expressed in the feminine, is in deadly earnest and one-dimensional. Above all, if John Bull appears angry, it is his anger he expresses; Liberty is not representing her own freedom. She herself is caught by the differences, between the

ideal and the general, the fantasy figure and the collective prototype, which seem to hold through the semantics of feminine and masculine gender in rhetoric and imagery, with very few exceptions.

It is hard to refuse Liberty's invitation to be part of her, precisely because she is so unsuccessful as a work of art; clumsiness itself is democratic in a way a masterpiece cannot be. But the Statue of Liberty also engulfs us because she inspires one of the great sensual pleasures of the eye, dependent not upon aesthetic delight but upon the psychology of vision, inherent in the layered meaning of the very word. She gluts the eye with a sense of power, springing from the sensation of seeing the future. When we sail to the island, we know that downtown New York was not what it now is when the Statue of Liberty was made, that the tip of the island of Manhattan was wilderness not long before. When we look across from the foot of the statue towards the massed towers of steel and glass and stone, exploding as if in frozen fission, like a giant crystal's spars, we are looking at a future that has happened. We experience Manhattan paired with Liberty, twinned by upward thrust, by man-made origin, by vastness of scale. The city's pile becomes itself allegorical of human size and form: load-bearing and boned like the human body in its totality, the column that Vitruvius saw as analogous with that body, made gigantic. The city and the statue strike echoes one off the other, and both come to stand for America itself. So passengers arriving by boat and immigrants bound for Ellis Island saw Liberty as America's symbol, a version of the allegory Columbia, who had been hymned by the army during the War of Independence as the spirit of Liberty:

> Hail! Columbia happy land,
> Hail! Ye heroes, heaven-born band....
> Peace and safety we shall find ...[22]
> Firm, united let us be
> Rallying round our Liberty
> As a band of brothers joined
> Peace and safety we shall find ...[22]

The statue raised immigrants' hearts and hopes. Kafka's protagonist mistaking her torch for a sword may appear apt, but it is not clear that the irony was intentional. Emma Goldman, the anarchist, found that her eyes filled with tears when she first saw the statue – then new – in the dawn mist in 1886: 'Ah, there she was,' she wrote, 'the symbol of hope, freedom, opportunity! She held her torch high to light the way to the free country, the asylum for the oppressed of all lands.'[23] Half a century

later, towards the end of the Second World War, when the Greek immigrant Christos Gatzoiannis sent a postcard showing the Empire State Building to the family he had left behind, he said, 'I am writing this from the top of the tallest building in the world. It has 102 floors. On one side I can see the Atlantic Ocean and the statue of the woman called St Freedom, which is so big you can climb up and stand in one of her fingers. This is how America looks.'[24]

Since then, the outcrop of Lower Manhattan, shooting up skyscrapers in ever-increasing density, a coppice of titanic mineral growth, at once primeval, like the origin of the world before blood and lymph and vegetable matter, and futuristic, made of smooth planes and impermeable surfaces like a space capsule, appears to have given Liberty an answer, almost a reward: Manhattan seems to say, 'This is what you have brought about, this is how you have made America look.' The pledge of freedom is understood as power, not just promised, but achieved. And unlike the statue, Lower Manhattan is one of the most splendid sights in all the world and one which cannot be resisted. It offers itself to view as a planar, scenic whole. From the vantage point of the statue, itself one entity, Liberty in a single form, you contemplate the spectacle of the great computing city as another, and the effect is exhilarating, the sweep of the city unfurled as a single vista. The film *Superman*, the first of the series, directed by Clive Donner with a lyrical sense of fantasy, includes a long dreamy sequence in which Superman takes Lois Lane flying above New York; the city looks enchanted, the Statue of Liberty a doll in the starlit map laid out below them. But it is only fitting that the hero who fights 'a never-ending battle for truth, justice and the American way' should fly down to circle the head of Liberty.[25] When the lamp was taken down for renewal, in the summer of 1984, a full scale ritual marked the occasion, in order to cancel any ominous resonance that the extinguishing of her precious torch might create. Speculators vied to take possession of scrap metal from her fabric, like pardoners in the Middle Ages hunting for relics, and workmen commissioned to polish and renovate were widely interviewed and spoke of the task in awed tones, as if they had heard a call, not been given a job.[26] The statue does not record the past, except for the allusion to the Declaration of Independence. It anticipates continuously a future that is always in the process of becoming: hence Liberty's determined step forward, her lamp held up to illuminate the space we cannot see, the time to come. She expresses intention, more emphatically than act; we are all subjects of incorporation in that regard. We all hope to be free, we could all be free.

That is what the statue holds out for us to accept, as we stroll the island with the kids who scoff their 'monster crunch', their 'club' and 'hero' sandwiches and jive, on the spot, all girls together, to giant ghetto-blasters standing on the ground, while the boys line themselves up on the wall opposite Liberty's back and watch.

The Statue of Liberty has been used to legitimize political campaigns, to seal them with moral dignity, like the posters of World War One which urged Americans – especially immigrants – to remember Liberty and buy government bonds (Pl. 4).[27] Now the cipher turns up in sunglasses and sweater, lipstick and transistor earpiece, on a poster for New York's rock radio station WAPP, in advertisements for cut-price air travel, in a publicity shot of Mae West guying the pose with her hour-glass figure, striped like the US flag in lamé and satin, and a fall of blonde curls and invitingly half-parted lips. WeeGee took a photograph around 1950 of the statue warped and stretched as in a fun-fair's hall of mirrors. The children's books still aim to be edifying and patriotic to keep up the moral tone, but it is becoming harder to use Liberty for serious causes without irony. She identifies the city and by extension the nation, and she provides a benchmark of an ideal few people still believe has been upheld or will ever be fulfilled. Mae West and the rock radio sweater girl deflate all that earnest endeavour of the later nineteenth century, with its innocent optimism that looks so antiquated from our post-war vantage point.

She was not the first representation of Liberty in a public place in America. On the dome of the Capitol in Washington, DC, a bronze Freedom Triumphant, sculpted by Thomas Crawford, was raised in 1863. She is nineteen and a half feet high, compared to Liberty's one hundred and fifty-one feet one inch, but she stands at the centre of Washington, and dominates the city, visible from a great distance in a town where buildings taller than the Capitol's dome are banned. Crawford, a distinguished neoclassical sculptor based in Rome, created a more appealing figure than Bartholdi later managed. Sensitively modelled, in a heavy-fringed mantle, she stands in a relaxed position. On her head she wears a wreath of stars round a feathered helmet like a Renaissance allegory of the New World, the fourth continent America, but seen from the ground this headdress makes her look like a Red Indian, a heroine like Minnehaha. Crawford had wanted to cover Freedom's head with the customary liberty cap of Europe, but by then the bonnet was a sign of thoroughgoing radicalism, and the design aroused the objection from the architectural overseer of the Capitol that it was not intrinsically

American enough.[28] Crawford made the alteration, to feathers, and he thereby unwittingly and effectively robbed his statue of universal connotation. Any such specific historical reference to identity or history can put a strain on an image's survival as symbol; the fate of the Indian under American freedom consigned Crawford's fine interpretation to necessary oblivion.

Classical allegories, using the female form, abound in the United States' public places. In New York, Justice, holding her scales, stands over the law courts. The chapel of St Paul in the Civic Centre district, founded in 1764, is the oldest church in the city, an example of British classical architecture, stranded like an architect's model between the dizzy columns of Wall Street. It displays inside the arms of the State of New York, painted by a naïve eighteenth-century artist in imitation of the highest Western models. The bearers of the arms are Justice and Freedom, the latter in rosy décolletage and carrying on her spear an uncensored liberty cap. And at night, on the downtown skyline, a single feminine form lights up and dominates the view of TriBeCa and the business district by her singularity and her height, as she stands in a gentle amber aureole among the glinting shafts of Wall Street and the Trade Centre. The windows around wink and flash in cryptograms, a galactic console of messages coded in light, in diamonds and topazes and amber. High up on the pinnacles of the grey pyramidal mass of the Civic Centre's Municipal Building there appears this single shape that recalls the human form and not the electronic impulse or the illuminated and abstract perforation. It is gilded, sinuous (especially in the context of Lower Manhattan's perpendiculars and horizontals) and represents Civic Fame, under the aspect of a classical figure of Victory, bearing a palm to the winner. The statue was sculpted by Adolph Alexander Weinman, and erected a generation after Liberty, two generations after Freedom Triumphant on the Capitol.[29]

Weinman's *Fame* is perched too high up for us to make out the artistry of his execution but, even at such a distance from the ground, she does not move as lightly as Augustus Saint-Gaudens' uptown interpretation of Victory, in gilt and bronze on the southern corner of Fifth Avenue and Central Park (Pl. 43). She leads General Sherman's horse by the rein towards the bountiful naked nymph in front of the Plaza Hotel as if stepping forward through the throng and the traffic to drink at her fountain. Saint-Gaudens was born in Ireland in 1848, but came to New York as an infant. He returned to Europe to study, in Paris and Rome, and his graceful, precise, elegant and often elongated forms bear the imprint both of Second Empire Paris and of the Belle Epoque, and are

alive to the gifts of the senses and redolent of pleasure.[30] His Victory is perhaps too light-hearted to commemorate the grim General Sherman, but she is an ornament of *raffiné* appeal in New York today. The comparative shallowness of the pedestal makes the goddess appear to float just above the passers-by, almost at one with them, as they enter the park or press to the kerb at the Walk/Don't Walk sign.

The times in which Thomas Crawford, Frédéric-Auguste Bartholdi, Augustus Saint-Gaudens and Adolph Weinman worked have marked their formal aesthetic. Their central assumption, however, that an abstract concept – liberty, justice or victory – can be appropriately expressed by a female figure, remains in force today, and it is rarely challenged, although few people think that women have special claims on liberty, or victory, or justice. No visitor, looking up at the colossus of the Statue of Liberty, imagines her appearance is a sign that women have enjoyed privileged access to freedom in the United States, then or now, or that the society which has accorded her such a high place in its symbolism ever believed that to be the case.

The convention arrived in America from Europe, by way of Rome, where Crawford for instance kept his studio, but above all by way of Paris, where the architects and sculptors of the United States in the nineteenth century had all gone to school. In Paris, the metaphor of the female body had proved serviceable for over a century of civic aggrandizement and inspired self-adornment. Patrons, politicians, connoisseurs, kings – and rulers of other kinds – had embellished the capital with images of their ambitions and their deeds, just as the early Christian monarchs studded the covers of their most precious books with cabochon stones. Gems have no worth without the value and significance ascribed to them from without; but women, so often the predominant conveyors of ulterior meaning in Paris, are not mute mineral, and their marvellous allegorical range, in a single small area of central Paris, can tell us something about what we have cherished, found valuable, held *dear*.

CHAPTER TWO

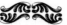

The Street (Paris)

In every period of history, those who have governed people have always made use of paintings and statues, the better to inspire the feelings they wanted them to have, be it in religion, or in politics.

LE CHEVALIER DE JAUCOURT[1]

The indifference of a nation with regard to sculpture betokens a great fault in public education. Where disdain is felt for the cult of beauty, there can be no love of philosophy, for the love of form is a prerequisite of wisdom.

CHARLES BLANC[2]

It's a bright morning. The trees seem to quiver in the sharp blue light, but that effect will pass as the full chill of the winter air begins to thaw towards noon; besides, it is beautiful, this winter day in Paris, it suits the blonde of the local stone, the brown, choppy waters of the Seine, churned by slow, smooth-backed alligator barges, the gleaming slate and the buff-strewn *allées* between the pleached skeletons of the chestnuts and the limes.

From parliament to palace, police station to mausoleum, from cathedral to museum, the trace of power in Paris can be easily picked up and followed by the *flâneur*. The genius of its planners, especially of Haussmann, who became Prefect of the Seine in 1853, under the Emperor Napoleon III, and inaugurated one of the most extensive remodellings of a city ever undertaken, has rendered Paris and the imagery of the architecture as legible as a chapbook, when the writers and readers consent together to shared meanings and beliefs. London, by contrast, is a blurred palimpsest, and to decipher its plan you can need the expertise of a tracker as acute as a !Kung tribeswoman, who can tell not just that someone has passed, but who it was from the weight of the footprint

on the ground. In London the Prime Minister works from a small house approached obliquely down a side street. The city's main church, St Paul's, is hidden from view by a railway bridge and a clutter of offices; no processional thoroughfare leads to the seat of justice or police headquarters. Paris puts Paris' points like a rhetor making a speech: important buildings are visible from afar – Notre-Dame, the Eiffel Tower, the Sacré-Cœur – or they close vistas with majestic drama – the Arc de Triomphe, the Invalides, the Madeleine, the obelisk of the Place de la Concorde. The city is an ensemble, each of the sections combining to produce one of the most splendid and pleasurable urban landscapes in the world, a palpable realization of beauty on a grandiloquent scale. But Paris holds sway over us through charm too. The charm flows from the familiar details of Paris' overall look: the *terrasses* with the basket-weave, oval-backed chairs and the Ricard bottles and ashtrays in bright yellow, the awnings with plump flowing lettering giving the names of cafés and restaurants, the dark blue and white enamel rectangles of the *arrondissement* and place names, the newspaper kiosks of dark green, the billboards like dovecotes, and the distempered pale grey of the tall houses of Vieux Paris, with narrow louvred shutters and the steep gabled windows of the *chambres de bonne* on the sixth, seventh floor. But the city is also rescued from portentousness chiefly by the lavish use of architectural ornament, the efflorescence of stone on façade and portal, the scrolls and garlands and swags, beaded cornices, fluted pilasters, windows hung about with splendid trophies, floral entablatures, and, above all, by the concourse of human figures.

Baudelaire wrote, in 1859:

You walk through a great city grown old in civilization, one of those containing the most important archives of universal life, and your eyes are drawn upwards, above, to the stars; for in the public squares, at the corners of crossroads, motionless characters, taller than those who pass by at their feet, relate to you in a silent language high legends of glory, of war, of knowledge, of suffering.... Were you the most carefree of men, the unhappiest or the meanest, a beggar or a banker, the stone phantom seizes you for a few instants and orders you, in the name of the past, to think of things which are not of this world.

This is the divine role of sculpture.[3]

From the *ancien régime* through a succession of Republics, kingdoms and empires, French governments have used the human form, and especially the female form, to decorate the seats of authority and prestige. Paris' rational plan, the neoclassical pomp of so many of its greatest

buildings (with the clear exceptions of the Eiffel Tower and the Pompidou Centre) are sweetened by the presence of bodies, of sylph and muse, goddess and dryad, caryatid and angel. Even angels: in nineteenth-century Paris, winged beings of the air are unmistakably bosomy, unlike their austere counterparts in the mediaeval cathedrals' images of the Last Judgement, where the manly archangel Michael spears the devil. The play of female figures upon the masonry of Paris provides a palliative to the city's formal, official reasoning, its ceremonious utilitarianism, the collective and anonymous voice of its public beautifiers with their boasts made manifest in marble. The sinuosities and interruptions of the buildings' presence eroticizes their appearance, just as the drape that still clings in broken waves around the legs of a Venus Anadyomene enhances the enticing apparition of her body. Like the drape, architectural ornament, even in the shapely and beckoning guise of nymphs, can remain invisible unless attention is consciously drawn to it; its presence is ancillary, a hint, an accent like the underscored violas in a symphony, almost unheard but essential to the harmony. When the figures' role is central, in a frieze on a pediment for instance, or at the apex of a building, they can deepen and soften the building through a story or a memory of past crises, often disasters masquerading as glories. But they can also, especially when badly executed, increase the unremitting pressure of the building as propaganda. The unconscious erotic draw of the human figure in itself remains, sharpening the text, in its falsehood or its veracity. A statement in words can be refused acceptance more easily than a statement represented by the human body, male or female. Our own identity as human beings has somehow been put at stake by the image's form, drawing us to consent to its meaning.

Pierre Vidal-Naquet has warned,

> There is a danger – that of taking refuge in what Hegel used to call 'the serene kingdom of friendly appearances'. . . . Institutional, social and economic history . . . yields its full values only . . . when it can be combined with the representations which accompany, or one could even say penetrate, the institutions and the observances of the social and political game.[4]

The city carries a story, the city presents a lure into its own version of the past; you could say it tells tales; that it lies.

But let us walk through the kingdom of friendly appearances,[5] starting in the Place du Palais-Bourbon, where the harmonious eighteenth-century south front of the building that now houses the Assemblée Nationale faces out over the pearl-grey shuttered elegance of the square. A motherly recording angel holds the tablets of the law over the gateway

to the inner courtyard, now the back entrance to the parliament. In the square, a regal seated figure of the Law sits in Roman tunic and mantle, her brows clasped in laurel, while on the plinth more wreaths enclose the emblems of Equality and Truth: a snake curls round a mirror to denote Prudence, branches of bay entwine a short broadsword of Righteousness, and the vigilant Jacobin eye stares between the pans of Justice's scales. *La Loi* is a dull statue, commissioned to celebrate the Constitution of 1848 by the Minister of the Interior from Jean-Jacques Feuchère, but only erected in 1854, when the Republic had collapsed, and Louis Napoleon had seized power in France, and the Constitution had become a dead letter (Pl. 6).

The irony of that *main de justice*, the sceptre of legality she holds in her right hand, seems heavy, and too neat. Perhaps it is pietistic to point out the discrepancy: officialdom everywhere marshals similar rhetoric to its support, and Feuchère's Law in the Place du Palais-Bourbon is comparatively innocent, not being sentient. So, too, is the sculptor himself, since that is the artist's condition, to wait upon patrons, private and public.

Feuchère's *La Loi* represents the formal conventions of mid-century, as so often inferior works do more clearly than exceptional achievements. For without her mountainous bosom there could be a problem: we might mistake the seated figure for an individual, a ruler or emperor whose deeds might not have been exemplary all the time, a Galba or Heliogabalus. The face is cast in the noble mould; impassive, resolute, vacant, without sex, but tending to the masculine. But Feuchère leaves us in no doubt that we are not gazing at reality but at a materialized ideal of Law. The female body that shows through the tunic makes the figure anomalous for any real context, since women in men's clothes did not rule.

La Loi is practically invisible; central to possibly one of the most charming small squares in Paris, few visitors look at her or register her existence, however imposing. Mediocrity of execution, banality of interpretation have given her the fairy tale's magic gift. As Robert Musil has written, invisibility is the condition of statues:

> ... the most striking feature of monuments is that you do not notice them. There is nothing in the world as invisible as monuments. Doubtless they have been erected to be seen – even to attract attention; yet at the same time something has impregnated them against attention. Like a drop of water on an oilskin, attention runs down them without stopping for a moment....
>
> They virtually drive off what they would attract. We cannot say that we do not notice them; we should say that they de-notice us, they withdraw from our senses....

What becomes more and more incomprehensible the longer one thinks about it is why, if matters are the way they are, monuments are produced particularly for great men. It looks like fiendish malice. As one cannot harm them any more during their lifetime, one has chosen to hurl them, with a memorial stone around their neck, into the sea of oblivion.[6]

But the figures of legend who clothe themselves in the magic cap of darkness act upon other characters unbeknownst to them. If La Loi were removed from the square, her absence would be acutely felt, even if her precise identity could not be recalled exactly.

Rounding the Palais-Bourbon itself, as you walk towards the river, you come to the Assemblée Nationale's monumental façade, built in the previous reign, that of Louis-Philippe, on to the back of the Palais, in order to provide a balancing portico to the Madeleine which stands opposite on the other side of the Seine, across the Place de la Concorde. The Assemblée Nationale was not cleaned during Pompidou's campaign, and its storied face, the two bas-reliefs flanking the colonnade and a vast pediment of grandiose ambitiousness are covered in a thick slut's wool of urban grime, which moulds and clothes the muscly contours of the many bared arms and legs and torsos of the figures.[7]

The pediment, by Jean-Pierre Cortot, was finished in 1842. It would remain drearily didactic and inanimate even if it were dusted. It duly conforms to classical formulae, showing a stout République with a tablet marked 'Liberté Egalité Fraternité', flanked by one or two male figures – Mercury, for instance, and Mars – but generally by women of the dimensions politely termed Juno-esque, who represent the Seine, Abundance, Agriculture, Geometry, Engineering, Justice, to name but a few of these Olympian epigones. Strength appears on the Republic's left. A female Hercules, literally, she leans on a huge club with a lion's pelt thrown over her head, the paws knotted over her capacious breast.

A work like Cortot's takes note of antique sculpture with the dull pupil's conscientiousness; under his chisel, the antique language of personification and the neoclassical taste for elaborate public statements in the allegorical mode become empty. The reason does not lie in the iconographical language itself or the formal observances of Cortot's pediment as such, and it is the laziest form of criticism to maintain that it does. Such a pediment, and other works of similar heaviness and boredom, taint the visual language of classical allegory by association. Another artist, like his greater contemporary François Rude (d. 1855), who worked on other parts of the building, might have made the stone dance and leap. The claims of political sculpture can be put more subtly too; the Assemblée Nationale's cluster of hollow meanings at its very

door gives added point to the placards and slogans of the protesters who gather in front of this building to picket or march. A contrast is immediately produced between meant rhetoric – the sincerity of the demonstrators – and meaningless rhetoric, the bad faith of the parliament's portal. Bad public art lies clumsily, and though less inept lying clearly imperils us too, bad art endangers us as insidiously in a different way.

The demonstrators this bitter winter day are a handful of medical students in white, circling while the watchful police group in a concentric ring around them. Their orders of surveillance were probably issued from the offices of the Préfecture de Paris just round the corner from the Assemblée Nationale, in the Hôtel des Invalides. The Esplanade des Invalides makes a resplendent and gracious sight, symmetrically deployed in theatrical perspective to lead the eye up to the vanishing point of the narrow and airy proportions of Mansart's dome above Libéral Bruant's magnificent façade. The wind lashing the wide empty space is making the passers-by sway between the pollarded lime trees and over the small ancient cobbles, while official Ministry cars slide past like black fish, waved on by the soldiers who stand guard under the trophy-garlanded windows by the cannons and other mementoes of war.

At the Invalides, the Sun King and Napoleon are joined in memory across the gap of time like embracing tetrarchs. Louis xiv built the Invalides to house the casualties of his military campaigns, the *mutilés de guerre*, the war veterans whom its name recalls, and ordered that they be cared for in a hospital that was a counterpart of the royal palace at Versailles. Versailles' architect, Hardouin-Mansart, worked on the church of Saint-Louis, surmounted by the famous dome of the Invalides, behind the huge Hôtel itself. The whole hospice extends an apologetic for the King; his magnanimity is here enshrined. In the harmonious deep arch of the central tympanum over the entrance, he rides in bas-relief on a plinth on which his generous gift is recorded. On either side, reclining against his pedestal almost nonchalantly, Prudence and Justice sit. Prudence looks into her hand mirror, in which a snake is also regarding itself, and in the glass they both see clearly what is to be done, as does their protégé the King, while Justice looks up at the monarch.

The sculptures were mutilated in the Revolution, for in times of political upheaval previously bland images acquire precise meanings and sudden, high visibility; and so are torn down or defaced. In 1815, they were restored. The original soft roundnesses of flesh under the crisp taffeta and heavy satin draperies achieved by the subtle chisel of the elder

Guillaume Coustou in 1735 have been lost altogether in the figure of the King and his horse and only survive in part in the figures of the two Virtues. But Coustou's skill can be savoured in the surviving statues of Mars and Minerva who flank the doorway; like the Virtues, they survived because they do not portray anyone in particular, and are insignificant and therefore innocent before history's tribunal.

To enter the Dôme des Invalides, you take a corridor to the side of the huge building. It takes you past a statue of Napoleon which was submerged in the Seine for safe keeping during the Commune in 1871, and reached its present site, in the chief temple to the Emperor in Paris, in 1911.

To the south the entrance portal is surmounted by four severely eroded statues of the Cardinal Virtues by Antoine Coysevox (d. 1720), genial interpreter of Louis XIV's hedonist tastes, and placed there when the church of the Invalides was the veterans' private chapel. But they have now been annexed by Napoleon to exalt his posthumous reputation, as have also Coysevox's spirited renderings of Saint Louis and Charlemagne, forerunners of righteous military triumphs, in niches on either side of the entrance.

Napoleon said, 'I desire that my ashes should lie on the banks of the Seine in the midst of the French people whom I have loved so much.' These words are written in bronze over the entrance to his vault and are recited out loud in awed emotion by the dozens of visitors. The body – not the ashes – of the emperor was returned to France in 1840, and sealed in a magnificent tomb of red quartzite, resembling imperial porphyry, given by the Tsar. The sarcophagus lies under the apex of Mansart's dome as if the *ancien régime* had foreseen the need to provide France's future emperor with a fittingly glorious burial place.

The circular chamber below ground level, at the centre of which stands the sarcophagus, separated from the visitor as if by a moat of marble, creates a drum-like resonance that stretches the silence most powerfully. It is an awesome experience of public narrative to gaze on Napoleon's tomb from the balustrade, and to circle it, finding at every column a gigantic figure of Victory standing in vigil over the tomb, deepening by her static pose and massy scale the effect of eternal sleep under the dome.

There are twelve Nikai, or Victories, on guard. They were commissioned from James Pradier, for it was under his patron Louis-Philippe that Napoleon's remains were returned to France and the Invalides arranged to receive them. The statues are slightly differentiated by attributes – one holds keys, another a scroll, another a sword – and by

modified hair-styles, but the overall effect is of an unbroken female rampart of broad breasts, broad hips and half-bowed heads. Only their eyes are wakeful.

Napoleon's Guard of Honour is pagan. The marble bas-reliefs which cover the walls of the ambulatory extol different phases of the emperor's ecclesiastical politics, also in classical icons: Napoleon as Roman Emperor tramples underfoot Envy and Discord while uniting Church and State. In some plaques he is heroically naked; in another, with all-embracing eclecticism, he appears as Christ the Judge. 'Everywhere that my reign has passed, it has left enduring traces of its benefits', reads one of the many glorifying inscriptions beneath an image of Napoleon as the sun god Helios, presiding over the rebuilding of Paris, the four bridges over the Seine, as well as the harbours, canals and roads that he saw developed all over France. The use of the first person at the Invalides is crucial to the transfiguration of Napoleon in death; his unquenchable spirit still speaks from the grave: but not of the dead French people he loved so much and left on the fields of Europe – a death toll of thousands in twenty years of warfare – but of those benefits he conferred, legal, cultural, educational, commercial. Pradier's Victories embody Napoleon's triumphs under the least military guise available in the repertory of easily understood forms. As wingless angels, descending from the grandeur of the first Rome, they evoke the second Rome of culture and civilization that the emperor in the tomb claimed to bring into being, and banish memories that he was also a soldier whose hubris brought him defeat and exile.

Walking back to the river from the Invalides, the *flâneur* faces the Pont Alexandre III, built for the Great Exhibition of 1900, and named after the Tsar who visited Paris that year. Its lavish style echoes the baroque ornamentation of the Invalides' fronds and garlands, masks and cartouches with skittish exuberance, while beyond the bridge, the gleaming seal-grey forms of the two great exhibition halls, the Grand Palais and the Petit Palais, built at the same time, swell as if inflated by air. They are as studded with statuary and ornament as a truffled galantine by Brillat-Savarin laid out for a repast of giants (Pl.8).

This prospect from the Esplanade des Invalides over the water epitomizes Paris of the Belle Epoque. The bridge's blend of colours, the blonde stone of its columns, the faded gilt of the Renommées – the figures of Fame – who blow their trumpets from the summit, the bright verdigris of the hammered copper sculptures on the parapet, and at the corners, the dark grey of the fantastic chandeliers and the pale violet glass of their globes, creates an ensemble at first glance almost garishly variegated and

cacophonous. But in the stiff breezes that whip up the river, the vista soon communicates a hectic, intoxicated mood, a frenzy of gaiety, not of chaos or despair.

The ornamentation that makes up this froth of stone and metal imitates organic form. In tribute to the waters the bridge spans, many aquatic fancies, marine flora and fauna, besport themselves on its structure: there are dolphins and baby Orions playing on their backs, mermaids and ships' figureheads, Tritons and Nereids, seaweed and shells, while in the centre Georges Récipon's *Nymphs of the Seine* form a pair with the *Nymphs of the Neva* in honour of the Tsar.

The number of skilful sculptors, engineers and technicians working in Paris at the turn of the century is a matter for awe. The bridge itself is cast in a single span of 107 metres, itself a huge undertaking. No fewer than fourteen sculptors worked on the decoration: not only Récipon, but also the bright Emmanuel Frémiet (d. 1910). He created the buoyant Renommées on the right bank, who with rearing winged horses seem about to prance and take off from the tops of the columns, and in their slender horsemanship form a gallant and festive variation on *Horse Tamers*, the famous classical statues in the Piazza del Quirinale in Rome. With the exception of the Cupids and Orions, the boy children on the bridge, and one or two Tritons, there are no male figures. The bridge itself, an iron arch thrust over the racing river, has been prettified in a way its contemporary, the Eiffel Tower, never has, and disguised in curves and frills. The famous Parisiennes of legend, the *petites mam'selles* and the *grandes demoiselles*, have here been translated into an ideal universe. The *cocottes* and the *poules*, the Zazies, Irmas and Olympias, the *grandes horizontales* and the *demi-mondaines*, the *poules de luxe*, the *soubrettes* and the *midinettes*, with their suggestions of a stereotyped Parisian eroticism, have assumed, in this décor of the 1900s, a corporate identity, as part of the face Paris turns to the visitor, to the Tsar, to the excited crowds, overtaken by *Russo-folie*, who came to the Great Exhibition of 1900, and to the visitor today. The nymphs and Renommées, riggish and tousled, ribands their only accoutrements, tunics of muslin pressed against their bodies, smiling at contemplated and experienced pleasures, conjure the image of a city too prosperous to have a care in the world. And the jubilation that produced this tribute is still contagious.

The only severe statues on the Pont Alexandre III are seated at the foot of the columns at each end of the bridge, and they represent France at different periods of history. They are all, needless to say, female figures (Pl. 7). None of the sculptures is interesting artistically, unlike Frémiet's or Récipon's contributions, but they continue the tradition of personify-

ing the nation, which began with the Romans' Gallia, who was stamped, like Britannia, on the coin of the newly conquered colony. Polemical literature had often dramatized the allegorical figure of France herself, lamenting the state into which kings and clerics had allowed her to fall.[8] But the appearance of France on the Alexandre III bridge is anomalous, because 'La France' traditionally personified royal France, while Marianne bodied forth La République, representative of liberty. Maybe the monarchical mode was approved by the Third Republic in this instance in order to honour the Tsar.

The group of sculptures possesses great idiosyncratic interest within the history of female personification, for two periods of French history are depicted as a contemporary woman, and the distance between allegory and reality closed. Laurent Marqueste's *France in the Time of Louis XIV* on the left bank, who bears a feeble resemblance to Coustou's superb Minerva opposite, outside the Invalides, and her counterpart, *Renaissance France*, by Jules Coutan, in swashbuckling mantle, are the customary divinities, half-travestied in male dress in order to ensure their difference from ordinary women, and their association with manly *virtus*. But on the right bank, Alfred Lenoir has made *Charlemagne's France* resemble a Hollywood costume drama's version of a Carolingian queen, with a thick pair of plaits to well below her waist, and a jewelled orb so large it would break her arm, while Gustave Michel, interpreting *La France contemporaine*, has carved a recognizable woman of 1900 (Pl. 7).

Gustave Michel, virtually unknown today, was one of the most famous sculptors of the first decades of this century in France. He excelled in what the Symbolist movement considered 'l'art philosophique', the transposition of subjective theories into visual form. In the exhibition of 1900, he showed a *Prigioni*-like marble group, now in the Musée des Beaux-Arts in Lille, called *Form frees itself from Matter*, for which he won the Grand Prix. He liked to invent his own allegories, and had pantheistic inclinations, interpreting such themes as *The Rhythm of the Waves* or *The Ecstasy of the Infinite*. He adapted a classical formation, in the tradition of Pradier and David d'Angers to the more fluid, personal, even swooning poeticism, closer to his contemporaries among painters, Eugène Carrière and Odilon Redon.[9]

The statue *La France contemporaine* yields few indications of Gustave Michel's interest to the visitor who, chilled from the sharp wind on the bridge, scuttles past to find shelter in the broad foyer of the Grand Palais. Bland and aloof, she is nevertheless carved with a light touch. The flowers in her hair and the damasked brocade of her dress lift and move in a breeze that Michel has imagined blowing up from the pavement,

from the onlooker's position, revealing her arm in her sleeve and unfurling a drape which a small sprite holds above his head as he rises from the crook of her left arm. She does not look at him, but gazes serenely into the distance, while he looks adoringly up at her. He represents the French, active and real, and of human dimension; she embodies the motherland. The text this sculpture illustrates is identical to the other three on the bridge. If Gustave Michel's figure did not carry the curious man-sprite on her left arm, she would be indistinguishable from a fashion plate of the period, or one of Lartigue's affectionate photographs. Anyone passing her in 1900 would have seen France symbolized by a woman whom they could see stepping at that moment down the Champs-Elysées or leaving her carriage to visit the Great Exhibition. Personification and person fuse in Gustave Michel's interpretation.

The fusion rarely occurs in allegorical images of women. Even if executed with a high degree of naturalism, female figures representing an ideal or an abstraction hardly ever intersect with real individual women. Devices distinguish them: improbable nudity, heroic scale, wings, unlikely attributes.

In spite of the suggestive overlap between real and ideal which Gustave Michel's *La France contemporaine* achieves, the sculpture is no revolutionary work, but gives an unquestioning support to the *status quo*. With her narrow, long torso well stiffened with stays, the wide shelf of her bosom, placed to form a whole with her sloping but strong shoulders, her straight neck and smoothly dressed hair adorned with fresh flowers, *La France contemporaine* represents the *grande monde*, not the *petit peuple*. She represents the ladies seen by Proust as a young man, in the Champs-Elysées, and given to his narrator to remember in *A la recherche du temps perdu*.

What Michel's statue captures faithfully is the class of woman – of lady – whom the Third Republic thought could embody France in 1900. As Proust's narrator was to say of the Duchesse de Guermantes (after he had tamed his initial dismay that she had a pimple on her neck and a big nose), 'Glorious even before Charlemagne, the Guermantes enjoyed the right of life and death over their vassals; the Duchesse de Guermantes descends from Geneviève de Brabant. She does not know, nor would she deign to know, any of the people who are here.'[10] Disdain, that glance at no one and no thing, affected by Michel's gentle lady, stands in for hauteur of *race*. The *femme du peuple* who inspired the allegorical visions of La République since the Revolution, and in 1900 still quickened the old *Communard* Jules Dalou's pulse, found no niche on the Tsar's bridge. (See Chapter 12.)

Chorus girls in fetching *déshabillé* may have modelled for the sportive naiads and exulting Victories on the bridge. But for France the exemplar was chosen, in all probability unconsciously, from the aristocracy, or at least from the women who chose the aristocratic mode, dress and manner. While *La France contemporaine*'s dress is made of rich stuff, it is striking that she is not adorned in jewels, as one of Guy de Maupassant's equally contemporary French *poules* might have been; jewels can signify money, and connote impurity.

Mayday 1900 saw the opening of the Grand Palais, amid scenes of wild and unruly rejoicing. The insouciant delight in the new century, as yet unburdened by forebodings or forewarnings, was expressed in the exuberant and luxury-loving designs of P. Girault at the Petit Palais, and H. Deglane, Louvet and A. Thomas at the Grand Palais. Achieving monumentality and frivolity at once, the immense exhibition halls face each other like playful siblings who have dressed up in the trappings of pomp, borrowed from parents' cupboards, in order to impress, and yet simultaneously manage to look coquettish and not altogether serious about it. This effect of irresponsibility arises in part from the bulbous, inflated shapes of the dome, but chiefly from the statuary. The Grand Palais has a seriously imposing classical portico and colonnade, but above the visitors' heads Georges Récipon has let fly two chariots and their charioteers, quadrigas of nervous, apparently untamed horses pawing the air as they leap from the parapet, unrestrained by bit or bridle, giving every sign of romantic excess in the *fin-de-siècle*, untrammelled style, with flared nostrils, long uncombed manes, pillows of cloud beneath their churning hooves, while the humans they hurl into the air from the roof of the Grand Palais look sublimely airborne, confident and exultant, as they leap over their sprawling victims in the clouds. On the side of the Seine, Discord falls under the hooves of Harmony, and on the side of the Champs-Elysées, Old Father Time, bearded, furrowed and wielding his scythe, tumbles superannuated under Immortality as she rides victoriously forward. These two sculptural groups, sea-green now but once gleaming copper, are feats of technical skill, and imaginative daring. Everything in them is subordinated to exuberance; apart from the art of their manufacture, nothing in them pays attention to reason. Though perhaps Récipon did not intend to flout logic altogether, he has added considerably to the high-spirited madness of his work and to the almost jazzy disorder of the building's total effect by putting the chariots back to front. The prows face backwards and the charioteers ride perforce on the shafts (Pl. 10).

Harmony is naked and androgynous, Immortality another Victory in

flying drapery with a Belle Epoque half-smile playing on her lips. Elsewhere on the Grand Palais the Arts of different periods are represented by female figures in appropriate dress and attitudes, thin and stiff (Egyptian), supple and rounded (Asian), while on either side of the huge entrance two groups express the experience of the artist at work. Paul Gasq carved in stone a voluptuously curvy but slender young woman emerging from the unworked stone under the title *L'Art et la nature*, or *La Sculpture*, in a group that is a pleasant eye-twister, a self-referring tautology, since it is a sculpture of itself in the process of being made. Its counterpart on the other side of the door, *L'Inspiration* or *La Peinture* by Alfred Boucher, puns in a different way, on the name of the sculptor himself, rather than on the activity he is engaged in, by portraying the painter's dream as a rococo nude, her sex concealed beneath a frond of roses and her legs slightly straddled as she looks over the artist's head. The roses, the pose and the style of allegory itself come of course straight out of a painting by Alfred Boucher's eponym, the *ancien régime* painter François (Pls 8 and 9).

On the steps of the Petit Palais opposite, more nudes, river nymphs, seasons, muses and the city of Paris herself, as well as the twin geniuses of Sculpture and Painting, are revealed in different degrees of disarray, with less accomplished hedonistic effect than on the grander palace opposite. One or two gods also appear, to preside over their thronged harems in sea and sky.

With the river on the right, if you then walk upstream, towards the Place de la Concorde, its central obelisk guiding you through this Garden of the Champs-Elysées, you will come across one of the few statues so far (on this particular wandering route through the city) to commemorate a historical person. This lonely lot falls on King Albert I of Belgium, who rides at the western corner of the Place.[11] His statue was erected in 1938, and escaped being melted down for use of the bronze, a fate that befell many other cast statues during the German Occupation. Here and there in the squares and gardens of Paris, plinths inscribed with the names of forgotten Great Men still stand empty, like the artefacts of conceptual art.

The parliament, police headquarters, the national heroes' mausoleum and state exhibition halls behind, you then enter the heartland of the city's propaganda for its own excellencies, the Place de la Concorde. It is one of the most spacious squares in Europe, still commanding respect for its grandeur and harmony, in spite of the squealing taxis that slalom through the whirlpool of the traffic towards the river banks' motorways. The Place de la Concorde was first lit by electricity in 1866, on the

birthday of Napoleon III, and at night, when dozens of lamps are lit and the illuminated fountains play against Jacques-Ange Gabriel's exquisitely paired buildings, and the Champs-Elysées' starry path leads to the faraway Arc de Triomphe, the Place is at its most beautiful. But it is also one of the nodes where the forces at work in Paris' historical formation have converged to light up some things, to blot out others: it is as brilliant an achievement of visual rhetoric and historiography as St Peter's, Rome, is a masterpiece of Vatican self-portraiture.

In 1793, it was called the Place de la Révolution. Three years before, Docteur Guillotin had submitted his proposal for a new method of execution: 'The blade hisses, the head rolls, the blood spurts, the man is no more; with my machine I will have off your heads in the twinkling of an eye, and all you will feel will be a very slight chill on your neck.'[12] But his report was filed. In the Terror however his invention was re-called, and the guillotine was set up, first in the Place de Grève and then in the Place Louis XV, renamed the Place de la Révolution (Pl. 11). The spot where it was placed is now charmingly covered by the southern fountain's decorative fantasy of coral-fishing and pearl-diving, and the spouting jets and the mermaids' sport now hide the place where the many victims of the Terror died (Pl. 13).

The equestrian statue of King Louis XV had been toppled, in August 1792, and replaced by a plaster Minerva, representing Liberté (Pl. 12). She had been modelled as a temporary replacement by the sculptor Lemot, to a design current in the processions and pageants of the Revolution masterminded by the painter Jacques-Louis David.[13] Two of the most sublime outdoor sculptures in Paris were already in place to overlook the executions as well: Antoine Coysevox's statues of Fame (Pl. 15) and of Mercury, each astride a Pegasus on either side of the entrance to the Tuileries gardens leading off the Place. Carved around 1700 out of a single block of marble, both sculptures rival Bernini in their tactile delicacy and the mettle of the figures' movement. They were brought to the city about twenty years after they were made, from Marly-le-Roi, Louis XIV's country pleasure dome, and in 1794 David, to beautify still more the Place de la Révolution, also had conveyed to Paris the statues that had replaced them at Marly, the *Horse Tamers* by the elder Guillaume Coustou, and set them up opposite Coysevox's pair on the other side of the square. After Coustou's *Horse Tamers* were placed *in situ*, on 26 October 1795, the square was euphemistically renamed the Place de la Concorde.[14]

These works of Coysevox and Coustou have become symbols of Parisian urban grace. At the entrance of the Tuileries, by the flying

horses' pedestals, a pastrycook called Madeleine used to sell a certain type of little cake during the years of the First Empire and the Restoration.[15] It is no slur on the sculptor's genius that the allegory of Fame, poised lightly side-saddle on her flying charger's bare back as he soars over a sumptuous collection of trophies and spoils, should seem to trumpet through her long slim instrument the glories of whatever regime happens to be in power, there, just over the river, in the direction of her apparently far-seeing gaze, in the Assemblée Nationale. It is in the intrinsic nature of public art that it seems to adapt, to collaborate. It could be said that it has no coat to turn.

In the 1830s, Louis-Philippe ordered that the obelisk from Luxor given to him by the Viceroy of Egypt should replace the disintegrating seated statue of Liberté. The obelisk is an almost neutral symbol, though it fulfils one of Napoleon's ambitions, and commemorates the Egyptian campaign. The Beaux-Arts architect, Jakob Hittorff, redesigned the rest of the square at the same time. He levelled the ground, dreamed up the ornate fountains, the light-hearted lamp-posts, and placed on top of the delightful small pavilions that had formed part of Gabriel's eighteenth-century plan the huge forbidding matrons who sit there today. Their function is to speak in stone of the other great cities of France, of Lyon and Marseille to the south, Bordeaux and Nantes to the west, Brest and Rouen to the north, Lille and Strasbourg to the east. The roads of France lead here, to this vortex of traffic; in a homely fashion characteristic of Louis-Philippe's reign, the Place de la Concorde was again reorganized to proclaim the unity of the French people.

The personifications of the regional capitals are ugly sculptures, too big for the pavilions under them, but Hittorff was characteristic of his period in his fondness for monumental females. They also form part of his design for the Gare du Nord, where they represent points home and abroad reached by the trains, including London, and they surmount the heavy, Hittorff-influenced riverside façade of the Gare d'Orsay, visible to the south-east of the Place de la Concorde.

The actress Juliette Drouet, the companion of Victor Hugo, posed for James Pradier's interpretation of Strasbourg (compare Pl. 14). It is not one of the sculptor's most eloquent creations, since her contemporary plaits, earphone-coiled, look absurd under the turreted crown, traditional head-dress of cities on Hellenistic and Roman coins. But the statue's meaning does not require sureness of artistic handling to become clear and potent: during the period after 1871, when Alsace – and Strasbourg – were occupied by the Prussians, the statue became a political altar, the focal point of pilgrimage, and patriotic manifestations there on

Bastille Day led to the establishment of the national feast of 14 July in 1880.[16]

Walking on, into the Tuileries gardens, past the point where stood Madeleine's warm-smelling stall, towards the Louvre, more marble muses and goddesses, classical priestesses, hetairai, continents and seasons (an *Autumn* by Gustave Michel), a Medea here, a nymph ravished by a centaur there, scattered allegories like *La Comédie humaine*, some dating from the late seventeenth, some from the early eighteenth century, but most set up under the reigns of Louis-Philippe and Louis Napoleon, add to the beauty of the orderly Italian garden laid out by André Le Nôtre.

Coysevox in 1698 portrayed a virile divinity with rippling beard and muscles to suggest the mightiness of La Seine, the capital's artery to the sea; other sculptors followed suit. Nicolas Coustou ignored the feminine gender of the Seine and carved *La Seine et la Marne* as a connubial pair, with frolicking rivulet-cherubs for offspring, and Corneille van Cleve reversed the grammatical genders of *La Loire et Le Loiret* to represent that river and its tributary again as a divine couple, a mature god with his Venus-like bride, in the two breeze-lifted and pleasurable groups which ornament the central broad walk through the Tuileries gardens (Pl. 16).[17]

In spite of the highly uneven quality of the works now in the Tuileries, which range from the sublime Coysevox to the egregious Laurent Marqueste (his *Hommage à Waldeck-Rousseau* includes two unmistakably modern males stripped of their trousers), the almost incandescent marbles against the dark trunks of the chestnut trees and the grey and beige apartments of the Rue de Rivoli beyond enhance the great pleasure and refinement of the broad walks, the rectangular lawns, the sanded paths.

Through the Tuileries gardens, and then on to the Carrousel and the Palace of the Louvre, you come to the windy space where the Tuileries Palace stood until 1871 when it was burned under the Commune, and where its ruins remained until 1882 when the Chambre des Députés voted that this reminder of past republican turbulence should vanish altogether from view. In 1884 nothing remained, and the site is now the playground of Maillol's ripe celebratory nudes, of fountainheads and maidenheads. The Arc du Carrousel, a graceful, almost dainty version of the Arch of Septimius Severus in Rome, also struggles to give an acceptable perspective on the past. It was built to celebrate Napoleon's victories, and the triumphal chariot on top was once drawn by the four bronze horses of St Mark's, driven by the Emperor in effigy. But he has now been replaced on the arch and so have the originals of the horses he looted; with equal despatch, his image was removed from the centre of the arch's inside vault. The figure of Victory, who used to place the

garland on his head, now crowns nothing at all except a collection of flags and spoils, hastily improvised in 1815 to fill the gap, and never restored. For Victory abides, though the receivers of her favours change.

White-limbed nymphs stand in the gardens where the altar to the Supreme Being was once raised by Robespierre, and fountains have played for a hundred years where his head rolled, along with so many others, during the Terror. If memory be selective, how much more so commemoration must be. At the Hôtel de Ville upriver, where a comprehensive programme of statuary records the great men and a few great women of France, there is a void for the years of the Commune. It was in the days of the Commune that the preceding Hôtel de Ville was sacked and burned to the ground, giving rise to the need for the resplendent new edifice commissioned by the Third Republic and finished in 1882.[18] As Milan Kundera has pointed out, 'the struggle of man against power is the struggle of memory against forgetting'.[19]

Beyond the arch lies the outer courtyard of the Louvre, with the two large arms of the Pavillons on either side. In our mind's eye, when we reconstruct a building in memory, we see linear forms, articulated along the line of stress and strength. If asked to render the Palais du Louvre on paper, we might draw its noble proportions, roofs, windows, portals, but would we remember the plethora of forms that swarm on its walls and anthropomorphize the lines of its structure? From the Cour Carrée, the oldest part of the Louvre, to the Nouveau Louvre overlooking the Arc du Carrousel and the Carrousel gardens, the fabric teems with girls. Once you look at the building to grasp its figurative, not its structural, aspects, satiety can overwhelm you quite quickly. The eye travels over the lavish panoply of stone blossom, of verdure and trophies, angels and nymphs, at mezzanine and piano nobile, at attic and balustrade, on either side of windows and in the eaves, on the string courses and in the tympana of pediments, in the niches and architraves of the windows, on the cornices under the roof and perched on parapets above the porticos.

The oldest part of the Louvre, on the inner Cour Carrée, is a masterwork of French Renaissance architecture, built from 1546 to 1556 by Pierre Lescot. It is embellished by Jean Goujon's fine, and often gay, carving (Pl. 17); when the Louvre was added to, as it was in the course of the next four centuries, the decorative example of Lescot was followed. During Napoleon III's renovations of Paris and extension of the Louvre, the style of décor became even more ostentatious, the ornamentation more profuse; the sculptor Barye called it 'haute confiserie'. The implied scorn, however good-humoured, fails to record the energy and grace of much of the work, some of it Barye's own. Two stone

groups on the Pavillon de Flore, for instance, are by the brilliantly gifted Jean-Baptiste Carpeaux. They should be restored and exhibited inside the Palace, salvaged from the fumes of the city that have blistered the nakedness of France personified and flayed the river gods who attend her, discoloured the plump curves of Flora below and damaged the dimpled warmth of her smile.

In the early nineteenth century, real beings began to mingle with unreal: Thucydides, Herodotus, Napoleon I, Louis XIV appeared in their solid historical authenticity, contrasting with the evident mythological identity of their *ancillae* and muses. Napoleon III, responsible for commissioning so much of the Louvre as we see it today, appears on the pediment above the present entrance to the museum in the Pavillon Denon as part of a bas-relief by Pierre Simart. The Emperor, in his own smart clothes, with his belt well tightened, a military sash, decorations and top boots, stands with Peace and the Arts on either side in Greek costume. It is, surprisingly, the only outdoor image of the Emperor in Paris, the city he did so much to change and beautify; and the claims of his rule have again been reified in the form of classical female figures. As Aristotle, Cicero, Euclid stood in relation to Logic, Rhetoric and Geometry in the sculpture programmes of mediaeval cathedrals, so the Emperor is portrayed as the exemplar of a peaceful and cultured civilization. Beneath him, paired caryatids, three times his size, bear the pediment on their heads. They are nineteenth-century versions – by Ottin, Brian, Jacquot and Robert – of the magnificent works on the Pavillon de l'Horloge in the Cour Carrée, carved almost two hundred years earlier.

Now restored to its pristine champagne colour, the Pavillon de l'Horloge is upheld by eight Greek caryatids arranged in pairs. They hold hands like Graces, or turn to each other as if absorbed in conversation, and appear even less concerned about the roof they support than their sisters from the Erechtheum who inspired their designer, Jacques Sarazin, in the early eighteenth century (Pl. 8). Vitruvius wrote in his study of Greek architecture that the columns fashioned in the shape of women were called caryatids because they were modelled on the widows of Carya, a city which had mistakenly sided with the Persian enemy against the Greeks, and was defeated. The menfolk were slaughtered, and the women led away as captives, still dressed in all their finery, and 'to ensure that they exhibited a permanent picture of slavery ... the architects of those times designed images of them specially placed to uphold a load'.[20] The *korai* or maidens of the Acropolis may not be the caryatids Vitruvius described. They do not seem widowed, grieving, or even

humbled by the burden they bear; but they were identified as such by 'Athenian' Stuart and Nicholas Revett, and have since inspired other caryatids in their shape all over Europe and the United States. And as nameless and captive bearers, they epitomize the condition of the flocking allegorical figures.

From *La Loi* in the Place du Palais-Bourbon, to the caryatids surveying the Cour Carrée, from parliament to palace, is barely an hour's walk if you do not stop to enter Napoleon's tomb. Yet the sheer quantity of human figures, and especially female figures, is staggering. And only some of them have been mentioned here. The experience could be recreated on almost any other route in central Paris: from the grave thirteenth-century stone carvings at Notre-Dame of the Virtues and the Wise and Foolish Virgins, to Garnier's effervescent and glittering honeypot, the Opéra, the female form was used for seven hundred years as the vehicle of shifting ulterior meanings more publicly and more frequently in Paris than in any other major city. It appears as the embodiment of certain qualities like Justice, as in public notaries' signs, as the personification of the Roman city, Lutetia, as on Paris' gas point covers, or of water's bounty and purity, as in the green Wallace fountains' graceful nymphs found scattered here and there.[21] It changed, but it survived, through ruptures and discontinuities, upheavals and revolutions, and the fluctuating lot of women themselves.

The female figure is the dominant sign, with a multitude of significations; it is the overarching image in this capital, this city of ladies. Although its recurrence reflects upheavals of French history and a particular brand of romanticism, although it interacts with the erotic's special place in French culture, many of the themes present in the *architecture parlante* of the city have informed the use of the female body elsewhere, as we shall see. But in the late twentieth century, it has all but vanished from contemporary architecture or urban ornament and sculpture; the female figure has instead moved sideways across the repertoire of communication codes, to the advertising hoarding and the magazine cover. The buildings which now proclaim Paris' pride, like the Pompidou Centre and the Forum des Halles, the Palais Omnisport and I.M. Pei's projected pyramid for the Louvre, not only reject all figural ornamentation whatsoever, but also refuse identification with the body of anything more creaturely than a crustacean which wears its bones on the outside and hides all its soft and vulnerable parts within. At the Opéra or the Gare de Lyon, the soft profusion of figural sculptures recapitulates the anthropomorphism – or should it be gynaecomorphism? – of the buildings themselves, with their bosomy and vaginal contours,

their pillowy roofs and open-mouthed entrances (Pl. 15).[22] Beaubourg (the Pompidou Centre), on the other hand, one of the most popular attractions in contemporary Paris, is a scaffolded exoskeleton, and much less capable of withstanding weather and pollution and strain than its predecessors.

On to the female body have been projected the fantasies and longings and terrors of generations of men and through them of women, in order to conjure them into reality or exorcize them into oblivion. The iconography appears chiefly in public commissions and in the edifices where authority resides because the language of female allegory suits the voices of those in command. But public statements have their roots in private dreams; Parisian female allegories in stone and marble achieve existence, impinge on the passer-by at the intersection where the collective becomes personal. It is partly because so much of this imagery does not possess the high-visibility status of fine art and of individual old masters' works, or at least has not attained recognition in the canon of contemporary aesthetics, that its meaning can be deciphered and its origins and effects can be interpreted in terms of the society which produced the image, and to which we belong or can imagine ourselves to belong. Walking through Paris, you can see the caryatids speak; if you can unlock the silence of the stone, you can begin to see why they take the form they do, and what effect they might have.

The relation between the artistic convention and social reality produces meaning; the representation of virtue in the female form interacts with ideas about femaleness, and affects the way women act as well as appear. As Aristotle argued, mimesis - imitation - brings about methexis - participation - and a constant exchange takes place between images and reality. We are living now among female forms who have adapted the allegorical language of the past, but are not reproducing it in stone or plaster or copper, but enacting it live in order to take up tenancy of the hollow monuments and enter that process of individual and collective imagination by which 'imperishable things are imitated by things in a natural condition of change'.[23]

CHAPTER THREE

The Front Page (London)

It is the magic of nationalism to turn chance into destiny.

BENEDICT ANDERSON[1]

On 9 June 1983, the day of the general election in Britain, the *Sun* newspaper endorsed Mrs Thatcher for a second term, on its front page with the two-inch headline, 'Vote for Maggie' (Pl. 24). Under the sub-heading 'She is carrying the banner for ordinary people', the paper's favourite politician appeared in a heavy line drawing as Britannia, with trident, Union Jack shield, and (smiling) lion, proffering an olive branch. She was helmeted and breastplated, but wearing high-heeled shoes and a beaming grin. The paper told its readers to vote for Maggie, 'To give you and your children a better Britain'. The article that followed ex-plained:

> There is just one compelling reason why the Tories are heading for an emphatic victory in today's election.
>
> Not the shambles that is the Labour Party. Not the flop of the much-vaunted Alliance.
>
> Not victory in the Falklands, the taming of inflation, the promise of better times ahead.
>
> The reason is a lady
>
> *It's Margaret Thatcher all the way.*
>
> More than any leader since Churchill was ...

Continued on page two.[2]

The *Sun* was not alone in identifying the success of the Tories with their leader. So, after the paper's brazenly disingenuous association of Mrs Thatcher with the country's most famous wartime leader, and after the obligatory disavowal that the Falklands war had anything to do with her success, the article broke off. If readers then turned to page two, they would have read the rhetoric of Liberty: she 'has captured the

hearts, the minds and the imagination of this nation ... that Mrs Thatcher set about striking off the shackles ...', that 'In a way that Labour could never manage, Margaret Thatcher, the grocer's daughter who leads the party that was once rooted in privilege, is carrying the banner for ordinary people.'

As the drawing on the front page claimed, she contained the strength of the nation's spirit: 'When she tries to put backbone in the appeasers ... and makes the country strong and respected in the world, everybody applauds.'

The cartoon on page two abandoned the allegory of nation on the front page, and plumped for an icon of pioneer bravery, the cowboy. Mrs Thatcher, still in high heels (boots this time), with one of the floppy bows at her neck she favours standing in for a cowpuncher's string tie, and wearing a brace of sharpshooters on her thighs, stood cocking a thumb in the direction of two graves a cheerful gnome was digging behind her. The two opposing contenders – Michael Foot for Labour and Roy Jenkins for the Alliance – sweated in front of her, approximately a third of her height, and shaking from top to toe. 'There's a couple of crosses marked for you already,' said the cowboy Prime Minister, again with a broad smile.

This Franklin cartoon was placed opposite page three and the customary pin-up, and the most interesting thing about the juxtaposition was their similarity. The profiled contours of 'angelic' Caroline's left breast were the same as the drawn Prime Minister's thrusting bust; Caroline was smiling at the camera and paper's readers next to a small white-on-black cartouche heading, 'The loveliest girls are always in the *Sun*.' Meanings flowed conjoined through the newspaper, the images bore one upon the other, as Mrs Thatcher and Caroline were cast in received and understood images from the repertory of female types – Britannia, angels, cowboys (or rather cowgirls: *Annie Get Your Gun*).

The chief difference between Caroline and Mrs Thatcher on this occasion was marked by their attributes, the weapons the cowboy was wielding (and the cocked thumb) contrasting with the pin-up's passive pearls. This is by no means always the case. Weapons of various kinds add to the sultriness of many images of women in popular magazines: Britannia's trident often appears in the form of a harpoon sported by a deep-sea diving beauty. But the congruence of imagery between pin-up and PM was emphasized by the identical right-facing position of all three images. Whereas Caroline was denied phallic power, the PM was endowed with it as well as with the vitality of female sexuality, strongly delineated by Franklin in the cowboy's nipped waist, high bust and

parted legs as well as the front page draughtsman's circled breastplates. Fitted one to the next like nesting tables, Britannia, Thatcher and 'angelic' Caroline assembled an image of an armed female victor, arousing the vim of sexual energy but channelling it to proper use.

On page four, the theme continued. A neutral snapshot of Mrs Thatcher, the only reportage photograph of her in the newspaper, showed her shielding her eyes from the sun. 'Victory in sight', read the caption, instantly injecting meaning into the picture, in the allegorical fashion. The paper reported some remarks the Prime Minister had made on the television the night before, in which she said, a year before the miners' strike and the worst civil disturbances since the war, that if her party won a landslide victory at the polls, the country's divisions of class and wealth would be healed: 'We are British, and I don't divide between one group and another.'

The claim intensified the overall message of the *Sun* that day, that Margaret Thatcher embodied the best interests of Britain in the most appetizing and attractive and irresistible way. It was not alone in doing so, nor did it originate the thought, and the paper on 9 June was representative of thinking in all the other daily papers with the exception of the *Financial Times* (strikebound), the *Guardian* (sympathetic to the Alliance), and the *Mirror* (loyal to Labour). The *Star* told its readers to vote Tory, and though individual writers on *The Times* wrote sharply about Mrs Thatcher and the Tory programme, the editorials enthusiastically endorsed her. The metaphors used to describe the Conservatives' success, from the clubroom style of *The Times* to the street language of the *Sun* and *Star*, brought the same imagery to serve: of butchery, of warfare, of hard surfaces clashing against hard surfaces. After the Tory victory, the time-worn image for Cabinet changes – reshuffle – faded before the more vicious and appropriate metaphor of the eighties, and 'carve up' made many of the week's headlines. The papers took their cue from Mrs Thatcher herself, who inclines to military and triumphalist language, mingled with homely illustrations. She inspired the sub-editors of Fleet Street when, after her victory, she was asked about the new Cabinet, and, neatly combining her two preferred theatres, kitchen and war, replied that she was not a butcher, but 'I've had to learn to carve the joint'.[3]

Margaret Thatcher has never repudiated as alien or undesirable the image of strength that clothes her, rather she interiorizes it with almost grateful eagerness, for it provides her personality with a dimension that traditional definitions of female nature exclude.

Many catch names begin as insults and become badges of honour, and

the 'Iron Lady', at first a Soviet sobriquet for Mrs Thatcher, became a positive description of her resoluteness. Enoch Powell, in the House of Commons during the debate about the Argentine invasion of the Falklands, goaded the Prime Minister: 'There was no reason to suppose', he said, 'that the Right Honourable Lady did not welcome and, indeed, take great pride in that description [Iron Lady]. In the next week or two this House, the nation and the Right Honourable Lady herself will learn of what metal she is made.'[4] Two months later, after the Task Force victories, Mrs Thatcher welcomed the echo of the Iron Duke, conquering hero, and said on American television: 'I have the reputation as the Iron Lady. I am of great resolve. That resolve is matched by the British people.'[5]

Margaret Thatcher was not foolish enough to claim the Falklands victory as her own personal success, but proclaimed it the result of British spirit, unbeatable and courageous. Yet her leadership and the Falklands military victory became inextricably intertwined. The multiple reasons for British enthusiasm during the Falklands war – which include the associations with Empire, with bygone glories, nostalgia for a rose-tinted past – are beside the point here. What is fascinating is how smoothly the Falklands conflict sent Margaret Thatcher victorious, happy and glorious, to a second triumph at the 1983 general election.

The identification of the Prime Minister with the renewed military grandeur of Great Britain was accomplished in part through the language of female representation; it was natural, as it were, to see Mrs Thatcher as the embodiment of the spirit of Britain in travail and then in triumph, because of the way that spirit of Britain has been characterized, through its famous great queens on the one hand, and the convention of Britannia on the other. The first female premier did not rebel against the assimilation of the nation and herself; what Prime Minister would? For Britannia's image, developed through coins, banknotes, stamps, political propaganda and cartoons, has become synonymous with being British, with belonging to Great Britain. Any politician who can make her party seem inextricably entwined with the nation's identity, and any dissent from her views as unpatriotic, has achieved a notable propaganda success, however fallacious that popular impression may be.

Margaret Thatcher does not reject the combative identity and the imperial attitudes epitomized by late Victorian Britannias; she has rather revived them:

There were those who would not admit it – even perhaps some here today – people who would have strenuously denied the suggestion but – in their

heart of hearts – they too had their secret fears that it was true: that Britain was no longer the nation that had built an empire and ruled a quarter of the world.

Well, they were wrong. The lesson of the Falklands is that Britain has not changed and that this nation still has those sterling qualities which shine through our history.

This generation can match their fathers and grandfathers in ability, in courage, and in resolution. We have not changed. When the demands of war and the dangers to our people call us to arms – then we British are as we have always been – competent, courageous and resolute

Britain found herself again in the South Atlantic and will not look back from the victory she has won.[6]

This speech, made by Mrs Thatcher after the resolution of the 1982 conflict in the Falkland Islands, could not catch more accurately the authoritarian tone by which rulers attribute their own aims to the people they wish to lead.

Recently Mrs Thatcher has inclined more and more, even in civilian concerns, to combative imagery; the language of conflict and intolerance has come to prevail in domestic affairs, not just in foreign policy. Mrs Thatcher speaks of democracy itself as if it were a military authority: 'It is time for freedom to take the offensive,' she told the Canadian parliament. 'There is a battle of ideas to be won. We are better equipped than our adversaries, for our ideas are better.'[7]

The front page of the *Sun* could not have been created without her response to the Falklands crisis. The trope – Thatcher–Britannia – needed a battlefield to germinate and grow, and as it did, the image of Margaret Thatcher benefited from those accidents of British history which have helped confuse the ruler with the ruled, the monarch with the personified nation. In France, for instance, where Salic law forbade the throne to a female heir, the king embodied power, while the nation, La France, often personified as a lady – consort, ward and daughter at once – represented his subjects the people. With rare exceptions – like the Queen Regent Marie de Médicis in the seventeenth century – the body of the nation and its head were not confused, but perceived in complementary relation to each other. But in Britain, queens have sat upon the throne during periods of wealth, expansion and cultural flowering. Whether the connections of Elizabeth I and Victoria with the splendours of their long reigns are fortuitous or not, they came to symbolize the nation in their own persons, to represent in different ways both figurehead and ship. The interaction of media, popular responses

and her own personality generated around Mrs Thatcher a particular charisma, recognizably expressed in language borrowed from traditional royal allegory in Britain, which cast queens as country, and did not dramatize the interdependence of king and country, but conflated one with the other.

At the rally before the general election, when 2,500 Young Conservatives gathered in the huge hall of Wembley under the slogan 'Britain for Youth – Young and Free', Mrs Thatcher made a speech about the new renaissance that Toryism was about to inspire in Britain. Her analogy, which she developed at some length, was Elizabethan England, when merchant venturers – as she chose to call them – roamed the seas for Britain's gain. Her speech was preceded by a rousing medley of English patriotic songs, 'Rule Britannia', 'Land of Hope and Glory', and a number by a pop singer, Lynsey de Paul, in which the words of 'God Save the Queen' were adapted to suit: 'Send her vic-Tory-ous.'[8]

Mrs Thatcher's choice of Elizabethan times as a parallel was a departure from her more usual Victorian theme. She was not indicating the Queen (the second Elizabethan age?) but rather herself, she who now holds the executive power. Elizabeth I was the monarch in whose person imago and ego were most thoroughly confused, in the pageants, progresses and portraits that conjured her as Gloriana and Astraea and structured her reign from her accession to her death.[9] As Clifford Geertz has penetratingly commented:

> The centre of the centre, Elizabeth not only accepted its transformation of her into a moral idea, she actively cooperated in it. It was out of this – her willingness to stand proxy, not for God, but for the virtues he ordained, and especially for the Protestant version of them – that her charisma grew. It was allegory that lent her magic, and allegory repeated that sustained it.[10]

Caricaturists were quick to notice that the same transformation seemed to be taking place in Mrs Thatcher's case during the Falklands' aftermath: in 1983, after the ceremony of Trooping the Colour, Thatcher sat in for the Queen on her horse in almost every cartoon in the papers the next day.[11]

In Great Britain, the symbolic centre of power – the Queen – does not exercise power; many think the paradox helps to dignify British society and save it from dictatorships. But it sets up a fracture at the apex; as Geertz has pointed out, leaders do not wholly possess charisma in themselves. 'It is a sign, not of popular appeal or inventive craziness, but of being "near the heart of things".'[12] It is conferred upon them when they take up occupation of the centre. But centres are 'concen-

trated loci of serious acts',[13] and the Queen's acts are rarely politically serious. The rituals in which she and other members of the royal family take part do not affect legislation, foreign policy, taxation, or parliamentary representation. Yet while the real powers of the monarch have withered away, there has been an increasing growth in public ceremony surrounding them. Although Queen Victoria was the focus of a popular cult, marked in particular by the tremendous Jubilees towards the end of her reign, her own children married quietly, among relations and friends. But her descendants' weddings are mass solemnities, which, through the medium of television, all the members of the nation and far beyond are invited to attend. The stages of the monarch's reign are marked by fanfares and public pageantry on an international scale. Victoria never saw a single country of the British empire at the height of its dominion; the present Queen, her sister, sons, daughter-in-law and cousins have travelled in great progresses to every corner of the now-independent nations of the Commonwealth. In an age of agnosticism, rapid change and enormous difficulties – social and political – such grand ceremonial helps to give 'an impression of stability ... of continuity and comfort'.[14] But the central actors in the rites are themselves powerless, and their capacity to reassure is undercut by this aspect of their condition; the tendency to hedge Mrs Thatcher about with the trappings of their lost divinity may reflect an unconscious acknowledgement of royal debilitation on the part of the public. As the royal persons are no longer at the political heart of things, those rituals, icons, tributes, processions and audiences which mark out the centre in a society and anoint its occupants and invite obeisance from the people, have therefore shifted to confer charisma on the figure who is.[15] It has become common to have to point out to British children that the Queen and the Prime Minister are two very different individuals.[16]

Margaret Thatcher has benefited more from this development than other Prime Ministers perhaps because she came to power at a time when the celebration of monarchy is especially inflated. Its excess of aura, symbolically misplaced in powerless individuals, has spilled over to swell her own, and made her vaunted traditionalism seem above party politics, and to represent the past (though in many ways she has shattered the British post-war continuum). But also, as Prime Minister at a time of loudly declaimed national crisis, she stood near the magic heart of things.

Although Mrs Thatcher's queenliness, both arrogated and projected, reflects historical perceptions of female monarchs, it is exceptional for a leader, royal or otherwise, to be perceived as Britannia herself. Queen

Elizabeth I's national guises were frequently richly imaginative poetic inventions of her contemporaries, not classical simulacra; even Victoria, whom one might expect to find frequently vested with Britannia's trappings, appears rarely under this aspect. A standing statue, on top of a column in Westmorland carved by the eccentric provincial sculptor Thomas Bland to celebrate her accession in 1837, remains an unusual example.[17]

But the first female Prime Minister has inspired caricaturists, both friendly and hostile, to assimilate her to the personified nation. The cartoonist Gerald Scarfe, a lonely imagination in revolt, made a huge sculpture of her in armour (Pl. 26), as well as drawing her welcoming the Task Force in Britannia's breastplate and helmet, with a shield inscribed Victory.[18] Later, when political analysts began to understand the foolish cost and temporary nature of the achievement in the Falkland Islands, Scarfe accompanied a critical article with a cartoon showing a proposed monument to the Falklands, costing £100 million, on which sat Margaret Thatcher, of course, enthroned in the guise of Britannia.[19] Scarfe's angry, nervy pen struck at Margaret Thatcher, and his attacks were based on a widespread confusion at the very centre of Mrs Thatcher's reputation and popularity. Her assimilation to the national symbol reflects major shifts that have taken place in representations of Britannia: the symbol's increasing identification with official power, as Britannia became an imperial figurehead, and the growingly portentous solemnity of the image itself.

Britannia reappeared on British coins, on copper farthings and halfpennies in 1672, under Charles II (Pl. 21).[20] The King's mistress, the Duchess of Richmond, Frances Stewart, may have posed for the image. This literal expression of country as beloved by its ruler provoked Pepys to comment, 'In little there is Mrs Stewart's face as well done as ever I saw anything in my whole life, I think: and a pretty thing it is that he should choose her face to represent Britannia by.'[21] John Roethier, the chief engraver at the Royal Mint, had returned for inspiration to the Britannia represented on the copper coins struck by the Roman emperors Hadrian and Antoninus Pius to celebrate their colonization of Britain (Pl. 20).

This acute irony, that the allegory of Britannia was first developed to characterize a conquered country, is often overlooked. One of the earliest images of her, recently discovered, a part of the marble relief decorations which flank the processional way of the city Aphrodisias in Asia Minor,

shows the Emperor Claudius seizing a fallen warrior woman by her hair (Pl. 19). She twists under him, her right breast bared Amazon-style, her booted legs dragging. The ornamental avenue led to a temple or Sebasteion dedicated to the divine Julio-Claudian family, and the capture of Britannia was intended to magnify their glory.[22] In the first version of Britannia's image on Roman coinage, minted under the Emperor Hadrian in AD 119, she was also shown as a captive, leaning on her hand like a pensive or even forlorn goddess or spirit of place, fallen before the might of the Roman empire. On another coin, where Britannia sported the war gear of the Ancient Briton, including a spiked shield, tribute was thereby paid to the fighting spirit of the island's inhabitants; but again only to draw attention to the victors' own prowess in overcoming them (Pl. 20).[23]

After her revival in the seventeenth century, the immobile and, it must be said, rather characterless goddess who personified Great Britain on early Roman coins was brought to more vivid life through a variety of literary and popular media which helped to make her the familiar figure of today. Propaganda, marshalling supporters to one cause or another, became Britannia's chief theatre of activity. As Britannia stepped into the controversies dramatized by political images, tableaux, performances and cartoons, she lost her inert, abstract character. She was always associated with patriotism, especially after 1672, when the crosses of St George and St Andrew appeared on her shield. But her primary significance was the British constitution, her secondary, the pride that grows from the benefits it confers. The legend that Neptune, lord of the seas, had yielded his sceptre to Britannia became popular as a new, founding myth of the triumphant naval nation, and in 1652, for instance, John Selden engraved the scene, showing Britannia sitting on a rock heaped with spoils and trophies, receiving Neptune's surrender.[24]

Around a hundred years later, James Thomson wrote the poem 'Rule Britannia!' with music by Thomas Arne, as the finale of his masque *Alfred*. It was composed at the command of the Prince of Wales, and performed at his summer residence in 1740. The rhetoric exposes the tension between the Britannia who upholds the freedom of democracy –

> The nations, not so blest as thee,
> Must, in their turn, to tyrants fall;
> While thou shalt flourish great and free . . .

– and the Britannia who herself brings nations under subjection:

All thine shall be the subject main;
And every shore it circles, thine.[25]

The composition was received by the 'brilliant audience' with great approval, but it did not become a 'national anthem' until the next century.[26] Nor was Britannia usually conflated with the monarch himself. He is seen rather as her champion, her beneficiary, her agent, or even her violator, for she often represents a libertarian opposition to established authority.[27] In 1784 Thomas Rowlandson drew Charles James Fox valiantly trying to rouse the slumbering Britannia to the dangers facing her from the King, George III, who, ignoring the House of Commons, wants to pursue his own interests.[28]

James Gillray, Rowlandson's contemporary, also uses Britannia to represent the law, the law which is meant to protect the people against abusers of power, like kings, tyrants and, given Gillray's sceptical and conservative temper, revolutionary idealists like Tom Paine. He draws Paine bracing himself against Britannia's bottom as he tries to lace her into stays, in the 1793 cartoon, 'Fashions for Ease; or a Good Constitution sacrificed for Fantastic Form'.[29]

In the generation following Gillray and Rowlandson, George Cruikshank, another artist to make caricature a distinctive British form, also makes plain that Britannia embodied for him the freedoms enjoyed by the English, not the authority vested in their rulers. In an attack on the radicals – including Tom Paine again – of 1819, 'Death or Liberty! Or Britannia and the Virtues of the Constitution in Danger of Violation from the Great Political Libertine, Radical Reform!', a cartoon shows a grotesque skeleton, wearing Deceit's mask and Liberty's bonnet, raping Britannia. She has fallen to her knees but is attempting still to brandish her sword, inscribed 'The Laws' (Pl. 23).[30]

The olive branch which appeared in Britannia's hand during Charles II's reign and on the magnificently modelled pennies and 'cartwheel tuppences' of the 1790s was perhaps a euphemistic attribute politically. But in formal terms it presaged the Britannia who was to predominate in the nineteenth century (Pl. 22). For Athena, the goddess of wisdom and war who, according to her myth, gave the first olive tree to her city Athens, provided the principal model for the monumental conception of Britannia, as in Roubiliac's magnificent tombs, to the Duke of Argyll and to Sir Peter Warren, in Westminster Abbey.[31] Athena inspired the idea, proposed in 1800 by John Flaxman, that a gigantic statue – 230 feet high – should be raised on Observatory Hill in Greenwich to commemorate the recent British naval victories. 'As Greenwich Hill is the place

from whence the longitude is taken, the Monument would, like the first Mile-Stone in the city of Rome, be the point from which the world would be measured,' he wrote.[32] *Britannia by Divine Providence Triumphant* was not commissioned, and the maquette, in Sir John Soane's Museum in London, shows that he was probably inspired by Phidias' famous - but lost - colossal Athena in the Parthenon. The statue had become an object of marvelling speculation to eighteenth-century antiquarians since the influential publication of James 'Athenian' Stuart and Nicholas Revett's magnificent folio studies *The Antiquities of Athens* in 1752.

Enthroned Athena/Britannias now survive in official imagery of all sorts, not only monuments and tombs, but on life insurance emblems and on British notes of all denominations. Athena's customary helmet appeared on Britannia's head on coins in 1821, in the aftermath of the Napoleonic defeat, and Britannia's military aspect persisted throughout the nineteenth century, until 1971 and decimalization, when the designer Christopher Ironside restored peaceableness to the national cipher by putting the olive branch back into Britannia's hand. This heptagonal fifty-pence piece, with the Queen's head on the obverse and Britannia seated on the reverse, is still in circulation. Though a sad falling-off from the noble designs of the seventeenth and eighteenth centuries, it must be one of the most unnoticed and common instances of female allegory in daily use.

As Britannia's transformation into a sagacious and serious Athena took place, she shed the blowzy, put-upon character of the wench in Rowlandson and Gillray and came to represent the *potestas* of the law-givers, rather than the rights of the people bound in a shared identity through the law under which they live. In the course of the nineteenth century, Britannia, the personification of the constitution, fades before Britannia as the might of Britain (Pl. 22). Not surprisingly the dissemination of the figure increases during the reign of Queen Victoria. She appears on the new bronze coin issued after 1860, and achieves widest currency, through a variety of artefacts, in the 1890s at the zenith of Victorians' imperial faith and enthusiasm, displayed so grandiloquently at the Queen's Diamond Jubilee of 1897. Edward VII, then the Prince of Wales, called a royal yacht *Britannia* for the first time in 1893.[33]

Just over a decade after the first postage stamp was issued showing the profile head of the young Queen, the 'penny black', Britannia began to appear on the stamps of the colonies, of Trinidad in 1851, of Barbados in 1852, of Mauritius in 1854, and then spreading through the empire in the 1880s and 1890s.[34] The engravers were often inspired by the seal of

the colony, which, in the case of Newfoundland, showed 'Fishermen bringing gifts to Britannia', an imaginative dramatization of the usually insipid seated figure.[35] The translation of such images to stamps from seals, used on official documents, obviously accelerated the acceptance of the ruling power personified in this classical manner. It is noteworthy that Britannia appears more frequently on the stamps of subject nations than on the stamps of Great Britain itself, revealing her shift from personification of a free people to symbol of the authority which endorses it. One of the boldest imperial interpretations of Britannia was first struck on the florin in 1895, during the apogee of British pride, and showed her standing, in the pose of a Victory, with a trident and shield, and her robes blown against her body by a stiff sea breeze. Lady Susan Hicks-Beach, the daughter of the Chancellor and Master of the Mint, posed for the chief engraver, G. W. de Saulles, and the image they achieved together was so liked that it circulated until the accession of George V.

Of Britannia's surviving manifestations, possibly the most downfallen of all is the Britannia of Euston Station. She was carved by the fine Victorian sculptor John Thomas in 1849, and she once queened it grandly over the doorway to the Shareholders' Room in the Great Hall of the station. But she has now been brought down to our level, and mingles with the groundlings in the station's waiting room, just by a space invaders' machine and next to the cafeteria. All her grandeur, the four painted lions on her helmet, her victor's palm, her shield with fasces, her voluminous cloak, her trident, the ship she sits on with its frieze of dolphins, her magnificent train – Hermes and a nymph – have been made as nothing by Pentelled lipstick and a Hitler moustache.

The mythical Britannia, late Victorian champion of right and might, interlocks with an historical character, whose exploits were retrieved from ancient annals of antiquity during the century, Boadicea or Boudicca, and the interaction between Britannia and the ancient British Queen still informed the conception of Britain entertained by enthusiasts of the Falklands war. Boadicea is inherited from the Victorians and is redolent of selective myth-making, a real figure colonized to become a symbol of British greatness in a Victorian myth of Empire. Thomas Thornycroft's famous bronze group stands on Westminster Bridge opposite the Houses of Parliament, illustrating the freedom of Great Britain and the doughtiness of British defenders. The full-bodied, amply draped Queen stands in the chariot with scythes' blades springing from the hubs of the

wheels. Her two daughters crouch, half-naked and unarmed, one on either side behind her, while she wields a spear in her right hand and raises the left skywards. Two unharnessed horses rear up, wild-eyed and showing their teeth, the very epitome of mettle.

Thomas Thornycroft worked on the model for fifteen years, from 1856 (the Crimean War) to 1871 (the Franco-Prussian War and fall of Napoleon III, an ally of Great Britain). Prince Albert liked the work of the whole Thornycroft family of sculptors, and he lent horses to Thomas to study.[36] But the model was not cast in bronze until John, Thomas's son and a naval architect, presented the model to the nation in 1896. The London County Council raised money to have it cast by direct appeal to the country, and it was erected in its significant site in 1902, after victory over the Boers under Lord Kitchener, and the year after Queen Victoria's death. When Victoria was dead, and the mystique of the empire was at its apogee, the atmosphere of holy patriotism made John Thornycroft's gift appropriate and acceptable. The statue is inscribed in letters of gold with a quotation from William Cowper's poem of 1782, 'Boadicea':

> Regions Caesar never knew,
> Thy posterity shall sway.[37]

As V.G. Kiernan has pointed out, the British people do not notice the irony that a queen who resisted the Roman empire's invasion with indomitable and bloodthirsty courage has been made now to serve as pious propaganda for the rule of its British descendant.[38]

Tacitus and Dio Cassius told the story of the red-haired Queen of the Iceni whose kingdom was annexed by the Romans after her husband's death, who captured Colchester and St Albans and London back from the Romans, and whose very name meant 'Victory'.[39] 'She was very tall', wrote Dio, 'and her aspect was terrifying, for her eyes flashed fiercely and her voice was harsh. A mass of red hair fell down to her hips, and around her neck was a twisted gold necklace.'[40] Defeated soon after in a bloody battle at Colchester in AD 62 (Tacitus says 80,000 Britons were slaughtered), Boadicea took poison rather than submit to her conquerors. They had flogged her, raped the kingdom's joint heiresses, her daughters, and plundered her rich household; besides she knew the Romans liked to parade captive queens in chains in their public triumphs.[41] Holinshed's *Chronicles* (1577) included the tale of her revolt, and Fletcher wrote a play inspired by his account, which was performed some time before 1619. She was not yet, however, the Boadicea of the awed public-school classroom. Milton called her 'a distracted woman,

with as mad a crew at her heels' in his *History of Britain* of fifty years later.[42] The figurehead of righteous Britishness and glorious British might was William Cowper's innovation and became popular only in Victorian times. Tennyson wrote a poem about her, in a complicated metre called galliambics:

Far in the East Boädicéa, standing loftily charioted,
Mad and maddening all that heard her in her fierce volubility . . .
Yelled and shrieked between her daughters o'er a wild confederacy . . .
'Me the wife of rich Prasútagus, me the lover of liberty,
Me they seized and me they tortured, me they lashed and humiliated,
Me the sport of ribald Veterans, mine of ruffian violators!
See they sit, they hide their faces, miserable in ignominy!
Wherefore in me burns an anger, not by blood to be satiated.[43]

The nineteenth-century interest in Boadicea formed part of a renewed patriotic inquiry into the pre-Roman – and therefore specially 'native' – past, which also awoke widespread Arthurianism as well, and was matched, or even surpassed, in France during the same period, where Gauls and Vercingetorixes in profusion were produced to adorn the town halls of the Third Republic.[44] Tennyson's comic note is inadvertent of course; recently Bill Belcher (so-called), noting the scythes on Boadicea's chariot, was more nimble:

Boadicea
Was rather a dear
She drove about with great abandon
And left her critics without a leg to stand on.[45]

In Margaret Thatcher, this prodigy of illusion has transpired; in her, Britannia has been brought to life. But she achieved this singular hypostasis not because she is a battle-axe like Boadicea, but because she is so womanly, combining Britannia's resoluteness, Boadicea's courage with a proper housewifely demeanour. She is known after all by two cosy names as well: 'Mrs T' and 'Maggie'. It may seem paradoxical to argue that Mrs Thatcher's femininity matters, since it is more usual to note her determination, toughness, dynamism and strength, and then assert that this is characteristic masculine equipment, making her female by sex alone. According to this view, Margaret Thatcher had to outdo men in virility to earn the respect of her colleagues and the country. It is she who is 'the best man in Britain'; she who 'wears the trousers'.[46]

But the conundrum she poses is more complex: she never wears trousers. She is careful to live up to the conventional image of good

behaviour in women prescribed for Conservative supporters. This image exists, like Britannia, in the realm of ideas; but Mrs Thatcher, both in reality and in iconography, surpasses the best Tory wife in Victorian domestic and female virtue. She has had herself photographed curled up on a sofa, that feminine position few men except dancers and gymnasts can achieve after puberty.[47] She allows photographs of herself doing the washing-up, stocking her larder, hanging wallpaper, wearing a lacy mob-cap, she tells the nut-sorter in the marzipan factory that marzipan is difficult to make, she knows. She cooks for her ministers, she attends formal conferences in shoes that make her teeter. Her hair is in place. Politicians and press see her in capable, female roles, as a nanny, a matron, a governess.[48]

Julian Barnes, contemplating Margaret Thatcher's rule for four more years, looked forward in gloom to 'the cold showers, the compulsory cod liver oil, the fingernail inspection, and the doling-out of those vicious little pills which make you go when you don't want to. No wonder the sick bay's overpopulated.'[49] Anthony Barnett in *Iron Britannia* developed another character:

> Has the governess now taken over from the squire? The question might seem an odd way to address the Falklands War for those who are not British. Yet within the UK it is a recognizable interpretation of the dispatch of the Armada. The country house has at last been captured. But is has not been stormed by an aroused rabble of gardeners, against whom it was well fortified. It has not been taken over by the disgruntled servants, who have been closely policed. It has not been seized by a radicalized scion of the mansion who had the misfortune to be repelled by its inequality and attracted to theory. It has not even been overrun by the proletariat, who are kept a good distance away. Assault from all these likely quarters had been foreseen and was defused. Instead, the pillar of rectitude and narrow-mindedness, the governess whose loyalty had never been in question, who naïvely *believes* in the whole thing and regards it as virtuous, has decided to run it herself.[50]

Nanny, matron, governess: characters from the youth of the landed classes, of the Edwardian nursery and the prep school dorm. These are not Mrs Thatcher's personal role models. But they are perceived to be in character because they are women of discipline. Margaret Thatcher has tapped an enormous source of female power: the right of prohibition. She exercises over unruly elements, near and far, the kind of censure children receive from a strict mother. It is a very familiar form of female authority; it just looks novel applied by a prime minister. It is also an authority that many are used to obeying.

Margaret Thatcher's fulfilment of women's role as wife and mother

also provides proof positive of her worth, she gains thereby legitimacy as a proper woman. Without this certificate of conformity she would be irregular, anomalous, and dangerous. But the traditional definition of womanliness embraces many pejorative 'feminine' qualities. Margaret Thatcher has isolated the virus that brings women into contempt and extracted a serum from it to inoculate herself. No one thinks of her as a sweetheart, or – God forbid – as their 'old lady'. These other stereotypes, with their overtones of affection, are not in charge. Besides, they are associated with comfort and indulgence and consolation, with love.

Thatcher's firm voice, her 'flintiness', her 'piercing' quality, her hard hair, her tough manner all go to prove not that she is as good as a man, but that she is not under the governance of Venus, that she is a stranger to the exactions and weaknesses of the heart, that her most private organ is her gut. No one ever thinks of her own mother, her children's grandmother. Her father, the mayor of Grantham, has been scrutinized. His views are known, and they coincide with hers. His daughter has so successfully ingested his high maleness that she seems, like Athena, to be daughter only to the male, not to the female. (See Chapter 4.)

Semantic shifts that operate in language have occurred to legitimize Margaret Thatcher, the potentially subversive female figure who has leapt the barriers to female power in Great Britain. As in a coded series, the semantic progression converts probity into an absence of moral weakness, and, in the case of women especially, this strength converts into sexual virtue, and sexual virtue means sovereignty over the heart, and this sovereignty, this control – this stoniness, this flintiness, this granite, this metal, this hardness – call it what you will, this is Margaret Thatcher's predominant political characteristic. Though she possesses so many of the very characteristics men have long diagnosed in pushy women and heaped with scorn, she does not earn traditional contumely, for she meets traditional demands on women in all that she has accomplished as housewife and wife and mother. And in doing so, she earns the right to inspire traditional chivalrous, even exaggerated, praise, in a way that a woman more contemporary in style, like Shirley Williams, fails to do.

One of her enthusiasts, the Cambridge philosopher Roger Scruton, writing about sexuality in the week before she was re-elected, described men as 'the victims of an impulse, which, left to itself, is one of the most destructive of human urges ... the lust that seeks ... to relieve itself upon her [woman's] body'. Historically, he wrote, women subdue, pacify, 'quieten what is most wild'.[51] Margaret Thatcher has benefited from this belief in women's virtuous power to control and discipline

rampant male libido, from this contrast between male agency and female containment. Scruton's notion is redolent of urban Victorian prescriptions about angels in the house, but he fingered accurately a widespread *idée reçue*, and one with continuing influence.

The female guardian of virtue is a familiar English figure. There is no single statue or icon that has achieved a cipher's instant recognizability, like the Statue of Liberty. But Glasgow, Edinburgh, Manchester, Leeds, Birmingham, Cardiff, Dublin, Belfast and London, most of them cities embellished by Low Church Protestant money (even Dublin, Anglo-Irish in the nineteenth century) and by citizens less inclined to view graven images with delight than their Papist contemporaries across the sea, are still filled with ideal figures who express the conquest of desire through will in the form of an armed woman. She is sometimes termed Peace, Victory or Fortitude, sometimes Courage, sometimes Justice, sometimes Truth, sometimes she bears the name of the town where she has been raised to central domination of town hall pediment or stock exchange portico. But she is always feminine in bodily form and lovely of demeanour and expression, and she is militant, expressing her potency through weapons. There are several Victories, alighting on pinnacles of London monuments: one reins in the horses of war on the triumphal arch to the Duke of Wellington at Hyde Park Corner since 1912 when she was sculpted by a cavalryman, Captain Adrian Jones; another, gilded and graceful, flies from the top of the Victoria Monument in the Mall, a successful group by Thomas Brock (Pl. 44). She spreads her huge, albatross wings over the marble statues below, of the old Queen herself, surrounded by Courage and Truth and Charity. Both Truth and Courage are armed, hard and resolute, sternly vanquishing their enemies. On Admiralty Arch, closing the vista from Buckingham Palace and the Victoria Monument, an amply built, draped female cradles a submachine gun in her lap. She represents Gunnery.[52] But there are two sculptures above all that bring special light to bear on the theme of the virtuous soldier.

The London monument to Gladstone stands in the Strand, just next to the beautiful small baroque church of St Clement Dane's and in front of the Law Courts. It is by Hamo Thornycroft, the son of Thomas Thornycroft who sculpted Boadicea, and it represents Gladstone wearing the voluminous cloak of the Chancellor of the Exchequer, in beaten and textured bronze. It is a fine piece, strong, dignified, earnestly expressive of the moral yearnings Gladstone lived to foster and proclaim, during his long period of influence. Gladstone's attendants are Aspiration,

Brotherhood, Education and Courage. They are personified as women, and two of them are almost narratives: Education is pointing ahead and teaching a child to read, Aspiration, with a huge closed book on her lap, gazes up and gestures towards the sky. Courage is however represented symbolically (Pl. 55). She grasps a snake by the neck, its jaws open, its tongue erect. A naked child clings to her, while she raises a scimitar in her right arm, about to strike. We could be in India, as described in one of Kipling's short stories – except that Courage is veiled and draped, as an ideal personification, and conceived, in pre-Freudian lack of self-consciousness, in the form of a rearing snake's decapitator.[53]

Hamo Thornycroft's Courage pays open tribute to a magnificent Victorian work, the sculptures of Alfred Stevens for the tomb of the Duke of Wellington, in which Truth is portrayed as a sweet-faced, gently smiling, ripe young woman, her huge body curving with the pressure she is bringing slowly and apparently tenderly – judging from her look – to bear on Falsehood, the satyr writhing under her as, with a pair of long pliers, she pulls out his tongue.[54]

These works of art – they count among the finest Victorian sculptures in London – do not express the individual concerns, fetishes, fears of castration or homages to sexual denial of the sculptors Alfred Stevens and Hamo Thornycroft themselves. They use the familiar and respectable trope of female personification to express an accepted view of goodness, hence their acceptability as official and public tributes to the major figures of the nineteenth century, Wellington and Gladstone, their status as welcomed commissions, and their condition of invisibility now in the life of the city's passers-by. Their form and appearance, the drama they perform – the serpent beheaded, the satyr silenced – obey naturally and simply certain prescriptive metaphors which associate sexual control by women and the suppression of erotic desire with moral worth, or, in Freudian terms, with the formation of the social human being and his super-ego. And they help us to understand how this wonder, a female Prime Minister of the Conservative Party, has come about.

Margaret Thatcher affirms the master fictions interwoven in British memory;[55] but not everyone consents to them. At Greenham Common, since 1981, protesters against the nuclear defence policy of Great Britain and Cruise missiles in particular have attacked those fictions and sought to empty them of influence and meaning. The constantly changing members of the group camping outside the base took the label 'Iron Lady' at face value and flung it back in the face of the Prime Minister

as an insult, as they evolved a long, complex, richly inventive allegory about good and evil, in which they were the champions of life, and their adversaries the soldiers of death. This group also knew that, by placing themselves near an active centre of power, and by confronting its force, they excited media attention on an international scale, and thereby increased remarkably in charisma. It is notable that a band of women, pitched in Berkshire in tents called 'benders', after the gypsies' most primitive shelters – plastic sheeting slung over a branch – with no official organization, no leaders, could have alerted so much anxiety about the deployment and control of nuclear weapons on British soil (Pl. 27).[56]

Like a mediaeval morality play about the dangers and perils of Everyman (Everywoman), the continuing demonstration at the former USAF base, now officially under the British RAF, has unfolded a dramatic cycle of scenes about a visionary peace and a nightmare war. In real life, the protesters have undergone a series of ordeals, constructed as *tableaux vivants*, about their terrors, their hopes and the character of women and the female order. The media have given them unstinted attention, often hostile, often scornful, sometimes sympathetic, not because they were interested in the arguments or the ethics on the whole, but because 'Greenham Women', as the members of the peace camp have come to be typed, have wrought a theatrical *coup*: the battle of the sexes, something embedded in the deepest strata of common culture, a drama performed in the pubs, on the buses, in television sit-coms, in the gossip columns, as well as in Shakespeare's comedies, had been annexed to name the sides in a political struggle.

The women invert the perceived male order in a series of dramatic gestures: they throw back in the faces of the soldiers working in the base the image of men as the saviours and defenders of the world; pinning them down inside the wire, like prisoners in surroundings they have themselves made, the demonstrators literally hold up mirrors in which the men see themselves reflected, and make them willy-nilly represent and stand for the work they are doing. The protests are intended to brand them, to forbid them claims to individually mitigating circumstances, to make the forces accept they have given their allegiance to violence, impersonality and extinction. And the lines between the people inside the wire and people outside are drawn in the name of sexual difference. 'Greenham Woman' is a compound sign, personifying peace and love and the future, in an apocalyptic allegory of human struggle for survival in which 'Greenham Man' is the angel of death. A banner made by T.D. and C.I. Campbell and J. Higgs for the blockade of the Common in July 1983, just two months after Mrs Thatcher's resounding

success at the polls, vividly expressed the polarity. On the left-hand –
pink – side, milk, fruit, flowers and doves encircled the floating green
earth proffered by hands, black and white; on the right – blue – side,
bombs, hooded like phalli, a battleship, a tank, rockets and the two-
headed eagle of imperialism surrounded a world shadowed and blasted
by war. 'It's Them or Us', read the caption.

To look across from one of the beleaguered women's camps at the
gates of the base, itself established in anticipation of beleaguerment on
a worldwide scale by another, far more distant adversary, immediately
introduces any visitor to Greenham to the two symbolic worlds created
by the protest. Concrete, wire, uniforms, grey, dark blue, machines,
cleanliness, order, regulations characterize the space of the nuclear deter-
rent; its heart conceals the bombs. The focus of the women's camp is
fire, too, the campfire, the kitchen, the ancient symbolic hearth where
the flames of nourishment and transformation of a different kind were
to be kept ever burning, the protesters hoped (though the series of
evictions which took place throughout 1983 and 1984 made their am-
bition impossible). The space of anti-nuclear protest is improvised, make-
shift, disorderly; the benders are put up here and there, razed by eviction
squads, erected again. Coloured ribbons used to hang festively from the
bushes, plaited wool in bright dyes decorated the women, their quarters,
their few scant possessions: flowers, struggling through the rubble tipped
on to the camp site by the Berkshire authorities to discourage the de-
monstrators, grew by the wire; the toys of childhood, puppets made like
corn dolls, paintings of the mother goddesses and moon deities marked
out the women's sphere. In one painting, a freedom fighter lifted a fist
and proclaimed again in the language of liberty, 'I am a woman, and if
I live, I fight, and if I fight, I contribute to the liberation of all women
and so victory is born even in the darkest hour.' Another painting
showed a woman crucified, her breasts and womb marked to indicate
the body as the vessel of reproduction, for beside her a blackboard read,
'I am Woman/Inflicted with the burden of bearing mankind.'[57]

In the early days of the camp, one of the women began weaving webs
of coloured wool, and thereafter the web spread as the symbol of the
women's peace movement itself. An organic structure, found in nature
rather than man-made, fragile in its parts and strong in its whole, adept
at capturing and defeating large predators, woven in the manner women
have worked for centuries, and also evoking memories of Gandhi's
pacifism, the web became an image of the message radiating from the
peace camp and the bush telegraph which could gather hundreds, even
thousands of women together for a mass protest.[58] It was used with

telling, mythopoeic effect on 12 December 1983, when the fence of the base was encircled by demonstrating women who wove into the wire mementoes, toys belonging to their offspring or others, flowers, ribbons, snapshots of loved ones, of children, grandchildren, and all manner of peace offerings, to represent the private sphere of affection, stability and fertility which the protest desires so desperately to maintain in the face of possible annihilation. Powerful at a symbolic level, the web even proved practical: the intricate tangle of symbols had to be laboriously unpicked by the authorities, proving far more arduous to clear than the rubbish of placards left by a more usual march. During the lie-in of October that year women enmeshed themselves on the ground under a tangle of wool and lay quiet; to pick them up and carry them off, the police had to cut loose the strands, an operation which forced them down to the women's level, to personal contact of a more delicate kind than the regular violent hauling and dragging and struggle of an arrest. On both occasions, the forces of the law found themselves undertaking a fiddly task of the kind women are traditionally required to do. In the film *Carry Greenham Home* (1984), made by two members of the peace camp, Biban Kidron and Amanda Richardson, one of the scenes shows the guards at the base attempting to unlock a bicycle chain placed on the main gate by the women. Unable to hack, saw or pick it, the police, ever increasing in strength, rushed the entrance in a posse. The lock did not give; the gate came away instead at its hinges. The women laughed, as well they might, at the grim sight of force failing to prevail against humble craft.

Greenham Woman dances, keens, picnics in fancy dress, wears witches' costumes; constantly, she has recourse to archaic female customs and tasks, as mother, mourner, midwife and wisewoman. The imagery used derives from stock definitions of what is feminine, and does not hesitate to assume many descriptions of women's 'nature' which feminism has rejected. The female order presented by Greenham is nurturing, peaceable, kind, fostering, forbearing; women soothe, they comfort, their nature is sacrificial.

The protesters are indeed living out a life of extreme hardship: enduring their fourth winter at the time of writing, and under continual harassment, from bailiffs, police, soldiers, and from local youths, who have attacked them with pig's blood and excrement. The soldiers behave obscenely; their children make V-signs and have been taught to swear at the women. They endure it on others' behalf, to bring about a revolution in consciousness, to bear witness to the horror contemplated by the defence policy makers. But in almost all other respects Woman,

as dramatized by their gestures and protests, bears no resemblance to the people they have to be in order to act her; the text they perform does not speak directly of the anger, strength, celibacy, courage, unhomeliness, determination and militancy of the protesters, though of course their actions confirm all these qualities. The surface text says one thing, about love and peace, joy and the maternal character of women, but the way the message is conveyed upsets all assumptions any soldier in the base might have entertained about accompanying docility or desire to give pleasure, to accommodate, to obey. By confusing their enemies' impulse to chivalry on behalf of women and children, by robbing them of this rationale of war and soldiery, Greenham Woman has taken a master fiction and turned it inside out. She invokes a stereotype in order to shatter it, and in so doing she has earned her popular character as a deviant.[59]

Like the revolutionary sects of the seventeenth century, and like earlier millennial movements which also anticipated the end of all things, Greenham Woman wants to turn the world upside down and substitute her radical vision for the prevailing order of salvation. And the dream she performs sets the symbol of woman at its centre; the Greenham drama belongs to the long tradition of expressing virtue in the female form. The demonstrators embody the concepts they strive to put before us as an alternative. They have made fundamental sexual difference the premise of their vision, and they ground that difference in the body, from which their mental and emotional attitudes follow. They have hung rags dipped in red paint on the wire to symbolize menstruation, investing the blood from which babies could be born with apotropaic power to face out death. A child was born in the camp, out of a shared need to show that women on their own can deliver life as well as give birth, and do not need obstetricians and hospitals, identified with the impersonal, mechanistic male world. During the deeply ugly struggles when bailiffs violently seized the campers' possessions and turned them off the land in 1984, the women, trying to protect one another from manhandling, pleaded the privilege of their sex. 'She's a woman, she's precious,' said one, trying to prevent a bailiff from pulling her friend into a van.[60] When some women returned, in the summer of 1984, eight of them commemorated the fortieth anniversary of the bombing of Nagasaki by stripping themselves naked and smearing their bodies in ash and blood-red paint, thus crystallizing three years' sacramental imagery of the human body and the female body in particular.[61]

The courage and determination of women at Greenham pose a dilemma for a believer in nuclear disarmament and in sexual equality. The

dominant voices among them hark back to the fantasy of the archaic, all-encompassing mother of creation, and this may be ultimately the most dangerous and intractable patriarchal myth of all, responsible for the long history of inequity argued from biology. The camp at Greenham acts out the predicament of women's marginal status and scapegoat condition. The protesters have harnessed the powers that the anomalous outsider within any society possesses, to inspire loyalty, sympathy and rage, to infuriate and alarm, to move and to prophesy. But some of the Greenham women do not see this as conferred by their adversary role, but claim such powers are intrinsically, essentially and uniquely female, the result of women's deeper intimacy with the life forces. Greenham women have been remarkably effective as propagandists, at raising the alarm, at uncovering the evasions of government, but the drama of the sex war they perform may have surprisingly traditional roots.

On returning from her holidays in 1984, Margaret Thatcher announced publicly and immediately that the returned demonstrators at Greenham would be again removed. Both the representative of due order, who has so judiciously avoided identification with the female interest, and the subversives who have risen up against the values she represents have been shown through newspapers and television all over the world as signifying something other than their own persons. The Prime Minister was elevated through an allegorical use of her figure at the time of the Falklands war, and she has played the part as well as she can, once it was thrust upon her. The peace campaigners at Greenham Common, and the sympathizers who have imitated them in other nuclear bases in Great Britain, in Italy, in the United States, by establishing women-only protests, have shown the inspiration and the zeal of religious radicals, the spirit of the Ranters and the Levellers and the Diggers, and the Quakers who are still active in the peace movement, when they enact, in the life they have chosen, or in small protests like the memorial for Nagasaki, or in mass demonstrations, the living allegorical drama of Everywoman, violated by her offspring who are blind to her gifts of life.[62]

PART TWO

The Figure in Myth

Myths are nothing but a ceaseless, untiring solicitation, an insidious and inflexible demand that all men recognize themselves in an image, eternal yet bearing a date, which was built of them one day as if for all time. For Nature, in which they are locked up under the pretext of being eternalized, is nothing but Usage. And it is this Usage, however lofty, that they must take in hand and transform.

ROLAND BARTHES[1]

CHAPTER FOUR

Engendered Images

It is a great compliment methinks to the sex, says Cynthio,
that your Virtues are generally shown in petticoats. I can give
no other reason for it, says Philander, but because they
chanced to be of feminine gender in the learned languages.

JOSEPH ADDISON[1]

The general view of women in the Judaeo-Christian tradition can be
grasped, not unfairly, from the sighs of Siracides:

> Any wound rather than a wound of the heart!
>> Any spite rather than the spite of woman! . . .
> No wickedness comes anywhere near
>> the wickedness of a woman,
>>> may a sinner's lot be hers! . . .
> Sin began with a woman,
>> and thanks to her we all must die.
>>> (Ecclus. 25: 13-24)★

Later, St Paul, blending Greek and Judaic misogyny, notoriously defined
woman's place in the plan of redemption, and gave her little space for
spiritual potential:

> I am not giving permission for a woman to teach or tell a man what to do.
> A woman ought not to speak, because Adam was formed first and Eve
> afterwards, and it was not Adam who was led astray but the woman who
> was led astray and fell into sin. Nevertheless, she will be saved by child-
> bearing.
>
>> (1 Tim. 2: 12-15)

The argument against woman, aligning the female with carnality, weak-
ness and nature, with 'womanishness', and the male with spirituality,
strength, and mind or reason, beats its persistent rhythm down through
the years, and though the values assigned to each category shift and alter,

★ Biblical references are to the Jerusalem Bible unless otherwise specified.

63

women usually fare the worse. The demiurge in Plato's *Timaeus*, a book which exercised a profound influence on the development of mediaeval philosophy, mixes the souls of humankind in his bowl, 'and ... being of two sexes, the better of the two was that which in future would be called man'.[2] Later, developing a non-Christian doctrine of reincarnation, the *Timaeus* nevertheless strengthened latent Pauline misogyny: 'Anyone who lived well for his appointed time would return home to his native star and live an appropriately happy life, but anyone who failed to do so would be changed into a woman at his second birth.' The next stage down the ladder of being was 'animal'.[3]

The Platonist Methodius of Olympus, writing the century after Paul on the merits of chastity, casts the ten speaking subjects of his *Symposium* as women but insists that they are honorary males, for virginity's principal attraction is its ability to cancel woman's womanliness. The Christian soul, who achieves a true resemblance to Christ, also changes gender: 'The enlightened spiritually receive the features and image and manliness of Christ.'[4] The contemporary Catholic prohibition against the female priesthood still argues that the priest represents Christ, who was a man in his masculine character (*vir*), not the generic *homo*. A priest cannot therefore be female in sex.

But language had played this odd trick on philosophical discourse: Arete, the very name Methodius gives to the leader of his contemplations on chastity, means virtue in Greek, and is feminine in gender, as is *virtus* in Latin, as are abstract nouns of virtue, of knowledge, and of spirituality, with some exceptions, in Greek and Latin, and the languages which derive from them or borrow greatly from them. The words for the three theological types of virtue, Faith, Hope and Charity, the four cardinal ones too, Prudence, Justice, Fortitude and Temperance, for the Seven Liberal Arts of the mediaeval scholastic curriculum, for Wisdom – Sophia, Sapientia, and in Hebrew Hokhmah, the wisdom of God, and Shekinah, the presence of God – are feminine in grammatical gender.

Congruity with the female character was hardly ever adduced. Rather, the oddness of language's alignments provoked comment. After all, if woman were a defective male, as Aristotle's defective biology claimed, and considered by Greek law, for instance, incapable of running her own finances, or bearing witness in a court of law, it was uncomfortable that lofty speculations on the nature of justice and the soul were necessarily expressed in the feminine.[5] Paul's contemporary Philo Judaeus, in the first century AD, tried to rationalize the discrepancy between the status and character of women in his time and the feminine gender of abstract nouns:

Indeed all the virtues have women's titles, but powers and activities of consummate men. For that which comes after God, even though it may be the highest of all other things, occupies a second place, and therefore was termed feminine to express its contrast with the Maker of the universe, who is masculine.... For pre-eminence always pertains to the masculine, and the feminine always comes short and is lesser than it.[6]

In the sixth century, Isidore of Seville, in his etymology, overlooked the discrepancy of gender, and found another reason. He derived the word *vir*, man, from *virtus* and gave his reasons:

He is called 'man' (*vir*) because there is greater 'strength' (*vis*) in him than in women: whence 'virtue' takes its name.... But 'woman' (*mulier*) comes from 'softness' (*a mollitie*) ... therefore there is greater virtue in man and less in woman.[7]

The problem was still vexing the Renaissance iconographer Cesare Ripa at the beginning of the seventeenth century. Ripa did not take Philo's point that women's secondary status accounted for abstractions' gender; and he proposed various other reasons in his *Iconologia*, one of the most widely disseminated handbooks for artists from its appearance in 1602 until the end of the eighteenth century. Strength (*fortezza*), he laid down, should be represented as an armed lady with big bones and a 'petto carnoso', a stalwart chest. He went on:

She should be a Lady, not to declare thereby that a strong man should come close to feminine ways, but to make the figure suit the way we speak; or, on the other hand, as every virtue is an appearance of the true, the beautiful, and the desirable, in which the intellect takes its delight, and as we commonly attribute beauty to the ladies, we can conveniently represent one by the other; or, rather because, just as those women who deprive themselves of the pleasures to which nature has made them incline acquire and preserve the glory of an exceptional honour, so the strong man, risking his body, putting his life in danger, his soul aflame with virtue, gives birth to reputation and fame of the highest esteem.[8]

Ripa thus gives alternatives for representing Strength as a woman: to follow grammar, to conform to the Platonist idea that beauty in all its aspects reflects the divine and women are more beautiful (!), and, thirdly, to express the Christian idea that, as women are morally weaker, their strength is all the greater if they actually manage to be good. It is an intriguing cocktail, and a fair résumé of some of the thinking behind the Statue of Liberty, for example. But in Victorian Britain, when a great number of our images of Justice and Courage and so forth were made,

the reasons for continuing to conform to classical grammar were different. After all, Italian and French preserve masculine and feminine gender, but English only distinguishes between neuter things (it) and people (he and she) except in a very few instances, like ships, tornadoes, heavy artillery, military companies, and cars.[9] Yet buried gender continues to influence rhetoric and art.

Gender in language poses a problem. Every student of an inflected language has suffered from its practical difficulties; anyone who has questioned the usage of masculine and feminine, as contemporary feminists have done, has wondered what effect it has on our conception of male and female. Yet there is little equivalence in linguistic gender between the feminine and the female. *La bête* in French means 'beast' or 'insect' regardless of the sex of the animal or brute or insect in question: *la victime*, a victim. In Greek, *teknon*, 'child', is neuter, while *pais*, 'boy and girl', could be either masculine or feminine; in German today, young girl, *Mädchen*, is neuter. There can be no rationale behind a system which allots knife, fork and spoon to different genders, as happens in Greek, and no intended agreement with biological sex in languages which characterize female sexual organs as masculine and male as feminine, an inversion which occurs in popular French words for genitals: *le con* (feminine) and *la pine* (masculine) for example.[10] As the linguistic historian A. Meillet declared: 'Grammatical gender is one of the least logical and most unexpected categories of grammar.'[11] Its incoherence should have condemned it to decay, as it has virtually in English. But it has survived, he laments, almost intact in most of the Indo-European group of languages.[12] As the poet Tom Disch has observed, in his witty and argumentative 'On the Use of the Masculine-Preferred':

> In the French language night
> Is a woman and day is a man,
> And no poet or poetess can escape
> The implications. We are free
> Who speak English from wondering why
> Our hands, though masculine in form,
> Are, even so, feminine nouns.[13]

Gender attempted to make an important distinction in the parent language Sanskrit: between animate and inanimate phenomena. Masculine and feminine gender nouns belonged to the animate categories of beings, inhabited by a *daimon*, or active principle; neuter to the inanimate. This difference is still clearly marked in English, where on the whole 'he' and 'she' mark living beings, and 'it' refers to non-sentient

and inanimate things. Nothing is so simple in the Romance languages however, where the neuter has become absorbed into the masculine, and hundreds of inanimate objects can be masculine, neuter or feminine without rhyme or reason. The same things can be named by words of different gender: *le siège* or *la chaise*, *la tavola* or *il tavolo*. The genders were only named 'masculine' (*arsenikon*, from the Greek *arsen*, male) and 'feminine' (*thelykon*, from the Greek root *thel* – which gives the words for suckling, and teat as well), and 'neuter' *oudeteron* (meaning 'neither') by grammarians, like Dionysius Thrax in *c.* 200 BC who attempting to provide a system for the complexities of Greek language, named the genders after the proportionately larger number of biologically male and female creatures within each morphological category.[14] The ascription has proved much more important than the grammarians could have perhaps foreseen, as the connotation of femininity certain nouns thereby acquired has inspired ponderings over the semantic links with human female character.

Three aspects of feminine gender have deeply affected the use of abstractions in rhetoric and in iconography which depends on rhetoric. First, abstract nouns in Greek were formed in relation to verbs and adjectives which are not in themselves marked by gender; when they commanded masculine or feminine articles and inflexions, they were incorporated into the linguistic group of animate things, not inanimate things. They could then acquire the face and character of divinities, and appear active through an indwelling daimonic agent, as we shall see. But the majority were formed with suffixes which take feminine agreements, including the characteristic *-eia* and *-e*, so productive of abstractions like *giustizia* in Italian or *justice* in French. This original animate character of the feminine has not been effaced, and is particularly marked in English, where the neuter has continued. Any personification in English must switch from the neuter to the personal pronoun: in the famous passage in 1 Corinthians 13, where the apostle talks of charity, the translators of the King James Bible felt the pressure of the Greek *agape* and Latin *caritas* and at one point submitted to Paul's sustained personification by changing from 'its' to 'her':

> Charity suffereth long, and is kind; charity envieth not; charity vaunteth not *itself*, is not puffed up, Doth not behave *itself* unseemly, seeketh not *her* own, is not easily provoked, thinketh no evil.
>
> (1 Cor. 13: 4–5)

A second aspect of feminine gender has influenced the character of abstract nouns' behaviour in our verbal and visual imagery. Nouns

themselves do not indicate their gender (though certain endings predominate and can give an inkling; but *mater* (mother) and *pater* (father) for instance share an identical form in the nominative). We learn it not from the sense, but from the endings of the adjectives which qualify them, or the articles which designate them (*un* or *une*, *le* or *la*). The feminine form of agent words is derived from the masculine, not vice versa; unpalatable as its social implications have become, it is the masculine which is generic, and the female counterpart is formed verbally from the male. In Greek, *despotes* (master) gives *despotis* (mistress); in French, *instituteur* (teacher) is modified to give *institutrice*; in English, the feminine diminutive suffix–ette has proved rich even today; the hovercraft crossing from Dover to Calais promises the attentions of a 'purserette'; *Private Eye* talks of 'hackettes', female journalists; Catholic churches now issue the day's liturgy in a 'missalette'. This morphological dependence on the masculine has provoked a widespread association of femininity with contingent and smaller status.

Thirdly, while feminine nouns belong to the animate category of Indo-European, in Greek and Latin they are less often agent nouns but much more frequently nouns of action, as in the case of the root of the word 'agent' itself: formed from Latin *agens*, the present participle from *ago*, to act, it gives *actor* (masculine – actor) and *actio* (feminine – action). This pattern is extremely common in Greek, Latin and the Romance languages, and survives in such triads as *aeido* (I sing), *aeidos* (singer), *aeide* (song, feminine); *juger* (to judge), *le juge* (a judge – masculine, whether the judge in question be male or female) and *la justice* (feminine – justice). Of course, as grammatical gender is in question, nothing so simple can be formulated, and there are hundreds of exceptions. Action nouns of the masculine gender are plentiful in Greek – *moros* (doom) *hypnos* (sleep) – though less so in Latin and its descendants. But a pattern begins to emerge: feminine gender is animate, it was named by grammarians after the biological maternal role of female animals, it depends for its verbal formation on the masculine, and it often describes effects or actions.

All these elements are present when we contemplate a statue like F. W. Pomeroy's Justice of 1907 over the Old Bailey in London, or Bartholdi's Liberty in New York: absolute concepts embodied in the female form an account of grammatical gender, they proclaim the result of the systems enacted not by themselves, but by others. The nouns designating the latter – the judges, the lawyers, the American people, US citizens – will tend to be masculine in gender, and so assign the images a maternal relation to those agents who carry out the principles they represent.

But the filiation also works in reverse. As the effect of another's agency, the designated quality also stands in relation to him as offspring. Abstract principles are engendered by the exponent who displays them; they are further engendered in the female form because, according to the Aristotelian contrast between matter and form, the female provides the stuff of origin (*hyle*) while the male stamps it with form (*eidos*) and gives it identity and shape.[15] This metaphor of motherhood and filiation works in both directions. The principle is brought forth by the agent but cannot take substance in the visible world unless it be mothered in matter, embodied. *Meter* (Greek), *mater* (Latin) and *materia* (matter) share the same root, *ma-*, source or origin. It is like a chemical experiment: a particular catalyst precipitates out the essence, the crystal; but catalyst and crystal must be formed of matter. The female form provides the solution in which the essence itself is held; she is *passio*, and acted upon, the male is *actio*, the mover. Without being too reductive, since gender's arbitrariness refuses to yield a coherent pattern, we can say that this process is implied by such Victorian monuments as Gladstone's in the Strand: Gladstone is both son and father of these qualities – Brotherhood, Education, Courage and Aspiration – who attend him in female form (Pl. 55).

The relations of linguistic gender and society are extremely hard to describe, and the interaction is certainly not straightforward. It is a mistake to assume the attitudes of a people to the sexes can be deduced from its laws of gender: Persian and Armenian are the only Indo-European languages to have abandoned gender altogether, and neither society exhibits a concomitant indifference to sexual differentiation in social custom. In the case of Iran, the present political and religious situation has dramatically widened the distinction between men and women, their appropriate conduct and character, even though the language offers no corresponding gender contrast. In China, where footbinding, female slavery, concubinage, and the exposure of girl babies were common, ideograms are not grammatically masculine or feminine, while the Yin and Yang principles identified with femininity and masculinity, to which concepts are aligned, are held to be in equal balance and of equal importance.

But however arbitrary and adventitious grammatical gender in the Romance languages may be, it imposes its law on language, and we are the inheritors of figures of speech deployed in literary texts by poets and tragedians, who, since the earliest Greek literature we have, the epics of Homer and Hesiod, have had to obey linguistic rules and have therefore followed gender. 'Languages serve to express the mentality of the speak-

ing subjects, but each one constitutes a highly organized system which imposes itself on them, which gives their thought its form and only submits to the action of this mentality in a slow and partial manner, only as and when it happens.'[16] The effect linguistic gender has had on the way we think is hazardous to analyse. But it can be said that one of the consequences of gender has been the seemingly animate and female character of numerous abstract nouns.

The early Greek writers do not distinguish between personal gods and active principles, between Styx as a waterfall by whom the gods swear their oaths, Styx as the daughter of Oceanus the river and of Tethys, who lives in the sea, or Styx as the mother of Nike, goddess of victory and of Bia (Force) and her sons Zelos (Glory) and Kratos (Power) who, the poet Hesiod tells us in his influential mythology, the *Theogony*, 'sit for ever at the side of thundering Zeus'.[17] Aspects of his power, they are also members of the divine pantheon. The difficulty we experience telling whether a Greek mythographer intends to deploy a figure of speech (personification) or describe a personal being is compounded because early Greek manuscripts were written in majuscule: no initial capital letters discriminated between *dike* the principle of justice and an aspect of Zeus's power, and Dike, his divine daughter, between *peitho* as persuasiveness, and Peitho the goddess of persuasion, one of Love's hand-maids. Only context and sense can indicate to the reader the divine corporeality of these principles; and frequently, and especially in the *Theogony*, context does not help us very much.

Hesiod's *Theogony* tells the Greek myth of creation, and since the eighteenth century, when it was first widely read again, it has provided the principal source for the Greek view of the gods and their inter-relations. The verse epic could antedate Homer; at least the case has been persuasively argued by West that Hesiod was writing *c.* 730–700 BC, just before Homer.[18] Through Hesiod, we understand the gods to be people, not personifications, often because they connect with one another sex-ually; the dominant, recurring metaphor for the disposition of the world in all its aspects is procreation. *Theogony* – his very title – implies the physical origin of the gods through generative process.

At the very beginning there is formless Chaos. 'But next appeared/ Broad-bosomed Earth';[19] she is Gaia, Mother Earth, and her siblings are Night and Darkness, who then couple to give birth to Day and Space. Though Chaos is a neuter noun, the metaphor of generation overrides grammatical gender, and Chaos is treated by the poet as a bringer-forth like Gaia.[20] More often Hesiod obeys grammar, and the steady chanted

concatenations of unions and progeny that form the most mantic passages of his epic follow grammatical categories as the mating divinities are told like beads on a string. Eros, Love, is present too, almost from the start, appearing beside Gaia after Chaos, a near demiurge who does not behave in these early couplings as an individual taking part, but as a pervasive demiurgic force.[21] When Gaia gives birth to Heaven, Uranus, they then create the mountains and the sea, together with the first generation of those whom we accept more easily as personal gods, like Iapetos, the father of the Titans, famous Prometheus amongst them, or Thea and Kronos, the parents of Zeus who will eventually rule Olympus. The progeny whose names do not mean anything to us, the gods whose natures are not disclosed in the words that designate them, seem to us to be individuals, like Zeus or Athena, for instance, whereas Mnemosyne (Memory), later mother of the Muses, or Hyperion ('Dazzling'), one of the epithets of the sun, both of them offspring of the coupling of Gaia and Uranus, Earth and Heaven, sound to our ears like abstractions personified. But it would be wrong to think that Hesiod or his audience perceived this difference; immortals are all personal and impersonal at once.

As West writes, 'In Hesiod's time it was not understood what abstractions are – no more was it in Plato's. They must be something; they are invisible, imperishable, and have great influence over human affairs; they must be gods.'[22] But the meaningful names evoke associations, and so when the poet comes to describe the descent of Night, a poetic litany flows from him in a stream of consciousness that makes Night the virgin mother, in this case, of dark daimonic things, of Thanatos (Death), and his associates, Doom and Distress (Moros and Ker); then, by analogy, of Sleep, which but death's picture is; then, by functional connection, of Dreams. Without a shift of tone, as if the slippage from one type of association to another meant nothing to him, Hesiod tells us that Blame and Distress, aspects of the dark night of the soul, then appeared. The Hesperides, the nymphs who guard the golden apples beyond the edge of the world, where Heracles had to go to steal them, are next. Their westernmost dwelling place, the land of the setting sun, suggests nighttime, though their garden and its golden fruit contradict the sombreness of their fellows who precede them. After them, the goddesses of destiny, so active in Greek experience, the Moirai and the Fates, are born, and with them all the dark aspects of human life, that these goddesses 'who never cease from awful rage/Until they give the sinner punishment' deal out to 'men and gods'. They are followed by the goddesses Nemesis (Revenge), and Eris (Strife), and then the human experience of Deceit

and Sex paired, with all their implications of cheating and love pangs. Eris herself, who threw down the Apple of Discord at the wedding of Peleus and Thetis with the label 'For the most Beautiful', and by inciting the rivalry of the goddesses Hera, Athena and Aphrodite began the long tragedy of the Trojan War, leads Hesiod to link her with a host of ills:

> And hateful Strife gave birth to wretched Work,
> Forgetfulness, and Famine, tearful Pains,
> Battles and Fights, Murders, Killings of Men,
> Quarrels and Lies and Stories and Disputes,
> And Lawlessness and Ruin, both allied,
> And Oath, who brings most grief to men on earth
> When anyone swears falsely, knowing it.[23]

These names are not personified to add literary flourish to Hesiod's verses; Night's children, born of her without a father, are not mere abstractions, whose status is not divine, not worthy of the cult offered to the gods and of cult's foundation, story. They possess independent force as daimonic entities. As Fletcher has warned, 'We should make no automatic assumptions about the "unreality" of allegorical personifications.'[24] Hesiod, by naming the active principles, good and bad, in the universe, performs a priestlike task inherent in language's attempt to order the universe, that of making distinctions. The daimons are active principles and he designates them by name as aspects of human destiny; both destiny, *moira*, and *daimon*, are derived from different roots for words meaning *share*, distribute, or divide. *Moira* is the lot apportioned to a human being;[25] an early meaning of the word 'demon', so down-fallen in Christianity, was 'a distributor, usually of destinies'.[26] Hesiod, by discriminating so pessimistically between aspects of human fate is showing that the lots can be given out in differing forms. 'Daimons . . . share this major characteristic of allegorical agents, the fact that they compartmentalise function.'[27]

Eris, Strife, a close relation of the later Christian demon of envy, reappears in Homeric epic and later myth as both the functional agent of discord, and a well-bounded, individual character, the mistress of strife. In the *Iliad*, she fights alongside Ares. 'Once she begins she cannot stop';[28] her 'great and terrible war cry' rings out down the line of Greek ships to rally the men.[29] She has perhaps survived in the wicked fairy of fairy tale, the Carabosse who interrupts another festal occasion, the christening of the Sleeping Beauty.

The establishment of Zeus as ruler of the gods is the theme of Hesiod's

Theogony, and he delays the moment of its consummation with great skill, as he places the story of Zeus's ancestors, of his descent, birth and violent struggles, at intermittent intervals between the several genealogies he deploys as framework, so that the varying motifs of his epic resound off one another like singers answering the players in an oratorio. They combine to tell the story of Zeus, and then separate to fill in the cosmological background of the world that will eventually be his dominion. At last, Zeus's apotheosis puts an end to the cycle of parricide and mayhem that beset the destinies of his predecessors, and out of the natural cosmos moves us into an anthropocentric political society, regulated by law under Zeus's kingship.

His undivided and absolute rule established, Zeus marries. His first spouse is Metis the Titaness, who is, Hesiod tells us without equivocation, 'wisest of all, of gods and men'. She helped Zeus defeat his father and the Titans, for she is 'Resourcefulness' itself, Cunning Intelligence embodied, as her name in Greek signifies. But Zeus is warned that a son by her would depose him as he has usurped his own father, Kronos, and Kronos his father before that; and so Zeus confirms his claim to eternal kingship in Olympus by ending the feuding from generation to generation. He seduces Metis into allowing herself to be eaten by him. He takes her down into his belly,

> so that the goddess could
> Counsel him in both good and evil plans.[30]

In the myth, the fabulous dimension of the story, the swallowing of the Titaness by Zeus, can have no meaning separate from the assimilation of wisdom by the father of the gods.[31] The marriage metaphor, which first united him to Cunning and Resource, did not suffice; he must ingest them, make them one with him. Incorporation is a stronger bond than union and grants total control.

As a daimon who dwells within the paternal womb of Zeus, Metis no longer possesses the individuality of separate physical existence, by which we understand her to be a person. But her powers remain unimpaired, only differently sited and generated. Metis is both agent and manifestation of Resourcefulness, practical wisdom; Zeus's incorporation of her into his being robs her of freedom of agency but does not diminish her force; the *thea* (goddess) loses definition to the daimon, and the personal patriarch with his multiple-faceted valency takes over from the plurality of the earlier pantheon, representing separate powers. Once Metis is interiorized, then the spirit of Wisdom can be distinguished

73

once again from Zeus's body, and subordinated to him, by another actualizing metaphor, by filiation.

According to the famous myth, Athena was then born from the head of her father, for Metis was pregnant when she was ingested. The new, second goddess of cunning intelligence, or wisdom, is born of the god, as his daughter. Hesiod tells us that Zeus bore

> from his own head
> Grey-eyed Athena, fearsome queen who brings
> The noise of war and, tireless, leads the host,
> She who loves shouts and battling and fights.[32]

In another description of her birth, the Homeric hymn to the goddess, she erupts 'holding the golden-gleaming weapons of war', and the gods stand by astounded as 'she springs from the immortal head brandishing her keen spear'.[33] Pindar describes how the head of the father of the gods was cleaved open by the lame craftsman god Hephaestus 'and his bronze-beaten axe', and

> Athena jumped out, and cried with a monsterous shout.
> And the sky shuddered at her, and Mother Earth.[34]

In other versions of the story, it is Prometheus who splits Zeus's brows to bring forth his fully grown daughter.[35] The scene appears often on vases, some of great power and beauty: Zeus sits, either in profile or full-face, impassive and majestic in his Olympian regalia with the sheaf of forked lightning that is the sign of his power in one hand, while on either side of him the Eileithyiae, or goddesses of childbirth, 'the travail-makers', sometimes beat their arms up and down, like midwives giving the labouring wife a rhythm to breathe to during her pains. From his head, holding her spear and her shield, with the snake-trimmed aegis thrown over her chest, Athena leaps out, one leg flying forward, while the gods turn to stare at her momentous irruption into life (Pl. 29).

In Hesiod, Zeus then takes for his second wife another Titaness, Themis, who stands as Metis' counterpart. Whereas Metis sets in train associations with the unpredictable, the unexpected, with flashes of inspiration, duplicity, cleverness and craft; whereas she conjures the keen wits of those who think on their feet, who cut across the grain of customary behaviour and arrive at the ruse that will do the trick – like Odysseus, who is *polymetis*, 'wily Odysseus', the gifted trickster of the Homeric epic – Themis presides over the opposing code of conduct,

over regularity and stability. Her name signifies law established by custom, long tradition, due process observed.[36] By her, Zeus becomes father of the Hours, a sacred, public triad, composed of Eunomia (Order), Eirene (Peace) and Dike (Justice).

Some of the great choir of Greek daimons remain pale, muted shadows; others live vividly in an oneiric and impossible landscape, like Metis, the Titaness, in Zeus's womb. The devices which Hesiod uses that intensify the colour and the sound of his abstractions for us are chiefly the metaphors of filiation and espousal; when abstract nouns marry, bear children, they spring to life in our receiving imaginations. Or when Hesiod names them, as he does in long rhythmic lists, he breathes life into populous and entrancing divine guilds, the Nereids, and Muses, and Hours. When no daimon exists, the poet seems to have invented one. Sometimes Hesiod's personal names recall their bearers' characteristics or name their functions. Thalia, for instance, the Muse of Comedy, derives her name from the word for good cheer, her sister Erato from the adjective that means lovely, inspiring of love, and so forth through the nine daughters of Zeus and the goddess Mnemosyne, so that the reader is left with the vision of refined and peaceful content, of light-footed dancing, singing, playing and gifted girls. In Erato's case, Hesiod catches the echo of a word he had already used to describe the 'loveliness' of the sound of the Muses' feet and of their voices singing. Hesiod may have even invented the Muses' names, improvising on different aspects to bring them to undivided life. But if he did, his inventions were swiftly adopted, for in the sixth century BC, the François vase, now in Florence, depicts the nine Muses with Hesiodic names (with the exception of Terpsichore, Muse of Dancing).[37] Hesiod's sea-nymphs too, the Nereids, all fifty of them, reflect properties of their watery origin. All but four bear allegorical names: they too are 'lovely', 'cheerful', 'glittering' like the sea (Glauce), sweet as honey (Melite); some recall by their names the harbours and shores where they live, some the creatures, like the swift, who also can be found by water (Cymothoe).[38] 'The total effect of the catalogue is to give a picture of the sea and its role in the life of man,' wrote Norman O. Brown in his edition of Hesiod's *Theogony*.[39] The Graces too, the Charites are aptly titled:

> From their glancing eyes
> Flowed love that melts the strength of a man's limbs,
> Their gaze, beneath their brows, is beautiful.[40]

Aglaia means 'dazzling in beauty', Euphrosyne 'full of mirth' and, again, Thalia 'cheer' (or, in Norman O. Brown's version, Pageantry, Happi-

ness, Festivity).[41] Hesiod, dreaming of *jeunes filles en fleurs*, invented an imaginary taxonomy like the nursery rhyme writer who fantasized,

> Monday's child is fair of face,
> Tuesday's child is full of grace ...

and created a fancy which every little girl and boy has at one time believed might mean something personal.

The deities whom Earth brings forth without a father, 'without pleasant love', stand apart from the family of Zeus;[42] they have a single matrix, in the maternal dark, rarely have offspring, and possess no personality. But Zeus, who marries and mates wantonly, has spectacular and undeniable personality, engendering children right and left, for, as Homer's Poseidon says, 'a god's embrace is never fruitless'.[43] We need this anthropomorphic context of sexual generation to understand abstractions as persons; Hesiodic personification largely relies on an analogy between vitality and sexuality, profoundly and unselfconsciously assumed in his writing.

Weak personifications, on the other hand, like the terrible children of Night, are not only virgin-born, but often issueless too. For the most part, these dim images do not bear offspring, abstract or otherwise. The line ends with them. They derive from a single state, and end in the same way. They do not contribute to the flow of the myth Hesiod tells, the story of Zeus's succession. The daimons who participate in the genealogy of Zeus have on the one hand the force of preterites in syntax, they make the sentence about the god's origins work; the others, pale abstractions, are floating nouns and lack activating power.

The elements of the cosmos and the multifarious aspects of human destiny become animate in Hesiod's text; his universe is crowded by daimons. In Homer, too, phenomena can be possessed of an indwelling valency, a power, the virtuality that makes them actual in the created universe, though in the epics the numbers and powers of such divinities are few compared to Hesiod. Phobos (Panic), and Deimos (Rout) are states produced by war: Panic also dwells in the grim aegis of Athena, part of the horrible panoply with which she strikes fear into all who see her.[44] But the pair are also the sons of Ares, god of war, and appear in attendance upon him in battle.[45]

Personified forces take possession of men and women's minds, in the form of 'psychic interventions', as E.R. Dodds put it.[46] Like the demons of later Christian belief, who only survive with pejorative connotations, they intersect with someone's destiny, enter and occupy. The gods too can be thought of as daimonic; the word is even given to both the

goddess of love, Aphrodite, and to the queen of the gods, Hera, in the
Iliad.[47] When Helen in the *Iliad* castigates herself in bitter terms for
forsaking her husband Menelaus and their home in Sparta to elope with
Paris and marry him as well, Homer shows the human insight that his
epic can so often display with regard to women. She avows to Hector,
Paris' brother,

> I wish I had found a better husband ... but as it is, this husband I have got
> is an inconstant creature; and he will never change, though one day he will
> suffer for it.... However, come in now, my dear brother, and sit down in
> this chair. No one in Troy has a greater burden to bear than you, all through
> my own shame and the wickedness of Paris, ill-starred couple that we are,
> tormented by Heaven to figure in the songs of people yet unborn.[48]

In the *Odyssey*, Helen makes a similar confession, when Odysseus arrives
in Sparta and finds her there, restored to Menelaus.[49]

The word Helen uses in both passages for her *shame* and the *blindness*
of her elopement is *ate*, and elsewhere Ate figures powerfully as the
subject of one of Homer's most sustained passages of personification. In
the *Iliad*, when the Greeks have suffered dreadful losses in battle, includ-
ing the death of Patroclus, Achilles' beloved friend, Agamemnon and
Achilles are at last reconciled. Achilles agrees to fight again for the
Greeks, and Agamemnon apologizes handsomely for precipitating the
fatal wrath of the hero against his own chieftain and his own side by
taking Briseis, Achilles' prize. He lays the blame for the haughtiness and
arrogance of his behaviour towards Achilles on the gods, in the Greek
manner, on 'Zeus, and Fate and the Fury who walks in the dark'. But
specifically he names a power that took possession of him: 'Ate, the
eldest daughter of Zeus, who blinds us all, accursed spirit that she is,
never touching the ground with those insubstantial feet of hers, but
flitting through men's heads, corrupting them, and bringing this one or
the other down'.[50] 'Ate is a state of mind – a temporary clouding, a
bewildering of the normal consciousness. It is in fact a partial and tem-
porary insanity; and like all insanity, it is ascribed, not to physiological
or psychological causes, but to an external "daimonic" agency.'[51] In a
shame culture, *ate* can explain conduct that has brought about ruin
without accepting complete responsibility.

But Ate is described by Homer as Zeus's daughter, and the metaphor
of filiation gives her personality. Agamemnon increases this impression
when he continues with another story, to excuse himself further. He
reveals how even Zeus himself was overwhelmed by Ate, by fatal folly.
Zeus was boastfully announcing that his love-child by Alcmene, the hero

Heracles, was to 'have dominion over all his neighbours', but when Hera
his wife heard his vaunting she decided to trick him. She secured Zeus's
solemn oath that any child of his born that day would become king in
Argos; and then, using her powers as goddess of childbed, she delayed
Alcmene's delivery and hurried on instead the birth of another child of
Zeus's descent, but far less promisingly heroic: Eurystheus. Pipping Her-
acles' birth through Hera's cunning, Eurystheus was later able to lord it
over Heracles; it was he who later set Heracles his twelve terrible labours.

Although in Agamemnon's story it is Hera who duped Zeus, the
father of the gods laid the blame with Ate, for dulling his mind to his
wife's tricks. 'In his rage, he seized Ate by her glossy hair, and swearing
a mighty oath that this arch-destroyer of the mind should never set foot
in Olympus and the starry sky again, he swirled her round his head and
cast her down from heaven and its stars. Ate soon found herself in the
world of men.'[52] Thus cast down, like the fallen angels, she does her
mischief, making dangerous fools out of Helen and Agamemnon,
prominent among many. By banishing her, Zeus confined her to earth,
where she acts as an agent of his retribution.

In the early period of Greek religion, multifarious aspects of human
destiny were accorded cults, sometimes propitiatory, sometimes celebra-
tory. As Hesiod wrote in his other long poems, the pastoral and didactic
epic *Works and Days*, even the most unpleasant sides of life had to be
confronted in ritual. He writes of Eris, for instance:

> ... She wins no love
> But men are forced, by the immortals' will,
> To pay the grievous goddess due respect.[53]

The dimmest of personifications could inspire ritual observance. Oli-
garchia (Oligarchy) was shown as a woman carrying a torch and setting
fire to Democratia, in a memorial raised to the oligarch Critias, with
verses approving the 'good man who for a brief while held the accursed
Athenian demos in contempt'.[54] A little more vivid, perhaps, Pheme,
or Common Report, was erected an altar in Athens when the news of
a victory reached the city with especial speed, in 467 BC, after the battle
of Eurymedon. Limos (Famine) was worshipped in Sparta, under the
guise of a woman, in order to appease her.[55] Even in the later, more
sceptical period in Athens, the sculptor Kephisodotos was commissioned
to make a statue of Eirene and Ploutos, Peace and Wealth, as a mother
and her child like Aphrodite and Eros, for the annual feast of Peace
instituted in 375 BC after the naval victories of Timotheos.[56]

The gods of the Greeks encompass wide-ranging aspects of experience;

one could say all imaginable areas of human destiny are bodied forth by them. But the greatest of the religious thinkers of Greece did not accept them as such. Plato himself shows embarrassment at the anthropomorphism of the Hesiodic pantheon and an underlying preference that metaphysics should remain abstract and not take on human form; after writing of Earth and the stars in their courses, he reserves judgement with heavy irony:

> It is beyond our powers to know or tell about the birth of the other gods; we must rely on those who have told the story before, who claimed to be children of the gods, and presumably knew about their own ancestors ... even if they give no probable or necessary proof of what they say: we must conform to custom and believe their account of their own family history.

He then gives Hesiod's genealogy (in part) but very briefly, as if it were of little consequence.[57]

The gods were criticized openly even earlier, in the sixth century by Xenophanes, who complained, 'Homer and Hesiod have attributed to the gods everything that is a shame and a reproach among men, for they steal, commit adultery and deceive each other.'[58] Aristotle noted that the Homeric gods inhabit bodies which are not bound by the laws of our somatic nature nor by laws that are consistent within their own structure. He pointed this out when he complained that the gods are immortal, yet need nectar and ambrosia to sustain them, else, as Hesiod tells us, they lie 'without a breath, without a voice ... hidden in evil trance'.[59] Aristotle rebelled against such illogical thinking: if the gods eat only for pleasure, needing no human sustenance, then deprivation would not condemn them to 'disease' and inertia; if they need to eat to live, how can they be said to be the 'deathless' gods at all?[60]

Disavowals of divine anthropomorphism, and scepticism on the part of the Greek philosophers, inspired the early allegorical explanations of the myths and later Stoic and neo-platonist thoroughgoing metaphysical exegeses. For Christians, living in contact with the pagan world, and exploring later the rich legacy of classical culture, allegorical interpretations disinfected some Greek divinities from the stain of personality and individual power and made it possible to view them as embodied aspects of the ideal.[61] Guillaume de Conches, glossing a story of an attempted rape of Athena by Hephaestus, the god of skill, suggested that the assault was not necessarily evil, as she represented wisdom, and the god natural intelligence. He was thus able to overlook the distastefulness of the incident altogether.[62]

The mythological beings who could be more readily set free from

Hesiod and Homer's powerful anthropomorphism were those who, like Athena, were not continually involved in amorous escapades, prolific childbirths or sequential polygamy, or, paradoxically, the dimmest and weakest among the plethora of Greek divine beings. Nike and Dike, goddesses of no individuality, survive in our culture; the least tainted by sex, Hesiod's recurrent metaphor for life, were the most equipped to survive under Christianity. The scrapes and japes of the Olympians were hardly approved: Augustine poured famous scorn on the pagan gods in his impassioned though often fine condemnation in *The City of God*. Writing of Jove, Zeus's Roman counterpart and successor, he says:

> Now as for this great nature's master and cause-disposing god, if the vulgar ... adore him with such horrible imputations of villainy as they do, they had better ... call any one Jove that were worthy of these horrid and hateful horrors, or set a stock before them and call it Jove ... than to call him 'both thunderer and letcher, the world's ruler and the women's ravisher, the giver of all good causes to nature, and the receiver of all bad in himself'.[63]

Venus, with her son, Eros/Cupid at her side, survived as the wicked temptress to sin, not a principle of love, until Renaissance neo-platonism sublimated erotic love itself.[64] By contrast, Nike, goddess of victory, a divine figure of pagan cult, never indulges in love, never becomes a victim of an amorous escapade, never inspires personal narrative. So this cipherlike daughter of Styx survived resplendently in the Christian world, her beautiful winged image appropriated to become a holy image of heaven, altered in sex, and as it were baptized, to emerge as an archangel. (See Chapter 7.) Dike, Justice, a daughter of Zeus in Hesiod, generates no stories and certainly never participates in any erotic encounter. So she survives too, passing from Greek myth to Latin ethical philosophy and thence into religious allegories, told in verse, fresco, sculpture. (See Chapter 8.) And Athena, the virgin goddess who dispenses justice, survives in her purity as a type of Wisdom, and as the Roman Minerva becomes the embodiment of Prudence, another of the Cardinal Virtues, established by Christian interpretations of classical moral treatises.[65]

The Romans developed the Greek inclination to worship divine abstractions. Nike, who in Greece had remained an emanation of Athena or Zeus, an aspect of their power as givers of victory until the Hellenistic period, became in Rome the formidable independent goddess Victoria. (See Chapter 7.) The dangers which beset the republic, and later the propaganda needs of empire inspired propitiatory cults and self-aggrandizement to flourish. Concordia was built a temple in the Forum

– according to Roman legend – as early as 366 BC, by the warrior Camillus; in AD 70 Vespasian raised the Forum of Peace, dedicated to the goddess Pax, behind the temple of Romulus. 'The deification of such beings', wrote Burckhardt, 'must have been hedged with a profound seriousness.'[66]

On Roman coins, throughout the republic and the empire, divinities proclaim the welfare of the state, its glories, its qualities, the brilliance of its rulers. Iustitia, Pax, Securitas, Liberalitas, Fecunditas, Ops (Wealth), Libertas, Hilaritas, Pudicitas, Salus (Health), Felicitas Saeculi (Well-being of the Century), all appear as goddesses on its coins. A very few, like Bonus Eventus (Happy Occasion), and Honor, are ephebes, charming godlings. The coins' fountainhead, the mint itself, takes the form of Sacra Moneta, with the scales of Justice and the horn of Abundance, Holy Money herself, riches and just measure.[67]

Plato had distinguished between the Olympians and the elemental principles, like the sun and the stars, the earth, night and day, and granted them a legitimate place in the story of creation;[68] similarly, under Christianity, Mother Earth and even Father Ocean had little difficulty surviving. They appear for instance, in their usual classical guise, reclining with tree branches and a large fish under a figure of Christ ascending into heaven, where he is courteously greeted by two Nikai turned angels, on an ivory plaque from the Rhineland of the mid-eleventh century, now in the Cloisters Museum, New York. The Sun and Moon are routinely personified in early Christian art, often appearing in their spheres, weeping into draped hands over crucifixion scenes, as in that wonderful mediaeval English ivory, the Bury St Edmunds cross, also in the Cloisters.[69] Helios was an aspect of Apollo, another title for the sun god, Selene another goddess of the moon, but as their names designated physical phenomena they could be assimilated in Christian mythology as principles and not actual individuals. If Greek daimons could be seen as personifications or allegorical figures, they could survive Christian proscription. The early Christian allegories continued the classical genre established in such famous works as Macrobius' *Dream of Scipio* (first-century) and Boethius' *Consolation of Philosophy* (sixth-century), in which the reader does not have to believe in the existence of the personified forces as divine and deathless gods, though personification confers life upon the concepts.[70]

Personification is simply one of the poetic language's most effective and eloquent devices, and has been used from Hesiod to W.H. Auden and John Ashbery, in spite of the strictures of critics like Coleridge.[71] Baudelaire, for instance, that most modern sensibility, adopts the device

continually, to pierce us with the vivid array of his sufferings, with the grim, dreaming figure of Boredom, and the turbulence of his Sorrow and the malignancy of Beauty, his muse.[72]

Although personifications can exist outside allegory, as in the poetry of Baudelaire, allegory requires personification to function as drama, both in the mind's eye and before the eyes of the body. In its Christian usage, from earliest times through the Middle Ages and into the High Renaissance, the allegorical tradition personified concepts – like the three Theological Virtues (Faith, Hope, Charity), the four Cardinal Virtues (Prudence, Temperance, Justice and Fortitude), the three Monastic Vows (Poverty, Chastity and Obedience), the Seven Gifts of the Holy Spirit, the Heavenly Beatitudes, the Five Senses, the Seven Liberal Arts, as well as Continents, Seasons and Months.[73] In influential texts like Martianus Capella's *De Nuptiis Mercurii et Philologiae* (fifth-century), Alain de Lille's epic *Anti-Claudianus*, Hugh of St Victor's *De Fructibus Carnis et Spiritus* (both twelfth-century), and Frère Lorens' *Somme-le-roy* (thirteenth-century), allegorical figures, from Dame Nature to Lady Philology, enliven the lessons and spice the pedantry.[74]

The Christian attitude to virtues like Justice or powers like Victory or deposed deities like Athena/Minerva forbade their worship, of course, but not their iconic representation for veneration or emulation. Monotheism accorded them a complex, vaguely defined, but most interesting supernatural life. They were perceived as personal forces indwelling in the individual soul, and at the same time as acting upon human destiny from the outside to change it for the better, as they had sometimes done as gods and goddesses; but a rich ambivalence marked their existence as beings at all. At the end of the *Purgatorio*, during Dante's long, painful vision of the Church's distress, just before Beatrice unveils her eyes to the poet to dazzle him with the sight of one who knows paradise, Dante is bathed in the river of Lethe and then handed over, still wet, to the four dancing Virtues, who tell him, 'Noi siam qui ninfe e nel ciel siamo stelle . . .' (Here we are nymphs and in heaven we are stars).[75]

The presence of the Virtues could be invoked by entreaty and assured by the correct rites; their exact status is often ambiguous. In the play *Sapientia* by Hroswitha of Gandersheim, a nun writing in the tenth century, the three virgin daughters of the eponymous Lady Wisdom are Faith, Hope and Charity, who are then cruelly martyred in front of their mother. (See Chapter 9.) The supposedly historical incident transforms allegory into history and brings the Virtues to life as individual saints. The cult of Sainte Foy (Saint Faith) flourished during Hroswitha's lifetime at Conques on the pilgrim route to Compostela, where her golden

effigy is still kept. Sainte Foy could have been a historical person named after the virtue (the shrine claimed to have her relics); but she also animates the allegory of the theological virtue by professing her faith unto death, and, through the heroism of her stand against the Roman persecution in southern France, confirms the faithful in their belief.[76]

By clothing ideas in human shape, either in Dante's classicizing manner, in which virtues become nymphs and constellations, as if in a metamorphosis by Ovid, or, at a more popular level, by attributing personality and story to an abstract principle, as in Sainte Foy's cult and Hroswitha's play, the immaterial takes on material substance, and enters our imagination as real. Myths, written or pictured, enflesh abstractions and, by incarnating imaginary beings, they reproduce the very process they narrate; it is the image and the text which bring the idea to life, although the artist, the mythographer and the sources they are both using, often assume that they are transcribing an ulterior reality. The vitality and beauty of their realizations can persuade us, too, of their veracity: this is the illusion of allegory. In Christian theology, Jesus Christ is the only divine being to become man; in mediaeval Christian literature, the qualities of heaven rarely seem disincarnate; the stories give them bodies and, by embodying them, bring them to life, express their reality. The structure of language itself, and the incidence of feminine gender, especially in the mediaeval clerical *lingua franca*, Latin, provided a hospitable framework within which new allegorical figures, like the Beatitudes or the Seven Gifts of the Holy Spirit – Christian divine guilds like Hesiodic Nereids and Muses – could inspire the faithful to further virtue.

In mediaeval hortatory literature and imagery, the female form came to be used as an unquestioned metaphor of transcendence, however problematic its implications. The unknown artist, for instance, who designed the double ring of dancing figures in the mosaics of the dome of the Ascension in St Mark's in Venice in the late twelfth and early thirteenth century gave us an allegorical vision of the heavenly beatitudes as human girls. It was characteristic of his time that they were not branded as different from historical women by clumsy and preposterous attributes, as happened a hundred and fifty years later, when Temperance appears literally bridled and Fortitude wears an anvil on her head, nor are they distinguished by scale from human creatures on the level of earth.[77] In these images, ontology and reality are inspiringly collapsed one into the other; and the girls dance on this most desirable interface. Worked in mosaic on a gold ground, sixteen figures circle the figure of Christ Pantocrator at the apex, stepping this way and that to the unheard

music of the empyrean. The Virgin Mary stands at the node of their vital unbroken measure, marking the moment when heaven and earth intersected in history and God became Man. The dancing maidens carry scrolls to identify them, and the inscriptions recall the chosen ones of Jesus in the Sermon on the Mount, the Humble, the Meek, the Pure of Heart, the Merciful, the Peacemakers, and so forth. Humility's phylactery reads, 'Beati Pauperes ...' – 'Blessed are the poor, for they shall enter the Kingdom of Heaven' (Matt. 5: 3–10). Her magenta scarf whirls out on either side of her, and her elongated limbs accentuate the dynamism of her motion. With her tunic blown in whorls over her breasts, belly and thigh, her scarecrow hair, she seems more the Dionysiac maenad of Greek vase drawing than an emanation of the Christian paradise (Pl. 50). The Virtues have joined in the Beatitudes' ring. Fortitude wrestles with a lion, forcing open his jaws as the youthful David did in the Bible (1 Sam. 17: 34ff.) (Pl. 49.). Only Charity, called here Mother of the Virtues, seems not to take part in the round. Wearing the dalmatic, stole and orb of the Byzantine emperors to emphasize her pre-eminence, she stands as if in contemplation while the others tread their measure round the dome.[78]

Together, with Mary at the centre, these circling figures form for an unbeliever one of the most poignantly uplifting groups in Christian allegorical imagery. When Mary appears thus alone, without the child in her lap, she becomes a galaxy all of her own, in which are crystallized the multilayered aspects of the divine power, wisdom, mercy, justice, and his earthly creation, the Church; linguistically feminine in gender, they become female in appearance. In the dome of St Mark's, where Mary stands with her hands in the gesture of prayer, calm and stately in the midst of those almost wantonly active Virtues, she denotes the daughterhood of the faithful Church to the Creator who appears in the apex, and calls to mind the Church's wisdom and the clustered biblical texts glimmering around divine wisdom, Sophia, the feminine aspect of the Christian godhead. The poet Anthony Hecht may have been thinking of these mosaics in St Mark's when he wrote his magnificent long poem, *The Venetian Vespers*:

> Gradually
> Glories reveal themselves, grave mysteries
> Of the faith cast off their shadows, assume their forms
> Against a heaven of coined and sequined light,
> A splatter of gilt cobblestones ...

And we are gathered here below the saints,
Virtues and martyrs, sheltered in their glow,
Soothed by the punk and incense, to rejoice
In the warm light of Gabrieli's horns,
And for a moment of unwonted grace
We are so blessed as to forget ourselves.
Perhaps.[79]

Iconography, rooted in rhetoric, which is itself bound by the laws of grammar, generated a semantic contrast affecting significance from the almost meaningless contrasts of linguistic gender. Feminine personification had established itself so thoroughly that, in the High Middle Ages, *Honours*, or Honour in French, one of the few abstract nouns of virtue in the masculine gender, submitted to the convention and changed in Froissart's *Le Livre du trésor amoureux*, where Lady Honour guards the beloved's palace with six other allegorical ladies.[80] A fifteenth-century tapestry in the New York Metropolitan Museum, showing Honour weaving chaplets of flowers in a spring meadow for her children, might have been inspired by such contemporary courtly celebrations of chaste and honourable love, incarnate in the beloved mistress of lyric since the twelfth century.[81]

Occasionally, artists ignored grammatical gender in favour of male images: Hercules can provide a type of *Virtù Eroica* or Heroic Virtue, as in Ripa's *Iconologia*, and of Valour (*il valore* in Italian but *la valeur* in French).[82] Sometimes, by choosing the infinitive, artists could experiment with masculine figures: *il sapere*, or *le savoir*, turns up as active wisdom in some Renaissance emblems.[83] In the seventeenth century, as we saw in some of the Tuileries gardens' statuary, sculptors like Coysevox and Coustou preferred the classical convention of river gods, and also overlooked grammar to represent the large, broad, potent masculine nature of rivers. But such inversions are unusual; and the tendency to personify in the feminine became more and more marked rather than decreased. A revolutionary pack of cards issued in France to celebrate the new order characteristically casts the kings as sages - Solon, Cato, Rousseau and Brutus - and the queens as Virtues - including 'La Liberté de la presse'.[84] Rodin called dozens of his sculptures by feminine names: *La Fatigue, La Pensée, La Méditation*. It was a formula. By his time, the allegorical convention had set so hard that it provided a solid foundation for some wondrously newfangled superstructures. The Hôtel de Ville in Paris contains concatenations of *fin-de-siècle* figures, including a wall painting of *Le Téléphone*, showing a nymph attending to the dangling receivers and oversize dials of a primitive apparatus (Pl. 18), and *Le Gaz*,

a carved spandrel relief of a young woman with gaslamp and gasome-
ter.[85] The former could be an early receptionist, except that she has bare
feet and nothing else on under her grey satin drape; but *Le Gaz* could
hardly be a contemporary lamplighter as she is naked except for a
transparent furl here and there. She is sister to the other benefits of the
modern world – to Photography, Electricity, Steam Power, Universal
Suffrage and Social Security or Family Benefits (*L'Assistance publique*), all
personified in the Hôtel de Ville. The artists paid little attention to incon-
sistent grammatical genders.[86]

But perhaps the finest extrapolation of the allegorical tradition to fit
post-classical technological developments can be seen in a garden in
Montpellier where the scientist Gustave Foex is commemorated. After
the phylloxera epidemic of the 1870s, Foex grafted the afflicted French
vines on to American stocks; Jacques Villeneuve's sculpture shows a
nubile Bacchic follower kissing a withered bag of bones: *La Vigne fran-
çaise régénerée par la vigne américaine* (The Vine of France regenerated by
the Vine of America) runs the title.[87]

With this allegorical embrace, we reach an absurd apogee of the
classical language of personification. The lengths to which the creators
of *Le Téléphone* or *La Vigne américaine* took the trope could be ludicrous,
however delightful, yet they still remained in line with the same tradition
of inventive personification present in Hesiod's poetry. But while Hesiod
was not revived as a popular poet in the eighteenth century, the sculp-
tor's experiments in extending the convention's range of meaning in the
nineteenth directly inaugurated modern advertising. At the turn of the
century, when stations like the Gare de Lyon in Paris were adorned with
naked *belles* emblematic of the railways' gifts to civilization (Pl. 15),[88]
the first posters selling goods began to appear, and their visual style was
determined by the conventions of official art, including the affixing of
meaning – any meaning – to a pretty girl – any pretty girl. Oscar Roty, a
sculptor and medallist who was trained at the Beaux-Arts in the 1880s,
was one of the century's artists who annexed the language of personifi-
cation to the new technology, creating images of nymphs as the spirits
of electricity, flight and the combustion engine. Roty made one of the
earliest advertising plaques, showing a naked mother pouring wine into
the mouth of a child at her breast. The slogan reads: 'O nymphe/Le vin/
Mariani/Va le sauver/Mais prends garde/à ton coeur' (O nymph, Mariani
wine will save him, but take care of your heart). A soft sell, displaying
solicitude and virtue, the advertisement taps the symbolic identification
of Charity and Nature with the nursing mother to persuade consumers
of the efficacy of the product.[89]

Linguistic gender provided one rationale for the depiction of so many disparate and often incongruous concepts in the female form. Another, equally fertile and important, source was classical myth itself, and the spheres of influence it allotted to the goddesses, and especially to Athena. Of all the plethora of Greek divinities, Athena above all others influenced the representation of the virtues and other desired qualities personified in the post-classical world.

Athena, the virgin-born, chaste goddess of wisdom, the unyoked guardian of the city, the patroness of women's skills and work, is the immediate model of those exemplifications of Justice, Prudence, Fortitude and Temperance who adorn such institutions as the National Gallery, London, where the goddess sits on the eastern corner of William Wilkins' serenely proportioned building, or of Somerset House, and the Tate Gallery, where she surmounts the pediment of the entrances, or of various life insurance companies in Britain's great cities, where her presence pledges the integrity of their conduct. Divorced from the religion that gave her worship, disinfected of pagan cult and ritual, Athena provided the mould in which the language of virtue was cast first in the Renaissance and again, during the second climax of the classical revival in Europe, during the later eighteenth and the nineteenth centuries. The examples of personification which still surround us, like Britannia, often return directly to Athena; she provides the original standard measure, as it were, the pound weight, the foot length that is kept in the vault of memory and to which all later measures are apt to conform. If we are to understand the origins and the continuing significance of such signs in our daily lives, it is essential to look at her nature and her character, as transmitted to us through the Greek texts in which she appears as a protagonist, a dominating force and the arbiter of an ideal order.

CHAPTER FIVE

The Bed of Odysseus

It is impossible to bring [the divine] near to us within reach
of our eyes or to grasp it with our hands – although this is
the main road of persuasion entering the minds of men.

EMPEDOCLES[1]

Ambiguities about the divine body enliven the texts which tell the Greek
myths. Although the Olympians eat and drink and make love, as Xeno-
phanes and Aristotle found incongruous; and sit on chairs, as Athena
reveals when she offers hers to Thetis; and sleep, as Zeus does when
Hera has seduced him; and sicken, if they perjure themselves having
taken an oath by the waters of Styx, their bodies are evoked in multiple,
overlapping and sometimes contradictory ways and resist any simple,
single description.[2]

In statues and vase paintings they were given costumes and attributes
to distinguish them, and this original repertory of symbols and guises,
learned and developed in the Renaissance, crystallized their visual
appearance so that they could be easily identified: Athena became un-
mistakable in her helmet and breastplate, Hermes in his winged cap and
sandals, Zeus with thunderbolts zigzagging from his hands. All these
motifs appear on Greek pots, yet the consistent anthropomorphic visual
representation of the Olympians obscures their fantastic transformations
in the written tradition. The constantly changing shape of a goddess like
Athena reflects the operation of the principles she embodies; the poly-
morphousness of her vitality and presence in both the *Odyssey* and the
Iliad figures forth the values and the qualities of mind that she stands
for. Through the poetry of Homer, the relation of the Greek deities to
personified virtues in the later Christian tradition can be appreciated
with greater richness and possibility than we achieve by contemplating
a static monument on which the goddess with attributes sits fixed, mute
and no longer vibrant.

Although among themselves the gods inhabit anthropomorphic

88

forms, when they enter the sensory world of mortals, they undergo metamorphoses: they can choose to be seen or unseen, huge or bird-like, ethereal or palpable. As Odysseus says of Circe, 'When a god wishes to remain unseen, what eye can observe his coming or his going?'[3] Hera grasps the sea in one hand and the earth in the other,[4] and Eris, 'though her feet are still on the ground, she has struck high heaven with her head'.[5] They hide their physical presence from mankind in mist, as when Poseidon and the other gods sit down to parley on the high earthwork near the Greek ships.[6] Sometimes, covered in this mist, the gods in Homer's text sound like the elements of landscape. Their physical parts are sacred (*hieros*) and also deathless (*athanatos*), their seed is abundant, like the foam of Kronos that gave birth to Aphrodite, and always fertile ('never fruitless').[7] Their blood is distinguished from the flux of humans, with its own name, *ichor*, and may have been thought to be golden.[8] When Diomedes, running amok in battle, goes in pursuit of Aphrodite after she has intervened on the Trojan side to save her son Aeneas from death, he strikes at her with his spear.

> [He] cut her gentle hand at the base of the palm. The point, tearing the imperishable robe which the Graces had made for her, pierced the flesh where the palm joins the wrist. Out came the goddess' immortal blood, the ichor that runs in the veins of the happy gods, who eat no bread nor drink our sparkling wine and so are bloodless and are called immortals.

She screams and drops her son, the pain is so terrible. Iris, the rainbow messenger of the gods, rescues her, and carries her off to Ares who lends her his immortal horses and chariot. She speeds off 'in great distress' to her mother Dione, who strokes her and soothes her, and, wiping the wound between her hands, takes the sting out of the pain and heals her.[9]

The gods also fight one another, and indeed Dione first imagines that Aphrodite's hurt must have been given by a god. When Athena later lashes out at Ares, she wounds him in the belly, and he whines and whirls up 'in a welter of rage' to Zeus in protest, showing his father the 'immortal blood pouring from his wound'. 'We are all at loggerheads with you', he complains, 'for having cursed the world with that crazy Daughter of yours, who is always up to some devilment or other ... you neither say nor do a thing to check the creature: you let her have her head, because she is a Child of your own.'

Zeus reviles Ares for wailing and cringing and sends him packing to be healed by the gods' medicine man Paeeon. 'Paeeon spread soothing ointment on the wound and healed it, for Ares was not made of mortal stuff. Indeed he made the fierce War-god well in no more time than the

busy fig-juice takes to thicken milk and curdle the white liquid as one stirs. Hebe bathed him then, and gave him lovely clothing to put on.'[10]

The gods and goddesses' 'fair flesh' is clothed in softly woven garments that the goddesses sometimes make: Athena is mistress of the art of weaving and spinning and embroidery, and she above all distributes fine clothes among the pantheon, including Hera's wedding garments. Aphrodite's robe was woven by the Graces, and she herself gave Hector's wife, Andromache, the 'gay headdress' of her trousseau.[11] The goddesses' limbs inspire awe and admiration, even love; they have slim ankles, like Nike, goddess of victory, and shapely arms; they have necks worthy of note, they have beautiful feet. Hera in Homer is ox-eyed, white-armed. Athena's hair is golden (*xanthe*); many of the nymphs have fair cheeks (like some of the mortal girls too).

They have laps, above all, for the destinies of men, as Athena reminds Telemachus, lie on the knees of the gods.[12] Knees are the seat of pity and of physical power; their surrender signifies humbling, and to clasp them is to beseech their owner to relent.[13] The gods' weight can be felt on the earth, heavily, as when Athena replaces the charioteer in her protégé Diomedes' chariot to ride off behind him into the battle:

> As she spoke, she reached out, dragged Sthenelus [the charioteer] back, and hustled him out of the chariot - he was only too glad to leap down. The eager goddess took his place in the car beside the noble Diomedes, and the beech-wood axle groaned aloud at the weight it had to carry, a formidable goddess and a mighty man at arms.[14]

The immortals sometimes present themselves in a way that expresses their special spheres of interest. When Aphrodite approaches Helen to bring her in to join Paris in their bedroom, she tries to look like an old woman, a Spartan wool-worker whom Helen held in affection, but Helen, who in both the *Iliad* and *Odyssey* has more percipience and acumen than her later reputation has granted her, sees only the beauty of the goddess of love:

> Helen was perturbed and looked at the goddess. When she observed the beauty of her neck and her lovely breasts and sparkling eyes, she was struck with awe.... 'Lady of mysteries,' she said, 'what is the object of this mummery?'[15]

Helen is half-mortal, daughter of Leto by Zeus himself, and perhaps, though Homer does not say so, this gives her insight into the mysterious transformation of deities. Achilles, who is also semi-divine, having the goddess Thetis for a mother, can confront the immortals without media-

tion; in the very first book of the *Iliad*, he recognizes Athena 'at once – so terrible was the brilliance of her eyes',[16] when no one else is aware of her, not even Agamemnon. Few mortals in Homer possess the ability of Helen and Achilles to see the gods for who they are. They can sometimes make themselves known by their voices: Ares' howl of rage and pain after Athena wounds him rings over the Trojan plains and terrorizes all who heard 'that appalling cry from the god who never had his fill of war'. Though it sounds like 'nine thousand or ten thousand battling men', there is no mistaking who is howling.[17] Diomedes prays to Athena, and she sweeps the mist from his eyes so that he can identify Aphrodite in the mêlée,[18] and when Athena mounts his chariot, he knows her also.[19] Such recognitions are rare in Homer, and a privilege, marking Diomedes out for favour. A goddess and a man more usually inhabit discrete spheres. Divinities step into the human framework by adopting the face, the demeanour, the voice of a mortal person; they personify themselves, so to speak. Odysseus calls Calypso, his lover, 'that formidable goddess with a woman's voice'.[20]

When Achilles appeals to his tutelary deities Poseidon and Athena in his struggle with the river god Scamander, they respond readily, and appear beside him to help him. 'Adopting human form,' says the poet, 'they took his hands in theirs and uttered reassuring words.'[21] The varied semblances of a god are indeed semblances, divine metamorphoses from one shape to another, often assuming a particular human individual's features, as when Zeus tricked the virtuous Alcmene into sleeping with him by appearing to her in the guise of her husband Amphitryon.[22] Zeus could even change sex to deceive immortals, as when he seduced the nymph Callisto by wooing her in the shape of Artemis, the goddess she followed.[23]

Sometimes divine metamorphoses take place in dreams. Athena adopts the features of loved ones familiar to the sleeper, or sometimes, remaining her impalpable self, appears to grant another kind of revelation, as when she invented the bit and gave it to Bellerophon to break in the winged horse Pegasus. In Pindar's ode she calls to the hero:

> Do you sleep, King, son of Aiolos?
> Come, take this charm for the horse. . . .
> In the darkness the black-shielded Maiden
> Seemed to say this to him in his sleep.
> He leapt upright to his feet,
> And seized the marvel that lay at his side.[24]

Even though the gods may be ambiguously anthropomorphic in their bodily shape on earth, they behave in a human, all too human way, whether on Olympus or below, all the time. They engender children on

one another, and on mortals too; goddesses can conceive by mortal men, like Aphrodite with Anchises, the father of Aeneas. They quarrel, they grieve, they exult, they display arbitrary favouritism and unswerving loyalty; they laugh, they feel shame. As Moses Finley observes, with admiration, 'What a bold step it was, after all, to raise man so high that he could become the image of the gods.... What they [Hesiod and Homer] did ... implies a human self-consciousness and self-confidence without precedent, and pregnant with limitless possibilities.'[25]

One line of possibility leads to the spiritual ambitions of humanism and the Renaissance belief that an individual possessed the potential to achieve a divine greatness, through the exercise of mind; another inspired the allegorical explanation of the pantheon. Because the gods and goddesses only took on human form or other shapes to intervene in human affairs, they could be rationalized as personified aspects of human destiny and then reclaimed, as mirrors of human promise and ideals, especially if, as in Athena's case, they seemed to represent recognizable and enduring desiderata. In the *Odyssey*, the epic which centres on Odysseus' homecoming under Athena's auspices, the appearances and disappearances of the goddess under different guises shape a poem which is distinguished by the strength of its structure and resolution. Her transformations also helped to define the goddess, for Homer's Renaissance readers and after, as the special patron of the arts of peace and the presiding genius of all intelligent mortals, prefigured by the hero, her protégé, the cunning Odysseus.

Although we see Athena throughout the poem, Odysseus himself does not, until he reaches home. Athena ministers to him throughout the *Odyssey*, and even in the *Iliad* 'dances attendance' on him 'like a mother'.[26] She refrains from showing herself to him, however, 'out of deference to her Father's brother [Poseidon]', who, because Odysseus blinded Polyphemus, Poseidon's son, 'persisted in his rancour against the noble Odysseus till the very day when he reached his own land'.[27] But finally, on Ithaca, Athena reveals herself. There at last he recognizes the goddess who has intervened on his behalf and protected his son Telemachus and his wife Penelope from the start. The movement through masks, deception and counterfeit to the transparency of this epiphany, on his native and beloved island, possesses triumphant artistic beauty, and a weight of significance that is lacking from Diomedes' encounters with the goddesses Aphrodite and Athena in person. The recognition of Athena by Odysseus brings to a climax of mutual respect and love the series of magical metamorphoses that the goddess of wisdom, daughter of Metis, has undertaken in order to accomplish Odysseus' homecoming.

Athena first appears in the epic on Mount Olympus, in her Olympian self, pleading with Zeus that Odysseus, cleverest of mortal men, should be freed from the lovebonds of the goddess Calypso. She then flies down, wearing her sandals of untarnishable gold to speed her across the sky, from Olympus to Ithaca, where she appears to Telemachus, Odysseus' son, in the first of her many personae, that of Mentes, a chieftain from Taphos. In this disguise, she talks to the boy 'as a father talks to his son', then, changing into a bird, she reveals herself to be divine, and flies through a hole in the roof, leaving Telemachus refreshed, emboldened, 'full of spirit and daring', and quite incurious as to the apparition and vanishing of Mentes. He accepts with simplicity that a deity has been with him.[28]

The goddess often favours old men for her disguises; Mentor, one of the Greeks who fought at Troy, is a favourite character she assumes, first to prompt Telemachus to sail away and search for his missing father, then to help him fit and man his boat, and to advise him on his journey. Mentor/Athena accompanies the youth as far as Pylos and the court of King Nestor; there, she advises the company to sacrifice to the gods; then, taking wing like a sea-eagle, and confounding them all, she flies off.[29] Towards the end of the *Odyssey*, when the goddess helps Odysseus and his son to fight the suitors' heirs, who take up arms against them to avenge their relatives' murders at Odysseus' hands, she again appears as Mentor. She calls the conflict to an end and, still disguised, arbitrates the peace between the parties, thus concluding the *Odyssey* as we have it handed down.[30]

Athena also changes herself into Telemachus himself, when she wishes to pick a crew for him as quickly and efficiently as possible and give them secret instructions to gather at the boat for his departure. She later meets them there and gives them their orders, still impersonating the boy.[31] Throughout her quasi-maternal, 'kourotrophic', dealings with the young Telemachus, she makes magic on his behalf, slipping in and out of recognizable and terrestrial forms to abet his plans, and changing him too, to accentuate his stature and improve his handsomeness so that 'all eyes were turned on him in admiration'.[32]

Athena also stands in a special relation to Penelope, Odysseus' wife, who is a mistress of the goddess' art, weaving, and its requirements, agility and craft. As a trick to fool the suitors, Penelope had asked them not to press her to choose among them until she could finish the robe on her loom, the winding-sheet she was weaving for Odysseus' father Laertes. They agreed, and for three years Penelope delayed the hour, unravelling each night the work she had done in the day. But her

servants betrayed her, and she was then forced to complete her handiwork, though not yet to fulfil the bargain and choose a second husband.[33]

Athena was the patroness of women's work, and even enjoyed the epithet, Ergane, Worker. At the great Panathenaic Festival held quadrennially in Athens to celebrate the goddess and her protection of the city, young women from the country took part in the procession to the acropolis that the Elgin Marbles depicts, carrying with them a peplos, the woollen cloth customarily draped by Greek women over their heads and shoulders, which they had woven and embroidered for presentation to the cult statue of Athena. Skill of hand and eye depended on the intelligence the goddess held in her gift; the imagery of weaving, from the first spinning of the thread to the straight line of the selvage and the complex pattern in the web, remains inspiringly apt for Athena's wisdom and her power over human fate. The Forum of Nerva in Rome bears a relief showing the involvement of women in Athena's worship, through the long, intricate processes of clothmaking, from the weighing of the wool to the finished robe.[34]

In Hesiod's *Works and Days*, it is Athena who teaches Pandora the first woman to weave[35] and makes her bridal garments, including the belt which, once loosed, signifies the woman's surrender of her maiden state.[36] (See Chapter 10.) The Phaeacian women of Alcinous' land are specially praised in the *Odyssey*: they are 'cunning workers at the loom, for Athena has given to them above all others skill in fair handiwork, and an understanding heart'.[37]

In the *Iliad*, Hector tells his mother to collect the older women together in Troy and take them to the temple of Athena the Warrior, and offer her 'a robe, the loveliest and biggest you can find in the house and the one you value most yourself, and lay it on the Lady Athena's knees'.[38] Hecuba hurries to do what her son suggests, hoping to soften the goddess' implacable enmity against Troy. The robe she picks out from her scented storeroom was 'the largest and most richly decorated' and 'glittered like a star'. But when the ladies present it to the goddess, laying it in the lap of the statue, and promise to sacrifice twelve heifers as well, if only Athena will have mercy on the city, she shakes her head.[39] She is the Protectress of Cities, Athena Polias; but not of Troy.

Women played varied parts in Athena's cult. An inscription has come down to us dedicating a monument in Athens to the goddess from a certain Callicrate in 520 BC. It is one of only four votive inscriptions of this kind by a woman. The priestess was appointed to the new temple

of Athena Nike on the Acropolis after a selection for which all Athenian women were eligible. She received a salary as well as the offerings made by the public for the rituals.[40] In the *Iliad*, which reflects social custom of a date later than the setting of the epic, Athena's priestess Theano is married, for we are told the name of her husband, Antenor the charioteer.[41]

Penelope is Athena's special ward: her surpassing skill with cloth as well as her foxiness (*kerdeia*),[42] the quickness of wit that Athena's most cherished protégés possess in full measure, attest to their mutual allegiance. Cunningly, Penelope weaves to preserve her honest marriage: on three different planes, intellectually, practically and morally, her single activity makes her the virgin-born maiden goddess' votary. When Penelope despairs that Telemachus has sailed away without telling her and might come to harm, Euryclea, Odysseus' old nurse, advises her to pray to Athena; Athena hears her entreaties and lulls the troubled mother to sleep, for the second time in less than four books of the epic.[43] Then she sends her a dream, in the form of her sister Iphthime, and promises her that Telemachus will return home safely. But when Penelope asks for news of Odysseus himself, Athena's *eidolon* or phantom refuses to answer.[44]

The goddess also toys with other mortals who entreat her favour, not just by appearing to them in disguise, and by withholding the knowledge they seek, but even by sharpening longing and pain. In the sleep she later brings again to the tormented Penelope, Athena increases her beauty, 'First she cleansed her fair cheeks with a divine cosmetic like that used by Cythereia when she puts on her lovely crown to join the Graces in their delightful dance. Then she gave her the appearance of greater stature and size; and she made her skin whiter than ivory that has just been sawn.'[45] The goddess wants to increase the suitors' desire for her, in order to enhance the value of Penelope in the eyes of her husband and her son. So she puts her in mind, suddenly, and uncharacteristically, to attire herself and show herself off to them in her newly accentuated loveliness. When she appears, the suitors are 'staggered' by her appearance, and the disguised Odysseus among them has to witness their gross behaviour and listen to their insults and insinuations as they respond in their coarseness to Penelope's desirability. Again, the poet explains, Athena's motive was clear: 'She wished the anguish to bite deeper yet into Odysseus' royal heart',[46] so that he will be brimful of the rage he needs to murder them, all one hundred and eight of them, in the carnage which sets the seal upon his long homecoming.

No slur, needless to say, clings to Odysseus for his infidelities, willing

or unwilling, to Penelope in the course of his wanderings homeward. The faithfulness required of a man to his home and his kin does not include the chastity of his body as it does in the case of his wife. Athena is the patroness of the social institution of the family, and protects Penelope as a dutiful wife. She does not preside over the husband and wife's erotic experience of each other. She is a civic goddess, not the custodian of the heart. Athena urges Odysseus' return home, hastens his journey, strives to overturn the obstacles other gods place in his way, from her opening pleas to Zeus to the end, where she fulfils her role as guardian of the spotless domestic hearth by her ferocious and blood-thirsty help in the massacre of the suitors. When Odysseus assaults them, she fights by his side, spear in hand, and raises her terrible aegis. The suitors, at the sight of it, 'scattered through the hall like a herd of cattle whom the dancing gadfly has attacked and stampeded'.[47] With the murders of those who presumed against the pattern of faithfulness, Penelope, and against the holiness of the ancestral home, Athena avenges the institution of marriage in its civic aspect, and the interests of property, lineage and social status it serves against its profaners.

Between this beginning and this climax, Athena and Odysseus are matched, two pastmasters of disguise and trickery, in loving collusion as they both change shape and assume differing personae to conceal their identities, Athena from mortals, including her beloved Odysseus, and Odysseus from other men and women. The essence of both their charac-ters is to dissimulate. The masks that Odysseus assumes reflect his own Athena-like cleverness and adroitness; his transformations, within their earthly limits, have been learned in her mould, and are often achieved with her assistance. Athena's protection of Odysseus provides the poem with its main spiritual theme, and its own thematic imagery is of dis-guise. As Odysseus says to his son Telemachus, once they have been reunited, and Athena has magically transformed the old beggar whom the youth first encountered into a resplendent figure of a man, 'It is easy for the gods in heaven to make or mar a man's appearance.'[48]

The reach of this divine power to transfigure and metamorphose makes itself felt with special intensity in the story of the Phaeacian princess Nausicaa. After seven years with the divine nymph Calypso, Odysseus starts wandering the seas again, and once more, through the unabated fury of Poseidon, comes to grief and has to swim for shore. Battered, caked in brine, stripped of his clothes by his ordeal, Odysseus lands on the island of Alcinous, father of Nausicaa. Athena meanwhile changes herself into a girl, an intimate friend of Nausicaa, and visits her in a dream. She passes through the door of the princess' bedroom like

'a breath of air', and urges her to come with her to the river to do some laundry.[49] Odysseus has fallen asleep by the river bank, when he hears the band of girls playing ball after their washing. He picks a stout branch to cover his nakedness, creeps out, and salutes Nausicaa with handsome words. The young girl, strengthened by Athena to put fear aside, tells her friends to give him new clothes and olive oil to rub down his limbs.[50] When they leave him to bathe in the river water, Athena accomplishes her next magical transformation:

> [She] made him seem taller and sturdier than ever and caused the bushy locks to hang from his head thick as the petals of the hyacinth in bloom. Just as a craftsman trained by Hephaestus and herself in the secrets of his art takes pains to put a graceful finish to his work by overlaying silverware with gold, she finished now by endowing his head and shoulders with an added beauty. When Odysseus retired to sit down by himself on the seashore, he was radiant with comeliness and grace.[51]

Later, Athena marks the length of his discus throw at the games Alcinous holds, and tells him he shall be the winner. She is pretending to be one of the crowd.[52] But she is not the only one to make believe she is someone else. Odysseus does not tell Nausicaa or Alcinous who he is; not until the tears are running down his face at the minstrel's tales of the Trojan War does he reveal his identity to the company. In this way does Homer the poet tell us of the transforming potency of poetry itself; it is the story of his other epic, the *Iliad*, which causes Odysseus to own to who he is.[53]

And then his stories are all of changed identities, concealment and entropy of self, the mark of his genius: he recounts his ruse to escape Polyphemus when he and his men hid by clinging to the sheep's bellies by their wool and of the spells of Circe that turned his men into beasts,[54] and he tells them of the most profound change of all that all men undergo, the change from living person to dead soul, to the gibbering and squeaking shadows of the underworld, whom Odysseus visits in the eleventh book of the *Iliad*. Goddess and mortal can meet in the material world without ritual mediation, at the will of the divinity. But the shades – with the single exception of Tiresias – can only see Odysseus to speak to him if they are given the blood of a sacrificed ram and ewe to drink. When his mother's ghost comes up to him, Odysseus sees her, but she only recognizes him after taking a 'draught of the black blood'.[55] Partaking of the creaturely world gives her access, for a time, to human experience. Nowhere in the *Odyssey* does Odysseus of the many wiles let slip who he is until it is absolutely safe for him to do so. He invents

characters and their biographies in plausible and entertaining detail; it is a light beam shone into his nature that his most successful pseudonym of all, the one that tricks the Cyclops Polyphemus, is 'Nobody'. Rather than reveal himself in his true self, Odysseus would rather be No one.[56]

When Odysseus first lands in his homeland, Athena performs another piece of magic, and wraps the island in mist, the substance of so many divine disappearances in the *Iliad*, so that Odysseus does not at first recognize his home. She does so, not to prolong his anguish, but to give herself time to disguise Odysseus, so the epic says.[57] As he laments once more that he has landed in an unfamiliar place, the goddess appears to him, 'as a young shepherd, with all the delicate beauty that marks the sons of kings. A handsome cloak was folded back across her shoulders, her feet shone white between the sandal-straps.... She was a welcome sight to Odysseus.'[58] The 'shepherd' reveals that they are indeed in Ithaca. But Odysseus, though his heart leaps for joy, is too *rusé* to admit pleasure or reveal who he is. Instead he spins another tale and makes up another character. The goddess and the hero trip around each other as cautiously as circling wrestlers, and it is Athena who finally reaches across the barrier of their pretences to dispel hostility and end the feints and play-acting, at least where she is concerned. For suddenly, she changes again, and 'now she looked like a woman, tall, beautiful and accomplished. And when she replied to him she abandoned her reserve.'[59] Smiling, and caressing him with her hand, she says, 'What a cunning knave it would take to beat you at your tricks!' She avows to Odysseus that 'Even a god would be hard put to it', and then claims him as one of her own kind.[60] In a remarkable speech, she honours him as her like:

> 'We are both adepts in chicane. For in the world of men you have no rival as statesman and orator, while I am pre-eminent among the gods for invention and resource.
>
> 'And yet you did not know me, Pallas Athena, Daughter of Zeus, who always stand by your side and guard you through all your adventures.'[61]

Home, on his own territory, from which he has been exiled for twenty years, Odysseus comes for the first time face to face with his protectress in an encounter during which she tells him that they are two of a kind. Face to face, so to speak, for she has only taken on the appearance of a woman to make herself known to him in this climactic epiphany. Odysseus, always quick on his feet, responds revealingly: 'Goddess,' he says, 'it is hard for a man to recognize you at sight,

however knowledgeable he may be, for you have a way of donning all kinds of disguises.'[62] Later, when he is reunited with his son, Athena is again present, but remains invisible to the boy, 'since it is by no means to everyone that the gods grant a clear sight of themselves'.[63]

The themes of alteration and concealment continue after this mutual recognition. The last person to acknowledge Odysseus finally in the epic is Penelope, and the scene echoes with variations of the declaration of Athena to Odysseus and the acknowledgement of mutual collusion and similarity. Others after Telemachus – the dog, the old nurse – see through the wanderer's disguise and believe his story, but it is the re-cognition scene with Penelope that brings the wanderings of Odysseus to a blissful and peaceful consummation. Indeed, early commentators thought that the epic ended here.[64]

At first, Athena delays their reunion, diverting Penelope's attention when the old nurse for instance realizes it is her master whose feet she is washing.[65] Penelope cannot discern Odysseus for certain in the man before her, in spite of the feats he has performed; she wants to be sure that no one is up to any tricks.[66] Odysseus may resemble Athena, but Penelope too is under her special care, endowed with her cleverness and craft. Cunning of head and tongue, weaving and story-telling are apportioned between Penelope and Odysseus, forming a whole. The metaphors are still interchangeable in English: to spin a yarn, to tell (count) a length of cloth, a row of stitches. The symbols of Penelope's gifts are the woof, the web and the flying shuttle, of Odysseus' the trap, the masquerade, the puzzle, the tall story. Both have brilliance of mind that is expressed by their practice, in work and speech. In their recognition scene, the worker confronts the speechmaker, and challenges him to show himself to be true. Odysseus is impatient, he wants to be reunited, after so long a gap of time, with his wife. Athena has again sharpened the situation by enhancing his handsomeness once more, in a reprise of the earlier encounter with Nausicaa.[67] But Penelope holds out for proof, and, producing a ruse as trippingly as her husband on his best form, she makes sure any impostor would be unmasked by telling the maid to move the bed out of their room. Odysseus explodes: 'You exasperate me! ... Short of a miracle, it would be hard even for a skilled workman to shift it somewhere else, and the strongest young fellow alive would have a job to budge it. For a great secret went into the making of that complicated bed; and it was my work and mine alone.'[68]

He then describes how he built his bed into the very fabric of the room:

'Inside the court there was a long-leaved olive-tree, which had grown to full

height with a stem as thick as a pillar. Round this I built my room of close-set stonework, and when that was finished, I roofed it over thoroughly, and put in a solid, neatly fitted, double door. Next I lopped all the twigs off the olive, trimmed the stem from the root up, rounded it smoothly and carefully with my adze and trued it to the line, to make my bedpost. This I drilled through where necessary, and used as a basis for the bed itself, which I worked away at till that too was done.... There is our secret, and I have shown you that I know it.'[69]

By the sign of the olive tree with its living root, Penelope and Odysseus' bed is held in place, so that it cannot be moved. The gift of the goddess Athena to the land of Attica was the olive tree; her oldest cult statue in the Parthenon, for which the festival's peplos was woven, was carved of olive-wood; and the victor at the Panathenaic Games was given an amphora of olive oil. The olive is Athena's symbol, a sign of her presence. She watched over Odysseus' return to his hearth and over Penelope's vigil in the house squatted by importunate and adulterous suitors, and helped Penelope to keep her love for the wanderer intact, and her governance of his kingdom secure. The bedpost carved from the still-rooted tree is concealed; the bed itself is a secret concealed by the disguise of its ordinary though splendid appearance from outsiders' ken. For two craft workers, the bed constitutes another story in itself, a secret one shared by them alone and the goddess. It is the ultimate sign in an epic of altered and metamorphosing and deceiving appearances, expressing the centrality of Athena to the love of Penelope and Odysseus, and to chaste married fidelity for women. It is also Athena's final hiding-place, a disguise that is not anthropomorphic or personified, but equally potent in a text pervaded throughout by praise of her wisdom, her care, her vigilance, her arts. The cunning that went into the contrivance of such a bed is her gift, too, through her mother Metis, Cunning herself, to Odysseus (*polymetis*), a craftsman like the men of her city Athens who paid her special tribute. There could hardly be a more fitting marvel to unite again the long-suffering husband and wife under their own roof than this special bed. It is no wonder, though it melts our heart wonderfully too, that when Penelope hears Odysseus reveal himself truly to be Odysseus by the sign of their bed, 'her knees were loosened where she sat, and her heart melted ... then with a burst of tears she ran straight toward him, and flung her arms about the neck of Odysseus, and kissed his head and spoke'.[70] Then 'Penelope's surrender melted Odysseus' heart, and he wept as he held his dear wife in his arms, so loyal and so true.'[71] Athena then stays the dawn, so that they may enjoy a longer night together.

The high value given to the work of women and to the obligations of the household in the *Odyssey*, and the consequent dignity of some of the female characters, of Penelope, and Helen, and Nausicaa and Arete (who presides over Alcinous' household with equal honour and perhaps more authority than her husband), have always been noticed by commentators on Homer. The contrast with the *Iliad*'s military ethic is remarkable, as we shall see. Samuel Butler found the feminine cast of the *Odyssey* so marked that he argued, in a famous book, that the epic had been written by a woman. His theory was published in a series of essays, first in the *Athenaeum*, appropriately enough, in 1892. Butler argued fiercely that the poet had introduced herself to the readers under the guise of Nausicaa herself. The theory is put with charm and drive and love, all of them very persuasive emotions; and though nobody takes Butler's conclusion seriously today, his perception, that the poet of the *Odyssey* 'was extremely jealous for the honour of woman' can still stand.[72]

A definition of female character and function radiates from Athena; she determines by her protection and her presence the exalted but bounded sphere of married female conduct, restoring the king to his kingdom when she restores him to his exemplary wife, who has acted as regent in his absence with proper respect, unlike the usurper and termagant Clytemnestra, who murdered her husband Agamemnon at his homecoming from Troy. His shade inveighs against her when he laments to Odysseus in the underworld:

> And so I say that for brutality and infamy there is no one to equal a woman who can contemplate such deeds. Who else could conceive so hideous a crime as her deliberate butchery of her husband and her lord? Indeed, I had looked forward to a rare welcome from my children and my servants when I reached my home. But now, in the depth of her villainy, she has branded not herself alone but the whole of her sex and every honest woman for all time to come.[73]

But Penelope, Athena's ward, is an exception, as Agamemnon goes on to say, adding however that Odysseus nevertheless should mistrust her, and 'make a secret approach' to Ithaca, to come upon her unawares.[74]

The goddess Athena in the *Odyssey* comes in dreams, in travesty, in other people's shape and form, and as inspiration; throughout the epic she exists as a personal, bounded, identifiable power, but is magically polymorphous; she is the goddess of cleverness, and she behaves like intelligence itself, and metamorphoses into the very intelligence of her wards. She acts within the mental processes of Penelope, Telemachus

and Odysseus, her special favourites, as well as upon others like Nausicaa, and can only be seen, in this epic, by the cleverest man of all, the mortal who matches her for *metis*. Just as Metis the Titaness, her vanished mother, was protean, so Athena, daughter of Metis, functions in the *Odyssey* as an individual agent of reversal and advance in the story, but also as an abstraction, a daimon internalized in other characters of the poem. She is artful, both goddess of thought and personification of thought processes, of the restless and infinite changes that the mind performs as if assuming and abandoning so many costumes and disguises, in the course of play-acting, in paint, sculpture and writing.

As Pope wrote in the essay which accompanies his translation of Homer, 'We find that he [Homer] has turn'd the Virtues and Endowments of our Minds into Persons, to make the springs of Action become visible; and because they are given by the Gods, he represents them as Gods themselves descending from Heaven.'[75] E. R. Dodds refined Pope's rationalization of the Homeric gods' antics with the psychological insight that the intervention of Athena displaces responsibility from man to an exterior force. Describing the scene in the *Iliad* where she prevents Achilles from striking Agamemnon by pulling his golden hair, he defines how even so she still functions like the inner workings of the human mind rather than exists as a physical being: 'She is the projection, the pictorial expression, of an inward monition. . . . One result of transposing the event from the interior to the external world is that the vagueness is eliminated: the indeterminate daimon has to be made concrete as some particular personal god.'[76] Athena is not the only deity of the Greeks to transubstantiate in this way what a priest might call the conscience of a man, or an analyst, the unconscious. But because she stood for ideals approved under Christianity, she could be retained in undiminished splendour.

Nevertheless she had to undergo several new transformations in keeping with her character as the goddess of change. Her later metamorphosis in humanist classical myth as Minerva, patron of the Arts, exercised a charm over the imagination of women in particular who, in the tradition of Penelope, felt that they must live by the light of their minds and foster their native skills of hand and eye; Penelope's inward monitor as well as Odysseus' special conscience and inspiration and protector, she inspires the High Renaissance interpretation of her as the spirit of wisdom, the feminine aspect of the godhead. (See Chapter 9.) Interestingly enough, William Gladstone, whose love and respect for Homer led him to write several works on the epics during his immensely busy life, proposed a synthesis between Christianity and classical myth in the man-

ner of a seventeenth-century hermeticist, suggesting that Zeus and God the Father shared a deal in common, that aspects of the Saviour were reflected in Apollo, and that the divine Logos 'appears to be represented in the sublime Minerva of the Homeric system'.[77] The Logos, or Word of God, was identified with the Second Person of the Trinity, and, according to the Greek Fathers, the Logos was God's Wisdom, as the dedication of Hagia Sophia to Jesus Christ makes clear. Both the Wisdom figure of the Bible, as manifest in the visions of Hildegard of Bingen and other mystics, and the changing identity of Athena in the *Odyssey* reveal how multilayered and fertile anthropomorphic metaphor can be, when it is in a condition of constant renewal through different eyes. But this mutating, wondrously affirmative Athena of the *Odyssey*, the patroness of handiwork, cleverness, and peace was eclipsed during the classical revival of the last century by the totemic and less labile aspects of the Greek goddess. Athena, goddess of war not peace, emerges forcefully in the other Homeric epic, the *Iliad*, the poem which remarkably became a handbook of ethics, not just in Great Britain, but over a wide swathe of Europe, from the end of the eighteenth century onwards, and exercised an immeasurable influence on our imaginative life.

Athena of the *Odyssey* displays the warlike side of her character only against the suitors, when she helps Odysseus massacre them; in the *Iliad*, a ferocious goddess appears, who is the immediate progenitor of the armed maidens who people our public buildings and personify virtue in the combat against vice. It is the univocally martial Athena who unfortunately prevailed in the nineteenth century over the protean goddess of the *Odyssey* in posterity's imagination and culture; but this warrior woman could not have been acceptable as a figure of good to Western civilization, almost at any time and certainly not to the Victorians, if she were not predicated on an unimpeachable ethic of proper feminine conduct. Domestic fidelity and moral justice are embodied by the Athena who guides Odysseus home and helps Penelope and Nausicaa to be patterns of strong and admirable and noble womanhood. The guardian of the bed Odysseus made and its indwelling spirit lurks somewhere under the metal-bound bodies of the Britannias and Virtues who familiarly surround us. If she did not, the warrior maiden would have been an unacceptable threat, as the Amazons were to the Greeks. Rather, as we shall see in the next chapter, she incorporates an important myth about order's victory over disorder, symbolized by the aegis she wears on her breast and its gruesome trophy, the head of Medusa.

CHAPTER SIX

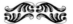

The Aegis of Athena

'This is my favourite,' [Freud] said. He held the object toward me. . . . It was a little bronze statue, helmeted, clothed to the foot in carved robe with the upper incised chiton or peplum. One hand was extended as if holding a staff or rod. 'She is perfect,' he said. 'Only she has lost her spear.' I did not say anything.

H.D.[1]

The transfiguration of a Homeric hero is achieved through armour. 'Big and beautiful' as the gods are, big and beautiful as the heroes are, men like Achilles, who is anyway semi-divine, or Odysseus, who is Athena's darling, a mortal only reaches fullness of splendour when arrayed in bronze; the *Iliad* returns to the arming and equipping of a sequence of heroes as the melody of a symphony comes back for its most urgent and powerful expression to the high strings and the shrill brass thrilling together, flesh and metal in conjunction before the combat and the bloodletting. The warrior covers his fleshly animal envelope in imperishable mineral matter: tin, silver and gold, as well as the ever-recurring bronze. His radiance then becomes something unearthly, something belonging more properly to the firmament, evoked by Homer with similes from the cosmos, of sun, of stars, of meteors.

When the Trojans led by Hector are setting fire to the ships of the Achaeans, Patroclus seeks out Achilles, weeping for the destruction. Achilles sends him into battle, and gives him his own armour, made for his father Peleus as a wedding gift from the gods:

Patroclus put on the shimmering bronze. He began by tying round his legs the splendid greaves, which were fitted with silver clips for the ankles. Next he put on his breast Achilles' beautiful cuirass, scintillating like the stars. Over his shoulders he slung the bronze sword, with its silver-studded hilt, and then the great thick shield. . . . When the Trojans saw the stalwart son of Menoetius

104

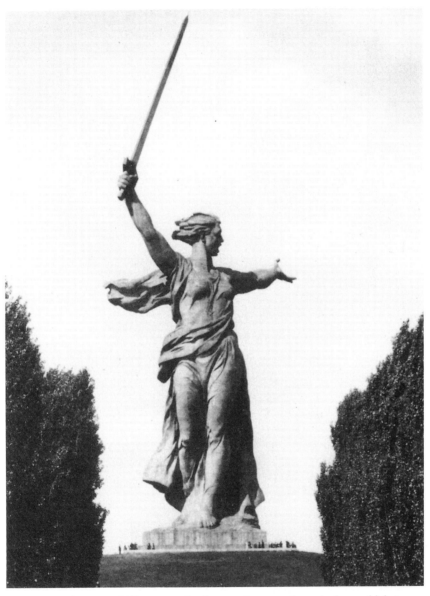

1

The New York Statue of Liberty may be the most famous colossus in the world, but
it has its rivals. This recent giant, *The Motherland*, rallying her sons (1), commemorates
the Soviet victory over the Germans in the last war, and dominates Volgagrad,
formerly Stalingrad. The sculptor, Evgeni Vuchetich, combined the scale of Bartholdi's
matron with the dynamism of Delacroix's freedom-fighter.

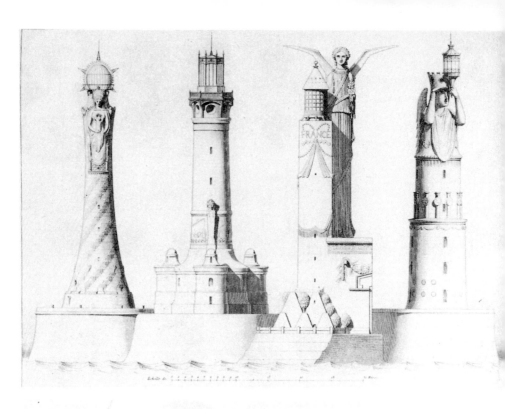

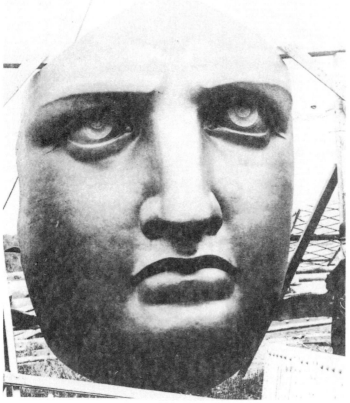

HAT LIBERTY SHALL NOT
ERISH FROM THE EARTH
BUY LIBERTY BONDS
OURTH LIBERTY LOAN 4

ne Pharos at Alexandria and the Colossus of
hodes, two of the seven Wonders of the World,
spired Beaux-Arts students to devise these
thropomorphic lighthouses in 1851-2 (2). They
ticipate Bartholdi's Statue of Liberty, seen here
ider construction in New York in the 1880s (3).
seph Pennell's poster for the war effort of 1918
sualized Liberty decapitated and New York in
mes under an air raid (4); Claes Oldenburg was
ert to the pompous propaganda of the
onumental tradition when he proposed a
erset for the grand entrance of a stock exchange (5).

5 Stock exchange entrance

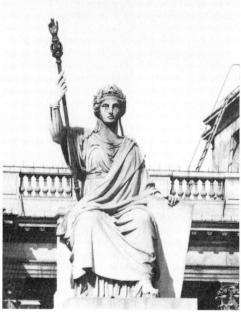

Parisian allegories: in the Place du Palais
Bourbon, Feuchère's *La Loi* commemorates Louis
Napoleon seizing power (6); on the Pont
Alexandre III, Michel's *La France contemporaine*
looks like a fashionable Parisienne of the day (7);
the façade of the Grand Palais (8) teems with girls
in négligé apparel: by the door, a sculptor by Paul
Gasq discovers a nude within the marble (9), and
on the roof, Immortality overtakes Father Time
(10).

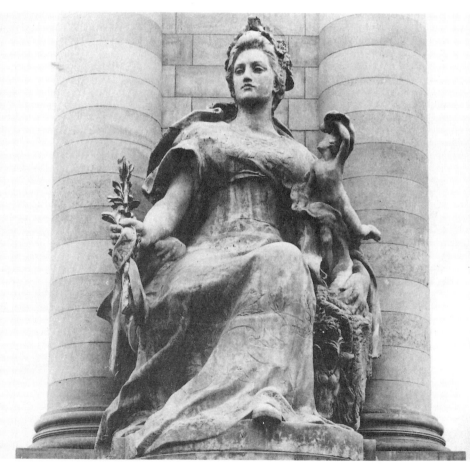

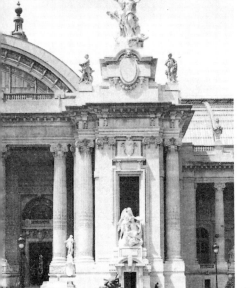

8

9

10

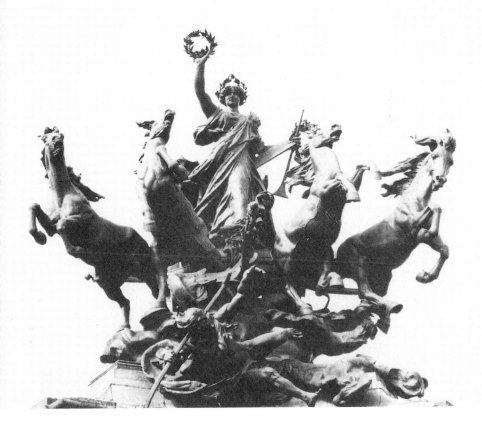

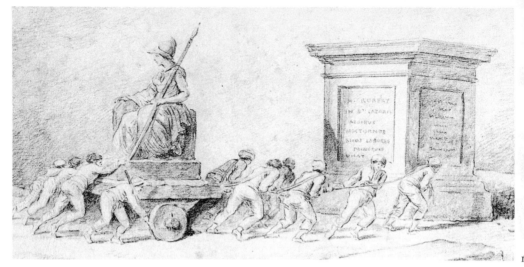

12

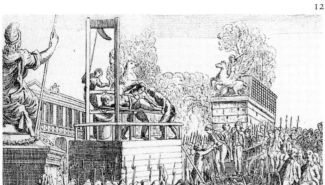

13

The Place de la Concorde: a
monument to Louis xv was replaced
during the Revolution by a
Minerva, symbolic of Liberty and
the Republic (11); she then presided
over the guillotine (12). The site
vanished under a fountain (13) when
the square was redesigned, from
1836 to 1846; the towns of France,
personified as classical goddesses (14),
were added to the décor.

14

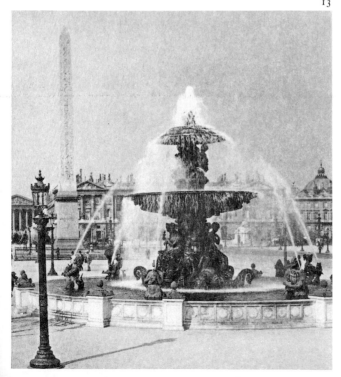

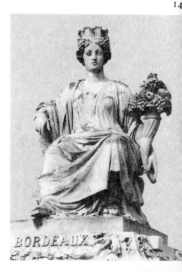

BORDEAUX

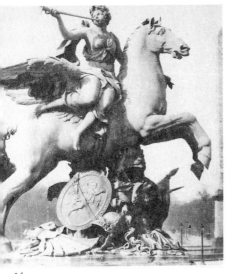

15

16

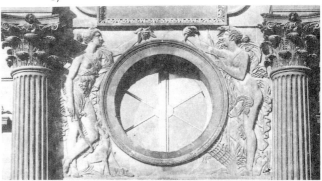

17

Antoine Coysevox's Fama (15) rides
at the entrance to the Tuileries
gardens, where, among the throng
of allegories, lies Corneille van
Cleve's nuptial pair of rivers, *La
Loire et Le Loiret* (16). In the most
ancient part of the Louvre, the Cour
Carrée, built between 1546 and 1556,
Jean Goujon carved exquisite
huntresses (17), and in the Hôtel de
Ville, one of their descendants
advertises a *fin-de-siècle* invention –
the telephone (18).

18

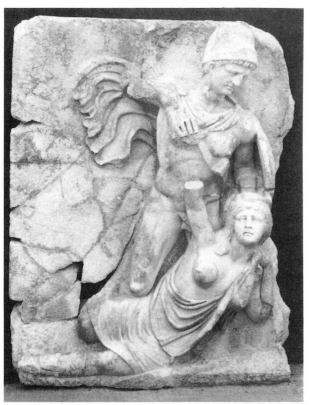

19

20

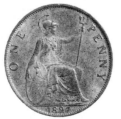

22

21

Britannia first appeared as a defeated nation: the Emperor
Claudius seizes her in a bas-relief from Asia Minor (19);
Antoninus Pius later commemorated the conquest of the island on
his coins by representing Britannia with her war gear and spiked
shield (20). The Duchess of Richmond, the King's mistress, posed
for John Roethier's medal in 1667 (21); Britannia later became a
military Athena, as on this penny dated the year of Victoria's
Diamond Jubilee (22), but all the coins hark back to the Roman
prototype.

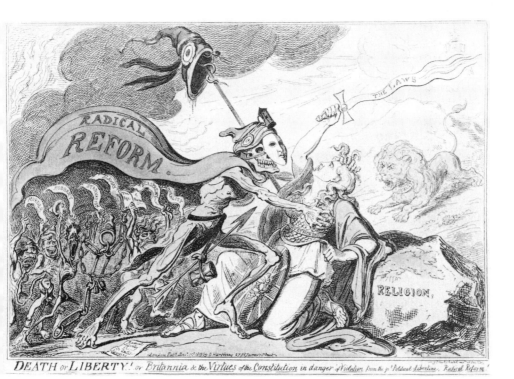

DEATH or LIBERTY! or Britannia & the Virtues of the Constitution in danger of Violation from the ye Political Libertine, Radical Reform!

23

Britannia was once identified with the body politic: George Cruikshank in 1819 saw her as embodying 'the virtues of the Constitution' (23). In 1983, the *Sun*'s front page proclaimed those virtues were now incarnate in Margaret Thatcher (24).

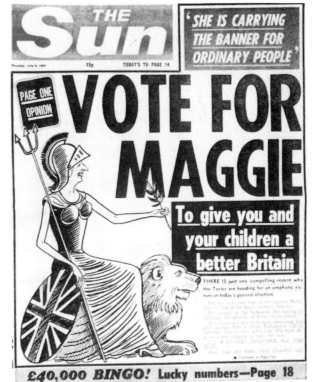

24

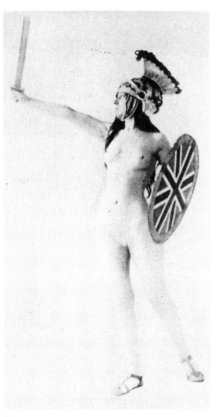

Britannia's identification with Britain's fighting spirit has not declined in this century: in 1912 the plight of Belgium inspired an artist's model to try a patriotic pose, 'Britain steps in' (25); during the Falklands War, the Iron Lady's success was lampooned by Gerald Scarfe (26).

25

26

The peace camp at Greenham Common, 1984 (27) with 'benders', the only shelters of the demonstrators. A slogan painted in 1982 at Upper Heyford (28) summed up one view of women's predicament.

28

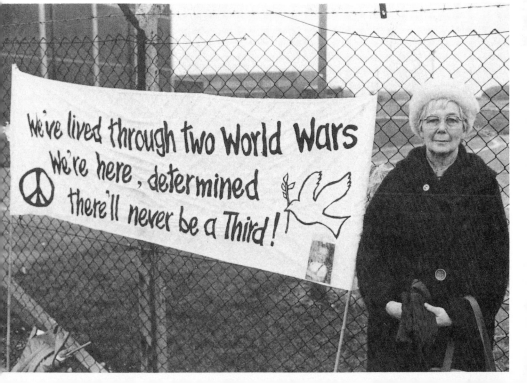

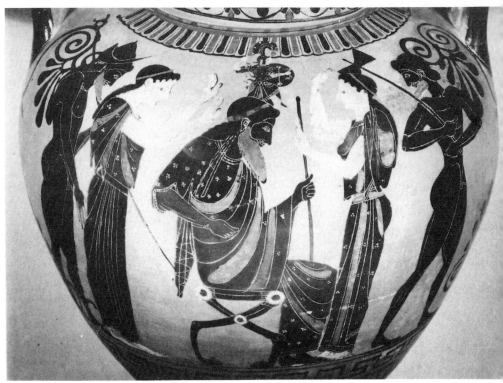

29

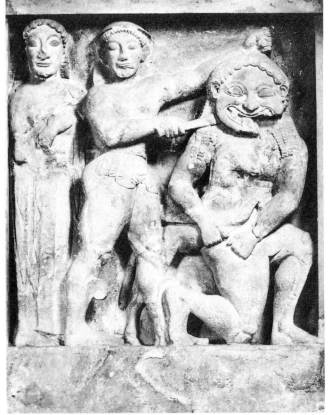

Athena springs fully armed from the head of her father Zeus, while the Eileithyiae, goddesses of labour, help with the birth (29); on an archaic metope from Sicily (30), Medusa is beheaded by the hero Perseus, Athena's protégé, and brings forth the flying horse Pegasus from her blood, while Athena stands by.

30

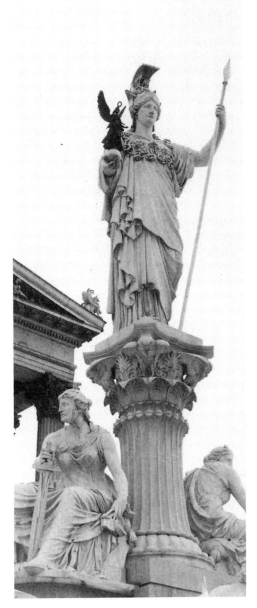

thena, the embodiment of the law and culture
f her city Athens, has inspired many
escendants: she appears as a huge fountain figure,
vith a winged Victory in her hand and the
virtues at her feet, put up outside the parliament
building in Vienna, in 1902 (32); and she 'shot
down from Olympus like a falling star' in a
children's book of 1928 (31).

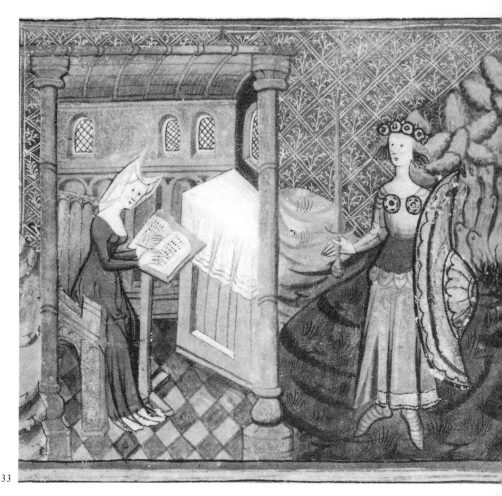

33

Minerva was the patroness of artistry and learning and handiwork, a sister of the Muses. Christine de Pizan invoked her help when she embarked on a treatise on the rules of chivalry (33); a Flemish illumination of Ovid's *Metamorphoses* shows the goddess at work at a loom after the mortal Arachne rashly challenged her. For this Arachne was turned into a spider (34).

34

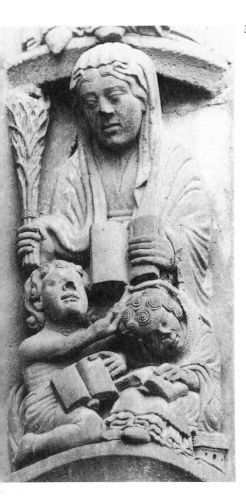

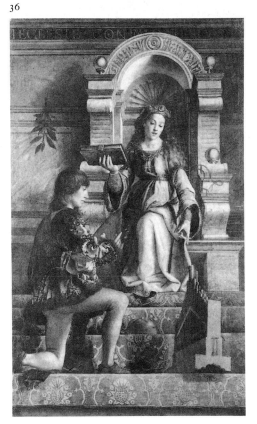

he Seven Liberal Arts, associated with Wisdom
Sapientia, included Grammar, who at Chartres
tempts to discipline her charges (35), and Music,
ho confers knowledge of her subject on a
outhful prince, possibly Federigo da
ontefeltro, in Joos van Wassenhove's painting (36).

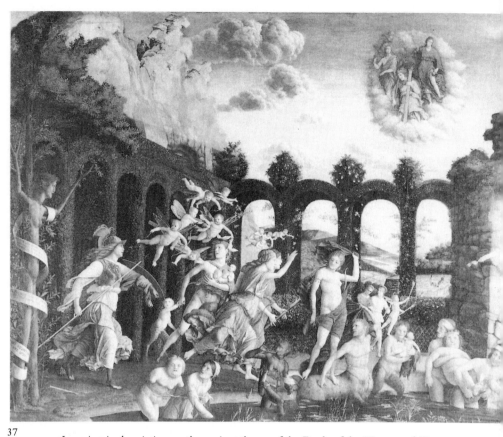

37

In an inspired variation on the ancient theme of the Battle of the Virtues and Vices, Andrea Mantegna showed the goddess Minerva attacking Lust and Ignorance and other Vices while the Virtues look down on her from heaven (37).

[Patroclus] and his squire Automedon beside him, in all the brilliance of their bronze equipment, their hearts sank and their lines began to waver.... Every man looked anxiously around to find some sanctuary from sudden death.[2]

A body like Patroclus armed is fetishized as an engine of destruction, bright with potency, and sends out flashes; both this glitter, this shimmer, this flashing quality, and the precious carapace of metal itself are lost when he dies. The collapse of his transfigured heroic self, and his terrible doom are communicated to us by the poet in a passage of the epic in which two metaphors of loss are wrought together. He loses the very vision of his eyes, and then the Trojans despoil his fallen body. The god Apollo, who always intervenes on the Trojan side, has decided to end Patroclus' triumphant rout. He steals up on the hero wrapped 'in a thick mist' and then hits him so hard between the shoulders that Patroclus' eyes start from his head and his helmet flies off.[3] Everything becomes dim, his inner light and his outer brightness, including Achilles' divine armour: 'It rolled away with a clatter under the horses' hooves and its plume was smeared with blood and dust. The crested helmet that no man had ever been allowed to tumble in the dust when it protected the head and comely face of the divine Achilles fell into Hector's hands.'[4] Patroclus' spear falls to pieces, he drops his shield, and then to strip him further Apollo undoes his corselet so that, stunned and stripped, Patroclus cannot run from a Trojan spear thrust. Retreating, the wounded Patroclus is then struck by Hector 'with a spear in the lower part of the belly, driving the bronze clean through'.[5]

For the whole of the next chapter, the body of Patroclus becomes the quarry over which the Greeks and Trojans are locked in their death struggle. His body, in its rent and dimmed condition, represents much more than the hero alone; Greeks and Trojans invest their honour in the securing of this corpse, and it becomes the stake of their self-esteem. Homer brings to the task of evoking this terrible episode a sequence of frenzied similes from the hunt, to culminate in what is probably the harshest comparison of the whole epic:

Tugging the body to and fro between them in that restricted space, they were like the men to whom a tanner gives the job of stretching a great bull's hide soaked in fat. They take the hide, stand round in a ring, and tug at it with many hands till it is taut in every part and the moisture comes out while the fat sinks in.... The result was such a scrimmage over the corpse as would not have displeased even the warmonger Ares, or Athena, in their most pugnacious mood.[6]

Athena here is the warlike goddess who presides over bloodshed, not the patron of the loom and the olive.

It is of course Patroclus' death, the eclipse of his glittering beauty into the lightlessness of Hades, that brings Achilles back into the fighting, and leads to the victory of the Greeks over the Trojans. His return to battle cannot be accomplished until new arms are provided for him, since Patroclus has lost his; the passage describing the forging of his new set of arms under the twenty bellows and on the anvil of the lame god Hephaestus at the urgent plea of Thetis, Achilles' mother, is among the most famous – and justly so – in the epic; the ecphrasis that describes his shield, embellished all over with thronged and moving scenes of war and peace, has an astonishing dream quality that exceeds even the normal oneiric dimension of Homer's tale of gods and men.[7]

While the lame god plies his tongs and hammer, Achilles has been temporarily equipped for battle, by none other than Athena herself. 'Athena cast her tasselled aegis round his sturdy shoulders; and the great goddess also shed a golden mist around his head and caused his body to emit a blaze of light', which flares up towards heaven, connecting her chosen one with the aether, the gods' own habitat. His war-cry rings out and she mingles her voice with his, in her huge 'shout of bronze':

> The Trojans were utterly confounded. Achilles' cry was as piercing as the trumpet call that rings out when a city is beset by murderous enemies; and their hearts all turned to water when they heard that brazen voice. Even the long-maned horses felt something evil in the wind and began to pull their chariots round. And their charioteers were dumbfounded as they saw the fire, fed by Athena of the Bright Eyes, blaze with a fierce and steady glare from the head of the lion-hearted son of Peleus.[8]

Chaos radiates from Achilles' force field; twelve Trojans instantly die as he sallies forth, on their own spears by their own chariots, and in the confusion, the Greeks are able to retrieve the all-important prize, Patroclus' despoiled body.

The blazing armour Patroclus wore prepared the way for the greater marvel of Achilles' sublime transfiguration as he, the favourite of Zeus and the other darling of Athena, goes to war. His mortal body vanishes in Athena's transforming blaze, his human vulnerability is cancelled by her light, her voice and her aegis.

The dual interplay of quick flesh and dead metal, and the paradoxically divinizing effect of armour upon human matter is central to the Greeks' conception of a male warrior's body and to their somatic characterization of the goddess who presides over his success. Athena, the

goddess of wisdom as well as war, the parthenogenetic daughter of Zeus, is firstborn of armed maidens, and her warlikeness pledges her authenticity, and her descendants', as personifications of virtue. The iconography and the rhetoric of virtue operate within the metaphor of defensive combat.

When Athena throws her aegis over Achilles' shoulders, she marks him by a very great sign as her own. The aegis is the goddess' distinguishing dress. It is leathery, and worn as a cloak, a breastplate, or a sling, obliquely across the breast.[9] Even Praxiteles' *Pacific Athena*, which showed the goddess unarmed, with one hand on her hip, and the other extended towards us, palm upward, and a compassionate expression on her face, still wore the aegis, with a Gorgon's head, small, but present, in a fold of the drape of her chiton.[10] The aegis ripples in loricated scales all the way down her back to her thighs in the statue of her in Poitiers, which was discovered in 1902, appropriately enough in the courtyard of the Ecole Primaire Supérieure de Jeunes Filles. In the famed colossal fully armed statue of her by Phidias that stood in the cella of the Parthenon, she also wore the aegis over her breast.[11] The aegis' appearance always helps to distinguish Athena from other goddesses who wear similarly fluted tunics, like Hera, the queen of the gods, or Demeter, goddess of the harvest. Though Phidias' wonder is lost, more descriptions of this awe-inspiring work of votive art have come down to us than of any other Greek statue: it was about twelve metres high, and Athena's divine flesh – her arms, her feet and her face – were carved out of ivory. Her armour was sculpted in elaborate relief, with a sphinx, prancing horses, deer and griffins on her helmet; her battles with the Giants and with the Amazons were represented on both surfaces of the shield, the birth and arraying of Pandora on the pedestal, and the fight of the Lapiths and Centaurs appeared even on the platform soles of her sandals. All her accoutrements were of gold. The death's head of the Gorgon was emblazoned on the centre of her golden aegis; it, like her body, was made of ivory.[12] (See front of jacket.)

When the aegis first makes its resplendent show in Homer's *Iliad*, it adds to the evocation of Athena under her recurring epithet, *glaukopis*, 'of the flashing eyes', and intensifies the impression that she kindles the Greeks' ranks like fire. It is her 'splendid cloak, the unfading everlasting aegis, from which a hundred golden tassels flutter, all beautifully made, each worth a hundred head of cattle'.[13] If you stop to consider that, during Patroclus' funeral games at the end of the *Iliad*, the famously munificent Achilles offers the loser in the wrestling match the handsome compensation prize of 'a woman thoroughly trained in domestic work'

whose value in the camp was reckoned at four oxen, and the winner a cauldron worth a dozen oxen,[14] then the implication of Homer's figure for each of the aegis' tassels can be grasped: a sum beyond price.

The aegis spreads darkness too, and the epithet Homer applies to it, *eremnaios*, is also used of a thundercloud's chilly darkness.[15] The aegis is so strong that, we learn later, it 'can withstand even the thunderbolt of Zeus'.[16] Shield and cloak at once, it covers the wearer and protects him, and constitutes a sign of the special favour of the gods.

For the aegis belongs originally to Zeus; he is referred to routinely as 'aegis-bearing Zeus', and when Apollo is arrayed in the aegis to do battle on the Trojans' side, he carries like a shield, 'the invincible aegis, grimly resplendent with its tasselled fringe', and we are then told that Hephaestus gave it to Zeus 'to strike panic into men'.[17] But Athena his daughter is also born wearing it. One tradition relates that Athena's mother Metis forged armour for her at the time of her conception, so when Zeus swallowed her, he ingested mother, child and a full panoply.[18] According to Lucian in a comic dialogue, Athena at birth danced a war dance shaking her aegis in her ecstasy.[19] It is the same aegis that she raises to strike fear into the suitors during their massacre in the *Odyssey*.[20] In the magnificent British Museum sequence of fifth- and fourth-century Panathenaic amphoras, the tall jars that carried the oil for the victors of the races in the goddess' honour at her festival in Athens, the aegis can look like a fluttering poncho, with curling pig-tails on its border; similarly, on a magnificent black-figure amphora from Gela *c.* 500 BC, now in the Syracuse museum, Sicily, Athena, protected by her aegis, fights with the Giants and when she steps lightly up into her war chariot, on another slightly earlier crater, a magnificent two-handed vase of exquisite draughtsmanship, the curlicues that fringe her aegis can be seen for what they are, rearing snakes' heads.

For, according to a famous cycle of stories, Athena's aegis bore the head of the Gorgon Medusa, killed with her help by the hero Perseus, and may even have been made of her flayed skin. Medusa was the only mortal of three terrifying sisters, daughters of Ceto and Phorcys, themselves children of Earth and Sea. The Gorgons were monsters with boar's tusks protruding on either side of wide leering jack-o'-lantern jaws, lolling tongues, and double wings, curved back upon themselves into sharp fins. The written texts say they were golden, but in the black-figure vases that often depict the sisters, their colour is sombre. Poseidon made love to Medusa once but they chose one of Athena's sanctuaries for the tryst, according to Ovid, and the goddess was outraged at the violation. For punishment, she turned Medusa's hair into snakes, thus

disfiguring her more than her two immortal sisters, Sthenno and Euryale.[21] But in one of Pindar's much earlier odes, all three Gorgons are serpent-headed virgins.[22]

Medusa's stare could turn to stone anyone who looked at her, and its powers were celebrated in sacred precincts. Her face appears, for instance, scaring any would-be pollutant of the holy places, on the pediment of Artemis' sixth-century BC temple at Corfu, and grinning from another that once stood on the acropolis of Selinus, and has now been reassembled in the Museo Nazionale in Palermo.[23] The hero Perseus was warned not to look at her, but to deflect her stony stare into a polished shield; he did so, and was able to approach her. He then cut off her head with the *harpe*, a saw-toothed sickle, the instrument that Zeus had used to castrate his father Kronos. Athena took care of the hero while he performed his task. In the archaic metope from another temple at Selinus in Sicily, of the sixth century BC, Athena stares out with huge unblinking giglamp eyes and full lips and hyacinth curls while Perseus, as gigantic in size as herself, with his body twisted in profile but his face fully towards us, holds up Medusa by her hair. She tries to flee from him, posed in genuflexion, the posture that denoted running in archaic art, but he thrusts at her throat under her split grimace. It is a grim, magnificent carving, effectively inspiring awe and horror in the viewer, as it was intended to do, and all the more so for the clumsy stiffness and frozen movement of the figures (Pl. 30).[24] On some black-figure pots, Medusa's sisters Sthenno and Euryale pursue Athena for vengeance, but unavailingly.[25] When Euryale cried out 'her strong and loud lamentation', Athena tried to imitate her, and, turning threnody into new song, invented flute-playing by the way.[26] The goddess then impaled the Gorgon's severed head on the aegis on her breast as a war trophy.

The aegis was indispensable to Athena as goddess of war. Homer tells us that when Athena decided to enter the fighting before Troy, she stood on the threshold of her father, dropped the soft embroidered robe she had made herself, and 'threw round her shoulders the formidable tasselled aegis'. He then adds this description: 'Which is beset at every point with Fear, and carries Strife and Force and the cold nightmare of Pursuit with it, and also bears the ghastly image of the Gorgon's head, the grim and redoubtable emblem of aegis-bearing Zeus.'[27]

Like the war-cry and the weapons, Medusa's face with her petrifying eyes is an instrument of terror that Athena takes for her own. The look is 'apotropaic', she 'turns away' danger by her greater menace. The Gorgon roots assailants to the spot with fear, she freezes their blood. Indeed, Homer even describes Hector, when his blood is up, as 'glaring

at them [the Greeks] with the eyes of Gorgo'.[28] Detienne and Vernant have commented: 'The aegis, the Gorgon, the dazzling fire and the shattering voice are all aspects of the warrior magic which Athena Glaukopis possesses and whose secret lies in her flashing, mesmerizing gaze.'[29]

But as Hector himself says, 'War is men's business.'[30] So why did the Greeks give it into the care of Athena, when they already posited and believed in a god of war, Ares? Why does she fight 'in the first ranks'? Why is it Athena, in the *Iliad*, who alongside Ares would not be displeased, even in a 'most pugnacious mood', by the scrimmage over the corpse of Patroclus? Why is her aegis the victor's breastplate? Why is Athena the Greeks' greatest goddess, outside the domestic sphere, at the heart of men's business? Her interventions to rally the warriors are continual; even though she scorns Ares' crass warmongering and rampages, and with the goddess Hera checks 'the Butcher in his murderous career',[31] Achilles, her favourite, has with her approval 'killed pity'[32] (though not entirely with Homer's, who calls Achilles' sacrifice of twelve men on Patroclus' pyre 'an evil thing').[33] But there is a further reason for the choice of the Gorgon mask on her aegis, beyond the sheer panic it inspires. It aligns Athena with patriarchal priorities, and thus makes her appropriate and safe as a goddess for a society like Athens.

Freud, in a paper probably written in 1922, and published after his death, and in other references in his writings, saw Medusa's head as a symbol of female castration and consequently an instrument of terror for men. Bleeding and hairy, the head stood for the maternal vagina; its bristling snakes bodied forth, by multiplication, the desired penis, and could therefore be marshalled to strike terror in others. 'To decapitate = to castrate', he wrote, and continued,

> The terror of Medusa is thus a terror of castration that is linked to the sight of something. Numerous analyses have made us familiar with the occasion for this: it occurs when a boy, who has hitherto been unwilling to believe the threat of castration, catches sight of the female genitals, probably those of an adult, surrounded by hair, and essentially those of his mother.... The sight of Medusa's head makes the spectator stiff with terror, turns him to stone.... Thus in the original situation it offers consolation to the spectator: he is still in possession of a penis, and the stiffening reassures him of the fact.[34]

Freud, living in Vienna at the turn of the century, was surrounded by Medusa's heads in the architecture of the modern city that had just gone up around him, during the decades of the 1870s and 1880s, in the

grandeur of the new Ringstrasse buildings, and the experimental pavilion of the Sezession movement.[35] On the pediment of the university, Athena's birth is sculpted by Josef Tautenhayn the Elder; her aegis is scaly, though Medusa herself is not visible from the street. But on the huge fifty-foot-high fountain outside the parliament building a little further west down the Ringstrasse, Medusa is emblazoned, in gold, on the golden aegis of the huge white statue of Athena by Karl Kundmann, a homage to Phidias' famous lost masterpiece. Though this fountain was designed at the same time as the classical building behind it, 1874–83, it was only erected in 1902. It effectively dedicates the capital of the Austro-Hungarian empire to the goddess of Athens (Pl. 32).[36]

Austria had just passed its liberal constitution during the university's construction, as recorded on the pediment behind Athena, and the Ringstrasse's magnificence was intended to celebrate the new mood of the empire. But by 1902, Athena the goddess of war, rather than the fountainhead of wisdom and moderation, was the more appropriate symbol for the growing militarism of the empire. Freud would not have seen Athena only as part of the programme of official architecture: Athena's emblems dominate the famous House of the Sezession designed by Josef Olbrich in 1898 for the exhibitions of the breakaway group of artists in Vienna.[37] Her emblematic owls perch ornamentally on the flank of the building;[38] over the front entrance, three masks bristle with snakes, while between the parapet and the entablature over the same door, other serpents seem to be writhing in and out of the gap above the inscription with scalp-raising energy. Freud and his fellows in Vienna were thus reassuringly surrounded by such wriggling reminders of their virility. Freud commented further on Medusa's head, 'This symbol of horror is worn upon her dress by the virgin goddess Athena. And rightly so, for thus she becomes a woman who is unapproachable and repels all sexual desires – since she displays the terrifying genitals of the mother.'[39]

As Hegel said, 'A philosopher is necessarily a child of his own time, and his philosophy is that time comprehended in thought.'[40] Freud was the captive of his time and place: as we are all captives of our cultural frame. He saw in Medusa's head a symbol of civilizing sexual castration; but it seems rather an expression of the required subordination of wives and mothers in patrilineage, as exercised both in Athens and, so much later, in Vienna. Professor Catherine Gallagher has observed that the misogyny expressed by Medusa's defeat arises not out of 'a fear of the weakness of the vagina, but a fear of its reproductive power'.[41] Other thinkers have interpreted Medusa's head differently: Robert Graves sees in Medusa the goddess of the matriarchy he believes existed before the

Greeks established their society; and her destruction, as well as the death of the Chimaera at the hands of the hero Bellerophon, as the historic memorial of her cult's eclipse: 'The myths of Perseus and Bellerophon are closely related. Perseus killed the monstrous Medusa with the help of winged sandals; Bellerophon used a winged horse, born from the decapitated body of Medusa, to kill the monstrous Chimaera. Both feats record the usurpation by Hellenic invaders of the Moon-goddess' powers.'[42] Jung and his colleague C. Kerényi, the classicist, argued that Medusa conceals within her the figure of Persephone, queen of the underworld, who was violated in rape by Hades, ruler of darkness, just as Medusa was violated by murder at the hands of Perseus wearing a cap of darkness. They support this argument by referring to Odysseus' fear, when he descends into the underworld, that if he lingers to commune any longer with the shades of the dead, Persephone will send him the Gorgon's head and keep him there for ever.[43] She is mistress of the head and its powers, Jung and Kerényi claim, though nothing else in Greek myth supports this, and Odysseus' exclamation can more easily be taken as figurative, that hell's terrors might root him to the spot.[44]

Although Graves sees the matriarchy which the Greeks feared as an historical phenomenon, rather than a fantasy, he perceives clearly Medusa's relation to mothers – and to power. Autochthonous or otherwise spontaneous and anomalous births inverted the due and proper order that should obtain in the world of mortals; only the gods could command such miracles.[45] A most important part of that social order on earth was father-right, upheld, as we shall see, by Athena. The figure of Athena/Medusa is no crude statement of patriarchy, however, but a luminous and sophisticated symbol, its constituent parts beautifully counterpoised to embody the principles of civilized society as understood by the Athenians, and profoundly influential afterwards.

Medusa is filled with ambiguous potency: she is both death-dealing and capable of bringing forth miraculously. When Perseus cut off her head, there sprang from her neck the mortal hero Chrysaor, and from her blood the winged horse Pegasus. He can be seen leaping into life under the monster's arm in the Selinus metope (Pl. 30).[46] A creature of slender beauty, tiny in scale in the crook of his monstrous mother's arm, but perfect, whole and beautiful, he prances upwards. Pegasus and Chrysaor had been conceived by Medusa, Hesiod tells us, when she lay with Poseidon.[47] But in the characteristic telling of the myth, the god's fatherhood is overlooked: both are perceived as Medusa's offspring. The pediment of the Corfu temple represents Chrysaor's miraculous birth as a

full-grown youth, as small in scale as Pegasus, beside his mother's winged foot and under her now vanished hand; a kylix in the British Museum depicts both offspring, Chrysaor entering the world as a beautiful naked *kouros* with braided long hair;[48] a terracotta relief, found on Melos, shows Chrysaor emerging from Medusa's severed neck.[49]

Medusa's ambivalent potency, fatal and procreative at once, is enshrined too in the myth that Euripides used in his play *Ion*, where Creusa the heroine has inherited from her ancestor, the legendary king Erichthonius, two drops of Gorgon blood, one that kills and one that heals. They were given by Athena to this mystic king in a phial, and Creusa's father, Erechtheus, bequeathed it to her. She still wears it round her wrist.[50] When Ovid much later told the story of the Gorgon's death in his *Metamorphoses*, where he tries to explain the origins and development of creation, he tells us that snakes were instantly generated from the Libyan desert when the earth combined with drops of blood from Medusa's head as Perseus hovered overhead.[51] She was capable, even in death, of giving birth spontaneously to the snake, a prime archaic symbol of vital energy, through its ability to slough its skin and so renew itself, as if eternally. She was also still petrifying in death: the hero turned the giant Atlas into a mountain by uncovering 'the horrid head of Medusa'.[52] Then, most ingeniously, Ovid combines Medusa the Gorgon's opposing chthonic powers of generating life from the earth and turning it to stone, by ascribing to her the creation of coral. Perseus rescues Andromeda by killing the monster threatening her and then rinses his bloodied limbs in the sea:

> In case Medusa's head, with its growth of snakes, should be injured in the harsh sand, he made a soft bed of leaves on the ground, covered it with seaweed, and there laid down the head.... The freshly gathered weed, still living and absorbent, drew into itself the power of the monster; hardening at the touch of the head.... Even today coral retains this same nature.[53]

The transformational potency of the dead Gorgon originates with Athena in part: if it was Athena who set the snakes, symbols of regeneration, on Medusa's head, then when Athena clamps the dread mask to her breast, she takes back a power she herself bestowed. But the combined figure Athena/Medusa also represents a solution to the fundamental theme of origins, a reply to the eternal question that much exercised the Greeks: who is more important, the mother or the father? With regard to lineage, Medusa stands to mothers as Athena stands to fathers, and Medusa's subordination to the Athenian goddess signals a predominant bias to accept that purity of descent can be more reliably

traced through a male than a female line. The necessary role of mothers is not overlooked or altogether suppressed: the blazon on Athena's aegis acknowledges it openly, but relegates it to a secondary position, ancillary and external, a part of the armour that marks Athena out as Zeus's daughter, an invincible masculine force, like the fetishized male warriors she protects. Medusa's head represents the womb as patrimony.

Athena's birth connects with Medusa's own birth-giving powers; Athena leaps from a wounded body, Medusa brings forth her fabulous children from her wounds, from her headless trunk in the case of Chrysaor and Pegasus, from her trunkless head in the case of Ovid's snakes and coral. In Medusa's case, the father, Poseidon, plays a secondary role and, indeed, in the characteristic telling of the myth is often overlooked altogether. In Athena's case, her mother is suppressed in favour of her father, Zeus. In another part of the Gorgon's myth and one that extends by association Medusa's identification with female reproduction, Perseus offers King Polydectes anything, even the head of Medusa, if only he will desist from his plan to marry his mother, Danaë, whom he has held against her will.[54] In Perseus' eyes, the Gorgon's head makes a suitable substitute for a wife: Polydectes agrees to accept one for the other, a startling exchange perhaps, but one that possesses a certain logic, given the other links the Gorgon's myth provides so often with generation.[55] But Perseus

> made Polydectes rue
> The gifts he asked for, and Danaë's
> Long slavery and forced love!

for with his spoil, he turned to stone his mother's importunate suitor and all his people at Seriphos.[56] Medusa thus avenges a mother's wrongs.

Even more significantly, Euripides, who infused so much intensity of feeling for those wrongs into his poetry, develops the symbolism of Gorgon blood in *Ion*, a play that concerns above all a mother's status.

The play at one level makes a frank attack on the gods and their dealings, especially on Apollo's with young women; Creusa, the heroine, daughter of King Erechtheus of Athens, believes that she was cruelly raped by the god when a girl.[57] On another level the play satirizes the credulity of believers like Creusa, who dupe themselves into believing that such divine metamorphoses could take place, rather than face the truth of human iniquity and misfortune. But in either interpretation, Creusa's

right to the child she bears after the rape constitutes the matter of the play. For, frightened and ashamed, she exposed it in a basket with certain tokens in the same cave where 'Apollo' pursued her. Among these tokens she laid a cloth she had woven herself as a young girl practising at her loom, with a Gorgon's head at the centre, fringed with snakes 'like Athena's aegis', and some leaves from the sacred olive tree of Athena's shrine.[58]

Creusa's subsequent marriage remains barren, and the play begins with her arrival with her husband Xuthus at Delphi to pray for a child. Unknown to her, the son whom she exposed has survived and is Ion, serving in the temple. But the god Apollo claims through his priestess at the shrine that Ion is Xuthus' son, and the husband accepts him joyfully as his heir, attributing his birth to some Dionysiac coupling at a Delphic festival in his own youth. In her ignorance of Ion's true origins Creusa believes that she is to become mother to a stranger, and, lamenting the death of her own child from exposure, she plots to kill Ion with the lethal drops of Gorgon's blood she has inherited from her ancestor. The women's chorus urge her on in accents of despair, for they do not want to see Ion acknowledged in her house as her heir. Creusa is the descendant of the true line of Athenian kings, and Ion an outsider, as they see it, no kin by blood. They refuse to disavow the native-born, maternal line, and entreat the dark goddess Hecate to help:

> Queen of wandering ghosts that haunt the night,
> Visit this day with deadly power,
> Guide the cup that my lady Creusa sends,
> Blended with blood
> Caught from the Gorgon's gory throat –
> Guide the cup to his thirsty lips,
> Who comes to usurp Erechtheus' palace!
> Let the true royal house,
> Free from all alien taint,
> Hold for ever the throne and power of Athens![59]

But Creusa's attempt to kill the interloper fails. The tragic irony intensifies in this marvellous and neglected play as mother and son meet, still unknown to each other, and he calls her 'as venomous as the Gorgon poison' with which she tried to kill him, and condemns her to be flung from a rock for her attempt on his life: 'Let the crags comb out her dainty hair!'[60] But tragedy is prevented: the priestess intervenes in time, bringing in the cradle and the tokens, and Ion and his mother's minds are purified of their mutual hate and murderousness in the recognition scene, and the consequent rapt easing of the play's tension. Athena,

invoked by Creusa under the epithet Gorgophona (Gorgon-slayer),[61] appears *ex machina* and sets all in order by pronouncing Ion a worthy king of her city, Athens, and prophesying the breadth and splendour of Greece's colonies in Ionia and beyond. But as guardian of father-right she enjoins Creusa to leave Xuthus in his happy illusion that Ion is a son of his blood line.[62]

Euripides, in a play that openly confronts the troubled relations of stepchildren to their stepmothers, even sides with a woman bent on murder to maintain her rights in her home against a child supposedly fathered on a concubine. His dramatic poetry constitutes a bitter reproach to Apollo for the tragedy he so nearly caused when he falsely gave Ion to Xuthus for a son instead of revealing his true lineage. Throughout, the Gorgon provides symbolic reflection of a mother's predicament, as the image on the cloth in which Creusa wraps the fruit of her union with Apollo, and above all as the appropriate poison to despatch Ion when she thinks him a usurper of her house, and is acting as defender of the cognate or female line.

Euripides' championship of the wronged maiden and mother Creusa provides a gloss on the famous conclusion of his predecessor among the great tragedians, Aeschylus, and it cannot have been missed by his contemporaries. At the end of the *Oresteia*, when Orestes is on trial for matricide, Athena descends *ex machina* with the same sobriety and grace as in Ion in order to dispense justice. The Athenians vote on Orestes' fate: his mother Clytemnestra has killed his father Agamemnon, and he has avenged the murder by killing her. The decision involves the status in law of fathers and mothers. Who takes precedence morally? The Furies, like the Gorgon, represent for the Athenians terror of the original, primitive, matriarchal scramble for survival which they imagined had happened, and the misrule of 'mannish' women like Clytemnestra,[63] and they want Orestes to die for his crime. Following the inner logic of Athena's birth from her father's head, and its abrogation of the womb's precedence and the mother's importance, Apollo sues for Orestes' reprieve with the famous lines:

> 'The woman you call the mother of the child
> is not the parent, just a nurse to the seed,
> the new-sown seed that grows and swells inside her.
> The *man* is the source of life – the one who mounts . . .
> I give you proof that all I say is true.
> The father can father forth without a mother.
> Here she stands, our living witness. Look –'

The god exhibits Athena and invokes her:

'Child sprung full-blown from Olympian Zeus,
never bred in the darkness of the womb
but such a stock no goddess could conceive!'[64]

Apollo here contradicts the much more traditional view of motherhood, represented later by Aristotle in *The Generation of Animals*, that mothers provided all the material stuff of creation, and fathers the form (see Chapter 4), in favour of an exclusively patriarchal idea of origin.

Athena, the embodiment here of the 'Golden Mean', exhorts the jury to moderation, but she then declares that she herself takes Orestes' part, with the rousing verses:

'Orestes, I will cast my lot for you.
No mother gave me birth.
I honour the male, in all things but marriage.
Yes, with all my heart I am my Father's child.'[65]

The twelve men split equally: Athena's vote tips the balance for Orestes, Apollo's protégé. The matricide goes free, and the father's sovereign position is affirmed. But in her character as peaceful arbitrator, Athena then decrees that the defeated Furies, now to be known as 'The Kindly Ones' (Eumenides) should be worshipped on the Acropolis, 'before the house of Erechtheus', next to her temple, so that they may be paid due reverence too and harmony reign in the state. She annexes their power to hers, in the same way as when she appropriates the Gorgon's mask for herself, she proclaims its defeat while simultaneously acknowledging and incorporating the continuing power of its presence.[66]

In *Ion*, the god Apollo similarly takes a patriarchal view of lineage, when he seeks to establish Ion as the heir to Creusa's realm by naming him fraudulently the son of Xuthus. Consistent with the Aeschylean character of the god, Apollo makes plain that it is more important to trace Ion's rights of inheritance through his father, even spuriously, than admit a matrilineal principle. The god endorses by his chicanery the opinion that the identity of Ion's mother has no bearing on his legitimacy; throughout the play, Euripides dramatizes with forceful eloquence the injustice that leads Creusa into dishonour for bearing a love-child, but places Xuthus' putative bastard in line for the Athenian throne with no taint to father or son.

The rights of the father to identify and claim his children and the necessary control of women's powers of reproduction represent an important facet of this law-giving character of the civilized state.[67] Without

law, a man can never know whether a woman's child has been engendered by him or by another: that is the nightmare represented in the *Oresteia* by the Furies' claims on behalf of mothers; the unjust consequences, when father-right takes precedence altogether, reverberate in Euripides' answering drama, in which even the daughter of a king cannot acknowledge or raise her own child and yet can be forced to accept her husband's as her own.

The commitment of the chorus to the children of an Athenian woman, like Creusa, and their combined revolt against an outsider fathered by a non-Athenian who has married into the community, interestingly reflect Pericles' citizenship law, passed in 451 BC and re-enacted in 403-402, about five years after Euripides himself had left Athens for Macedon in disgust at the reception meted out to his unorthodox views, especially about women. Women, under Athenian law, remained subject to their lord, their *kyrios*, either father, husband or appointed guardian, and could not control inheritance in the form of their dowries or their children's material fortunes transmitted through them.[68] Nevertheless, Pericles' law declared that an Athenian male gained legal citizenship through his mother as an Athenian, and not through his father, as Xuthus in *Ion* was trying to claim against Creusa and chorus.[69] John Gould has perceptively written about this internal contradiction in Athenian law, 'Women stand "outside society", yet are essential to it (and in particular to its continued, ordered existence); their status derives from males, but theirs, in turn, from the women who are their mothers.'[70] Athena herself, a masculinized, patrilineal yet female figure, fathered but not mothered, who embodies as Athena Polias the city and its citizens, represents the reconciliation of these contrary themes in Athenian identity: it is derived from a woman's body, but its instruments, controllers and agents are men.

Both the *Oresteia* and *Ion* relate their stories to the foundation of the Athenian state itself, in different ways. In *Ion*, King Erechtheus, a legendary early ruler of Athens, is given as Creusa's father, and Erichthonius as her ancestor. But the genealogy of the Athenian royal house is very confused and stories about these two figures of legendary Athenian kingship overlap at many points, while variants abound. The famous temple of the caryatids on the Acropolis, the Erechtheum, near the Furies' shrine inaugurated by Athena, is dedicated to the cult of Athena Polias, the guardian of the city, and to the eponymous mythic king of Athens; the building we see now was completed only two years after Euripides' death in 406 BC, and so the dedicatee's story, and the myths enshrined in the sanctuary, must have been vividly in mind in Athens at the time.

According to his myth, Erechtheus was born, Homer says, 'a child of the fruitful earth'. Homer himself does not give the circumstances; but later mythographers describe how Erichthonius, his counterpart as another autochthonous founding figure of Athens, found his origin.[71]

Poseidon had suggested to Hephaestus, as part of the usual Olympian daredevilry, that Athena was longing to be raped by him. He proceeded to assault her as told, and when she in high indignation pushed the lame god off her, he ejaculated against her leg. Disgusted, Athena wiped herself clean with a ball of wool, emblematic of her role as patroness of the loom, and threw it away. Gaia, Greek for the earth as both matter and goddess, then received the seed, which sprouted.[72]

Erechtheus/Erichthonius was born, a chthonic child of the dark earth, but when Gaia, the goddess Earth, would not accept this incidental offspring and refused to mother him, Athena relented, and took him in as her own son (Pl. 29a). She hid the baby in a basket, giving it into the care of the three daughters of King Cecrops of Athens. The goddess forbade the royal nursemaids to peep at the child. But curiosity of course got the better of them; they were so horrified by what they saw that they immediately committed suicide, together with their mother, thus incidentally killing off the entire female branch of Cecrops' line. The baby either had serpent's tails for legs, or was entirely snake-like.[73]

Athena began to care for the child herself, and she placed him in no other cradle than her aegis, where, as if in a modern baby-sling, 'she reared him so tenderly that some mistook her for his mother'.[74] She was his mother manquée, in all but biology. For Athena Parthenos, virgin-born and virgin herself, cannot have issue from her own body, is not a soil from which life can spring. She must borrow the maternal, autochthonous womb from Earth herself, and then foster the child, whose origins are symbolized by his snaky form. Pausanias wrote that the serpent which appeared beside Athena's shield on her statue by Phidias in the Parthenon might indeed represent Erichthonius, as he called the child.[75]

It is this legendary founding father of Attica whose cult was established by Athena on the Acropolis,[76] and whose ancient temple, the Erechtheum, where he traditionally lies buried, was built over a snake-pit. He was thus linked again with the same powers of regeneration as the Gorgon, whose subjection to social control was commemorated on his 'mother's' aegis. Like mother, like son, Erechtheus' parentage is anomalous: he is a type of native son of the soil, or autochthonous offspring, she is born through parthenogenesis. But the important aspect of his origin is that he becomes her 'child' only through law and social

institution, not through physical nature. Athena produces a split between the superimposed images of motherland and mother's body, to produce a socialized fatherland, which she represents.

King Erechtheus makes his appearance among the Attic heroes and heroines on the west pediment of the Parthenon, with Cecrops and one of his daughters beside him. King Cecrops, in this important group of myths about the political beginnings of Athens, shifts in his relationship to Erechtheus/Erichthonius. But he too figures as a founding father, and is described and depicted, as on the Parthenon itself, with the same snake legs as Erechtheus, for it is essential to show that he too is born of earth, native to Athens, the motherland.[77]

Cecrops' role in the Athenian myth rests on two significant verdicts he delivered when acting as an arbiter over the quarrelling Olympians. He is present in that capacity on the Parthenon; the central scene of the west pediment, now lost, showed the contest between Poseidon and Athena for the protection of Attica. Poseidon, having just struck the rock of the acropolis and brought forth a spring of salt water as his proof of strength in his trial with Athena, was reeling back from the prodigy with which Athena so grandly replied: her gift to Greece was the olive tree, which was shown as it sprang suddenly out of the dry earth. Cecrops naturally gave Athena the victory.

In another segment of his myth, Cecrops was again asked to choose between Poseidon and Athena, and having consulted the oracles as to what he should do, was advised to ask *every* Athenian to vote for their preference, 'for at that time it was customary in those parts for even women to have their say in public votes'.[78] The referendum chose Athena, because women outnumbered men. In revenge for this preference, the other gods decreed that women should be deprived of their right to vote, they were no longer to be called 'women of Athens' but were to be known through their fathers and their husbands as 'daughter of so-and-so' or 'wife of so-and-so'.[79] Crucially, children were also no longer to be given their mother's name. In a significant interpretation of this decision putatively placed during his rule, Cecrops is given credit for inventing monogamy because he ruled that children should be understood as the offspring of father as well as mother; his double nature, half-man, half-serpent, symbolizes the double origins he created in law for every child, with the snake portion standing for the natural, maternal or Gorgon contribution. 'In Greek eyes, Cecrops' role here is that of a culture-hero', writes Pierre Vidal-Naquet. When the Greeks looked back upon history and how their society had evolved, Cecrops was seen to have 'brought the Athenians out of savagery into civilisation'.[80] For this

society dominated by a goddess deeply feared a return to an imagined matriarchal past, and it projected its fear into the potent myths of the fierce Amazon queendoms and societies ruled by women.

Zeus, the father god who gathered all power into his hands, had his prepotentiary eminence confirmed by Athena's birth from his 'single stock'. She was not the only case. Dionysus, her fellow Olympian, who reclines semi-naked on the pediment that once depicted her birth, was himself born of Zeus. And while Athena is the most masculine of the pantheon, he is the most feminine. Many stories associate him with femininity; he disguises himself as a girl in one, he is changed into a woman for seven years in another, he appears with soft bosom and beardless cheeks on many vases and in many sculptures.[81] Dionysus, like Athena, is born of his father Zeus's body. Semele his mother was one of the many mortal girls whom Zeus ravished; when Hera jealously warned the girl that her lover's claim to be divine might be false, and that she should ask him to reveal himself in his true form, she knew such an epiphany of Zeus's godhead would destroy the girl. Zeus, goaded by Semele's refusal to sleep with him again until he had shown himself, appeared as thunder and lightning. Ovid describes the result:

> So, deeply grieving, he [Zeus] mounted high into the upper air. By his nod he drew together obedient mists, and coupled them with stormclouds and lightnings, with winds and thunderclaps, and with that bolt which none can escape. Yet he tried to diminish his strength as far as possible, rejecting as too fierce the fire with which he had struck down the hundred-handed Typhoeus. There is another lighter thunderbolt which the Cyclopes' hands have forged with a flame less cruel, a less wrathful weapon.... But Semele's mortal frame could not endure the exaltation caused by the heavenly visitant, and she was burned to ashes by her wedding gift.[82]

Semele was already expecting Zeus's child, and this baby, six months in the womb, was saved by Hermes, who took him from his mother's body and sewed him into the thigh of his father to gestate there for the further three months needed. Then, as Euripides describes in the *Bacchae*, Zeus undid the golden clips that held the child in the paternal womb, and the infant Dionysus was safely born.[83]

The twofold origins of Dionysus, 'child of the double door',[84] confirm how the birth of all humans from a mother provided the Greeks with a natural law that could be inverted to define supernatural power. The impossible is a field that can yield a rich harvest of divine attributes:

male biological maternity, that human impossibility, becomes an aspect of divinity. The king of the divine pantheon fills in this lacuna in the natural order; it serves dramatically to make his power manifest. In both the stories of the births of Athena and Dionysus, the mothers are annihilated to give Zeus the grand double act of engendering and bringing forth; his two offspring also demonstrate his polymorphousness as the originator of life. For Zeus does not reproduce himself, as a primitive organism like a worm or an amoeba divides and becomes two beings;[85] such a simple series could not reverberate with the same potency as Zeus's complex fatherhood. Zeus combines male and female functions within him, he possesses the totality of sexual difference within him as a virtuality; that is made clear by the two offspring of his arrogated womb: the daughter who is like a son, the son who is like a daughter. He is the greatest among the gods partly because he can accomplish this miracle, he can give birth to Athena, a daughter who possesses his qualities as a male, and then to complete the gap in the series, to Dionysus, a child of his own sex with the femininity of the other.

Hesiod tells us that Hera, angered by Zeus's usurpation of a mother's biology, responded to the arrival of Athena by producing in her turn a son, Hephaestus, 'without the act of love'.[86] In his craftsmanship and cunning, Hephaestus becomes Athena's only rival among the Olympians, a god who can forge a net so fine that Ares and Aphrodite are trapped in its golden mesh and cannot move hand or limb to escape, while the other gods look on and laugh at their discomfiture.[87] He is, like Odysseus, Athena's favourite, a maker of traps and player of tricks. But Hephaestus was a cripple, and so, in spite of his cleverness and his powers over Zeus's arsenal and armaments, he could never threaten Zeus's kingship. Athena, on the other hand, could. She represented so many beneficent aspects of Zeus's rule, as well as his potency as protector, that she could have become a threat, if she were not a woman. In Greek myths, only evil women become usurpers like Clytemnestra; the good wives and daughters of story, like Penelope, reflect faithfully the state of affairs prevailing in the society that relates their lives. But the stability Athena represents, both in the internal architecture of the Olympian family, and in the larger complex of the Athenian polis, was certified by her virginity. The myth of Metis' ingestion puts an end to the cycle of destruction of fathers by sons, and confirms Zeus's victory (see Chapter 4), and Athena represents the end of Uranus' line, as a daughter who cannot inherit. Under Athenian law, fortunes could pass, in the absence of male heirs, through the female descendant, to her affines, or male heirs of her body, at the discretion of a husband appointed by her male kinsmen, if

her father had died before she married.[88] The destiny of Erechtheus/ Erichthonius reflects this: he becomes established in Athens by virtue of his adoption by Athena, lordship of her city is granted to him through her. But her technically unmarried and childless state means that semi-divine though he is, he does not carry on Zeus's line in a way that could threaten Zeus; the line of descent from Zeus is broken by Athena's virginity.[89] Virginity in this instance represents surety for Zeus's state, the impossibility of inroads on his capital made by his heirs because, unlike humanity, he is immortal and does not need heirs to consolidate his line; Athena's virginity paradoxically performs the function of human marriage to ensure in the same way the safety of property's transmission from male to male, and, in the case of Zeus, its permanent residence in him. In Greek the word *eggy-e*, means both betrothal and security, and implies that the bestower of a plighted woman or the giver of a pledge of financial security did not lose control of the stake they assigned.[90] Athena's foster-motherhood guarantees Zeus's status. L.R. Farnell has commented in his great work, *The Cults of the Greek States*, on the lack of *ethical* content in Athena's virginity. Though she protected fidelity in wives, she was no patron of a Christian-style abstinence. Athena Parthenos, the Maid, was a favourite title of the goddess, but did not receive a cult that extolled virginity for women.[91]

It is sometimes thought that Athenian culture, by worshipping a virgin goddess, resembles the Christian Church exalting the Virgin Mary. The Duomo in Syracuse, now a baroque cathedral dedicated to the Assumption of the Virgin, was in the fifth century BC a Doric temple of Athena.[92] The light from the polished shield of her colossal statue flashed across the sea to guide ships into harbour. But around the sixth century AD the Byzantines built up the spaces between the massive Doric columns and hollowed the cella walls to convert it into a church, and dedicated it to Mary. Behind the tumultuous baroque façade of a characteristic southern European cathedral of the Assumed Virgin you can still see the titanic fluted pillars of Athena's former temple. Historically there seems a certain logical train of association; and many visitors savour the piquancy of this historical improvisation, that makes the temple of Athena Parthenos, the Maid, a shrine to another Virgin. But such perception of the development is not altogether exact; Mary is both Mother and Maid, she bore Jesus, even though the extent or even existence of her physical pain in giving birth has exercised theologians considerably; furthermore, according to the legend about her own family that was

first developed in second-century apocryphal writings and then embroidered in mediaeval Europe, she herself had human parents, even though miracles attended her conception. Her virginity was the proof that the child's father was divine, not human, and its symbolic function was quickly interpreted by the Fathers of the early Church as an endorsement of the moral value of bodily sexual abstinence, especially for women.[93] Such a thought was altogether foreign to the Greeks worshipping their maiden goddess. In Athena's case, her virginity is a more radical symbol of patrilineage, and it is not morally prescriptive of asceticism, but of wifely fidelity. She issues from a single root parent, a father who has ingested mother to become one, and she herself remains single and without issue. The child attributed to her – Erechtheus/Erichthonius – is carefully defined as not of her body. Like the riddling song, she is a prime number, the indivisible, unreproductive, irreducible integer: 'One is one and all alone and ever more shall be so.'

The patriarchal implications of Athena's story can explain in part her pre-eminence and her popularity in Victorian England. Her semi-masculine appearance, her eager participation in battle, her surrender of the interior and secret womb to the external and open control of society; her armour in general and her aegis above all represent the legitimacy of authority administered by males, invested in her as the symbolic fountainhead of the city's identity. It may seem a long way from the grisly trophy of Athena of the Flaming Eyes to the conventional ample-breasted metallic chest of Britannia in Euston Station, but the two figures stand in close affinity. Armour is worn by so many imaginary women, projections of the ideal, visual and literary, in our civilization today in order to demonstrate by deep association their law-abiding chastity, their virtuous consent to patriarchal monogamy as the system by which descent is traced and property transmitted. The scaliness of the armour on figures who in our culture have inherited Athena's warlikeness and righteousness, like Mantegna's painting of Minerva expelling the Vices from the Garden of the Virtues in the Louvre (Pl. 37), or François Rude's rallier of the great war-cry in his bas-relief on the Arc de Triomphe in Paris (Pl. 46) or in commonplace engravings of figures like Justice and Fortitude, derive from this classical association of Athena's triumphant legitimacy with Medusa's defeat, the desirable subordination of women to men over children's lineage. Their bodies are made masculine through buckler, breastplate, helmet, and spear, often directly recalling representations of Athena, to manifest their good behaviour in recognizing male precedence in kinship, or male authority in

society and the home. The chastity of the female body and the fidelity of a wife are essential to that, and for this reason as well as others, as we shall see, armour eventually became the distinguishing sign of many allegorical virtues themselves.

The coincidence of the Athenian code and Victorian domestic ideals inspired a renewed, official celebration of the goddess Athena in the nineteenth century in England, Germany, Austro-Hungary and the United States. Of all the Greek divinities, she represented the most familiar ethics, and in a century that made Homer required reading in boys' schools, and trained its governing classes in studies of the classics under the rubric 'Humanities' or 'Literae Humaniores', she shone as an exemplar of an altogether higher status than even Apollo and the range of qualities and endowments termed Apollonian, as by Nietzsche. Athena was morally sound, to Christian eyes. You could hardly have a respectable gentlemen's club called the Demetrium, or even the Persephoneum without stirring uneasy memories of rape and rampage, let alone one called the Aphroditeum, or some such risqué dedication; but an Athenaeum was quite in order in 1830, when Decimus Burton's harmonious white stucco palace opened its doors to right-minded Victorians (exclusively male) in Waterloo Place in London, under E.H. Baily's copy of the Pallas of Velletri, in gleaming gold, with a Corinthian helmet on her head and her aegis with Medusa's head impaled on her breast.

But the goddess also inspired private enthusiasm. In 1869 John Ruskin gave a series of lectures about Athena, which he published as a book, *The Queen of the Air*. He argued with passionate eloquence for taking the Greek myths seriously and listening to the sincere faith and moral wisdom that inspired their tellers. Athena anticipated for him the Christian classification of the virtues:

> In her prudence, or sight in darkness, she is Glaukopis, 'Owl-eyed'. In her justice, which is the dominant virtue, she wears two robes, one of light and one of darkness; ... her robe of indignation is worn on her breast and left arm only, fringed with fatal serpents, and fastened with Gorgonian cold, turning men to stone; ... in her fortitude she wears the crested and unstooping helmet; and lastly, in her temperance, she is the queen of maidenhood – stainless as the air of heaven.

He reminded his listeners that Britain was the New Athens and identified Athena with all that was good for them, including the medical discovery of his generation: 'Whenever you throw your window wide open in the morning, you let in Athena, as wisdom and fresh air at the same instant; and whenever you draw a pure, long, full breath of right heaven, you

take Athena into your heart, through your blood; and with the blood, into the thoughts of your brain.'[94]

Farnell in 1896 summed up the prevailing opinion:

> The character of Athena, both in the religion and the myths, appears then to be a reflex of the civilised Hellenic polity.... The great indictment of Arnobius Eusebius and Augustine against paganism is drawn *from other parts of the religion* ... her religion is eminently political, growing and waning with the Greek *polis*: her *pronoia* [foresight] was the 'providence' of the city-community in war and peace.... The virtues she inspires and approves are ... the public virtues of political wisdom, courage, concord, discipline and self-restraint.[95] (Emphasis added.)

Though there is never a neat symmetry matching symbolism and society, it is none the less striking that while the virgin warrior Athena's pre-eminence was being celebrated alongside the Christian deity in British cities, in London, Manchester and Birmingham, and while Britannia, Athena's epigone, was achieving her universal recognizability, married women were unable to control their own property, administer their own earnings or even, on separation, retain control of them. Even more harshly, estranged wives were not permitted to keep custody of their children. The nineteenth-century paterfamilias, like the Athenian patriarch of so many centuries before, assumed authority over property and offspring which had come to him through his wife. It was in 1857, after the tenacious campaigning of Caroline Norton for the right both to her children and her earnings as a writer after her marriage had broken down,that the first version of the Bill reforming the marriage and divorce laws in Britain was passed. The equality of women, married or unmarried, before the law was recognized only in 1882 by the Married Women's Property Act. It accomplished a quiet but fundamental revolution by effectively repealing the writ of Aeschylus' Athena and recognizing that children are offspring of their mother and that women need no longer pass into the economic control of their husbands upon marriage.[96] There is always a syncopated, erratic exchange between social developments and the mythological representation of them, and Athena's popularity did not wane on the morrow of the Act's appearance; but it did begin to fade, and few people have the Victorians' regard for the armed goddess of the *Iliad* and the Athenian upholders of father-right.

CHAPTER SEVEN

The Goddess of Success

He who binds himself to a Joy
Doth the winged life destroy;
But he who kisses the Joy as it flies
Lives in Eternity's sunrise.
WILLIAM BLAKE[1]

'Sculptors make the history of our century speak, but Rude alone makes it roar',[2] commented the art critic Louis de Fourcaud on the high-relief carving François Rude created for the Arc de Triomphe in 1831. Dubbed *La Marseillaise* after the Revolution's marching song, the sculpture celebrates the Departure of the Volunteers, the citizens' army, of 1792; in the heady days of the 1830 revolution which established the 'citizen king' Louis-Philippe, the official perspective proclaimed by the stones of Paris gloried in the connections between 1789 and their own day. But François Rude's skill gave him enough *élan* to overcome the deadening effects of a state commission.[3]

Above a group of straining, heroically nude soldiers, rallied by a veteran in abundant Gallic moustache and beard, a figure of the winged Victory soars, sword to the fore, left hand upraised, huge wings unfurled, her torso plated in aegis-like scales, urging the men forward to victory (Pl. 46). Her head – of which a splendid maquette in terracotta exists in the Louvre – gives the composition its convulsive violence; cover the yelling mouth, the staring Gorgon eyes, the flared nostrils, and the flying figure could even be benign, angelic, in spite of her weapons and speed. Uncover that screaming woman, and the figure leaps into ferocious life.

Rude added romantic accents to classically derived ideas. His Victory figure's flowing Napoleonic hair, her excesses of sash and mantle, the phantasmagoric gargoyle and other creatures on her helmet mark her a

progeny of the new turbulence and anguish, and a descendant of Eris, goddess of strife. But Rude adapted the imagery of vengeance and horror by combining it with one of the longest-lasting traditions in female allegory.[4] The winged figure herself is a Greek Nike, a familiar cipher of Victory in the Western world and one of the mythological figures to survive almost without interruption from Greece to Rome to Christian Europe. Nike was familiar from coins, vase painting and Greek and Roman sculpture. The whole iconographical plan of the Arc de Triomphe is heavily classicizing: the lifeless group by Etex behind *La Marseillaise* on the other side, representing *La Paix de 1801*, shows a stiff Minerva protecting the arts of peace, and was influenced by Etex's travels to Naples, Rome and Florence to study antiquity.

Nike was an epithet of Athena: the goddess of the polis was the bringer of victory. The statesman Aristides invoked her in an oration: 'Alone of all the gods, and likewise of the goddesses, [Athena] is not [just] the namesake of victory, but synonymous with victory.'[5] Beside Athena's Parthenon and the Erechtheum on a spur of the Acropolis stood a third temple, begun in 448 BC, probably by Callicrates the architect, and dedicated to Athena Nike, Athena of Victory. It is small, with a row of Ionic columns at the front, and decorated with a relief frieze (now damaged) that was sculpted to celebrate Alcibiades' victory in the Peloponnesian War in 410-409 BC. Nikai, one after another, were shown, processing with bulls for the sacrifice, and raising trophies. Two of the most sublime and influential Greek relief carvings of drapery, now in the Acropolis Museum, come from this frieze of Pentelic marble. One shows a Nike flying forward, like an angel announcing to Mary, another represents the goddess adjusting the strap of her sandal with one hand, as she balances on one foot (Pl. 38).[6] These exquisite figures of Victory represented aspects of Athena Victorious, and the shrine confirmed the goddess' character as the protectress of Athens, the giver of glory if her cult were duly observed and the values she stood for accorded proper reverence. The multitude of Nikai on her temple's decoration expressed the possibilities of her worship, the materialization of the rewards that followed in the goddess' train.[7] The Athenian sculptor Callimachus asked for a statue of Nike to be raised to Athena if he should die in the battle of Marathon (490 BC), with the inscription: 'Callimachus of Aphnidai to Athena has offered me, the messenger of the immortals, who inhabit wide heaven.'[8] Athena was habitually represented with Nike or Nikai in attendance, either hovering overhead with a garland of victory, as in scenes of the goddess' birth, or standing in the palm of her hand like a trophy of war as in the Athena by Phidias

in the Parthenon, or behind her on a pillar, the concomitant of her presence, as on the Panathenaic amphorae. Nike embodies the goddess' gift to the victor in the Panathenaic games, or in battle, or sometimes, on some of the most exquisite drawings on vases, to the performer on the flute or lyre. Nikai, wings outstretched, bring crowns or fillets for the winners in festivals, to athletes, poets and dramatists. In one vase in the British Museum, by the 'Painter of Athens', Nikai fly around two flute players offering them dishes and a girdle, with the latter's domestic and erotic connotations in strong contrast to the goddess of victory's usual military concerns.[9] In another, in the Ashmolean Museum, Oxford, a Nike harnesses a bull, who submits with loving, rolling eyes (Pl. 39).

Nike was not Athena's exclusive boon, or uniquely her attendant. Zeus's colossal statue of Olympia also carried a statue of the goddess of victory in the palm of his hand, and Hesiod tells us, as we saw, that she was one of Styx's quartet of children who sat always by his side. Triumph was his to give and to refrain from giving. Zeus and Nike were invoked together, according to Herodotus' account of the battle of Salamis.[10] Poseidon was also depicted 'Nikephoros', bearing Victory, in the third century BC, and Apollo and Hermes were represented with her beside them at different times.[11]

But Nike acts above all as Athena's emanation, enhancing the goddess' might and stature by her hovering, often discreet, but always graceful presence. She was most closely associated with her, and the Niketeria festival, held in honour of Athens' goddess, commemorated the victory of Athena over Poseidon for the soil of Attica; on the west pediment of the Parthenon, depicting their contest, it was probably Nike who appeared as Athena's charioteer.[12]

Nike can come in plural numbers, for she has no personal character that demands confinement in a single body. Pericles set up several Victories of gold on the acropolis; Nikai swarm in the décor of temples, as on the roof of Olympian Zeus's temple at Olympia; several processed in the frieze of the temple on the Acropolis, as we have seen; she was appropriated by ambitious regimes all over the Greek empire, appearing on the famously noble Arethusa coin of Syracuse, as she strides through the air with wings outstretched above one of the quadrigae the Sicilian aristocracy sent to compete in the Olympic games.[13] Throughout the fifth century BC, Sicilian metalworkers rendered Nike's flight with wonderful imaginative power, altering her pose, chiselling the draperies and the plumage to intensify the sensation of her flight.[14]

Nike did not receive worship as a distinct goddess in her own right

until Hellenistic times, and her separate cult interestingly coincides with the development of divine kingship. Alexander instituted the Nikaia, a feast of Victory, and set up altars to Athena and Nike separately. His coins portrayed her prominently. Apelles painted him accompanied by Nike and the semi-divine heroes Castor and Pollux; on his catafalque, a huge Nike held a trophy of arms.[15] In Roman times the emperors enthusiastically worshipped the ancient local goddess Victoria, whom they assimilated to the Greek Nike. Nike then became detached from the higher Olympians whose shadow she had once been, and also lost her intimate associations with the peaceful arts of music or athletics. Augustus established Victoria as 'custos imperii virgo', the virgin guardian of the empire, and using her to magnify his own name, he appears on his coins with Victory beside him; her statue was placed in the Senate chamber, where each senator offered her libations of wine and burned incense. Augustus also issued a victory coin for the battle of Actium, showing Nike/Victoria flying poised on a globe on the reverse, and Pax inscribed on the observe. On the emperor's feast day, 3 January, when the Senate pledged their loyalty and prayed for his health, Victory was hailed by raised salutes as the 'salus generis humani', the salvation of the human race. She became thereafter every emperor's constant companion or *comes*, present at feasts, consecrations, funerals, sometimes in the form of a personal talisman that would guarantee success. Automata, or mechanical statues of her, might even have been manufactured to crown the emperor in pageants.[16]

Nike is, however, a goddess without story. Though her dashing and spectacular presence is so well known through sculpture and vase paintings, she herself has inspired no myths. She has no individuality, and so it does not matter to us when she has no face. She is pure personification, first of desire, the desire for success, and then of its realization, success itself. By the side of Athena or Zeus, she personifies the power they have to change human fortunes, and when she crosses the barrier from the divine universe into the human, she signifies that those fortunes have been changed for the best, for the person at whose side she stands or whose head she crowns, for the state on whose beaked ship she alights. She emanates from the immortals like a daimon, an aspect of their potency, and she passes into mortal experience to mark a moment when something changed. Hesiod attempted to realize her in the context of his extended divine family, by describing her as the offspring of the Titan Pallas and the river Styx, and the sister of Glory (Zelos), Kratos (Force), and Bia (Violence) but this is an example of his extemporizing personal deities from conceptual associations: Pallas was a title of Athena

and the battlefield requires Force and Violence and leads to Victory and Glory. Nike has no children, no lovers; she exists outside human sufferings; as success itself, Nike does not undergo the pains of loss, material or spiritual. Again, the special mark of this human condition is sexuality; as someone who is a foreigner to failure and its companion sorrow, Nike possesses a kind of godlikeness very comprehensive to the later theological tradition about the godhead, not in the person of the incarnate Son, but the person of God himself. Nike inspired no tales: success itself cannot suffer, in the same way as dwellers in the Christian heaven cannot either, fulfilled as they are by the beatific vision of the God who chose to suffer by becoming man. Nike's very sterility as a member of the Greek pantheon, the lack of sexual or human specificity in her identity, helped her survival in the Christian world.

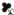

With the exception of Nike Apteros, the wingless Victory whose statue stood in Athena/Nike's temple on the Acropolis, Nike arrives on extended wings from the grandest monumental statues to the daintiest golden jewellery;[17] wings convey her speed and her lightness, her origins in heaven, the world above. The wings of Nike are always feathered; the Greek word *pteros* means feather and wing, and the wings of a statue like the Victory of Samothrace resemble the fleecy, dense plumage of the big water birds, of a heron or a spoonbill or a swan, rather than a bird of prey like a vulture, large though they are. Athena herself takes the form of a sea eagle in the *Odyssey*[18] when she leaves Telemachus and Nestor, and the old man recognizes the goddess from this magnificent transformation. So it is possible that Nike, as Athena's attendant, flew on the wings of that bird (*phene*), whom the goddess chose as one of her forms, a counterpart of her father's prime symbol, the land eagle. The birds that hunt over water stir more apt associations with Nike, giver of victory, for their prey is always live, never carrion. When they swoop down, the quarry has not yet submitted to fate as death, but its destiny is subject only to the hunter; similarly, the triumph Nike brings changes the victor's fortune utterly, and admits of no prior intervener whose harvest she might now gather as spoil. So though the analogy cannot be pressed too far, since the raptor brings death and Nike brings enhanced life, the idea of a sudden interruption in the normal undifferentiated passage of time symbolized by Nike's advent argues associations, in that archipelago of the Aegean, with the winged hunters of the sea, not scavengers of the land.

In ancient Egypt the feather's hieroglyph was a homophone of Justice,

maat, and at the last judgement of a soul just after death, Thoth, the scribe of the gods, laid a single feather in the scales against deeds of the dead person's life to judge if they balanced against the sign of justice. The wings of the goddesses Isis and Nepthys enfolded the dead god Osiris before they resurrected him; on mummy cases like the coffin of a priestess of Amon Re in the British Museum, the *rishi* or feather pattern on their winged arms is minutely painted in azure and green, symbolizing the deathlessness of the goddesses who are there to bring the dead to eternal life.[19] Plutarch, when writing about the myths of the Egyptians, conflated Nepthys with Nike since they accomplished the victory of life over death by their powers of resurrection, and wore the wings of the classical goddess of victory.[20]

Wings denote speed, flight, lightness, as well as heavenly immortality. In Plato's *Phaedrus,* Socrates explains flight's metaphysical connotations: 'The natural property of a wing is to raise that which is heavy and carry it aloft to the region where the gods dwell: and more than any other bodily part it shares in the divine nature.'[21] The messenger of the gods, Iris, the rainbow, is borne on huge wings,[22] while Hermes puts on his winged cap and sandals to fly. Perseus borrows these when he undertakes to kill Medusa and rescue Andromeda. Daedalus, in order to escape from Crete and King Minos, makes wings, with tragic results for Icarus, his son, who soars too near the sun. Wings also evoke lightness in both senses, the weightlessness of flight and the brightness of day. Eos, the Dawn, so often described by Homer as stretching her rosy fingers, appears on vase paintings in full flight, often abducting the mortal Cephalos from earth to join her in the sky.[23]

By contrast, when monsters have wings their nether parts are bestial: the Sphinx with her Komodo dragon-like ribbed and recurved wings and her lioness' body; the Sphinx's mother, Echidna, whose lower half was a speckled serpent;[24] and the bird-like, claw-footed Harpies and Sirens.[25]

Mantegna, who after long study of the classical myths was sensitive to these categories, makes us shudder at the Vices whom the goddess Minerva drives out of the Garden of the Virtues in his great painting of 1502 in the Louvre. His despised cherubs of lust in the goddess Venus' train are winged, but like butterflies or dragonflies or beetles, not like birds of the higher air. Their gauzy, glittering and brightly coloured wings suggest worlds of murky and perverse sins, as scary and as peculiar as the similar insect wings the Victorian fairy painters like Richard Dadd, Joseph Noel Paton and John Anster Fitzgerald gave to the little folk.[26]

For the wings of auspicious Nike must belong to the day categories,

'up', 'above', 'light'. The winged creatures of the night conjure fears of darkness, and the world below. One of Athena's attributes may be an owl, but Nike's wings could never be those of such a solitary, secret bird; and it would be clearly quite wrong for her to beat through the sky on bats' wings. Yet with regard to Nike, the most significant beings to be winged are all aspects of fate which can overwhelm a human life; like the wings of Nemesis (Revenge), of Thanatos (Death) and of Lyssa (Madness),[27] or of Eros (Love), Nike's wings suggest the suddenness of her strike and its external, unlooked-for character. Both the Erinyes (the Furies) and the Keres (the Fates) can also be depicted winged, flying in to direct an individual's destiny. Brandishing a flaming torch, an Erinys stands with wings unfurled below Ixion fastened to the wheel of his punishment in Hades, with winged Nikai on either side of him, in a vase from Cumae now in Berlin.[28] Her central position below the sufferer designates her the mistress of his destiny. On another vase, in the Louvre, Orestes, holding the knife with which he committed matricide, flees from another winged Erinys in pursuit.[29] In Aeschylus' *Oresteia* the priestess Pythia, describing the Furies in pursuit of Orestes, says they are as loathsome as the Harpies. She adds that they

> have no wings . . .
> but black they are, and so repulsive. . . .[30]

Artists gave them wings, however, to emphasize the relentlessness of their chase. By contrast, Nike is a sign of good omen, and her wings are golden.[31] But for the Greeks both Nike and the Furies represent, through the wings that bear them swiftly on, the inescapable aspect of destiny.

Nike belongs to the salubrious, sunlit, upper air, and her wings mark her out as otherworldly, at one with the sky above and a spirit of concord and harmony, like Athena, who in early representations, as an Oriental tamer of beasts, sometimes appeared with curved wings.[32] But, most importantly, she represents a power for whom speed is of the essence, yet who hallows and glorifies the spot of her temporary halt. This makes Nike resemble an aspect of time itself, or more precisely a way we see our relation to time. She represents the propitious event that interrupts the ordinary flow and singles out the lucky winner.

In their book *Metaphors We Live By*, George Lakoff and Mark Johnson have analysed the imaginary models we use, in common with Greek and Latin, to grasp the concept of time. According to one way we think – and talk – about time, time is a continuum which continually passes us,

travelling into the past and bringing the future into the present, as in Marvell's love poem:

> At my back I always hear,
> Time's wingéd chariot hurrying near

or the Horace tag:

> Postume, Postume, labuntur anni. . . .
> (Alas! Postumus, Postumus, the fleeting years glide swiftly by...)

or the much-loved song from the film *Casablanca*, 'As time goes by'.[33] As time passes, the future follows in its train, so that the day after tomorrow indeed comes after, while the day before yesterday indeed took place before. But, at the same time, we also habitually think of the future lying ahead of us, and the past behind us. As Lakoff and Johnson have shown, these two orientations towards time are inconsistent, but they share a major entailment, that we conceptualize time as a moving object, that has, like any moving object, a front and a back in the direction of travel.[34] We are like passengers on a train walking against the direction of travel as time shoots into the past and we make our way into the future. When we speak of the years ahead, we are moving into the future, and talking of our motion as distinct from time's. But when we speak of the years following or the month after, we are talking of time's motion, seeing things from time's point of view, and we are more at harmony with our destiny as it unfolds. But this viewpoint occurs far less frequently in imagery and rhetoric. Time and humanity are rarely at one, and language explores the separation.

For Shakespeare time has time for no one; we pass by, and time takes no notice:

> For time is like a fashionable host
> That slightly shakes his parting guest by the hand,
> And with his arms outstretch'd, as he would fly,
> Grasps in the comer: welcome ever smiles,
> And farewell goes out sighing.[35]

And Auden imagines a stalker:

> Time watches from the shadow
> And coughs when you would kiss.[36]

The figure of Nike, flying in to land on the victor's ship or hovering overhead with the garland of victory, cancels time's inauspicious vigil on her subjects' lives; she materializes as form in art the point at which the destiny of a single person converges auspiciously with time. Like

time she is travelling at speed, but unlike time, she is not moving regardless of us. She has become conscious of our passage into the future. The arrest of Nike in mid-flight, her halt over the head of the victor folds together the moment of unutterable good fortune when we come to the attention of destiny instead of hurtling on willy-nilly while undifferentiated time streams by. When she comes to a standstill in mid-flight over us she tells us that time now augurs well. And for a moment time's dread fades.

It is interesting that Nike is so often represented as a sculpture, that she was carried around as a fetish by rulers in the form of a statuette. Her essence is that we have caught her and brought her to a stop. By turning her into stone or metal, the artist succeeds in conveying this more surely. Her flight halted eternally by art, according to Winckelmann's neoclassical criteria of the ideal, she effects a reconciliation of the two metaphors, that time moves past us and that, volitionless, we move forward through time. As Baudelaire wrote about statuary, 'Sculpture, real sculpture, confers solemnity on everything, even on movement; it gives to everything that is human something of eternity, which partakes of the very hardness of the material used.'[37]

Nike appears on vases as a statue; she appears on statues as a statue, standing in the palm of Athena, or of Zeus. Her form stirs us so profoundly and has survived so resonantly because, without myth, without story, she nevertheless tells with unsurpassed eloquence of the greatest of mysteries, humanity's passage through time, and seems to promise us dominance in the area where our wills can have no power. History can be annexed and turn into personal story, a moment of glory, if the angel stays on our side, keeping us in sight.

Under the Romans, Nike/Victoria, as the angel of moment, was sometimes conflated with Fortuna, the goddess of fortune, who enjoyed an early cult in Rome, as the principle of destiny, Fors Fortuna. Servius Tullius, a legendary king of Rome, was born the son of a slave; hence he was said to be Fortune's child, or, in another version of his myth, Fortune's beloved.[38] Like Victoria, Fortuna kept company with the emperors as a golden statuette, and her cult was observed throughout the Roman empire. She was depicted carrying a cornucopia, and often enthroned, or standing on a sphere, as Nike sometimes does; occasionally she appears wearing wings. More fickle than Nike, 'caeca Fortuna' (blind Fortune) arises from a culture that believes in random chance more than inexorable fate; the Roman Fortuna is Lady Luck, and her images are often closer to disappearing Occasio or Opportunity than to an epiphanic figure like the Victory of Samothrace.[39]

But the associations between success and good luck are so close that the two divine personifications could be said to be cousins. Nike, winged, fleet and singling out her chosen ones, was in possession of her wits and clear-sighted, a conscious rather than unconscious agent. Her beneficiaries see themselves as deserving her, while Luck's protégés know no merit of their own is involved. And whereas Lady Luck is fickle, and 'bloweth where she listeth', Nike is earned. Her presence beside an emperor or a general argues, however mendaciously, a justly deserved triumph, not the quality of his lucky star.

The Fortune of a city, the personified spirit of the place, its *tyche*, is nevertheless also associated in political imagery with the purposeful goddess who brings victory. The Tyche of Constantinople, holding a cornucopia and a magnificent turreted crown, turns towards Roma, as if deferring to her, on Gratian's gold double solidus of *c.* AD 375–8. Both hold in their right hands an orb on which a Nike has alighted and is holding up a crown. The inscription reads: *Gloria Romanorum* (Glory of the Romans). The Tyche of Rome, goddess Roma herself, appears alone on a throne exquisitely rendered by the engraver with carved legs and lions' heads on the seat, again with a Nike flying on to her regalia, in a silver medallion of around AD 410 issued by the Emperor Priscus Attalus, bearing the legend: *Invicta Roma Aeterna* (Rome Eternal and Unconquered). These images, literally in common currency, split destiny into the ordinary course of events on the one hand, and sudden events of moment on the other, into permanent auspiciousness and transient glories, personified on the one hand by the seated figure of the city's fortune, its sedentary Tyche, and on the other by fugitive, speedy Nike. United, they guarantee Good Fortune.[40]

Tyche's origins are very ancient; Hesiod identified her as a daughter of Oceanus and Tethys, appointed by Zeus to 'have charge of young men'; and in 470 BC Pindar invoked this goddess as Zeus's daughter, and called her 'soteira Tyche', 'saving Fortune'. He then painted a characteristically Greek picture of humanity's powerlessness:

> I beg you, daughter of Zeus the Deliverer,
> Watch over Himera's wide dominion,
> Saviour Fortune. At your will
> Fast ships are steered on the sea,
> And on land stormy wars and assemblies at council.
> The hopes of men are now thrown up,
> Now down again, as they cleave
> The wind-tossed sea of lies.

> No man on earth has yet found from the Gods
> A certain token of success to come,
> But their sight is blinded to what is to be.
> Many things fall against men's reckoning,
> Contrary to delight, and others,
> After facing the enemy surges,
> Exchange in a brief moment
> Sorrow for deep joy.[41]

The word *tyche*, signifying an agent or cause of fortunes beyond man's control, could also mean the *act* of that divine agent; it was both a daimon *and* the effect of that daimon; the act of a god, and even, by extension, the act of someone impelled by necessity, by fate. While Tyche seems to imply a continuum, Nike denotes an aptitude for success that happens only occasionally. Hence the stillness of Tyche's posture in imagery counterbalances the dynamism of Nike's glimpsed passage.

Nike, barren of myth but potent to behold in her living drapery with her vibrant wings, was transformed into the archangel of Christian glory because the imperiousness and splendour of her identity, her chastity, as well as her essential dimness as a personality compared to the complex brightness of other personifications, like her own mother Styx, helped her to pass into Christian iconography. Christian sculptors in Pannonia, when they were threatened with martyrdom under the Emperor Diocletian, refused to make statues to Asclepius, the god of healing, but made no demur about carving Nikai, goddesses of victory.[42] The goddess who had affirmed the victorious propensities of one pagan ruler after another proved adaptable, and announced similar qualities in their Christian successors. On the gold solidus of Aelia Flaccilla, for instance, the wife of the Byzantine emperor Theodosius I, in AD 383, Nike inscribes the first two letters of Jesus' name, the *Chi-Rho*, on a shield.[43] Earlier, she had proclaimed other gods, on Trajan's column and on many pagan coins depicting her with military trophies. But by this date she could be an archangel, if her hair were not bound by a fillet like a woman's.

The Byzantines rang changes on the figure. A wingless Nike with a flying curve of drape makes obeisances, swinging a censer, as she walks backwards before the Emperor Constantius II on his horse, on a gold solidus of the mid-fourth century AD; at the end of the fifth century, Victory would be hardly recognizable as the classical goddess at all, as she holds a tall cross staff, like the archangels', if it were not for the inscription that identifies her. Justinian's famous great medallion of gold, possibly struck in 534 to celebrate the defeat of the Vandals under his general Belisarius,[44] demonstrates the fidelity of the nineteenth and

twentieth centuries' return to classical forms in public art (Pl. 42). Like Augustus Saint-Gaudens' statue of General Sherman led by an angel, the emperor on his horse with his spear couched is preceded by the figure of Victory springing forward on her left foot, wings swept back behind, and turning her head to look upon the face of the emperor with a kind of benign approval, while he, solemn, huge-eyed, and almost melancholy, makes his triumphal entry. The angel of victory, the halo around his head and the star that floats between emphasize at this date the holiness of his person as Christ's agent on earth, not as a divine king in his own right.

The angel of Christian tradition borrowed Nike's features.[45] In the meantime, the goddess changed sex, following the gender of the Christian *angelos* or *angelus*, the translation of the Hebrew word for messenger in the Bible, *māl'āk*. Justinian's beautiful equerry is unmistakably feminine, but earlier Byzantine mosaics portray winged victories who are angelic messengers and masculine, like St Michael with orb and staff on a leaf of an ivory diptych made in Constantinople only a few years before Justinian's medal or the trumpeting angel who promises glory to St Demetrius in a delicate sixth-century votive mosaic in his church in Salonika.

While Nike more usually appeared alone, angels appeared in pairs and even hosts. In the ninth-century mosaics in Santa Prassede in Rome, Victory angels preside over the gathering of the apostles on either side of the figure of Christ above the conch. They often perform the epiphanic function of Nikai, by showing forth the glory of the victor, in many of their traditional poses in Christian iconography. They support Christ in a mandorla, just as they disclosed the divine emperors of Rome, in mosaic in the chapel of San Zeno's vault in Santa Prassede, or on an early Romanesque tympanum, like the one above the Prior's Door of Ely cathedral, in the fenland; or the Byzantine-influenced Venetian bas-relief of the thirteenth century in the Kunsthistorisches Museum in Vienna; and they designate the choice of heaven, alighting in the chamber of the Virgin Mary in countless Annunciation paintings and reliefs. The Old Testament gave inconsistent indications of angelic form; messengers of God, like Gabriel, Raphael and Michael, are not described as winged (see Mark. 16:5; Luke 1:11 ff, 26 ff; 24:4 ff); only in one case, in the Book of Daniel, does an archangel fly (Dan. 9:21). The cherubim who show forth God's glory in the Book of Kings (1 Kgs 6:23-29) and Chronicles (2 Chron. 3:7, 10-13) are anthropomorphic in shape and wear double wings; their images were carved on the mercy seat of the ark of the covenant (Exod. 25:18-20, 26:6, 13) and woven into the veil of the Holy of Holies (2 Chron. 3:14); the seraphim are manlike beings too, but possess six wings – two to cover their faces, two to cover their

feet, and two to stretch to fly (Isa. 6:2). Ezekiel's vision of winged creatures who attend the throne of God provides details most difficult to visualize, let alone render congruently with divine splendour: 'Every one had four faces and every one had four wings ... and the sole of their feet was like the sole of a calf's foot; and they sparkled like the colour of burnished brass.' (Ezek. 1:6-7 AV).

A flying pagan victory was visually preferable to angels with hooves; and Nike provided artists from the fourth century on with a figural type of Christian divine messenger. In Byzantium, the mosaicists sometimes chose to interpret the prophet Isaiah's bodiless winged creatures (Isa. 6:2-6; Exod. 33:20). These seraphim, with flaming rainbow wings folded cross-wise, are the agents of rapture and vision, as in Giotto's fresco of St Francis of Assisi receiving the stigmata. But the migrant and transmuted Nike proved the more popular form in East and West. She changed her fluttering Greek tunic for the Christian dress of Byzantium, the deacon's dalmatic. In Greek Sicily, for instance, the most majestically beautiful deacon-like archangels soar around the grave-eyed Pantocrators of Cefalù and the Cappella Palatina in Palermo and the Duomo in Monreale; sometimes they fly with draped hands in the manner of the emperor's courtiers making their obeisances, sometimes they are wrapped in the long gemmed stole of the emperors themselves, with superbly coloured wings, peacock-eyed and striated in gold, the tips parted to control their motion, while their drapery flies about them in constant airy movement (Pl. 41).

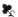

Angels, whose very name means messenger, retained the goddess Nike's classical function as the bearer of good tidings. In worldly terms, such tidings mean success, glory, reputation, fame. This role was not always taken over by archangels, though they attended emperors and kings; the split between secular and spiritual aims in the conduct of a successful life often remained far too marked for the same spirit to encompass both in Christian culture. The cultural character of the goddess Nike survived into the secular sphere in a second guise, the goddess Fame, Fama in Italy, or La Renommée in France, where she proved very popular indeed. This good fairy of the world's business proclaims the success of her godchildren with a trumpet that her forebear Nike bore only rarely, in some medals, like the example reported of Demetrius I of Macedonia, struck between 295 and 287 BC.[46] But otherwise Fama resembles Nike closely, spreading huge wings of swanlike whiteness, as in Bernardo Strozzi's allegory in the National Gallery, London. Her most beautiful

example of all, the *Renommée* of Antoine Coysevox of 1702, who – as we saw – makes a pair with Mercury at the entrance to the Tuileries gardens, is however not herself winged, though the magnificent plumage of her mount is spread behind her and there unfurls from her shoulders a banner of stiff baroque silk drapery in marble like a wing, adding to the ecstatic lightness of her pose (Pl. 15).

Interestingly, artists creating the figure of Fame usually ignored her namesake, Fama, in the extremely well-known classical texts describing her. In literature she was not in the least related to the graceful and spirited Nike, but a monster like Eris, goddess of strife crossed with the Harpies who befouled Phineus' table.[47] Virgil makes the transition from Dido's early bliss with Aeneas to her eventual ruin though the figure of Fama, Rumour, who brings about her fall. She is:

> ... of all pests the swiftest.... She begins as a small and timorous creature, but then she grows till she towers into the air, and though she walks on the ground, she hides her head in the clouds. ... Rumour is fleet of foot and swift are her wings; she is a vast, fearful monster, with a watchful eye miraculously set under every feather which grows on her, and for every one of them a tongue in a mouth which is loud of speech, and an ear ever alert.[48]

Even children, construing these hexameters for their school examinations, recognize the accuracy of Virgil's vicious goddess of gossip all too clearly; yet artists often intent on extolling their patrons have shied away from this Argus-eyed bird woman with her irresponsible imprecision, her woven lies and truths, and from the equally undiscriminating figure described by Ovid in the *Metamorphoses*.[49] A Renaissance classicist, like Cartari in his *Imagini dei dei e gli antichi*, shows himself faithful to the ancients, for he adorns the goddess Fame with Virgilian eyes on her legs, her tunic, her arms and her wings. But such fidelity is unusual.[50] When artists wanted to celebrate the good genie of the good name, they let Rumour well alone and invoked Fame under the features of the goddess of victory.

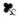

The figure that has crystallized the concept of classical Victory for the contemporary public more than any other had not yet been discovered when Christian artists created images of angels. It was only in 1863 that a small team of archaeologists, led by the French consul at Adrianople, found on the island of Samothrace a damaged marble figure of Victory (Pl. 40).[51] This statue has had an immeasurable effect on the public iconography of glory. The head and the arms of the *Winged Victory* are

missing, but the skill with which her, maker has carved her legs, her torso and her wings out of the soft-apricot-coloured stone so fills the space around her with the energy of her flight that the ecstatic thrust of her other limbs and the probable set of her head are unmistakably implied, although their exact position cannot in fact be ascertained.

Her muslin-like shift swirls against her thighs and breast and belly, delineating in crisp rills the curves of knee and calf, haunch and navel, and the hollow of her groin in a small crosswise turbulence of folds. Another length of cloth balloons out from below her waist at the back like a filled sail caught over one leg. Over her shoulders and on either side of her stomach the delicate crinkled stuff of this tunic has been whipped by her motion into smaller and faster pleats, while between her thighs the cloth of chiton and loose flying drape has tangled into a full swathe that only holds up, wrapped against her legs, through the thrust of her forward flight. The wings too, differently angled, and broad-feathered like the grandest of seabirds, streaming from forewing to tip, the coverts almost fluffy in spite of erosion, create an impression of irresistible power. The dynamism of the figure is so marked that she seems almost to propel herself and to use the wings only to soar up like a kite, rather than beat herself forward like a swan; they are tipped inwards at the elbow, and this impression that she angles them as a sail rather than uses them as an engine, possessing the thrust within herself, is exact: Nike, the goddess of victory, has just alighted, as the still heap of material at her left side on the ship reveals. The prow of the massive ship that forms her pedestal was reassembled sixteen years later from rubble found with the figure, by the same French consul, Charles Champoiseau, who first excavated her. The sculptor's skill makes us grasp her as a figure poised after flight, who then tips to hold her balance in the onrush of wind from the sea as she faces out from the boat's prow; two winds work on her, but the one most powerfully invoked by her wonderful whirling draperies is the wind that she herself has generated by her speed and that has brought her to the point where she has arrested it and where she now stands, the elect place of her presence.

In 1867 the *Winged Victory* was placed, without her stone prow, in the hall of classical statuary, the Salle des Caryatides, in the Louvre; but in 1884 she was moved to the apex of the first flight of stairs of the Escalier Daru, above the long hall through which most visitors pass to go into the Louvre, and ever since then her excitement and her beauty have taken possession of the minds of the millions who have seen her there. It is a spectacular position and enhances her qualities, making it difficult to understand how some of the first experts who saw her dis-

missed her as a late, inferior work. She was sculpted later than the Parthenon's reliefs, in the second century BC, by a disciple of Lysippus, according to some experts (including Champoiseau himself), or by pupils of Scopas, and was placed on a clifftop near the sanctuary of the Cabiri on Samothrace around 190 BC in thanksgiving for the defeat of the Syrians under Antiochus III (d. 187 BC). On this vantage point she commanded views from a great distance over the sea.

Twelve years after the Victory of Samothrace was found another Nike emerged – from the sea.[52] The Nike of Olympia was made during the most sublime epoch of Greek sculpture, and she too is larger than life (around two m.). The vibrancy of her flight and her impetus are almost more thrilling than the *Winged Victory*, though she has survived in an even more fragmentary state. The Nike of Olympia bears an inscription identifying her: she was set up after 425 BC to give thanks to Zeus in his great shrine for a victory in battle; her maker, the only sculptor of the time whose work has come down to us signed, was Paeonius of Mende in Chalcidice. He had won the competition for adornments to the temple of Zeus, with his design for the roof acroteria in the form of glittering gold Nikai. His goddess probably reproduces this design on a grander scale. Seven feet high and stepping forward with her left foot, she seems to fly though she has lost her wings. Her speed has stripped her light tunic from one breast and her thigh and moulded it to the basin of her belly and her shallow mound of Venus; slightly tilted to her right as she alights with her left arm raised and what little remains of her right stretched down in front of her for balance, she is even more suggestive of ecstasy than the *Winged Victory* of Samothrace.[53]

From the turn of the century onwards, the figure of a woman in dramatic flight became once again the visible manifestation of triumph. D'Annunzio, with his Nietzschean leanings, invoked her in 1896, in a sonnet that amounts to a prayer, written in French to pay her special honour – no doubt he would have composed it in Greek if he could:

> Je vois soudain jaillir ton essor véhément,
> Ô Victoire, je vois ton marbre où le sang coule
> prendre soudain, du socle, un vol qui se déroule
> comme l'aube d'un astre au sein du firmament....
> L'Ame chante le chœur auguste d'Euripide;
> – Niké très vénérable, en le chemin rapide
> accompagne ma vie! Au but, couronne-là![54]

Saint-Gaudens' light-footed Victory in New York leading General Sherman by the rein was made in 1900 and put up three years later

(Pl. 43). The *Silver Lady* Charles Sykes modelled for Rolls-Royce was added to the apex of the car's radiator temple in 1911 as if it were an acroterium itself.[55] At the turn of the century, Ettore Ximenes crowned the pompous Palazzo di Giustizia in Rome with a quadriga driven by a winged Victory. In 1911 the gilded Victory aflutter on the pinnacle of the Victoria Monument in the Mall in London, by Thomas Brock, was unveiled (Pl. 44). The sculptor was knighted on the spot by a delighted George V.[56] In 1912, the Victory driving the four-horse chariot on top of the Wellington Arch at Hyde Park Corner in London was presented to the city as a memorial to King Edward VII by Lord Michelham, a financier, who had commissioned the work from Adrian Jones, a captain of Hussars and a qualified vet, and otherwise almost unknown as a sculptor.[57] Sykes unfurled yards of material round her arms and swept her body forward into the wind, in the case of the Rolls-Royce symbol; Brock bared both breasts, deepened the belly button and added sinuosities to the alighted figure who dominates the Mall. The Wellington Victory by Jones cannot be seen in detail from the ground; only her tremendous silhouette, expressive of the rush of triumph, with wings spread and drapery aswirl, can be deciphered from below, in the whirling traffic of Hyde Park Corner. And she is still represented, on the reverse of the Iron Duke's portrait, on the British five-pound note.

Movements of all persuasions adopted Nike: she appears in the emblem Sylvia Pankhurst designed in 1908 for *Votes for Women*, the weekly journal of the Women's Social and Political Union, as a suffragette angel in green and purple and white, blowing a trumpet with the bannerette 'Freedom'.[58] Even the iconoclast architect Otto Wagner could not resist her symbolism: although the Sezessionists rejected ornament, he included Nikai, standing erect with garlands, on the corners of his key building, the Post Office in Vienna.[59] The Waldorf Astoria Hotel in New York appropriated her too: a naked, winged nymph, *The Spirit of Achievement*, was created for their entrance by Nina Saemundsson in 1931.[60]

From the 1880s onwards, the goddess of Victory ratified innumerable claims, commercial as well as political. Nike/Victoria appears on trademarks, cigar labels, as a stamp of quality, a guarantee of authenticity. A cipher, she speaks to us - mutely but all the time and insistently - of winning through against the odds, and perpetrates the illusion that triumph is ours. By chance, she even gave her name to the age. The future queen and head of the Church of England was not christened Victoria after a saint - who is a little-known member of the Christian host - but somewhat prophetically, was called after the classical goddess.[61]

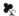

Walter Benjamin was this century's most acute critic of public lies and the culture of illusion. In 1921 he bought a small watercolour Paul Klee had painted the year before, entitled *Angelus Novus* (Pl. 47).[62] It hung on his wall in the different places Benjamin worked until, fleeing the Nazis, he left Paris, in June 1940. He returned to the image of the flying figure at different times in his writings. Through this wide-eyed creature of fantasy, who raises arms in surprise or even alarm, Benjamin meditated with profound sensitivity on the relation of the individual in his own times to fate and history and, perceiving in the image the ancient cluster of time's messengers – Nike-Fama-Fortuna-Tyche – he provides us with tragic testimony to the present century.

The year after his purchase, Benjamin called a magazine he started *Angelus Novus* after the watercolour, and related Klee's figure to the multitude of angels who in the Cabala come into being for a moment and fade away like fireflies after singing the praises of God. He identified himself and his journal as just such a transitory voice, radically subjective and ephemeral. But in 1931, in his essay on Karl Kraus, the Talmudic angel merged with the messengers of death from Greek tragedy and allegorical religious paintings, and became 'both child and cannibal. . . . Lamenting, accusing, or rejoicing?' Still identifying writers like himself and Karl Kraus with the angel, Benjamin asserted the need to accuse the old order, and bring destruction to the bourgeois culture which would culminate in the Nazis. The 'new angel' hoped to vanquish it. But by 1933 Benjamin's despair inspired a new, terrible split between himself and the angel that he might háve been: he saw that the angel who, as his *alter ego*, was breaking up history to reconstitute it anew, and who represented the effective self of dreams and promises, was now leaving him to draw him on unwillingly into a future which was already determined. The figure he evoked is masculine, following the Latin and German gender for angel:

> His wings are similar to the wings of the angel in that very few thrusts were sufficient for them to maintain themselves for a long time unmovingly in the face of the one whom he resolved to let go never again. . . .
>
> For even [the angel] himself, who has claws and wings that are pointed, or even sharp as knives, does not display any intent to throw himself upon the one whom he has sighted. He fixes his glance upon him – a long time; then he recedes haltingly, but inexorably. Why? In order to pull him along, on that way toward the future from which he has come and which he knows so

well that he traverses it without turning back and thus losing sight of the one whom he has chosen.[63]

The winged figure always contains in itself the potential to depart; in that lies its truthfulness as a representative of destiny. But at the same time in this vision it was not itself subject to that destiny, but was in control.

In 1940, however, Walter Benjamin, writing in the last year of his life, before he left Paris and committed suicide, again turned to Klee's angel and invested the image now with the full tragedy he witnessed in Nazi Europe, as experienced by people like himself. Using the vocabulary of social advance that the Nazis had tainted with their propaganda, he re-created the former angel of promise as a doomed force for healing, no longer in command, but become a victim like himself:

> His eyes are staring, his mouth is open, his wings are spread. This is how one pictures the angel of history. His face is turned toward the past. Where we perceive a chain of events, he sees one single catastrophe which keeps piling wreckage upon wreckage and hurls it in front of his feet. The angel would like to stay, awaken the dead, and make whole what has been smashed. But a storm is blowing from Paradise; it has got caught in his wings with such violence that the angel can no longer close them. This storm irresistibly propels him into the future to which his back is turned, while the pile of débris before him grows skyward. This storm is what we call progress.[64]

In this remarkable ecphrasis of a small watercolour, Benjamin extends with tragic imagination the metaphor of time's halt implicit in the figure of the Greek goddess of victory. By describing the propitious angel blown off course and away, unable to command the movement of its wings, incapacitated by a greater force which forces submission, and therefore unable to stop in mid-flight, Benjamin dismantles unforgettably an image of coherence and control. He strikes at the centre of the crucial metaphor for security – the accompanying angel, epitomized by Nike, deliverer of good tidings – and conveys to us thereby most powerfully our shattered condition, our severance from happy days.

CHAPTER EIGHT

The Sword of Justice

You walk on corpses, Beauty, undismayed,
and Horror coruscates among your gems;
Murder, one of your dearest trinkets, throbs
on your shameless belly: make it dance!
CHARLES BAUDELAIRE[1]

In his *Histories*, written in the fifth century BC, Herodotus tells us that
a festival used to be held in Libya by the tribe of the Auses, in honour
of a goddess who was 'the same as our Greek Athena'. The most beau-
tiful of the tribe's young women was chosen, dressed up in full Greek
armour, with a Corinthian helmet on her head, the visored type Athena
herself often wears, and then driven in a chariot round the lagoon where
the festival was taking place. It included a battle, a setpiece of ritual
combat: as a further tribute to the goddess, the girls divided into two
gangs and assaulted one another with stones and sticks. 'If any girl,'
writes Herodotus, 'during the course of the battle, is fatally injured and
dies, they say it is a proof that she is no maiden.'[2]

Athena was the Libyan virgins' patron; the bodily integrity of sexual
innocence endowed them with physical strength through the sympath-
etic magic of metaphor, and the chaste among them were rewarded by
victory in battle. Herodotus' anecdote thus performs three major shifts,
to subsume moral worth, physical prowess and military triumph into a
single seemingly organic argument. But what is more remarkable is that
Herodotus then goes on to characterize these people of Libya as
thoroughly alien in their mores. 'The women of the tribe are common
property,' he writes, 'there are no married couples living together, and
intercourse is casual – like that of animals. When a child is fully grown,
the men hold a meeting, and it is considered to belong to the one it
most closely resembles.'[3] The battle of the maidens takes place within a
kinship system – or rather anarchy – which flouts Greek respect for
patrilineal blood lines and faithful, subordinated wives. Herodotus,

whether recounting hearsay or embroidering an inspiration of his own, patterned the Libyan ritual on the opposite of Greek custom. He took his own civilization as the norm, and saw divergence from that norm as barbarism.[4] In so doing, he nevertheless recognized the young warriors' closeness to the goddess of Athens, and reveals to us, reading him now, the fascinating aberration that Athena once again epitomizes and blesses.

The armed maiden is also vitally present as an anomaly in our cultural symbolism. From Joan of Arc to the television and children's book heroines, Wonder Woman and Teela, from the fantasy toy *Masters of the Universe*, the subversive power of the armed maiden has been harnessed to work magic on the side of the good against the bad; a fantasy of unruliness and wickedness in the first place, when she goes over to the right side, her dark energies become light. Her capacity to conquer passes into the control of the forces of goodness. Herodotus' virgin fighters belong to a culture in which women are promiscuous, disorderly and savage, like the Amazons whose extermination by Greek heroes like Theseus and Heracles confirmed those same heroes' greatness as the founders of civilization. And we detect that Herodotus holds them in respect.

Athena too, another female anomaly, warrior and maiden, is the Greek goddess whom the Enlightenment and the Victorians cherished, and her myth has stamped its character on many unruly and warlike virgins, both emblematic figures and historical people: Justice armed with her sword, Judith the tyrannicide, even the Virgin Mary, in her aspect as death-dealer to demons. The inviolate body of these maidens possesses innate strength; their *virtus* is both 'virtue' and 'strength', and that strength proves itself through battle to the death of the wicked adversary.

For early Christians, the energy of the fighter was a form of grace. St Paul first used the metaphor of combat within the imagery of an athletes' contest when writing his famous passage on the need to subdue the passions:

> All the runners at the stadium are trying to win, but only one of them gets the prize. You must run in the same way, meaning to win. All the fighters at the games go into strict training; they do this just to win a wreath that will wither away, but we do it for a wreath that will never wither. That is how I run, intent on winning; *that is how I fight*, not beating the air. I treat my body hard and make it obey me.
>
> (1 Cor. 9: 24-27, emphasis added.)

Asceticism and struggle: the symbol of the victor's body, hardened and exercised, arises from Paul's text as a symbol of the virtuous soul. But

he talks of his body, and he never addresses women specifically in any such manner.

The image recurs, with what could be an intended echo, in Perpetua's *Passion*, composed soon after, in the second century. Perpetua, who wrote down her visions before she was put to death in the arena in Carthage, saw herself transformed into a man, an athlete whose limbs are massaged with oil before a fight, when she dreamed she fought in hand-to-hand combat with evil:

> And we joined combat, and fists began to fly. He tried to grab my feet, but I struck him in the face with my heels. And I felt airborne, and began to strike him as if I were not touching ground. But when I saw there was a lull, I locked my hands, clenching my fingers together, and so caught hold of his head; and he fell on his face, and I trod upon his head.... And I awoke. And I knew I should have to fight not against wild beasts but against the Fiend; but I knew the victory would be mine.[5]

Perpetua, composing her remarkable document on the meaning of her own martyrdom, adapted the Pauline metaphor of the heroic athlete to turn herself into the first unsexed Christian warrior maiden.

It was in her town, Carthage, that Tertullian, in the next century, first used the armed allegorical maiden figure of Christian virtue, at the climax of his diatribe against the Roman games, the *De Spectaculis*:

> What greater pleasure is there than disdain for pleasure? ... than to find yourself trampling underfoot the gods of the Gentiles, expelling demons, effecting cures, seeking revelations, living to God? These are the pleasures, the spectacles of Christians, holy, eternal, and free. Here find your games of the circus, - watch the race of time, the seasons slipping by, count the circuits, look for the goal of the great consummation, battle for the companies of the churches, rouse up at the signal of God, stand erect at the angel's trump, triumph in the palms of martyrdom.... Would you have fightings and wrestlings? Here they are - things of no small account and plenty of them. See Impurity overthrown by Chastity, Perfidy slain by Faith, Cruelty crushed by Pity, Impudence thrown down into the shade by Modesty; and such are the contests among us, and in them we are crowned. Have you a mind for blood? You have the blood of Christ.[6]

Tertullian's savage topos has classical antecedents: the Romans adapted the iconography of the Amazon fighter to represent Virtus, the principle of Virtue herself who stands beside great men on their sarcophagi, manifesting their inner goodness as they dispense largesse or plight their troth in marriage; Virtus also appears in images of heroes' hunts. In high-relief carvings on Roman sarcophagi like the third-century example of a Lion

Hunt in the Museo Capitolino in Rome, lions are slaughtered by young huntsmen and huntsgirls, armed with weapons and keenly plunging into the fray. Like Diana, the goddess of the chase, and Atalanta, the heroine of the footrace, who killed the Calydonian boar with the hero Meleager, the figure of Virtus can be recognized by her short tunic and her buskins, but unlike them she wears a Minerva-like crested helmet over her long hair, falling in wild tendrils to indicate her mettle. There is an exceptionally beautiful image of her in a relief from the Villa Medici, Rome, accompanying a hero whose name we no longer know. In the country of the Auses, of Perpetua and of Tertullian, North Africa, the Greek colony of Cyrene was sculpted as an Amazonian combatant wrestling with a lion in a dedicatory tablet of AD 120-40. The nymph Cyrene, celebrated in one of Pindar's odes, lived wild and overwhelmed a lion with her bare hands;[7] in the British Museum's votive tablet she grips the animal in a tackle round his neck, while Libya, personified as a stately matron, holds a garland over her head(Pl. 48).

The victory of a girl redounds all the more blazingly to her cause's justice because she is weak; that is the underlying premise of the triumph of good over evil when it is represented as a battle between feminine virtue and brute vice. Weakness can overcome strength, the nymph floor the lion, because right is on her side. The wider context of the battle itself encloses a fundamental human experience within a metaphor that has lasted throughout our history, and is still the dynamic of popular films like the *Superman*, *Star Wars* and Steven Spielberg series, in which armed warriors, male and female, rush to the defence of light against dark forces.

This dualist view of the human condition was dramatized a hundred and fifty years after Tertullian used the image of the armed maiden, in the first Christian allegory in verse, Prudentius' *Psychomachia* or *The Battle in the Soul*.[8] Prudentius borrowed the trope from Tertullian who influenced him profoundly, but the metaphor of combat for an internal spiritual struggle was his own. It has since become so habitual it seems natural. In his long and graphic epic poem, Vices like Libido and Luxuria (Lust), or sins like Anger and the Worship of the Ancient Gods, wage war on the doughty Virtues, armed maidens one and all, however 'modest' or 'patient' or 'humble' they may be, in a series of engagements. Most are hand-to-hand combats, though Lust succeeds through seduction, and Discord through deception, but only for a time. One by one the Virtues triumph.

Prudentius was a civil servant from Saragossa or Calahorra in Spain, who died around 415 AD, and his conflation of war and conscience into

a single image proved an inspired insight into imaginative needs: some twenty illustrated manuscripts of the *Psychomachia* survive, and it has also been interpreted in tapestry, ivory carving, painting, sculpture, as well as numberless renderings in poetry and prose.[9] Theodulf of Orleans, Charlemagne's court poet who died in 821, adapted it. Queen Mélisande of the crusader kingdom of Outremer commissioned an ivory bookcover for her Psalter, now in the British Museum, which depicted the battle of the Virtues and Vices. In the same century – the twelfth – the great abbess Herrad of Hohenburg included a fully illustrated version of the poem in *The Garden of Delights*,[10] while Hildegard of Bingen was inspired to write a dramatic and psychologically astute version, the *Ordo Virtutum*, for the nuns in her convent to sing.[11]

Virgin warriors overwhelming vices appear on the twelfth-century St Peter's font in Southrop, Gloucestershire, and on another English work, the exquisite casket of gilded *champlevé* enamel made *c*.1170, now in Troyes Cathedral.[12] The subject was considered especially edifying in secular surroundings: a Psychomachia was painted on the walls of the king's bedroom in the Palace of Westminster in the thirteenth century. The conquest of the daughters of Sodom, Lust and Luxury, was thus ever present before the eyes of English kings.[13]

The literature of chivalry adapted the motif: in the thirteenth century, Huon de Méry wrote a poem, *Le Tournoiement d'antéchrist*, in which Christ, accompanied by armed and mounted Virtues as well as the knights of King Arthur, rides into the lists against the devil who carries as a token part of the chemise of Proserpina, queen of the underworld.[14]

The battle was also a favourite subject of tapestries. In the Burrell Collection, Glasgow, a quotation from a Psychomachia poem is woven into the top of an appealing late fifteenth- or early sixteenth-century skirmish involving Charity, a splendidly fashionable young woman, mounted on a sturdy little elephant. She is seizing Envy, a craven knight, as he plunges through the *mille fleurs* undergrowth on a bridled hound in an effort to escape her wrath (Pl. 52).

The theme does not usually inspire subtle art; its dialectic is too bald, the characters, like Castitas or Fortitudo, lack ambiguity to say the least, the resolution is known from the start, and such reverses as occur in narrative Psychomachiae delay the outcome with what can only seem a gratuitous relish for gore, whether the interpretation be ancient – Prudentius – or modern – as in the film *Raiders of the Lost Ark*.

Prudentius himself set the bloodthirsty tone that has continued to dominate this leitmotiv, Christian or post-Christian. When Discord tries to stab Concord, Faith intervenes and Discord is then torn to pieces by

the pack of Virtues, Fasting, Sobriety and so forth, who in a reminiscence of the biblical fate of Jezebel, toss her dismembered carcass to the animals. Sobrietas brings Sensuality to an appalling end too when she smashes her face in with a stone:

> Chance drives the stone to smash the breath-passage in the midst of the face and beat the lips into the arched mouth. The teeth within are loosened, the gullet cut, and the mangled tongue fills it with bloody fragments. Her gorge rises at the strange meal; gulping down the pulped bones she spews up again the lumps she swallowed. 'Drink up now thine own blood, after thy many cups,' says the maiden, upbraiding her. 'Be these thy grim dainties.'[15]

Mantegna's suitably austere and relentless imagination has given us probably the most famous Renaissance interpretation of the theme, in his highly wrought painting, of *The Expulsion of the Vices from the Garden of the Virtues*, which now hangs in the Louvre, but was originally painted for Isabella d'Este, Duchess of Mantua, in 1502 (Pl. 37).[16] This remarkable visualization of evil's undoing has a chilly stiffness and an unappealingly superior attitude to the Vices who leave the garden under Minerva's onslaught. Wearing cuirass, Gorgon's head, helmet, shield and spear, the goddess of wisdom, chastity's champion, strides into the arcaded paradise, preceded by two of her maidens, who cry out their indignation. They drive before them a motley crew of half-clad, half-animal Deadly Sins: Venus/Lust riding on a centaur, the centaur's satyr-like companion carrying a baby, hermaphroditic Ignorance lolling in the support of withered Avarice and Ingratitude, the dark monkey of Malice, armless blind Sloth and the crone Inertia who leads him.

Fortitude, Temperance and Justice float high above such earthly matters but gaze down approvingly on their sister, Prudence, with whom Minerva is here assimilated; on the top left-hand side, a craggy cliff-face flares sulphurously behind the dark verdure of the topiary-work arbour, while Minerva's routed evildoers plunge struggling into a reed-filled pool. But even more than the vulnerable nudity, mutilation, ugliness and, indeed, defeat of the righteous goddess' enemies, the woman nearest to the goddess disturbs the moral of the painting. She clutches three babies to her breast, and drags another by her free left hand. This toddler has satyr legs, and a furry penis like a plume. The babies in her arms also have animal legs, while her own knees are hirsute and her hooves cloven. Like a classical faun, a spirit of lasciviousness, she has pointed ears. Above her swarm cherubim, except that they have owl heads and sinister insect wings instead of birds' feathers. The problem is that she turns with her mouth open in dismay, and bears such a likeness to the

conventional figure of Charity, nursing unweaned infants, that she excites our pity; also, no society, and certainly not northern Italy in the Quattrocento has held such a simplistic view of sexuality and its sinfulness. Mantegna, who was gradually becoming obsessed with the struggle against ignorance, was unable in his *Expulsion of the Vices* to avoid the moralistic overtones of a campaign against sensuality rather than folly.

Isabella d'Este stipulated the didactic tone of Minerva's victory over Venus, but in spite of Mantegna's meticulous labelling, the *bello significato* on which his patron insisted risks being turned inside out by the viewer today, who flinches at the cripples and the mothers harried by the untouched and untouchable goddess. This strain of unexpressed disquiet for the victim should be borne in mind, for its existence infuses many images of female virtue with an ambiguity that will help us disclose their significance today.

The many interpretations of the Psychomachia and related confrontations between virtues and vices share a common indecisiveness about one aspect of the theme: the form of the vices.[17] *Vitia* (vices) or *peccata* (sins) are neuter in gender, and the larger category has affected the representation of the subspecies – the specific sins themselves – in Christian and other imagery. Though particular vices are feminine in gender, few are consistently female in appearance, unlike the virtues. *Ingiustitia* (Injustice) in Giotto's cycle for the Arena Chapel, Padua, is a man; Mantegna, in spite of his pedantic tendency, ignores grammatical gender too in his *Expulsion of the Vices* in a way that Renaissance artists rarely do when it comes to virtues. His Ignorantia (feminine) is as eunuch-like as his Otium (neuter). In earlier, mediaeval treatments of the subject, the vices are variously represented as men, monsters, animals, devils, or armed knights in recognizable and historical clothes, like Envy in the Burrell Collection tapestry (Pl. 52). Sometimes, the vices are feminine: Envy (Invidia), for instance, is often depicted as a raddled and toothless hag (see Chapter 13), and in *Le Roman de la rose*, the dreamer sees the vices painted on the wall of the garden as hideous, grimacing women. A most chastening example of the fluctuating tradition occurs on the portals of Strasbourg cathedral, where, interestingly enough, the Virtues are portrayed as noblewomen and the Vices as burghers' wives, both recognizably of the period – around 1280 – when they were carved (Pl. 51).

The association of men with vice may not only be empirical (!); the frequent representation of even feminine gender nouns in a male form reflects the active agency of masculine nouns, of the doer rather than the deed. In a faith which believes that evil does not exist absolutely, it

would be heretical to imagine the vices or the sins in the universe of fixed forms, in the ideal heavenly dimensions of the virtues. The sculpture programmes of mediaeval cathedrals therefore tend to tell stories of temptation and lapse, rather than posit eternally abiding figures of evil.

But another reason why the depiction and rhetoric of vice follow a different pattern lies in the formal structure of imagination: the opposition good/evil translates into another familiar dyad – female/male. The predominance of feminine gender in words for virtue seems to have given virtue a monopoly on the feminine category: this, by contrast, has generated masculine gender imagery for its opposite. The Psychomachia theme, by positing a direct conflict, inspired a series of similar paired oppositions which only appear equivalents at a superficial level; the destruction of evil by good clearly does not carry the same significance as the killing of man by woman. This distinction cannot, however, be borne in mind when the visual metaphor ignores it, with serious consequences: the routine use of feminine forms for the goodies, and of the male for their victims, the baddies, has widened the affective range of the imagery into the most problematic area of the contemporary psyche.

Freud often referred, almost offhandedly, as if it went without saying, to the phallic symbolism of weapons. 'Nor is there any doubt that all weapons and tools are used as symbols for the male organ: e.g. ploughs, hammers, rifles, revolvers, daggers, sabres, etc.'[18] If Freud was right, what are we to make of this tradition, which has placed armed maidens in the libraries, museums and town halls of Victorian England and not only in mediaeval cathedrals or kings' bedrooms? Truth with her mirror and Justice with her sword stand on either side of the chimneypiece in Manchester Town Hall's State Rooms, designed by Alfred Waterhouse;[19] Courage is about to behead a snake with her scimitar, in Hamo Thornycroft's monument to Gladstone, as we have seen (Pl. 55); Justice, again with her sword, is painted on the wall behind the dais in Birmingham's Council Chamber. Do these phallic females represent a collective castration complex of a whole culture? And moreover one that has lasted over a thousand years, if we trace the motif back to Prudentius, or even Tertullian?

Dream figures from the ideal world the Virtues may be, but their translation into paint, stone, material of all kinds and into text and its movement places them in consciousness, and there, their weapons, however big and threatening, do not automatically refer, in this writer's opinion, to the phallus, unless the sphere of reference is itself sexual. But it often is. Charity overcoming Lust clearly unmans lust by her righteous fury: when Pudicitia (Modesty) runs through Sodomita Libido (Sodom-

itic Lust) with her sword, the Freudian interpretation that she has taken
the Vice and destroyed its penis, in a setpiece of castration terror, has a
ring of persuasiveness.[20] The diagnosis by Freud of castration fear in
men and penis envy in women occurred at the turn of the century when
the arts - literature, painting and music - were beginning to place
sexuality at the forefront of their concerns and to reinterpret perennial
themes, like the paired contrasts good/evil, male/female, in the light of
a new perception of sexual repression, its function and its dangers. The
armed maiden who tramples, beheads, pierces and otherwise despatches
trespassers has lost her innocence; as a figure of virtue she has become
saturated with perversity and contradiction.

But it was not always so. Our own cultural and historical circum-
stances, the post-Freudian complex itself, have given her a new dimen-
sion and changed her, almost irretrievably. Yet the two virtues most
frequently depicted armed and embattled were not Chastity, but Justice
and Fortitude, also labelled the 'political virtues' and enjoined upon
princes in works inspired by Aristotle's *Ethics* and Cicero's *De Officiis*.[21]
It is however only with difficulty that we can now receive their images
as figures of a divinely inspired social law, and not sexual fantasies. But
it is worth trying.

Ambrogio Lorenzetti's frescoes in the Palazzo Pubblico in Siena, exe-
cuted just before the Black Death of 1348 swept away the painter,
number among the finest examples of painted mediaeval allegory we
have (Pl. 63). Programmatic and didactic, they still sing from the wall of
the Sala dei Nove as a lyrical sequence of images, stately, serious, but
beguiling none the less.[22] Significantly, these three wall paintings were
commissioned by the Commune, not the Church, and set up in a town
hall, not a sacred place, thus becoming one of the few secular interpre-
tations of the redemptive Christian schema to survive.

The allegory is elaborate, and mingles anecdotal and observed scenes
with personified virtues and vices, though these are marked out from
the denizens of Siena themselves - the citizens, soldiers, malefactors - by
their monumental size and still postures. On one wall, now severely
damaged, the painter warns against Bad Government and its conse-
quences: famine, war, unemployed skills, unharvested gifts. On the other
wall, opposite, *The Effects of Good Government* are painted in glimpses
and vignettes, against a rendering of Trecento Siena itself, and set in one
of the most tranquil and blooming early landscape paintings of Italian
art. A ring of young women dance to a tambourine, builders tile a roof,

cobblers cut out shoe patterns, a man reads, another group ride out hawking. However removed from the reality Siena was experiencing at the harsh beginning of the fourteenth century, Ambrogio Lorenzetti created a dream of well-being that is as captivating today as it was then.

The principal allegory, which occupies the main wall, mediates between the frescoes of Good and Bad Government's effects on either side. It shows the Commune of Siena itself, personified as a wise ruler resembling biblical illuminations of Solomon, and dressed in the black and white of the Balzana, the Sienese Commune's flag. The political Virtues – Justice and Fortitude – are seated on either side of him, while Faith, Hope and Charity fly above his head. The normal four Cardinal Virtues have been increased to six, by the pleasant inclusion of Magnanimity and Peace. In shining raiment with a garland of olive, reclining on cushions in contrast to the others' upright posture, Peace tramples armour and weapons with her bare feet. Fortitude is armed with sword and shield, as is usual, and so is Justice, on the Commune's far left. On her right knee, under the hilt of her upraised sword, the beheaded trophy of a tyrant lies. We know he is a tyrant because she holds his toppled crown on her lap, and as she is labelled Justice, her act was *ipso facto* righteous. Also, as we shall see, Justice is often defined by her victims' overthrow. Peace's expression is alert, in spite of the relaxation of her pose. She occupies the centre of Lorenzetti's composition, to the Commune's right, and beyond her, set apart from the dais, where she and her sister Virtues preside, another personification of Justice sits enthroned.

She is not quite as titanic in proportion as the Commune figure, but balances him all the same in her powerful isolation on the left of the fresco. Like him, she is gem-studded and the back of her throne is splendidly draped in gold embroidered stuff. She glances up to heaven towards Sapientia or Wisdom who hovers overhead; and she places her thumbs evenly in the pans of the golden scales suspended from Wisdom's right hand. On one side a red angel is beheading a miscreant, while another kneels and receives a crown. This, the partly defaced inscription tells us, is 'Distributive Justice'; on the other pan, an angel in white presents one man with a spear, another with money. This is 'Commutative Justice'. Both are expressions taken from Aquinas' commentary on Aristotle, one of the many sources for Lorenzetti's complex allegory. Beneath Justice in scarlet and gold sits Concordia in a pale rose tunic, with a carpenter's plane on her knees; she is holding threads in her right hand which have passed from Wisdom, through Justice's scales, and she hands them to the Sienese represented by her side, as a symbol of the unity of the city-state. The inscription to the whole painting begins:

Questa santa virtù là dove regge
Induce ad unità li animi molti.
(This holy virtue, where she reigns, brings
many minds to unity.)[23]

Lorenzetti redeems the overt propaganda of his allegory by the gravity
and decorum of the twenty-four citizens, who walk towards the figure
of the Commune like the blessed in images of the Last Judgement, and
by the pervasive atmosphere of idealism that animates his vision.
Although the Virtues' stance is hieratic, their immobility an effect of
their abiding eternally in the empyrean of fixed forms, they also take up
the positions of women in the diurnal here and now which was lived by
Lorenzetti and his contemporaries, for they resemble closely the seated
courtly ladies who attend to their champions in tournaments taking place
below their dais.[24]

But the events in the political life of a nation or a city can only be read
hazardously from its imagery, and Lorenzetti's chronicle of reality was
indeed selective: his dramatic allegory of Sienese justice speaks to us only
in muffled tones of the conditions in his city. For the penalties of me-
diaeval justice were varied and cruel; in the fresco on the effects of good
government, Lorenzetti included one allegorical figure, whom he calls
Securitas, and who flies over the whole peaceful happy scene with a
grim attribute, a gibbet, from which a culprit swings, to remind the
fourteenth-century viewer of the dangers of transgression, and of the
human justice which both anticipated and mirrored the divine version.
Rosemond Tuve, the great scholar of mediaeval allegory, has put the
case for this unfashionable, difficult iconographic genre persuasively:
'Men were interested not only in the tempted and struggling mind, but
in the precise nature of great and important quiddities.... A great
attraction of images of this kind is that they are interesting. They can be
moving, but are often not so; they do not typically vivify; they rather
think something out in front of us.'[25] Lorenzetti, of the many early
Renaissance artists who attempted large-scale instructive programmes,
comes the nearest to stirring us to pity, to fear, to pleasure, as he thinks
out in front of us the hoped-for interdependence, in an equilibrium as
fine as in an orrery, between the wisdom and justice of God and his
interpreters and ministers in the State.

The economy of salvation and God's unfathomable providence were
also dramatized in mediaeval morality plays; Justice participated fre-
quently in the tribunal where the fate of a single human soul was
debated. In a French *Mystère de la Passion*, of around 1410, attributed to

Eustache Mercadé, man is on trial at the parliament of heaven before the judgement seat of God. Justice stands on his right and opposes man's advocates, Mercy, Truth, Charity and Wisdom. The phases of Christ's story then unfold, culminating in his death, resurrection and ascension. Only then, through Christ's intercession, can the Virtues embrace Justice, when man's salvation is assured.[26] Other versions of the Virtues' reconciliation, inspired by Psalm 85: 'Mercy and truth are met together; righteousness ['iustitia' in the Vulgate] and peace have kissed each other' (Psalm 85:10), appear in many mediaeval writers' meditations on divine justice and the redemption, like the long English morality play, *The Castle of Perseverance* (c.1425) amongst others.[27] The allegory inspired one of the magnificent tapestries, woven c. 1500, in the *Deadly Sins* cycle at Hampton Court. In this sequence of scenes we see the Vices, Lust and Gluttony, represented as worldly young women, overwhelming Homo, Man; Justice rushes him with drawn sword but is caught in time by Mercy; he escapes the sword, and is himself armed by the Grace of God and Peace, who give him breastplate and helmet.[28]

Lorenzetti suppressed the shortcomings of human agency in his idyllic dream of the Sienese Republic; such dramas as *Le Mystère de la Passion* gave solace in the face of God's incomprehensible purpose. But as the humanist recognition of human autonomy grew, with all its understanding of weakness and limits, and as the mystery of evil in the divinely ordained universe remained, the imagery of ideal Justice reflected the strains and contradictions. By the sixteenth century, fewer people wrote about or painted the kiss of Mercy and Justice before the infallible court of God than had in the fourteenth and early fifteenth centuries, while the court of man inspired an even darker vision.

In 1559, for instance, Peter Brueghel the Elder drew an allegory of Justice in a spirit of unsparing historical scrutiny as part of a set of eight Virtues (Pl. 54).[29] (He added Patience to the usual seven.) The engraving documents the torments of the accused in an unflinchingly matter-of-fact style, which effectively accentuates the appallingness of Justice's exactions. Justice stands in the centre, with her eyes bandaged to guarantee her impartiality, her scales in one hand, her unsheathed sword in the other, while all around her and in the background, miscreants are undergoing penalty: one man is tortured on the rack, another's right hand is chopped off, the horizon bristles with those deadly raised cartwheels and gibbets familiar from other paintings by Brueghel, on which crumpled and twisted bodies are hanging or exposed to die. Scholars have debated inconclusively what Brueghel's intention might have been: did

he mean to point to the injustice perpetrated in the name of justice? To the necessity of harsh measures? He wrote under the images, 'The aim of the law is either through punishment to correct him who is punished, or to improve the others by his example, or to protect the generality by overcoming the evil.'[30] Was this intended ironically? There is something bitter in mood about the detachment with which the artist has arranged the individual dramas, side by side, without special emphasis, and dispersed among the scenes of courtrooms and executions, bystanders and onlookers who show little involvement except attentiveness. This dispassion is strikingly different from traditional Netherlandish pity for the dying or dead Christ, or, in Brueghel's own engraving of the death of the Virgin, from the grief-stricken gestures of the apostles gathered by her bed, and it carries a meaning of its own. Do these impassive watchers stand condemned by the artist, or does he show us we must be stoic while we are being 'improved' by Justice's procedures? Yet the enigma Brueghel poses does not shatter the engraving's impact at all, but intensifies it, especially when we correlate the work with the times: the Netherlands were then dominated by Catholic Spain, who had reintroduced the Inquisition. The Dutch would rebel against their domination thirteen years after Brueghel's sequence of Virtues.

The dilemmas posed by the concept of justice itself, social, legal, divine, are so immense that representation often wavers before them. In an earnest conversation reported between Mantegna and another humanist by Battista Fiera in 1515, Mantegna admitted the formal difficulties, and referred to the authority of a learned monk: 'Speaking as a theologian, and the most serious and devout of men, he has always maintained that Justice cannot be depicted at all.' Mantegna's companion replied,

> And there he is certainly right. If all these different opinions of philosophers were so, I also agree with him. How can you represent Justice both with one eye and many eyes: and how can you depict her with one hand only, and yet measuring, and at the same time weighing, and simultaneously brandishing a sword? – unless, of course, they are all raving mad. Flatly, the thing can't be done.[31]

The two humanists' exasperation with the proliferating attributes of Justice, and the difficulty they demonstrate of finding an appropriate imagery for Justice's complex philosophical definitions helped to shift representations of the virtue from allegory towards typology, towards

the legends and true stories of individuals who had conducted themselves justly, or had dealt out justice to others. Of all the Christian virtues, Justice is the one who is most frequently brought before the eyes of the believer through the acts of real women, not through ideal ontological figures. Justice's exemplars merit special attention in a book about female personification, because they encompass life at an historical and a figural level at the same time, and relate the ideal to the actual.

One of the conventional ways of depicting justice was to show evil done to death, as in the Psychomachia; heroines who had overcome sin in one way or another became types of God's justice on earth. Their most common weapon in this struggle is a sword, and in this cluster of symbols, the battle, the heroine and sword, we can locate the significance the female form bears in the representation of virtue, and the important, even fatal changes that have overtaken it.

Justice's raised sword, in Brueghel's engraving, is an emblem, not a literal weapon; it compresses the argument that the Psychomachia topos deploys at length, that evil is being destroyed. The sword of justice belongs in the hands of saints from the Christian calendar who are dragon-slayers: like St Michael, who in the Apocalypse battles to over-come the great Dragon, the primaeval serpent, known as the devil 'Satan' (Rev. 12:9) and speeds him back down again to hell, or St George; it occurs in the grasp of female saints who have overcome evil by other means than its blade. Its presence, together with a wheel and sometimes a book, identifies St Catherine of Alexandria, who worsted the heathen emperor Maxentius and fifty of his most learned philo-sophers with her Christian wisdom, and after multiple horrors, including being broken on the wheel, was finally beheaded; St Margaret of An-tioch, who was swallowed by a dragon, as usual symbolic of the devil, but was too pure to digest, and so was vomited to safety, also appears armed. She too was martyred by beheading (decollation, in the liturgical phrase), and her attribute, together with the monster she defeated, is the sword. In the case of both these famed and much-loved saints of the mediaeval calendar, the sword recalls their death and their victory over evil both in life and in the manner of their death, with the kind of brilliant precision that visual metaphor can achieve. Both saints, like their male counterparts, the sauromachs Michael and George, trample underfoot the vanquished: in the chapel of the château of Châteaudun for instance, the fifteenth-century array of carved stone saints includes Mar-garet standing on a big dragon and Catherine on the dwarfish body of the emperor, whose large crowned and bearded head peeps out from under the point of her sword, a markedly, and intendedly brutal visage

compared to the Gothic delicacy and wistfulness of the saint's own features. The Emperor is almost always present in Catherine's votive images, especially those originating in France in the fifteenth and sixteenth centuries. Sprawling, prostrate, or even crouched like a double-jointed tumbler, Maxentius reminds us that evil is abroad and must be combated, for though crushed, he is still alive; the Psychomachia is a battle that we are always in the midst of fighting, or so these ciphers of the human condition tell us.[32]

The sword in these images does not unconsciously represent the usurped phallus, or the completion of the poor defective woman's body by the addition of a substitute penis in the form of a sword. It acts as the tool of separation, as the instrument which cleaves one into two, and it can thus symbolize generation, just as in ancient cosmogonies, including Genesis, Day separates from Night to produce the time in which we exist; Sky separates from Earth to produce the space in which again we move and have our being. The phallus today has absorbed into itself these meanings, but only today. Thought processes themselves, especially during the Aristotelian Christian centuries, were considered to achieve fine discriminations between one thing and another; Aquinas' *Summa*, constructed in question and answer form, represents a perfect model of a binary mode, dependent on sets of distinctions, descending one from another in a series of dyads, until a solution is generated and truth, as it were, comes into being; contemporary computer programming demands the same demarcated pairs of opposites deployed in prolonged concatenations until the result itself issues forth, a resolution of the series of conceptual separations. Justice's sword represents the ability of humanity to judge between one thing and another, to part right from wrong, truth from falsehood, yes from no; it does not often illustrate the weapon used by executioners during the time the images of Justice might have been made, except by coincidence, as in the Brueghel engraving's instance of a beheading. It was a cipher of a basic aspect of judgement, the drawing of distinctions. But it came to suggest, through the story of the virtuous heroine Judith, other personal meanings.

Eclipsing even such saints as Catherine and Margaret in popularity, the biblical heroine Judith represents, in both written and visual materials, the triumph of virtue and the justice of that victory. She appears in works by northern and Mediterranean artists, even though the Book of Judith, which tells her story, had been relegated to the Apocrypha in some Protestant translations of the Bible, and does not appear in the Authorized Version of the King James Bible at all. The Book of Judith appears in the Catholic Bible, at the end of the historical

books and before the Wisdom writings, between Tobit and Esther, with which it forms a distinct triptych.[33] Against a pseudo-authentic background in which geography, people and chronology are cavalierly jumbled, all three tales dramatize the workings of God's providence through unlikely individuals (a woman, a blind man), who turn their God-given gifts of beauty and courage to the destruction of enemies: in Tobit, Tobias, son of the blind Tobit, is led by an angel to meet Sarah, who has lost seven bridegrooms through the machinations of the demon Asmodeus; they are married, safely, and Tobit is restored to sight at the same time; in Esther, the eponymous heroine saves her people the Jews from massacre by the Persians, and reverses the situation, so that the Jews exterminate their enemies instead. Esther is a savage romance; so in many ways is Judith. Written in Palestine around the turn of the second century BC, it tells another story of a woman champion of her people, whose very name means 'Jewess'.

Judith is a young widow, and irreproachable: at her entrance into the book, she has mourned her husband Manasseh for three years and four months wearing nothing but sackcloth and weeds and never leaving the house. She has fasted too, continuously without break, except for certain feast-days. 'Now, she was very beautiful,' the writer adds, 'charming to see.' And rich too: 'Her husband Manasseh had left her gold and silver, menservants and maidservants, cattle and lands; and she lived among all her possessions without anyone finding a word to say against her.' (Jdt. 8: 7–8).

Bethulia, in Samaria, Manasseh's native town, and consequently Judith's home, has come under siege from the Assyrian general Holofernes, who wishes to starve the Samaritans into capitulation to his deified lord, Nebuchadnezzar, 'lord of the whole world' (Jdt. 6:4) and make them surrender both their political and religious identity as Israelites. As well as the harshness of the siege conditions, Bethulia is suffering from prolonged drought, and the elders of the town have decided to yield to the Assyrians in five days' time unless God intervenes to help them. Judith, hearing this news, summons two of the elders, and upbraids them for their cowardice and presumption in putting God's providence to the test; she tells them to help themselves by prayer, and that she has a secret plan.

She flings herself on the ground and covers her head with ashes, bares her breast like a mourner and prays long and ardently for the destruction of Israel's enemies and the victory of her God:

> By guile of my lips
> strike slave down with master,

and master with his servant.
Break their pride
by a woman's hand.

(Jdt. 9: 10–11)

She then collects herself together and prepares to strike her blow for her people. The text shifts from anthem to romance: images of luxury and pleasure begin and will continue to flow through the story until Holofernes lies dead. She goes down to the rooms she only uses on feast-days, and thus signals the beginning of the festive semblance she will assume to bring her ruse to its grim conclusion. She takes off her sackcloth and widow's weeds, then 'she washed all over, anointed herself with costly perfumes, dressed her hair, wrapped a turban round it and put on the dress she used to wear on joyful occasions when her husband Manasseh was alive' (Jdt. 10: 3). The wilful ironies do not end there: 'She put sandals on her feet, put on her necklaces, bracelets, rings, earrings and all her jewellery, and made herself beautiful enough to catch the eye of every man who saw her' (Jdt. 10: 4). She fills a bag with barley cakes and bread and dried fruit, and gives her maid a wineskin and flask of oil to carry as well.

As the elders marvel at her transformation, she leaves Bethulia and passes into the Assyrian lines. Challenged, she answers that she has defected, and wants to see the general Holofernes, to give him valuable information. Her beauty astonishes the soldiers, and they tell her the way to Holofernes' tent. Their remarks, and those of the crowd round Holofernes' quarters, flatter Israel itself through flattery of Judith's powers: 'Who could despise a people having women like this?' (Jdt. 10: 19). She embodies the nation, even to its enemies.

With Holofernes' appearance in the story, the atmosphere of voluptuousness intensifies. He is lying on his bed, 'under a canopy of purple and gold studded with emeralds and precious stones' (Jdt. 10: 21). When he leaves his bed to come out to see Judith, he is preceded by silver torches. She falls to her face on the ground before him, completing the first stage of her masquerade; his servants raise her up.

She says she will not lie to him, and that she pledges herself to Nebuchadnezzar; she flatters Holofernes fulsomely: 'You have no rival for ability, wealth of experience, and brilliance in waging war' (Jdt. 11: 8–9). Her (virtuous) duplicities know no limits: she seems to betray her people, and at the same time veils her speech in dark ironies only the reader understands. 'God has sent me to do things with you at which the world will be astonished' (Jdt. 11: 16), she tells him.

Holofernes is befuddled by her clever talk and her loveliness, and invites her to eat and drink with him, off his silver dishes. She says she must keep to her own dietary laws, and eats her own food; he gives her a tent nearby. Three days pass, and then Holofernes invites Judith to a banquet; she comes, arrayed in all her 'feminine adornments' and, making more graceful speeches, takes her place in front of him on a fleece she has been given by Holofernes' henchman. 'The heart of Holofernes was ravished at the sight; his very soul was stirred. He was seized with a violent desire to sleep with her; and indeed since the first day he saw her, he had been waiting for an opportunity to seduce her' (Jdt. 12: 16). Holofernes begins to drink, watched by Judith sitting opposite him, until he collapses 'wine-sodden on his bed', alone in his tent with her (Jdt. 13: 2). She tells her maid to go out for a moment, prays for strength, takes down Holofernes' own scimitar from the bedpost, 'caught him by the hair and said, "make me strong today, Lord God of Israel!"' (Jdt. 13: 8). She strikes at the nape of his neck twice and cuts off his head. She tears down the canopy, the badge of his voluptuary's life, and then puts his head in her maid's bag, where once the ritually prepared foods were placed, thus symbolizing the trophy's equivalence to the survival of Israel's law. With her maid, she makes her way out of the Assyrian camp, past the guards who, through her cunning, are already used to seeing her leave to pray each morning. Safely in Bethulia again, she raises her voice and shouts 'Praise God! Praise him!', reveals Holofernes' head, and cries again, 'The Lord has struck him down by the hand of a woman!' (Jdt. 13: 16). The writer is careful to make plain nothing untoward has occurred, for Judith continues, 'My face seduced him, only to his own undoing; he committed no sin with me to shame me or disgrace me' (Jdt. 13: 16).

In the Assyrian camp, the sight of Holofernes' head, raised on the battlements of Bethulia, arouses panic; and when his body is discovered, the army is plunged into despair, and it scatters, pursued by the Israelite army. The Assyrians are massacred. Judith is praised as the deliverer of her people, and given the riches of Holofernes as her booty; in her ecstatic paean she and 'the whole people' recapitulate the story (Jdt. 15: 14).

Judith never marries again, the book tells us, in spite of many suits for her hand; in the Vulgate version by St Jerome, there is a passage that makes her virtuousness even clearer. Judith is extolled here, 'since you have behaved like a man, your heart was strengthened, because you loved chastity and have known no other man since your husband'.[34] Jerome was using a corrupt Latin text, which has since disappeared, for

his translation; this verse, turning on the equation of manliness–chastity–virtue axiomatic in so much early Christian asceticism, matches Jerome's expressed opinion elsewhere, and might well represent an attempt to allay the fears Judith's methods inspired.

Judith was propounded in the Middle Ages as a forerunner of the Mother of God, peculiar as that may seem. In the fourteenth-century *Speculum Humanae Salvationis*, the Mirror of Man's Salvation, Judith and Mary appear side by side. On the right Judith severs Holofernes' head, as he lies tucked up in his pavilion; on the left, Mary, carrying the column, scourge, cross and other symbols of Christ her son's Passion, spears a bound devil with her lance through its mouth.[35] Judith's deed foreshadowed, the moral proclaims, Mary's defeat of Satan by her consent to bring the incarnate Redeemer into the world.[36]

This typological textbook was eclectic in its choice of material. Judith is followed by Jael, who struck a tent-peg through the head of Sisera (Judg. 4: 17-22, 5: 24-27) and also thereby prefigured Mary who

> with the naile of the crosse
> has striken through oure enemy.

It includes Tomyris too, the Queen of the Massagetae, who in Herodotus' *Histories* sought out the body of Cyrus her enemy where he had fallen on the battlefield and then 'pushed his head into a skin which she had filled with human blood', crying out, ' "Though I have conquered you and live, yet you have ruined me by treacherously taking my son. See now – I fulfil my threat: you have your fill of blood." '[37]

The *Speculum*'s author was not put off by the bloodthirstiness of the Queen's ritual outrage; Tomyris, too, prefigures Mary, through a recondite comparison between the blood shed in the Passion to quench the devil's thirst and the blood in which Tomyris steeped Cyrus after his destruction.[38] Jael and Tomyris were often included among the Neuf Preuses, or Nine Female Worthies, whose cult reached its apogee in the fifteenth century, as counterparts of the popular heroes, the nine male Worthies. The more festive the occasion for their appearance the more attenuated became the heroines' connection with the Christian mysteries of the New Testament. Joan of Arc, when she suddenly flashed across the troubled scene in 1429 and secured the freedom of Orleans from the English besiegers, was hailed explicitly by her contemporary, the historian, feminist and poet Christine de Pizan, as a fine successor to the valiant Preuses. She compares her to Esther, Judith, Deborah, 'ladies of great price – Through them God restored his people, who had been hard pressed. And I have heard of many others too, valiant ladies every

one ... but through this Maid he has done more.'[39] Joan of Arc, an armed maiden within historical memory, was painted standing beside Judith, in a miniature to the manuscript of *Le Champion des dames* by Martin Le Franc, only thirty-seven years after her death, and became thus a type of the miraculous liberator, like the Virgin in the early *Speculum Humanae Salvationis*.[40]

Patterning memories until past and present were woven seamlessly into a repeat, Christian typology preferred to see likenesses rather than differences. But of all the Famous Women in the Middle Ages, none is familiar today, in spite of aroused historical awareness of women's achievements, except Judith. Again, the association of chastity with a female figure has assisted her survival, however problematic Judith's character may seem. Her figure came to be recognized as an exemplar because, again like Athena and Nike, she was ostensibly above suspicion, especially sexual. Her story warns above all against the dangers of lust. Holofernes, with his jewels and pillows, his wine and sexual appetite, is identified with sin, and Judith with Chastity as well as Justice; in Frère Lorens' *Somme-le-roy*, the popular moral treatise on the behaviour of princes, which was translated by Caxton, Judith and Holofernes illustrate the victory of virtue over lasciviousness, and appear, in one manuscript illumination at least, beside a picture of Joseph resisting the seductions of Potiphar's wife (Gen. 39: 7-8).[41] The frame of deceit Judith set up as a snare for Holofernes in order to deliver her people becomes a positive act of continence; his unchastity, however provoked by her blandishments, defines her chastity. This analysis of Judith's tyrannicide as an aspect of her sexual restraint is typical of reductive thinking about women; but the story's atmosphere of voluptuousness and its moral, however strained, justify it and the theme continued to be developed in the Renaissance.

Donatello, for the sublime bronze Judith in Florence, chooses the moment just before the assassination (Pl. 53). The huge, half-naked body of Holofernes lolls, but the young woman, smaller and neatly wrapped, pins his hand under her foot and seizing him by the hair, raises her scimitar. Cosimo de' Medici, who commissioned the sculpture, and set it up in the courtyard of his palace, had inscribed on it a couplet by his son Piero. It proclaims that the statue stands as a warning, to princes and citizens alike, of the dangers of Luxuria or Lust:

> Kingdoms fall through licence; cities rise through virtues;
> You see the proud neck struck by a humble hand.
> (Regna cadunt luxu, surgunt virtutibus urbes;
> Caesa vides humili colla superba manu.)[42]

Adrian Stokes evoked Judith's grim dedication to her task:

> ... beneath the enormous pile of the Palazzo Vecchio, without shelter, stronger, even in the distance, than the great wall of building, a metal point of lightning amid the circumambient marbles - and you see ... this Helleno-Gothic Fury, this anima of the lean Umbrian eagle, austere and powerful, peaked.

But not everyone responded with an easy mind to the exemplum. When a public hearing was held in Florence in 1503/4 to discuss the site for Michelangelo's *David*, one speaker suggested that the new statue should take Judith's place in the square: 'because the *Judith* is an emblem of death (*segno mortifero*), and it is not fitting for the Republic - ... and I say it is not fitting that the woman should kill the man'. And he went on to blame the Florentine defeat at Pisa on Judith's 'evil star'.[43]

Besides Donatello's group, Mantegna's interpretation, in the National Gallery of Art, Washington, is one of the few post-1400 images which in their structure avoid immediate associations with that other biblical figure who brings about a man's death through her charms: Salome. Mantegna's Judith stands at the parted crimson curtains of Holofernes' tent, where a single foot is visible at the end of a gilded bedstead - an almost surrealist touch. The heroine averts her face as she holds the bleeding head over the bag her servant is opening to receive it. The story is told with circumstantial detail, the mood filled with *gravitas*, the eyes of both figures do not seek ours, nor do they make contact with each other or with the trophy in Judith's hands. Looking away, they take responsibility in a spirit of decorum. Donatello's heroine also grieves; neither does she show relish in her task.

But what is glaringly perverse about the Book of Judith is that its heroine is cast as a biblical wanton, and this was not missed by later artists. Retellings of the stories of Salome and of Delilah reveal the similar structure of these tales about women's powers and the exploits of Judith. Jerome conferred mannishness on Judith in order perhaps to counterbalance the profusion of 'feminine' sense impressions in the story, the jewels, the fleece, the wine, oil, cakes, rich dresses, accoutrements which also find a place in the horror story of Jezebel, for instance, that 'cursed' woman, who also adorned herself and showed herself to a king - Jehu - who was her enemy, in order to placate or neutralize him.

In the famous words of the King James Version: 'She painted her face,

and tired her head, and looked out at a window' (2 Kgs 9: 30). Jezebel is thrown down by her eunuchs from that window, to be trodden by the horses of Jehu and eaten by dogs, a fate few people reading the Bible have questioned morally. The Bible condemns coquetting; as well as that guile Judith uses when she woos Holofernes' trust. The Book of Proverbs warns against harlots' wiles:

> the lips of this alien drip with honey,
> her words are smoother than oil,
> but their outcome is bitter as wormwood,
> sharp as a two-edged sword.
>
> (Prov. 5: 3-4)

But Holofernes, the Assyrian pagan, clearly had not read the Bible.

In the sixteenth and seventeenth centuries, there are numberless versions of Judiths who look like Salomes holding the head of John the Baptist. Yet the story of Salome inverts the moral of Judith: Salome brings the lustful and the wicked to a (momentary) victory, when at the request of Herod she dances at his birthday banquet and is promised anything she asks. At the urging of Herodias, her mother and Herod's new wife, Salome asks for the head of John the Baptist, 'here, on a dish'. Herod was 'distressed', writes Matthew, but he had given his word to Salome, and so John the Baptist was duly beheaded, and his head brought to Salome, who gave it to her mother (Matt. 14: 1-11). John the Baptist had aroused Herodias' fury because he had denounced her remarriage to her first husband's brother as unlawful; in this case, the champion of chastity is destroyed by the perpetrators of licence, epitomized by the dance of Salome.

Salome's painted emotions fluctuate between languor, regret and solemn meditation on her deed; her story warns against the power women unconsciously possess and exercise to destroy men far greater and stronger than they, the power of their bodies to undo and contaminate. The theme has inspired some sobering paintings on the tragedy of misplaced desire: Titian's loving version of around 1515, all the more troubling for its tranquillity; Rubens' richly circumstantial interpretation, flaming in scarlet and crimson; Caravaggio's tragic meditation.[44]

In many of the treatments, Salome's voluptuous connection with the dead prophet is communicated by her eyes. She looks at the head she has brought to this condition,[45] (in Wilde's notorious poetic drama of 1893, contact is not limited to eyes) or, sometimes, it is our eyes she seeks, drawing us into complicity, either as victims of her charms, or

sharers of them, depending on our sex. Salome makes it impossible for us to forget the dangers of female sexuality.

And so does Judith; the similarity between them, at opposite ends of the moral pole, frequently inspired painters to depict Judith as a wanton. Judith's body, chastely covered in the painting by Mantegna or the bronze by Donatello, discovers twists and curves, rich disarray and cushiony settings which should properly characterize Holofernes' or Lust's domain;[46] her eyes seek out the glance of the dead tyrant with varying and conflicting emotions, very like Salome's mixed expression. Or they look out boldly at us, taking responsibility for the bloody head she holds in her hand. Circumstantial narrative elements fade: the maid, in a fluid drawing by Giuliano da Sangallo (d. 1516) from the Albertina in Vienna, stands literally pale and incomplete beside the erotically revealed body of her mistress, who gazes almost imploringly at the noble head she holds up in her hand. The tent, the camp, the besieged Israelites disappear from iconic renderings of the theme, in which the destruction of Holofernes warns less against Lust than against women. Conrad Meit (1475 – c. 1545), in an unprecedented invention, stripped Judith altogether for his small painted alabaster sculpture now in the National Museum in Munich (Pl. 56). Holding her sword in one hand, she seems almost to pat the head of Holofernes gingerly with the other as, again, she contemplates her harvest. Although Adrian Stokes wrote that Donatello's sculpture was the precursor of a new way of looking ('It is a miracle, the Renaissance, Judith's scriptural fury shall animate the nude')[47], it is Conrad Meit, with his petite, painted, alabaster fetish, who divined, in another part of Europe at around the same time, the inner and enduring meaning of the heroine's ferocity, and fulfilled its sexual implications.

Eye contact with the viewer can produce an even more chilly *frisson*. Johann Liss's version, painted in the early seventeenth century, in the National Gallery, London, confronts us with a carefully structured surprise: the gushing trunk of the headless Holofernes is repeated by the lively head of Judith herself, who turns as if disturbed by us and throws us a hard, unabashed look. Christian painters also used the versatility they had acquired depicting the dying or dead Christ or saints' gory martyrdoms to render Holofernes agonistes. Few visitors could look upon his screaming head, in Carlo Saraceni's *Judith*, in the Kunsthistorisches Museum in Vienna, without experiencing *pietà*; or, in the same gallery, at Lucas Cranach the Elder's death's head held in place by Judith's gloved and bejewelled fingers, and not feel more sympathy for the victim than for the champion of Justice, Chastity, Courage, who with narrow, foxy eyes looks out at us under one of Cranach's charm-

ingly frivolous velvet plumed hats. Significantly, Cranach dressed his Judith in the same festive and expensive laced dresses as the three Princesses of Saxony in his 1530-5 portrait of them. The biblical story was reinterpreted here by Luther's friend and portraitist, to point an ancient moral as old as the story of Eve, that man still falls by woman's guile. And enjoys herself all the while - if the Saxony girls' close smiles mean anything. Perhaps the very nearness of the tale to more traditional views of women's dangerousness paradoxically helped make Judith acceptable as an exemplary figure; the moral about virtue triumphing through the hand of a woman could so easily be collapsed upon itself and taken the other way round.

When the sphere of moral debate involves sexual relations, as it often must, then the sword of discrimination, while it attempts to sever bad from good, finds that it proves unable to draw the distinction cleanly; incarnate in women's bodies, the virtues develop a fluid enigmatic character instead of discrete firm absoluteness; the inspirer of desire and the sinner through lust are not the same, but the concepts of sexual culpability and sexual pleasure are much too volatile to be caught in the dialectical confrontations of the Psychomachia motif, that virtues overcome vices and that ultimately both can be unambiguously recognized for what they are.

Judith shocks us, especially in the grisly and fiercely imagined images of the sixteenth and seventeenth centuries. But springing from the mind of a male painter, she seems inevitable, almost natural. We are accustomed to the fantasy of the armed maiden issuing from the head of her father.

But that shock redoubles in intensity, and what seems natural finds its true status as fantastic when the armed maiden issues from the head of her mother. When the spectator learns that the *Judith and Holofernes* of *c.* 1614-20 in the Uffizi is indeed by Artemisia Gentileschi, by a woman, the image's ferocity and mercilessness cause us to avert our eyes with a shudder (Pl. 58). Male praise for Judith's action, however ambiguously charged, seems legitimate because the victim is a man; the distance placed by Donatello between himself and Holofernes guarantees his impartiality; by accepting that the tyrant has been rightfully killed, the image-maker himself acts like a wise judge, ruling that the double inversion of natural law – the female champion, the good murder – is acceptable. But the dispassionate wisdom of the artist-as-judge evaporates if a woman is in question; we cannot help feeling she must see herself in Judith. And such identification is almost unbearable.

In Artemisia's version in the Uffizi, Holofernes, skilfully foreshort-

ened, struggles on the bed; blood trickles on his satin sheets as Judith, holding herself at arm's length from his terrible head, saws at his neck with her sword, its blade cleaving the painting itself almost exactly in two. Her maid is helping her hold down Holofernes, but he resists them both in agony. The expression on Judith's face, repelled and concentrated, contrasts piercingly with the passion of Holofernes in his death throes, and the emphasis of the painting strikes these faces, for they are lit from a hidden source at the side, and further defined by the simple tripartite colour, scarlet for the maid, cobalt for Judith, white for the bedclothes of the naked man. Caravaggio influenced the composition, lighting and the face of the heroine, but Artemisia's *Judith* is the more ferocious.

Artemisia Gentileschi's own story contains much cruelty and humiliation; like a poet more than a painter, she returned to its themes in her art, and with reason.[48] In 1611, when she was seventeen, she brought a case for rape against Agostino Tassi, a young painter who had been employed to teach her perspective. Her father, the painter Orazio Gentileschi, claimed that his 'property' had been damaged by her violation. She herself claimed that Tassi had forced her and then promised to marry her, and that after this betrothal, a customary contract in Italy at that time, she agreed to sleep with him. But he never married her, perhaps because he had a wife already. The circle of friends to whom Artemisia's own father had introduced her was so seamy that Tassi may even have earlier arranged his wife's murder. He and his friends claimed Artemisia was a prostitute; and at the trial Artemisia was tortured to change her evidence, and capitulate. After the thumbscrews were applied, she cried out to Tassi, 'This is the ring you give me, and these the promises!' Tassi was jailed, and after five months released; Artemisia later married a relation of the only one of her seducer's friends who had stood by her story.

Artemisia Gentileschi returned several times to the subject of Judith and Holofernes in her painting, and the Uffizi version, described above, is much the most gory of the group. It was the first she painted, soon after the trial and her marriage, in Florence, where she had moved no doubt to escape the surroundings of her early life. The punishment of lust here has a different quality; it turns Artemisia herself into judge and executioner. 'Artemisia did not choose to dwell upon her disappointment', comments Greer. 'She developed an ideal of heroic womanhood. She lived it, and she portrayed it.'[49] Artemisia's point of view, springing from her personal ordeal, changes the import of biblical figures like Judith. Artemisia coalesces allegory and reality; her heroine bears little

relation to the sermons of schoolmen on lasciviousness, or to the bloody dichotomies of Prudentius' moral epic. Her private wrongs pour into the public cipher of Justice's sword and make it sing out, not with the politeness of conventional allegory but with the passion of felt griefs.

Although the story of Judith from the Bible was predominantly a Catholic exemplum, its visual interpretations made a great impression on Victorian Englishmen travelling to Europe, and in the nineteenth century it underwent further metamorphoses at their hands. William Etty exhibited controversial treatments of the subject at the Royal Academy in 1827-31,[50] and Alfred Stevens, returning to work in his native country in 1842 after nine years spent studying the classical and High Renaissance art in Italy, was inspired by Judith, pre-eminent type of armed maiden, in his designs for the monument to the Duke of Wellington in St Paul's Cathedral, and especially in the two heroic sculpture groups which flank the baldaquin over the sarcophagus. (See Chapter 3.)[51]

One group shows Valour overwhelming Cowardice; the other Truth vanquishing Falsehood. The bronze tomb figures themselves are hard to see in the gloom of the cathedral's interior, but the full-size models in terracotta are displayed at floor level in the Victoria and Albert Museum. The two groups are very finely modelled. In both, a male ignudo, a homage to Michelangelo in style, represents the vice, though Michelangelo himself would not have reversed the Latin genders (Cowardice: Ignavia; Falsehood: Mendacitas, both feminine in gender; Valour, masculine). But Alfred Stevens was obeying the iconographical oppositions between Vice and Virtue mediated through mediaeval imagery of the Psychomachia and Renaissance celebrations of Judith, in which heroines were heroines and villains villains. Valour leans on a knotted club, once Hercules' emblem, and wears that hero's lion's mantle over head and shoulders; she leans her left knee and right foot on a circular shield under which the bound slave cowers; Truth braces herself against Falsehood's chest with one bare foot as she manipulates a pair of pliers and hauls out his tongue. Again, her regard, lowered on the wretch who writhes below her, is filled with that quiet, cold contemplation we have been accustomed to in imagery of Judith – and of Salome. Thus the Iron Duke came to rest under images fraught with repressed sensuality and the apprehension of its tragic possibilities.

Although Alfred Stevens' style owes most to Renaissance Italy, these two sculptural groups, modelled and cast between 1858 and 1875, mark the secular circulation and acceptance of an ancient Christian theme, in

its ancient Christian dress, trailing with it many assumptions and unex-
plained premises. And in so doing, it anticipates the interpretations that
prevailed by the turn of this century, when the weapon of the armed
maiden used man's erotic power against him and her act was not ac-
claimed as virtuous, but only inspired terror of this projected potency.
Gustav Klimt (d. 1918), painting at the turn of the century in Vienna,
turned the key of the Bible stories' erotic inner chamber, and painted
Judith and Salome as explicit counterparts of each other among the
sequence of undulating, dreamy, ravening females he created in jewelled
and enamelled bright hardness and ever-increasing masochistic sensuality
over twenty years.[52] His Judith of 1901, exposing her gauzy flesh rip-
pling lightly in blue-rose brushstrokes, has the face of one of the society
ladies whose portrait Klimt might have painted; her coiffure is contem-
porary, and she looks out at us with heavy-lidded eyes and parted lips.
A highlight of white paint gleams on her revealed front teeth. Holo-
fernes, with his eyes closed, echoes a number of dreaming, passive men
in Klimt's work, who submit to a fantasy of tentacular mermaid women
or predatory nymphets, as in the *Adam and Eve* of 1917-18 or the
phantasmagoria, unfinished, *Die Braut* (The Fiancée) of the same year,
also in Upper Belvedere Gallery in Vienna.

Klimt's *Salome* of 1909 even bears the alternative title *Judith II*. His
subject's prehensile hands claw at her own body, at the level of her
groin, as she cranes forward, offering mouth and breasts.[53] And it was
Klimt's genius that fused the twentieth-century themes of justice and
repression in his proposal for the mural *Jurisprudence* for the University
of Vienna of 1903-7.[54] The sword of Justice severs good from evil
according to the human desire for order; the scimitar of Judith over-
comes the turbulent desires of the flesh, by unbending chastity, according
to Christian idealism, and the phallic mother subdues incestuous desire,
according to Freudian analysis, so that the boy child's super-ego can be
constructed. In Klimt's painting, a granite-faced Justice, with Truth on
her right and Law on her left, presides, erect, glamorous and infinitely
remote, in a stony and gleaming stratosphere, while the law's victim,
naked and withered, with his eyes bound for execution, bows his
head weakly as a giant polyp coils around him. Three of Klimt's
watersnake-like damsels accept the tentacles' embraces and may even be
administering the penalty of this grotesque death. 'Not the idealized
figures above,' writes Carl Schorske in his masterly analysis, 'but these
snaky furies are the real "officers of the law".' Schorske goes on to show
how Klimt has turned upside down the triumph of reason and civiliza-
tion over instinct and barbarism that was for instance proclaimed by

Athena in Aeschylus' *Oresteia*. 'Klimt inverts this classic symbolism, restoring the Furies to their primal power, and showing that law has not mastered violence and cruelty but only screened and legitimized it.'[55] The anguish of Klimt's perception in *Jurisprudence* was personal, as Schorske also describes: Klimt's prophetic unfolding of the released unconscious and its ambiguity in the first two ceiling paintings for the university, *Philosophy* and *Medicine*, had so frightened official Vienna that the government had refused to confirm his appointment as Professor of Fine Arts. Subsequently, the law came to seem to Klimt a perpetrator of injustice; but what remains consistent with earlier treatments of Justice and Judith, the just heroine, is that bisection and defeat still provide the structure for his revolutionary and tormented interpretation. The culprit's dark world contrasts with the law-givers' bright world above; his surroundings curve and change, while they inhabit planar geometric shapes. In Klimt's hands, the exhausted, simplistic language of dialectical pairs crackles and hisses again with savage energy.

But after the First World War, the Symbolists' total immersion in this fantasy equivalence of death and sex, decapitation and depletion had become a cliché, and could be mocked. A light-hearted image, like the photographer Olga Wlassics' collage of 1930, shows a new Judith, disrobed except for a shiny scimitar, with the death's heads of shop window mannequins at her feet. Many of them are grinning and rolling their eyes (Pl. 57).[56]

The armed maiden has become a stock figure in popular imagery today; but her imperilling energy retains its impact. The comic-strip characters Wonder Woman (Diana Prince) or Barbarella, heroines like Princess Leia Organa of *Star Wars*, or Athena Adama of *Battlestar Galactica*, Princess Ardala of *Buck Rogers in the 25th Century*, Yeoman Rand of *Star Trek*, Leela of *Dr Who*, or Sheba from *Mission Galactica*, are principles of virtue in science fiction films and television serials, and in almost all cases, as their Amazonian nomenclature implies, they are warriors in the cause of righteousness, their secondary sexual characteristics usually sheathed and shielded by breastplates, jockstraps, pelvic girdles.[57] Their wicked counterparts are sometimes also female, but lack their resonance. Little-known characters like 'sensuous' Princess Aura, the 'incredibly beautiful and mischievous daughter of Emperor Ming' from *Flash Gordon*'s 1980 remake, or 'Sinful Seductive Servalan' from *Blake's Seven* ('beautiful but cold-hearted ... typical streak of ruthlessness ... kills without compunction ...')[58] and the black queen from *Superman 2* and Mayday from *A View to a Kill* are also symbolically encased, in chitin-like carapaces, often black and impermeably glossy, to emphasize

their *terribilitas*. But they are few and far between and there are signifi-
cantly more male villains, from the fully armour-plated Darth Vader of
Star Wars to the blackly reptilian warlord of *Superman 2*, both of them
reflections of Tolkien's dark lords of evil. In the space fantasies consumed
by children and grown-ups today good girls far outnumber bad girls, as
they have consistently done since virtues and vices were first personified,
and the stories themselves are variations on the age-old Psychomachia
theme, magnifying the struggle in each human conscience into cosmic
proportions. In *Superman 3*, Superman even splits into two people,
one good and one evil, and they then smash at each other in a long
and bloody fight, like the battle for possession of the individual soul
in Prudentius' poem of 1,400 years earlier, or the angels and devils'
struggle over the sinner's deathbed in mediaeval morality plays. A
characteristic twentieth-century difference is that Superman is presented
as the hidden but authentic Clark Kent, and no longer brought into
play as a single aspect of the soul, with its multiple virtu-ality, as a
mediaeval writer would have admitted, or a contemporary psychologist
recognize.

The heroines' images reproduce audiences' fantasies, and flow back
into their imaginations, to inspire simulacra in the real world. Toyah
Willcox, the singer, has sometimes girt herself like a cross between an
American footballer and a samurai to sing out her images of unruly
potency: 'I Explode', 'Rebel Run', 'Martian Cowboy' are the Amazon-
ian titles of her songs, and in the video films released with her records,
she leaps, stamps, threatens and shows enough fighting spirit to take on
Darth Vaders in battalions. Kate Bush, another singer who metamorph-
oses from one persona to another, from bat to barbarian to angel in the
images she devises, chose for the cover of her 1984 video a clip of herself
fully armed, yelling and leaping into the air in a frenzy of power.
Refusing the ancient characterization of passive femininity, these per-
formers draw inspiration from the prevalent symbolism of armed
maidens, from their virtuality of positive action. And in so doing, they
release the trapped energy of the mode, and disclose its intrinsic ambi-
valence, the Salome inside the Judith, the disorderly woman inside the
virtuous freedom fighter. The rhetoric of justice tips over easily into the
dramatics of insubordination; the girl singers shriek or coo their anarchic
revolt using an old language of order's victory over chaos. As Natalie
Zemon Davis pointed out in her brilliant essay 'Women on Top',[59] the
World-Turned-Upside-Down carnivals of sixteenth-century Europe,
where women took charge for a single day of feasting and riot, inverted
morality and thereby defined it and confirmed it; but at the same time,

women were indeed on top for a space of time, and within that brief space they learned a new mode of acting and reacting, which was an experience liberating in itself. Within the phallic dialectic of conquest and battle, the Amazon, with her masculinized female appearance, effectively provides women today with freedom of speech.

The warriors of the Psychomachia become she-men through renouncing ascribed female identity (gentle and weak). Thereby they gain unwomanly powers. It is as if the capital of women's seductiveness, established by the twin myths of Pandora and Eve, as we shall see in Chapter 10, were converted into an equally valuable currency of moral authority; the dominion women's bodies can exercise, through the projected desire and fear of them flourishing in both Greek and Judaeo-Christian culture, slides from the dubious category of sexual conflict to the approved category of moral struggle. But the turbulence of sexuality cannot be stilled altogether, even by virgins' vows, and the stories of battles between the Virtues and Vices, or of champions of right, like Judith, beheading tyrants of evil like Holofernes, still drag with them a sexual cargo of longings and terrors. When we look at one of the many Renaissance interpretations of Judith with Holofernes' bloody head, we may know that she is the foremost biblical exemplar of Fortitude and Justice, the pattern of heroic virtue, but she looks like a killer all the same. The suffering head of her victim fills us with pity for ourselves, be we male or female. If we are men, Judith stirs fears of castration, and if we are women, she recalls the prescribed predicament that females are perpetually castrated and therefore castrators, seeking to make our own what we cannot have. For these are the cultural themes by which we live today, and we cannot escape outside our own cultural frame.

Pornography arms women and sheathes them too; implacable expressions and cruel gestures are its stock-in-trade. Male repression seeks an outlet in fantasies of phallic power that women are made to bear, reassuring the voyeur of his own potency, and confirming the rationale of his antagonism. Pornography fills up the subject body of the depicted woman with all the meanings of its consumers' antagonism and self-loathing, and it renders women complicit and even instrumental in the violence with which they are seen.

In the twenties, soon after Klimt's death, in the same city, Freud discovered penis envy as the feminine correlative of the masculine castration complex.[60] He thereby uncovered a fantasy. But the symbolic order possesses the power to generate reality. Penis envy has become a social phenomenon, visible in female fetishism. But it is not an innate and given law. As Lacan has pointed out, 'there is nothing missing in

the real', and a girl child can only perceive the absence of a penis if she
has already formed an idea that the body should have one.[61] We are
still trapped in the phallocentrism that Freud analysed and unfortunately
confirmed, conferring on it the status of revealed truth; the armed
maidens of righteousness, from allegorical Justice and Chastity to the
symbolic exemplars Judith, Tomyris and so forth, and their present day
dramatizers, like Siouxsie of the Banshees or Toyah Willcox, or the
body-builder Lisa Lyon, remain prisoners of the fantasy even in the
midst of trying to turn it upside down.[62]

Like the female swallowtail butterfly, who changes colour to imitate
the foul-tasting species her enemies would not care to eat, in order to
keep herself and her larvae safe, some of the women who cultivate a
ferocious, masculine aspect, brandish weapons and increase their
weight-lifting strength, may be practising a form of Batesian mimicry,
constructing themselves a persona according to the masculine code of
values in order to protect themselves from that code. But in the event,
they may also be falling into an evolutionary trap - for changes in
consciousness happen only a little less slowly than the slow march of
biological adaptation: the predators have begun to find the challenge of
their bitter taste desirable. The camouflage of self-protection can turn
into the colours of the mating dance, within terms of reference set by
the predators, not by friends or members of the swallowtail species itself.
Until those terms of reference are rejected and the metaphorical equations
between hardness and potency, explosion and energy are abandoned,
the phallus will remain the symbol of the triumph of the righteous over
the wicked, or, as in the Psychomachia, 'our' just victory over 'them'.

CHAPTER NINE

Lady Wisdom

And what is her *jouissance*, her *coming* from? It is clear that the essential testimony of the mystics is that they are experiencing it but know nothing about it.

These mystical ejaculations are neither idle gossip nor mere verbiage, in fact they are the best thing you can read.... What was tried at the end of the last century, at the time of Freud, by all kinds of worthy people in the circle of Charcot and the rest, was an attempt to reduce the mystical to questions of fucking. If you look carefully, that is not what it is all about.

JACQUES LACAN[1]

The Sapiential writings of the Old Testament furnish, from within the very heart of patriarchal monotheism's scripture, a body of erotic, feminine and mystical imagery that sets up marvellously reverberating contradictions in a text devoted to the supremacy of a Father God. For feminine nouns predominate in the evocation of divine aspects: *Hokhmah*, the wisdom of God, Sophia, Sapientia, *Ru'ach*, the spirit of God, and *Shekinah*, the shining immanence of God, which overshadows the Ark of the Covenant in Exodus 40: 34, sometimes lose in translation, as in Greek *pneuma* or Latin *spiritus*, the personal, female tenor of the original language.

Hokhmah, Wisdom, is an aspect of the demiurge, and when she speaks, the godhead appears as a separate female being:

> She is a breath of the power of God ... nothing impure can find a way into her. She is a reflection of the eternal light, untarnished mirror of God's active power, image of his goodness.
>
> (Book of Wisdom, 7: 25-6)

In Ecclesiasticus, Wisdom is God's attendant and agent, and the author gives her voice in poetry which beside the Song of Songs ranks with the most voluptuously beautiful in the Bible. She describes her own perfections:

From eternity, in the beginning, he created me,
 and for eternity I shall remain.
I ministered before him in the holy tabernacle,
 and thus was I established on Zion
I have grown tall as a cedar on Lebanon,
 as a cypress on Mount Hermon;
I have grown tall as a palm in Engedi,
 as the rose bushes of Jericho;
as a fine olive in the plain,
 as a plane tree I have grown tall.
I have exhaled a perfume like cinnamon and acacia,
 I have breathed out a scent like choice myrrh,
like galbanum, onycha and stacte,
 like the smoke of incense in the tabernacle.
I have spread my branches like a terebinth,
 and my branches are glorious and graceful.
I am like a vine putting out graceful shoots,
 my blossoms bear the fruit of glory and wealth.
 (Ecclus. 24: 3-18)

Writing in Egypt, around 190 BC, Ben Sira, or Siracides, the author
of Ecclesiasticus, displays the luxuriant imagery of growth and greenness
and scents characteristic of Alexandrian allegorizing mysticism[2] to create
a figure of Wisdom who, again like Athena, is daughter to the godhead
('he created me'), has no mother, waits upon him and does not jeopardize
her father's power ('I ministered before him'). He brings her to life in
a southern landscape, refracted through the light that makes the flowers
blossom and the fruits ripen and causes perfumed sap and oil to flow;
we of the north who read the text receive Wisdom's words as hot and
exotic, fragrant and spicy in ways to which we are not as accustomed as
the Egyptian milieu where the passage was born. But the fertility of the
imagery carries the same connotations, and Wisdom ends her praise song
by proffering herself to her votaries, as love both maternal and erotic:

Approach me, you who desire me,
 and take your fill of my fruits,
for memories of me are sweeter than honey.
 (Ecclus. 24: 19-20)

But the Wisdom writings of the Bible, while they softened and
stretched the vengeful disciplinarian God of Genesis and Exodus, did not
only strike notes of spiritual excitement and rhapsody. The purpose of
Ben Sira was practical. In spite of the intense, imagined sensuality of the

passage in which she speaks, Wisdom concludes by presenting herself as a moral preceptor, who will lead her followers to live a good life:

> Whoever listens to me will never have to blush,
> whoever acts as I dictate will never sin.
> All this is no other than the book of the covenant of the Most High God,
> the Law that Moses enjoined on us.
>
> (Ecclus. 24: 22–23)

It was passages like this, in which the lovely and inviting Hokhmah presents herself as the ethical guide of God's people, that helped later Christian exegetes to identify divine Wisdom with the Church founded by Jesus. Hokhmah/Sophia, characterized as the bride and spouse of the godhead ('She it was I loved and searched for in my youth; ... I fell in love with her beauty' [Wisd. 8: 2]), was conflated, in some of the earliest and most inspired allegorical interpretations of scripture, with the beloved and languishing Shulamite of the Song of Songs:

> You are wholly beautiful, my love,
> and without a blemish.
> (Song of Songs 4: 7)

From a key passage of the Book of Revelations which closes the New Testament, she was also perceived in the figure of the New Jerusalem, who comes down to the wedding feast of the Lamb 'like a bride dressed for her husband' (Rev. 12: 2), and is 'clothed with the sun, standing on the moon, and with the twelve stars on her head for a crown' (Rev. 12: 17). This apocalyptic bride, a figure of the saving Church, was to become a symbol of great moment, which throughout the mediaeval centuries could inspire meditations on the indwelling female wisdom of the godhead.[3]

Sometimes Jesus, as the Logos, the Word of God, was identified with the expression of divine Wisdom, and acquired feminine qualities through reverse-sex metaphors of startling resonance. St Anselm in the twelfth century and Dame Julian of Norwich in the fourteenth both create memorably personal prayers in which they invoke God as mother.[4] But inspired as their meditations are, they are not representative; in general, the figure of the bridal Wisdom of God, manifest in his Church, was developed by Christian mystics as a separate and distinct female figure, a power with whom, in differing but equally enriching ways, they could establish a personal, intense connection in order to reach closer to God himself.

While Sophia/Hokhmah, the beautiful bride, excited intense responses

in both men and women, male contemporaries show a greater need to give her an historical character and to purge the erotic force of the scriptural metaphors by imagining an unimpeachable object of their ardour. The incarnational tendency of Christian imagination led the greatest thinkers of the mediaeval Church, like St Bernard of Clairvaux (d. 1153), to identify their bride mother with a terrestrial individual, Mary the Mother of God, and to explore her prefigurement in the Wisdom texts.[5]

Mary's identification with Wisdom is very ancient. In the seventh century, the sensuous verses of Ecclesiasticus 24 had been included in the liturgy to celebrate all women who had consecrated themselves to God and withdrawn from the world. By the tenth century, the Wisdom texts of the Old Testament were also being read on Mary's feasts, and the passage from Ben Sira was included in the first cultic celebration of her, the Saturday Mass. For her Nativity on 8 September, also an early Marian feast, the same verses were read, alongside the opening of the Gospel of St John, thus associating the Word who existed from the beginning with his mother, who, like Wisdom, had also been created 'in the beginning'.[6] For a sermon on that day, St Peter Damian (d. 1072), one of Mary's early Western enthusiasts, took the biblical description of Solomon's throne, the Seat of Wisdom ('Sedes Sapientiae') (1 Kgs. 10: 18-20) and demonstrated its affinity to Mary's virtues: its ivory was white with the whiteness of her virginity, the twelve lions that stood on the throne's steps were the twelve apostles who gazed up at the mother of God in stupefaction, saying, from the Song of Songs,

> Who is this arising like the dawn,
> fair as the moon,
> resplendent as the sun,
> terrible as an army with banners?
> (Song of Songs, 6: 10)[7]

Mary still appears under her title Sedes Sapientiae over the Portail Royal at Chartres, where the child sits on his enthroned mother's knees, as the Logos issuing from Sophia.[8]

Realized figures of speech, exploring the mysteries of redemption through an array of female forms, including the Virgin but embracing a plurality of other figures too, afforded a special pleasure and opportunity to women. The web of allegorical imagery woven by the Wisdom texts offered metaphysical writers, like Hildegard of Bingen in the twelfth century and Hadewijch of Brabant in the thirteenth, a language with an even greater potential for subjective and strengthening subli-

mation than the contemplation of Mary's perfections provided their male counterparts.[9] Early female mystics did not focus on Mary, the maidenly, motherly and humble, with the intensity of their spiritual brothers; and although in their rhetoric they might deplore women's weakness and littleness, they do not justify their allegorical concept of female Wisdom by appealing to womanly qualities, as Guillaume de Conches did when he commented that Boethius' consoler Philosophia appeared to him *sub specie mulieris*, in the guise of a woman, because 'a woman softens the ferocities of the soul, nourishes children with her milk, and is better accustomed to taking care of the sick than men'.[10]

It is perhaps surprising that the cult of Mary is less marked in the texts of women writers of the Middle Ages, that the biblical passages which sustained her praises in the twelfth and thirteenth centuries were not always applied to her by nuns with the same effusions as they excited in monks. The asymmetry springs from the erotic character of the imagery: votaries' relationship to Sophia, to Holy Wisdom, was changed by the question of sex. In general, while a mystic like Bernard imagined the bride as the object of his love, his contemporary Hildegard identified herself with the symbol of transcendence itself, not with its worshippers.

In the Latin Vulgate, where 'Wisdom' is translated as 'Sapientia', it carries connotations of empirical knowledge as well as the mysticism implied by Sophia. Through these intellectual dimensions of the biblical figure, the schoolmen of the West had been able to annex pagan culture to Christian purpose. Alcuin, in the eighth century, interpreting the passage from Proverbs, 'Wisdom has built herself a house, she has erected her seven pillars' (Prov. 9: 1), identified her house as the house of learning and the pillars as the Seven Liberal Arts, the *trivium* and *quadrivium* classified by Boethius: the threefold way to eloquence (Rhetoric, Dialectic and Grammar) and the fourfold way to philosophy (rather less severe – Music, Arithmetic, Astronomy and Geometry). Albert the Great, applying the same text from Proverbs to the Virgin Mary, wrote that 'she possessed the seven liberal arts ... perfect mastery of science'.[11] Mother Church, assimilated to the figure of Wisdom, could permissibly be represented as the continuator of the classical tradition, the fountainhead of knowledge, practical and mystical, soteriological and historical, as well as the source of the Christian virtues; the biblical Sophia, and the community of the faithful in Holy Church, could absorb and repeat the lessons of the pagan Philosophia.[12]

On the Portail Royal of Chartres cathedral, on the archivolts framing the Virgin enthroned as the Seat of Wisdom, the Seven Liberal Arts appear to make a clear statement about the educational ideals of the

twelfth century. Beneath each personified Art, an exponent of genius practises the discipline of which she is the heavenly muse. Most of these great men are classical figures: Priscian for Grammar, Aristotle for Dialectic, Cicero for Rhetoric, Boethius for Arithmetic, Ptolemy for Astronomy, and possibly Euclid for Geometry and Pythagoras for Music.[13] But the female sculptures are strictly emblematic only in one case – Dialectic – who carries a flower and a dog-headed dragon to symbolize good and evil. Otherwise the Arts themselves also practise their skills; Grammar even appears with a raised birch in her hand to discipline the young curly-headed rascals who squat at her knees with their books (Pl. 35).

Female education was a possibility, within the clergy at least, and a learned nun, like the Saxon writer Hroswitha of Gandersheim in the tenth century (b. before 940, d. *c.* 1002), also seized on the opportunity the gendered name of Wisdom – Sapientia – offered. Although she often makes conventional apologies for her sex's failings, she translated her own Saxon name into Latin, calling herself 'Ego, clamor validus', 'I, the mighty voice [of Gandersheim]', and in the preface to her collection of plays stated clearly: '... my object being to glorify, within the limits of my poor talent, the laudable chastity of Christian virgins'.[14]

In the play, commonly called *Sapientia*, dramatizing the deaths of Faith, Hope and Charity, her daughters (as we saw in Chapter 4), the women are hypothetically historical characters, and at the same time they stand as emblematic exemplifications of their sex. When Sapientia is wooed by the pagan emperor Hadrian, who wants to deflect her from the true religion, he says to her, 'The splendour of your ancestry is blazoned in your face, and the wisdom of your name sparkles on your lips.' She confounds him and his ministers with her learning, displaying her mastery of Boethius' science of numbers, among other things. When Hadrian tries to force her and her daughters to worship Diana, they refuse, and Sapientia tells Faith, Hope and Charity, 'I nourished and cherished you, that I might wed you to a heavenly bridegroom.' Faith is then beaten horribly and her nipples are cut off. They spurt milk not blood, like Wisdom herself, who was often portrayed nourishing her followers like nurslings. Gruesome excesses are in store for Hope and then for Charity. After burying her children and praying over them, Sapientia dies as well, but of grief.[15]

Hroswitha, while composing Sapientia's display of erudition, necessarily displayed her own; also, when her sister nuns in the royal abbey of Gandersheim put on the plays, they enacted a community statement of the strength and fidelity of their sex. In another, longer, play, *The*

Passion of the Holy Maidens, Hroswitha effervescently abandons a high edifying tone and depicts the erring pagan protagonist, Dulcitius, Governor of Thessalonica, falling under an enchantment. Mistaking pots and pans for young girls, he kisses them with passion until he turns sooty black all over. Taken for the devil, he is then beaten up by his own soldiers. But even in this unusual example of a religious farce the undaunted trio of maidens bear allegorical names – Agape (Love), Chionia (Snow-white, the emblematic colour of purity) and Irene (Peace), and when the persecuting emperor Diocletian says to Agape, 'The pure and famous race to which you belong and your own rare beauty make it fitting you should be wedded to the highest in our court',[16] the audience of nuns at Gandersheim – and the performers – would have grasped the intended multiple *entendres*. The metaphor of marriage applies to the relation of Virtues like Love, Chastity and Peace to the Logos. They are the Word's bridal handmaidens, like the New Jerusalem, like the wise virgins who keep their lamps lit waiting for the bridegroom (Matt. 25: 1-13). Hroswitha's farce, influenced by the comedies of Terence to which she had access (she apologizes for their profanity), manages to combine effectively broad Roman humour with the metaphysical uses of feminine gender inspired by the Bible.[17]

The imagery was not confined to convents: courts adopted it as well. The poet Baudri de Bourgueil (d. 1130), hoping to find favour with Adela, Countess of Blois, and daughter of William the Conqueror, wrote her a long and learned ecphrasis about her bedchamber, which he called her *thalamus*, doubtlessly intending the nuptial overtones. He may have exaggerated its magnificence, and even invented its décor, for his poem records a kaleidoscopic and dreamlike accumulation of furnishings. But even as fantasy, it provides us with a description of how a worldly interior might be appointed at the orders of a woman towards the end of the eleventh century:

> Astiterat dictans operantibus ipsa puellis,
> Signaratque suo quid facerent radio.
> (She herself stood by directing the young women at work,
> and pointed out with her staff what they should do.)[18]

Tapestries showing the Creation, the Garden of Eden and the Flood covered one wall; another showed the siege of Troy and the foundation of Rome. But the *pièce de résistance*, according to Baudri, was the countess' bed. A woven picture of the battle of Hastings and her father's conquest of England hung at the head, the canopy above was worked with the signs of the zodiac, stars and planets, and around it stood three groups

of statues, representing Philosophia herself, with her seven disciples, the
Liberal Arts. Carved in ivory, Philosophy's breasts were flowing to
nourish her followers, and though she was 'full of days', like the pri-
mordial Church, she was also vigorous, beautiful and unbesmirched, like
the bride of the Song of Songs.[19]

A courtly flatterer, hoping for employment in the service of a learned
lady, thought that such allegorical figures were appropriate guardian
angels for her sleep.

Baudri's description sounds fantastic; it probably is. Yet in mediaeval
art, Wisdom, the maternal aspect of the godhead, frequently nurses her
adepts like a mother giving suck. She appears, convincingly majestic, in
Herrad's *Garden of Delights*, where the framing mandorla around Sapien-
tia distances her from the disciples who drink at the seven streams flow-
ing from her breasts.[20] But the visual arts can dramatize the figure of
speech to sometimes hyperbolic effect. When Mephistopheles promises
Faust –

> And thus each day will bring you greater zest
> To draw on wisdom's most beneficent breast[21]

– we do not recoil immediately at the incongruity as we do when
we contemplate a manuscript illumination in which Sophia nurses two
swarthy, bearded, grown men – Saints Peter and Paul – like babies at
her breast.[22]

A century after Hroswitha, near Wiesbaden on the Rhine, around the
same time as the mosaicist in St Mark's imagined the blessings of heaven
as dancing girls, the great seer Hildegard of Bingen (1098-1178) wrote
to a fellow abbess: 'The form of woman flashed and radiated in the
primordial root.... How so? ... both by being an artefact of the finger
of God and by her own sublime beauty. O how wondrous a being you
are, you who laid your foundations in the sun and who have overcome
the earth!'[23]

This wonderful being, the form of woman in the beginning, pre-
existent as idea in the mind of the Creator and issuing then from his
hand, gave Hildegard one of the potent, multilayered metaphors that
charge her many different writings. Again and again she returned to the
sublime beauty of woman as a symbol for human spiritual potential on
this earth; she mined both the allegorical tradition of meditating on
scripture, and of late classical philosophical texts, and in her hands alle-

gory became a living, personal form of speech, which still flies across the centuries to ring inspiringly for us today.

The twelfth century, when Hildegard was writing, marked a pinnacle of Christian humanism, celebrating every soul's potential in relation to a benevolent divine providence. It would never be achieved again so resplendently, not with Renaissance humanism, or romantic idealism; this early humanist vision was fixed on transcendence, while avoiding the damaging dualism that rejects the world as corrupt. In the sculpture programmes, stained glass and soaring arches of Chartres, in the mosaics of St Mark's, and in long, densely patterned texts like Alain de Lille's *Anti-Claudianus*, or *The Rejoinder to Claudian on the Ideal Man*, there exists a dynamic affirmation of this world, with all its weaknesses, flaws and lapses, as nevertheless ordered radiantly and beautifully by its maker.

In Alain's poem, the paragon hero, Iuvenis or the Youth, is fashioned by Nature and Wisdom working in partnership, while the Senses and the Virtues, all personified as graceful and maidenly forms, minister and assist his creation, until he is born, the perfect and equally balanced amalgam of matter and spirit.[24] Hildegard's writings are also representative of her time, in their use of allegory, their close acquaintance with scripture, their frank acceptance of the dignity of the created world, and their ability to take wing up to lofty banks of metaphysical cumulus; but she possesses a unique vision too, and, with regard to the uses of the allegorical female form, she is a major writer who continually reaches within these conventional confines a personal and private place.

The song she wrote to St Ursula opens with an invocation of the Church.[25] 'O Ecclesia' sing the two female voices, blended together to praise the beauty of the institute to which they belonged. Hildegard composed her music for her sister nuns in the convent of Rupertsberg which she had founded, and where she lived, wrote and composed, until her death. Their Church has eyes like sapphires, and ears 'as the mountain of Bethel' and a nose 'as a mountain of myrrh and incense'. And her mouth is *quasi sonus aquarum* (like the sound of many waters). The sound of the rapidly ascending and descending voices in the recent recording directed by the musicologist Christopher Page resembles the sound of many waters too. With her music, Hildegard intended to praise the divine life, both outside her convent and within it, and she did so through the lips of her sisters, and the language of oneiric nuptial mysticism taken from the Bible: sapphires stud the throne of the son of man in Ezekiel's vision; Bethel is the name Jacob gave the land Yahweh granted him in his dream (Gen. 28: 10–19); myrrh and incense perfume the lover's chamber in the Song of Songs.

The song then tells how Ursula longs to reject the world and join the son of God, *pulcherrimum iuvenem*, 'a most beautiful youth', in a theogamy, a sacred marriage. As the voices sing, they reveal to us how profoundly Hildegard identified herself with Ursula, an English princess of the fourth century who was a beloved saint in Germany. Her story survives in two mediaeval Passions.[26] Betrothed against her will to a pagan, Ursula travelled to Rome on a three-year pilgrimage in order to delay the unlooked-for union. But on her return she disembarked at Cologne, and there, along with eleven thousand virgins of her sisterhood, she was cruelly martyred.[27] Some of their relics were kept in the convent of Disibodenburg, on the Rhine, which Hildegard had first entered at the age of eight. Hildegard's contemporary, Elisabeth of Schönau, had received many revelations of Ursula and her companions, in 1156-7, and Hildegard, though she shows no direct influence of Elisabeth's visions, felt sympathy and corresponded with this other German mystic who, like her, had renounced the world and lived in a fellowship of women.[28]

Like Ursula, Hildegard was nobly born, if not a princess; like Ursula she had decided never to marry; like Ursula, Hildegard first received visions when she was only five, but kept her experiences to herself. In the song, when the young saint Ursula's longing to marry only her beloved Jesus becomes known, people mock her, as they had scorned the child Hildegard, inspiring her to keep silent about her own similar desires:

> Innocentia puellaris ignorantis
> nescit quid dicit.
>
> (What simple, girlish ignorance!
> She does not know what she is saying.)[29]

Ursula is then troubled, by an *ignea sarcina*, 'a burden of fire', like Hildegard again, who is perhaps referring here to her own experience, her gift of prophecy. For the young girl's 'burden of fire' recalls Hildegard's account of her own visionary ordeal, described at the beginning of *Scivias* (*Know the Ways of the Lord*), her autobiography:

A fiery light, coming with a great blaze out of a clear sky, transfused my whole brain, and my whole heart and my whole breast. It was like a flame but it did not however burn me, but warmed me as it set me alight in the same way as the sun heats anything on which it sheds its rays.[30]

And when Hildegard appears in her own manuscript, in one of the miniatures, tongues of fire are descending on her head, like the flames

of Pentecost that gave the apostles the powers of prophecy (Acts 1: 3-5).[31] (Pl. 61.)

After Ursula experiences the fire in the song, people recognize her holy vocation and allow her to leave: 'Scorn of the world/is like the mount of Bethel' it continues.[32] So the mount which in the first verse was likened to the ears of the Church reappears here, as a simile for the cloister; Ursula - Hildegard and her sisters' counterpart in turning her back on the world - becomes a type of the Church. In the song's beautiful concluding verse, sung in unison, Hildegard creates, in only a dozen words, a dazzlingly compressed epiphany of the mediaeval doctrine that God's virgins, pearly in their unspotted purity, will triumph over evil:

> quia guttur serpentis antiqui
> in istis margaritis
> materie verbi Dei
> suffocatum est.

> (for the throat of the ancient serpent
> has been choked
> with these pearls
> which are the stuff of the Word of
> God.)[33]

She there combines with consummate skill scriptural allusions to the wedding feast of the Lamb from the Apocalypse, where virgins stand by the side of Jesus, with a daring claim that virginity is consubstantial with the godhead, and a reminder of God's promise in the Garden of Eden that the serpent will be crushed by a woman, as in the flawed translation of the Vulgate (Gen. 3: 15).

Hildegard of Bingen was born in the Rhineland in 1098, the last of ten children. After entering the convent of the Disibodenburg, she came under the protection of the abbess, Jutta of Sponheim, who became the child's beloved foster-mother and teacher. Thirty-one years later, in 1137, Hildegard succeeded Jutta as abbess, but in 1150 she divided the community, taking with her a small band of sisters, and founded another convent, on the Rupertsberg not far away. She was forty-three when she received the command to write down her revelations. Cloistered all her life, she saw herself as an autodidact, and throughout her wide-ranging works she alludes to herself as 'a poor little thing in woman's shape' (*paupercula feminea forma*) and resorts to recognizable feminine self-depreciation, which rings at the same time with pride and defiance.[34]

She also suffered from recurrent painful illness, which caused her bouts of blindness and long spells bedridden and hallucinated; but she distinguishes these afflictions carefully from her visions, which never caused her pain, or ecstasy, or even loss of consciousness; she did not sleep through them or fall into trance. 'Truly I saw the visions I saw,' she wrote. 'Watchful I received them, looking around with a pure mind and the eyes and ears of the inner man, in open places according to the will of God.'[35]

In the twelfth century, though it saw the founding of the Inquisition to combat the Albigensian heresy in the south of France, mystics who claimed direct communications from God did not suffer the persecutions and even death sentences of the visionaries of the late thirteenth and fourteenth centuries. They could cite biblical authority for their visions. In Joel, Yahweh specifically includes women in his promises:

> I will pour out my spirit on all mankind.
> Your sons and daughters shall prophesy,
> Your old men shall dream dreams,
> and your young men see visions.
> Even on the slaves, men and women,
> will I pour out my spirit.
>
> (Joel 3: 1–2; A V 2: 28–9)

But the writings of a mystic like Hildegard were submitted for scrutiny; and could be condemned. Her revelations were discussed, at the Synod of Trier (1147–8), by Pope Eugenius III, and he issued a qualified approval, perhaps at the urging of St Bernard of Clairvaux, the greatest metaphysician of a great age, and a political force to reckon with.[36]

Hildegard was able to continue, uncensored, with her own multifarious interests; she was a woman of remarkably wide-ranging curiosity and gifts. She completed three great volumes of visions before she died at the age of eighty-one; as well as composing songs and hymns, she created the first musical drama, the *Ordo Virtutum*, a sung contest between the devil and the Virtues for the possession of a single sinner, the *Felix Anima*, or happy soul.[37] She wrote scientific treatises on natural history, medicine, and was quite capable of discussing biological reproduction without evasion. In these works, the *Physica* and *Causae et Curae*, she studies the structure of minerals, the properties of plants, the types and character of animals, with a startlingly scientific materialism, radically different in tone from her spiritual revelations.[38]

She wrote commentaries on the Gospels, on the Athanasian Creed, and on the Rule of St Benedict, which she and her sister nuns followed.

She corresponded with popes, archbishops and bishops throughout Germany, with the Holy Roman Emperors Conrad and Frederick Barbarossa, the Byzantine Empress Irene, Eleanor of Aquitaine and King Henry II of England, as well as with many other women who had taken the veil, who wrote to the 'Rhenish Sibyl' to put questions of ethics and revelations to her. Many of the letters she received beseech her to pray for the authors; many express longing to see her face to face; the language of Christian fellowship is warm, even extravagant to twentieth-century ears. Endearments frame the epistles: she is the best-beloved daughter, a *filia dilectissima*. Hildegard wrote long, considerate replies, both earnestly pedagogic and radiantly inspired.

Hildegard saw herself as God's instrument, an Aeolian harp that sang as the breath of God moved through it. She opens her visions either with the phrase 'The living fountain says' or 'The living light speaks' before she moves into the first person; she compared herself to a sounded trumpet or a filled vessel. She wrote to Elisabeth of Schönau that they were both like 'the earthen vessels' filled with the power of God which Paul mentions (2 Cor. 4: 7), and that the living light of her visions should blow through Elisabeth as it did through Hildegard, playing on her as if she were an instrument: 'So too I, lying low in pusillanimity of fear, at times resound a little, like a small trumpet note from the living brightness.'[39]

But her most memorable and original image for the visionary's relation to God comes from a folk-tale, not scripture. To another correspondent, a master in theology in Paris, she wrote:

> Hear, now hear: there was once a king, sitting on his throne, and around him stood great strong elegant columns, richly decorated, set up with ornaments of ivory, and unfurling all the banners of the king with great honour. Then it pleased the king to raise a little feather from the ground, and he commanded it to fly. And it did as the king wished. The feather flew not because of anything in itself but because the air bore it along. Thus am I.[40]

Hildegard returned to this marvellously eloquent image – the feather on the breath of God – in a remarkable letter she wrote at the end of her life to one of the many people who had been captivated by the personality that shines through her writings. To Guibert of Gembloux, who came to live near her in her last years, she stressed her weakness: 'I stretch out my hands to God, so that, like a feather which lacks all weight and strength and flies through the wind, I may be borne up by him.'[41]

But in spite of the utter surrender to his will, Hildegard also saw their

union as cooperation. In a telling passage in her *Vita*, her last autobiographical work, she describes the task of visionaries to create, shape and define, not only receive, and to show themselves forth as God's works. Taking a metaphor from art, she explains:

Man with every creature is a handiwork of God. But man is also the worker (*operarius*) of divinity, who provides shading (*obumbratio*) for the mysteries of divine being ... who ought to reveal the holy trinity to all, since God has made him in his image and likeness.[42]

Hildegard's writing rarely achieves these shadings and transformations through adopting a novel vocabulary or extending her repertoire of images; she mines the same words deeper and deeper until she penetrates through to the anagogical core, and daylight no longer refers to the light of the sun, but to divine goodness, and the vocabulary of female sexual surrender signifies only renunciation in the religious life, that of birth, the neo-platonist regeneration of the spirit. She rarely applies a metaphor literally; the anthropomorphism of her visions is often ambiguous. But by retaining the language of the erotic life, as so many Christian mystics did, she experiences that life and its energy at the level of imagination, even if the meaning she has attained runs counter to usage in the 'real' world. Her mantic powers are never more in evidence than when she praises virginity in the accents of rapture: like a shaman, her words conjure states of being that lie beyond their conscious application. In a particularly fervent letter to another community of nuns, Hildegard tells the *turba puellarum*, this bevy of girls, to turn their backs on the frivolity, the dancing, the love affairs of the world, and prepare for the eternal dance, the epithalamia and the nuptials of heaven.[43]

For it is as Hildegard circles in closer and closer to her own story, of claustration in the Church's service, that the virginal body of a woman becomes her dominant symbol, itself unfolding into a many-petalled cluster of different meanings, emotions, memories and prophecies. When she exclaimed to the abbess in that letter, 'Woman ... what a wondrous being you are,' Hildegard was trying to justify an aspect of her convent life that had come under criticism. Hildegard's sisters at the Rupertsberg were famous for the beauty of their clothes; they wore costly raiment, and on their heads crowns, elaborately wrought diadems in niello enamel work in three colours, symbolic of the Trinity, with four roundels showing the Lamb of God, an angel, a cherub and a human being. As Hildegard wrote when she described these circlets, or *rotae*, 'This emblem, granted to me, will proclaim blessings to God, because he had

clothed the first human creature in radiant brightness.' Her justification, granted to her in a vision, unites imagery from the Apocalypse of John in the New Testament, Paul's commentary on the splendours of chastity, and the voluptuous drama of the Song of Songs. She and her sisters are God's brides; unlike married women, who must only dress in gorgeous clothes if it pleases their husbands, virgins dedicated to Christ have reproduced on earth the primordial state of blessedness they will attain in heaven when they stand, at the Last Judgement, by the side of the Lamb in garments of white. The state of virginity corresponds to the innocence of Eden, and virgins do not need sackcloth and ashes to expiate worldly transgressions. She could surround herself in her abbey with girls who in their very dress signalled their identity with the holy and the divine.[44]

Hildegard's writings are filled with conjurations of this ideal girl, queenly, autonomous and beautiful, whom she has brought into being in the enclosed precinct of her convent. The heads of Humility, Patience and Abstinence, in other showings, are also crowned with jewelled circlets;[45] sometimes the Virtues are veiled *more femineo*, in the fashion of older women, not young girls;[46] sometimes they are bareheaded too, to symbolize their *aperta conscientia*, their clear consciences.[47] She describes her vision of Caritas, the virtue Charity, in another letter, 'A most beautiful young girl, her face flashing with such splendid brightness that I could not look at her fully.... All creatures called this girl *domina*, mistress.'[48] Her Charity is winged, but has given her feathers to Humility so she can fly in the *pressura*, the word for the pressure that Hildegard feels during a vision.[49] As Peter Dronke, the most sensitive and learned translator and exponent of Hildegard's genius, has written about Hildegard's Lady Charity:

The allegory unfolded from this vision is about creation and redemption.... It is when we see these images in relation not only to their allegories but to that image of the bride of God which Hildegarde wanted to embody in her disciples, that certain aspects of her thought cohere in an unexpected way. In paradise, the first woman was created ... as the embodiment of the love that Adam had felt. Eve ... was initially, in her paradisal state, the glorious *puella* whom Hildegarde describes ... and insofar as the virgin brides on the Rupertsberg could still re-enact that paradisal state, they could manifest something of the splendour of this *puella*.[50]

They were the living expression of virtues, hypostasized in the real world and freed through inner purity from constraints of reality; their raiment, however elaborate in worldly terms, was a symbolic dress; and

she, their abbess, was their *domina* or mistress, like Lady Love herself, winged in the midst of her visions, with dazzling brightness streaming from her face.

Perhaps such reasoning to excuse pleasure is contrived, or at best deluded; readers may perhaps smile at Hildegard's living fantasy, her own realization of desires from deeper well-springs, maybe, than even those from which her visions emanated. But even so, the daring, the quality of high imagination, the fascinating elision of art, faith and life cannot be dismissed; she plundered the common Christian stock of images and showed that, given inspiration, it could be transformed to open the gates of a new heaven.

Hildegard was sensitive to the categories of male and female, and her language reflects her distress at the negative value attached to her own sex and its attributed characteristics. Her vision created an ideal world in which Christian strictures were questioned. She wrote to Bernard of Clairvaux, for instance: 'Ego misera et plus quam misera in nomine femineo' (I am wretched, and more than wretched that I am called woman).[51] When she wrote to another fellow abbess on the fall of mankind in the Garden of Eden, she let slip how she endorsed the disparity between the sexes as perceived in her time:

> But the serpent who came breathed eloquent words to the woman, and she received them, and yielded to the serpent. And as she had tasted what the serpent gave her, so she gave the same to her man, and it remained in the man, because a man does all things fully.[52]

Latin gave Hildegard a means of escaping sexual difference and its pejorative charge of femininity. To Bernard she wrote, for instance, apologizing for her lack of book learning but claiming another special power: '*Homo* sum indoctus ... sed intus in anima mea sum docta' (I am a *man* of no learning ... but deep in my soul I am learned).[53] The resonant opening of her first book of visions, *Scivias*, describing how she was commanded by God to write, also casts Hildegard throughout as 'homo', 'man'. Not *vir*, male man, or *femina* or *mulier*, female woman, but *homo*, the generic, undifferentiated human creature.[54]

Hildegard needed to sink herself into the generic, to escape her femaleness, in spite of her combative exploration of symbolic possibilities for the female, because even in the twelfth century, when great ladies enjoyed more autonomy than in the ensuing centuries, and courtly manners accorded women a high place in the scheme of redemption through love, highly influential thinkers were still deeply distrustful of female nature. St Bernard, for instance, in his remarkable rhapsodies on the

Song of Songs, recalls the traditional opposition between strength and weakness, and distinguishes damagingly between the symbol of the bride in the Canticle and a real bride, maintaining the rupture that Hildegard was inspired to mend: 'The bride is called beautiful among women,' he says, 'but women signify carnal and secular souls, which have nothing virile in them, which show nothing strong or constant in their acts, which are completely languid, soft, feminine.'[55]

It is not surprising that Hildegard, whose life's work constitutes a rejoinder to such judgements, characterized Faith itself as a girl, but a *manly* one, above sexual congress: 'Her virginity, which is the Catholic faith, they [infidels] wish to corrupt. But she resists them manfully (*viriliter*) and is not corrupted, because she always was a virgin, and is and will remain so, in the true faith, which is the stuff of her virginity and remains integral against all error.'[56]

Hildegard's extended writings can sometimes have a scholastic flavour absent from her poetry, her letters and her music, but they also deploy the body as metaphor. *Scivias* teems with personifications to flesh out the mysteries she propounds. But what makes her revelations even more fascinating to us today are the manuscript illustrations she commissioned to accompany her texts. The elaborate figures she described in the book flicker in lavishly applied precious pigments, gold and vermilion, cobalt and magenta, existing in the illusion of art at one degree closer to corporeal reality than the imaginary scenes, figures and actions Hildegard's writings conjure before her readers' eyes.[57]

Hildegard herself appears in the first miniature, apparently giving instructions through an opening to her scribe-artist whose head is poking through to listen; she is holding a pen on a tablet, while those flames of inspiration descend on her head; the illumination suggests that she sketched out her ideas and handed them over for execution to another, more practised painter (Pl.61). If this is the case, she was able to translate the labile profusion of her visions with quite breath-taking clarity and control of visual imagination; some of the richly coloured images are intricately enfolded, frame within frame, border within border, pattern upon pattern, as sublimely sensuous and almost as abstract as Hindu mandalas; others exert a different kind of authority over the flux of her words, and make intelligible and even harmonious some of the more outlandish emblematic details seen by Hildegard, the scores of eyes on the wings of the cherubim, nearest in rank to the godhead of the nine orders of angels, or the fishing net in which the Church catches souls at baptism (Pl.62).

However 'wretched' in the name of woman she was, she vindicated

her sex triumphantly with a resplendent sequence of allegories, in which the mysteries of creation and redemption, Wisdom, the Church, the Virtues, the souls of men and the sacraments are chiefly represented through female figures. Ecclesia appears most frequently, and she is contrasted with the Synagogue in two full-page miniatures of exceptional power.[58] Hildegard, who may have been influenced by the anti-Semitic churchmen of her day like the preacher Benjamin of Tudela, saw the Synagogue,

> black from her navel to her feet, and bleeding at her feet, yet surrounded by the whitest and purest cloud. Bereft of her eyes, she held her hands under her armpits, standing near the altar which is before the eyes of God, yet she did not touch it.[59]

This towering figure, breaking out of the miniature's vermilion frame with her huge feet steeped in blood, keeps her sightless eyes shut and her arms crossed over her breast as Hildegard describes, to symbolize her rejection of Christ and her blindness to the truth of his incarnation. But the intensity of the weariness and grief the painter has managed to communicate in her stance and her face surpasses even Hildegard's powers of expression in words. The colossal magenta and silver Ecclesia, who appears five illuminations later, holds out her arms in the *orans* gesture of public prayer and her wide, large-set eyes gaze in melancholy beyond the viewer – *acutissime*, keenly, says the vision – out of the side of the acanthus-leaved border (Pl.62). Hildegard saw the Church as the 'image of a woman' of huge size, as big as a great city, with a crown on her head and splendour falling from her arms like sleeves, just as the artist has captured. Ecclesia's fishing net did not cause the illuminator the problem it might have done: he interpreted it as a gold mesh pattern on Ecclesia's body. In the breast of the figure, framed by huge golden plumes like the flames of the inspiration, several nuns and some priests kneel in a cluster, around a praying figure in long blonde plaits. They represent virginity and the priesthood, which must exist at the very heart of the Church. It is hardly accidental that the nuns and the central praying girl are dressed and coiffed in the style of Hildegard and her flock.[60]

Hildegard of Bingen foreshadows the mysticism of the Flemish Beguines, of Meister Eckhart and Henry Suso in the later Middle Ages. A campaign for her canonization started soon after her death, but was not successful; her friend Elisabeth of Schönau became a saint, so prejudice against female ecstatics cannot have prevented Hildegard's own sainthood. There were miracles, however, and a local cult flourished in

Germany.[61] Sainted or not, Hildegard is one of mediaeval Europe's truly original minds. But she was by no means eccentric in the language and imagery in which she phrased her mystical experiences; she stretched a shared vocabulary of her time and deepened its metaphors through her personal commitment to the meaning of her allegorical figures, but they were entirely traditional in Christian thought.

With Hadewijch, the mediaeval Netherlandish poet of the century after Hildegard, we find the stream of personal Christian mysticism that flows through the Benedictine and Cistercian movements nourishing the visions of a woman seer to inspire raptures more familiar in their keyed-up, sensuous sweetness than Hildegard's glitteringly elaborate constructions.[62]

Hadewijch lived in the early thirteenth century in the Lowlands and may have come from Brabant; she belonged to a community of Beguines, religious sisters who did not take vows, but lived together in Béguinages, and worked for their living. Next to nothing is known about her otherwise, and her works were only rediscovered in 1838.[63] Since then she has become one of the most important writers of early Dutch literature, because, like Dante in Italy, she chose to write in the vernacular. In her accounts of her raptures, and her letters of spiritual counsel to her sisters, Hadewijch wrought yet another transformation of the figure of Divine Wisdom, simultaneously the second person of the Trinity, the Holy Spirit, and Sophia, when she conjured her symbol of Love, *Minne*, a female power who courses throughout her writings. For Minne, Love, is feminine in gender in mediaeval Dutch, like Caritas, or Agape, but unlike the more familiar Western concepts of Eros and Amor.

In her seventh vision, granted appropriately at Pentecost, the feast of the Spirit, she wrote of Jesus,

He came in the form and clothing of a Man, as he was on the day when he gave us his Body for the first time; looking like a Human Being and a Man, wonderful, and beautiful, and with glorious face, he came to me as humbly as anyone who wholly belongs to another. Then he gave himself to me in the shape of the Sacrament, in its outward form, as the custom is; and then he gave me to drink from the chalice, in form and taste, as the custom is. After that he came himself to me, took me entirely in his arms, and pressed me to him; and all my members felt his in full felicity, in accordance with the desire of my heart and my humanity. So I was outwardly satisfied and fully transported. Also then, for a short while, I had the strength to bear this;

but soon, after a short time, I lost that manly beauty outwardly in the sight of his form. I saw him completely come to naught and so fade and all at once dissolve that I could no longer recognize or perceive him outside me, and I could no longer distinguish him within me. Then it was to me as if we were one without difference. . . .

After that I remained in a passing away in my Beloved, so that I wholly melted away in him and nothing any longer remained to me of myself.[64]

The importance of this powerful vision lies in the harmonic shift as Hadewijch's union passes from sexual transport, repeatedly qualified as 'outward', to the strong resolution when this outward lover dissolves into her inward being, and reciprocally, she enters into a state of pure desire and melts away into his already annihilated self; in this *grondeloze gront*, as she calls it elsewhere, this foundation-without-foundation, or abyss-without-end, the vanishing point of the ego, where it passes through space and time into the boundless infinity of zero, Hadewijch finds her fulfilment.[65]

Hadewijch does not engage with the historical humanity of Jesus in the manner of her contemporaries, like St Bonaventure, who lingered lovingly on the circumstances of the Saviour's infancy and upbringing, garnishing the bright image with profuse details, in an attempt to make the story of the redemption work its efficacious magic on the hearts of the audience.[66] She shows no interest in Jesus' biography. He metamorphoses in her visions into a being who belongs in the perspective of eternity on the one hand, an angel or archon, and on the other, in her own private processes of self-evolvement. Like Hildegard, she drew on the allegorical tradition and on the Sapiential texts of the Bible, to create a range of fictive personal reflections of her ideal self.

In one of the boldest poems she wrote, 'The Strongest of All Things', Hadewijch reworked a story that occurs in the First Book of Esdras (included in the Vulgate by St Jerome, but now to be found only in the Protestant Apocrypha, not the Jerusalem Bible). A cautionary tale, it issues a sharp warning against the powers of women. The First Book of Esdras relates that once, when Apame, the 'favourite concubine' of King Darius of the Persians, 'was sitting on the king's right; she took the diadem off his head and put it on her own, and slapped his face with her left hand; and the king only gazed at her open-mouthed'. She laughed at him. And he then laughed too (1 Esd. 4: 29–33, New English Bible).

Hadewijch conflated this anecdote of love and its folly with other stories from the tradition of symposia, in which sages debate the merits of different ways of approaching knowledge, and even added a remin-

iscence of the legend of St Catherine, who worsted pagan philosophers with her Christian wisdom.

In the poem, four wise masters argue before a king about what could be the most powerful thing in all the world. The first suggests wine, the second says a king, the third says a woman, and the fourth says truth. With some obscurity due to extreme compression, and some forcing of her meanings, Hadewijch develops their reasons: all four answers represent love under different aspects. Wine is sorrow, the sorrow of an unfulfilled capacity to love, which leaves the lover suffering from a continual intoxication of 'hope and fear'.[67] Like one of Dante's torments in the *Inferno*, the power of this wine binds the sufferer for ever. The symbol of the king, the second power, turns topsy-turvy in Hadewijch's verses, to become the poor at heart whom Christ blessed in the Sermon on the Mount, the soul who seeks for no worldly riches or pleasure but 'refuses all that is not brought him by Love'.[68] For the third power, woman, Hadewijch audaciously allegorizes the story of Apame's cheeky bid for sovereign authority, sweeping on to say that she is the strongest of all things:

> The reason, which the third master ventured to explain,
> Is that she is truly able
> To conquer the king and all men.

Hadewijch then gives her a novel identity:

> This woman is humility.[69]

And she goes on to expound a conventional personification of the virtue as a queen, incarnate in the Mother of God, who was so pure and good that she overcame Lucifer, once the first of the angels, now the embodiment of Pride:

> She made the [dark] Lord a slave...
> he fell from his sublimity
> Into this unfathomable chasm.

She then turns to invoke her audience and tell them that, in order to experience the fullness of love, they must be prepared to bow their necks to humiliation and obloquy.[70]

But the fourth power, greater than wine, the king, and greater even than Mary, is truth:

> It conquers all
> That was, and is, and shall be.[71]

According to Hadewijch's doctrine, whose tap-root runs down to the Bernardine scriptural axiom that 'God is love' (1 John 4: 8), the power of truth is 'to live for Love'.[72] But what else, besides the godhead, is 'Love' in Hadewijch's thought, but Minne, Lady Love, evoked by Hadewijch's poetic polyphony: Minne, who speaks now in the voice of the Beloved, of Hadewijch's objects of love as she searches for God, and now in the voice of Hadewijch herself? Her poem concludes with an anthem to this ultimate love, the spirit of truth, strongest of all things, to whom wine, kings and woman must all yield. But they who know this truth are souls who understand all four powers of Love. And of course it is Hadewijch, the knowledgeable exponent of heavenly mysteries, like Dante's Beatrice in paradise, who has achieved that understanding:

> When the soul loves perfectly
> And truly understands all these powers,
> It loves eternally as it should –
> And as I gladly loved and willed to love.[73]

This is the last time in the poem that she uses the first person pronoun, and it forms a diptych with the first time, both detonating a small shock of surprise at the measure of Hadewijch's claims. At the beginning, she makes it clear that the sages are putting forward knowledge that she shares:

> Then each of them expressed my opinion –
> Although I was not there then – [74]

And this last time, after telling us

> And as I gladly loved and willed to love,

she describes the dimensions of what she means:

> Love knows no distinctions;
> She is free in every way;
> She knows no measure in her functions;
> Therefore she cannot heed the purely reasonable truth.[75]

This heedless, unreasonable, immeasurable power of love is greater than truth itself, in its 'reasonable' form at least, and again arrives at full plenitude in forgetfulness of the difference between without and within, as in Hadewijch's deepest mystical knowledge of God:

> She is so noble and so valiant,
> Both in omitting and in doing,
> That she considers neither loss nor gain,
> If only she returns into herself.[76]

This startling, splendid and profoundly spiritual boast brings the poem to its end. Yet, as a whole, Hadewijch's bravery concedes hints of inadequacy and even of humbleness of heart between the asseverations of privilege; she communicates a questing restlessness, not a triumph of complacency.

In the writings of Hildegard and Hadewijch, the contending strains in Christian thought about women are present, but are resolved to produce a remarkably affirmative corpus; they explore the affinities between the idea symbolized and its outward womanly semblance. As the twelfth-century neo-platonist school of Realism at Chartres believed, 'visible reality reflects invisible reality. . . . Thus the symbol contains, in part, the essence of what it symbolizes.'[77] In mediaeval allegory, image and idea were conjoined by aptly suggestive resemblance; the lion stands for courage because it possesses the courage of a lion; by analogy, Lady Wisdom or Ecclesia or Minne were no mere mechanical ciphers of Wisdom or the Church or Love but in sympathetic connection with their very essence, as both Hroswitha and Hildegard recognized in spite of their disclaimers of womanhood.

But in the ensuing centuries, the misogynist strain began to cleave image and reality, and the disjunction between women and the positive ideas they traditionally represented in allegory was increasingly stressed. Though it is always perilous to generalize, the decline of this Christian mode of thought and the withering of the mystical poetry that drew its inspiration from the Sapiential books of the Bible reflected the developments of the fifteenth century, when works like the *Malleus Maleficarum* were compiled to justify the great witch-hunt of the Renaissance and codify the alternate, evil, canonical text for the intrinsic wickedness and folly of women.

A parallel development in the fourteenth century onwards also assisted the widening divergence between the use of the female form as symbol and woman as person. The rediscovery of the classical gods, not in itself a misogynist process, nevertheless widened the distance between Lady Wisdom and her exponents on this worldly plane; she began to recede into a mythology thronged by dead divinities, and no longer take her living place in the ever-present community of the faithful. According to

the theology by which a nun like Hildegard lived, every member of the Church, of Ecclesia, partook of her essence in the here and now, was incorporated into her body, the mystical body of the eternally renewed Christ, and relived his recapitulated redemption, through the ritual of the Mass, and the sacrament of the Eucharist. Through each year's liturgical re-enactment every believer experienced the cycle of his life, and so ingested the wisdom of God, itself alive in the world through his foundation, Holy Church. But the Greek and Roman deities, who began to circulate freely as new embodiments of the virtues and the arts after the fourteenth century, did not invite identification in the same way; they themselves were no longer actors in a continuously ritual performance of their stories, in which the audience could also join; nor were they commonly represented in the mien of the men and women of the time. Their history belonged in the past, where they were perceived as reflections of an ideal, distant culture.

Sophia/Sapientia, leader of the Liberal Arts, as she appears for instance in Herrad's *Garden of Delights* or on Nicola Pisano's pulpit in Pisa cathedral, began to shed her biblical character and assume the features of Minerva, Roman goddess of wisdom, as for instance in the famous set of engraved cards, the Tarocchi of *c.* 1465, formerly attributed to Mantegna, in which Philosophia is represented as the goddess. Prudence too, one of the four Cardinal Virtues, was sometimes conflated with the same classical goddess, while Fortitude and Justice were assimilated to Minerva's earlier, Greek counterpart, the chief goddess of classical civilization, Athena. The Liberal Arts become less and less active as they lose their resemblance to allegorized religious Virtues practising their skills, and begin to function more and more as classical Muses: in Joos van Wassenhove's representative Quattrocento interpretation, the allegory of Music indicates the organ standing untouched beneath her and hands over to the young nobleman, possibly Federigo da Montefeltro, mastery in her subject (Pl.36)[78]

The Muse was invoked as divine inspiration by Hesiod and Homer in the opening lines of their poems.[79] Named by Hesiod, who says their 'one thought is singing', the nine Muses were only apportioned their spheres of influence over aspects of dance, music and recitation much later, in allegorizing Alexandrian scholarship.[80] The Italian humanists rediscovered them, and it was Coluccio Salutati, the leading Florentine classicist, who, at the turn of the fourteenth century, first aligned the Muses of antiquity with the mediaeval scholastic curriculum.

It is in the guise of classical Muses that the Seven Liberal Arts, under the presiding genius of Wisdom, receive the young Lorenzo Tornabuoni

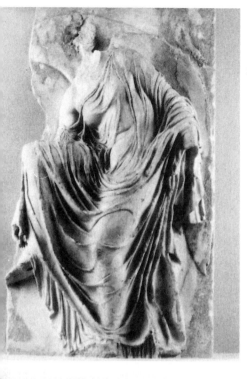

Nike, goddess of victory,
balanced on her wings, stoops to
fasten her sandal on the frieze
from the temple of Athena Nike
on the Acropolis, Athens (38),
and on a red-figure cup ties a
sash around a willing bull (39).

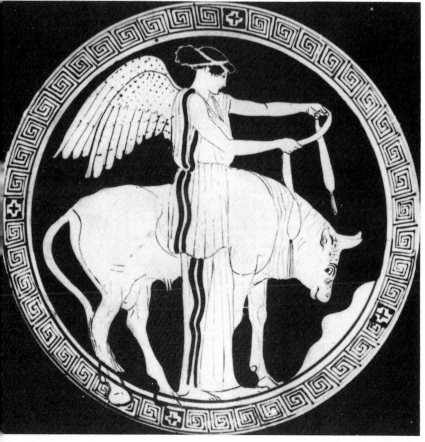

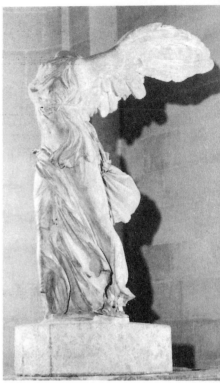

The classical Nike, like the famous *Winged Victory* of Samothrace (40), inspired the iconography of Byzantine Christian archangels, with their sweeping wings, as in the twelfth-century mosaic of St Michael from the church of La Martorana, Palermo (41).

41

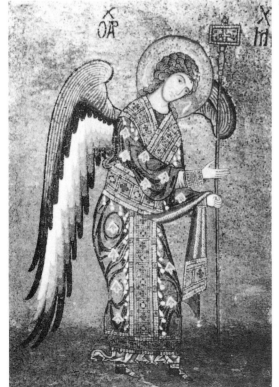

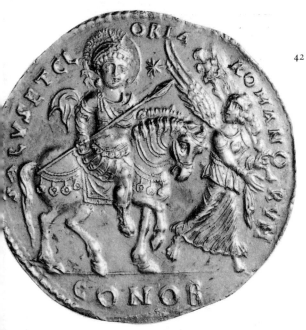

42

The Emperor Justinian's equerry, both angel and Victory, on his golden medallion (42), reappears nearly one thousand four hundred years later in the modern urban landscape in the statue of General Sherman in New York by Augustus Saint-Gaudens (43).

43

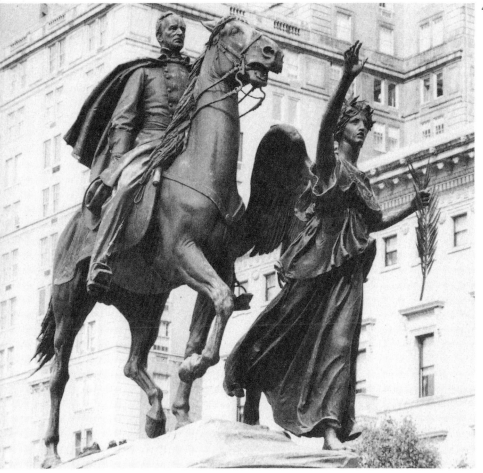

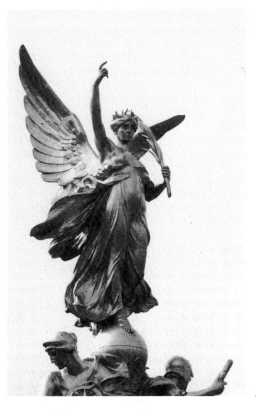

44

Thomas Brock's Victoria Monument in the Mall,
London (44), uses the classical language of
personification without incongruity; but when a
real woman stands in for Victory, as in Eric
Peltier's spoof of Le Nain's allegory in the
Louvre, the convention becomes hard to accept (45).

45

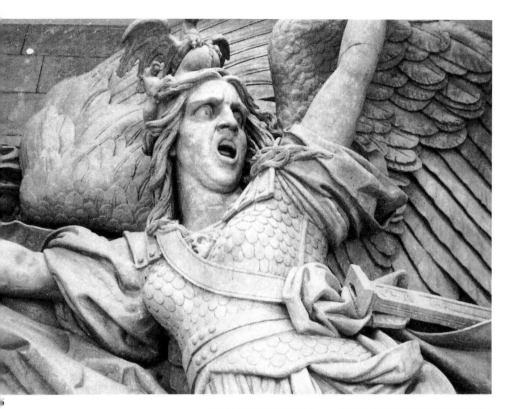

ançois Rude adapted the classical
inged figures of Nike and Fate in his
mous sculpture on the Arc de
riomphe, known as *La Marseillaise*,
hich celebrates the partisans of 1792
6); in the next century, Walter
enjamin was inspired by another
inged figure, Paul Klee's *Angelus
ovus* (47), to meditate on
tastrophe, warfare and history.

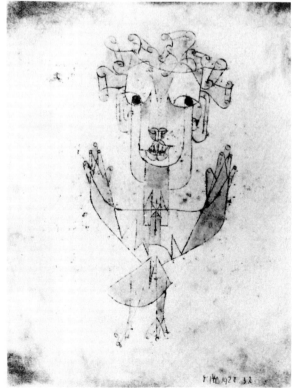

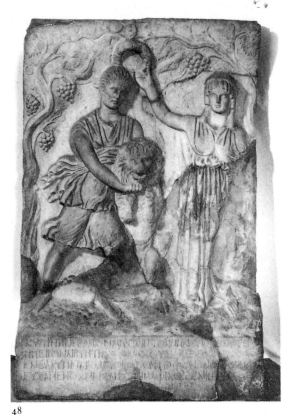

48

The nymph Cyrene, founder of the colony
of her name in Africa, lived wild and was so
strong that she overcame a lion with her
bare hands (48). The classical type of
Amazon inspired the allegorical virtue
Fortitude (49), wrestling with a lion, in the
twelfth-century mosaics in St Mark's,
Venice, where the Virtues appear with a
chorus of heavenly Beatitudes, including
Humility dancing (50).

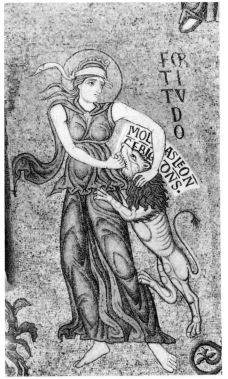

49

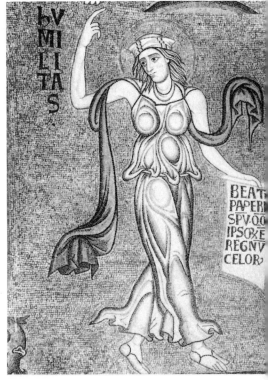

50

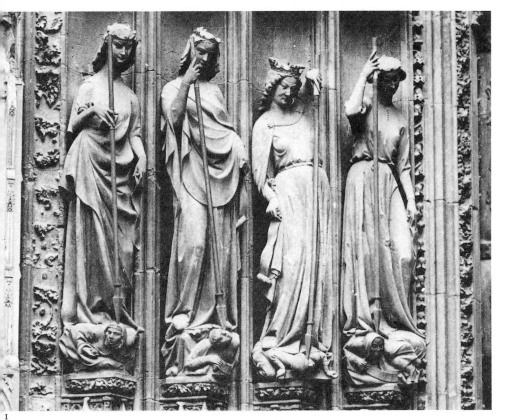

I

On the cathedral at Strasbourg, the Virtues, personified as queenly maidens, trample the Vices, represented as their social inferiors, contemporary burgesses (51); a tapestry version of the same Christian theme, the Psychomachia, shows Charity in gorgeous apparel, seizing Envy, portrayed here as a craven knight (52).

52

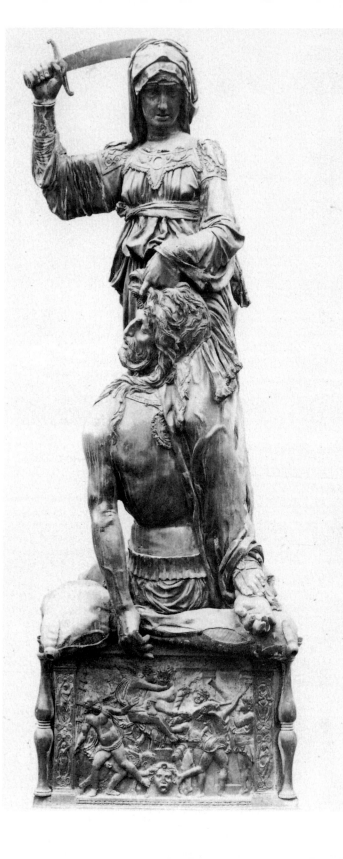

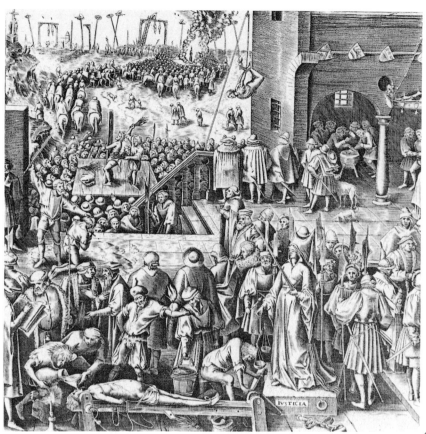

Donatello's bronze Judith of 1457
warned that 'Kingdoms fall through
licence' and 'cities rise through
virtue' (53). The biblical heroine
who slew the tyrant Holofernes
became a pattern of Christian justice
and courage; her emblem, the
sword, is also Justice's attribute, as in
Brueghel's unsparing engraving of
the penalties meted out in the
virtue's name (54). W. H.
Thornycroft, for his sculpture of
Courage on the Gladstone
Monument in London, created a
Victorian version of the armed
maiden (55).

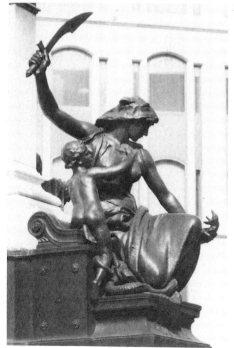

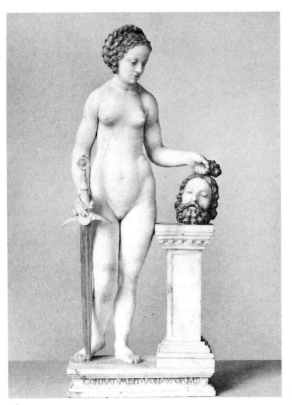

56

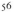

57

Conrad Meit made explicit the latent
sexual ambiguities of the Judith story with
his naked, painted, alabaster statuette (56);
Artemisia Gentileschi, who painted her
self-portrait as La Pittura (Painting), (59),
treated the heroine's exploit with a passion
that sprang from her own personal history
of sexual mistreatment (58). The
murderous stereotype became so common
that the photographer Olga Wlassics, in
Vienna around 1930, made fun of the
insistent morbidness of the tradition (57).

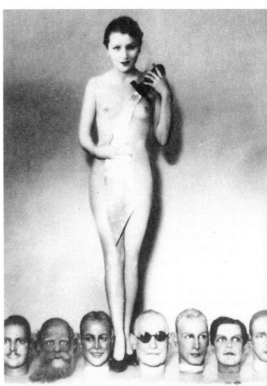

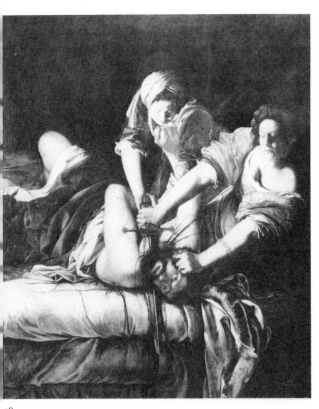

58

59

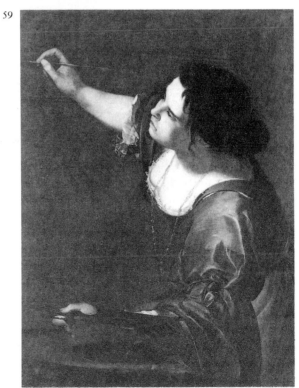

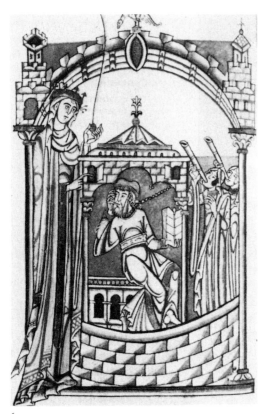

Boethius, the author of *The Consolation of Philosophy*, saw the Lady Philosophy herself in a vision (60); his description influenced the iconography of the biblical Sophia, or Wisdom, and of her exemplar and faithful daughter, the Church, Ecclesia. Hildegard of Bingen, in the twelfth century, commissioned illuminations of her visions from a scribe (61), and represented Ecclesia with nuns like Hildegard and her community tucked up in her breast (62).

60

61

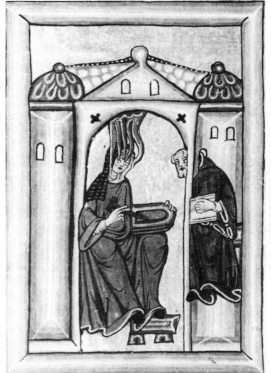

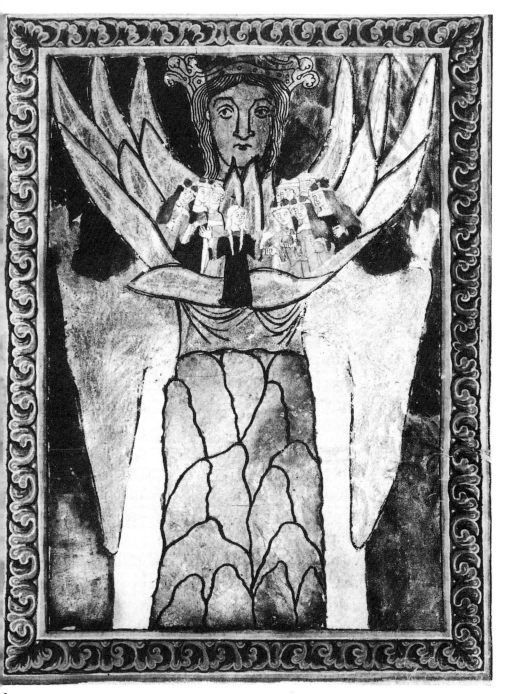

2

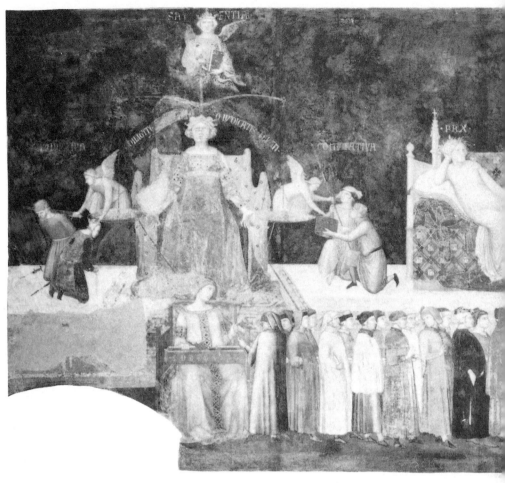

63 *The Allegory of Good Government* in Siena, by Ambrogio Lorenzetti, perhaps the finest allegorical cycle of mediaeval art, shows Justice enthroned on the left, beside a dais, on which the personified Commune of Siena sits, with Virtues on either side of him and Peace reclining in the centre, trampling weapons with her bare feet (63).

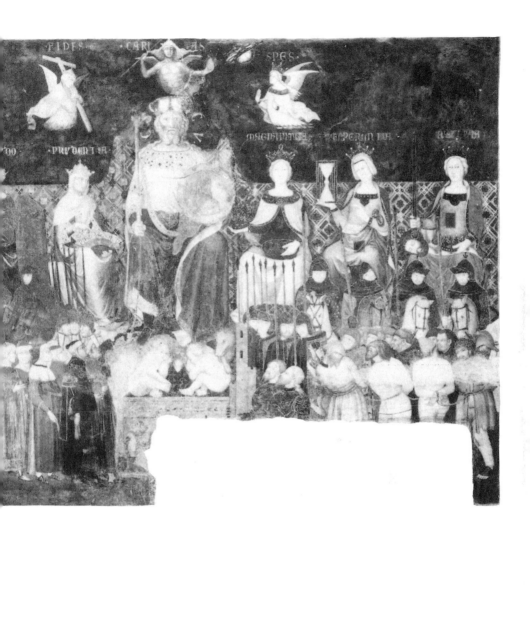

FIDES · CARITAS · SPES · PRUDENTIA · MAGNANIMITAS · TEMPERANTIA · IUSTITIA

Vermeer's *The Art of Painting* shows one of the artist's familiar models posing as the Muse of History, Clio, while at the same time remaining palpably herself (65); Angelica Kauffmann liked to represent herself as a Muse, as in this painting of *The Artist in the Character of Design Listening to the Inspiration of Poetry*, in which she sits beside her friend the writer Maria Cosway (64).

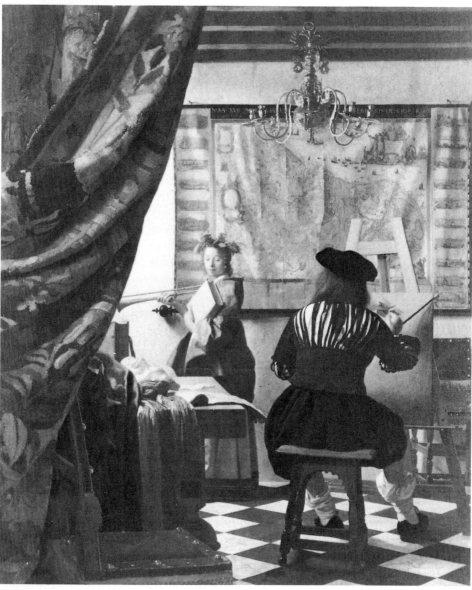

in the exquisite fresco of 1486 by Botticelli for the Villa Lemmi, now in the Louvre. They hold the traditional mediaeval emblems of their calling; but the *trivium* wear their hair up, like Greek married women, while the *quadrivium* wear their long, rippling hair loose like *korai*. The whole company is dressed *all'antica*, in chitons of diaphanous, swirling light material caught up in folds and overfolds into a cestus above the waist. Lovely as they are, persuasively summoning us to think of higher things, successfully expressing the world beyond, they are ethereal emanations, not solid or even potential exponents of the skills they bequeath upon the youth ushered into their midst.[81] By comparison, Hildegard's view was fairly fixed in the here and now, before her eyes.

Influenced by Sapientia's sway over the Liberal Arts, the imagery of humanist classicism also put Minerva, the classical goddess of learning, in Sapientia's place as the leader of the Muses. Although Athena/Minerva appears with these figures of divine inspiration on Roman sarcophagi,[82] it was Apollo in Greek myth who led their chorus. But in Ovid's *Metamorphoses*, Minerva visits the Muses on Mount Helicon, in order to see the spring Hippocrene, struck by the foot of the winged horse Pegasus, and one of the Muses tells the goddess, '... you [who] would have been one of our company, had not your courage directed you to greater tasks'.[83] The Renaissance seized on this affinity between them, and, bringing about another transformation of Athena, the goddess of changes, granted her a pre-eminent place as goddess of the arts, as well as of other branches of learning.[84]

Around the same time as Coluccio Salutati was allegorizing the Greek myths for Christian humanist purposes, Christine de Pizan (1365-1430?), a devout Christian as well as widely read in classical studies, created a bridge between the new mythology of the early Quattrocento and the mediaeval tradition of female allegory about Wisdom and her children.[85] She tried to retain the language of personification on women's behalf, using it for overt feminist goals. In her *Book of the City of Ladies*, written in 1404, and its sequel *The Treasure of the City of Ladies*, she continued her campaign to redress the wrongs of misogyny, perpetrated in particular, she considered, by *Le Roman de la rose*'s continuator, Jean de Meung, and by Boccaccio in some of his tales of famous women, the *De Claris Mulieribus*.

Christine de Pizan was the daughter of the Italian court astrologer and physician of King Charles v of France and her father had overruled her mother and insisted that his clever daughter receive the kind of education only a son would normally be granted. She grew up with a wide-ranging knowledge of the classics, of history, and of contemporary

Italian and French literature. After her husband died in 1390, leaving her a young and indigent widow, she continued to educate herself, and became the first woman in Western letters to support herself, her three children and her mother by her pen, by writing poetry and history, military and educational treatises, and polemical tracts against the detractors of women. She won a committed following among great prelates like Jean Gerson, Chancellor of Paris, and munificent lords like the Dukes of Burgundy. She died in retirement in a convent, probably in 1430, the year after Joan of Arc's victory over the English at Orleans, an event that so inspired her that she broke the self-imposed silence of her disillusioned old age and composed one of her finest poems in praise of Joan of Arc.[86] In her girlhood and her courage and her faith, Joan had proved the greatness of her sex:

> Hee! quel honneur au feminin
> Sexe! Que dieu l'ayme il appert.
>
> (Aah! What an honour for the female sex!
> It's clear that God loves it.)[87]

The Book of the City of Ladies had been written nearly a quarter of a century earlier; Joan of Arc had ridden out of Domrémy as the living proof of Christine's earlier argument that God, truth and wisdom were on women's side.

In The Book of the City of Ladies, Christine rings changes on the visionary tradition and, purposefully echoing Augustine's City of God, she reveals the building of a new sacred city, by three ladies, Dames Raison, Droiture and Justice – Reason, Rectitude and Justice.[88] Its stones and fabric will be the lives and deeds of great heroines and female exemplars, found in ancient history, myth, hagiography, literature and folklore from a wide range of sources. They will give the lie to the traducers of women, so numerous and all-pervasive that – in her 'folly' – Christine laments at the opening of her book that she was ever born one.[89]

Lady Reason, who directs Christine through her vision, shares the power of consolation with Boethius' pagan Philosophia and the insight and beatitude of Dante's Beatrice in the Paradiso, a poem Christine was the first to mention in French; but she also turns upside down Jean de Meung's Dame Nature from Le Roman de la rose, a text Christine had bitterly rebutted in some of her earliest writings. Dame Nature represented for Meung the biological necessity of the race to reproduce, the carnality and consequent inferiority of females as the members of the

species, instinct with drives to procreate. Christine in her book coolly and cogently deploys her contradiction of Dame Nature. For what could be more rational, spiritual, well-behaved or wise than Ladies Rectitude, Justice and Reason?

Christine's paean to her sex culminates in praise of Mary, the Queen of Heaven, who is brought to the City of Ladies by Justice to be its sovereign, for she is 'the head of the feminine sex' and the reason that honour must be paid to women. Thus Christine reverses the more usual opinion that Mary was the exception among women, the pure among the impure, the only one fit to be Mother of God, and makes her the essential type of female virtue and the proof of women's worth. Then Justice addresses Mary:

> My Lady, what man is so brazen to dare think or say that the feminine sex is vile in beholding your dignity? ... Since God chose his spouse from among women, most excellent Lady, because of your honour, not only should men refrain from reproaching women, but should also hold them in great reverence.[90]

Christine can be repetitive and frequently didactic in the scholastic manner; but she was a startling pioneer. She is the first writer of her sex to coalesce the image repertoire of classical antiquity with Christian symbolism; in her work, as in the first harbingers of the pagan retrieval like Alcuin, Mary and Minerva fuse as the highest representation of woman. Like Renaissance classicists who later interpreted mythology as prefiguring Christian mysteries, Christine perceived no split in the continuum between the goddesses and the Christian redemption. In *The City of Ladies*, Minerva, like her Greek avatar Athena, presides over the cultivation of the olive, the art of weaving, the forging of armour and the playing of flutes; but in Christine's tale, she is the historical inventor of these arts, and others, including shorthand. Lady Reason explains her to Christine:

> This maiden was of such excellence of mind that the foolish people of that time ... said she was a goddess descended from Heaven.... Through her ingenuity she invented a shorthand Greek script in which a long written narrative could be transcribed with far fewer letters ... a fine invention whose discovery demanded great subtlety.[91]

She goes on to describe how Athena first gave armour to the Greeks, thus betraying an historical conflation of Minerva, the Roman deity with her Athenian predecessor. She describes how the mistaken cult developed: 'After her death they erected a temple in Athens dedicated

to her, and there they placed a statue of her, portraying a maiden.'⁹² But by denying the goddess' divinity, Christine could with impunity introduce her into the feminist continuum of heroines and great creative intelligences.

Christine de Pizan was a Christian who annexed Athena/Minerva as one of her predecessors in wisdom and skill; in the invocation with which she closes *The Book of Feats of Arms and Chivalry*, a treatise on right conduct in war composed around six years after *The City of Ladies*, Christine entreats Minerva to help her with her undertaking:

> O Minerva, goddess of arms and chivalry, who by virtue of understanding far surpassing other women discovered and established the use of forging iron and steel among other noble arts.... Adored lady and high goddess, do not be displeased that I, a simple little woman, who am as nothing compared to the greatness of your famed learning, should undertake now to speak of such a magnificent enterprise as that of arms.

She continues her prayer – to this woman whom only 'foolish' people had mistaken for a goddess – by playing on Minerva's fellow feelings:

> Please look on me kindly, for I can share in some little way the land where you were born, which was formerly called Magna Graecia, that country beyond the Alps now called Apulia and Calabria, where you were born, and so *like you I am an Italian woman*.⁹³ [Emphasis added.]

For Christine de Pizan, the centuries since Italy was a part of Magna Graecia had elapsed but in the winking of an eye: Minerva was her reflection, inspiration and compatriot. In a manuscript of the time, Christine and Minerva are positioned side by side, like friends and allies (Pl.33).⁹⁴

Dame Reason is an allegorical figure, a figment of Christine's special pleading on behalf of women. But Minerva, the source of wisdom, had lived as a woman in Christine's view. Christine does not relegate her to the symbolic order, but acknowledges her reality, as Homer acknowledged Athena's. Christine cannot unpick the tangle of belief and knowledge in her work, which winds together the Wisdom figure of the Bible, the fountainhead of learning represented by the goddess Athena/Minerva, and the incarnate and historical individual Mary into a paragon who is also a type of the female sex.

From the vantage point of a learned and sophisticated court in the early Renaissance, Christine could marshal the conventions of female allegory, and their foundation in the accidents of grammatical gender, and support her argument for women in a polemical and open discourse that Hildegard of Bingen in the twelfth century did not attempt;

Hildegard never articulates the argument as overtly. She was a visionary, and her unconscious carries her towards a vatic imagery of self-revelation and self-affirmation that Christine, who was pedagogic by taste, chose deliberately and consciously to adapt.

Christine's is a more modern voice, the single authorial first person, and the autobiographical, even confessional, passages in her writings anticipate the innovations of the next century. By contrast, Hroswitha and Hildegard, and Hadewijch too, in their very different situations and at different times, nevertheless share the communality of their first person voice: they belong to a group and they speak with the voices of their fellow nuns and not just to them. Hildegard imparts information as she retells the messages of her 'living light', but she presents herself as a conduit, a sounded vessel, connecting earthlings to heaven. She and her hearers accept her as a link, not an isolated and embattled advocate. Nor do Christine's exemplary ladies move and act in such extended involving rituals, liturgical and theatrical, which both Hroswitha with her plays and Hildegard with her music were able to create; Christine's persuasiveness suffers from her isolated position, the comparative difficulty for a mediaeval pioneer feminist like herself to realize her allegories in the courtly society in which she lived, in spite of her success as its chronicler and ungarlanded poet laureate.

Two hundred years before, Hildegard of Bingen had harvested a store of imagery for a community of friends and sympathizers who shared it with her and were in the main in agreement with its latent praise of all human creatures' relation to the divine; but Christine de Pizan's voice is defensive, and insistent, and foreshadows the modern artist's predicament, alienated from the consensus of the world, who attempts from within to generate a world view that will shake that consensus, but finds she cannot, plead as she might. Perhaps that is why Christine de Pizan in her later years in a convent fell into the silence that became so much more customary for women than the brilliant, confident loquacity of Hildegard of Bingen.

Although Christine de Pizan's entreaty to Minerva strikes an original note of private and special identification, her granting the goddess skills in all the arts and sciences was typical of Renaissance conceptions of Minerva's functions. To Lilius Giraldus, Minerva was the embodiment of ethical and social wisdom. 'Sola prudentia liberum hominem faciat' (Prudence alone can make a man free), he wrote, acknowledging her relation to the will and behaviour of Homeric protagonists; she was the mistress of crafts, and, born out of the mind of Zeus, she was also, he states, 'the goddess of arts'.[95]

By the time Giraldus was writing, in the sixteenth century, mediaeval personifications of the arts had entirely yielded in popularity to the Muses, who have held their own ever since. If a university curriculum today appears blazoned allegorically on the walls of its buildings (as in Vienna), the subjects taught will be depicted, since the High Renaissance, with classical attributes and drapery like Muses, and Minerva will usually emerge as their leader. In the Library of Congress' Great Hall, Minerva, in an alcove, wreathed with her sacred olive, holds up a roll on which some of the new learning entrusted to her by our post-classical world can be read: Agriculture, Education, Mechanics, Commerce, Government, History, Astronomy, Geography, Statistics, Economics, Painting, Geology and so forth – a modern amalgam of the *trivium*, the Muses, and modern technology.[96]

Neither painting nor sculpture figured among the Hellenistic Greek lists of the Muses' separate spheres. They were associated above all with music and with recitative speech; but in the Renaissance the omission was rectified, and in sixteenth-century Italy, La Pittura, the personification of painting, wears round her neck a mask like the Muses of Comedy and Tragedy, in the footsteps of the goddess who also disclosed her artfulness through disguise.[97] Artists of humanist enthusiasm, lacking a patroness, borrowed Minerva and her new, adoptive daughter, the Muse of Art. Artemisia Gentileschi in her powerful self-portrait of around 1630, wears Pittura's medallion on a necklace to present herself as a working painter and the personification of Painting itself at the same time.[98] She shows herself leaning in to address the canvas with a sure, dynamic purpose, her head to one side as she looks around it towards the invisible model – herself in one of two mirrors she must have set up (Pl. 59).[99]

The arts of painting and sculpture were seen as aspects of Sapientia, who, from the sixteenth century onwards, loses her biblical character and is almost always represented under the features of the goddess of wisdom. When Queen Christina arrived in Rome, in December 1655, having given up the throne of Sweden in order to become a Roman Catholic, she was received with terrific pomp, as befitted such a brilliant conquest for Rome. The false façade by Rainaldi that instantly renovated the Palazzo Farnese where she was to put up was thoroughly decorated with saints and Victories and painted to imitate marble and gold; the arms of Sweden were supported by Strength and Wealth; Chastity and Grace, Goodness and Steadfastness also appeared, to enhance Christina in the eyes of her new home; but Christina's personal arms were borne by Wisdom and Generosity.[100] She took pleasure in

courtesies identifying her with Wisdom, the Christianized interpretation of the Greek goddess, and appeared on a medal as the 'Pallas Nordica' and posed as Minerva for a portrait.[101]

Angelica Kauffmann (1741–1807), painting a hundred and fifty years after Artemisia and a hundred after Christina's brilliant court in Rome was established, did not resist with Artemisia's sternness the mythic roles women played in classical imagery but rather embraced them lightly, smilingly, assuming their personae to enhance her own status and, in the figure of Minerva and the Muses, recognized and claimed kindred spirits.[102] She was steeped in the classical tradition, after a childhood spent travelling as a journeyman artist with her widowed father in Italy, and she returned equably again and again to the opportunity the convention of mythological allegory gave her to merge reality and the ideal under the same features. One of the most decorative neoclassical artists to work in England, she painted with a rich, bright palette, influenced by the Venetians whom she had studied, and brought to the prevailing fashion for mythological subjects and history painting a warmth of tone and a fresh, airy brushwork that avoids the high seriousness, the pomp of contemporaries like James Barry.

She was hugely successful in London, where she came to live in 1766, as a portrait painter and a provider of decorative panels for the Adam brothers' new buildings. In a celebration of *The Nine Living Muses of Great Britain* by Richard Samuel, painted around 1779, Angelica sits at her easel in the temple of Apollo beside other luminaries of the age;[103] she herself became one of the founder members of the Royal Academy in 1768. Commissioned to decorate its Lecture Room, Angelica Kauffmann created four decorative allegories of the creative process itself – Design, Invention, Composition and Painting – and used herself as model for the idealized figures. They are no longer in Somerset House, then the seat of the Royal Academy, but were moved in 1899 to the ceiling of the entrance hall of Burlington House. Few people, passing beneath, are aware of the self-assertion, gently expressed and lightly executed, of these appealing images, which in their superficial form resemble any number of classicizing passive allegories of architectural ornament at the time.[104]

After her return to Rome in 1782 with her second husband, the Italian Royal Academician Antonio Zucchi, Angelica again went back to the theme, in a gay but felt variation on the topos of the Choice of Hercules, or the crossroads of life, when a decision between two equally inviting pathways must be faced. Often such paintings show a man hesitating between two allegorical seductresses, as in Veronese's painting in the

Frick Collection in New York showing Hercules between Wisdom and Strength; or Paolo de Mattei's treatment of 1712, of the same subject in the Ashmolean Museum in Oxford, where the hero hesitates between Vice and Virtue. But in Kauffmann's personal, light-handed reworking of the frequently solemn theme, *The Artist Hesitating between the Arts of Music and Painting* (compare Pl. 64), she represents herself in youth, not in her fifties as she was when she painted it; she remembers how when she was young she was as gifted musically as artistically, 'a brilliant young personage [who] sang beautifully, painted portraits as well as anyone, and was equipped with a brand of charm few could resist'.[105] In the picture she made of her youthful choice, the classically profiled Painting points imperiously to a temple on a distant hill, while Music droops her head winsomely but ruefully as Angelica gently disengages her hand from hers to follow the more arduous, perhaps, but in her view the more rewarding taskmaster.

Angelica Kauffmann took thorough pleasure, which she communicates to us through the vitality and freshness of her images, in the possibilities for self-portraiture that the tradition of personification opened to her. If, as the mythographer Giraldus wrote, Minerva was the mistress of arts, and if the Greek goddess was for the classicizing painters of the eighteenth century the sum of human accomplishments rather than a goddess demanding religious worship, then it was easy to identify a living prodigy, like Angelica Kauffmann, with the divine ideal of inspiration; and indeed it so turned out, as reveals an affectionate story attached to the portrait of Cornelia Knight, painted in Rome in 1793.

Cornelia and her mother were friends of the painter, and the portrait was a gift to the sitter, who was herself the author of several works, including the novel *Marcus Flaminius*, which Angelica shows in the portrait. She is dressed in the studiedly carefree style called 'en gaule', with loose curls caught by a fillet and a simple shift gathered under the bosom into a band. Originally, the cameo brooch that fastened it was painted with the head of Minerva. But, as Lady Knight wrote in a letter later describing the portrait to a friend, 'We got her [Angelica] to alter it and put in a medallion of Angelica's head lettered with her name. Famous as she is in all she does, yet this is said to be the very best portrait she ever painted, and pleases everybody.'[106] Her friends liked to see her in the place of Minerva; she did not demur.

The female allegories which press upon us more noisily today than Hildegard's and Angelica's are informed by a different spirit, and a

different appreciation of the potential of woman. When Prince Albert was overseeing the designs for the new Houses of Parliament, he made a small but significant change in the classical sculptor John Gibson's monument to Queen Victoria, which still stands in the Prince's Chamber of the House of Lords. Gibson had proposed that the enthroned queen should be flanked by seven-foot-high allegorical statues of Justice and Wisdom. It is a reflection of the pressure brought to bear on the representation of women in female allegory by notions of feminine virtue that Prince Albert suggested that Wisdom be replaced by Clemency, 'as the sovereign is a lady'. 'I was pleased with this idea', commented Gibson.[107]

Mercy, always associated with women, the special quality of the Madonna as intercessor, was also a legal prerogative of queens and noblewomen in the Middle Ages. As queen of an era preoccupied with mediaeval chivalry, Victoria was ascribed part of the ideal lady's character. Nevertheless an aspect was also denied her, partly perhaps because she herself was no Minerva, but also partly because expectations of female excellence had changed.

In the Middle Ages, the Wisdom figure and her manifold meanings had proved a vehicle of transcendence for women; in the early Renaissance, Christine de Pizan had invoked as an ally the goddess of learning and art, Minerva. But however great a virtue mercy is, Albert's substitution on behalf of his wife the Queen betrays all unthinkingly how drastically the great mediaeval image store of female definition and possibility had been depleted in the century which precedes our own and has done so much to shape us.[108]

PART THREE

The Body in Allegory

Bodies are a kind of oracle.
RUTH PADEL[1]

CHAPTER TEN

The Making of Pandora

> Got myself a crying talking
> Sleeping walking
> Living doll
> Got a roving eye and that is
> why she satis-
> fies my soul.
> Got myself the one and only
> Walking talking
> Living doll.
> Take a look at her hair.
> It's real!
> And if you don't believe what I say,
> Just feel!
> I'm gonna lock her up in a trunk
> So no big hunk
> Can steal her away from me.
>
> LIONEL BART[1]

In the *Iliad*, when Thetis 'of the silver feet', the divine mother of Achilles, flies to visit Hephaestus in his miracle-working forge, she is greeted by the god 'of the crooked foot' with delight, for she had given him refuge in the depths of the ocean when Hera, hating her crippled son, had cast him out. While he tidies up his tools, Hephaestus tells his helpers at the smithy to entertain his welcome visitor: 'Golden maid-servants hastened to help their Master. They looked like real girls and could not only speak and use their limbs but were endowed with intelligence and trained in handiwork by the immortal gods.'[2] Like Hephaestus' marvels, Pandora, the first woman of Greek myth, was also brought into being through divine art, made so perfectly she looked like a real girl, and then, unlike Hephaestus' servants, transformed into a human being, given life.

Homer does not mention the first woman; it is Hesiod who tells us her story in his two poems, *Theogony* and *Works and Days*. He calls her 'the manufactured maiden',[3] made in 'the image of a girl'.[4]

In *Theogony*, she remains anonymous, and Athena and Hephaestus are

concerned with making the 'modest virgin';[5] in *Works and Days* other gods, including Aphrodite, goddess of love, join them to create her, and then, because she has been given so much by the gods, she is also given her name, Pandora, 'all-gifts'.[6] But in both stories, the first woman, no matter how beguilingly beautiful and filled with modesty, deeply endangers man who has lived till then without her; in both poems, Hesiod tells us that when Prometheus the Titan stole fire from the gods to give to mortal men, Zeus was so angered that he decided to take a terrible revenge. Pandora, the first woman, represents that divine retribution.

She is the 'bitter gift of all the gods' whom Zeus told the craftsman god to make, like a statue, out of clay:

> He told Hephaestus quickly to mix earth
> And water, and to put in it a voice
> And human power to move, to make a face
> Like an immortal goddess, and to shape
> The lovely figure of a virgin girl.[7]

She is arrayed like a bride: Athena makes her a belt, with its connotations of sexual secrets, like the belt that the bride loosens on her wedding night, which in Athena's shrine at Sphaera on the Troezene coast, young fiancées dedicated to the goddess before their nuptials.[8] She clothes the first woman in 'robes of silver', covers her face with a veil 'embroidered cleverly', and crowns her head with spring grasses, and a golden crown made by Hephaestus.[9] Like Achilles' marvellous shield in the *Iliad*, which the god also forged, it is intricately wrought in illusionistic relief:

> Upon it many clever things were worked,
> Marvellous to behold: monsters which earth
> And sea have nourished, made to seem as real
> As living, roaring creatures, miracles.[10]

In *Works and Days*, Pandora is a similar marvel of Hephaestus' artifice, all allure and ornament, and adorned like a bride; *charis* (grace) is given her by Aphrodite, and the Graces, the goddess of love's followers, hang golden necklaces around her neck.[11] The name of Hephaestus' own wife is Charis, and when she greets Thetis in the company of the golden maidservants, she is wearing a 'shimmering headdress', made – by implication – by the master craftsman and goldsmith of the gods, Hephaestus.[12] The lame god's other divine bride is Aphrodite herself, of whom Charis is perhaps an emanation. As Charis is his bride, so Pandora, full of grace, is created by him to be the bride of men.

Pandora is a most subtle and complex and revealing symbol of the

feminine, of its contradictory compulsion and peril and lovableness. Aphrodite claims her for her sphere in *Works and Days*, and makes her the cause for men of 'painful strong desire, and body-shattering cares',[13] yet this first woman is the foster child of Athena too, the goddess of civic responsibility, who teaches her, in *Works and Days*, as she teaches the Phaeacian women in the *Odyssey*, the first requisite of the domestic woman in Greece, the craft of weaving.[14] Immediately upon her entry into the world, Pandora is taken to wife by Epimetheus, brother of Prometheus, whose original theft of fire inspired Pandora's creation in the first place. Indeed, in Greek the words for 'woman' and 'wife' are the same, *gyne*.

Prometheus warns his brother not to accept Zeus's gift, but

> Epimetheus,
> The foolish one, who first brought harm to men
> Who live on bread, ... took Woman in.[15]

Hesiod's ambivalence about women radiates far beyond his own personal misogyny. In *Theogony*, he calls her a *kalon kakon*, 'the lovely curse', literally 'the beautiful bad *thing*', a neuter word that yoked oxymoronically with 'beautiful' produces one of those detonations in a text that continue to reverberate centuries later.[16] In *Theogony*, this badness is the essence of Pandora's being; she cannot help but do harm. By merely existing, she brings suffering to man. But in *Works and Days*, Pandora's actions bring about disaster, for there Hesiod tells the famous story of 'Pandora's box', as it is known. Before her advent, men lived

> Apart from sorrow and from painful work,
> Free from disease, which brings the Death-gods in.
> But now the woman opened up the cask,
> And scattered pains and evils among men.[17]

Only Hope – Elpis – remains in the cask, to enable humanity to continue in the face of the world's evils.[18]

Pandora's 'box' is not a box at all in the poem, not a *pyxis* but a *pithos*, a large storage jar for wine or oil, the kind customarily kept in the cool darkness of the earth to preserve the contents fresh during the heat of summer. The *pithos* might refer indirectly to Pandora as a bringer of all gifts, including fruitfulness, and to her manifestation in Greek myth, before Hesiod, when she appears as an epithet of Ge or Gaia, Mother Earth herself.[19] One of the few surviving images in Greek art of Pandora shows her rising from the earth, her arms joyously upraised in greeting as Epimetheus her husband stands by to receive her (Pl.66).

But *pithos* is also the word that Homer uses of the jars of Zeus, in which he keeps the lots he distributes of good and evil among mankind, and therefore its presence in Hesiod's story of Pandora fits her role in Zeus's vengeful disposition of man's fate.[20]

Hesiod is the first writer to relate Pandora's act of opening the jar, but he assumes his audience knows the tale, for the jar suddenly appears in his text without explanation, as if an earlier preamble or description were unnecessary. Yet although the evils of disease, labour and pain pour out of the jar, it is still Pandora herself above all who is the 'ruin of mankind', an instrument who bears the blame for Zeus's vengeance.[21]

Hesiod's tirade against womankind need not detain us, except in one respect: Pandora is named by the same word as is used of the art that went into her making: *dolos*, trick. In *Works and Days*, the poet tells us that Zeus ordered Hermes 'to put in sly manners, and the morals of a bitch'; this done, 'the deep and total trap was now complete'.[22] *Dolos* is used by Homer for the net of fine mesh that Hephaestus made to catch Aphrodite and her lover Ares and hold them up for ridicule in front of all the other male immortals.[23] It is also the word used for the Trojan horse made by Epeius 'with Athena's help'[24] and guided by Odysseus, who is the special protégé, as we have seen, of the goddess of cunning, who is also the giver of gifts to Pandora. Pandora is made like a work of art, and she seduces through the arts that she has been given by the artist–creators, the gods and goddesses who made her. As Froma I. Zeitlin has written in an inspiring and brilliant essay:

> Fashioned at the orders of Zeus as punishment for Prometheus' deceptive theft of celestial fire for man, the female is the first imitation, who, replying to the first deception, embodies now for all time the principle of deception. She imitates both divine and bestial traits, endowed by the gods with an exterior of wondrous beauty and adornment that conceals the greedy and thievish nature of her interior. Artifact and artifice herself, Pandora installs the woman as *eidolon* in the frame of human culture, equipped by her 'un-natural' nature to delight and deceive.[25]

Pandora is a 'trap' for Hesiod because her beauty, desirability and her cunning speech entice hapless men into marriage; marriage itself, in Hesiod's poems, is an artful snare, a double bind, from which man can no more extricate himself in good shape than Ares and Aphrodite could disentangle themselves from the meshes of Hephaestus' net: he is faced by misery, as a husband, but also as a bachelor.

For although women in Hesiod can be drones who feed on others'

labour, ever-hungry bellies that have to be filled by the toiling and moiling of men, without them – Zeus in his furious wisdom intensifying the bane – without them, there can be no children:

> If a man avoids
> Marriage and all the troubles women bring
> And never takes a wife, at last he comes
> To a miserable old age, and does not have
> Anyone to care for the old man.[26]

On the other hand, if a man is fortunate, and is able to choose carefully and train a woman:

> No prize is better than a worthy wife.[27]

Pandora's birth, in Hesiod's poems, primarily inaugurates the institution of marriage, and only secondarily, by inference, the pleasures of sex; all her sly morals and bitchy manners are instruments, in this poet's view, of the inveigling wiles of women who want to get riches; a result of her appearance in the world is the mixed evil of matrimony:

> From her comes all the race of womankind ...
> Who live with mortal men and bring them harm,
> No help to them in dreadful poverty
> But ready enough to share with them in wealth.[28]

J.P. Vernant has penetratingly analysed the analogies between Pandora's arrival and the need for mankind to labour; before her coming, Hesiod tells us that wheat grew naturally, without need to cultivate the ground. But after woman's advent, man must sow his seed in more senses than one. Pandora is made from earth, and the recipient of this 'gift' that all men love and desire to their ruin retains the character of the stuff of which she is made; she must be ploughed and tilled and sown and tended. The enticement of her body leads to the work contract of marriage, not to erotic delights; in spite of Aphrodite's attentions, Pandora's bridal investiture by Athena and her train result in the economic and social unit, the husband at work, the wife at child-bearing; both subject to the evils let loose from the jar Pandora opened. Hesiod's view allows little room for carefree dalliance.[29]

Hesiod's message that sexual desire for a woman lies at the root of man's undoing inspired the later sexual misreadings of the myth, when the phrase 'Pandora's box' acquired its continuing highly erotic connotations. Apuleius began the confusion, which was disseminated by Lilius Giraldus, the sixteenth-century mythographer, who in his *De Deis Gentium* told Pandora's story with wistful relish, and lingered circumstan-

tially on Epimetheus' inability to resist her charms, in spite of his brother Prometheus' explicit warnings. He then elaborated the story of the opening of her box, with all its symbolic charge of surrendered virginity.[30]

Through the identification of woman's creation with the institution of marriage, this teleological view of her directly ordained purpose, the Greeks again came back to the characteristic difference between the gods and men, and between humanity and beasts, which they celebrated in their cult of Athena and the Gorgoneion on her breast. The gods could produce of themselves, by themselves; sexual coupling was not absolutely necessary to them, as it is to human creatures; the gods can engender their own children, like Athena and Aphrodite and others whose 'virgin' births are recounted in *Theogony*. And when it came to producing human beings prior union was not necessary at all, either for Hephaestus, who is Pandora's maker in Hesiod, or for Prometheus, who, according to other story-tellers, assisted the god in shaping the first men out of mud.[31]

The god of the forge and the bringer of fire are the first woman's makers; her mud is transformed by their element; she is fired by their fire. We know from Pausanias and Pliny that the cult statue of Athena by Phidias, standing in the centre of the Greek world, at the heart of their most important temple, had the birth of Pandora carved upon the pedestal.[32] In the world below, Pandora became the equivalent of Athena on Olympus: a god-made maiden, who never passed through infancy in a woman's care, and the sculpture stressed the relationship. (See front of jacket.)

The myth also distinguishes men and women, with their social institution of marriage, from animals who mate haphazardly, without stability and almost without consciousness. Athena, tutelary goddess of the city that saw itself as the fountainhead of law, had the first woman's story carved upon her pedestal because she had presided as mother at the inauguration, through Pandora's creation, of the specifically human institution of marriage, with its admixture of good and ill. Her cult guaranteed the wisdom and harmony of union. Just as the goddess protected Penelope in the votive bed of her union with Odysseus from the bestial depredations of the suitors, so she stands in a special relationship to Pandora who was made from the beginning as a wife.

With the coming of woman, progeny of single parents come to an end; after Pandora, all human beings must issue from the union of a pair, not from an integer, like Athena born of her father. This is the significant difference in another, later, story of spontaneous generation, in which Pyrrha, the daughter of Pandora and Epimetheus, takes the

role of creator alongside her husband, Deucalion. In Ovid's version from the *Metamorphoses*, Deucalion and Pyrrha, left alone in the world after the Flood, consult the oracle of Themis as to what they should do, and she tells them to 'throw behind you the bones of your great mother'. After a little while, they grasp that by this Themis means stones of the earth. They carry out the oracle's instructions and, walking forward, throw stones behind their backs: 'Who would believe what followed, did not ancient tradition bear witness to it?' asks Ovid.

> The stones began to lose their hardness and rigidity, and after a little, grew soft. Then, once softened, they acquired a definite shape. When they had grown in size, and developed a tenderer nature, a certain likeness to a human form could be seen, though it was still not clear; they were like marble images, begun but not yet properly chiselled out, or like unfinished statues. The damp earthy parts, containing some moisture, were adapted to make the body: that which was solid and inflexible became bone. What was lately a vein in the rock kept the same name, and in a brief space of time, thanks to the divine will of the gods, the stones thrown from male hands took on the appearance of men, while from those the woman threw, women were re-created.[33]

The issuing of children from the congress of man and woman is a law of nature; even the autochthonous creations of Pyrrha and Deucalion are made by the couple acting as a unit. Children who come in other ways – virgin births, like Jesus – automatically tell that they are not of our universe as we know it.

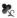

In the Bible, Yahweh works the lump of clay that is mankind too, though the dominant metaphor for his artistry is pottery, not sculpture. Isaiah begs him:

> Yahweh, you are our Father;
> we the clay, you the potter,
> we are all the work of your hand.
> Do not let your anger go too far.[34]
>
> (Isa. 64: 7)

In the Christian story of the first human creatures, it is the man, Adam, who is made of clay, as his name in Hebrew implies, and whom, like a lifeless statue, God animates: 'He breathed into his nostrils a breath of life, and thus man became a living being' (Gen. 2: 7). Eve herself is not made of 'dust of the soil' like Adam, but according to this second, scriptural story of human origin, she derives from him, issuing out of

his body, and not the other way round, the man coming from the woman, as in the way of nature:

> So Yahweh God made the man fall into a deep sleep. And while he slept, he took one of his ribs, and enclosed it in flesh: Yahweh God built the rib he had taken from man into a woman and brought her to the man. The man exclaimed:
>
> > This at last is bone from my bones,
> > and flesh from my flesh!
> > This is to be called woman,
> > for this was taken from man.
> >
> > (Gen. 2: 21–23)

The resemblances between Pandora, the first woman of classical myth, and Eve, the 'mother of all the living' in Judaeo-Christian story, are not complete, but they point to important aspects of our shared legacy. In both, the fashioned woman who is born beautiful to behold in her future partner's eyes is blamed for the distress that befalls humanity almost immediately after her advent; in both Genesis and Hesiod, her coming and the fall she unwittingly causes then establish monogamous marriage as the origin of children. The Bible says: 'This is why a man leaves his father and mother, and joins himself to his wife and they become one body' (Gen. 2: 24).

The thinkers of the early Church noticed the analogies between the two stories and commented on them. Tertullian argued against Pandora's claim to be the first woman,[35] and Tertullian's contemporary, Origen (d.254), made fun of Hesiod's tale of the jar that Pandora opened, while defending, against the pagan philosopher Celsus, the sophistication of the Genesis story, and its multilayered meanings.[36]

Painted interpretations of the scene of Eve's creation never attempt to represent the process, so clearly described by the Bible, of the Lord God enclosing the rib in flesh and building it into a woman. Instead, with the percipience so often shown by the unconscious of the artist, and communicated from one to another through shared images, Eve rises fully formed out of Adam's body. Wiligelmo's 1100–06 carving in the Duomo at Modena represents Adam's belly bulging in pregnancy;[37] in Bartolo di Fredi's lunette in the Chiesa della Collegiata in San Gimignano, painted in 1356, the opening in Adam's side is ovoid and outlined and fleshy, unmistakably resembling the vulva stretched in childbirth, while all about the rising woman and sleeping man the trees of Eden bear fruits and flowers in the same season, evoking the supernatural fertility of the scene. 'Come Dio fece la prima donna' (How God made

the first woman) runs the inscription, in Italian, not Latin, so that everyone could understand the miracle (Pl.67).

The story of the rib, derided by feminists and spoofed in the title of the magazine *Spare Rib*, represents the second Bible version of the creation of humanity, and of the institution of couples. At the very beginning of Genesis, 'God created man in the image of himself, in the image of God he created him; male and female he created them. God blessed them, saying to them, Be fruitful, multiply, fill the earth ...' (Gen.1: 27-28AV). The mismatch between the two stories was ingeniously mended in mediaeval Talmudic lore by a Jewish myth that the 'female' created by God in the first chapter of Genesis, the very first woman of history, was not Eve, but Lilith. Lilith is a winged female demon who preys upon children and visits sleeping men with dreams, and it was only after she had failed to suit that Eve was given to Adam as his wife:

> Adam and Lilith never found peace together; for when he wished to lie with her she took offence at the recumbent posture he demanded. 'Why must I lie beneath you?' she asked. 'I also was made from dust, and am therefore your equal.' Because Adam tried to compel her obedience by force, Lilith, in a rage, uttered the magic name of God, rose into the air and left him.[38]

When angels threatened her that if she did not return to Adam at once a hundred of her sons would die daily, Lilith crowed, since strangling new-born babies was her sport. An unnatural mother, and a clear case of fantasy inversion, Lilith struck fear into Jewish families well into the High Middle Ages, and amulets giving protection from her were hung around the necks of babies.[39]

Lilith, a succubus who links the contradictions between Genesis 1: 27 and Genesis 2: 21-23, turns upside down the figure of the fatal and fated mother of us all; in Lilith's case, rather appropriately, she literally refuses to stay the right way up, that is beneath him. The equality she claims is grounded in the identical material from which they were made at the same time; the Jewish myth of Lilith thus confirms the traditional view that the later story of the rib gives Adam precedence in creation, tantamount to primacy and authority.

His power to name the first woman follows: he gives Eve her identity as the mother of all living (Gen. 3: 20) after they have eaten the apple, after childbirth (in suffering) and toil (in the sweat of thy brow) have entered the world, just as they did with the making of Pandora and the union of man and woman in Hesiod. Eve, in contrast to her imagined predecessor, Lilith, accepts to be subordinate to Adam, to come second,

and to obey; 'Your yearning shall be for your husband, yet he will lord it over you' (Gen. 3: 16).

Eve and Pandora, the first women in two traditions that are intertwined in our history, are both 'subject matter', with both terms in that phrase to be taken at full force. Like Eve, Pandora too is made, does not name herself, and inspires desire rather than experiences it. They are both subject too not in the sense that they have been given a voice to speak with in the first person, for their subjectivity is in fact denied them. Rather, they are given a character by their authors, by the deities and men who take on a mother's role in making them. They become, in the verses of Hesiod and the Yawhist, the primary matter from which all humanity finds its origin, the very first mothers of men and women. At the same time, with the social institution of marriage, seen with jaundiced eyes by both the Greek and the Jewish writers, that primacy is changed into subjection, by the explicit command of God in Genesis, by the implications of authority, however bitterly and ambiguously experienced, in Hesiod's view of the first husband, the householder.

Among the many authors who, during the Renaissance and after, drew the comparison between Eve and Pandora, Milton is the most famous, in *Paradise Lost*:

> Here in close recess
> With Flowers, Garlands, and sweet-smelling Herbs,
> Espoused *Eve* deckt first her nuptial Bed,
> And heav'nly Quires the Hymenaean sung,
> What day the genial Angel to our Sire
> Brought her in naked beauty more adorn'd,
> More lovely than *Pandora*, whom the Gods
> Endowd with all their gifts, and O too like
> In sad event, when to the unwiser Son
> Of *Japhet* brought by *Hermes*, she ensnar'd
> Mankind with her faire looks, to be aveng'd
> On him who had stole *Joves* authentic fire.[40]

The poet here finds the beauty of Pandora and Eve the cause of later tragedy; woman is an occasion of sin and an agent of fatality through the desire she inspires, not experiences.

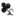

Helen, wife of Menelaus, King of Sparta, whom Paris abducted to be his bride in Troy, belongs alongside Pandora and Eve, as another beauty who brings about tragedy; she was the cause of the Trojan War, she

herself declares in the first of many poems that talk of her, the *Iliad*, when she says to Hector, as we have already heard, 'No one in Troy has a greater burden to bear than you, all through my own shame and the wickedness of Paris, ill-starred couple that we are, tormented by Heaven to figure in the songs of people yet unborn.'[41]

Helen sees herself as the subject matter of song; in the *Iliad*, we also see her weaving, and in the tapestry she is binding together as story the fragmentary and swiftly passing happenings of the very war which is in the process of being fought on her account.[42] Like the poet, she is making the stuff of the poem itself.

In the *Odyssey*, Helen, who has reformed and returned home to Menelaus from Troy, soothes the company by drugging their wine, 'with the power of robbing grief and anger of their sting and banishing all painful memories'.[43] She casts a spell over them with her potions and her beauty – and then proposes that the company weave more illusions, that they 'tell tales'; she is a mistress of ceremony, and stories are part of the ceremony. When she opens the proceedings she chooses to tell a tale which expressly aligns her with power over deceit and masks: she describes how she pierced through Odysseus' disguise as a beggar.[44] Then she elicits other tales, turning first to Menelaus.

He describes how Helen walked around the Trojan Horse, imitating the voices of the wives of the men hidden inside in order to lure them out.[45] As a mimic of other women in this disturbing story told by the husband who knows her powers of enchantment, Helen reflects her role in the *Iliad*, where her identity, as the universal femme fatale, is fabricated at the gods' pleasure, and where she becomes, even more than most Greeks, an instrument of fate. In obedience to the jealousy of Aphrodite, Helen is made her tool, and has to behave according to the goddess of love's caprices, against her own love for Menelaus, her home and her child. Helen becomes, willy-nilly, an enchantress whose volition is no longer under her control, but taken over by the gods, in order to precipitate the fatal elopement and the Trojan War.[46]

Although Homer's Helen possesses beauty, and the powers of deception and transformation, which the Greeks held that art also possessed, she remains a woman in the epics, not an artefact. But in the play *Helen*, an oddity among Euripides' works for its high-spirited sense of comedy and cross-purposes, the plot makes explicit the analogy between Helen and art. In the opening speech, Helen, exiled in Egypt, tells us that she has lived there throughout the Trojan War, and that 'Hera, baulked of her victory over the other goddesses, in her resentment turned the substance of Aphrodite's promise into air. She gave the royal son of Priam

for his bride – not me, but a living image compounded of the ether in my likeness. Paris believes that he possesses me: what he holds is nothing but an airy delusion.'[47] When Menelaus enters the scene, shipwrecked in the Nile Delta as he toils homeward to Sparta, he sees Helen; and their exchange can be read as a comedy of mistaken identity in Shakespeare's most good-humoured vein:

> M: Who are you? Whose face am I looking at?
> H: But who are *you*? We are both in the same perplexity.
> M: I never saw anyone more exactly alike.[48]

Later she explains, 'I did not go to Troy. That was a phantom.'[49] The word used is *eidolon*, the same Homer uses for Athena's disguise in human shape, when she comes to Penelope in a dream as her sister, and also of the double of Aeneas Apollo creates to deceive the Greeks after he has spirited the real Aeneas away to safety.[50]

The *eidolon* of Helen then bears the blame for the war; and Helen herself is exonerated. The play pictures her isolated, a Penelope-like figure, steadfast and chaste, resisting unto death the pressures of the local Egyptian ruler to marry her – an icon of virtue. Euripides, vindicating the real Helen and portraying the Greeks in Troy fighting for a phantom, was attacking the Sicilian wars that the Athenians had disastrously mounted in 416 BC, which had come to a terrible end in 412 BC. His virtuous Helen dignifies peace and domestic harmony, against strife and vainglory. At the same time, Euripides is making a point about images and their powers to enchant. Helen, in the *Iliad*, works at the web of her own story, and makes herself the subject of art in which she is the object of desire; the stories of Eve and Pandora, Helen's prototypes among femmes fatales, oscillate around the same confusion, that they cause others to feel and to act, and become the centre of stories in which they play a secondary and passive, almost autistic part; they are subject matter, reified in the minds of others who perceive their beauty, their desirability and their dangerousness.

Pandora, Eve and 'Helen of Troy' in Euripides' play are all made; their stories express an understanding that they bear meanings ascribed to them by their creators, that their identity is perceived through the eyes of others, not their own. This is the condition of beauty and of being the object of desire, a form of profound Otherness that Simone de Beauvoir analysed so inspiringly as the condition of the Second Sex.

At the heart of this web of symbols, where woman as *fons et origo* and woman as a manufactured maiden are assimilated, where woman as original matter and woman as artefact become interchangeable terms in

the discussion of the creative act in life and art, we can find the source of the tradition of ascribing meaning more readily to the female form than the male. The female was perceived to be a vehicle of attributed meaning at the very beginning of the world, according to the myths that lie at the foundation of our lives, ever since she was made in all her allure as man's fatal partner. Eve did not have the power of naming in the garden; if she had been granted such a power, then Adam might himself have become subject matter and the form on to which Eve could have projected meanings as she wanted.

The objection can be put that Adam is made of earth, so is matter too, that he too is cursed to return to that dust from which he came; that meanings have also been attributed to the male form, and symbolic dimensions have effaced men's individual natures. At the centre of Christianity, after all, there stands the apotheosis of the body as symbol, Jesus, the new Adam.

But in reply it can be said that Jesus, contained inside his specific and circumstantial narrative, never loses particular definition as a single personality, however boundless the symbolic reverberations of that story and that personality are. Mary his mother, for instance, possesses protean powers of transformation into plural identities and presences until her specific historical figure vanishes into a complex and richly symbolic fabric in which contradictions of all kinds may occur, even about her birth and her death. The female form tends, as we have seen, to symbolic interpretation; the male resists anonymous universality more robustly, and often manages to retain individuality even while calling higher things to mind. If fishermen had brought up from the sea off the coast of Calabria two naked female figures instead of the two male nude bronzes of Riace, the masterpieces of ancient Greek sculpture found in 1972, archaeologists would probably not have debated *who* they were – victors in the games? heroes modelling as gods? – before arguing that they represented the heads of the ten tribes of Attica.[51] The female nudes of Greek sculpture are images of generic feminine eroticism and the individuals who posed for them are rarely credited with an historical identity or retrievable from oblivion.

The definition of woman partakes of the definition of art: both are beautiful and exercise fascination. Hesiod, in his spleen, declares woman's charms counterfeit in the same way as later Plato warned against the illusion of images. Even though the centuries separate them and again separate us from them, we share in the iconodulia of the Greeks. The worship of beauty, especially the physical beauty of the human body, inspired in the fourth century BC a type of idealized realism that then

held sway over the Renaissance, especially influencing neo-platonism in Florence. The classical Greeks admired *enargeia*, pictorial vividness, above all; the wonder-working powers of Hephaestus, blurring the distinction between creature and artefact, between life and art, mirror the concentration on lifelikeness in the Greek aesthetic. The ideas of divine generation and artistic craft were intimately connected. Pindar, for instance, in the seventh Olympian ode, combines in a single poem the birth of Athena from the head of Zeus with the making of figurative statues.[52]

The ode celebrates the island of Rhodes, birthplace of the poem's dedicatee, Diagoras, a winner in the boxing games. Pindar invokes the island's blessedness in the eyes of the gods by a startling synapsis, as he closes the gap between two distinct events. In mythic time, Rhodes was made rich by Zeus:

> The great King of the Gods
> Soaked a city in golden snowflakes...[53]

Then he intensifies the force of this direct Olympian benediction by making it coincide with a far more momentous event, the advent of Athena herself. Both happen simultaneously; the oneiric sequence of images suggests that Zeus's boon of golden snow flew from his body just as Athena leapt from his head, the two linked by 'the craft of Hephaestus', who wielded the axe:

> The great King of the Gods
> Soaked a city in golden snowflakes,
> When, by the craft of Hephaestus
> And his bronze-beaten axe, from the top of her Father's head
> Athena jumped out, and cried with a monstrous shout.[54]

Pindar returns to his image cluster later in the ode, reminding us that Zeus's 'tawny cloud ... rained much gold', and then passing on to describe Athena's special legacy of gifts to Rhodes's craftsmen, famed for their skills in her domain of manufactures and art:

> And the Bright-Eyed One gave to them
> Every craft, to surpass earth-dwellers
> In hands most skilful at labour.
> Streets carried their works like to living
> Creatures and walking: and deep was their glory.[55]

The 'works' (*erga*) are like 'living creatures' (*zooisin*), capable of movement. The Rhodian master craftsmen whom Athena blessed possess, Pindar suggests, that power to make creatures like Hephaestus' 'golden maidservants', to simulate life itself. The imagery of the verses taps the

energy of the word *zo*, 'live', and 'quick' as opposed to dead, which gives *zoon*, for a living creature (hence our 'zoos'), and also significantly verbs meaning to propagate, to engender and to sculpt.[56]

According to one Greek myth about craft and the illusion of art, Rhodes was the home of the Telchines, nine dog-headed flipper-handed metalworkers, who forged both the *harpe* Kronos used to castrate his father Uranus and the trident of Poseidon (which the god of the sea later yielded to Britannia).[57] Although they only appear by name in sources later than Pindar, the poet may have had them in mind when he praised Rhodian wizardry, for the Telchines were the first artists to make images of the gods. As inventors of sacred icons, they make fitting wards of Athena, herself born fully fledged, like a work of art, at the hands of Hephaestus, god of craftsmen.[58]

After describing the Rhodian craftsmen's wonders, Pindar issues a warning: 'Art is better without guile', he says.[59] He shows there a typical unease about art's capacity to deceive, which went hand-in-hand with the Greek appetite for prodigies of realism; in the same way as they appreciated loveliness like Pandora's and were also filled with anger at its power. Yet the cult of lifelikeness later inspired several legends about artists' powers to imitate or even surpass nature: the famous sculptor Myron, it was said, was so skilled that calves lowed at his cow, and one died for want of nourishment from her bronze teat.[60]

In Pliny, the painter Zeuxis earned his fame too through miracles of illusionism: he painted a bunch of grapes so faithfully that birds flew in to peck at them. His rival, Parrhasius, was not to be outdone, and painted an image of a curtain. 'Zeuxis, proud of the verdict of the birds, requested that the curtain should now be drawn back and the picture displayed. When he realized his mistake, with a modesty that did him honour, he yielded up the palm, saying that whereas he had managed to deceive only birds, Parrhasius had deceived an artist.'[61]

Pygmalion, the hero of Ovid's story in the *Metamorphoses* about art and the female model, creates an exact simulacrum too; but in his case the image's lifelikeness ceases to be mere semblance.[62] Ovid does not mention Pandora, though Hesiod's poems were known throughout the classical period of Rome; he may even have invented the story of Pygmalion, as no earlier version has come down to us.[63] But the stories share interesting points in common.

Pygmalion was a mysogynist who repudiated all ordinary women because he was disgusted by the behaviour of public prostitutes. Instead he made himself a statue 'with marvellous artistry', and it was 'lovelier than any woman born'. He used ivory, the material conventionally used

to depict the flesh of goddesses in antique sculpture like the metopes of Selinus or the Phidian Athena. Being of animal origin, ivory has a greater affinity with animate life than mineral substances, stone or metal. Like Pandora, and the golden maidservants of Hephaestus, Pygmalion's creation 'had all the appearance of a real girl', but was as beautiful as a goddess. Indeed in some accounts it was an image of Aphrodite Pygmalion imitated from one of the naked cult statues that began to be sculpted in the fourth century BC. Ovid lavishes on Pygmalion's work the same praise as Zeuxis and Parrhasius earned: 'It seemed to be alive, to want to move, did not modesty forbid, so cleverly did his art conceal its art.' He falls passionately in love with the statue, his own creation, the daughter of his mind, and caresses and fondles and kisses it, imagining that it reciprocates. He brings his idol presents and jewels, and dresses her up, rather as Athena dressed Pandora. Finally, he takes the statue to bed with him.

At a festival of Venus that takes place soon after this, Pygmalion prays fervently to the goddess that he may be granted 'the ivory maid' for a wife. When he returns to bed that night, he finds the statue warm to his touch. 'The ivory lost its hardness, and grew soft.' Ovid now opens the implicit analogy with artists' procedure: 'Just as wax of Hymettus melts in the sun and, worked by men's fingers, is fashioned into many different shapes, and made fit for use by being used,' she begins to live. Pygmalion is amazed, but 'it was indeed a human body!' Gradually, under his caresses and his kisses, she becomes animate. 'Timidly raising her eyes, she saw her lover and the light of day together.'[64]

Ovid does not name her; later writers called her Galatea, like one of the nymphs. She mediates between the world of image-making and the creation of life; she is not altogether an *eidolon*, a phantom, like Euripides' Helen in Troy or the shapes the gods take on to deceive men, or the substanceless shades of the dead whom the living cannot embrace – the ghost of Patroclus in the *Iliad* or the shade of Odysseus' mother in the *Odyssey*; unlike them she is made of material and tangible stuff; but she does not possess life. When she steps out of illusion into reality through her creator's desire, she fulfils the delusory promise of art itself, the nearest equivalent to generation in the single, uncoupled manner of the gods that a man can reach.

Ovid's *Metamorphoses* were a source of widespread inspiration in the Middle Ages. *Le Roman de la rose*, the thirteenth century's great poem, included a version of Pygmalion's story, by Jean de Meung, filled with all the energetic sensuality that brought him into such contumely with Christine de Pizan and Jean Gerson. His Pygmalion, a celibate like

Ovid's, is simply the best sculptor in the world who, to amuse himself, makes an ivory statue. As she outshines Helen in beauty, the poor man finds himself in love, suffered with all the tears and laughter, dreams and delirium that the mediaeval poet traditionally describes; he dresses her in costume after costume, each finer than the next, and bedecks her with jewels, but he always leaves her face uncovered – unlike the Saracens, Meung comments. He dances, sings, caresses, kisses, takes her to bed, to no avail:

> Ainsinc s'ocit, ainsinc s'afole,
> Seurpris en sa pensée fole,
> Pygmalions li deceüz,
> Pour sa sourde image esmeüz

(So he drives himself to death and madness, possessed by his crazy idea; Pygmalion is deluded, overwhelmed by his deaf image).[65]

At last, he prays to Venus, and she, delighted that a young man of hitherto pure life should now be filled with lust, treats him 'like a repentant sinner', and sends a soul to enter Galatea and bring her to life.

Stories of statues of women coming to life can be found in folklore from Finland to North America to Babylon.[66] One widespread folk-tale is cast as a riddle: a woodcarver carves the doll, a tailor makes her clothes, and a gardener gives her speech, to whom does she belong?[67] In this folk-tale the creator's role is split three ways, and creation is seen as possession, since the aim of desire, with its life-giving powers, is construed as appropriation. The famous children's story *Pinocchio*, written as a serial by Carlo Collodi in 1883, extends the fantasy of these folk-tales. Geppetto the woodcarver is an old man, and he longs for a child of his own; he makes a marionette, and through his love infuses it with life.[68] The carver is mother, and father, to the doll, with authority over it. In late nineteenth-century Italy, it was perhaps a stronger dream for a poor workman to possess a son and heir than to have a woman; it was certainly more acceptable to the newspapers who published the strip as children's literature. In this case, Pinocchio also remains made of wood, and does not quicken into flesh like Galatea. Part of the story's pathos lies in the marionette's longing to become a real child, and his inability to do so until the end.

In the earlier story *Frankenstein* (published 1818), Mary Shelley consciously tapped the mythic potency of the tale – she subtitled her book *The Modern Prometheus* – when her hero brings a man to life by assembling him from dead flesh and then, like a god, animating the whole. Like his classical forebears, Frankenstein begins to fashion him a mate,

but destroys this second creation in disgust. As in the story of Pygmalion, the creature's name has no importance; indeed, in the same way as slaves in North America were known by the name of their masters, Franken-stein has given his to his creation; the latter lacks the power to name himself and is thus marked out as subordinate, like Eve. Mary Shelley's tale of horror was possibly inspired by her traumatic knowledge that her own mother had died giving birth to her; the mystery of procreation realizes in her novel one of its most perturbing nightmare visions, en-thralling in different forms readers and audiences ever since it first appeared.[69]

In another group of popular stories revolving around the theme of the living image maker, victim or lover are not one and the same, and the statue's irresistible charms lead to destruction. Pliny tells us that the Cnidian Venus of Praxiteles was so lifelike that a man enamoured of her beauty stole into the temple one night. The traces of his profanation could be seen on the marble.[70] Famous mediaeval variations on a story from William of Malmesbury dramatize the thraldom of a youth to a statue, of Venus in some cases, of the Virgin Mary in others. In Gautier de Coincy's early thirteenth-century French version, a young boy is playing ball near the doors of a church and, not wanting to damage the ring given him by his beloved, looks for somewhere to put it safe, and catches sight of a statue of Mary, 'Qui toute estoit fresche et novele' (Which was all fresh and new). He falls to his knees at her loveliness, renounces his earthly love and proclaims himself Mary's bondsman:

> Car onques mais ne remirai,
> Dame, meschine ne pucele
> Qui tant me fust plaisans et bele,
> Tu iez plus bele et plus plaisans
> Que cele n'est cent mile tans
> Qui cest anel m'avoit doné.

(For I have never seen, Lady, young girl or virgin who was as pleasing and lovely. You are a thousand times lovelier and more pleasing than she who gave me this ring).[71]

Fatal words. The beauty of stone puts out her hand and closes on the ring he slips on her finger so firmly – 'si durement' – that no one could ever prise it loose again. The boy screams in fright; everyone runs up, tells him he must now leave the world and serve Mary as a hermit. But he forgets his promise, and marries the lady who first gave him the ring. The night of his wedding, all desire abandons him; he falls asleep.

Whereupon the statue slides into bed between him and his wife, it seems to him, and reminds him of his vow. He wakes up in fright, again tries to make love to his bride, and provokes the fearsome rage of Mary. She appears 'orrible, fiere et desdaigneuse' (dread, proud and full of contempt) and covers him with abuse:

> Bien t'ont dyable fannoié
> Et avullé, fait Nostre-Dame,
> Quant tu por ta chaitive fame
> M'as renoïe et degerpie.
> S'en la pullente pullentie
> De la pullente t'enpullentes
> Es santines d'enfer pullentes
> Seraz pullens enpullentés
> Por tes pullentes pullentez.

(Demons have really taken possession of you and blinded you, said Our Lady, that you can reject and repudiate me for your wretched wife. If you befoul yourself with the foul foulness of that foul creature, you'll find yourself foul too, befouled in the bottom depths of foul hell for your foul foulness.)[72]

No wonder the youth leaps out of his nuptial bed.

The story's ending is sad, for in obedience to the edifying message that heavenly dedication is better than earthly love, the boy flees his wife and the world for a monastery.

In *The Winter's Tale*, Shakespeare radically transformed these old tales of statues coming to life in the powerful final scene, when Hermione is revealed to her husband Leontes as a work of art. Sixteen years before, Leontes had cruelly imprisoned Hermione after falling into a jealous fury. Her friend Paulina, the almost magician-like instrument of wisdom in the play, is looking after Hermione in secret, but tells him that Hermione has died. He realizes his wrongdoing and repents bitterly of his folly and violence. But then Paulina concedes that she can at least show him Hermione's likeness. It is described as:

... a piece many years in doing, and now newly performed by that rare Italian master, Julio Romano; who, had he himself eternity and could put breath into his work, would beguile Nature of her custom, so perfectly he is her ape: he so near to Hermione hath done Hermione that they say one would speak to her and stand in hope of answer.

(Act v, Scene ii)

When Paulina draws back the curtain on the statue, Leontes is struck dumb with wonder, and exclaims:

> Her natural posture!
> Chide me, dear stone, that I may say, indeed
> Thou art Hermione.
>
> (Act v, Scene iii)

When he remarks, with some pathos, that his wife was 'not so much wrinkled', Paulina explains that the sculptor's art so excels he has shown her 'as she liv'd now'. Perdita, Hermione's daughter, wants to touch her, and the others present wonder in more and more excitement at her lifelikeness. Paulina then says she wants to draw the curtain across,

> lest your fancy
> May think anon it moves.

Leontes prevents her. In a transport of hope he proclaims his determination to hold and kiss the statue. Paulina prevents him:

> The ruddiness upon her lip is wet:
> You'll mar it if you kiss it; stain your own
> With oily painting.

But, seeing his love aroused, she promises to conjure more 'amazement', and make the statue move. She calls out:

> Music, awake her: strike!
> 'Tis time; descend; be stone no more: approach.

The polychrome statue comes to life, and Hermione steps down and into Leontes' embrace. He cries:

> O! she's warm.
> If this be magic, let it be an art
> Lawful as eating.

With the restoration of Hermione to Leontes' love, and the marriages of Perdita and Paulina to appropriate suitors, the play ends in a garland of weddings, Shakespeare's happiest manner of comic conclusion.

But it took Shakespeare to ring the crucial change on the old story and give it a profound significance for the figure in the statue and not just for its maker or beholder. Hermione does not achieve her identity through Leontes' imagination; he is compelled to recognize her true worth and loyalty and goodness as an independent being outside the fantasy of jealous love that made him suspect her in the first place. Her survival in secret after her reported death guarantees her separate existence from the husband she loves, and gives her a liberty that Paulina captures when she exhorts Leontes,

> present your hand;
> When she was young you woo'd her; now in age
> Is she become the suitor!

This fulfilment is reached through the fiction of the statue; Paulina, an embodiment of unswerving good heart and truthfulness, uses the deception of art to make manifest Hermione's virtue.

Statues representing the virtues were very familiar at the time, as Shakespeare himself confirms with Viola's famous metaphor for the lovelorn: 'Patience on a monument/Smiling at grief'.[73] Paulina uses traditional iconography to reinstate Hermione, whom she considers a paragon of virtue. Recalling another legend about the painter Zeuxis, that he took elements from five different beautiful young models to create a perfect image of Helen of Troy,[74] she adapts the metaphor with regard to Hermione when she says to Leontes:

> If one by one you wedded all the world,
> Or from the all that are took something good
> To make a perfect woman, she you kill'd
> Would be unparallel'd.
>
> (Act v, Scene i)

In Shakespeare's source, Robert Greene's prose romance *Pandosto* of 1588, the story of the statue does not appear, and the queen, the origin of Hermione, does not survive her husband's wrath. By his addition Shakespeare gave an altogether new twist to the myth of a statue quickened and to its usual import, that males can control and own their objects of desire, generated through art. He turns the story inside out, to show a woman exercising control of her own significance in the eyes of others. Hermione, reified by Leontes as a fallen woman, daughter of Pandora and Eve and Helen, consigned to Otherness, can step out of the illusion of art into the autonomy of existence, and there – although Hermione herself is still bounded by the illusion of Shakespeare's play itself – can begin to control herself as subject matter. This reversal of the customary use of personified desires, in statues or other images, is entirely characteristic of Shakespeare's breadth and the generosity of his imagination as he inhabits his heroines' spirit. Hermione and Paulina are unusual, but not alone, in turning the language of art to their own advantage, which in their case coincided with the service of truth.

In his beautiful picture *The Art of Painting*, of around 1665 (Pl.65), Jan Vermeer also meditates on the interplay of ideal and actual within a single female figure, and addresses directly, with gentle intelligence and

sensitivity, the relation of artist and model, painter and living muse.[75] This teasing and sublime painting slips from one level of unreality on to another and back again through a cascade of internal images within images that conjure reality in different modes. It shows an artist from the back, sitting before an easel. He has just begun painting: the first elements of his model's garland of blue-green bay appear under his hand, which rests on a mahlstick. Her body has been sketched, in a few brush lines on the canvas. His head, even from the back, can be seen to be turned to gaze upon his model; she stands to his left, just to the side of a table on which are scattered an open sketchbook, a cast of a colossal male mask, a large bound book, and some gilded and grey silk lengths of cloth. These are the standard props of studio fiction, either deliberately cast aside, or about to be assumed for another painting, and thus highly suggestive of the task of reconstructing a transient, impermanent, and immaterial past in imagery. The model stands near this evocative flotsam with the precise stillness of a pose; Vermeer has actually managed to catch her immobility as the subject matter of his painting, an immobility that will not be caught, we know, in the lifelike image that the artist will commit to his canvas. The girl there will look as effortlessly present as possible, all trace of the labour that went into the making of her image will be erased.

One of Vermeer's recurring models, she stands before the artist in fancy dress, with her decorative and unruly garland of bay leaves lightly placed on her fair ringlets, carrying Fame's trumpet in her right hand, and in her left the heavy book of Recorded Time, bound in yellow vellum; she wears a drape of the blue sheeny silk like a shawl that Vermeer has rendered with his usual sparkling attention to effects of lucency, falling over a full dress of heavy yellow stuff bordered in a deep chocolate braided hem that just skirts the chequer-tiled marble-veined floor. The big book on her arm and the bookish and archaeological litter in the studio identify her as Fama's cognate, History, and History's Muse, Clio, following a tradition established as early as the twelfth century, when the abbess Herrad of Hohenburg, itemizing the nine Muses and their functions, began with 'Clio id est fama' (Clio that is fame) and then designated 'hystorie' as her sphere of influence.[76]

Vermeer's painting concentrates on the nature of art; he reminds us of the artificiality of image-making itself by drawing aside a heavy rich tapestry curtain to disclose the scene in the studio as if it were a tableau in a stage setting. He is painting an allegory as it really is, not as it claims to be, and in so doing reveals the dimension of allegory in painting itself. The artist is oddly dressed in a self-conscious costume, a hat of black

velvet on his dishevelled long hair, a doublet, elaborately slashed at the elbows and across the entire back, over a white shift, enormous brown-black velvety-looking pantaloons, red underhose, fallen white hose and heavy black-tongue shoes. His apparently dressy outfit has proved difficult to place historically; but it would seem that Vermeer, who often used studio costume, intended to distance us from his subject and sharpen the pleasant complications of the painting. He alludes to himself at work on the picture we are beholding, and simultaneously refuses the identification by portraying the painter in clothes that Vermeer would only have worn as fancy dress. Thus he tantalizes us with the possibility of a self-portrait, to which he then refuses to commit himself, both by turning his back and by donning a disguise.

The studio we see may or may not exist as the artist's own, and the girl posing in it may be a real model, as well as an allegorical figure and the insubstantial sum of the paint that makes her visible. But this play of reality and unreality by no means exhausts the limits of Vermeer's cunning. On the wall behind Clio's head, a map hangs; it has been painted with the famous patient verisimilitude of the Dutch masters, as a replica of contemporary cartography, with topographical views on either side. The map that has been so assiduously achieved in breath-taking lifelikeness bears no less than five coats of arms or cartouches, and four of these are held or surrounded by bearers and supporters. Many of them, though not all, are emblematic figures, like Fama who stands to be painted. In the top left-hand corner the arms of the Seventeen Provinces are supported – in an almost invisible self-reference – by Art, with palette, brush and a scroll with a view of the city, and by Science, with cross-staff and compasses.[77]

Thus we are tumbled, with incomparable serenity, through the illusion of the whole painting to the illusion disclosed by the curtain of a young girl. But she too is pretending, and the disclosure of her as the allegorical figure of Clio/Fama is itself another illusion, as she poses for the promised Clio/Fama who will materialize on the almost empty panel that stands on the painted easel. The painting contains still more fictions: the simulacrum of the map has its authenticity strongly confirmed by the many seals of provenance it wears, situating it in real history and time; those seals and coats of arms are supported by allegorical figures who represent, just as the model in the studio makes us believe she stands for something else, the provinces, the cities, and their qualities which also appear, in another order of reality, in the naturalistic 'photographic' views by the side of the map. The complexities increase if you try and imagine how the painting was made; it asks us to imagine Vermeer

painting from an image reflected in a pair of mirrors, in order to portray himself from the back. He could then see the model in front of him, and her reflection in the mirror in front of his easel, in which her image, passing through two mirrors, would not be reversed either; but the mirror itself does not appear in the painting. This is Vermeer's one concession to the deception of art.

As Svetlana Alpers has observed in her masterly work, *The Art of Describing*, Vermeer, by juxtaposing his faceless presence with the luminous, peachy loveliness of his model, pays unequivocal tribute to her autonomous life;[78] her smiling personality escapes the constrictions of costume, stillness, pose, the fiction of allegory itself, and the ownership of the artist. She remains one of the women whom Vermeer in his art constantly observes in their own secular settings, absorbed in some task – reading a letter, playing an instrument – while a man attends them as the painter here attends her too.[79]

Coming back from behind Vermeer's sturdy plastered wall, with its eroded surface so sensuously shaped by the shadows of the nails from which the map hangs, we pass through the looking glass of artistic practice. But the journey soothes the imagination, by its frank and joyful improvisation on the theme that in art play-acting is always necessary to make the world visible. By communicating so much, Vermeer's picture also petitions that immortality, the undying fame represented by the model, be granted to the painter who is his *alter ego* as well as a figure of the universal Artist.[80] Thus the relations of power between the woman as subject matter of art, as beloved partner and muse, are used in this work by Vermeer as an analogy of the artist's future possession of fame and mark in history, if he respect the subject's complex and separate integrity; a proud, prophetic claim, since Vermeer's fame is bound up with this, one of the most beautiful and celebrated of the few paintings that have come to us from his brush.

From 1800, when the study of Greek and Latin spread through the grammar and the public schools in Britain, the stories of Pandora and Pygmalion, and the consequent identification of mastery and art, gained a greater popularity than they had ever enjoyed, even during the Renaissance in Italy, when classical learning was still the privilege of a small humanist group. The consequence of children's exposure to the myths of Greece and Rome can only be imagined, but alongside Christianity there existed an ethical and secular cult of personages, divine and other, who were very unlike Jesus in their adventures and temperament, though reverence for the classics accorded them exemplary status, as we

have seen. The myth of Pandora provided a canonical Greek confirmation of nineteenth-century ambivalence about women; it furnished a classical scripture for women's powers, held by them but not controlled by them. Pandora becomes the subject of paintings, like James Barry's colossal and earnest canvas now in the Manchester City Art Gallery, which was painted around 1791–1804. Unfortunately it confirms the view that Barry is a great painter manqué, all the more manqué for so desperately striving to be great.[81] Sir John Soane commissioned another faithful depiction of Hesiod's text for the ceiling of his library in Lincoln's Inn Fields, now the Soane Museum, in 1834, from another Royal Academician, Henry Howard. It shows the creation of Pandora on one side, the fatal opening of the vase on the other. Harry Bates's sculpture of 1890 in the Tate Gallery depicts Pandora naked, gazing raptly at the ivory and gold casket before she opens it. On its lid, she herself is represented lying asleep, poised between non-being and being, on the threshold of existence, as she is borne to earth by a horse-drawn chariot. This was a favourite theme of Bates, associating Pandora's entry into existence with sculpture's condition of inanimate but lifelike existence.[82] The model for John William Waterhouse's Pandora of 1896 has been negligently draped in an unmistakable studio prop, an embroidered shawl, with her shoulders and feet bare. Her lips as she peeps into the casket are parted in clear sensual expectancy.[83]

In Prosper Mérimée's famous short story *La Vénus d'Ille* (1837), the story centres on a newly discovered antique bronze Venus, who displays the cruel beauty typical of nineteenth-century femmes fatales: in the course of the wedding night, she crushes the life out of her lover with her embrace.[84] By dint of stressing his narrator's scepticism and much amiable discursive antiquarian pseudo-learning about the statue's provenance, Mérimée heightens the Gothic chilliness of his tale, one that he considered his *chef d'œuvre*.[85]

A compliant statue was a higher desideratum: Thomas Woolner, the sculptor, wrote a poem in twelve books about Pygmalion;[86] and Edward Burne-Jones's *Pygmalion and the Image* relates the story in four idealizing panels, now hanging in the Birmingham City Museum. The first, *The Heart Desires*, shows an androgynous artist standing rapt in meditation before a marble group of the Three Graces; in the second, the statue, life-size, marmoreal and slightly bowed like a classical goddess, has been completed, but *The Hand Refrains*; in the third, *The Godhead Fires*, the spirit of love, again of indeterminate sex, but riding a cloud and accompanied by roses and doves, touches the statue. Her flesh has become rosy and she now leans as if needing support to step down from the pedestal.

In the fourth, Pygmalion kneels in adoration before the naked and wistful girl, fervently kissing her hands and staring up at her. But she stares past, with the Burne-Jones look of stunned vacancy. *The Soul Attains* is this panel's title, attempting to gloss the sequence as a kind of neo-platonist or at least spiritual quest for love. Burne-Jones attenuates his forms' limbs and drains their flesh of colour to avoid the suggestion of any fever stronger than flu;[87] but the sequence of paintings remains fascinating. It makes explicit a hitherto obscured facet of the Pygmalion myth, in its nineteenth-century revival. The sculptor and his model resemble each other. Burne-Jones notoriously found it hard not to paint the same features over and over again. But in these paintings his handicap is revealing. Galatea, here cast as angelically desirable, unlike her wicked forebears Pandora and Eve, does not represent the allure of the Other, but a more simpleminded projection of the goddess inside the artist himself. Galatea is his mirror image of himself as an idealized ethereal force, hence his femininity of appearance, his resemblance both to the statue and to the spirit of love, 'the Godhead', who brings her to life. As a mirror of his desired self-image, denied any personality outside the projection, his Galatea represents the generic idealized figures painted and sculpted in the nineteenth century. With the difference, the amusing difference, that female figures more often reflect their makers' masculinity, and are huge, broad, strong, full of might and main.

The mythological figure of Galatea is a type of doll. When Pygmalion makes her come to life, we imagine she will be just to his liking. She will move and speak and love him according to his fantasies, just as the doll talks back to her 'mother' in the game of Mummies and Daddies at the wish of her animator.

In collectors' portraits, a sub-type of Renaissance representation, the antique fragment which the subject holds in his hand, the treasure which identifies him as a man of discernment, a lover of art and a cultivator of beauty, is sometimes a statuette, a small, collectable naked figurine, which the patron holds like a doll, as in Titian's *Jacopo de Strada* in the Kunsthistorisches Museum in Vienna. It is an owner's prerogative to touch and fondle sculpture, not a visitor's.[88]

Woman, as the prime subject of art, participates in art's exaltation; but the condition also empties her of her humanity. The conflict can be seen in a pastime of the eighteenth century, inspired by the classical revival: striking 'attitudes'. Society occasions would invite its female ornaments to pose, as mythological or historical figures of antiquity, as if they were works of art. Emma Hamilton's interpretations of muses and goddesses were famous.[89] In the next century, *tableaux vivants* became

a popular form of theatre, public and private. In Edith Wharton's *House of Mirth* (1905), she relates how the heroine Lily Bart poses as a painting by Reynolds, one of Emma Hamilton's portraitists, and earns the accolade a young woman in society is educated to desire, the admiring gaze of all:

> The unanimous 'Oh!' of the spectators was a tribute ... to the flesh and blood loveliness of Lily Bart. She had shown her artistic intelligence in selecting a type so like her own that she could embody the person represented without ceasing to be herself. The impulse to show herself in a splendid setting – she had thought for a moment of representing Tiepolo's Cleopatra – had yielded to the truer instinct of trusting to her unassisted beauty. The noble buoyancy of her attitude, its suggestion of soaring grace, revealed the touch of poetry in her beauty that Selden [her admirer] always felt in her presence, yet lost the sense of when he was not with her. Its expression was now so vivid that for the first time he seemed to see before him the real Lily Bart, divested of the trivialities of her little world, and catching for a moment a note of that eternal harmony of which her beauty was a part.
>
> 'Deuced bold thing to show herself in that get-up; but, gad, there isn't a break in the lines anywhere, and I suppose she wanted us to know it!' [90]

Selden sees Lily as a beauty who, like classical sculpture to nineteenth-century eyes, is 'noble', possessed of 'soaring grace', 'a touch of poetry', 'divested of trivialities' and filled with 'eternal harmony'. But Wharton contrasts his idealizing gaze with the rough remarks of Ned Van Alstyne, who appraises Lily's body like an auctioneer before a bibelot. In this passage, the author catches with terrible accuracy the reification of a beautiful woman. She thereby foreshadows the predicament of her heroine, who will prove too independent to be gift-wrapped as an *objet d'art* and so precipitate her own tragedy.

Major currents run through the companion myths of Pandora and Pygmalion, and have shaped the tradition of personification: the woman is created from earth or stone; she is not a rival, but a daughter, like Athena, who will not usurp her father, or a spouse, like Pandora and Galatea; female forms are associated from the very start with beauty and artistic adornment and its contradictory and often dangerous consequences. Their creation becomes a paradigmatic metaphor for the act of artistic creation, so that artists 'give birth' to their works. These mythological principles, confusing women and art, together underpin the idea that man is a maker and woman made, in mythic reversal of biology (both sexes issuing from woman). They have assisted the projection of immaterial concepts on to the female form, in both rhetoric and iconography. Men act as individuals, and women bear the burden of their dreams.

One of the strategies women can adopt regarding the myths which shape and spark our consciousness is to recast the ancient stories, by retelling them so that they can be understood, and once understood changed from within. The contemporary sculptor Rose Garrard has created a sequence of works in different forms – painted, cast, filmed and performed – in which she sees herself as Pandora, subjected to the desires and shaping will of others, and given, when she does open the box, few choices from the gamut of archetypes.[91] By intertwining the myth of Pandora's making and transgression with her own childhood pattern of obedience and disobedience, Rose Garrard has shaken the determinism which condemns Pandora to be for ever a figure of the generic feminine, the 'lovely evil', and frees her from deadly passivity and unconsciousness, to become a true 'bringer of gifts', the 'all-gifted one', an agent, empowered to understand, to describe, to delineate, to plumb, and in so doing to refashion. In Rose Garrard's work, in the hands of a woman, the prime subject of art becomes her own raw material, but the relations that usually obtain between artists and their subject matter are dissolved and the claim to ownership and authority is not made.

Edwin Muir, the poet, has written that

> earth's last wonder Eve [is] ...
> the first great dream
> Which is the ground of every dream since then.[92]

We all dream, and we may try to capture those dreams in memory, and even make them come true; but we also know we cannot control them or hold them in subjection. Neither in their origin nor their development nor their end, will they do what we will; it is the great seduction of illusionistic art, conveyed by the figure of the dreamed model, muse and living doll, that through art man can become a lord of creation.

CHAPTER ELEVEN

The Sieve of Tuccia

After they have got them [the just] to the other world, they
sit them down to a banquet of the Blest and leave them
garlanded and drinking for all time. ... That is the sort of
recommendation they produce for justice. The unjust and the
irreligious they plunge into some sort of mud in the under-
world or make them carry water in sieves.

PLATO[1]

Downstairs at the National Gallery in London, where the lesser paintings
are hung in tiers and almost frame to frame in old-fashioned accumula-
tion, there is an early work by Giovanni Battista Moroni, an allegory of
the virtue Chastity (Pl.69). The painting, created on commission in the
mid- or later 1550s, can be trusted to raise a chuckle in the viewer. Yet
it is skilfully executed and most solemnly composed, and bears the
earnest legend: 'Castitas infamiae nube obscurata emergit' (Chastity, once
obscured by the cloud of slander, comes forth). The seated figure reveals
none of Moroni's usual human insight, nor does she possess the chal-
lenging presence of many of his splendid Titianesque portraits. There is
something preposterous, almost appealingly ludicrous about her big,
parted marmoreal legs, her naked muscly arms, and the Amazonian
undress she wears, her tunic fastened to her neck with a string halter and
uncovering her regular, glabrous bosom. She looks trapped by her con-
dition as allegory, forlorn in the unlikelihood of appearance and dress
that her emblematic character has necessitated.

Moroni was perhaps too committed to the vagaries and nuances
of observed personality to create a believable ideal figure, and unlike
Raphael or Titian, he could not attain an imaginative fusion of the here
and now with the ontological above and beyond.[2] The improbability of
his Chastity distracts the amused viewer from the emblem she tenders
on her monumental right knee, which her hands and her proud glance

towards us ask us to note: a colander-like sieve, cribbled with regular punctures and yet filled with water.

This sieve, defying all laws of nature, stands as the sign of Chastity; it belongs, in the order of history, to the Vestal Virgin of Rome, Tuccia, known from the works of Pliny the Elder and Valerius Maximus. It is only an occasional attribute in mediaeval and Renaissance Christian art, but it comes as near to a perfect instrument of disclosure about the nature of the virtuous female body as any imaginative *figura* can.

The inviolability of the allegorical figure, portrayed as a sealed container of the meaning she conveys, helped to differentiate her sphere from the individual female's, who belongs to time and flux and is subject to change. Tuccia the Vestal lights up the antinomy between the real and the ideal with happy brilliance. Pliny's *Natural History* and Valerius Maximus' *Facta et Dicta Memorabilia*, both written in the first century AD, were cheerfully absorbed by readers in the Middle Ages and Renaissance.[3] Both authors were born story-tellers with a taste for the prodigious and the bizarre, the event that would freeze the blood, the natural phenomenon that would amaze. Tuccia was accused of breaking her vow of chastity as a priestess of Vesta. To refute the slanderers, and reveal just how chaste she was, she prayed to the goddess and then made her way to the river Tiber. There, panning its waters with a sieve, she filled it to the brim and carried the water back to the temple of Vesta, to offer it to the goddess as the proof of her continence. The very word 'continence' reveals the association between the whole unimpaired body of a virtuous person and a virgin, and the sound vessel or container that suffers no puncture or crack; Tuccia's sieve, miraculously made whole by the power of her own wholeness, provides us with a symbol of ideal integrity, that puns on the semantics of virtue, and constitutes in itself a kenning on the inherent properties of goodness.

Tuccia's sieve exercised a moderate appeal to artists; it can appear in the hand of the virtue Prudence, or on her head, as in Brueghel's engraving of 1559-60, and it illustrates there her close affiliation with Wisdom's power to discern, to sift judiciously chaff from grain.[4] Tuccia's trial by ordeal literally tinkers with this aspect of a sieve; and its miraculous inversion of the vessel's ordinary function replicates the prodigy of virginity itself. The affiliation of sexuality and incontinence, of chastity and virtue, led that champion of good behaviour, St Augustine, to tell Tuccia's story in *The City of God*, and thence her story passed into Christian teaching, and her honour was posthumously extolled.[5]

Tuccia was confirmed in fame throughout Europe by Petrarch, for she appears in his *Trionfi*, a long sequence composed in *terza rima* towards

the end of Petrarch's life, around 1355. The Triumphs were widely read and the source of an enormous body of art.[7] In the first, Petrarch, writing in the first person, invokes his beloved Laura, who spurns him. Then he sees in a dream the victorious procession of Love, with Cupid aloft on a chariot of fire and around its wheels 'innumerabili mortali', 'mortal men without number', who have been vanquished by Love's powers. But Eros 'Love' must then give way to Chastity. She attacks him in a battle - a Psychomachia - so tremendous Petrarch's similes compare it to the crash of Etna when the giant Enceladus shook the mountain, or the clashing of Scylla and Charybdis.[6] There is an anonymous Quattrocento panel in the National Gallery, London, depicting this affray as a courtly duel between a lightfooted nymph with spiked ball and chain assailing an equally exquisite and graceful Eros, whose arrows lie broken on the ground.

In Petrarch's allegory, Chastity emerges at the head of her warriors, the 'gloriosa schiera', the glorious host of virtues, Honesty and Shame, Good Sense and Modesty, Perseverance and Glory, Courtesy and Purity, and others who, Petrarch says, are 'penser canuti in giovenale etate', 'hoary thoughts for young years'. With them in the fray are the famous though often paradoxical exemplars of chastity from history, Ersilia who led the Sabine women's capitulation, Judith who slew Holofernes, and

> la vestal vergine pia
> che baldanzosamente corse al Tibro
> e per purgarsi d'ogni fama ria
> portò del fiume al tempio acqua col cribro.

(the holy Vestal Virgin who boldly ran to the Tiber and in order to cleanse herself of all ill repute carried water from the river to the temple in a sieve).[8]

Petrarch does not name Tuccia, suggesting that her story was so well known to his contemporaries that there was no need to do so. But she appears with her sieve in many depictions of Chastity's Triumph, a favourite subject on *cassoni*, the decorative trousseau chests taken by a bride to her new home. In one Sienese example, Tuccia appears immediately below the figure of Chastity riding on her triumphal car. She carries her sieve and stands in focal prominence among the throng of other exemplars, dressed in a white habit and scapular like a nun, to underline the sympathy between Vestal vows and Christian virginity.[9] Francesco di Giorgio told her story separately, in a sequence across another cassone, painted a little later, around 1470, in which Tuccia and her 'sisters' look exactly like those flocks of lapwing nuns familiar to any of Francesco's contemporaries in northern Italy.[10] In the same century,

Jacopo del Sellaio (d. 1493) portrayed her in classical fly-away tunic, striding, bent forwards over her brimming sieve as she bears it back to her vindication (Pl. 68).[11]

In the seventeenth century artists drew direct illustrations to Valerius Maximus rather than Petrarch. In a splendid drawing by Joannes Stradanus,[12] the river Tiber reclines in opulent idleness and gushes water over Tuccia's sieve, which catches its spilling force intact.[13] Several women patrons fancied themselves as Tuccia: Vittoria della Rovere, of the great family of Urbino, sat for Justus Sustermans (d. 1681) in a satiny dress, with her hair wavy and loose and her soft plump available face giving a gentle lie to the sieve she points to with an insistent finger;[14] another, eighteenth-century, portrait is thought to be of Anne Preston, Lady Clifford, in the guise of the Vestal.[15] But by far the most eminent and famous of these self-styled paragons is Elizabeth I, the Virgin Queen, epitome of chastity, exalted as Belphoebe by Spenser in his allegory of virtue. She was painted several times in different portraits carrying the sieve of Tuccia. The portrait in the Siena Pinacoteca (Pl. 70) shows her moon-pale, in the sable hue of renunciation and her usually bejewelled hands bare of rings. Elizabeth's effigy of rectitude clasps her sieve lightly between finger and thumb of her left hand. On the rim the motto appears: 'A terra il ben male dimora in sella' (Good falls to the ground evil remains in the saddle), identifying the vessel as the instrument of discernment and the emblem of Prudence. But the associations of Elizabeth with Vestal spotlessness were too well known for her contemporaries to miss the double allusion to Tuccia as well. The base of a column behind her is also pointedly inscribed with a quotation from Petrarch's *Trionfi* on the perils of love: 'Stancho riposo et riposato affano' (Weary I rest and having rested, am still weary). 'The Triumph of Love,' writes Frances Yates, 'with its pains and struggles, is over for her; and she is joining, in the character of the Vestal Virgin Tuccia, in the Triumph of Chastity.'[16] Elizabeth's contemporary, William Camden, accurately observed that the Queen, who was the centre of an elaborate mystique expressed in complex ciphers, emblems and symbols in the pronounced taste of the sixteenth and seventeenth centuries, 'used so many heroical devices, as would require a volume; but most commonly a Sive, without a Mot, for her words, "Video, taceo" (I see, I keep quiet) and "Semper eadem" (Always the same), which she as truly and constantly performed.'[17]

The association of emptiness and badness, fullness and good, of leaky

vessels with wrongdoing and sound vessels with righteousness is very ancient, and the reference to female sexuality recurs throughout the tradition. The Danaids, for instance, the fifty daughters of Danaus, notorious for killing their husbands on their wedding night, were condemned to pour water eternally into vessels that could not hold it. The Danaids are the central characters in a tetralogy by Aeschylus of which only one play, *The Suppliant Women*, produced between 470 and 460 BC, survives (apart from a few tiny disputed fragments).[18] A drama about virginity, it portrays the Danaids at the beginning of their legend. Speaking throughout as a chorus, they are the suppliants, who are suing at the court of Pelasgus, King of Argos, for protection against the fifty sons of Aegyptus, their father's brother, who want to marry them against their will. Throughout, the Danaids plead their love of virginity and their hatred of the proposed marriage, and maintain that they are fleeing in such terror from their suitors through loathing of the marriage bed itself.[19] Like Aeschylus' *Oresteia*, the drama focuses on female revolt, but whereas Clytemnestra's desecration of marriage stands condemned as the monstrous inversion of order, the Danaids' transgression against the ordinary marital destiny of womankind is here treated reverently, and they appear as admirable and remarkably prophetic rebels against loveless and arranged marriage. Their father supports them in their horror of the suitors; without his paternal authority, they too would be unruly women, monsters of improper conduct, like Clytemnestra. He endorses their revulsion against marriage by abduction or rape, which is what the fifty sons of Aegyptus are proposing, and tells his daughters to value restraint, or chastity (*sophrosyne*), 'more than you value life'.[20]

At the end of the play, however, he seems to envisage other partners for them, rather than a life of virginity. The chorus of future brides accepts this ruling in the Greek spirit of resignation to destiny:

> What will be, will be. The purpose of Zeus
> Is a strong frontier which none can overstep.
> This marriage might well achieve its end
> In happiness greater than women have yet known.[21]

The sequel of the Danaids' story has become more famous. As Prometheus prophesies in Aeschylus' *Prometheus Bound*, an account of the tragedy which, unlike his Danaid cycle, has survived:

> For each [Danaid] shall plunge her sharp sword in his throat, and kill
> Her husband. May such love come to my enemies![22]

Forced in marriage to the sons of Aegyptus after all, the Danaids obey their father's order to kill their husbands on their wedding night. They do so, with the exception of one sister, Hypermnestra, and from her, Prometheus tells us, the hero Heracles will descend and found the noble Argive race.[23] Aeschylus does not describe the other Danaids' penalty, and it may be a later accretion to their myth.[24] But it follows the internal logic of the myth's imagery with witty aptness, for the hellish retribution of fetching and carrying water in leaky pots provides an objective correlative both to the murder by sharp weapons they committed, and to virginity's loss, which their act was intended to prevent.[25]

Horace tells the Danaids' story fully in a magnificent ode, where he grieves for their unnatural act and praises Hypermnestra's courage:

> audiat Lyde scelus atque notas
> virginum poenas et inane lymphae
> dolium fundo pereuntis imo,
> seraque fata,
>
> quae manent culpas etiam sub Orco.
> impiae – nam quid potuere maius? –
> impiae sponsos potuere duro
> perdere ferro.
>
> una de multis face nuptiali
> digna periurum fuit in parentem
> splendide mendax et in omne virgo
> nobilis aevum,
>
> 'surge' quae dixit iuveni marito,
> 'surge, ne longus tibi somnus, unde
> non times, detur; socerum et scelestas
> falle sorores,
>
> quae, velut nactae vitulos leaenae,
> singulos eheu lacerant; ego illis
> mollior nec te feriam neque intra
> claustra tenebo.'[26]
>
> (Let Lyde hear of those virgins' sin
> and punishment, the liquid disappearing
> through the base of the empty jar,
> the long-deferred fate
>
> that awaits the guilty under Orcus.
> Those monsters – what worse could they do? –
> those monstrous women put down their

246

husbands with cold steel.

Just one of the many, a virgin
noble for ever, honoured the marriage torch
and was shiningly false to
　　her perjured father.

'Get up!' she said to her youthful husband,
'get up! lest a long sleep come from where
you least suspect: frustrate my father
　　and wicked sisters –

alas! like a lioness making a kill,
each rends her own young bull: but I,
more gentle than they, will neither strike
　　nor imprison you.)[27]

Interpretations of a myth which has been related by many in varying forms, have differed greatly, and the way it has been understood can reveal to us earlier readers' values. The great Victorian scholar Gilbert Murray, in his 1890 translation of Aeschylus' *Suppliants*, praises the Danaids' disgust with their forced partners and interprets their mariticide (husband-murder) as a defence of their virginity against rapists. He goes on to try and argue away the contradiction in which he then finds himself, that the Danaids' myth pays tribute to Hypermnestra for her act of mercy, affirms the necessity of marriage for women, and condemns the other Danaids' unnatural chastity. He wriggles: 'Since virginity is an impossible ideal for the race; and since the whole drama is set in an atmosphere in which virginity is a sacred thing, dearer than life itself, this (loving marriage) is the only solution possible.'[28]

Gilbert Murray takes exception to the view of other scholars that the Danaids were condemned to Hades for their rebellion against the social institution of marriage. He suggests that their punishment merely represents misunderstood images of their function as water priestesses,[29] and remains intent on their virtuousness as *virgines intactae*. Yet Pindar wrote:

Nor went Hypermnestra astray
When she kept in its sheath
Her single, dissentient sword.[30]

And Horace, later, calls the Danaids the 'scelestae sorores', the wicked sisters, and clearly considers them guilty of a terrible crime, husband-murder.[31]

In his Victorian idealism, Murray did not see the condign imagery fitting the punishment to the crime. In thematic counterpoint, perfora-

tion answers defloration, threatened or suffered. Rejecting perforation, the Danaids commit murder by sharp weapons. Not an eye for an eye or a tooth for a tooth, but a hole for a hole, according to the logic, off-colour but apposite, of the unconscious and its literal reproduction of semantic structure in imagery. The pattern, twisting together the issue of fluids – blood, water – with the loosening of sexual restraint, traverses the whole of the Danaids' myth. They rail in Aeschylus' *Suppliants* against 'wedlock which pierces their heart' (in Murray's version: 'heart-stabbing shame'); and when they themselves fear piercing, they pierce in return, invoking the image of priests sacrificing animals by slitting their throats.[32]

In another episode of the myth, situated before their *noces de sang*, the country where the Danaids are living is suffering a prolonged drought; but their sway over perforation and flow gives them the first knowledge of sinking wells.[33] In yet another part of their story, dramatized by Aeschylus in the last, lost satyr-play which closed his Danaid cycle, their father sends one of his daughters, Amymone, to find water, and tells her to give every honour to Poseidon, god of that element. At the spring, a satyr assaults the Danaid, who then calls upon her tutelary god of waters. Poseidon rescues her from the rapist by hurling his trident at him. The weapon misses, but sticks fast in rock, and Poseidon himself then takes advantage of the girl's awe and gratitude. Afterwards, when she pulls out the god's trident, water gushes from the holes its tines have pierced in the rock.[34]

In the ancient world, sexual union in marriage – *gamos* – began for women a new era of fertility and ended sterility, and any threat to paternal or husband or fraternal control over this female fertility constituted a threat to the state and its organization of blood lines and inheritance, as we have seen regarding Athena's cult. The Danaids are divided between husbands and father, and out of this conflict arises the tragedy, which Aeschylus may have developed in the trilogy, just as in the *Oresteia*, he dramatized the *agon* of Orestes, divided between loyalty to father or to mother. Posterity's judgement condemned the sisters for choosing the wrong allegiance and denying their fertility; for this they will flow continually.

In a fascinating essay on Greek myths about female misrule, Simon Pembroke has suggested the imaginative link between the Danaids' punishment and the phrase 'a Melian boat', used for a vessel which is no longer seaworthy. The explanation relates how one Hippotes was sent on an expedition and could not find a crew to sail with him. The men made excuses: that their wives were not well, that their boats leaked. So

Hippotes cursed them, that they would always suffer from leaky boats, that they would always be ruled by women.[35] The disorder brought about by women in charge, who dominate their husbands by preventing them from leaving home to work, or rise up to murder them, leads only to emptiness, to barrenness and death, and finds it appropriate imagery in effluvia, leaky vessels, and sieves.

In Plato's *Gorgias*, Socrates puts the analogy with clarity; developing a play on words first expressed, he says, by 'a witty man', he calls 'the part of the soul in which our appetites reside' a pitcher, a *pithos*, and then continues:

> that part of their soul which contains the appetites, which is intemperate and as it were the reverse of watertight, he represents as a pitcher with holes in it, because it cannot be filled up. Thus ... he maintains that of all the inhabitants of Hades – meaning by Hades the invisible world – the uninitiated are the most wretched, being engaged in pouring water into a leaky pitcher out of an equally leaky sieve. The sieve, according to my informants, he uses as an image of the soul, and his motive in comparing the souls of fools to sieves is that they are leaky and unable to retain their contents on account of their fickle and forgetful nature.[36]

The wretched Danaids' punishment fits the crime – and the folly – of their intemperate conduct.

Significantly, virginity itself is rarely represented as a virtue on its own, though obsessively lauded in Christian writing of the early and mediaeval church. Chastity, a part of the threefold vow made by monks and nuns, is sometimes personified as a maiden, as in the vaults of the Basilica Inferiore in Assisi, where St Francis embraces Chastity, who sits apart from the world, in her tower of strength.[37] The sixth Beatitude, 'Blessed are the pure in heart', was interpreted as Chastity, by the master of the twelfth-century mosaics in St Mark's, for instance,[38] and Castitas also does battle with Eros, or Love, and Luxuria, or Lust, in those mighty conflicts between the Virtues and Vices that became a familiar topos, as we have seen. But Virginitas appears exceedingly rarely as a maiden, and does not form part of the extended systems, the holy guilds of Virtues or Gifts or Beatitudes, which the churchmen loved to tabulate and comment upon in the weighty compendia of Hugh of Saint Victor and Frère Lorens. Virginity signified the specific and physical state of bodily integrity resulting from sexual innocence. Chastity on the other hand need not imply lack of experience (especially for men), but resolute

renunciation, and the virtue was closely linked to fidelity, in writings influenced by Christian thinking from early times to Spenser and Milton.[39] Augustine willed himself chaste; he was not a virgin. It could be argued that Mary, the pattern of virginity in her miraculous body (*virgo in partu* as well as at Jesus' conception), and the exemplar of elected chastity, represented the associated virtues sufficiently to impress their importance on believers; but this does not really provide an answer to the startling omission of Virginitas from the canonical lists and tables.

A reason could be that sexual abstinence and the conquest of carnal passions, symbolized by virginity, are so fundamental to Christian ethics that they are understood to be intrinsic to each virtue; certainly, in the handbooks, like Cesare Ripa's famous *Iconologia*, which, as we have seen, systematized the representation of abstract ideas in the seventeenth and eighteenth centuries, the female figures who body forth Faith, and Hope, Prudence, Justice, Fortitude and Temperance and so on, are understood to be virginal, issuing from the godhead, espoused to him, as chaste and dedicated brides, without issue, monads of primal integrity like Athena. Virginitas herself does appear in Ripa's *Iconologia*, as a typical maiden, garlanded, pale and slender, with a lamb beside her.[40] She is as it were the dressmaker's dummy, on which the patterns of other Virtues are all cut differently. The only maternal adult is Charity, who feeds her babies at her breast; though even here, it is not certain these are her children. She could be a foster-parent, exhibiting a mother's care, spontaneously, not necessarily. Indeed, the numerousness of her hungry nurslings usually conveys the impression that they are not her offspring; like Wisdom, Charity, nourishing the faithful, is a nurse rather than a mother (Pl. 82).[41]

Although the virginal body can be inferred from allegorical representations of desired qualities or virtues, it is often fashioned, dressed, adorned and accoutred in such a way that the inviolate integrity of the figure cannot be mistaken, through a series of visual devices arising out of common verbal metaphor, playing on the figurative associations of hardness, imperviousness and wholeness.

The personified abstraction, like Justice or Courage, La République, or Britannia, often wears armour to demonstrate her struggle for the forces of good against the forces of evil. The armed maiden is a long surviving protagonist of that ancient duel. Her armour, as we have seen in the case of Athena, shows that her allegiance lies with the fathers; it masculinizes her. But the armour does something else, related to both these themes: it renders her a watertight, strong container, like Tuccia's sieve. It helps to abolish the ascribed nature of womanly bodies, and confirms an irreversible virginity. The armour inverts the sign of the woman's body

so that it can properly represent virtues or ideals; it emphasizes that a leaky vessel (the Danaids' sieve), has turned into a sound vessel (Tuccia's miracle). The imagery is rooted in the ancient pattern of associations: woman was mother and matter, and matter was volatile, dangerous, passive, opposed to spirit, and often judged the inferior principle. Her kinship with matter was linked to her reproductive processes, and these were frequently described, in a strong Judaeo-Christian tradition, as effluents, liquids and fluids oozing from the improperly stopped container of the female body. In order to stand for virtue, the physical condition of this metaphorical body had to be turned upside down, and the soft, porous, effluent-producing entity made hard, impermeable and corked, so that its contents, dangerous on contact, could be kept hermetically sealed and safe. Blood inside the body does not endanger us, but gives us life; but blood shed on to a bandage or a napkin becomes dirt. A virile integrity, impregnable and intact, could ensure safety from contamination and loss.

The metaphor of the body as vessel is used for both sexes, but women, as wombs, are more closely associated. It is the underlying metaphor of the container that inspires the use of feminine gender for ships and cars, and perhaps even the Bank of England's nickname, 'The Old Lady of Threadneedle Street'. In the New Testament, however, women, and specifically wives, that is mature women, are 'the weaker vessel' (I Pet. 3: 7).[42] The contents of this unsound creature were horrifyingly described in the Christian tradition, as enforced celibates tried to hold to their uncomfortable resolve. St John Chrysostom in the fourth century wrote to 'The Fallen Monk Theodore', who had left the hermit's life in the desert to return to his love, Hermione: 'The whole of her bodily beauty', warned the saint of the 'golden mouth', 'is nothing less than phlegm, bile, rheum, and the fluid of digested food.'[43] The emphasis on effluents continues in the homiletic literature of the Cluniac movement. Abbot Odo of Cluny, in the tenth century, inveighed:

> The beauty of a woman is only skin-deep. If men could only see what is beneath the flesh and penetrate below the surface with eyes like the Boeotian lynx, they would be nauseated just to look at women, for all this feminine charm is nothing but phlegm, blood, humours, gall. Just imagine all that is hidden in nostrils, throat and stomach. ... We are all repelled to touch vomit and ordure even with our fingertips. How then can we ever want to embrace what is merely a sack of rottenness?[44]

In this type of text the materiality of women's bodies increases with fertility and parturition, since pregnancy opens the container and lets out

the dangerous contents. Venantius Fortunatus, writing in the sixth century to fortify women who had vowed themselves to virginity, lingers graphically on the pleasures of the virginal body and the horrors of the maternal condition: 'The chaste limbs of virgins are His [Christ's] temples: therein He dwells and is at ease. Freely He penetrates viscera known only to Himself and with greater joy enters paths where none has ever been. These limbs, he feels, are His own: unsoiled and unshared by any man. Tenderly and with affection He kisses the breast.' Venantius Fortunatus then contrasts this idyll to the consequences when another occupant enters the woman: a baby. 'Happy virgin! ... She does not weigh down sluggish limbs with an imprisoned embryo; ... the belly swells from its wound and sensual dropsy grows, ... the raised skin is so distent and misshapen that even though the mother may be happy with her burden, she becomes ashamed.'[45]

The Middle English treatise *Holy Maidenhead*, addressed again to women to confirm them in their choice of virginity, extends the comparison between the pure, sealed, virginal body and the horrid maternal body, subject to external change and fluxes:

> Thy ruddy face shall turn lean, and grow green as grass. Thine eyes shall be dusky, and underneath grow pale; and by the giddiness of thy brain, thy head shall ache sorely. Within thy belly, the uterus shall swell and strut out like a water bag; thy bowels shall have pains and there shall be stitches in thy flank, and pain rife in thy loins, heaviness in every limb. The burden of thy breast on thy two paps, and the streams of milk which trickle out of thee.[46]

Such statements on the condition of maternity, supported by God's curse on Eve to multiply greatly her pains in childbirth, continue to seep evilly through much more up-to-date literature. Professor Boxer found, in a treatise destined for Latin American missionary work in the sixteenth century, traces of the contempt characterizing women as bestially material. The author, an enlightened Dominican, Francisco de Vitoria, one of the founders of international law, who advocated comparative humanity in dealing with the Amerindians, nevertheless was of the opinion that, 'Woman does not have spiritual knowledge, nor is it fitting that she should have. It therefore follows that she cannot discriminate in spiritual matters. And it would be a most dangerous thing to entrust the spiritual health of souls to a person who is incapable of distinguishing between what is useful or harmful for the good of souls.'[47] Taking another, more highly coloured tack, a handbook for priests written in 1924, and still read by clergy in Spain in the sixties, according to the anthropologist William Christian Jr., instructed the neophytes:

What is a woman? St Jerome replies that she is the door of the devil, the way of iniquity, the sting of the scorpion. In another place, he says that woman is flame, man tinder, and the devil bellows.

St Maximus calls the woman the shipwreck of man, the captivity of life, the lioness that embraces, the malicious animal. St Athanasius the Sinaite calls her the clothed serpent, the consolation of the devil, the office of the devils, the ardent oven, the spear in the heart, the storm in the household, the guide of darkness, the teacher of sins, the unbridled mouth, the calumny of the saints. St Bonaventura says that the woman dressed up and lovely with her finery is a well-sharpened sword of the devil. Cornelius Alapidus says that her look is of basilisk, and her voice that of a siren; that she bewitches with her voice, befuddles the judgement with her look, and with both things corrupts and kills.[48]

Through the display of pedantry - that litany of authorities - we can yet hear the instructor's relish and fascination, and seminarians must have found this catalogue a more riveting lesson than elements of canon law. The images are of openings (the door, the gorgon eyes of the basilisk, the singing siren, the 'unbridled mouth', the 'oven'), or of active forces for change and disruption (storms, flames, and cleavage [spearthrusts]). As Christian observes, commenting on Spanish women's strong religious role and faith: 'Men have little contact with cycles of purification. The women not only bear the weight of religion on their shoulders, but by and large they bear the sins of the entire culture.'[49]

The reprehensible biology and sexuality ascribed to the female sex could be neutralized - the word is apt - by elected virginity. In Arete's concluding discourse in Methodius of Olympus' *Symposium*, she recommends, 'It is most imperative then that anyone who intends to avoid sin in the practice of Chastity must keep all his members pure and sealed - just as pilots caulk a ship's timbers - to prevent sin from getting an opening and pouring in.'[50] *Holy Maidenhead* again deploys the metaphor: 'This [virginity] is yet the virtue that holds our breakable vessel, that is our feeble flesh, in whole holiness. And as that sweet unguent and dearest beyond all others that is called balm protects the dead body that is rubbed therewith from rotting, so also does virginity a virgin's living flesh, maintaining all her limbs without stain.'[51] And when we turn to the imagery praising the virgin of virgins, Mary the Mother of God, we find her maidenhead extolled in metaphors taken from the Old Testament and interpreted allegorically; images of cincture, or of closure, or bonded goods and sealed contents abound: Mary was identified with the 'spring shut up, the fountain sealed' and these images appear in ordinary iconography, from altarpieces to church furnishings, like the fifteenth-

century choir stalls in Barcelona cathedral. She was 'the enclosed garden' and 'the closed gate', from the same sequence of erotic invocations in the Song of Songs to a bridal figure, on the eve of union and therefore still *intacta*. In the Catholic prayer, the litany of Loreto, in use since the thirteenth century, Mary is invoked under other mystical titles of sound vessels: she is the Spiritual Vase, the Vase of Honour, the Vase of Remarkable Devotion, the House of God, the Tower of David, the Tower of Ivory, the House of Gold, and the Ark of the Covenant.[52] The only image suggestive of opening is 'Gate of Heaven': perhaps the place annuls the perils attendant upon entrances which give access to other, less happy homes. Even as the Burning Bush which burned and burned but was never consumed, Mary figures as a being immune to attenuation, division and above all, destruction.[53]

Tuccia's sieve is an unsound vessel that becomes sound by a miracle, like the body of a woman, which, with its open orifices, dangerous emissions and distressing aptitude for change, can yet become preternaturally sound when representing the good. Tuccia herself may be a peripheral character in the multiple teratologies of Christian anecdote, but the principles her story reveals are actively present in many other dramatic renderings of virtues in the female form.

Jesus told many parables. But not all of them have become familiar from mediaeval Christian art. Until the Counter-Reformers returned to neglected passages of scripture, we rarely find women – or men – mending old clothes with new patches, widows with their mites, or the servant burying his talent while his fellows find methods of fructifying theirs. In the Middle Ages Good Samaritans and Prodigal Sons appear, but they are overshadowed altogether by the popularity of the Wise and Foolish Virgins. In the iconographical programmes of the great cathedrals, especially in the thirteenth century, at Amiens, Bourges, Paris, Reims, Sens, Auxerre, Laon, Basel, Strasbourg, Freiburg and Magdeburg, the Wise and Foolish Virgins' story is told as a parable that plays upon the antinomy between empty vessels and full vessels, between sound and unsound containers, between continence and incontinence (Pl.73).[54]

Jesus tells the story in Matthew 25 as part of a complex sequence of warnings to be ready for the Second Coming and the Last Judgement. The virgins' sad tale comes between the parable of the rascally servant and the parable of the talents, and all three illustrate the need for preparedness and good husbandry before the Last Day. The end of the world will be a wedding, Jesus tells his audience, and though he does not mention a bride, he describes ten bridesmaids, waiting for the groom, with their lamps lit. The bridegroom is late, and all ten fall

asleep, and 'they that were foolish' had taken their lamps, but 'no oil with them: but the wise took oil in their vessels with their lamps'. (Matt. 25: 3-4 A V). When he finally appears, the lamps of the foolish virgins have gone out. The wise virgins refuse to share their oil with them, but order them to go away and buy some. The door closes on the five lightless girls. When they return from the shops and beg to be admitted, the bridegroom only calls through the door: '"Verily I say unto you, I know you not." Watch therefore, for ye know neither the day nor the hour wherein the Son of man cometh' (Matt. 25: 12-13 A V). With these chilling sentences, the foolish virgins stand excluded from the wedding feast that is heaven.

The story was expounded in mediaeval treatises for the faithful as part of Christian eschatology, thus securing the position of the Virgins in the churches' sculptural programmes: on either side of Christ the Judge in scenes of the Day of Reckoning. The wise virgins stand on his right, for they will go to paradise with the elect. The foolish weep to his left, together with the damned, hustled away to be tormented by demons. They slept to the knowledge of God, and they failed to keep their lamps filled with the burning oil of charity, which is the love of God and his creatures. Instead they became victims of the senses, which number five, just like the foolish creatures themselves, who sometimes even came to personify them.[55]

The tympanum of the cathedral at Basel, carved in the twelfth century, shows the foolish ones on one side of a closed door, begging admittance; Jesus stands on the other side with the wise virgins, who are veiled, in orderly line and holding up their filled lamps. The foolish sisters are bareheaded, disorderly and hold their lamps upside down. On the façade to either side of this 'Gate of Paradise', statues carved in the next century portray the contrast between the two groups as the conflict between the worldly and the otherworldly: a courtly young seducer stands with the foolish virgins, and dimples at them charmingly, holding one glove he has taken off in his other gloved hand. He woos his 'foolish' neighbour to the love of this flesh, and she responds with swaying body and laughing face, opening the panels of her tunic at the shoulder with such suggestiveness that we know what the sculptor intended. On the other side of the door, her five wise sisters surrender to the heavenly bridegroom instead. The smiling girls of these German cathedrals are among the freshest and most enchanting likenesses of mediaeval women that we possess, the visible warrant of Aucassin's complaint, in the proto-romance *Aucassin and Nicolette* of around the same time, that heaven will be very dull as all the charming people go to hell.[56]

Martin Schongauer, towards the end of the fifteenth century, removed the wise and foolish virgins from their usual eschatological context and engraved them as separate, different, freestanding figures, in a poignant sequence of images. Schongauer was the son of an Augsburg goldsmith who worked in Colmar, and his work reveals a jeweller's sensitivity with burin and metal plate, as he clothes his sacred subjects in the vesture and features of the men and women around him. Influenced by Flemish naturalism in details of dress and utensils, and a gentle observer of the interaction between people, Schongauer also adapted the ethereal etiolation of forms found in Dirk Bouts and Rogier van der Weyden, and became a most graceful engraver of holy pictures. He relieves them of all didacticism and pomposity. His *Wise and Foolish Virgins* are no exception, and though in their fashionable attire and lovely Gothic undulations they fail to remind us of Christ's grim lesson, they are all the more appealing for that. He displays delicate pity towards the foolish virgins, those essential models of faithlessness. His wise virgins hold up their conical lamps with a certain smugness, and wear garlands of laurel on their brows; but the foolish ones' garlands lie at their feet, and they hold their lamps upside down. Some wear spectacularly modish pattens, some weep, fists in their eyes like children. These stand full length, filling the vertical rectangle. But the most successful and memorable *Foolish Virgin* of all does not belong to this series (Pl.74). She has been drawn independently, a half-length figure, with the mouth of the empty vessel towards us and two fingers curled around into its hollowness, as she holds it in front of her own deep *décolletage* and bodice, which opens unbuttoned over her stomach, like the lips of a shell or vulva. Her expression is still, her face filled with resigned woe, while out of her twisted turban a serpentine lock of hair falls in a knot on to her shoulder. In spite of her distress, her hair is wanton. Schongauer, born around 1445, was of the generation before the Reformers, yet we see here a prophetic image of the ineluctable fate of the damned. The foolish virgins may weep, but they are not forgiven.[57]

In Catholic belief, trusting in the forgiveness of sins, Mary Magdalen became the Foolish Virgins' patron saint, an example of profound sinfulness who was saved. The repentant prostitute who gained such widespread popularity both in the Middle Ages and the High Renaissance, held out to the wicked the hope that it was never too late, that as Jesus had saved her, so he could save the most foolish and empty vessel of all. In her votive images, she sometimes reveals a scroll, saying,

> Ne desperetis vos, qui peccare soletis:
> exemploque meo vos reparate Deo.

(Do not despair, you who are accustomed to sin: following my example, ready yourselves again for God).[58]

Mary Magdalen's iconographical attribute was a pyx, a container, resembling her protégées' lamps and recalling Pandora's fatal jar. Sometimes opened, in order to anoint Jesus' feet with its precious, rich contents, sometimes closed, it appears clasped between her reformed hands; in either case, the perfumed and costly oil within was linked with the 'love' to which Jesus referred when he defended the Magdalen against the apostles (Pl.71).[59] The shape of this identifying symbol, a vase of unction, inspired the water-carriers to dedicate their stained glass window in Chartres cathedral to her.[60] Her sexuality perhaps inspired images of flow; and even more materially to the theme here, when the whore Mary Magdalen leaves Palestine after the death of her Lord, according to the mediaeval legends about her life, she is put out to sea by infidels to drift, with her companions Mary Jacobi and Mary Salome, and her brother Lazarus, in a rudderless, sailless and unseaworthy boat; but this unlikely receptacle does not fail. An angel guides it safely to harbour in the south of France, and there Mary Magdalen retires in penitence to the grotto of La Sainte-Baume (Holy Balm) to repent her former courtesan's life.[61] Again, the distinctions between virtue and vice are played out in the legend in a series of inversions: the penitent whore arrives at the sacred place of her cult – which still flourishes at Les Saintes-Maries-de-la-Mer in the Camargue – by means of a leaky vessel; the woman who has known all the pleasures of the flesh regains her primordial sinlessness and separateness through penitence and a renewed virginal love of Christ, just as that same unlikely boat puts in at a safe harbour under the direction of an angel.

Empirical knowledge of the body, alongside complex social developments, has changed our attitudes to virginity. Physical innocence by no means evokes the same body image today as it did for the churchmen who, for instance, defined the bodily integrity of the Virgin Mary. The hymen, the 'gateway', no longer closes a defined precinct in our mental conception of a female body; with later and later marriage for women, puberty and sexual union do not coincide in time, and menstruation may take place for years before sexual contact through the 'unbroken' hymen, rendering the image of a virgin's body as 'a spring shut up, a fountain sealed' incoherent, and hence obsolete.[62]

Yet the image of the body as sound vessel persists as a common

metaphor for completeness and coherence, and forms that personify virtue depend upon this metaphorical maidenhead for their continuing significance. They are exemplified figures of speech, predicated on an equivalence between integration, firmness and imperviousness with right (integrity), and disintegration, softness and lability with wrong (lack of integrity). They are full when good, because seepage or leakage does not take place. As Lakoff and Johnson have discussed in *Metaphors We Live By*, it is commonplace to conceptualize thought itself as a vessel. They demonstrate from idiomatic speech how frequently we resort to the image of a container when referring to an idea: we say, 'That doesn't hold water', or alternatively, that it is 'watertight'; or 'This argument is full of holes' or 'rings hollow'; we talk of 'empty' thoughts. The very word 'content' itself, meaning that which is contained, suggests the unnamed container which the concept fills (Pl.72).[63]

Allegorical figures representing abstract concepts become such containers, composed of strong, firm materials, either literally, when they are made of bronze, or metaphorically, when they are drawn, painted or described as clad in armour. The content is the concept they contain, and the more securely they contain it, the more the content itself gains in fullness and sureness and definition and substance. The considerable and precious outer vessel suggests the important liquid inside, just as a jewelled ewer suggests a fine wine, not dishwater, or a strongbox valuables, not dust.[64]

Surfaces define outer limits: a container is formed of its bounding surface; the entity of the human body ends at the epidermis; we are bound by skin. But skin is porous, sensitive, and yielding: women's skin especially is thought to be soft. It does not evoke images of a surface or outer edge impregnable to externals such as sound vessels must possess in order to be filled and remain full. The body of a woman, when used to represent generalized concepts that strain at absolute definition, like 'Justice' or 'Fortitude', must have its surfaces reinforced, so that the poor, leaky vulnerable bag of skin and bone and flesh so despised by churchmen can become transformed into a form strong enough to hold within its ambitious contents. Some allegorical figures are strengthened by literal reinforcement. They are fully armed, in spite of the anomalousness of warrior women, as we have seen. They wear cuirasses, stomachers, greaves, brassards, and so forth, until the outer contours of their bodies become a carapace, and flesh and skin, connoting softness, are concealed and abrogated. The thought that the figure then represents thereby acquires desirable firm outlines and clean definition, cancelling the nebulousness and slipperiness of the concept thus illusorily captured.

Sometimes a mere hint – a helmet, a buckler – suffices to suggest the female body's unlikely hardness. Léopold Morice's statue to the French Republic, which won the prize after an open competition held to celebrate the Third Republic, was unveiled in the Place du Château-d'Eau on 14 July 1883 (now renamed Place de la République).[65] In spite of the statue's unsuccessful mix of stiff bulkiness and large-eyed sweetness of countenance, it still attracts the attentions of demonstrators who scrawl their protests on the pedestal. Morice's *La République* is a young woman standing on a big stone drum; she holds a many-leaved sprig of olive aloft in her right hand, and touches the tablets of the 'Droits de l'homme' resting against her leg with her left. Her copper has turned sea-green with age. Her Phrygian cap of liberty is garlanded with olive too, and her body swathed in a heavy cloak; but in spite of this peaceable gear, the body of Morice's *La République* is a well-armoured vehicle. Precisely because the statue is an ordinary one, acceptable to a committee in the 1880s and inoffensively unarresting today, it can reveal the norms governing allegorical figures. Under her voluminous wrappings, *La République* is wearing a corselet, the lappets of which are showing on her left upper arm, while above her thighs its main shape can be seen, worked in relief with classical motifs of victory. Her drapes are not operatic, but military, like the mantle worn by generals in the fray, and they greatly expand the surface of her body; she also sports the short broadsword of the Roman centurion, a favourite device of the Revolution, slung on a wide strap, bossed and buckled, across her chest. Below her, seated round the drum are the three figures of Liberté, Egalité, Fraternité. Egalité, holding on her knee a masonic level (another favoured emblem of the Revolution), and a flag in her right hand, is also well protected for the conflict of good against evil by her classical cuirass.

Justice, Prudence, Fortitude, Courage, as we have seen, are likewise commonly armed, partly because the battleground is our most common image for the dialectic between good and evil, partly because memories of Athena, dispenser of justice and warrior goddess, lingered on. Cities often wear a full panoply too, in the consular diptychs of the Roman empire and Byzantium, in which Rome, Constantinople or Antioch appear.[66] The emblem of the city walls, represented by the turreted headdress, is the 'very particular ... Quoiffure' of personified cities, as Addison remarked.[67] It forms yet another image of cincture, of outer reinforcement, of impenetrable containment. Cities have remained girdled and fortified in their public representation: the statues in the Place de la Concorde display various war *matériel* among their attributes

and their dress – Bordeaux wears a parapet on her head (Pl. 14). The Tyches or Fortunes of *département* capitals, designed after classical prototypes, which appear in the elaborate sculpture programme of the rebuilt Hôtel de Ville in Paris, are also wearing armour – castellated headdresses, caps and crowns, as well as shields, and swords on top of their nineteenth-century curves. Or they are sometimes encased in breastplates, too, like Jean-Charles Chabrié's *Le Havre* on the façade, where her cuirass is sensuously moulded over her swivelling torso and gently swelling stomach, or, also on the front, Charles-Elie Bailly's *Brest*, or Claudius Marioton's *Lyon* (on the façade Lobau on the east side).[68]

The bounded body need not be considered a speciality of nineteenth-century French taste for allegorical statuary. It can be found in Victorian sculpture too, in which surface is frequently reinforced through decoration and emphasis of contour, rather than literal armour. Allegorical figures, draped, half-draped, or even nude, inhabit bodies whose surfaces have been intensified by the sculptor's treatment of the plastic media themselves. Bronze acquires a chitin-like imperviousness in Hamo Thornycroft's allegorical statues on the Gladstone Monument in the Strand. Gladstone's robes fall in heavy folds, rendered with a haptic sense of the fabric's tug and pull on his limbs, while his hands are veined, showing their vulnerable insides and thus revealing Gladstone to be human, not ethereal; but his companions on the pedestal have arms so glossily metallic and smooth, so big, too, for the scale of their bodies, that their contours are literally enlarged and thereby stressed, and by that very stress, shown to be strong (Pl. 55).[69]

The hardness, bigness, and roundedness of public statuary of the nineteenth century strive to contain the fugitive thoughts the sculptures depict; their appearance does not altogether result from the sculptor's lack of skill, but arises anagogically from the semantic field in which this kind of art belongs. It is of course quite possible to carve stone to look soft and yielding, though most people think that such an illusion as Apollo's fingers sinking into Daphne's thigh requires Bernini's consummate technique. It needs skill, but that skill can be imitated by journeymen stonecutters. What they lack is Bernini's power of conception. It is Bernini's imagination which transforms the marble. When the contemporary sculptor Barry Flanagan wanted to start working in stone, he reverted to the tradition of employing *praticiens* and approached the master carvers Sergio Beneditti and Sem Ghelardini of Pietrasanta, in the Carrara mountains, formerly quarried by Michelangelo and Bernini and in a sense the cradle of Italian Renaissance sculpture. Flanagan rolled

clay into soft, edible-looking loaves or doughy knots, leaving the prints of his palms and fingers where he had pressed into the soft material, and the Pietrasanta stonemasons copied them. The results of their collaboration show how soft, malleable, and warm even white marble can be made to look.[70]

But the ladies of public architecture who personify civic virtues or national pride do not look soft or malleable or warm or permeable and, in many cases, the artists intended their appearance of petrification and frigidity.[71] It bore a relation, it seemed then, to the ideal. But this is a late, neoclassical development in taste. Greek statues were painted to create the greatest possible illusion of lifelikeness. Even details like the hairlessness of Greek female nudes compared to the curly pubic hair of young men and gods was observed from life, and not a consequence of Greek artistic censorship. It was the custom for women to remove their pubic hair by singeing, as is made clear by the ribald preparations which Mnesilochus undergoes in order to pass as a woman in Aristophanes' *The Poet and the Women*.[72] Ovid's story of Pygmalion evokes a painted simulacrum to suspend our disbelief; and later, in the Middle Ages, exact representations in polychrome were central to Christian ceremony. Cult statues of the dying Christ, life-size, polychrome, and rendered in fine detail, down to the hairs in Jesus' armpits and on his stomach above his loincloth, like the Quattrocento crucifix from Sant'Egidio, Montalcina, by Francesco di Valdambrino, worked on the beholder's senses to move them to faith and prayer.[73]

But the classical revivalists recoiled from the sympathetic magic of this type of cult instrument, and interpreted the Greeks' ideal of sublime illusionism with a difference. Henry Weekes, in his lectures to the Royal Academy of 1880, repudiated polychrome classical realism:

> That a too literal rendering of Nature renders a work of Sculpture commonplace, if not still more offensive, I need not urge on you.... The absence of colour in a statue is, in short, one of the peculiarities that remove it so entirely from common Nature that the most vulgarly constituted mind may contemplate it without its causing any feeling of a sensuous kind. The eye learns to look upon it, not as a real existence, but as a sort of visible representation of some admirable concentrated essence.[74]

There were a few Victorian experiments with coloured, jewelled, chryselephantine statues in the Greek manner,[75] and in the 1850s, John Gibson created a lightly tinted Venus.[76] But Gibson also declared that statues 'must be coloured with delicacy and taste – a conventional effect, *not that of a living being*' (emphasis added).[77] This kind of bloodless idealization

is now coming back into fashion: a version of the *Tinted Venus*, sold in 1983, made a record price at £68,000.[78]

Abstract concepts, containers of absolute significance, are more often treated in the nineteenth century in stone and metal to look unassailably solid, and inert and impervious: bronze remains bronze, marble, marble, in conformity with Weekes's anxiety that 'a too literal rendering of Nature renders a work ... commonplace'.

Even in the work of a sculptor like Jean-Baptiste Carpeaux, the contrast between hardness and softness operates, to designate the ideal and real flesh respectively; hardness signals subliminally to the beholder the presence of a sound vessel, appropriate to the conveying of abstract thought; softness a subject in history and time. Carpeaux is one of the most appealing nineteenth-century French sculptors, an artist of smiling panache and dazzling handiwork. His sculptured figures, the most famous being the group *La Danse*, formerly on the façade of the Paris Opéra, and now in the new Musée d'Orsay, Paris, are distinguished by their sensuous rendering of skin and flesh. When he portrays the individual he is capable of extraordinarily sensitive passages of modelling, not only in clay (a soft medium he favoured and used for his maquettes) or in stone but also in very hard substances, like bronze. The bronze head, cast in 1875, of Bruno Chérier, painter and friend of the artist, and native of Valenciennes, Carpeaux's home town, renders the features of a man of fifty-six with gentle authenticity.[79] The metal rises and falls over the bumps and furrows of eye socket and cheek-bone, of brow and neck tendons. His flesh is palpable, even though Carpeaux's mode is not markedly naturalistic, for Chérier's collar-bones are bared, suggestive of noble nakedness, and his hair, on his head and in his full beard, shows plainly the scudding masses of the original clay. The portrait expresses Carpeaux's affection and admiration for his friend in the serious highmindedness of his expression; Chérier is idealized, even while his individuality is being expressed, even heightened.

The irregularities and breaks in Chérier's face do not simply attest to his years in a realistic manner; when Carpeaux made images of children, like the bronze statue for a fountain, *Le Pêcheur à la coquille*, of 1858 or its companion, *La Jeune fille à la coquille*, of a few years later, he particularized the childlike musculature, the fold of stomach above navel, and kept their limbs' width and length in lifelike scale.[80] But when, from 1860 to 1873, he came to creating the group *The Town of Valenciennes Defending the Fatherland, or its Ramparts* for the Hôtel de Ville at Valenciennes, he seems to have applied his formidable skill to emphasizing the high tension of the central allegorical female figure's contours; Valen-

ciennes' limbs are exaggeratedly long, smooth and powerful, hardly a rugosity or dent or wrinkle mars the inviolate hard youthfulness of this contained argument for his native city's invincibility.[81] The finished plaster model of 1869 exhibits none of the gauzy textured flesh Carpeaux was capable of conjuring out of his raw material in other sculptures of women's bodies, like the *Flora* in the Louvre. The final bronze itself, cast only two years before the Chérier, positively gleams like burnished armour, and unlike most of Carpeaux's work gives no sense of vulnerability or subjection to time. Valenciennes, a town situated on a fraught border, will abide eternally all the same, and this idea is conveyed by the appearance of the material out of which she is cast. Carpeaux has made it retain its elemental character, the hardness of metal itself.[82]

In Carpeaux's *Valenciennes*, strong in her body to represent the city's strength, we can perceive a common prescriptive belief of our culture, a shared symbolic truism: the body of a person, the vessel of life, contains his or her individual life, is the receptacle of identity. The life of a concept is its meaning, and the allegorical body is filled with that 'life' when it can be named, 'identified'. The virtuous body, often feminine by grammatical propriety, possesses strength, endurance, integrity, and holds the fullness of its meaning inviolate and distinct; it does so by means of its representation, in text and image, as a sound impermeable vessel, a lamp of a wise virgin, the impossible sieve of Tuccia the Vestal.

By recognizing the type of pollution which allegorical entities are warding off by their whole impregnability we become more able to make them help us, not bind us, by playing with the assumptions which structure them, by refashioning the body which has been appropriated to mould an inverted image of collective fear.[83]

One female strategy has been to accept the prevalent characterization of women's internal physical nature, and to stress its value as sacred, tragic and changeable. The sign of the female body, shaped by female hands this century, does not present itself as an unbroken container. We see through the woman and into her, she is all carnal matter, not outer surface. Her spine is shattered, as in the great Mexican painter Frida Kahlo's 1944 painting *The Broken Column* (Pl. 75); a mess of blood, ganglia, skulls and monsters spill from her lips in her 1945 *Without Hope*; she shows us her bleeding heart, like the immaculate heart of Mary, in the double icon of 1939, *The Two Fridas*.[84]

Susan Griffin, the contemporary American poet, has found in the female body a focus of her most searching inquiries. She harvests the ancient equivalence perceived between women and nature, and inverts the allegorical language of completeness to create a figure of vulnerable

interiority. In her books *Pornography and Silence* and *Woman and Nature*, she writes of women and for women, but as she remakes woman's body, with metaphors taken from the wilderness and the forest, she creates a series of prayers, litanies to the possibilities of goodness and intercessions for the survival of living things. Her images for what is precious to her and essential to the salvation of the world come from the most humble, often buried, strata of the earth: the potato is preferred to the lily, plankton to the tiger, the pebble to the mountain. She does not describe an individual, or a particular group; her women have no names, no faces, no specificities as persons; she dismantles chronology and mixes cities and nations, in the furtherance of the task she sees as urgent, the alteration of ascribed value to fundamental metaphor. She invokes porousness, wetness, softness, permeability; she greets lightness (as in weightlessness), and banishes hardness, ascent, toughness, inertness and chastity, the axioms on which the symbolic use of the female form has so often been constructed. Above all she travels past the outer appearance into the mysterious interior which allegorical imagery denies. Susan Griffin writes in 'Her Vision – Naming' from *Woman and Nature*:

> We say mucous membrane, uterus, cervix, ligament, vagina and hymen, labia, orifice, artery, vessel, spine and heart. We say skin, blood, breast, nipple, taste, nostril, green, eye, hair, we say vulva, hood, clitoris, belly, foot, knee, elbow, pit, nail, thumb, we say tongue, teeth, toe, ear, we say ear and voice and touch and taste and we say again love, breast and beautiful and vulva, saying clitoris, saying belly, saying toes and soft, saying ear, saying ear, saying ear, ear and hood and hood and green and all that we say we are saying around that which cannot be said, cannot be spoken. But in a moment that which is behind naming makes itself known. Hand and breast know each one to the other. Wood in the table knows clay in the bowl. Air knows grass knows water knows mud knows beetle knows frost knows sunlight knows the shape of the earth knows death knows not dying. And all this knowledge is in the souls of everything, behind naming, before speaking, beneath words.[85]

The new 'essentialism' of which Susan Griffin is the most inspired and interesting exponent, holds that women are intrinsically different, that womanliness exists as an absolute concept, beyond cultural and historical conditioning. But because developments through time – blamed on males, according to this view – have oppressed and silenced women, the only unmistakable badge of identity is physical sexual difference. Because women are evidently different, one from another, in opinions, interests, expression, the single uniting common factor between them is biological; reductive and radically anti-historical as this definition of femaleness may

be, it beckons powerfully to feminist artists and writers. Affirming the strength and beauty of female sexual characteristics attacks the privileged symbolic discourse male authorities have enjoyed hitherto.[86] In the work of Judy Chicago, the monumental *Dinner Party*, each of the thirty-nine women of the past honoured by a place at the table is symbolized by a ceramic painted plate on an embroidered multi-coloured mat.[87] Each dish was designed by Chicago as a different mandala-like sunburst. 'I want to make butterfly images', she said early on in the work, 'that are hard, strong, soft, passive, opaque, transparent – all different states – and I want them all to have vaginas so they'll be female butterflies and at the same time be shells, flowers, flesh, forest – all kinds of things simultaneously.'[88]

Aiming at ambiguity, at plural significations, and at a positive iconography of the open orifice of origin, the vulva, Judy Chicago discarded the male allegorical language which shaped the ideal female form as a sealed fountain, an enclosed garden, an impossible, stopped-up sieve. Chicago is aware of her assault on symbolic norms:

> Women artists have used the central cavity which defines them as women as the framework for an imagery which allows for the complete reversal of the way in which women are seen in the culture. That is: to be a woman is to be an object of contempt and the vagina, stamp of femaleness, is despised. The woman artist, seeing herself as loathed, takes that very mark of her otherness and by asserting it as the hallmark of her iconography, establishes a vehicle by which to state the truth and beauty of her identity.[89]

The problem about inversion as a strategy for change, about reversing negative definitions, about co-opting abuse, is that such methods perpetuate the old distinctions, they still pivot on contrasts between open/closed, wet/dry, hard/soft, clean/dirty, culture/nature rather than dissolving altogether such oppositions in sexual difference as it is perceived.

It is also questionable whether emblematic vulvae can meet Judy Chicago's avowed and idealistic purpose, any more than a dinner party honouring men would succeed, if penises were symbolized at each setting to evoke the individual guest's presence(!) The face, that most traditional sign of the person as individual, would convey their uniqueness more expressively; a visitor to Judy Chicago's *Dinner Party*, though stirred by its hushed sense of reverence, can feel distanced from the women it celebrates, and lose, too, historical awareness of them as different people.[90]

To escape altogether from the symbolic sexual body, to search for new metaphors beyond anthropomorphism, may present a richer gamut

of possibilities. Frida Kahlo represented herself, in one of her most heart-rending portraits, as a wounded deer. The animal's body is pierced by arrows, but it looks at us with a human face, Frida's own.[91] Susan Hiller, the American-born artist who lives in London, has extended the range of self-representation beyond the whole figure as a receptacle of unambiguous meaning, into metonymies of the fragment, the palm print, the closed eye. In her paintings based on automatic writing, she has abandoned depicting the physical body to show herself through spontaneous gesture, unconsciously prompted marks, made according to the individual rhythms and stresses of her body and hand's movements.[92] She has written in notes to one of these works, *Sisters of Menon*: '"I" feel more like a series of activities than an impermeable, corporeal unit. Or rather, "I" am not a container. (This does not mean I do not accept personal responsibility.)'[93]

Through the medium of the body, not its image, she arrives at an idiosyncratic, hermetic notation which displaces the represented figure completely to make way for an almost Islamic emphasis on the potential of the pictured letter. Thus Hiller's indecipherable and ineffable scripts abandon anthropomorphism to follow the earlier intuitions of the Sur-realists like André Breton and abstract Expressionists like Jackson Pollock that the mark can be as personal and eloquent as the physical semblance. Perhaps we can only escape from the sexual definitions of allegorical anthropomorphism through such thorough severance from its symbol-ism, which has determined that the ideal female body, fitting container of high and virtuous meanings, should be an impossible object, like a sieve which does not leak.

CHAPTER TWELVE

The Slipped Chiton

Votre mère, c'est bien cette France féconde . . .
Oh! l'avenir est magnifique!
Jeunes Français, jeunes amis,
Un siècle pur et pacifique
S'ouvre à vos pas mieux affermis . . .
Chaque jour aura sa conquête,
Depuis la base jusqu'au faîte,
Nous verrons avec majesté,
Comme une mer sur ses rivages,
Monter d'étages en étages
L'irrésistible liberté!

VICTOR HUGO[1]

In 1889, in the newly named Place de la Nation, Jules-Aimé Dalou's monumental group of statuary, *The Triumph of the Republic*, was unveiled to celebrate the centenary of the Revolution. The sculpture was not yet cast; the plaster was painted to look like bronze for the occasion. It would take another decade before the gigantic monument was completed. At thirty-eight tons, it is the largest group cast in the capital at the height of the Third Republic's *statuomanie*. In 1899 it was officially inaugurated in front of the President of the Republic, during a day-long display of military and civic bravura designed to invigorate the beset regime. Marianne, the figure of the Republic, riding aloft on the pinnacle of Dalou's colossal triumphal car, was the focus of this profession of republican faith (Pl. 78).

Into this single figure, Dalou folded the essential themes of the French nineteenth-century national allegory. Like a classical Victory or Amazon, his Marianne wears a diaphanous tunic which has slipped off one shoulder; her feet are bare, and on her head, on her loosely coiled hair, she wears a cap of liberty, the emblem of the Revolution. Her undress coheres with her headdress to express her state, poised between the

reality of her identity as the French Everywoman (her common name), and her lack of personal identity as an emanation of the ideal. The slipped chiton – that modest phrase used by the cataloguers of antiquities – correlates with her Phrygian bonnet to tell us something as well, as allegorical female forms do, about ways of thinking about women themselves.

Jules Dalou (b. 1828) was of poor Protestant family and an ardent Republican.[2] During the Commune, he joined the Fédération des Artistes formed under Courbet and signed the artists' petition, which demanded the public exhibition of the nation's treasures, among other things; he was also appointed curator at the Louvre, where he was guarding the collections, the night the royal Palace of the Tuileries next door was burned down by the crowd. He escaped to England,[3] and in 1874 was sentenced *in absentia* to hard labour for life for his participation in the uprising.

Too red for France, he pleased Queen Victoria in Britain, who commissioned a memorial to her grandchildren, still in the royal chapel at Windsor Castle. It is a nice irony that Brock's figure of Charity behind the statue of Queen Victoria in the Mall was directly inspired by Dalou: the French sculptor's icon of simple republican citizenship has been made to attest to the bounty of the Empress of India on the plinth.[4]

In 1879, all political exiles were amnestied, and Dalou returned to France. He went in for the state competition for a statue of the Republic, but his gigantic programme did not meet the conditions laid down in the competition for the Place de la République's monument, and Morice's statue won. The radical Conseil Municipal pressed however for the execution of Dalou's design and the city of Paris immediately commissioned it.[5]

Few visitors to Paris go specially to see the sculpture now, though the Place de la Nation, with its revolutionary links, often still provides the starting-point for political demonstrations. From the pavement across the road, around the central island where it stands, Dalou's group seems massively moored, bulking like a battleship of dark sheeny metal in dry dock, its modelling too fine to catch the light viewed from afar. Dalou had always worked in small scale before, and he did not quite master here the grandiloquent silhouette of the public commission fated to the cursory glance. But his plastic vigour and subtlety reward a patient look, for at close quarters the distant portentous mass becomes a tender and vital ensemble; the figures of Justice, of Toil (Labeur) and the two pacing lions who haul the triumphal chariot forward are fashioned with splendid haptic dynamism, the many putti, gambolling and tugging at cornu-

copias brimming with every sort of ripe vegetable and fruit, are each one affectionately created from life, with individual faces. Fecund in their innocent nakedness, they have not passed unnoticed: it is amusing that, like the big toe of St Peter in Rome, their little penises have become burnished under fingers touching them for luck. If *The Triumph of the Republic* draws few tourists, it is still part of the life of the street.[6]

In an unusual departure from custom, Dalou's personification of the Republic and its constituent virtues omits all weapons: his Justice wears a contemporary bodice over a chemise and a voluminous and encrusted judiciary mantle. She looks out watchfully, with the steady intelligence shown by Dalou's sculptured mothers, and he probably used the same model, his wife Irma Vuillier who posed for him throughout his career.[7] A putto in front of her struggles manfully with her scales. The sword of Justice is nowhere to be seen, for instead she carries the mediaeval French kings' *main de justice*, a sceptre surmounted by a hand.

Dalou's characteristic addition to the Republic's slogans, 'Peace, with the attributes of Abundance', brings up the rear of the Triumph, scattering roses from the bouquet of various flowers on her left arm (Pl. 79). A Boucher-style Venus in the round with the typical gentle and secret smile of Dalou's female subjects, she surprised the former *Communard* himself. 'I have a bomb to drop,' wrote Dalou about his design. 'The monument has an inclination to Louis xiv, the style which I love above all others.'[8] Exuberant, sensuous, refusing grimness and praising pleasure, Dalou's sculpture differs in tone from the didactic and elevated austerities of his predecessors in the interpretation of French political liberties. He belongs in the aesthetic tradition of the inspired Coysevox, creator of the flying horses in the Place de la Concorde, and other *ancien régime* masters like Jean-Louis Lemoyne and Clodion, and his espousal of the sweet tone, the ecstatic reverie, links him unmistakably with the preceding regime's greatest sculptor, Carpeaux, eleven years Dalou's elder, who had taught him at the Petite Ecole.[9]

Dalou was stricken by the tenor of the 1899 ceremony: 'Where was the army of labour hiding during this old-fashioned gala? Where were my *praticiens*, my *ajusteurs*, my casters and my plaster workers? Or the millions of arms which create? Or those who labour on the soil? I saw guns and sabres, but not a work tool.'[10]

In spite of his originality, Dalou adopted most of the usual emblems, signs, devices and traditions in the depiction of the Republic. He interpreted Justice as the social expression of the Revolution's Egalité; his workman stands for the comradeship of labour, Fraternité, while Liberté is personified by an epicene boy who flings himself side-saddle across the

pacing lions with nothing but a drape flying from his shoulders. This Genius of Liberty recalls the classicizing memorial to the fallen in the July Revolution of 1830 put up in the Place de la Bastille nearby.[11] The Colonne de Juillet, as it is known, also features the boy Liberty, echoing Giambologna's exquisite flying Mercury and anticipating the Victorian Alfred Gilbert's famous Eros in Piccadilly Circus, London. It shows that the expedient of personifying the indwelling masculine spirit could have been adopted by artists if they had so wanted; but a male Liberty, even in as fine an interpretation as Dalou's fervent and sinewy sprite, never became established, like Marianne, as the expression of the Republic and its freedoms.

In his group, Dalou did not fail to establish the link between Marianne and Liberty. He ingeniously connected the youth riding the lions with his female allegory by turning the youth's head to gaze rapturously up at Marianne, where she stands, poised on a globe at the summit. She carries a bundle of sticks – the Roman fasces – which used to symbolize Unity until Fascism this century cancelled any possibility of the emblem's sincerity. Her right hand is outstretched in front of her, with the fingers lightly spread as if to give herself perfect balance in the act of alighting, rather than to gesture in any pontificating way. She represents the claim to unity and strength the Third Republic wished to make, when it welcomed back the insurgents of 1871, and extended its embrace to the radicals who, in Agulhon's words, 'had begun to distance themselves from the official Republic crowned only by ears of corn'.[12] The presence of the liberty cap on her head implied this expansiveness towards the more ardent socialists. For the *bonnet rouge* is an index of revolutionary zeal, as is his statue's state of undress, though nothing could be more inviolate than the exposed breast of Dalou's Marianne.[13]

The most famous prototype for Jules Dalou's Marianne is Delacroix's *Liberty Guiding the People*, of fifty years before, now become a universal image of revolution, in its glory and its terror (Pl. 77).[14] Delacroix painted the canvas after a short-lived enthusiasm for the 'Trois Glorieuses' – 27, 28 and 29 July – of the 1830 Revolution that brought down the Bourbons.

Caught up in the capital's excitement, Delacroix volunteered for the Garde Nationale. But in February of the following year, when the bourgeoisie had succeeded in placing Louis-Philippe on the throne, he was ambivalent about his own *engagement*. In an eloquent letter, he wrote:

> We are living, my dear friend, in a discouraging time. You have to have virtue to make beauty your only God. Ah well, the more people hate it, the

more I adore it, I'll finish up believing that there's nothing true in the world except our illusions. ... Come back quickly ... come and taste the sweet pleasures of the national guard which one fine day like an idiot I got myself stuffed into. Come above all to kiss us and speak badly of the human species, of the times, of this and that, of ourselves, of women above all.[15]

That autumn, Delacroix exhibited his famous picture of the July Days in the Salon. It possesses the full charge of disquiet he shows in his correspondence, the clash of cynicism and optimism in his feelings. The painting is smaller than the impression it gives in reproduction (2.60 metres high and 2.25 metres wide) and the paint is applied more thinly than expected, rather as if Delacroix dashed it off; the different characters – the gamin brandishing pistols, the imploring worker at Liberty's feet, the guard in the top hat to his right – have not fused completely with the dramatic scene at the barricades Delacroix has imagined. They bear the traces of the studio sitting in their fixed stance and studied expressions. Yet the image as a whole survives such criticisms; its essential tragic character makes them fribbling. Delacroix may have painted with brio, but the composition is very carefully considered; he has cast each type of citizen worker who rose in the July Days, and distinguished them by different headgear: a student's velvet cap on the pistol-waving boy, the Garde Nationale's shako on the boy to the far right, the labourer's beret on the man with the sabre, the agricultural worker's kerchief on the figure kneeling, the top hat of the town-dwelling artisan (not a bourgeois as is usually thought) for the man who holds a double-barrelled shotgun. On her head Liberty is wearing a Phrygian cap, like Dalou's later Marianne, and it is chief among the signs of her character, marking Delacroix's brief partisanship with the Left, and setting Liberty herself apart, in a place of ideal difference, as we shall see.

In one hand Liberty brandishes the tricolour and in the other she holds a flintlock, but otherwise she is in the classical costume of a goddess of victory, and her lemony chiton has slipped off both shoulders. Her breasts, struck by the light from the left, are small, firm and conical, very much the admired shape of a Greek Aphrodite, and her profile with its shallow indentation at the bridge of her nose is clearly inspired by a classical goddess' head. Her feet, like an ethereal being of the sky, are bare. But there her resemblance to antiquity ends, and Delacroix's brilliant invention begins. That bare foot is large, the ankle is thick, the toes grip the rubble of the barricade over which Liberty leaps; her arms are muscly, her big fists grip the flag and the gun, she has a smudge of hair in her armpit. She surges forward over a heap of bodies, and in her

heedless pace Delacroix has precipitated the tragic essence of this image: her robust, hearty undress underscores the pathos of the fallen man who, literally *sans culottes*, lies on the barricade to Liberty's right; his thin, stringy, limp legs lying in her way, his head flung back without vigour. Dying or dead, he has been stripped from the waist down; one sock only remains, there is a pubic shadow. Like a figure of Hector dragged behind Achilles' chariot, he lies stricken, prone, debased in despoliation and in this he acts as an almost exact reversal of Liberty's shameless, noble, invulnerable exposure: he is a victim of his mortality, whereas she cannot die.

Liberty's characterization was fraught with tension for the painting's first audience. A mere suggestion of body hair was intolerable to the public of 1831, reared in the glabrous convention of David and Canova, and Delacroix's image was roundly denounced. The word *sale* (dirty) recurs in the abuse. He had made Liberty look like a filthy creature, a *poissarde* (a fishwife), a whore, ugly, ignoble, *populacière* (of the rabble).[16] Delacroix was concerned to paint the ideal realistically; he had succeeded only too well. Moreover, in 1831, the *bonnet rouge* was a subversive emblem of the radicals and its presence on Delacroix's Liberty's head may account in part for the disappearance of the painting after the Salon. For although it was bought by the Minister of the Interior, it was not put on show, and was returned to Delacroix in 1839. It re-emerged twenty-four years later, after Delacroix had petitioned the Emperor Louis Napoleon to allow him to exhibit it again. During the next re-publican regime, in 1874, it was moved to the Louvre, where it now hangs. It is even possible that Delacroix painted over the original scarlet colour of the liberty cap. It is now a subdued brown, in no way picking up the brilliant red of her sash or of the tricolour Liberty waves to rally her followers.

Delacroix's dynamic vision dips its roots in a direct memory of the July Days. The barricades had not been seen in Paris for two hundred years, for the French Revolution took place without them: but the bourgeois revolution of the July Days gloried in the romance of the blocked city streets. Delacroix was influenced by the eager renditions of street fights from print-makers, engravers and others who worked quickly to celebrate the events.[17] The exploits of Marie Deschamps, a working woman who fought at the barricades, may have inspired his Liberty's courage in part; or the more distant bravery of Jeanne Laisné, nicknamed 'Hachette', on account of the weapon she wielded in the siege of Beauvais in 1472, when she rallied the townspeople to drive Charles le Téméraire from the walls. She had been celebrated in a painting

of the battle by Jules Le Barbier of 1778 which since 1826 had hung in the Town Hall of Beauvais where Delacroix might have seen it. The composition bears striking similarities to Delacroix's *Liberty*, with a heaped mass of mingled bodies and fighters rushing upon us and rising to the apex of a pyramid at the tip of the tricolour waved by the allegorical figure (in a slipped chiton) who leads Jeanne with her 'little axe' over the tumbled stones of the town's fortifications.[18]

But Delacroix's more immediate historical source was an earlier famous incident which had taken place in Greece, during the prolonged War of National Liberation against the Turks. A number of sketches, dating from before 1830, executed with Delacroix's magnificent assurance, provide models for the Liberty and other figures in *Liberty Guiding the People*. In 1792, the partisans of the small republic of Souli were rallied to withstand the troops of Ali Pasha by a Souliot woman, Moscho, wife of their chief Tzavellas, who seized pistol and sabre and led them to victory; the incident might have gone unnoticed if the Souliots, nine years later, had not been finally overwhelmed by the Turks, whereupon the womenfolk threw their babies into the ravine below the town and hurled themselves after. The mass suicide caught the imagination of the Romantics and turned Delacroix's eyes to their heroine Moscho.[19]

But even in the early sketches of the principal figure, the allegorical lineaments of Liberty's body are already marked.[20] Plucked from the history of women's courage, Moscho has been transmuted according to the precepts of the classical tradition, retrieved and reshaped during the years before and during the French Revolution.

The Phrygian cap, which Delacroix's Liberty and Dalou's Marianne wear on their heads, significantly combines two different types of antique headgear, each emblematic of an essential aspect of the freedom represented by the *bonnet rouge*. One type of hat indicated a foreigner, who had come from afar – from Phrygia – from an exotic and different place, charged with the exotic energy of that difference; the other was worn by the Roman slave released from bondage; both, in their way, represented another order of things, brought in from the outside by the strangers, inaugurated from the inside in the case of the freedman; both also participated in the symbolism of the unfettered: the foreigner is not bound by the same laws, the slave is set free from old ones; both could therefore stand for change.

The cult of the god Mithras, which was first kept in the east, in Asia Minor, was brought to Rome and popularity by the legionaries who had fought there from the first century BC onwards.[21] Mithras can

always be recognized by his Phrygian cap; he wears it for instance on an altar excavated from the foundations of San Clemente in Rome, where he is carved sacrificing the totem animal of his worship, the bull,[22] and in the justly celebrated second-century Roman sculpture of the same theme in the British Museum.[23] Paris, the Trojan, also from pastoral Asia Minor, wears it too, from the earliest representations of him to neoclassical interpretations like N.-F. Gillet's painting of 1757, *Paris the Shepherd*, in the Louvre.[24] In Christian iconography, the three kings who also come from the east to adore the Christ child appear in it in early Christian images of the Nativity. In the sixth-century mosaics in the basilica of Sant'Apollinare Nuovo in Ravenna, where the three Magi are identified by their legendary names, Gaspar, Balthasar and Melchior, they are gorgeously arrayed in orientalizing fashion, embroidered leggings, coloured, bordered tunics with belts, chlamydes with encrusted yokes.[25] They step forward as they proffer their rich and costly – and eastern – gifts of spices and treasure, and genuflect in the gesture of submission made by barbarians and prisoners of war to the Emperor of Rome, as we see on Trajan's column, or later on the obelisk of Theodosius I in Constantinople.[26] The Magi were outsiders too, and so designated principally by their cap, which is bright red in Sant'Apollinare. They only exchanged this 'barbarian' headgear for crowns in Carolingian images of the tenth century.[27]

The Phrygian cap has a rounded crown, which falls into a soft fold at the centre. It can have lappets which cover the ears and a long panel over the nape of the neck, or it can be cut in a single curve, dipping at the back of the neck but clearing the ears. It looks as if it originated in an animal skin.

Orpheus, also a mythic figure of the Orient, who moreover stills the beasts with his music and dwells in the forest, and is thus closely associated with the wilds, mourned the loss of his wife Eurydice in the hunting country of Thrace, and is depicted enthralling Thracians with his lyre-playing, on a jar of c. 430 BC, in the British Museum.[28] The Thracians are wearing animal skins on their heads, trailing down their backs. The headless pelt has been folded in half and stitched together, making a peak at the fold over the head, and corners over the ears out of the animals' paws. The shape is not the same as a Phrygian cap, but nearly so, and the wise men's scarlet headgear could have evolved from this primitive fur hat, for the association with the untamed world of the forest and the wild animal, with the domain of hunters and of Artemis, goddess of the chase, and of her followers the Amazons, is crucial in the radiating energy of the Liberty figure herself, as we shall see.

The emblem of French Liberty, confirmed by the Republic, which Delacroix's and Dalou's figures wear on their heads, has the same shape as the Magi's Phrygian cap, and has been commonly identified with it. But its meaning, not its appearance, derives from the *pilleus*, the felt cap worn by emancipated slaves of Rome, who exchanged the headband of bondage for the hat of a citizen. They were then given a new name, in accordance with their new status.[29] The pilleus, as we know it from the coins struck by Brutus in 44 BC to commemorate the murder of Caesar, was of similar shape to a fez, without the tassel: an upside down flower-pot, with no lappets, no nape drape and no reminiscence of animal skins. In the Roman Republic, this hat signified Roman Liberty, freedom of citizenship, and appears on the end of the staff the figure of Libertas holds on coins struck under Antoninus Pius.[30] Brutus' exact design, the fez-shaped pilleus together with flanking daggers, was revived, for this reason, by Lorenzino de' Medici (d. 1547) (Lorenzaccio) in Florence, on a medal which proclaimed his righteous tyrannicide of the ruler of Florence, his cousin Alessandro, in 1537.[31]

Lorenzo's deliberate archaism does not represent a widespread use of the pilleus as Liberty's emblem during the Renaissance; but in Cartari's *Imagini dei dei e gli antichi*, of 1556, Libertà makes an appearance with the pilleus as attribute.[32] At first, Cesare Ripa's *Iconologia* proposed a maiden holding the biretta of a cardinal (!), but by the 1611 and 1644 editions, Ripa had repented of his incongruous suggestion: Libertà appears holding the pilleus on a standard.[33] Ironically, one of the rulers who arrogated this pledge of freedom for himself was the absolute monarch, the Sun King himself, Louis XIV, who in 1678 celebrated the treaty of Nijmegen and the capitulation of Holland with a medal showing the Liberty of that country with pilleus and lance, standing beside Peace, and receiving the instructions of Prudence.[34] During the reigns of William of Orange and the first Georges, Britannia is sometimes accompanied by Liberty, with the pilleus on a spear; in one propaganda medal, William presents the liberty cap to Ireland, Scotland and England on their knees, with the inscription 'Veni Vidi Libertatem Reddidi' (I came I saw I restored Liberty).[35]

Sir Ernst Gombrich has pointed out that the transformation of the simple pilleus into the peaked and lappeted *bonnet rouge* itself, the red Phrygian cap, emblem of the Revolution, is mysterious. He discovered that its appearance after the fall of the Bastille was opposed with surprising force by leading Revolutionaries, including Robespierre himself, who upheld the tricolour as the proper symbol of the Revolution. But in the same year, a tremendous pageant - one of the grand sequence

masterminded by the painter Jacques-Louis David – was held to honour
the few survivors of a Swiss regiment who had mutinied against their
officers two years before. Some had been killed, but the survivors who
had been sent to the galleys had been ransomed, and they paraded with
a model of their prison ship and a triumphal cart of Liberty, past a statue
of the former king, Louis xv (the one in the later Place de la Concorde),
which had been blindfolded and covered with a red pilleus. Gombrich
adds that a law forbidding the wearing of red hats by galley slaves was
contemporaneously passed, in 1793. He persuasively suggests that a soft
red wool cap may have been part of the ordinary prisoner's uniform,
and therefore could well have lent itself to symbolize by inversion the
protest of a liberated revolutionary.[36] It was then conflated with the
ancient sign of the freedman, the Roman pilleus, and with the headgear
of the outsider, the 'man from the east', and acquired its floppy crown.
The layers of symbolism enfolded within the Phrygian cap proved ir-
resistible: as the hat of Mithras, Magi, and exotic pagans, it was a sign
of difference at a time when nothing was intended ever to be the same.

With varying degrees of popularity and opposition, the *bonnet rouge*
became the prime emblem of the Revolution; King Louis xvi put it on
in an attempt to woo the crowd and pose as the 'Father of Liberty',[37]
and adorned with the tricolour *cocarde* or cockade it began in 1792 to be
regular daywear for the revolutionary *citoyens* of France. It appears for
instance in an engraving in the Musée Carnavalet showing the new 'mar-
iage républicain' passed by the Constitution of 1791; the State's officer,
who conducts the exchange of promises between the bride and groom
at an altar of the god Hymen, wears a red Phrygian cap.[38] But the
radical and feminist Société des Républicaines Révolutionnaires were
laughed out of their attempt to promote the *bonnet rouge* as a hat for
female partisans as well; it had to remain the identifying sign of an ideal
Liberté, and could not be worn by a free woman.[39]

The Phrygian cap passed into international currency. American
fighters for independence were already using the symbol: in 1768 Paul
Revere created the beautiful Liberty Bowl to commemorate the rebel-
lion of the American House of Representatives' members against British
rule. He stamped the cap of liberty from Rome within a wreath above
a defiant and proud inscription.[40] Libertas Americana, hair streaming,
with a pilleus on a spear behind her, revealed a noble profile on a medal
struck to commemorate the surrender of the British at Saratoga in 1777
and Yorktown in 1781. Benjamin Franklin, who, when asked by sym-
pathizers how the American Revolution was progressing, would reply
in the words of the French insurgents' song, 'Ça ira', helped the medallist

Augustin Dupré with the design, and it was struck at the Paris mint.[41] Within a century, however, the American sculptor Thomas Crawford was persuaded to change the headgear of his statue of Freedom for the dome of the Capitol, as we saw in Chapter 1. The cap was by then considered too revolutionary for the United States Congress' figurehead.

In France, after reappearing during the Commune, the *bonnet rouge* also went underground again until the Third Republic's consolidation, around 1879.[42] It is highly significant that so very few public monuments to the red-capped Republic - Agulhon has traced one - survive from the two earlier Republics.[43] It is also revealing that the gift of *Liberty* from that same Republic to its sister across the Atlantic in the 1870s was crowned by the rays of the sun god Helios, no doubt less hot than a Phrygian cap; that she was fully dressed, too, static and matronly; that her hair was tidy. Although the cap does appear on the US dollar coin of 1890, Bartholdi's statue, forgoing a *bonnet rouge*, and breaking with the tradition of Delacroix's Amazon, represented the *Zeitgeist* of America accurately. Could a variation on Delacroix's revolutionary have been placed at the gates of the New World? It seems unlikely.

Containing a sequence of inversions, the iconography of Liberty thus operates on the central premise that signs of Otherness can be recuperated to express an ideal. The galley slaves' headgear becomes a cap of freedom; the capitulating barbarians' cap becomes a sign of Liberty; a woman, empirically less enfranchised than the man in nineteenth-century France, and even ridiculed when she wore the cap of liberty in real life, occupies the space of autonomy and pre-eminence. Above all, Liberty's exposed breast stands for freedom because thereby a primary erotic zone is liberated from eroticism. As eroticism is a condition of the depicted female body, a semi-naked figure, who is no longer constrained by it, becomes free.[44] The slipped chiton is a most frequent sign that we are being pressed to accept an ulterior significance, not being introduced to the body as person.

The allegorical female body either wears armour, emblematic of its wholeness and impregnability, as we have seen; or it proclaims its virtues by abandoning protective coverings, to announce it has no need of them. By exposing vulnerable flesh as if it were not so, and especially by uncovering the breast, softest and most womanly part of woman, as if it were invulnerable, the semi-clad female figure expresses strength and freedom. The breast that it reveals to our eyes carries multiple meanings, clustered around two major themes. It presents itself as a zone

of power, through a primary connotation of vitality as the original sustenance of infant life, and secondly, though by no means secondarily, through the erotic invitation it extends, only to deny. The first theme relates to the Christian iconography of Charity, and the eighteenth-century cult of Nature, as we shall see; the second to classical mythology about virgin goddesses and warrior Amazons. The slipped chiton rarely reveals the compliant body of Aphrodite or Venus or her train; they are naked to the thighs, or completely nude; it is the asymmetry of the undress worn by Delacroix's and Dalou's figures that is essential to the imagery, for it suggests both the breast's function as nourishment (one at a time is revealed to feed) and the ardent hoyden, so caught up in the action of the moment that she has no thought for her person.

The semi-nakedness of Delacroix's Liberty is emblematic. Those polished breasts which still recall the stoniness of their possible original have nothing in common with the genital pathos of the foreground corpse. As Anne Hollander has written in her book *Seeing Through Clothes*: 'Her exposed bosom could never have been denuded by the exertions of the moment; rather, the exposure itself, built into the costume, is an original part of her essence – at once holy, desirable, and fierce.'[45] The eager partisans Liberty guides reflect her heedlessness; the boy with the pistols surges towards us, his mouth open, regardless of the bodies that lie collapsed and dishevelled in his path, under the barricade.

That heedlessness is itself a reflection of Liberty's sincerity; this spirit of France has become like the French people themselves, the Franks, who are *franc*, full of *franchise*, that necessary quality of chivalry that goes with being free, en*franc*hised, and not in chains (Pl. 85).[46] The outward sign of this inward and crucial pun in Liberty's bared breast. The female breast, which we so quickly and reductively think of as only sexual, is as much the seat of honesty, of courage and feeling, as is the male. For both sexes it is the place of the heart, held to be the fountainhead of sincere emotion in both classical culture and our own (unlike the Chinese, who grant the head and liver the powers of affect we associate with the heart). Odysseus for instance communes with his *thymos*, his inner feelings, sited in his chest or midriff just as we 'consult our hearts' and enjoy 'bosom friendships';[47] in Latin, *pectus* carries the same metaphorical value, as the seat of feelings whose source lies in the heart (*cor*) it holds inside it. In French – as Liberté's bosom is in question – *le sein* can be used of the bosom of a masculine confidant, for instance. In English, the words 'breast' and 'bosom' were not sex-specific either until possibly very recently.[48]

In Greek art, the goddess who most frequently appears in a slipped

chiton is Artemis, the goddess of the hunt. On a beautiful amphora in the British Museum, she appears with a panther skin slung over her bare shoulders and another panther tame at her side, facing her brother Apollo.[49] But as Artemis is the fierce virgin who orders Actaeon's death after he has seen her bathing, her undress issues no erotic invitation, however wondrously it works on Actaeon's senses. Of all the Greek pantheon, she is most associated with dedicated virginity; in Euripides' *Hippolytus* the eponymous hero turns to her, not to Athena, when he spurns the love of women and the pleasures of the flesh.[50] She orders Callisto her favourite's death after Callisto has lost her maidenhead to a disguised Zeus.[51] Artemis belongs to the wild, to the forest outside Athena's polis, where she has dominion over animals who are her companions and her quarry. In one of the statues of her that have come down from antiquity, the Artemis Bendis, she is even wearing a Phrygian cap, sign of the outsider.[52] She is the patroness of unmarried girls, who on marriage pass out of her domain into the tutelage of other, less farouche, goddesses. The Amazons worship her, and model their lives on hers, hunting, forswearing friendship with men. At Ephesus, in Asia Minor, Artemis/Diana had her principal shrine; it was also the mythical capital of the Amazons' terrain, and an exquisite frieze of the fourth century BC from her temple there celebrates their strength and their courage in battle (Pl. 80).[53] Just as Artemis lives outside the Greek definition of normal womanhood in her virginity, so Amazons live beyond the border of civilization which made them the subject of so much fantasy.

The Amazons' appearance is often close to the delirious undress of the Maenads, followers of Bacchus, and thus suggests their abandonment, their whole-hearted ardour.[54] On the mid-fourth-century BC Mausoleum of Halicarnassus, one of the seven Wonders of the World, the Amazons were carved in relief, dressed in Greek tunics over their naked bodies, heroically resisting the onslaught of the hero Heracles and his warriors.[55] The Amazon frieze on the Mausoleum forms a pendant to another, on the other side, depicting the battle of the Lapiths and Centaurs, and both myths, which were immensely popular in architectural Greek art, celebrate the triumph of civilization, championed by the Greeks, against barbarians, represented by the outsiders, the code-breakers who come in from the wild: Centaurs who were so overwhelmed by lust they attempted to abduct the Lapith brides from their own wedding feast,[56] and the equally unbridled Amazons who also repudiated natural law, by refusing sexual union and living beyond the pale.[57] While conquering Centaurs and Amazons, the exemplars of

Greek mores show disapproval and at the same time hankering; the frequency with which both representatives of the outlandish turn up in their art, their very role in putting heroes like Theseus and Heracles to the test, establishes these imagined pariahs as central to Greek identity and self-definition.[58]

In Roman political iconography, the mirror image provided by the figure of the Greek Amazon became a true image: the inversion slides into the position of the ideal when Rome herself is personified on coins. It is often impossible to distinguish the principle Virtus from the goddess Roma, in the figure of an armed maiden, in short tunic like an Amazon.[59] Virtus, Virtue, as we have seen, assumes this form when she attends a great man at his great deeds; her iconographic counterparts are active, strong, independent heroines of myth, Atalanta the runner and huntress, Hippolyta the Amazon, and the goddess Diana of the chase. The rhumb linking the freedom of the chase and the run of the forests, to the unattached virgin, arrives at its resolution in the figure who personifies the claims of the State to be free, Rome itself. The goddess of such a place had to appear heroic, resisting, chaste and strong.

At the Temple of Roma and Augustus at Ostia, the cult statue of Roma showed the goddess of the city wearing a long tunic, slipped off one shoulder in the asymmetrical style of the Amazon; on the Severan Arch in Leptis Magna, Roma attends an imperial commemoration in the form of a young Amazon, in short tunic this time, a drape knotted on her shoulder and held by a baldric slung sideways across her chest with a helmet on her head. But Hadrian set up a new cult statue, representing Roma enthroned like a Tyche, in the Temple of Venus Felix and Roma Aeterna, in Rome around AD 135-6, and afterwards the Amazon-style goddess who resembled Atalanta or Hippolyta began to be effaced by the much more sedate and respectable matronly Tyche of the city; yet even she, as she appears on the coins of Nero and Vespasian, bears traces of her Amazonian past, in her short tunic and high buskins and crested helmet. Her chiton slips sideways to reveal a breast on the coins issued by Nero and Galba, and sometimes she carries a bow and quiver.[60]

The image of Liberty, developed in France from the French Revolution onwards, descends from this classical figure of the free state, with her overtones of Amazonian virginity and independence. Although Delacroix's cluster of identifying signs – from the Phrygian cap to that naturalistic armpit which so upset his contemporaries – comes to life through the vigour of his execution, his protagonist is appropriately female not only because *eleutheria* and *libertas* are feminine in gender in

Greek and Latin but because lack of constraint, liberation, *wildness*, are unconsciously aligned with the wild itself, with the world outside society as manifest in cities; 'cities' stand for civilization and culture, and its exclusion zones stand for 'nature'. Those who dwell in that natural domain, like huntresses and Amazons, develop a closer association with the wild and its energies.[61]

As the anthropologist Edwin Ardener has suggested, in a classic paper in *Perceiving Women*, human beings bond themselves together as a whole to distinguish between humanity and non-humanity, according to one set of criteria; but within human society itself, in the same way as men and women together look upon animals as different, we distinguish between men and women, and bond with our own sex to see the other as different.[62] But because men have generally controlled the processes of communication and the male view dominated social perceptions, it is women who have chiefly suffered from the imaginary overlap between sexual difference and non-humanity, 'because their [the men's] model for *mankind* is based on that for *man*, their opposites, *women* and *non-mankind* (the wild) tend to be ambiguously placed'.[63] From this ambiguity arise women's 'sacred and polluting aspects', so visible in the polyvalent significance of the bared breast. As Ardener goes on to say, 'Women accept the implied symbolic content by equating *womankind* with the men's wild',[64] although they know themselves to be threatened, not only by that characterization itself, but by the wilderness which men occupy *vis-à-vis* women: it is only when women find their voices that they conjure openly the defilement of their sphere by men's dangerous pursuits (as at Greenham Common). Otherwise they mutely preserve their own outlook and the anthropologist has an uncommonly hard task to break through woman's 'muted'-ness.

In her nineteenth-century form, the figure of Liberty reveals that the female who enjoyed and suffered the special stigma which associated her with the wild, could exercise in a time of ferment a positively perceived and desirable potency. The breast of a woman as distinct from the generic human bosom acts as a sign of nature and its wild connotations in visual imagery that complements and reinforces the magic outsider status of the Amazon. Of all the Virtues, only Charity, as noted before, perhaps possesses a non-virginal body which is capable of emitting and flowing without pollution. The infants who drink from her breasts and who are thereby kept in life are Charity's attributes, the equivalent of Egalité's carpenter's level during the French Revolution or Temperance's pitchers in the early mediaeval period (Pl. 82). Her breast becomes the mark of her natural, motherly relation to those who come into contact

with her. Adapted to political imagery, the exposed breast denoting the wild thing can also mutate her into a Tyche, a matron and nurturer, and a type of the protective state. The oscillation between these two dominant meanings of the breast is constant after the first Revolution in France, and it reflects swings between accepting woman as an active agent of change or desiring her to remain a passive source of strength.

In Greek, the root *mamm-e* gives both the word for the breast, the word for a child's cry for the breast, and the name of mother, as it still does in English, and the Romance languages. In Greek literature, the revealed breast often designates the claim of a mother's love upon a hero, the bond that still joins the private and the public worlds.

At the end of the *Iliad*, for instance, Hecuba implores Hector not to go out to the field and fight against Achilles. Priam his father has failed to move him with his chiliastic visions of his own terrible end, so Hecuba takes up the thread:

> And now his mother in her turn began to wail and weep. Thrusting her dress aside, she exposed one of her breasts in her other hand and implored him, with the tears running down her cheeks. 'Hector, my child,' she cried, 'have some regard for this, and pity me. How often have I given you this breast and soothed you with its milk! Bear in mind those days, dear child. Deal with your enemy from within the walls, and do not go out to meet that man in single combat. He is a savage; and you need not think that, if he kills you, I shall lay you on a bier and weep for you, my own, my darling boy; nor will your richly dowered wife; but far away from both of us, beside the Argive ships, you will be eaten by the nimble dogs.'
>
> Thus they appealed in tears to their dear son. But all their entreaties were wasted on Hector.[65]

In Aeschylus' *Oresteia*, a different mother makes the same gesture to entreat her son. But in this case, Clytemnestra sues for her life, not his, when she reminds Orestes that he is about to murder the woman who gave him life and nourished him at her breast:

> Wait, son – no feeling for this, my child?
> The breast you held, drowsing away the hours,
> Soft gums tugging the milk that made you grow?

Orestes wavers, but only for a moment; he remembers the fate of his father and his mother's love of Aegisthus, and forces her into the palace to kill her.[66] As Froma Zeitlin has commented: 'Clytemnestra's breast is the emblem of the basic dilemma posed by the female – [it symbolizes] the indispensable role of women in fertility for the continuity of the

group by reason of its mysterious sexuality, and the potential disruption of that group by its free exercise.'[67]

In ancient funeral rites it is the women who mourn, by unfastening their dress and baring their breasts and scoring their cheeks and chest with their nails. Although a very early Roman law, of around 450 BC, forbade the practice,[68] women mourners appear in sculpture and painting, as in the magnificent sarcophagus of the second century AD now in the Louvre showing the funeral of Hector. Hector's naked body is raised up over the shoulders of two Trojans, his head slumped back in a death's mask. His state arouses in the women who follow behind his corpse a wild lament; with their hair and their clothes loosed, and their arms flung wide, holding on to one another and imprecating against the heavens, they express vividly to the beholder the unrestrained nature of their grief.

The maternal body, in the disarray of sorrow or the undress of nurture, charged semi-nakedness positively even within the Christian tradition which had so obsessively focused on sexuality as an occasion of sin, and symbolized the Fall by the discovery of nakedness and physical shame. As the justifying function of women in the postlapsarian world was motherhood, childbirth and nursing gave legitimacy to a body that was otherwise a source of peril. The Virgin Mary gives suck to the infant Jesus both as his historical mother and as the metaphysical image of nourishing Mother Church.[69] The image provided artists with a chance to meditate on a mystic source of spiritual life, as in Dürer's woodcut of the Virgin and Child sitting on the crescent moon aloft in the heavens,[70] or to evoke the solemn unity of the holy family during Jesus' infancy, as in the beautifully calm and yet mysterious *Rest on the Flight into Egypt* in the Birmingham City Museum by Orazio Gentileschi (Pl. 83). The painter suggests Mary's primacy in the midst of her humbleness by depicting her nursing the naked child at her breast and seated barefooted on the earth, while Joseph lies absent in heavy slumber from the spiritual communion of mother and child. The apex of the triangular composition, binding Joseph and Mary together, is formed by the massive and faithfully painted head of the Holy Family's donkey, framed against an ultramarine evening sky, beyond a dilapidated wall under the lee of which they lie.

Orazio Gentileschi's painting condenses with elegant restraint many of the themes of lowliness and renunciation that the nursing Virgin often expresses; in her acceptance of her creatureliness, Mary demonstrates her Christian virtue of humility as well as her charity, ever since the Franciscans first developed the icon of the Madonna of Humility for contem-

plation.[71] Gentileschi's donkey, the broken wall, the homely grey bundle of belongings on which Joseph sleeps, Jesus' bare body, and Mary's bare feet all suggest to us the rugged and simple conditions the incarnate godling had willingly accepted. And these poor conditions are themselves outside urban civilization, just as the stable where he was born is normally the resting place of animals; according to Christian piety it is the humility of Jesus and Mary's life which inspires awe, not their splendour, and that humility resides in their physical hardships, which associate them with animals, and in their acceptance of basic – animal – biological human nature.

In the iconography of intercession, Mary the mother of Jesus makes the same gesture as Hecuba when she pleads for sinners' salvation before the judgement seat.[72] 'Happy the womb that bore you, and the breasts you sucked!' (Luke 11: 27–28) cried out a woman in the crowd around Jesus, in a scriptural salutation which has passed into the liturgy of Mary. But the theme was subject to fluctuations in ideas about decorum. In twentieth-century Spain, for instance, Mary sets an up-to-date – and very much more acceptable – example to poor carnal women, when, in the carving by Eusebio Arnau over the doorway of the Casa de Lactancia in Barcelona, she feeds the baby with a bottle.[73]

The allegorical figure of Charity, who often replaces Mary and the child as the expression of artists' pleasure in the subject, sometimes echoes the classical Abundance, with her horn of plenty, brimming cup, bunches of grapes as well as nurslings, as in Botticelli's most beautiful drawing in the British Museum.[74] But the materiality of Mary forms a thin source of her cult; it would be stretching the evidence to claim otherwise. A link does however exist between her nourishing the child Jesus at her breast like any ordinary mortal mother and the exalted nakedness of allegorical figures like Liberty; both achieve an unusual effect on the beholder's senses, and one which is genuinely helpful on a humanist level: they are stating that nature is good. Mary may only give suck to Jesus because she is so humble, and so apt to consent to an activity which the upper strata of society have frequently eschewed as fit only for hirelings,[75] but by doing so, she affirms fruitfulness and our animal condition at the same time, and she transforms the erotic dangerousness of the breast in Christian imagery to a symbol of comfort, of candour, of good.

The acceptance wrought by the maternal theme spreads through secular imagery: King Charles VII's beloved mistress Agnès Sorel may be commemorated as the Madonna in the altarpiece commissioned by the royal treasurer Etienne Chevalier from Jean Fouquet, where scarlet and

cobalt cherubim flock around the luscious young woman's uncovered form, promising all kinds of bounty other than spiritual.[76] There is no such intended *double entendre* in Rubens' 1615-22 celebration of his patron Marie de Médicis in the colossal sequence of paintings in the Louvre, where her status as allegory – as the earthly exemplar of Fecundity, of Truth and the repository of the Regency's prosperity – is marked by the sign of a single bare breast (Pl. 84). Rubens borrowed established visual language to proclaim the Regent's virtues, using the available repertory of ripeness and nakedness, as he did in his wise and human meditations on the griefs of war and the blessings of peace.[77] After the seventeenth century it becomes almost routine for noblewomen to be depicted as aspects of Charity by baring their breast, frequently asymmetrically, the pose that often indicates nourishment as well as selfless ardour.[78]

In France, visual representation explored the wider meaning of the revealed breast in playful fantasies which cautioned against the dangers of sexual love. In a marble sculpture like Jean-Pierre-Antoine Tassaert's *Sacrifice of the Arrows of Love on the Altar of Friendship*, a grieving Cupid looks on while a tender young woman (Friendship, Amitié) chidingly snaps his arrows in two on her votive fire. She is wearing a slipped chiton, to reveal her sincere and generous heart.[79]

Madame de Pompadour, when she was represented in the role of Friendship for the great Pigalle, appeared in a similar state of undress, indicating that softest spot with one hand and beckoning with the other.[80] Marie Leczinska, the wife of Louis XV of France, commissioned a statue of herself as Charity from Augustin Pajou, for her mausoleum. She had borne ten children herself, but she stipulated that orphans should appear at her knees. It is unthinkable today that any queen be portrayed in a symbolic state of undress, let alone uncover herself in life, but Marie Leczinska found it appropriate vesture for the statement she wished to make about herself for posterity.[81]

In the same century, Grand Tourists and classical cultists sometimes even daringly undraped themselves *all'antica*, as if they were ideal works of art. At the Grand Jubilee Ball of 1749, Miss Chudleigh, a maid of honour to the Princess of Wales, appeared in the costume of Iphigenia on her way to the altar of sacrifice. An anonymous caricaturist drew her in rather unclassical petticoats, and Mary Wortley Montagu remarked that the high priest would have had no difficulty inspecting the entrails of his victim.[82] Her costume, credited to a collaboration between herself and Mrs (Susanna Maria) Cibber, the actress, created a stir, but with its learned claims, did not upset her social standing.

In the fascinating and often beautiful engraving in the *Almanach Icono-logique*, published 1766-74, where the artists Gravelot and Cochin devised influential figures for the Virtues, the Sciences and other abstractions, the pastoral, charming interpretation of La Nature shows a young woman standing with her arms held out almost in the act of proffering herself. She is set in an Edenic wilderness of flowers and animals, with a many-breasted effigy of Diana of the Ephesians behind her; her own breasts are leaking milk (Pl. 97).[83]

This identity of motherhood and nature is present in the propaganda of the French Revolution; the Catholic iconography of Charity and the classical vocabulary of motherly gesture pervades its rituals, even though through those same rituals it aimed to inaugurate the world afresh and break with that past, especially the Catholic past. Its propaganda, inspired by Rousseau's *Emile*, also strived to break with the widespread custom of wet-nursing, and encourage mothers to feed their own babies.[84]

Rousseau had shrewdly intimated that the secular State should generate its own symbolism and ritual to replace the Church's role as moral arbiter over the masses, and during the 1790s the new Government's elaborate and didactic pageants and processions dramatized its shifting aims and ideology.[85] In these remarkable experiments in the invention of mythology and the control of thought, participants sometimes played themselves, as in sacred liturgy, and were cast as communicants in the mass ritual of the Revolution: in the Fête de l'unité of 1793, eighty-six deputies to the national Convention drank from the spouting breasts of the goddess of nature, an Egyptian-style statue surmounting a Fountain of Regeneration. Or, like devotees in a procession on a patron saint's feast day, the crowd solemnly marched behind a triumphal chariot where Liberté, rather than an effigy of a saint or the Virgin, was enthroned. For the Feast of the Supreme Being, of 1794, a procession made its way to the top of an artificial mountain which had been created for the occasion on the Champ de Mars, and, as cannons volleyed, the participants exchanged kisses beside the Tree of Liberty planted there, rather like concelebrating priests embracing one another at the conclusion of the Mass.

But the most notorious fête staged by the Revolution, which has come down in popular memory as a mobsters' orgy, was the Festival of Reason of the year before (1793), when the Goddess Reason was enthroned in Notre-Dame. The imitation of ecclesiastical rites was here overt; like the ceremony of the crowning of Mary's statue on the feast of her queenship in May, La Raison, presiding genius of the atheist radicals, was enthroned and garlanded. The blasphemousness of this rite

was underscored, not just by the nature of the usurping goddess, but by her presence in flesh and blood; as Agulhon had pointed out, live allegories characterize radicalism.[86] To place a real woman in the place of the ideal challenges the ever-elusive character of the ideal itself, and says something unequivocal about women. The ceremony was not however licentious at all, but solemn, administered by young women in white robes with tricolour belts and cockades, and torches emblematic of truth. The hymn to Liberty was written by André Chénier, later to die himself under the guillotine during the Terror. Reason was 'the very picture of Beauty herself'[87] and after her investiture in the cathedral of Mary, she was carried by 'four stalwarts from the market' to the Convention, where the deputies paid homage to her. In front of the President, the procession's leader declared the principles Liberty and Reason combined in the goddess and joyfully orated: 'Here we have abandoned inanimate idols for this animate image, a masterpiece of nature.'[88] The living woman was not acting Liberté: she embodied her. She was, the Jacobin Hébert said, 'a charming woman, as beautiful as the goddess she represented'.[89]

The interpenetration of actual and symbolic planes has rarely been as full as during the Revolution's early years, and such a convergence can present tremendous possibilities for emancipation. But the emphasis in the female allegories of 1794 and afterwards returned to Rousseau's ideals of virtue, purity and decorum, even bashfulness, to motherhood and nubility; and so women were not enfranchised or enabled by them. Although real women incarnated the presiding principle of the Revolution, they did not recall the historical participation of women in its early tumult; though personifications lived and moved, they projected a carefully considered ritual fiction. A veil was drawn over the unruly elements against whom Burke for one had inveighed in his *Reflections on the Revolution in France* (1790), the Parisiennes who, with 'horrid yells, and shrilling screams, and frantic dances, and infamous contumelies, and all the unutterable abominations of the furies of hell, in the abused shape of the vilest of women', had surged to Versailles to bring the King and Queen back to the city in 1789.[90] As Lynn Hunt has acutely observed, 'the collective violence of seizing Liberty and overthrowing the monarchy was effaced behind the tranquil visage and statuesque pose of an aloof goddess'.[91] The brave call that a partisan like Olympe de Gouges made for equality in property, education, authority and employment 'according to their abilities, and without distinctions other than their virtues and their talents',[92] was not answered, and the ineffectiveness of such proposals can be felt when we read about these solemn pageants,

where women still occupied the site of remote fantasy, not agency or power, unless they fulfilled their 'natural' role, as mothers to the new citizens.

The Republic declared itself as belonging to the order of Nature; it had rebelled against the old Christian God and had so declared itself heathen, 'pagan'. Just as 'paganus' originally meant a country-dweller, so the new regime saw itself as living outside the polis of the former state, in a newly discovered 'natural' world. It was 'human nature' to be born free, as Rousseau had so proudly said,[93] and when the revolutionaries swept away the old order, they abolished the Christian calendar too, with its personal stories about individuals, and replaced it with months called after the natural procession of the seasons and the characteristics of the months: Floréal, Thermidor, Brumaire, Ventôse, and so forth, installing the weather of the countryside at the centre of daily life.[94] The Feast of the Supreme Being was also dedicated to La Nature, and pregnant women were specifically summoned to take part in the processions.[95] Though the high status accorded to motherhood was a precious right, the equation between the divine Nature and women's maternity reflected the restrictions on women in other areas of life.

In terms of Gravelot and Cochin's iconography, the French Revolution's female allegory tended to prefer La Nature to La Liberté who, in their version, numbers a cat among her attributes, as cats will not be tamed.[96] By contrast, the breasts of La Nature were a domesticated, unthreatening and wholesome sign of the wild side of human nature brought under social control.

The cult of Nature also influenced a profound revolution in dress, and the changing fashions reflect faithfully, with a small time lag, the changing definitions of women's roles, according to the official ideology, expressed in the festivals. In 1794, the Société Populaire et Républicaine des Arts demanded that if the heroes of the Revolution were to be immortalized in monuments, they should be liberated from the 'paralysing' clothes of the ancien régime. The society called for a costume which would reveal them in all 'their brilliant beauty, in all their natural grace'.[97] When David was commanded by the Committee of Public Safety that year to design an appropriate costume for the French people, he reverted to the imagined simplicity of classical republican dress for the new citoyenne, and thus started a fashion of unprecedented revealingness.[98]

The new look liberated women of all classes from the constraints of earlier dress. The style was patriotically termed 'en gaule', and was created by muslin-like shifts, usually white to connote purity, which clung to the legs and hips and were caught at the waist by a sash.

But later, to emphasize the relation of woman's naturalness to her role as nurturer, the waistline crept up to under the breasts; it was quite in order for the rather niminy-piminy young woman who sat to a painter of David's circle around 1800 to show her bosom very plainly through the transparent upper bodice of her classical tunic.[99] In these fashions, the freedom which had been gained on behalf of the French woman was relayed to her dress by a kind of pun: she was relieved of restrictive clothing, and taboos on bodily display were lifted, just as she had been in theory relieved of restrictive government. But the predominant message was still conservative, stressing that women's potency was founded in her capacity to bear and to nurse, and forgetful of the activist and independent contribution of women to the early years in roles other than that of mother.

When the actions of women in the 1789 uprising were recalled, it was with disapproval; and the memory, compounded by the evasions of republican propaganda itself, effectively stigmatized the female revolutionaries as harpies and whores. In 1848, a Breton doctor characteristically decried the pageants of the First Republic: 'On the very altars where in the past you used to come to worship the true God, she [the Republic] exposes herself, half-naked, to the eyes of libertines who smile, and to those of the people as a whole who groan in the thrall of the Terror, and to those of a few admiring fools.'[100] In the literature of the nineteenth century, the women who call to mind revolutionary Liberté are often seen as sexual beings, driven by passion, not political consideration. In his novel of 1845, Les Paysans, Balzac's Catherine is a tigress, who 'resembles in every way those girls whom sculptors and painters took as a model of Liberty, as they used to of the Republic'; her eyes 'flecked with fire' with a 'nearly ferocious smile', she is 'the image of the People',[101] of 'this Robespierre with one head and twenty million pairs of arms' – the peasantry whom the Revolution had rendered ungovernable, he claimed.[102] In a later novel, L'Education sentimentale, Flaubert describes the sack of the Tuileries in 1848, and there sees a 'fille publique' (a woman of the streets) 'en statue de la Liberté – immobile, les yeux grands ouverts, effrayante' (like a statue of Liberty – motionless, her eyes wide open, terrifying).[103]

The propaganda of the 1790s, by failing to grasp and accept the implications of women's actions, had maintained the split between the two faces of Liberty, the matron and the virago, the nice and the not-so-nice, and ratified the former in order to obscure the latter. The effect of this was to intensify the field of energy around the wild, dishevelled, and asymmetrically bared Amazon; through her heterodoxy, she could

represent an original freedom still beyond the freedom promised by the first Revolution. The slipped chiton of Delacroix's Liberty of the 1830 Revolution gathered up this energy by replacing the emphasis on the unaffiliated and active character of the goddess, portraying her as feline, untamed, a Fury rather than a Tyche. But the constant swing between Liberté and Nature continued, and the next Republic rebelled again against the Amazon, in favour of the Tyche. When Daumier submitted an oil sketch to the 1848 competition for an image of the Republic, he showed her as a monumental Charity, sitting in majesty, while two sturdy children drank from large breasts and another read at her knee. Though the work was not commissioned, the study exactly catches the tenor of the Second Republic. Gentler, motherly, caring, the self-image of the 1848 Republic declared its disagreement with the frenzy of eighteen years before, expressed then just as clearly through the differently applied sign of the female breast, by the armoured chest of Rude's yelling Victory, and the slipped chiton of Delacroix's Liberty.[104]

In 1863, Baudelaire published a homage to the painter whom he admired all his life with unswerving passion. To Baudelaire, Delacroix was 'the most suggestive of all painters, the one whose works make one think more than any other's',[105] and his death the year before had left the poet desolate. He was a man he loved as a friend, as well as an artist who, through the powers of a colossal imagination, could faithfully capture the 'greatness and the native passion of the universal man'.[106] The same year, Baudelaire wrote a prose poem, 'La Belle Dorothée', which evokes a woman as a living Liberty, and reveals to us how the classical antecedents of the Republic's solemn allegories and Delacroix's vital reinterpretation had migrated, in the bourgeois capital of the Second Empire, into the private domain of affect and eros, and thrived there on the ancient symbolic associations of nature, fertility and paganism.

A paean to the vigour and splendour of a 'natural' woman, the poem evokes one of Baudelaire's 'Vénus noires', symbolizing the energy of the exotic and pagan. The imagery of sculpture from the city he wrote about so obsessively recurs, bringing now the art to life, now turning Dorothée herself into a work of art, against the background of a southern sea:

Cependant Dorothée, forte et fière comme le soleil, s'avance dans la rue déserte, seule vivante à cette heure sous l'immense azur, et faisant sur la lumière une tache éclatante et noire.

Elle s'avance, balançant mollement son torse si mince sur ses hanches si

larges. Sa robe de soie collante, d'un ton clair et rose, tranche vivement sur les ténèbres de sa peau et moule exactement sa taille longue, son dos creux et sa gorge pointue. . . .

De temps en temps la brise de mer soulève par le coin sa jupe flottante et montre sa jambe luisante et superbe; et son pied, pareil aux pieds des déesses de marbre que l'Europe enferme dans ses musées, imprime fidèlement sa forme sur le sable fin. Car Dorothée est si prodigieusement coquette, que le plaisir d'être admirée l'emporte chez elle sur l'orgueil de l'affranchie, et, bien qu'elle soit libre, elle marche sans souliers. . . . A l'heure où les chiens eux-mêmes gémissent de douleur sous le soleil qui les mord, quel puissant motif fait donc aller ainsi la paresseuse Dorothée, belle et froide comme le bronze?[107]

In Delacroix's painting, the real and the ideal overlapped; and when Baudelaire's Dorothée takes off her shoes, she can adopt with impunity this badge of dispossession and servitude, he says, partly because his word picture has established her so vividly as a type of sculpted and deified Liberty, a goddess of marble or bronze, *affranchie*, freed from the museums where works of art are confined.

The cipher of the female breast still tells us of revolutionary valour in Soviet propaganda images, like the colossal stone sculpture of *The Motherland* in the former Stalingrad, clearly influenced by Delacroix (Pl. 1),[108] or in Scandinavian images of nationalism, like the haggard champion who stamps on her enemy's grimacing head in Karlstad in Sweden, to commemorate the fiftieth anniversary of the 1905 treaty dissolving the union between Sweden and Norway.[109] A bared female torso - with nipples sculpted in an emphatic state of arousal - could still be considered eloquent of freedom in a socialist country - in 1955. When the women's movement urged loose clothing in the sixties, and when the newspapers spread the slogan 'Burn your bra', both feminists and their detractors were deeply inspired by the ancient significations of the breast and its release.

The State erects statues of Liberty, or appropriates painted images of them, even when the impetus to create them has been personal in origin, as in the case of Delacroix, but the State can only offer freedom under the law. It promises to guarantee individuals' rights by binding them in differing ways to varying degrees. In France, in the first half of the nineteenth century, an image of Liberty emerged to express this promise, and within it developed a symbolism, focused on the breast. It sometimes continued to represent the natural function of breast-feeding, in order to promise the State's protection as provider, comforter, and nourisher. But

Nature was perceived as possessing another aspect, epitomized by the autonomous and virginal Amazon, who neither consents to live within the purlieus of conventional, law-abiding cities, nor to perform the socialized female function of child-bearing within marriage. By harnessing the figure of this outlaw, through the connotations of the slipped chiton, the bare foot and the Phrygian cap, the Liberty image brings her under control; the containment of so many multilayered images of natural, wild, womanly processes paradoxically empties them of resonance.

If even an anarchic Amazon heroine can be incorporated into the State's self-image, as the Third Republic did with Dalou's version, then nothing remains beyond its reach, it encompasses all within its bounds. But every society will define its own 'wild' differently and then try to annex it,[110] until there can be no freedom outside its definition, and Liberty herself becomes captive in the image's frame of reference. However, by creating such an image of the Otherness that can be encompassed, the signs of Otherness become self-perpetuating, through the dissemination of the figure and its symbolic elements: if a wild natural woman stands for this, she can be condemned to remain so.

It is because women continue to occupy the space of the Other that they lend themselves to allegorical use so well; in spite of the convergence which occurred in the late eighteenth and nineteenth centuries, when real women represented the ideals of the Revolution, we would fail to respond to the symbolic content of such images as Delacroix's *Liberty* if we perceived her as an individual person. If women had had a vote or a voice, Marianne would have been harder to accept as a universal figure of the ideal.

Cast as a wild thing, who breaks the bonds of normal conventions, Liberty prolongs the ancient associations of women with Otherness, outsiderdom, with carnality, instinct and passion, as against men, endowed with reason, control and spirituality, who govern and order society. But she also subverts the value normally ascribed to these categories and, in so doing, she places women in a different relation to civilization, to its content and happiness as well as its discontents. La Belle Dorothée, who like a figure of Greek Victory and Delacroix's Liberty steps out in bare feet in swirling thin silks and pointed breasts, belongs to that unruly land beyond society's borders, where the wearers of Phrygian caps also dwell; this is also the conventional ascribed site of women, close to the natural processes, those mysteries of death and birth, which refuse to yield up to reason and social control.

Yet the figure of Liberty lives up to her name by affirming nature

within culture itself, as a necessary and intrinsic part of it. From the Amazon to Marianne, the female body's bounty and its ardour, often denoted by the bare breast, has been seen to possess the energy a society requires for that utopian condition, lawful liberation. But it has done so only by recapitulating the ancient and damaging equivalences between male and culture, female and nature. Otherness is a source of potential and power; but it cannot occupy the centre.[111]

CHAPTER THIRTEEN

Nuda Veritas

Your clothes and pantlegs lookin' out of shape
Shape of the body over which they drape
Body which has acted in so many scenes
But didja ever think of what that body means?

It is an organ and a vice to some
A necessary evil which we all must shun
To others an abstraction and a piece of meat
But when you're looking out you're in the driver's seat!

No man cares little about fleshly things
They fill him with a silence that spreads in rings
We wish to know more but we are never sated
No wonder some folks think the flesh is overrated!

JOHN ASHBERY[1]

The first realization of Adam and Eve after eating the forbidden fruit was that they were naked; Genesis tells us that their eyes were opened, not that their consciousness was dimmed; they fell into awareness of the physical body and hid from God, who cursed them with mortality and pain and work and child-bearing and drove them out of Paradise.

From the imagined start of human experience in the West, human identity is inseparable from the theme of the personal body and self-consciousness as a physical creature. Genital shame, adumbrated by the figleaves of Eden and drunken Noah's exposure to his sons, recurs as a motif in the Old Testament. Yahweh thunders at Jerusalem that unless she repent of her criminal ways,

> I will also pull your skirts up as high as your face
> and let your shame be seen.
> Oh! Your adulteries, your shrieks of pleasure,
> your vile prostitution!

(Jer. 13: 26–27)

The prophet Nahum takes up Jeremiah's curse, addressing Nineveh, another fallen community:

> I am here! Look to yourself! It is Yahweh Sabaoth who speaks.
> I mean to lift your skirts as high as your face
> and show your nakedness to nations,
> your shame to kingdoms.
>
> (Nah. 3: 5)

In the New Testament, the Apocalypse warns the unready that the Saviour will come as a thief, and woe to those found unprepared; the metaphor for unreadiness and sin is nakedness (Rev. 16:15).[2]

Mediaeval theologians, with their fondness for classificatory lists, usefully distinguished between four different types of nudity: *nuditas criminalis*, or the nakedness of the sinner, a sign of vice; *nuditas naturalis*, the human condition of animal nakedness, which should inspire humility since man alone among the animals has no covering, no bark, feathers, fur or scales, as the schoolman Pierre Bercheur picturesquely says; *nuditas temporalis*, the figurative shedding of all worldly goods and wealth and status, voluntary or involuntary; and *nuditas virtualis*, symbolizing innocence, the raiment of the soul cleansed by confession, the blessed company of the redeemed in heaven and of Truth herself.[3]

Nuditas criminalis, indulged in life, in death exposes the damned to the torments and fires of hell; in Giotto's *Last Judgement* in the Scrovegni Chapel, Padua, naked men and women hang from hooks through their tongues, or through their testicles or genitals, or swing by their hair from gibbets while demons torture them. The painter was depicting the legal penalties of his time, but he added the motif of criminal nudity.[4] The pink pathos of Bosch's sinners, two hundred years after Giotto, still sharpens the shudder we experience at his fantastic demons' cruelties of procedure and deformity of shape.[5]

The particular sin most commonly represented by a woman in the nude was Luxuria - Lechery or Lust. The vices were often described in anecdotal fashion, unlike the virtues, and the carvings on mediaeval cathedrals show a knight tumbling from his horse to illustrate Pride, or fleeing at the sight of a rabbit to indicate Cowardice.[6] Husbands beat their wives, to represent Anger. Lust was sometimes depicted as a couple embracing, the woman sometimes a nun, the man a tonsured cleric; they are never naked, though the circumstances might require it. Nudity is very rarely circumstantial, more frequently symbolic. But in various church sculptures in France of the twelfth and early thirteenth centuries, Lust appears as a naked woman undergoing horrors of suffering in the

very parts tainted by her sin: at the portal of Moissac, snakes devour her breasts and vulva while toads issue from her mouth (Pl. 89); on the south door of the church of Saint-Sernin in Toulouse snakes encircle a squatting woman's knees and suck her breasts.[7]

The wasted, haggard bodies of these stark and angular carvings draw us into the Christian symbolic equation between sex and death; corruption is of the soul and of the body, disfiguring one with the other; the body above all, with its appetite for gratification, becomes the locus of sin, and women who since Eve have tempted men to fall into concupiscence possess dangerous bodies 'beautiful to look upon, contaminating to the touch, and deadly to keep', as wrote the learned Dominican compilers of the *Malleus Maleficarum*, the witch-hunters' handbook, of 1484, summing up in extreme language a longstanding conception of woman.[8] As early as the second half of the twelfth century, the snake who tempted Eve was envisaged as her *alter ego*: 'Satan chose a certain kind of serpent ... having a virginal face, because like things applaud like.'[9] The devil and Eve exchange seductive looks, mirror images of each other, in *The Fall* by Hugo van der Goes (active *c.* 1467–82) in Vienna, painted around the time of the *Malleus Maleficarum*, and even in Michelangelo's Sistine Chapel ceiling.[10] The devil's hermaphroditism marks his evil nature by adding to a male body extra womanly erogenous zones, and the gargoyles of the Middle Ages, like the famous watcher on the roof of Notre-Dame in Paris, have full large udders, however hirsute and mannish the rest of their bestial form. Up to the Renaissance there are traces of the tradition. In some homely choir stalls from Jumièges in Normandy, for instance, Satan with pendulous female dugs tempts Christ to change stones into bread.[11]

The lexicon of sin – corruption, putrefaction, stain, filth, decay – draws its imagery from the physical body and its mortality. Age is a result of the Fall: Eve is the first old woman, as Piero poignantly and with dignity reveals in the scene of Adam's death in *The Legend of the Cross,* his fresco cycle in Arezzo. Without sin, there would have been no rot. Saints' bodies in Christian hagiography exhale a breath of sweetness: the proverbial odour of sanctity which floated from the very wall in which St Teresa of Avila was interred, while in mediaeval dramas of possession, by contrast, the devils' presence stinks.

Memento moris, carved as the Paternoster bead in the rosary, or cautionary stories like 'The Three Living and the Three Dead', warned lovers and merrymakers that the health of this world leads only to the grave, and that pleasures only trap the sinner for ever in the drama of physical disintegration.[12] At Moissac, Lust's punishment is to endure for

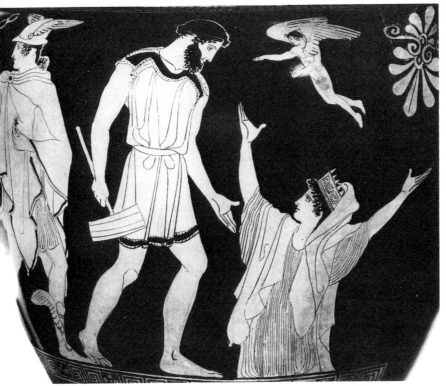

The first woman, Pandora, arrayed in the bridal headdress wrought for her by the gods and goddesses who created her, greets Epimetheus her husband as she rises out of the earth from which she was made (66). Eve, the first woman of the Christian tradition, often issues from Adam's side, as if he were giving birth to her, as in Bartolo di Fredi's fresco in San Gimignano (67).

67

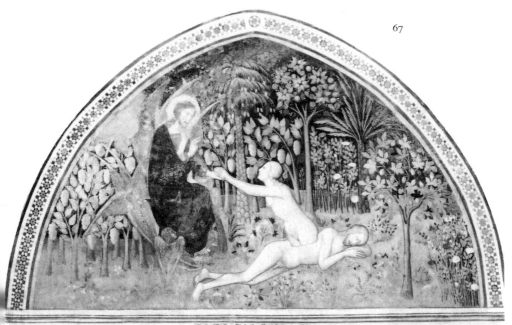

COME · DIO · FECE · L AP
RIMA · DONNA:

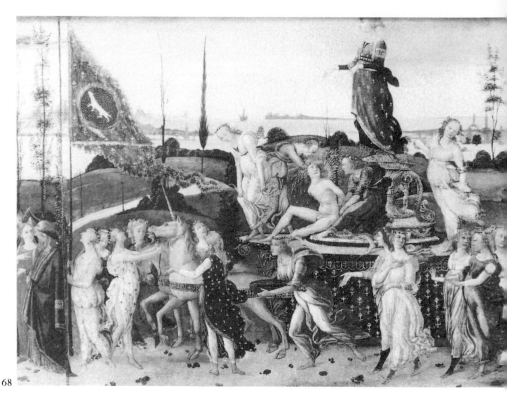

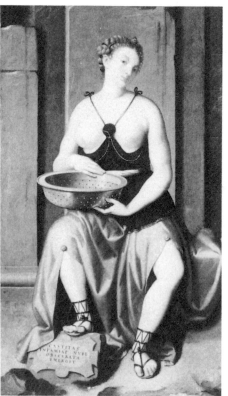

Tuccia, a Vestal Virgin, was accused of unchastity, but proved herself true when she miraculously brought back the waters of the Tiber intact in a sieve. Jacopo del Sellaio included her, centre foreground, in his *Triumph of Chastity*, beneath Eros bound, who is having his wings clipped (68). Moroni painted Tuccia as an allegory of Chastity (69), and Elizabeth I adopted her sieve as a device (70). A virtuous body must appear a sound, watertight container, like the jar of precious ointment that is Mary Magdalen's attribute, as in this painting by Jan van Scorel (71), or the miracle shopping-basket of a 1985 advertisement (72).

70

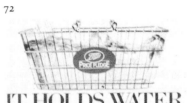

IT HOLDS WATER.

72

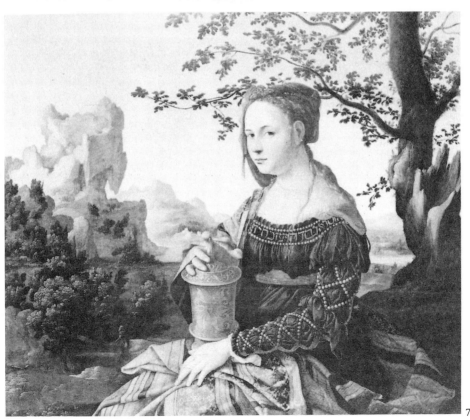

71

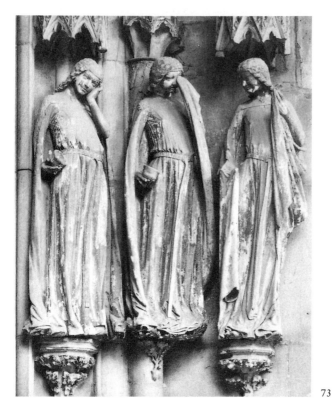

73

In the sculptures of Magdeburg cathedral,
the Foolish Virgins, epitomes of female
weakness and incontinence, weep, for the
heavenly bridegroom has refused them
entrance (73); in Martin Schongauer's
engraving, one shows us her empty lamp,
emblem of her sinfulness (74).

74

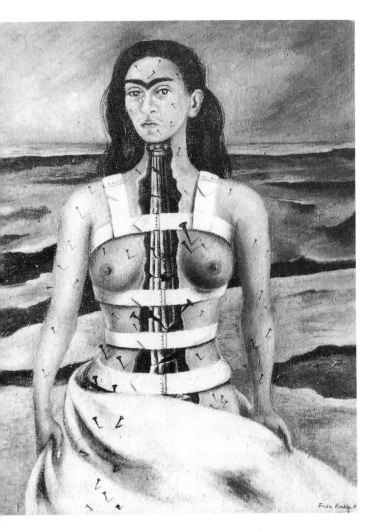

Frida Kahlo [4] 75

rida Kahlo, with her self-portrait *The Broken Column*, uses the imagery of female grief, weakness and vulnerability to create a powerful personal testimony to pain (75); in the Artemisia Gentileschi plate from *The Dinner Party*, Judy Chicago purposefully conjures the most feared aspects of women's physical characteristics to create an affirmative vision of the female sex (76).

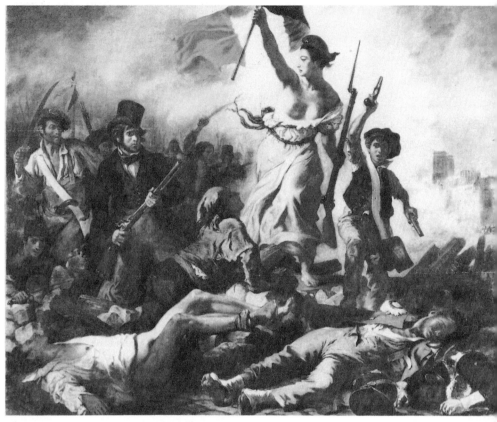

77

78

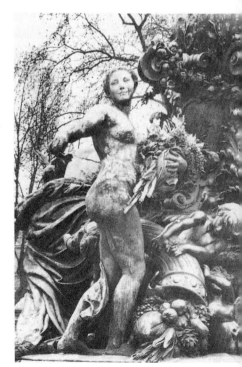

79

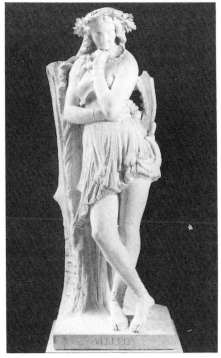

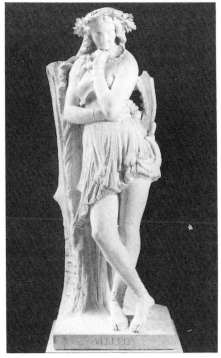

OPPOSITE PAGE
Liberty Guiding the People by Delacroix (77) recalls the
July uprising of 1830, by introducing the goddess into
a acutely observed crowd of participants; Jules-Aimé
Dalou's *The Triumph of the Republic* of over fifty years
later celebrates Marianne in similar allegorical dress,
but surrounded by symbolic figures: Justice and the
Genius of Liberty, on the model seen here (78), and
Peace scattering flowers, from the monument in the
Place de la Nation, Paris (79).

THIS PAGE
The slipped tunic or chiton of the Greek Amazons, as
in the relief from Ephesus (80), conveys the
untameable character of their courage and ardour, and
was borrowed by the figure of Marianne, the French
Republic. It also became part of the imagined costume
of ideal Gallic ancestors, like the heroine Velléda,
carved by Hippolyte Maindron in 1869 (81).

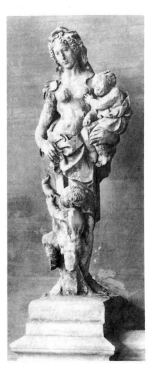

The breast can also stand for maternal bounty and love: the Virtue Charity is represented with nurslings in Jacopo della Quercia's sculpture (82), and the barefoot Madonna, giving suck to the naked child, in Orazio Gentileschi's painting, expresses the full mystery of her humility in consenting to the incarnation (83).

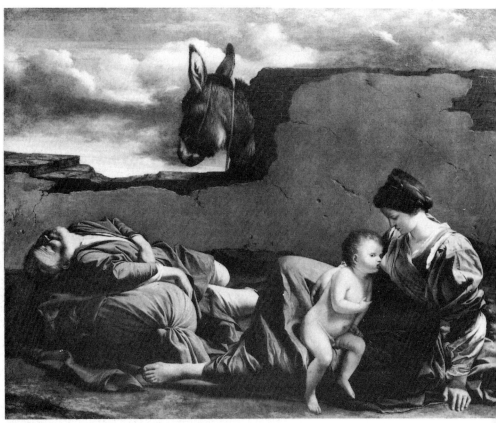

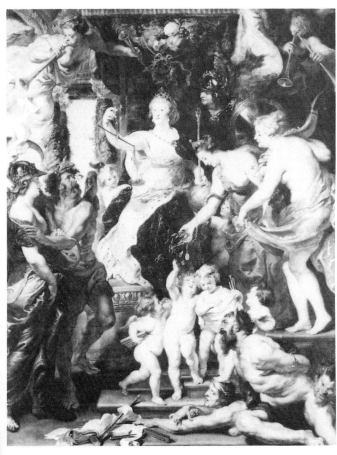

In Rubens' vision of the apotheosis of Marie
de Médicis, *The Felicity of the Regency* (84), the
Queen, in the undress of Charity with the
scales of Justice, assumes her pre-eminent place
in the rich and crowded pageant as an
allegorical figure among many. Abundance,
Health, Wisdom and various cherubs
personifying the arts and sciences flourishing
under her reign surround her, while Vices
writhe in their bonds. The later Republic, not
to be outdone, indicates her good and
generous heart (85).

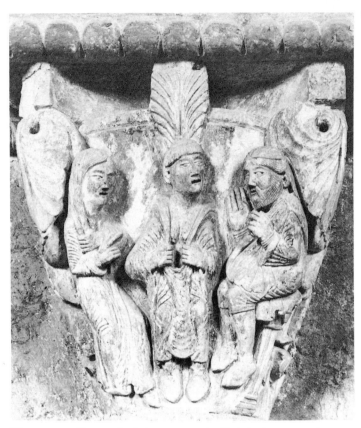

The uncovered human body is not as rare in Christian imagery as is usually thought, and carries a wide range of meanings. Saint Eugenia, accused of fathering a child, proves the charge false by showing her sex on a capital at Vézelay (86); angels and devils struggle to capture human souls, including a Friar Tuck, in the frescoes of the Last Day in the Camposanto in Pisa (87); and Mary Magdalen, after her conversion, lived in naked penitence to symbolize her rejection of all worldly vanities (88).

87

88

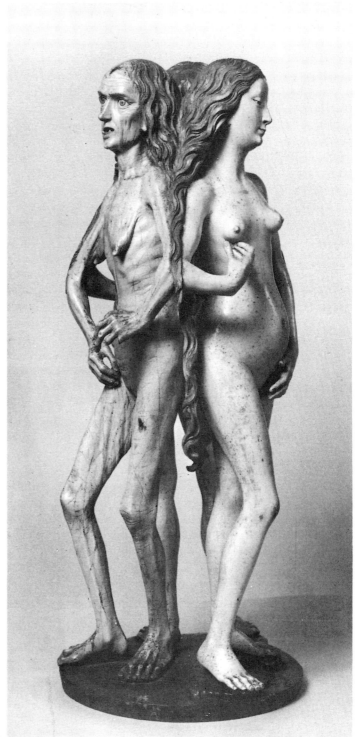

At Moissac, the sculpture of Luxuria (Lust) is devoured by snakes in the parts tainted by her sin (89); Gregor Erhart's *Vanitas*, a polychrome carving, warns against the pleasures of this world, as 'all flesh is as grass . . . and the flower thereof falleth away' (90).

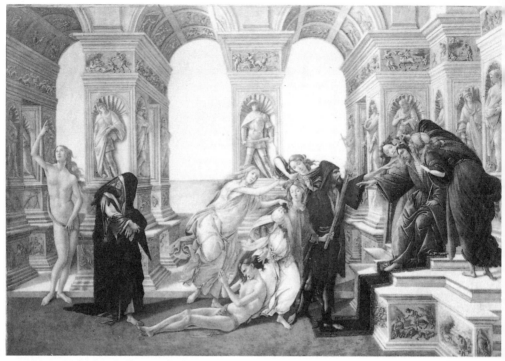

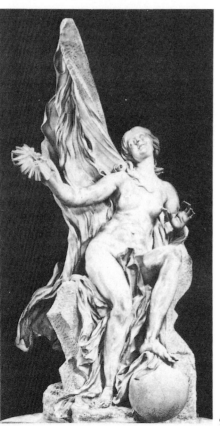

Truth is depicted naked, for she has nothing to hide. In Botticelli's *The Calumny of Apelles*, the evil judge in ass's ears on the right listens to the slanders against the victim whom Discord is dragging by the hair; on the left, naked Truth points to heaven, where all will be revealed, while Remorse creeps from her in shame (91). In Bernini's sculpture, Truth emerges radiant from the veils in which she is wrapped, holding the sun in her hand (92).

92

93

In François de Troy's *Truth Unmasking Envy*
(93), Truth's naked foot forms a contrast with
Envy's heavy shoe, for Envy dissimulates
while Truth conceals nothing. In Charles
Cochin's design for the frontispiece of the
Encyclopédie of Diderot and D'Alembert (94),
arts and sciences, including recent disciplines
like Optics, join the Virtues in the throng
around Truth, the source of light for the *siècle
des lumières*.

94

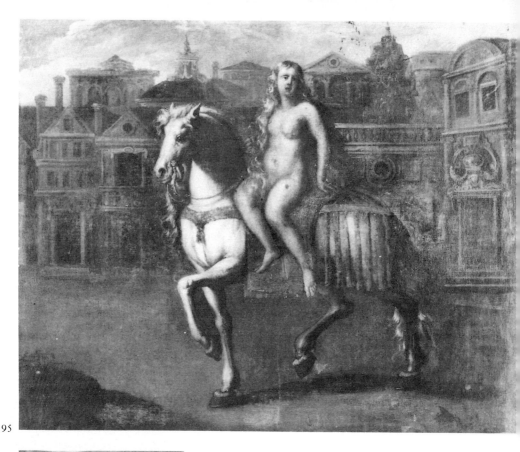

95

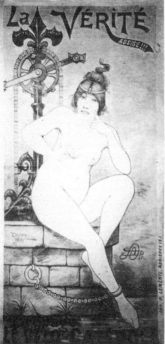

Lady Godiva, who rode through Coventry clothed only in her hair, becomes in her goodness and innocence a type of naked Truth, as in this anonymous sixteenth-century picture (95); at the turn of the present century, advertisements like this poster for bicycles annexed the aesthetic tradition to sell their products (96).

96

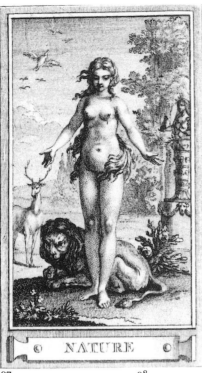

Longings for arcadia often inspire visions of the nude: Gravelot's design for 'Nature' shows her undraped, at one with animals and flowers (97); in Judy Dater's image (98), Imogen Cunningham the photographer appears beside her favourite model, Twinka, like a strayed city-dweller surprising a dryad in her proper place.

97 98

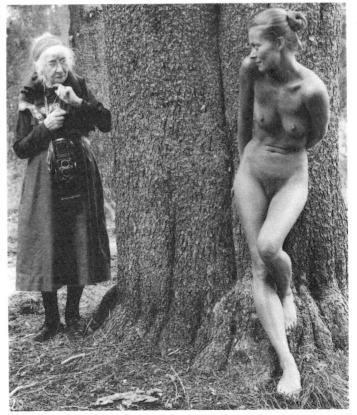

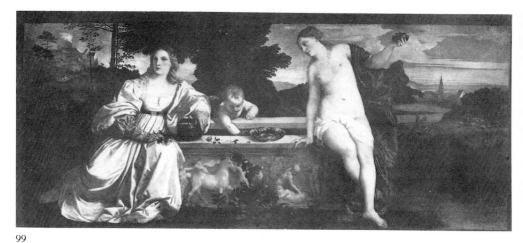

99

Titian's famous painting, traditionally called *Sacred and Profane Love*, has inspired many different explanations, which reveal in their very contradictions the ambiguity of the nude: is it the naked figure who is profane, or the other way round? Are both figures aspects of the same woman (99)? Thomas Eakins, with his painting *William Rush Carving the Schuylkill River* (100), tried to vindicate the holiness of the naked female body, and the practice of life-modelling itself.

100

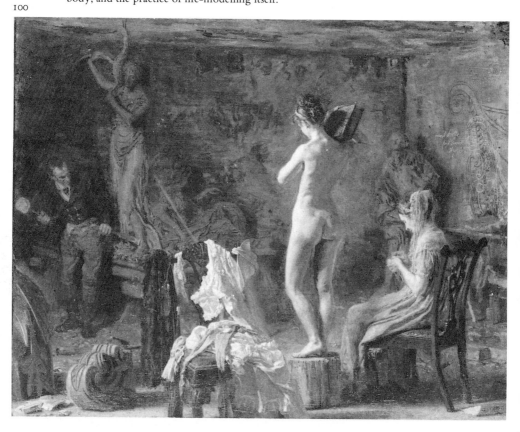

all eternity the ordinary decay of the flesh, the worms fastened on her body. One of the most terrifying variations on the theme of Vanitas is a marvel of a polychrome sculpture, standing about two feet high in the Kunsthistorisches Museum in Vienna (Pl. 90). A Gothic beauty, completely naked in the pose of Venus pudica, indicates her high small conical breasts with one hand, and her sex, rose pink under her fashionable swelling belly, with the other. Slim, firm, with long, slender legs, the wistful face of a northern European Madonna, and the improbably long, wavy, golden hair established as beauty's sign since Aphrodite herself appeared *xanthe* or blonde in Homer's epics, she stands back to back with a youth, also young, hyacinthine and blond. He has the epicene and gentle visage of an angel from a painting by the Van Eycks, and wears only a small loin cloth knotted at the hip. Back to back with both of them, a hag.[13] Withered, veinous, her breasts empty sacks, her sex exposed as a wrinkled sere gash sprouting sparse dark hairs, her mouth caved in over her gap-toothed jaws, she seems to start back in alarm at an invisible reflection of her own disintegration. Sculpted around 1500 by Gregor Erhart, this terrifying warning conveys the morbidity that informs fifteenth-century meditations on death, and its correlative, the interdicted body, and seems almost to illustrate Villon's *Ballade de la belle heaulmière*, written about forty years earlier, in Paris. The former beauty recalls herself: what has happened to

> Ces gentes espaulles menues,
> Ces bras longs et ces mains traictisses,
> Petiz tetins, hanches charnues,
> Eslevees, propres, faictisses
> A tenir amoureuses lisses;
> Ces larges rains, ce sadinet
> Assis sur grosses fermes cuisses,
> Dedens son petit jardinet?

(Those sweet little shoulders, those long arms and nimble hands, small breasts, those plump, high buttocks perfectly made for love-making's smooth tight caresses; that broad back, that little cunt sitting between big strong thighs, in its own little garden?)[14]

And she then laments her beauties' vanishing:

> C'est d'umaine beaulte l'issue!
> Les bras cours et les mains contraites,
> Les espaulles toutes bossues;
> Mamelles, quoy? toutes retraites;
> Telles les hanches que les tetes;

Du sadinet, fy! quant des cuisses
Cuisses ne sont plus, mais cuissetes
Grivelees comme saulcisses.

(This is the outcome of human beauty! Short arms and shrunken hands, shoulders all humped; Breasts? What? All collapsed; hips and head, all the same; as for my cunt, what's to be said? And as for my thighs, they're no longer thighs, but stringy, shrivelled little things, like sausages.)[15]

She turns from her own fallen state to issue some sound advice to *filles de joie* coming after her: make hay while the sun shines, for no one will take care of you when you are old. The fourteenth-century English poet John Gower, in *Le Mirour de l'omme* (which he wrote in French), had summed up the client's attitude la belle heaulmière knew only too well; when in the midst of praising Continence, the daughter of Charity, he issued this unpleasant warning:

Mais sur trestoutes je desfie
Le viele trote q'est jolie
Qant secches ad les mamelettes,
Q'ad tiele espouse en compagnie
Fols est s'il paie a luy ses dettes.

(More than all of them I despise the old bawd who is flirtatious when her breasts are withered. Whoever takes her for a friend is a fool if he pays up.)[16]

During the next century in France a new type of tombstone attempted to brave out mortality. Jeanne de Bourbon, Comtesse d'Auvergne, who died in 1521, was portrayed on her grave monument at the Cordeliers convent at Vic-le-Comte (now in the Louvre) with her gut hanging out in a coil and huge worms burrowing into her entrails and lips. Dishevelled and only half-dressed, she actually grips the side of the slab in which she lies as if she can feel the process of decay. The grisly defiance implied by such verismo informs many variations on the theme of the haggard naked body in France: the Prince of Orange, René of Chalon, stipulated that he should be represented on his memorial as he would be three years after his death. He was killed in 1544, and his widow, Anne of Lorraine, probably commissioned the sculpture from Ligier Richier, her remarkable countryman, and it still stands in the church of St-Pierre in Bar-le-Duc. A grim corpse, flesh and skin adhering in tatters to the emerging skeleton, stands upright, head turned heavenwards, challenging death and implying vividly that the soul is unconquerable. A naked impersonator of the grim reaper himself, his spirit refuses to lie down under death's sentence at its most violent and macabre.[17] Another

sixteenth-century noblewoman, Valentine Balbiani, wife of René de Bir-
ague, was memorably sculpted by Germain Pilon on her tomb (also
now in the Louvre). On the top, she lies in her sumptuous damask dress,
leaning on one elbow on a cushion as she dreamily reads a book while
a little dog plays; this image of worldly pleasantness is abruptly shattered
when she appears again below as a corpse, stripped except for a scanty
shroud, and wasted till the bones show.[18]

The theme of the denuded hag had classical antecedents, with over-
tones of vice, which probably confirmed sixteenth-century contempla-
tions of the consequences of death and sin. In Ovid's *Metamorphoses*,
Invidia (Envy) bears a close resemblance to the fiendish vices and demons
of Christian imagination:

> [Her] face was sickly pale, her whole body lean and wasted, and she squinted
> horribly; her teeth were discoloured and decayed, her poisonous breast of a
> greenish hue, and her tongue dripped venom.... Gnawing at others, and
> being gnawed, she was herself her own torment.[19]

Renaissance artists, for whom Ovid was a favourite author, often
depicted his hideous crone: Giulio Romano (d. 1546), in a modello for
one of the lunettes for the Hall of Psyche of the Palazzo Te in Mantua,
Psyche Receiving the Vase Containing Proserpina's Beauty, draws Envy
looking on with the full raging rapacity required by her name. A
raddled, withered, snake-infested hag, she is almost too ghastly too look
upon.[20] Another crone, a Fate almost as nasty in expression as Envy,
fortunately conceals the bodily epiphany of her own violence from our
eyes behind her mastiff, the two-headed Cerberus. Dürer's painting in
Vienna, his famous *Avarice*, mines the same glossary of horror: fallen,
wrinkled, knotty, hairy, bloated and chapfallen at once, the grimacing
old woman shows us one bag full of coins, and beside it her immense,
hanging breast, with a swollen teat.[21] Dürer intended to disgust us with
the vice of Avarice, and to do so he used the imagery of a hag. But she
who modelled for him could not quite inject the necessary viciousness
into her expression; those rheumy eyes invite our pity, less for the
condition of her flesh than the symbolic use to which Dürer, merely
following tradition, is putting it. His Avarice is witchlike, horrible and
fearsome; like most witches she was probably an ordinary old woman,
and her ugliness - if that is what it is - indicated the state of her soul no
more than a lychee's perfumed sweetness can be divined from the rough
bark of its shuck.

In Dürer's own country, and during the hundred and fifty years after
him, when the persecution of witches spread through Europe, the witch

herself was represented naked by his compatriot Baldung Grien especially; her *nuditas criminalis* was not understood to be symbolic; or, rather, symbolism had been effaced from memory and was believed as actual.[22] Witch-hunters declared that women stripped off their clothes to dance and frolic and couple with the devil. But of course the nakedness, so solemnly and ludicrously enacted by witches' covens today, was imagined. It symbolized the witch's sinfulness, her acts of spite, against neighbours and their goods and livestock (Envy), and the sexual acts of her ritual practices (Lust). Both vices were familiarly expressed through a code of physical hideousness; sometimes, however, a treacherous young beauty, modelled on Eve, is allowed to ride the broomstick beside the hag, or to charm us with her alluring nakedness, as in the panel in Leipzig, *The Lovespell*.[23]

When an artist attempted to strip the code of its symbolic dimensions, and portray an old person in life with candour, the result was too alarming to be acceptable; to render decrepitude without intending the habitual *double entendre* is in painting and sculpture as difficult as it is in writing to use the metaphors of crippling or malformation or weakness without implying moral condemnation. Voltaire was carved in 1770 by the great sculptor Jean-Baptiste Pigalle at the behest of a group of his friends. Pigalle took as his point of departure the radical naturalism of many Hellenistic sculptures' heroic nudity, whether their subjects be old pugilists or mature weather gods. He rendered Voltaire as a naked man in his seventies, as he then was. The philosopher himself modelled for the head, but an old soldier for the body; its verisimilitude, the scrawny and time-worn body, faultlessly carved seated on a draped column, with one furl over the knee to cover the genitals, and an appropriately discarded mask at his feet, proved shocking to the patrons, and the sculpture still remained in Pigalle's studio in 1785.[24]

The example of Pigalle's *Voltaire* is rare; an equivalent – of a living and eminent old woman portrayed naturalistically in the nude – is difficult to find. If historical women were represented naked, or seminaked, and many were, as we have seen, the passage of time rarely marked their bodies or shrivelled their bared breasts. The tombs of Jeanne de Bourbon and Valentine Balbiani are uncommon examples of profound penitence, and are effigies of the body in death. The female form must remain sound, healthy, young, firm, smooth, white, rosy and of whatever shape and size is in fashion, if she is not to speak to us of death or sin, or of lust, which represents the synthesis of them both. Rembrandt is a magnificent exception. Rembrandt, who scandalized his own contemporaries by the intimacy of his female nudes, by the marks

on the model's soft thighs where her garters had bitten into her, did attempt an old woman naked in two etchings of 1658, and through his exceptional empathy, especially in the intimate meditation on the figure sitting on a bed, shows that the ancient equivalence between ugly body and ugly mind is an aesthetic construction which could be overturned.[25]

Henri Gaudier-Brzeska took issue with the convention in a letter to Sophie Brzeska, the woman whom he loved and whose name he had taken to add to his own. He made a revolutionary claim against idealism and its ethical consequences, defending the sculpture Rodin had made of la belle heaulmière:

> You say that Rodin's 'Old Woman' is ugly because shrivelled. It is age, and it seems to me vicious to generalize over life and beauty.... An old man, decrepit (not disabled, for that is unnatural, a man with a wooden leg or crutches being ugly), is beautiful; a body, which has died naturally in old age, is beautiful; a well-set-up child, a sound man is beautiful, and Rodin's 'Old Woman' is beautiful – for beauty is life and life has three phases: Birth, Maturity, Death, all of which are equally beautiful. The forms of this Old Woman are lovely because they have character, like your hands, which are lovely; and just as you cannot see your hands as other than having character, it is impossible for you to speculate on what the statue might have been had it been void of character.[26]

But the hag is in general intended to repulse us; her image, as a type of death and evil, affects us, touches us in reverse. Desire is still the motive force of the image; she engages our libido in order to crush it, by warning us of unseemliness and contempt, as in Gower's lines, if we are women, by warning us off if we are men. But nakedness in its criminal aspect is indeed only the reverse side of the icon. Her poor mortal coil arouses associations with the weakness of the flesh, in all its different forms, as Vice, as Death, as Fate, as soul of the damned. So this nakedness belongs in the same imaginative sphere as beautiful nudity, which needless to say also aims at exciting our appetites.

According to the schoolmen's taxonomy, the hermit saints and penitents of Christian cult, who take to the desert and strip themselves of their clothing, accept their unconscious animality – *nuditas naturalis* – in a spirit of humility. Anchorites like St Onuphrius and St Macarius, who in the early Church forsake the world for the hermitages of the Sinai and Lower Egypt and Syria, become, in their semi-clad state, familiar and beloved figures of Christian hagiography.[27] St Jerome, who

retreated to the desert in the Holy Land to expiate his worldly fantasies and life of pomp in Rome, is probably the best-known hermit saint of art. The old, emaciated and haggard sage, beating his naked breast – seat of the private sins and felt repentance – appears in hundreds of wonderful images, like Leonardo's sepia painting in the Vatican, or Bellini's glowing scene of penance in the Frick Collection, New York.[28] It mortifies the body to strip it, to endure cold and heat without clothing, that distinctive outer sign of European culture; the process of mortification sanctifies nakedness. John the Baptist's coat of skins, St Jerome's bare body dramatize their spiritual askesis; and the female saints who belong to this strain of hagiography follow suit. With the exceptions of Mary as a baby in scenes of her birth, occasional souls at the Last Judgement, and Eve before the Fall, the only holy, naked female individuals of mediaeval Christendom are saints like Mary of Egypt and Mary Magdalen.

Mary of Egypt (d. *c.* 421) 'was to let herself dry out as a prune, for this was the remedy that she herself devised against her moral rot and decay', writes one hagiographer of the young girl.[29] She worked her way to the Holy Land as a whore on a pilgrims' boat, and then, at the very door of the Holy Sepulchre, repented, feeling that her way of life disqualified her from going in. According to their intertwined legends, both Mary Magdalen and Mary of Egypt retired to the desert in penitence for their lives of sin and there, to symbolize their absolute rejection of the world and its vanities, took off the luxurious apparel they were accustomed to, and went naked like the beasts.[30] Their renunciation inspired some of the earliest painted female nudes, like the panels showing Mary Magdalen's last communion and ecstasy in the altarpiece of the Apocalypse, painted in Hamburg around 1400, and now in the Victoria and Albert (Pl. 88).[31] Faced with this unusual chance to disclose the female form legitimately, Dürer did not skimp on Mary Magdalen's charming curves when he engraved her levitating in ecstatic prayer in the desert, attended by flying cherubim.[32] The anonymous Swabian sixteenth-century sculptor who carved Mary Magdalen and painted her in lifelike polychrome for a local church paid little heed to the rigours described in her legend; his cult statue remains a delectable and naïve votive pin-up, and a startling element of church adornment.[33]

Donatello, who was himself ascetic by temperament and a celibate, was more faithful to the austerity of the legend in his earlier impassioned wood carving of the Magdalen now in the Baptistery in Florence, one of the most powerfully expressive icons of chastisement created to honour the Christian militant spirit. Gaunt, grim, withered by fasting, her

limbs reduced to the sharp bone, and her eyes 'trenches in her face', Mary Magdalen has shed all memory of the world of culture and sex. It would be understandable for the casual visitor to mistake her for John the Baptist. But the hair that covers her limbs is no coat of skins, rather her own hair, grown to cover her shame and granted her by God specially to preserve her modesty.[34]

Saints Mary Magdalen and Mary of Egypt have refused the life of sexuality by embracing full degradation, and so by inversion remain identified with the biology of women. Their bestial hairiness, while clothing them, sets the seal on their humbleness too, and intensifies their outsider state, first as prostitutes, then as recluses. Through their ordeal in the wilderness, the two saints adopt *nuditas naturalis* to transform themselves into icons of penitent *nuditas criminalis*: they become shaggy, like animals in the desert, in order to live out on earth the torments that they, who have committed Luxuria, would have otherwise suffered in hell for eternity. Donatello's scarecrow in the Baptistery in Florence becomes a soul sister to the withered figure in Moissac's porch.

Nakedness was also '*naturalis*': for instance, in allegories of Dame Nature herself in a debate with Lady Reason, depicted in a French manuscript of *c.* 1500;[35] in scientific illustrations to medical texts; and in scenes of ordeals or martyrdoms which can take on the appearance of scientific graphism, especially painted in fifteenth-century Flanders, like Gerard David's terrifying *Judgement of Cambyses* in Bruges[36] or the even more gruesome St George retable of *c.* 1410-20 by an anonymous Spanish master from Valencia, now in the Victoria and Albert, London, in which a horrific glossary of tortures is depicted.[37]

St Eugenia, one of the virgin saints who lived as a monk in male disguise, was charged with rape by a young noblewoman. She was able to prove to her community that she was incapable of such a crime by opening her monk's robe and showing herself, as depicted on a capital at Vézelay. Carved by a twelfth-century stonemason, it is an extremely rare image in Christian art of a woman's vagina, encoded rather than described as a deep, lipped orifice, placed as high as her navel (Pl. 86).[38]

Saints Mary Magdalen and Mary of Egypt also accept *nuditas temporalis*: they divest themselves of earthly goods and comforts, like John the Baptist before them in his coat of skins and Jerome after them, naked in the stony desert. Job, in the midst of his sufferings, loses all, including his clothes, and appears, as in the magnificently coloured illumination attributed to Jean Bourdichon in the *Hours* of Henry VII, lying on his dunghill with barely a clout around his carbuncled and emaciated limbs.[39] Natural nudity and temporal nudity are sometimes difficult to

disentangle: in the fairy tale, Puss-in-Boots goes for a swim (temporal) and then finds his clothes have been stolen and is forced to go naked (natural – since, prince though he will be, he is still a cat).

When Jonah issues safely from the whale, he too appears, on early Christian sarcophagi, in his natural and temporal nudity.[40] One of the earliest borrowings from classical iconography, his nudity takes us into the most interesting type that the schoolmen defined, *nuditas virtualis*, the nakedness that clothes us when our bodies are confirmed in virtue. With this type, we reach the core of our theme, the 'good nude' within our tradition. Jonah appears on sarcophagi next to scenes of Christ's resurrection; he foreshadows Jesus' own conquest of death and holds out the promise to us that we too will live for ever. He is a prototype of the saved soul, and he is naked, because his faith has purified him of carnal taint so he can reveal himself in the state of Eden before the Fall. The whale has swallowed his clothes, but he has also been reborn innocent. Jesus too, in some resurrection images, wears only a mantle draped around his loins; souls of the elect are often naked too, as those in carvings of the Last Judgement on French Romanesque churches like Conques, or those who, like newly baked biscuits, sit in a napkin in 'Abraham's bosom' in the sculpture programmes of the Last Judgement at Reims cathedral.[41]

The Just – men and women – are exhaled from cracked tombs in their glorified nudity, young, firm, pink, and fly up, escorted by angels into heaven, in paintings like Pisa's Camposanto frescoes of *The Triumph of Death* in 1360 (Pl. 87), or, as late as 1899, peer apprehensively into the dark gateway of death over whose threshold they are about to pass in Albert Bartholomé's *Monument aux morts*, the solemn and dirge-like centrepiece of the Père Lachaise cemetery in Paris. During the Middle Ages, when the Harrowing of Hell was a popular motif in Christian imagery, naked Adam and Eve and Abraham and Moses and other souls of the just who died before the redemption were freed from hell by the Redeemer, who gives them a hand to pull them up out of the very jaws of Leviathan himself, as in the *Apostles' Creed* tapestry, woven in Germany 1530–40, in the Cloisters Museum, New York.[42]

This *nuditas virtualis*, an absolute primordial innocence to which everyone shall return at the resurrection of the flesh, was symbolized by the naked human form and enshrined at the very heart of Christian thought by the naked Christ (Pl. 83). Both as child and man Jesus accepts the full physical human condition, and expresses this consent through his nakedness; symbolically, he lies unswaddled in a thousand altarpieces on

the humble earth which he has chosen as his dwelling; symbolically, he hangs on the cross in pitiful vulnerability. The Gospel says Mary wrapped him up when he was born, as any circumstantial realist narrative requires, but scripture is ignored in favour of the emblematic wholeness of Jesus' humanity. As Leo Steinberg has pointed out in his overprotested but stimulating essay, 'The Sexuality of Christ in Renaissance Art and in Modern Oblivion', the nakedness of the Christ child is rendered with a frank completeness rarely accorded to other naked human forms in western Christian Renaissance art. 'The sexual member', writes Steinberg, 'exhibited by the Christ child, so far from asserting aggressive virility, concedes instead God's assumption of human weakness; it is an affirmation not of superior prowess but of condescension to kinship, a sign of the Creator's self-abasement to his creature's condition.'[43] Steinberg draws the conclusion that the theologians of the Renaissance wished to refute any Nestorian or Docetist type heresy that Christ was not fully human, and not therefore subject to the fraught conflict of desire. He goes on to argue that the streaming and convoluted furls of Christ's loincloth, flying like a banner from the cross, in paintings like Rogier van der Weyden's crucifixion in Berne,[44] similarly attest, by their analogously knotted and burgeoning form, to the genital humanity of the Saviour. But Steinberg can give only one example of a fully naked adult Christ, the famous marble figure (1514–20) by Michelangelo in S. Maria sopra Minerva in Rome, which consciously paraphrases an heroic figure of antiquity. It is almost unique in its classicizing nudity, and it was already provided with a bronze figleaf by the 1580s.[45] The grown Jesus' virility is not in general stressed at all in votive imagery; rather an androgynous asexuality.

The baby who lies naked on the straw or on his mother's veil in so many images of the Nativity partakes of the innocence of the cherubim and the redeemed souls; his shamelessness derives more from the theme of the child as an image of heavenly origin than from Steinberg's incarnational doctrine. Jesus himself said, 'Let the little children come to me … for it is to such as these that the kingdom of God belongs' (Mark 10: 14), and again, 'Unless you change and become like little children, you will never enter the kingdom of heaven' (Matt. 18: 1–6); and his wisdom continued to be heard in spite of Augustine's doctrine that we are all born in sin until baptism cleanses us of the original taint.[46] Also, the baby Christ child has many counterparts who are by definition disincarnate, being angels.

Gambolling putti become the materialization of cloud and air in Assumption images, as they bear the Madonna to heaven, or frolic above

the stable itself as heavenly harbingers of the godling who has come down to earth, as in Poussin's gloriously joyous *Nativity* in the National Gallery, London. The bright cherubim, spirits of love, and children themselves of the erotes who besport themselves around the goddess of love, lose their wings when they voluptuously draw nourishment from the breasts of Charity in mediaeval and Renaissance allegories; but they are recognizable kin to the high-spirited *amorini* and cherubs and cupids of classical iconography, and just as emblematic in their unashamed nudity. Freedom of expression in gesture and speech and song is their spontaneous gift: Donatello's cavort along the choir stalls he carved for the Duomo of Florence, some of the first classical putti transformed. Raphael's child angels sing at the steps of the *Madonna of the Baldaquin* in the Uffizi. Although the open borrowing of the classical eros was an innovation, these artists were faithful to the strain in Christian thinking that attributes sexual innocence to the beginning of life, before experience has changed pristine unselfconsciousness. Besides, artists and thinkers were drawing on ordinary human experience: infants are not ashamed of their nakedness, and revel in it until taught otherwise. The attitudes of people around them bring them to self-awareness too; thus the story of Adam and Eve recapitulates in essence the passage of a child to puberty and sexual knowledge. Raphael's and Donatello's putti are two- and three- and four-year-old children in the exhilaration of nakedness which adults, after the experience of desire, can never wholly regain. Freud confirmed this, when he described the child's 'polymorphous perversity'. While seeking to confront an aspect of human character with wise tolerance he sounds clinical and coldly condemnatory; but he perceived in children's freedom from physical self-consciousness a prelapsarian state like Adam and Eve's before they were ashamed of their nakedness. Adrian Stokes took this synthesis further, when he wrote 'We of the West have symbolized fecundity by the infant, by the play of infants in whom the primary desires that make the adult world limitless, subterranean, dark, are seen bright and immediate in their least unsettled state.'[47] Stokes saw Donatello's carved musical *angiolini* as blithe infants who do not shock, stone children of the matter-mother, released from its earthbound fallenness to fly, to bounce, to leap.

Yet even heavenly nudity still remains nakedness; the Christ child, free from sin, proof of God's love for humanity, icon of innocence, extends his bare foot for the kings to kiss in Adoration paintings, because it is the least part of him, and an obeisance to a baby's foot will set the seal on their capitulation.[48] Worldly, rich and powerful men, they acknowledge thereby the spiritual doctrine of humility, that the least shall

be first. Their homage exalts the kings, precisely because they accept to be humbled. The bare foot retains this dual symbolic force: it belongs to ethereal beings who do not tread the lowly earth, like angels, and cherubs, the Virtues and the Victories, and indeed it helps us to recognize them for themselves, for groundlings need shoes. In this world, only beggars or slaves go barefoot. (Dorothée, in Baudelaire's poem, knew she flouted this when she took off her shoes and turned herself into a living image of liberty.) So bare feet can also evoke those same groundlings in their greatest humility. St Bernard developed the symbolism in a sermon on the Song of Songs: 'If it seemed right to St Paul to describe Christ's head in terms of his divinity (1 Cor. 11: 3), it should not seem unreasonable to us to ascribe the feet to his humanity.'[49] It is still a sign of respect in some cultures to remove one's shoes, to accept inferiority, and avoid pollution. In the Maestro delle Vele's richly coloured frescoed spandrels in the lower Basilica of St Francis in Assisi, the saint's bride Lady Poverty wears a transparent chemise over her nakedness as she stands on stony ground in bare feet.

In Sassetta's later painting on the same theme Poverty has bare feet too. The three Franciscan principles to which the order was vowed – the maidens Poverty, Chastity and Obedience – are flying back to heaven, but Poverty, his bride, the virtue St Francis loved most, turns her head to look lingeringly on her spouse.[50] Francis himself in his lifetime played with dramatic genius a series of variations on the motif of nudity: he stripped in front of his father in the public square of Assisi in order to make public demonstration of his spiritual cause; he bore the mystical marks of Christ's Passion on his very body; and when he lay dying, he asked his brother to put him on the ground, the humble earth, *humus humilis*, to which he was returning.[51] Religious orders like the Franciscans and the Poor Clares still go discalced, or at best roughshod, and the friars who have inherited St Francis' idealism sum up their spiritual ambitions with the motto: 'Nudus sequi nudum Christum' (Naked to follow the naked Christ).[52]

The intrinsic ambivalence, in the Christian tradition, between the innocent natural body and the tainted carnal body, between divestiture as a sign of virtue and the naked body as an occasion of sin, between denudation as a gesture of ascetic renunciation and nakedness as an invitation to wantonness, provides the dynamic of a story which is by no means part of Christian teaching. Yet the story of Lady Godiva's famous ride plays on many Christian themes, not least the motif of redemptive

nakedness. It turns on her singular heroism and self-sacrifice in exposing herself to shame; but in effect it reveals at the same time the hallowed condition of the naked body when proved innocent. Like a defendant taking an ordeal, Godiva proves her truthfulness by literally revealing all.[53]

Lady Godiva's legend first appears in the chronicle of Roger of Wendover in the thirteenth century, and she has proved a highly popular figure ever since. Her ride was first revived in 1678 and has been held intermittently since then, most recently in 1982. Though Roger's report must contain mythical elements, Godiva herself was a historical woman: she appears in the Domesday Book as a Staffordshire landowner, and endowed several monasteries and churches. In her will, she left a necklace to be wound round a statue of the Virgin – possibly the first mention of a rosary in Europe.[54] Her husband was Leofric, Earl of Mercia, and her children, after her death in 1067, are known to have supported Hereward the Wake against the Conqueror.

In Roger's account,[55] Godiva is pious, 'a great lover of God's Mother', merciful and open-handed, and she longs to lighten the toll of taxation imposed by Leofric on the people of Coventry. But Leofric only tells her she should not ask for something so contrary to his interest. She continues, 'with a woman's pertinacity'. Exasperated, he turns on her and challenges her to 'ride naked, before all the people, through the market of the town'.[56] Like a spoiled princess in a fairy tale, Leofric demands an impossible task from the heroic protagonist, who then proceeds to take up the challenge, perform the feat, and succeed. Godiva takes two soldiers with her, and mounts her horse. 'The hair of her head and her tresses', as Roger pleonastically puts it, veiled her body so that no one could see anything except her 'white, white legs' (*cruribus candissimis* – the kind of detail that makes the scene leap to life, across nearly a thousand years).[57] Leofric is astonished; but, again as in a fairy tale's happy peripeteia, he keeps his side of the bargain, and delivers Coventry from the toll.

Roger of Wendover liked a spicy story, and he moves straight on in his chronicle to a version of the popular mediaeval tale about an unfortunate youth who accidentally marries a statue. Godiva's exploit did not retain him, and he gives no hint of a titter; but its suggestiveness has provoked many questions since. The story possesses no logic: when Godiva 'joyful' returns to Leofric, we would expect him – if this were straightforward narrative – to feel fooled and angry. But no, he is only 'astonished' and does not censure her or worry at her 'shame'. We might also expect a man who allowed his wife to undertake such a trial to be a knave. Yet Roger presents him as a munificent noble, and the incident and its instigation as quite normal.

Later writers have found this Leofric hard to accept, and he appears variously as a churl, a tyrant and an unsavoury voyeur, a second King Candaules, in Victorian treatments of the theme. Tennyson's grim earl in the poem 'Godiva' is a beast surrounded by beasts:

> And from a heart as rough as Esau's hand,
> He answer'd, 'Ride you naked thro' the town,
> And I repeal it;' and nodding, as in scorn,
> He parted, with great strides among his dogs.[58]

Godiva's motives and reactions are equally mysterious. She turns our expectations topsy-turvy too, when she takes up her husband's peculiar challenge and defies everything modesty and Christian chastity enjoin; but by so doing she triumphs, and increases her authority. She exposes herself and comes out unscathed and thus demonstrates that her virtue is proof against everything, even the profanity of public exposure. With the passivity thought suitable in a woman, she puts herself to the test, and succeeds.

A recent interpretation argues that Leofric only spoke metaphorically, and simply urged Godiva to strip herself of her worldly goods and give them away in the market-place. It is a plausible reading, but it only increases the significance of the traditional literal interpretation, which hearers of the story have so clearly preferred. The literal version makes Godiva's naked body the exact counterweight for Leofric's income in taxes. The fourteenth-century stained glass window in Trinity Church, Coventry (until it was destroyed in the war), showed Leofric and Godiva side by side, holding a charter saying,

> I Luriche [Leofric] for love of thee
> doe make Coventre Tol-fre.[59]

The inscription catches the equivalence between Leofric's possession of Godiva his wife and his control of the fortune he is prepared to forgo when, after the symbolic surrender of her body to the people, she returns to him inviolate.

The meaning of this reciprocal exchange of treasures was caught by later variations on the legend. One account relates how everyone fell silent as Godiva passed, except for a horse which neighed. As a result, taxes continued to be levied on horses passing through Coventry. Richard Grafton, who was MP for the town in 1562-3 and an ardent Protestant, printer of a Bible and of the Book of Common Prayer, shied from the brazenness of the mediaeval story, and told instead how Godiva had summoned all the magistrates and officials of Coventry and its

environs, and ordered them to make sure all windows were shuttered and all doors closed and everyone kept indoors 'under a great pain'. Those white legs on general view were too much for Grafton's reformed conscience.[60] It is essential to the message of the ride that Godiva provokes no lust, in spite of her nakedness. The only man to transgress this unspoken element of the story entered the tradition in the early seventeenth century. 'Peeping Tom' looked out from a window, 'but it cost him his life', says the chronicler.[61]

The story of Godiva's ride is about chastity placed under duress and holding up, and about the high price a man will pay for that virtue in a wife. Nevertheless, it is also clear from the story that Godiva's ride was thrilling; the licence it records is too much even for today, when the impersonators of the city's heroine always wear leotards from top to toe. In 1919, the horse wore trousers too.

One of the earliest surviving images of Godiva on her horse was commissioned by the City Council in 1586 from a Flemish painter who was probably a Protestant refugee from Spanish persecutions in Holland. It is an attractive canvas, confounding stereotyped views of Puritans, for the full white figure of Godiva is represented frankly, without prudishness or coy titillation (Pl. 95).[62] The same cannot be said for the comical maidens who clutch at drapes, dip and scuttle in later renditions, like John Collier's painting of 1898 and now in the Herbert Art Gallery, Coventry, or Jules Lefebvre's of the following year, now in Amiens.[63] These late nineteenth-century versions have overlaid the mediaeval story with Victorian attitudes to female nudity, focusing pruriently on the disrobed woman, who is showing reluctance.

Sometimes Godiva's name – which means gift of God – is spelt Good-Eve. Lady Godiva was indeed a good Eve. Her nakedness recalls the most familiar nude of Christian imagery, the Mother of All Living. By riding for a fall and escaping intact, Godiva confirms herself as pure and prelapsarian, like woman before that first fall in Eden. Lady Godiva sought to lift the burden of taxes: her ends were secular. Her type of sacramental nudism, interfusing many Christian aspects of the body's meaning, and assumed for political ends, has not been deadened by contemporary commercial exploitation of nudity: the Nagasaki demonstration at Greenham Common in 1984 (described in Chapter 3) stirs genuine distress in the spectator, even through the muffling medium of a photograph. And the story of the Doukhobors of Canada, told by Shirley Ardener in a sensitive essay, expresses the tragic depths symbolic nakedness can touch.[64]

The Doukhobors are a fundamentalist Christian sect from Russia, many of whom emigrated to Saskatchewan in 1899; they now number around 20,000. Their faith is pacifist, ascetic, and they held then to a utopian anarchism, believing that all are equal (including women), that no one should own property, or recognize any authority but God's. They could not therefore be responsible to any earthly government, in matters of law, or even education. Their way of life immediately came under pressure – from the Canadian authorities who, though tolerant and welcoming, wanted them to register titles of land and send their children to school, but also from less stringent members of the group, who wanted to settle their own homesteads in the new land. Some of the Doukhobors began demonstrating their revolt, by wandering from place to place, and in 1903 thirty-seven men and women staged the first of many nude parades which were to continue till the thirties and even afterwards. The very high-mindedness of the Doukhobor tenets made these protesting exhibitions all the more painful, even 'heart-rending', in Ardener's words.

The Doukhobors believed in searching the scripture for its hidden meanings, that the Bible should 'be understood symbolically to represent things that are inward and spiritual. It must all be understood to relate in a mystical manner to Christ within.'[65] By demonstrating naked, they divested themselves of earthly ties, 'in the manner of the first man Adam and Eve, to show nature to humanity, how man should return unto his fatherland'.[66] They traipsed from village to village, eating leaves and grass, and refusing the attempts of the police to get them to put on clothes again. Finally, by leaving lights on at night in their prison quarters, the authorities managed to use mosquitoes to accomplish what all else had failed to achieve.

The disturbances continued; in 1932, for instance, around six hundred Doukhobors were in prison for nude protests. To this public display of despoliation, some extremists were now adding arson: they burned and dynamited their own property or that of other Doukhobors, to maintain them in the strait and narrow. As Shirley Ardener points out, the sacrificial character of their first use of nudity gradually gave way in importance to nudity as a form of outrage, equivalent to radical anti-social violence, like arson. The same difference distinguishes St Francis' uses of nudity; aggressive, when he repudiated his father in the piazza of Assisi, and passive, when he forswore the world by lying down naked to die. The Doukhobors proclaimed a rhetorical equivalence between nakedness and nature, in a most dramatic manner, when they rejected society and so proved, by inversion, the relation between culture and clothing.

The naked figure, especially indoors, or in a city setting, stirs thoughts of the natural universe outside the confines of man-made society, and can readily issue an invitation to erotic fantasy and escape. Paul Delvaux's naked girls, obsessively treated in his paintings again and again, set up a similar disquiet because they move in sitting-rooms, in streets, in railway stations, where the nude, we have been accustomed to think, has no place. Full nakedness, like the semi-nakedness uncovered by the slipped chiton, relates to the wild, outside culture. Cult nudists call themselves naturists, to make the point that they are not licentious, but wholesome. The naked woman out of doors seems to participate in the very essence of nature, to become herself one of its fruits, a sweet drupe amid the vegetation, like the famous seated woman in Giorgione's *Tempesta*, or the nude in Manet's *Déjeuner sur l'herbe*, who provokes the painting's major *frisson* because her companions are not only clothed, but in city dress.[67] The witty and touching photograph taken by Judy Dater of the veteran photographer Imogen Cunningham working with her favourite model, Twinka, creates that special current of pleasure, what Barthes has called the *punctum* of a photograph, through the sight of Cunningham, with her paraphernalia of cameras, spectacles, headband, socks and shoes, coming upon Twinka, like a smiling dryad surprised, wearing nothing at all behind a tree (Pl. 98).[68] Classicizing dreams of Arcadia combined with a Christian vision of the body in paradise to justify the natural form, and bring it into the centre of our culture.

Karl Bitter's naked *Abundance*, on the fountain opposite the Plaza in New York in the midst of the city's stone and glass and metal, returns us to paregoric memories of woodlands, fields, the fragrant and dewy open;[69] Frederick MacMonnies' lyrical statue of Beauty outside the New York Public Library similarly implies that the ends of learning are some primordial state of grace, for which nakedness is a suitable sign.[70] In Paris, the golden girls of the Palais de Chaillot, who have looked out towards the scaffolded spire of the Eiffel Tower since the exhibition of 'Arts et Techniques' of 1937, are all nudes (except for one). We do not need to know their names – Spring, Fruits, Gardens, the Countryside, Morning, Flora and Youth – to feel soothed as we pass by the pastoral dream of goodness their nakedness holds out as a gift. The only clothed statue represents Birds – perhaps because unlike humans they are always covered, even in their untamed state.[71] In London, many of the public nudes are remarkably recent works: the kneeling bronze fountain figure in Sloane Square, sculpted by Gilbert Ledward, was put up in 1953.[72] The denser the population, the thicker the traffic, the more citified the

area, the more nude figures are there likely to be, to bring Arcadia to the metropolis. Nakedness holds out a dream of freedom from society's constraints, probably more so now than ever, because, at a practical level, it is increasingly impossible to go around with no clothes on. Most people will appreciate how Godiva's outdoor nakedness and the Doukhobors' protests placed them at risk, how even more intensely vulnerable they would have been in any city of the West. The most committed naturist might prefer to get dressed before taking the New York subway.

An important difference governed Greek attitudes to the male or female nude, and it is one which the reinterpretations of Greek and Roman art generally accepted and disseminated. Whereas athletes and warriors, gods and heroes in Greek art reveal their naked bodies without primary erotic connotation, the female nude, in its earliest classical manifestations, was assigned to Aphrodite's sphere. There are examples of heroines and goddesses in a state of *semi*-undress, as we have seen: Nike at Olympia, Artemis the huntress, the Amazons, the principle of Virtus herself. A tragic dying Niobid, now in Rome, falls naked under a swirl of drapery over her knee; but her disarray expresses her stricken state, like the disarray of mourners. On the Ludovisi Throne, an exquisite bas-relief of a flute-playing nymph represents another early (fifth-century BC) example of a full nude. But she may be piping for Aphrodite who, in the centre of the throne, rises from the waters in her clinging wet chiton. Generally, however, the revelation of the lower body of a woman, as in the fully naked cult statues of Aphrodite or of her followers the Three Graces, marks the figure as a prime and exclusive object of desire.

The depiction of the female pubic triangle carries a circumscribed sexual meaning, unlike male genitals, which are rendered with observant simplicity. On the earliest archaic kouroi, the pubic hair is carved as formal flat curls; on the later Hellenistic bronzes, it becomes more hyacinthine. Male 'heroic' nudity inspired no anxiety comparable to that of female nakedness; as is well known, it also reflected social customs, for the Greeks exercised in public and competed at their games in the nude. In Sparta, where young women were trained in athletics, they also did so naked, but this was not an Athenian custom.[73] Indeed, even a statue of a naked Aphrodite was provocative in a society which kept women indoors and under veils. According to a revealing legend reported by Pliny, Praxiteles was the first to carve an Aphrodite entirely naked. The islanders of Cos were scandalized by the innovation, and rejected the nude figure; the work was then accepted by the inhabitants of Cnidos, and became a famed talisman, the Cnidian Venus.[74]

Familiarity with the Greek cult of nudity can lead one to assume mistakenly that the Greeks did not live under the taboo of sexual constraint; in mixed company they did. A woman was erotic in her person, like Pandora at her birth, like Helen; desirability was a female condition. Consequently, even a woman's clothed presence could introduce the erotic and charge a man's nudity with overtones other than heroic or even aesthetic. Homer, admittedly writing long before most of the statues that have come down to us, gives us evidence that Odysseus felt a humanly recognizable compunction when he found himself with no clothes on in the vicinity of Nausicaa and her band of girls washing in the river. But he needs their help.

> So the gallant Odysseus crept out from under the bushes, after breaking off with his great hand a leafy bough from the thicket to conceal his naked manhood.... Begrimed with salt he made a gruesome sight, and one look at him sent them scuttling in every direction along the jutting spits of sand...[75]

Indeed, without the common ground of these mixed feelings, we would hardly be able to make the imaginative leap to sympathy with the adventurers and warriors of Homer's epics.

The neo-platonists in Florence in the fifteenth century, allegorizing the myths of classical Greece in pursuit of the most high-minded ideals, transfigured the erotic meaning of the female nude through mystical interpretations of Venus and her train. The future Pope Pius II was entirely characteristic of the thinking of his time when, as Cardinal of Siena, he placed a Roman group of the Three Graces in the library of the cathedral; Titian, when he painted his famous picture, usually called *Sacred and Profane Love*, did not intend a simple derogatory contrast between the naked figure who sits at the fountain of love beside a woman of Titian's day clothed in bridal raiment, as the painting's traditional and erroneous title suggests, but was creating an allegory of love in a wedding picture in its widest humanist sense (Pl. 99).[76] Although earlier Christian meanings attached to human nakedness inform the complex transformations of Venus in Renaissance painting, there is another, allegorical, nude figure, invented in the fifteenth century, who illuminates remarkably the intertwining of classical and Christian ideas about virtue and nakedness after the Middle Ages.

Truth, *aletheia* in Greek, *veritas* in Latin, and *emet* in Hebrew, all feminine in gender, was not it seems worshipped in a temple dedicated in her name, in Greece or Rome, unlike so many virtues, as we have seen; nor, perhaps even more surprisingly, was she generally numbered

among the Virtues. It is God himself who is Truth, and the Church, his faithful daughter, the instrument of that truth on earth. In the Old Testament, the Psalmist does personify Truth, when he dramatizes the judgement seat of God and, as we have seen, says:

> Mercy and truth are met together; righteousness and peace have kissed each other. Truth shall spring out of the earth; and righteousness shall look from heaven (Ps. 85: 10-11 AV).

In manuscript illuminations of the scene, as in the twelfth-century Jesse Tree from the Lambeth Bible, in which Mary in the centre represents Wisdom, Truth appears as a veiled maiden giving her hand to Mercy, while they exchange sympathetic glances.[77] Panofsky discovered an initial capital drawing of around 1350 for the psalm showing a tiny nude Truth,[78] and Giovanni Pisano carved a personification of one of the virtues, perhaps Temperance, perhaps Chastity, in the pose of a Venus pudica, on his pulpit for the cathedral of Pisa between 1300 and 10. But his sculpture, 'one of the most surprising false alarms in art-history' according to Kenneth Clark, anticipates the interpretations of the Renaissance by over a hundred years.[79] For, in general, mediaeval Christian iconography did not represent Truth naked; following rather the more traditional imagery of the virtues, it depicted her as a clothed virgin.

In language, however, the association of truth with disclosure is very ancient indeed, and this metaphor, when applied anthropomorphically, was translated into nakedness. The Greek *aletheia* means 'non-latency', something in which nothing is concealed or lurking, from *lathein*, 'to escape notice or detection', with a negative or privative *a-* prefix. In Latin, the imagery of human nudity was more immediately present as a motif: Horace speaks of *nuda veritas*[80] and Petronius of *nuda virtus*.[81] In English and the Romance languages, a tremendous variety of different images expressing the polarity between truth and falsehood turn on other contrasts, between nature and artifice, fundamentals and accretions, origins and derivatives, the pristine and the worn, wholeness and fragmentation, revelation and concealment. The wholly naked human body, carrying with it multiple meanings of nature, integrity and completeness, transmitted by the allegorical tradition, generated a personification of truth as a female form, often entirely naked, because Truth has nothing to hide and can never be less than whole. *Nuditas naturalis* and *nuditas virtualis* both inform the Renaissance personification of the 'naked truth'; truth possesses an eschatological body, transfigured and innocent; 'sprung out of the earth', she is also primordial and aboriginal, like nature, the origin of living things.

Her own origin as an allegorical figure in art can however be traced, to Leon-Battista Alberti, and his profoundly influential treatise, the *Della Pittura* (*On Painting*) of 1436. In it, Alberti advised his contemporaries to emulate a famous painting of antiquity, by the fourth-century BC Greek master Apelles, called *Calumny*. Though the painting was lost, Alberti was able to give a detailed description of its complex allegory by following the writer Lucian, of the second century AD. But Alberti made an error in translating from the Greek, as Panofsky noticed in his important essay 'The Neoplatonic Movement in Florence and North Italy', and it is a most revealing one, for in it the tensions of different associations with the nude can clearly be perceived.[82] Lucian had written that the figure of Remorse, 'weeping and full of shame', appeared next to Truth. But Alberti transferred the adjective for 'full of shame' (*aidous* in the Greek, *pudibunda* in the Latin) to Truth instead.

Aidos is the word used by Hesiod for Pandora's virgin modesty at her creation, and Alberti gave it to Truth because he must have visualized the figure as a Greek type of bashful beauty, like a Venus pudica. (Though in her cult statues Venus is drawing attention to her breast and vulva with her hands rather than screening them from our gaze as her title implies.) But Alberti's Christian humanism also made him shy away from the eroticism of the Venus or Pandora figure; though one aspect of the tradition he inherited made nudity an appropriate condition for truth, another aspect did not. So he strained to mitigate its sexual component, and suggested that truth was filled with compunction, a sentiment logically alien to the virtue itself.

Botticelli was one of several artists who took Alberti's advice and tried to reconstruct the lost masterpiece.[83] His small panel, *The Calumny of Apelles*, now in the Uffizi (Pl. 91), does not have the seductiveness of his famous large oneiric paintings nearby, the *Primavera* and *The Birth of Venus*.[84] Its setting is almost mathematically architectural; no verdure or blossom entrances us. Even the blue sky and the green horizon seen through the three regular arches cannot palliate the lesson in cruelty we are being given. Calumny in the centre is dragging her victim by the hair to judgement, while Fraud and Deception, her fragile and Grace-like attendants, twine her hair with roses. The judge has ass's ears and is listening to the slanders of Envy, the dark-hooded tatterdemalion who imprecates at the foot of the judgement seat. Ignorance and Suspicion are adding their lies to the evidence, whispering in the false judge's ears. Their group forms, on the right side of the painting, a vortex of unpleasing, contorted aggression. Indeed, Botticelli is so successful at summoning up tension and cruelty that his *Calumny of Apelles* has never

become a beloved image like the *Venus* and the *Primavera*, though they
are both as intellectual in origin. The *Calumny*'s jagged rhythm, stifling
ornamental interior and twisted figures can even make us miss the serene,
ethereal personage on the left who, straight-limbed and graceful, points
up towards heaven. She is the Truth of Apelles and Alberti, and a most
unusual example of an entirely chaste indoor nude. She holds a single
strand of something – perhaps her hair – lightly across her sex, imitating
in this the gesture of his Venus rising from the waves, whom she resem-
bles closely in pose, though her contours are more angular and she does
not drop her eyes at our gaze, but fixes them on the aether. The victim
of Calumny is almost naked too: he is also honest, Truth's follower. Her
clean form, where Botticelli shows his mastery of flowing, uncluttered
line, contrasts with the grotesque crone, swathed in black, who turns to
twist her head to look at Truth while stepping towards Calumny's gang.
She represents Remorse, and it was she, quite rightly, who originally
wept and was ashamed.

Botticelli's picture initiates a special type of Renaissance discourse in
art, the use of Truth personified in order to vindicate someone, either
the artist himself, or another whom he respects and wishes to defend.
For Botticelli may have painted his *Calumny of Apelles*, after his conver-
sion to a reforming brand of piety, in defence of Savonarola, the vision-
ary who had led Florence in a brief moral crusade. Botticelli had joined
him, but Savonarola fell from power and was burned to death in the
Piazza della Signoria in 1498. Botticelli may have painted it earlier than
1498, perhaps to defend the Medici who had been overthrown in Flor-
ence. The painting's origins are not fully understood, but in any case it
mounts a remarkable indictment of social injustice, false trials and the
fate of the wrongly accused, and its theme and constituent figures were
adapted by artists struggling against some personal injustice.

Pietro Aretino, damaged by a forged letter in which he slandered his
own patroness, fought back to prove his innocence by commissioning
a medal from Leone Leoni and publishing an engraving in 1536 in which
he elaborated Apelles' allegory, and specified that Old Father Time
should be shown preventing Truth from falling into a pit prepared for
her by Calumny.[85] Bernini, when he was humiliated by the demolition
of his campanile for St Peter's, also vindicated himself with an image of
Truth. His first dramatic sketches show a cringing creature of great
pathos, dynamically unveiled by a winged and muscular Father Time;
the sculptor-architect, greatest and most flamboyant genius of the sev-
enteenth century, was identifying in his failure with this pathetic, mis-
understood figure. But by the time he came to carve the figure, his

self-esteem had rallied, and his humble Truth is radiant, confident, warmly sensual in the folds of the cloak she has discarded as if hatching out of them; she holds the sun in her hand, as Cesare Ripa had suggested in his *Iconologia*,[86] and rises joyously, her upward dynamism intensified by the drapes that crackle like flames around her. Bernini made her beautiful because 'the most beautiful virtue in the world consists of truth'. The unfinished sculpture is now in the Galleria Borghese, Rome (Pl. 92); Old Father Time does not appear either in the vivid terracotta modello in the Louvre.[87]

The companion mottoes that 'Truth was the Daughter of Time' (*Veritas filia temporis*) and that 'Time Unveils Truth' continued to inspire secular art throughout the seventeenth century, when the taste for emblems and allegories was at its height in courtly circles. In Britain, the conflict between Protestants and Catholics inspired a struggle to monopolize the rhetorical image. Mary Tudor took 'Veritas Filia Temporis' as her motto at her accession, and when Elizabeth I went on a progress through London soon after she came to the throne, in 1559, a tableau was performed at Cheapside in her honour: Time led forth his daughter Truth, who was wearing white silk and carrying the Bible in English.[88] In France, the twin tropes gave painters licence to lay bare the bodies of women in all their ripeness. Poussin executed a ceiling painting on the theme around 1641 for Cardinal Richelieu called *Time Rescues Truth from the Assaults of Envy and Discord*, with a dizzy *sotto-in-sù* perspective. Saxl commented that the 'painting for Richelieu cannot fail to distress the believer in the progress of mankind. It is disheartening to see a graphic formula devised for the representation of a Platonic conception converted to the purposes of courtly eulogy and the praise of a painful political victory.'[89]

Rubens included a wriggling, nacreous-fleshed beauty drawn up by Father Time to join Marie de Médicis on the clouds in heaven above in *The Triumph of Truth*, which closed the 1622–5 cycle in the Queen Regent's honour now assembled in the Louvre.[90] In his version of *The Calumny of Apelles*, a beautiful drawing in the Courtauld, Rubens borrowed the traditional iconography of Envy to depict Remorse, thus stressing the duality between the crone and the beauty, between vice and virtue. In a painting by François de Troy (d. 1752) in the National Gallery, London, *Truth Unmasking Envy*, the hag Envy's heavy and crude leather slipper occupies the centre foreground of the picture, in emphatic contrast to Truth's pretty naked foot – concealment again counterpoised to revelation, age to youth (Pl. 93). Gravelot and Cochin, in their *Almanach Iconologique*, portrayed two figures in the nude; La Nature, who,

as we have seen, offered herself to us in a rural setting (Pl. 97), and La Vérité. 'This heavenly virtue is represented naked, because she has no need of ornaments' (1767).[91] Charles Nicolas Cochin le Jeune (d. 1790) was the more austere draughtsman of the two; Gravelot (the sobriquet of Hubert Bourguignon, d. 1772) was more ornamental in style. It was Cochin who designed, in 1764, the frontispiece of the great work of the age, the *Grande Encyclopédie* of Diderot and D'Alembert. He drew a radiant apotheosis of Truth, naked under transparent veils, emitting such light that the clouds part to disclose the personified pursuits of the *siècle des lumières*, including the new, important science of Optics and the recently dignified subject of Modern History (Pl. 94).[92]

While interpretations of *nuda veritas* like Botticelli's *Calumny* tapped the ethereal energy of the good nude in Christian iconography, figures like Rubens' versions of Truth return her to the family of Venus. Indeed Rubens, when he painted in later life the abduction of a nymph by the north wind Boreas, borrowed the composition of his apotheosis of Truth in the tribute to the Queen, Marie de Médicis. Tiepolo used a similar rosy, sleepy beauty for a figure of love in an allegory of Venus and Time, as he had for Truth in *Time Unveils Truth*.[93] It is noteworthy that iconography, seeking to match image to figure of speech, should pay so little regard to the personal or social implications of the scene, and that someone like Rubens, who painted so many magnificent pleas in the cause of peace and mutual tenderness, should treat rape and the discovery of truth as interchangeable.

Jules Dalou, the enemy of militarism and violence, modelled a figure of Truth in the grip of Father Time for his memorial to Delacroix of 1890 in the Luxembourg Gardens. Like Rubens, Dalou too was inspired by Bernini's *Rape of Proserpina*; as was Thomas Régnaudin, whose writhing and shrieking Cybele, carried off by Saturn, carved for the gardens of Versailles in 1678, provided Dalou with his immediate model.

The two meanings will not however fold together: Rubens' white beauty's reluctance and her dewy backward glance do not fit the argument, since Truth should surely rise to greet Marie de Médicis without equivocation; in Dalou's case, Time keeps such a hefty grip on Truth's naked form, he contradicts her slender semblance, while her torsion, derived from Cybele's protest, as she leans over backwards to give Delacroix her crown, becomes mere ornament, empty of any justifying motive. Only a nymph in the grip of a rapist flails and wheels and needs to be pinioned like that.

But artists chose the iconography of rape because it stands for appropriation. Unlike Botticelli or Cochin, Rubens and Dalou relished the

primary eroticism of the female as an image, whether representing sexuality or not. In spite of the undoubted power of their voluptuous virtuosity, they thereby attenuated the nude's significance. Although women have rendered the female nude with emotional conviction, and painted the fruits of Peace, the ardour of Liberty, the mildness of Mercy,[94] no female artist, as far as I know, has ever found rape the appropriate metaphor for Truth's acquisition. The trope values one desire – the abductor's turmoil of passion – and overlooks the absence of reciprocal desire in his victim. Yet the nude possesses the power to involve us in the subject's passions more than anything other than a great portrait; Daphne's terror as she flees Apollo in Bernini's virtuoso sculpture fills us with dismay,[95] Hendrickje's inward smiling sexual tenderness as the maid dries her foot after her bath in Rembrandt's wonderful picture Bathsheba admits us into the secret places of her moods through sight of her adorable body.[96] Christ's delicate flesh under his light white mantle when in Titian's painting he reveals himself to Mary Magdalen communicates the miracle of his resurrected body to us;[97] his broken carcass fills us with pity in hundreds of devotional images. The nude can make us feel what its subject feels, so when Truth flees from Time's grasp and we are meant to applaud his persistence and vigorous pursuit though she twists like a rapist's victim, then the significance collapses; we cannot see the truth in it.

The many women who are wounded by the continual public use of women's bodies today diagnose correctly that women are thereby reduced to objects of desire. Since the graphic artists of the turn of the century adapted the ancient hard sell of ideals and slogans, propaganda and claptrap by representing them in the female form, the inevitable lust of the eye for female flesh has been the premise of advertising.[98] In 1897 naked Truth herself makes perhaps her first appearance in an advertisement, a French poster for bicycles.[99] Sitting with the chain around her ankle, this Vérité, an early commercial pin-up, sums up the problem of the emblematic female. With its cycling belle safely attached to her post and to her significance in the advertisement, this Belle Epoque poster disingenuously annexes the convention to excite our appetite for the product it advertises, and thereby ironically unmasks the truth lying behind the image of naked Truth itself, that the nudity of the figure is there to excite our longing, it is intended to stimulate desire (Pl. 96).

The female form can excite that desire to sell soap, drink, cars, butter, aeroplanes, holidays, whatever. Her desirability, taken for granted, gives its light and its energy to the product. Women are expected to identify with the subject in the image; men to experience desire without such

mediation. To condemn altogether the applied erotic power of the female body entails denying an aspect of the human condition; the task we have to take up, as women who inhabit these centres of energy and as men who respond to their charge, is how to tap it and make it fructify.

There are so few images that have fulfilled the claim to represent Truth and have made the nude sing in a manner to arouse a general desire for the good, that have performed that most desirable entropy, the broadening of sexual desire to enliven other impulses in the human make-up, impulses to individual generosity and courtesy and considera-tion, to a wider *caritas*. But one such work is a small painting by Thomas Eakins, *William Rush Carving the Schuylkill River*, which the American artist painted in 1876-7; it now hangs in the Philadelphia Museum of Art (Pl. 100).[100] This delicately handled and deeply serious picture resumes many of the themes of this book, for it places the female body at the heart of an argument about art and art's capacity to turn our minds to the contemplation of our potential as human beings.

The painting shows a model, standing on a tree trunk, in the studio of William Rush (b. 1756), the Philadelphia sculptor, who had died forty-odd years before in 1833. He is carving, with hammer and chisel, his allegorical fountain of 1809, representing the River Schuylkill which was harnessed by Philadelphia's water works to provide the city with water.[101] The model has her back to us, and her clothes lie on a chair in the foreground, a brilliantly highlighted white summery dress and petticoat, a red-lined jacket, blue stockings and a chip sunbonnet with sash. She carries a book on her shoulder to hold the pose for the statue, which bears on its shoulder a bittern, the water bird that frequented the Schuylkill marshes and whose long bill, pointing upwards, was used to spout water eight feet into the air. Unlike the model, the carved figure is flimsily draped in the classical manner. Beside her, her chaperon is knitting, sitting on an immaculately painted Chippendale-style chair, the pair of the chair on which the model's clothes lie in their sweet disorder. Behind them stands Rush's statue of George Washington. Apart from the light which falls on the discarded clothes and catches the left side of the model's body, moulding the hollows and bumps of her shoulders, back, hips and foot, and even her left breast, the painting is sombre, almost Rembrandt-like in its ochre and umber palette, and its mood is very quiet.

William Rush Carving was exhibited at the centennial show of 1876, and it was immediately attacked for its gracelessness, for the naturalism of Eakins' handling of flesh, the directness of his gaze; his model was no

gleaming white marble wrinkle-free ideal form, but a slender, rather thin contemporary girl who – the heap of clothes in the centre foreground made it clear – had taken off her clothes. She was a local teacher, called Nannie Williams, who worked in a House of Refuge for wayward girls. By painting an individual, Eakins was making a declaration of the rights of art, by revealing that allegory draws its only sustenance from reality, that without the model, the studio, the labour with hammer and chisel, there could be no ideal personification of the Schuylkill River, no statue to gladden the crowd at the water works in the city park. As in Vermeer's *Art of Painting*, or in Courbet's monumental *L'Atelier* of 1855, which he subtitled 'Une Allégorie réelle' (A Real Allegory),[102] Eakins was playing with art's own game of illusion, and his model occupies allegorical and literal space at one and the same time. She is personal and public in equal balance, a figure of naked Truth who is at the same time a real girl. But while Vermeer's temper is playful and light, Eakins was in deadly earnest. He researched the painting of William Rush thoroughly, documented it carefully, and did dozens of studies. There were still some old people alive who had known Rush when he kept his carver's shop in the city; he had run a flourishing business in ships' figureheads as well as figures for the booming city's civic amenities. But Eakins admired Rush above all because, he claimed, the Schuylkill River was carved from the life, and 'Rush chose for his model the daughter of his friend and colleague in the water committee, Mr James Vanuxem, an esteemed merchant.'[103]

Eakins probably made up the story of Louisa Vanuxem's nudity, in order to put a personal case. For Eakins, as professor of painting at the Philadelphia Academy for Fine Arts, was finding himself in an increasingly isolated position because he insisted that his students, whether men or women, should study from the life, male and female. He was impatient with the customary 'breech-clouts', which in his view provoked more ribaldry than full exposure, and would remove the loincloth from the model even in mixed classes. By maintaining that a respectable young woman of a Philadelphian family had posed in the nude for one of the city's founding fathers of art, a sculptor who had carved the portrait of George Washington, Eakins challenged his critics with historical precedent, and incidentally created another powerful painting of Truth in the tradition of self-defence.

But the example did not convince his detractors. In 1882, the mother of one of his pupils exploded:

Does it pay, for a young lady of refined, godly household to be urged as the only way of obtaining a true knowledge of true art, to enter a class where

every feeling of *maidenly* delicacy is violated, where she becomes so hardened to indelicate sights and words, so familiar with the persons of degraded women and the sight of nude males, that *no possible art* can restore her lost treasure of *chaste and delicate thoughts*? Where is the elevating ennobling influence of the beautiful art of painting in these studies?[104]

The scandal was inflamed by Eakins' own sister's husband, who revealed that students had posed for one another as well as for Eakins; the painter was forced to resign, in 1886. The experience marked him deeply: in the words of his friend and biographer, Lloyd Goodrich, afterwards 'he was always to some extent an outlaw in his own community'.[105] He began to identify even more profoundly with the earlier Philadelphian, William Rush. Like him, Rush had been neglected, misunderstood, set aside from the canon of American art, until Eakins had brought him back to public attention; not content with the unlikelihood that Rush, at the beginning of the century, had used life models, Eakins also dreamed that Rush had been stigmatized too. Thirty years after the first oil painting, he returned to the theme, and in one version turned the model around to face us for the first time in his *œuvre*, and, as Matisse was doing in his different way in France at the same time, he showed her fully naked, including her pubic hair, a part of women's secondary sexual characteristics which had been tacitly avoided in representation since the ancient Greeks depilated their bodies. 'There was nothing immoral in the sight of a nude figure', he had always maintained to his students.[106] As Anne Hollander writes, 'The Eakins painting – a public work commemorating an even more public work – is designed to celebrate the unassuming natural look of the female body, neither excessively erotic nor formally beautiful'.[107]

The historical models, Louisa Vanuxem and Nannie Williams, as river and fountain, remind us that even while the nude body symbolizes nature and its bounty, it belongs to an individual who goes about in the world in the customary way, with clothes, who finds it necessary to pose with a book rather than perch a wild waterfowl, 'known for its loud thumping cries',[108] on her shoulder; who in her nudity still belongs to the world of civilization which produces art and sculpture. Eakins' careful study of a work of art in the process of being made acknowledges that art is a construction, that the nude is used as a sign, but that the sign is inhabited by a real individual. It accepts that the allegorical female figure in art is a fantasy based on an assumed universal erotic longing, but seeks to broaden the figure's range of emotion; it dramatizes the problem that image-making as a form of speech can be a prisoner of

anthropomorphism, and struggles against the limits imposed by that convention and its traditional eroticization of the female nude, by asserting that the allegorical array of significations trailed by the naked woman in art cannot undo her personal existence as a sentient being in society.

Yet Eakins did not overturn one aspect of idealization; in spite of his realism, he was also smitten with the dream of classical pastoralism, for which the naked human body – of both sexes – was the pure conduit of innocent pleasure, and he constructed his *William Rush Carving* around the nude as a sign of nature. He painted other famous pictures, using youths and men to convey a similar pastoral bliss, in the *Arcadia* of *c*.1883, and *The Swimming Hole* of 1883–5. But his hankering for a return to a primitive state of goodness through the nude has strong conventional roots.

Allegorical nude figures conjure the ideal not only because we have inherited classical aesthetic humanism which applauds the human body's beauty; nor because, as human beings, we are granted intimations or memories of pleasure and even rapture in contact with nakedness, and know that the giving and taking of caresses can transform the ordinary humdrum envelope in which we have our being into something momentarily blissful. Nude allegories express the desirable and the good also because we cast our aspirations in images that transcend the limits of what we know and live. The condition of heroic nudity or Arcadian undress is not one many people have often experienced, however long artists and writers have celebrated it by using individuals as models. We apprehend it as in itself rare and different and largely unattainable, and we have traditionally projected it outside what we think of as civilization; finding it fitting that Maenads rampaging outside the city should go 'bare-limbed', that travellers from Pliny to Marco Polo to the Spanish conquistadores of the Americas should bring back tales of 'barbarians' and 'savages' going about with no clothes.

Nakedness characterizes the Other, and that Other, being *ipso facto* different from ourselves, escapes the constrictions of a dweller in the same streets. The naked female subject in art often expresses this ever-elusive other, residing outside the confines of our flawed and fallen world, in some natural and primal paradise for which nakedness can be a sign. Yet this conflation of nature and woman only continues the false perception that neither is inside culture, that women do not participate in it, let alone create it. The converse is true. Both – woman and nature – are essential parts of an indivisible civilization, which cannot continue

without them. Theodor Adorno, in a short piece of 1945, addresses this relegation of women to the category of nature and issues a trenchant reminder of its danger:

> The feminine character, and the ideal of femininity on which it is modelled, are products of masculine society. The image of undistorted nature arises only in distortion, as its opposite. Where it claims to be humane, masculine society imperiously breeds in woman its own corrective, and shows itself through this limitation implacably the master. The feminine character is a negative imprint of domination. But therefore equally bad. *Whatever is in the context of bourgeois delusion called nature, is merely the scar of social mutilation.* ... The lie consists not only in the claim that nature exists where it has been tolerated and adapted, but what passes for nature in civilization is by its very substance furthest from all nature, its own self-chosen object.... The liberation of nature would be to abolish its self-fabrication.[109] (Emphasis added.)

As the feminist artist Barbara Kruger succinctly put it in the slogan on one of her collages: 'We won't play nature to your culture.'[110]

The figure of naked Truth trails clouds of glory from nudity's ancient glorious sites – from infants, and liberated souls, the elect at the last trump and blissful Adam and Eve in Eden and wild creatures of nature – and her image assumes all the while the beholder's erotic appetite for a body like hers as if she were a love goddess. She very rarely commands the drama in which she takes part; she is raped or at least arrested, uncovered, done to rather than doing. She is 'a negative imprint of domination' whose own erotic drives do not matter, only those she excites. The nude lies on architraves, holds up portals, ministers to great achievers in the streets of cities from London to Vienna to New York, and we are rarely asked to care for what she is feeling, rather to feel better because of what she makes us feel.

A most interesting variant on the traditional opposition between culture and nature, clothes and nakedness, order and disorder, occurs in the earliest literary text that has come down to us, the Babylonian epic of Gilgamesh.[111] The seduction of the wild man Enkidu at the beginning of the poem foreshadows the familiar theme of redemptive eros in Western thought, but it also introduces a revolutionary concept, that the sexuality of woman – not her love or her virtue – is a force for civilization. Pandora, Helen, Eve occupy a special place through their beauty which, like works of art, redounds to the credit of the culture to which they belong; but they are also seen to endanger mankind. In *William Rush Carving*, Eakins reminds us that the model belongs to the urban world, but she also stands for an ideal pastorale, according to a long-

established convention. It is very unusual indeed to find the naked woman and her desirability aligned with city culture, law and progress, to find her standing for the centre, and holding it, and a man consigned to the wild and the place of the Other. But an ancient instance reveals that it is imaginatively possible.

The poem relates how Gilgamesh, the pre-eminent hero whom none can overthrow in arms, in running amok in Uruk, his kingdom. That civilization is chiefly embodied in the families dwelling in the city, and they are devastated by his excesses: 'No son is left with his father. ... His lust leaves no virgin to her lover, neither the warrior's daughter nor the wife of the noble.'[112] So the people pray to the sky god and he and his fellow gods then turn to Aruru, goddess of creation, to distract Gilgamesh from Uruk. She does so, by fashioning a man: 'She dipped her hands in water and pinched off clay, she let it fall in the wilderness, and noble Enkidu was created.'[113] Like Adam, he is of the earth, and he belongs to the wilds: 'His body was rough, he had long hair like a woman's.... His body was covered with matted hair like Samuqan's, the god of cattle. He was innocent of mankind; he knew nothing of the cultivated land.'[114] Again like the first parents of Judaeo-Christianity, he is at one with the beasts; he even eats grass and drinks at their water-holes, thus exceeding even the primordial innocence in Eden. A trapper out in the hills catches sight of Enkidu and is terrified. He seeks advice from his 'father' and is told to go to Gilgamesh: 'Ask him to give you a harlot, a wanton from the temple of love; return with her, and let her woman's power overpower this man.'[115] Gilgamesh, on meeting the trapper, gives him clear instructions: 'Trapper, go back, take with you a harlot, a child of pleasure. At the drinking-hole she will strip, and when he sees her beckoning he will embrace her.' Then, says Gilgamesh, the beasts will reject him.[116]

'The child of pleasure' sits by the water, and takes off all her clothes as she has been told to do. When Enkidu, coming down with the wild animals, sees her, he is filled with 'eagerness'. They spend six days and seven nights together, the poet says, and when Enkidu has had enough of her 'woman's art', he tries to rejoin the beasts. But they flee him now. Nor is he any longer preternaturally strong, but has become weak, because 'wisdom was in him, and the thoughts of a man were in his heart'.[117] Then the woman instructs him in the life of the city, in civilization: she tells him Gilgamesh is a great king, that city men and women there smell sweet and are dressed in 'gorgeous robes'[118] and sleep in beds instead of on the ground ('the bed of a shepherd').[119] Enkidu listens to her 'good advice' with care. He accepts her division of

her own clothes to dress him and eats the food she puts in front of him. It is bread and wine, the fruits of civilization. He even learns table manners too. Then he rubs down his body and anoints himself.

'Enkidu had become a man,' declares the text. 'When he had put on man's clothing he appeared like a bridegroom.'[120]

He is ready to enter the city and confront its king, whose boon companion he is to become. When Gilgamesh meets Enkidu in combat, the King realizes that he has met his match; Enkidu brings to an end the era of his abuses, and they embrace as friends. With the wild man tamed, the city's ruler regenerated, order is restored in Uruk.[121] The instrument of this peace is a woman. She has no name in a poem studded with names, often repeated over and over; she is told what to do, and we are not told what happens to her after the encounter with Enkidu. So she herself is not an unambiguous symbol of female autonomy at all. She is the embodiment of the principle of eros. But it is perceived in the poem as an art belonging to culture, and important if not vital to sustaining civilization. Through her, Enkidu learns human sexuality, which here, in distinction from Genesis, means that he grows in stature rather than falls.

This ancient poem casts a hierodule, a temple prostitute, as the agent of tranquillity in Uruk; through the initiation of Enkidu, sexual awareness becomes proleptically synonymous with human civilization, mediated through the woman who 'made herself naked and welcomed his eagerness' and then told him, 'You are wise, Enkidu, and now you have become like a god.'[122] In a less approving spirit Yahweh echoes this, after Adam and Eve eat the apple, when he declares, 'See, the man has become like one of us, with his knowledge of good and evil' (Gen. 3:22). He then throws the first couple into the world of work and sex and death, tilling and reaping, out of the wild garden where everything grew without cultivation, into the human society as we still experience it.

Pandora's advent similarly inaugurates human society, as we have seen, for with her beauty and its effect on Epimetheus, the economic unit of marriage is established, however much it may disgust Hesiod. Again, in the myth he tells so rancorously, a woman's sexuality lies at the origin of social institutions. The epic of Gilgamesh differs of course fundamentally from the accounts of the Fall in Genesis and Hesiod because the woman who tames Enkidu is not cast as symbolic of nature at all; she is truly city-dwelling and city-bred. In Christian commentaries on Genesis, the primeval mother is almost always blamed for prevailing over Adam through her physical charms, and her sentence to physical

and biological suffering is therefore considered condign punishment. ('You shall give birth to your children in pain.') Only a dissident Romantic like Schiller could reflect magnificently that the Fall, like the initiation of Enkidu, started a new era of consciousness beyond the limits of the 'natural' life of Eden:

> As soon as his [Adam's] reason realized its initial powers, he spurned nature and her protective arms – or, better said: at the behest of an instinct which he himself did not even recognize, and unconscious of the act he performed at that moment, he tore himself free from the benevolent ties which bound him, and with an as-yet-weak reason, accompanied only from afar by the instincts, flung himself into the wild play of life and set forth on the treacherous path to moral freedom.[123]

Schiller forgets to include Eve in this tribute, but she too has her part to play in the break with the seamless past into the new, accidented era of event and awareness. And it is a part which effectively places her (and Adam) on the side of culture, in spite of the curse of the biblical Yahweh. This represents a dazzling reversal of the myth's usual import, but one which it is capable of making.

EPILOGUE

The Eyes of Tiresias

Je suis un homme complet, ayant les deux sexes de l'esprit.

JULES MICHELET[1]

Circe, the goddess with powers to change men's shape and see all things, knew that Tiresias was a great prophet. She told Odysseus, whom she loved, to seek him out first of all the shades he would encounter in the Underworld, because Tiresias alone, in all that crowd of the dead, still had his 'mind to reason with'.[2] So sentient is Tiresias, even in death, that he comes up to Odysseus and recognizes him and calls him by name before he has drunk the black blood of the sacrifice; even Odysseus' own mother cannot accomplish this, but must drink deep before her ghost can see her son for himself.[3]

Tiresias was Pindar's 'prophet of truth',[4] and he was credited with a special knowledge of sex. It was he who revealed to Oedipus that he was committing incest.[5] His carnal wisdom came when, as a child, he saw snakes coupling, and hit one with a stick and killed it. It was the female, and Tiresias, voyeur and murderer, was turned on the instant into a woman, as his punishment for sexual knowledge. In this new shape, the prophet continued to practise his expertise, and had a certain success in Thebes, as a prostitute. Seven years later, he again came across snakes intertwined as they mated, and again he smote. This time the male writhed under the prophet's blow and died.

The curse on Tiresias was revoked, and he became a man again, and the only person to have lived both as a man and as a woman, and to return to tell the tale.[6] T.S. Eliot called upon him as his *alter ego* in *The Waste Land*:

> Throbbing between two lives
> Old man with wrinkled female breasts....

Tiresias supplies visions of other people's intimacies:

> (And I Tiresias have foresuffered all,
> Enacted on this same divan or bed.)[7]

In the ancient story, the sexual pleasure of woman was all the wise man Tiresias was asked about. This is a shame, as Tiresias, who was in Circe's view and in Odysseus' experience so far-seeing, had known sexual difference from both sides of the divide, and could illuminate its wider implications for us today. But his gender seems to have remained male; at least the mythographers do not allow him to abandon his loyalties to the masculine sex. For all they tell us, all the answers they give us add up to an after-dinner joke: that when Hera reproached Zeus with his endless philandering, he defended himself by saying that women had much more pleasure than men anyway, so he had to compensate for the deficiency – quantity for quality; that Hera then protested, in her conventional character of nagging wife, and Tiresias, who knew, was consulted. He then declared,

> If the parts of love-pleasure be counted as ten,
> Thrice three go to women, one only to men.

Hera blinded him instantly for giving away women's secrets, but Zeus as a sop gave him the power to see the future, and a life span of preternatural length – seven generations.[8]

Tiresias' verdict was prophetic; in Emily Dickinson's words, he told the truth but told it slant. Not in its superficial import (the veracity of that is not worth discussing, since who is to say?), but in its expression of a man's unease about women, and its attempt to answer our unquiet curiosity about the feelings of the opposite sex. Tiresias' utterance is a fiction to lay to rest a perennial conundrum that troubles lovers of both sexes: What is it like for the other? What was it like for mother? What it is like for her? What is it like for me? Where did I find my origin? Tiresias' reply fails to soothe, and in the attempt to do so, it reveals truthfully the anxiety and the envy and the anger about female sexuality which have persisted for so long.

It is striking that the being of a woman, sited in her physical body with its different secondary sexual characteristics, has beckoned to men and women with equal lure; when women break their silence, they so often write of women. Virginia Woolf, who so rightly argued for the androgynous and protean mind of the writer, and wrote a version of the Tiresias myth in *Orlando*, is more interested in Mrs Ramsay and Mrs Dalloway than in Mr Ramsay or Mr Dalloway. Women's magazines print pictures of women on their covers; so do men's, while experiments

in male pin-ups, reifying the male body as the female has been, appeal to women less than to homosexuals.

But the changing representation of woman in text and image circles around the unanswered question, What is she? And, like a magnet twitching back from its like pole, it can never come to rest with an unchanging definition. The female form metamorphoses from one sign into another, and this flux of signs, each succeeding generation's variations on the ancient topic, is accepted as a sequence of statements of the truth. The body is still the map on which we mark our meanings; it is chief among metaphors used to see and present ourselves, and in the contemporary profusion of imagery, from news photography to advertising to fanzines to pornography, the female body recurs more frequently than any other: men often appear as themselves, as individuals, but women attest the identity and value of someone or something else, and the beholder's reaction is necessary to complete their meaning, to find the pin-up sexy, to desire the product the housewife poses to vaunt. Meanings of all kinds flow through the figures of women, and they often do not include who she herself is.

Adrian Stokes, in his expressive *Reflections on the Nude* (1967)[9] made a ringing plea for a return to the whole body as the sign of a recovered humanism:

> The human body . . . [he wrote] is a promise of sanity. Throughout history the totality of the nude may rarely have shone, yet the potential power will have made itself deeply felt. . . . The respect thus founded for the general body is the seal upon our respect for other human beings as such (and even for consistently objective attitudes to things as such); an important factor, therefore, in regard not only to respect for but to tolerance and benevolence.[10]

He makes us want to believe him, to find a way back to the high neoplatonism of the Florentine thinkers and artists who acknowledged human potential in the celebration of the body's beauty, in Botticelli's *Venus*, in Donatello's *David*. Surrounded as we are by the contemporary record of damage to the bodies that are the vessels of human life, Stokes's credo that the integrity of the body assumes the integrity of the spirit stands as an urgent prayer for life against death, for wholeness against disintegration.

But appealing as his faith is, Stokes was whistling in the dark; and the projection of meaning upon the female form, naked or semi-naked, has been contaminated, perhaps beyond all medicine. Could the wider range of significance be regained? Even the male, formerly free to portray individual nobility, has now fallen to pornography and advertising ap-

propriations; narrow sexual graphism has dulled his resonance too. Milan Kundera sharply satirized the contemporary state of allegorical nudity and made nonsense of any high claims on its behalf in his novel *The Joke* when he described a scene in a Czech prison where Cenek, an artist, has been at work:

> Cenek took up a position in front of the picture ... and gave us a talk that went something like this: Now, here to the right of our sergeant, that's Alena, the first woman I ever had. I ... I've painted her the way she looked at the time; you can be sure she's gone downhill since ... this one is Lojzka, I was much more experienced by the time I got to her, she had small breasts (he pointed to them), long legs (he pointed to them) and very pretty features (he pointed to them).... And this is our model from live drawing class, I knew her inside out; we all did, all twenty of us....
>
> Cenek was obviously hitting his stride, but ... in walked the boy commander and up we jumped ... he barked out at Cenek, What is the meaning of this? Cenek broke ranks and planted himself in front of the picture: Here we have an allegorical representation of the significance of the Red Army for the struggle currently engaged in by our nation, he declaimed. Here (he pointed to the sergeant) we see the Red Army, and flanking the Red Army (he pointed to the officer's wife) the working class and (he pointed to his schoolmate) the revolutionary month of February. Now these (he pointed to the other ladies in turn) are symbolic of liberty, victory, and equality, and here (he pointed to the officer's wife displaying her hindquarters) we find the bourgeoisie making its exit from the stage of history.[11]

Can the allegorical figure, nude or other, be recuperated? Perhaps. It would be more than a pity if radical feminists' restrictions erected such a barrier against the image of women's bodies that any attempt became a transgression, and another quagmire of guilt was formed to stifle expression for men and women. In our use of the female as sign, in text and image, we need to generate a philosophy of possibilities, not reaction; to adapt the convergence of linguistic gender and the feminine to expand our consciousness of one another, and an understanding of the female, not limit the areas of search, experiment and inquiry. Paula Modersohn-Becker, for instance, in her painting *Sixth Wedding Anniversary* of 1906, revealed herself with sensitivity and challenging candour, naked in her glass, as representative of motherhood.[12]

That broadening can come only through the creative energy of imaginative empathy, to draw us into the subject of a figure, make us feel inside the body on whose exterior we have until now scribbled the meanings we wanted. From inside the head of Liberty, we can see now that she can only represent an American ideal through a series of for-

gettings; to accept her as a representative of freedom we must forget the place of women themselves, the history of the female condition.

We are living through a time of extraordinary female energy, and much of its prodigal imagination and intelligence is attempting to re-constitute, re-member that body which has been exploited and violated again and again for this cause and that cause, for politics and propaganda and pleasure, and dismembered to shape up to imposed signification.

As Hélène Cixous has so passionately written:

> Her 'own' house, her body itself, she has not been able to inhabit. It is possible of course to imprison her, to ... bring off for too long a time this triumph of Apartheid – but only for a time. It is possible to teach her as soon as she begins to talk, and at the same time as she learns her name, that her region is dark. . . .Darkness is dangerous. In darkness you cannot see, you are afraid. Don't move because you might fall down. Above all don't go into the forest. And we have interiorised the dread of darkness. She has no eyes for herself. She has never explored her house. Her genitals appal her still today. She has not dared take pleasure in her body, which has been colon-ised.[13]

But the monuments, as William Gass wrote, are for rent, and the myths are acquiring new tellers for new listeners. Women now, in fiction, poetry, painting and sculpture, performance, dance, drama, have claimed squatter's rights to the public signs which have predicated their meaning on the female form, and they are reclaiming the female body as a private habitation in which we have all dwelt at one time, but where women have always had our being.

We do not have to be female to possess this imaginative power. Men and women can become Tiresias; we do not need his unique vision to discover the female form from the inside; the experience can now be spoken by those who know, communicated to those who do not and imagined by both, just as Shakespeare, and George Eliot and Henry James and Edith Wharton and Willa Cather were able in their fiction to create heroes and heroines, male and female protagonists, lovers, mothers and fathers. Biological sex cannot be the ring-fence in which the imag-ination lies wingless. Writers cleared it before painters; but visual repre-sentation, sculpted and painted, has continued to reify women in a manner some writers of fiction overcame some time ago, and mass communication of imagery has reinforced its limited code. As Matisse said in 1953, we live in an age 'when a flood of ready-made images . . . are to the eye what prejudices are to the mind'.[14] But our vision is at last unclouding, and our ears are becoming unstopped and we are learn-

ing to see through the subject with her eyes and respect the individual inside the symbol. They have begun to speak from within, so many fantasy figures, Pandora and Eve and Tuccia and Liberty and Athena and the other virgins, Justice and Temperance, and Lady Wisdom and naked Truth. Their voices are hoarse from long disuse, but they are gaining in volume and pitch and tone, they come to us from a long distance (their journey has been going on for more than two thousand years), and their limbs take time to move to the rhythm rising within, they have been subjected for so long. And they are saying, Listen.

NOTES

BIBLIOGRAPHY AND REFERENCES

ABBREVIATIONS

AB	*The Art Bulletin*
AD	*Architectural Digest*
Annales ESC	*Annales Economies Sociétés Civilisations*
ARSC	*Actes de la recherche en sciences sociales*
AV	*The King James Authorized Version of the Bible*
BJES	*British Journal for Eighteenth-Century Studies*
BM	British Museum, London
BN	Bibliothèque Nationale, Paris
DAGM	*Dictionnaire des antiquités grecques et romaines*, ed. Ch. Daremberg, E. Saglio and E. Pottier
HWJ	*History Workshop Journal*
JCH	*Journal of Contemporary History*
JEGP	*Journal of English and Germanic Philology*
JHS	*Journal of Hellenic Studies*
JRSA	*Journal of the Royal Society of Arts*
JWCI	*Journal of the Warburg and Courtauld Institutes*
LNHA	*Ecole du Louvre, notices d'histoire de l'art*
LRB	*London Review of Books*
MMA	Metropolitan Museum of Art, New York
NCE	*New Catholic Encyclopedia*, Washington, DC, 1967-78
NGL	National Gallery of Art, London
NGW	National Gallery of Art, Washington, DC
PC	Penguin Classic
PGGM	*Petits Guides des grands musées*
PGMP	J. Paul Getty Museum Publication
PL	*Patrologia Latina*, ed. J-P. Migne, Paris, 1844-55
RA	The Royal Academy of Arts, London
RAIN	*Royal Anthropological Institute News*
Scivias	Hildegard of Bingen, *Scivias*, ed. Adelgundis Führkötter and Angela Carlevaris, Corpus Christianorum, 43, 43A, 2 vols. (43 = 1, 43A = 2), Turnholt, 1978

TLS	*Times Literary Supplement*
VA	Victoria and Albert Museum, London
WPA	Works Progress Administration

NOTES

Full references are given in the bibliography; if more than one work by an author has been consulted, the date is given of the edition used, which is not always the same as the original edition. Page references to Homer are to Rieu's translations of the *Iliad* and the *Odyssey* in Penguin Classics, though I also consulted Richmond Lattimore's. Biblical references are to the translation in the Jerusalem Bible (London 1966), except where specified, in the interest of clarity.

EPIGRAPHS

1. Seamus Heaney, 'Station Island', IX, p. 86, in *Station Island* (London, 1984).

2. Artemidorus, *Oneirocritica*, 2.45, quoted by Zeitlin (1981), Foley ed., p. 203.

FOREWORD

1. On allegory, I am indebted to Fletcher; Gombrich (1971, 1972); Bloomfield (1970), pp. 251ff.; Rollinson; Murrin; Dronke (1974).

2. Trans. Patricia Matsen, 'From Spengel: "*Rhetores Graeci*"', in Rollinson, pp. 111-12.

3. Fletcher, p. 23.

4. Plato, *Republic*, p. 455.

PART ONE

1. Walter Benjamin, 'Zentralpark' (1939-40), in *Gesammelte Schriften*, Rolf Thiedemann and Hermann Schweppenhauser eds (Frankfurt, 1972ff.), vol. I, pt. 2, p. 660, in Werckmeister, p. 120.

CHAPTER ONE

1. Kafka, p. 13.

2. The best book on the Statue of Liberty is Trachtenburg, but the centenary, 1986, will inevitably see a crop of new ones.

The dimensions of the statue are:

from base to torch 151' 1"; from foundation of pedestal to torch, 305' 1"; her index finger is 8' long, her eyes 2' 6" wide; the total weight of the statue 225 tons.

3. See Taft, pp. 37-53, for Greenough's *Washington*. One critic captioned the statue, with its pointing arms: 'My body is in Mount Vernon, my clothes are in the Patent Office.' Bartholdi's draped figure recalls some mid-century representations, like Soitoux's 1849 *République* which stood outside the Institut, Paris from 1880.

4. Gombrich (1965), p. 35.

5. Robin Middleton, 'Vive l'Ecole', in Middleton, 1975, p. 47; Trachtenburg, pp. 41-56.

6. Mosse, p. 175; see Trachtenburg, pp. 84-5 on other colossi.

7. *The Statue of Liberty* (Las Vegas, 1979), p. 15.

8. Pietro Bellasi, 'Gulliver e noi', in *Prometeo*, pp. 40-1.

9. Oldenburg, p. 30.

10. For some of Oldenburg's other colossal projects, see Johnson. The builder's trowel is in the garden of the Kröller-Muller Museum, Holland.

11. Lippard, p. 144.

12. Agulhon (1981), p. 57.

13. Ibid., p. 57, quoting Charles Duveyrier Bénichou, *Le Temps des prophètes* (Paris, 1877), pp. 431-3; see also Taylor, pp. 168-9.

14. Trachtenburg, p. 59.

15. Ibid., p. 60.

16. Emma Lazarus, 'The New Colossus', in Dan Vogel, *Emma Lazarus*, pp. 158-9.

17. Thelma Nason, *Our Statue of Liberty* (Chicago, 1969), p. 4.

18. Natalie Miller, *The Story of the Statue of Liberty* (Cornerstones of Freedom, Chicago, 1965).

19. There was an Iranian protest at the deposed Shah's presence in the USA in 1979; a bomb exploded at the base in 1980.

20. William Gass, 'Monument/Mentality'. *Oppositions*, p. 138.

21. John Arbuthnot, 'Law is a Bottomless Pit ...', London, 1712. The down-home wisdom of Uncle Sam was developed by the journalist Seba Smith (d. 1868), who invented a character called 'Major Jack Downing', a fountainhead of political sagacity and Yankee humour. 'Downing' was much copied by other journalists and cartoonists and his patriotic costume became Uncle Sam's. Uncle Sam replaced 'Brother Jonathan' in popularity. According to legend, George Washington, finding none of his counsellors could suggest how more ammunition might be obtained, said, 'We must consult Brother Jonathan', meaning the Governor of Connecticut, Jonathan Trumbull. The phrase entered the language, and Brother Jonathan came to represent the whole genus of commonsensical, resourceful, independent Americans. See *The Oxford Companion to American Literature* (New York, 1983), pp. 102, 700-1, 780; and Surel.

22. '*The President's March' A New Federal Song*. Songsheet (Philadelphia, 1798). Composed by Philip Phile, words by Joseph Hopkinson, in Rabson, pp. 88-9. Cf. 'Star of Columbia', in *A Treasury of American Song* (New York, 1943), written by Timothy Dwight (1752-1817):

> Columbia, Columbia, to glory arise
> The queen of the world
> and the child of the skies....
> Be freedom and science and virtue
> thy fame.

23. Emma Goldman, *Living My Life*, 2 vols. (New York, 1932), I, p. 11. Quoted Forster, p. 284.

24. Nicholas Gage, *Eleni* (London, 1983), p. 140.

25. See *Superman - From the Thirties to the*

Seventies, E. Nelson Bridwell ed. (London, 1979), pp. 9–10.

26. See Peter Carlson, 'Miss Liberty; Restorers place Her under Intensive Care', in *Pan Am Clipper*, May 1984; Marcy Heidish, 'The Grande Dame of the Harbour', *Geo*, July 1984.

27. Trachtenburg, pp. 189–93; 'That Liberty shall not perish', poster by Joseph Pennell, for the Fourth Liberty Loan, 1918, (Pl. 4). Half a million copies were distributed. Pennell wrote a short book about the poster, published in 1919; Darracott and Loftus, pp. 47, 67.

28. Taft, pp. 72–7; *We, the People*, p. 54; Crawford's statue is reproduced in *Rush*, p. 66; for allegories of America in general, see Honour (1975).

29. *WPA Guide to New York*, p. 101.

30. For Saint-Gaudens, see Dryfhout; and Taft, pp. 279–309.

CHAPTER TWO

1. Chevalier de Jaucourt, 'Peinture', in the *Grande Encyclopédie* (Geneva, 1778–9), vol. XXV, quoted Leith, pp. 120–1: 'Ceux qui ont gouverné les peuples dans tous les temps ont toujours fait usage des peintures et statues, pour mieux inspirer les sentiments qu'ils vouloient leur donner, soit en religion, soit en politique.'

2. Charles Blanc, *Grammaire des arts du dessin* (Paris, 1867), p. 352: 'L'indifférence d'une nation en matière de sculpture accuse un vice dans l'éducation publique. Là où on dédaigne le culte de la beauté, on ne saurait aimer la philosophie, car l'amour de la forme est une condition de sagesse.'

3. Baudelaire, 'Salon de 1859', p. 419:

Vous traversez une grande ville vieillie dans la civilisation, une de celles qui contiennent les archives les plus importantes de la vie universelle, et vos yeux sont tirés en haut, *sursum, ad sidera*; car sur les places publiques, aux angles des carrefours, des personnages immobiles, plus grands que ceux qui passent à leurs pieds, vous racontent dans un langage muet les pompeuses légendes de la gloire, de la guerre, de la science et du martyre.... Fussiez-vous le plus insouciant des hommes, le plus malheureux ou le plus vil, mendiant ou banquier, le fantôme de pierre s'empare de vous pendant quelques minutes, et vous commande, au nom du passé, de penser aux choses qui ne sont pas de la terre.

Tel est le rôle divin de la sculpture.

4. P. Vidal-Naquet, *Le Chasseur noir* (Paris, 1981), p. 14.

5. It would be difficult to give full sources for this chapter, as I have visited Paris regularly since I was a child, but I have especially consulted: Hillairet; Kjellberg; Lucas; Biver; Pinkney; Lami; *Le Guide de Paris*; Agulhon (1981); Rearick; Middleton, 1975.

6. Musil, pp. 87–93. I am most grateful to Alfred and Reni Brendel for bringing the essay to my attention and translating it:

... das Auffallendste an Denkmälern ist nämlich, dass man sie nicht bemerkt. Es gibt nichts auf der Welt, was so unsichtbar wäre wie Denkmäler. Sie werden doch zweifellos aufgestellt, um gesehen zu werden, ja geradezu, um die Aufmerksamkeit zu erregen; aber gleichzeitig sind sie durch irgend etwas gegen Aufmerksamkeit imprägniert, und diese rinnt Wassertropfen-auf-Oelbezug-artig

an ihnen ab, ohne auch nur einen Augenblick stehenzubleiben.... Sie verscheuchen geradezu das, was sie anziehen sollten. Man kann nicht sagen, wir bemerkten sie nicht; man müsste sagen, sie entmerken uns, sie entziehen sich unseren Sinnen.... Was aber trotzdem immer unverständlicher wird, je länger man nachdenkt, ist die Frage, weshalb dann, wenn die Dinge so liegen, gerade grossen Männern Denkmale gesetzt werden? Es scheint eine ganz ausgesuchte Bosheit zu sein. Da man ihnen im Leben nicht mehr schaden kann, stürzt man sie gleichsam mit einem Gedenkstein un den Hals, ins Meer des Vergessens.

7. Antoine Houdon contributed the statue of Themis, on the left; Philippe Roland the copy of the Minerva Giustiniani, on the right. The bas-reliefs are by François Rude and James Pradier.

8. In Alain Chartier's Le Quadriloque invectif (1422), France is one of the speakers. Droz ed. (Paris, 1923).

9. Annie Scottez, 'Gustave Michel', in Carpeaux à Matisse, pp. 266–70.

10. Marcel Proust, A la recherche du temps perdu (Paris, 1954), vol. I, p. 230.

11. The sculptor is Armand Martial. Kjellberg, p. 86.

12. Hillairet, vol. I, p. 579.

13. La Révolution française, p. 153.

14. Ibid., p. 38.

15. Hillairet, vol. I, p. 419.

16. Mosse, p. 170; see Victor Hugo, 'En passant dans la Place Louis XV', in Les Rayons et les ombres (1840) (Paris, 1950), pp. 229–30.

17. Beaulieu (1980).

18. Hôtel de Ville, passim.

19. Kundera (1982), p. 3.

20. Vitruvius, De Architectura, i.4. 8–15, 11, quoted Plommer, p. 97.

21. The Wallace fountains, of which there are 48 in Paris, were given to the city by Sir Richard Wallace, of the Wallace Collection in London, in 1872. They were made after a design by Charles Lebourg, a pupil of François Rude, and show the direct influence of Germain Pilon's Three Graces, now in the Louvre. The four figures represent Simplicity, Goodness, Sobriety and Charity. Kjellberg, p. 40.

22. J.-L.-C. Garnier, p. 59, describes his aims and principles: the Opéra was designed to display living women as well as sculpted ones: 'Dans un grand théâtre il ne faut pas d'indécision sur la route à suivre à l'entrée et à la sortie, et il est nécessaire que le motif utile par excellence soit aussi un motif artistique qui prédispose déjà aux splendeurs de la mise en scène et au brillant chatoiement de la toilette des femmes.'

23. Aristotle, Metaphysics, quoted Wheelwright, p. 8.

CHAPTER THREE

1. B. Anderson, p. 19.

2. Sun, 9 June, 1983. For Mrs Thatcher's prime ministership, see Hall and Jacques; Seabrook and Blackwell; and especially Barnett.

3. News of the World, 12 June 1983.

4. 3 April, Barnett, p. 19.

5. Sunday Times, 13 June 1982, quoted Barnett, p. 135; in February 1984, Mrs Thatcher called herself the Iron Lady in eastern Europe itself, in Budapest. Observer, 5 February 1984.

6. 3 July 1982, speech to Conservative rally at Cheltenham racecourse, Conservative Central Office News Service, quoted Barnett, pp. 150–3.

7. *The Times*, 27 September 1983.
8. *Guardian*, 6 June 1983.
9. Yates (1975), passim; see also Berge-ron, pp. 11-64, 125-39; Robin Head-lam Wells, *Spenser's Faerie Queene and the Cult of Elizabeth* (Canterbury, 1983).
10. Geertz (1977), p. 157. I am grateful to Sylvia Rodgers for letting me see her paper on Mrs Thatcher's charisma, written in 1979.
11. 12 June 1983: e.g. *Observer* (Trog); *Sunday Times* (Scarfe); *Sunday Mirror* (John Walsh).
12. Geertz (1977), p. 151.
13. Ibid.
14. Cannadine, p. 160.
15. Geertz (1977), p. 153.
16. The Queen has actually suffered from this confusion. I have heard children transfer their dislike of Mrs Thatcher to her by mistake.
17. Read, p. 369. A very few cartoons as-similated Victoria with Britannia, but never as the dynamic power of Britain. One example, criticizing the Queen's prolonged seclusion after Albert's death, shows a vacated throne, draped with the symbols of sovereignty, and the caption 'Where's Britannia?' *Punch*, 1867, repro. in Wynn-Jones, p. 115.
18. *Sunday Times*, 20 July 1982.
19. Ibid., 19 September 1983.
20. For Britannia on coins, see Bass (I am very grateful to Graham Dyer of the Royal Mint for sending me his arti-cles); also, Grant (1958); Jocelyn M.C. Toynbee, *The Hadrianic School* (Cam-bridge, 1934), pp. 53-65, pl. XII; Bradley.
21. Samuel Pepys, *Diary*, 25 February 1667.
22. Erim.
23. During the reign of Hadrian's succes-sor Antoninus Pius (138-161) Britan-nia was still shown seated but turned profile, and carried a standard. The Ancient Briton's spike in the centre of her shield was later abandoned, and she was draped in a more familiar Roman style, like a Tyche or spirit of the place. Commodus' bronze medal-lion of 185 followed this iconography. See Addison, pp. 128-9.
24. See Bergeron, pp. 144 ff., 172 ff. for various patriotic naval pageants.
25. Thomson (1860), vol. II, pp. 250-1.
26. Sir Nicholas Harris, 'Memoir of Thomson', ibid., I, pp. xc-xci. Thom-son also wrote a longer 'Britannia, A Poem', in 1729 (Oxford, 1935), which pictures the 'Queen of Nations' weep-ing at her degenerate sons, and ends with a beautiful hymn to peace.
27. In 1714, George I had several medals struck for distribution to supporters showing him being crowned by a proud Britannia, who is even some-times accompanied by Liberty with her bonnet to demonstrate both the freedom the new Hanoverian king will ensure, and the spirit in which his accession has taken place. James Stuart, the Old Pretender (1688-1766), struck a contrary medal in 1721 in support of his cause, showing Britannia grief-stricken as the lion and the unicorn are trampled by the House of Hanover, while refugees flee from London in the distance. I am most grateful to Mark Jones for showing me these examples in the BM Coins and Medals collec-tions. See Colley, for an incisive account of the monarch's rise as a na-tional figurehead.
28. Grego, p. 141; cf. another Rowland-son cartoon, more polite to the King, which nevertheless makes several dis-tinctions clear as it shows 'Female Patriotism' (Georgiana) being pre-sented to Britannia by Liberty and Fame.
29. T. Wright, p. 157; cf. cartoon of 1793, showing William Pitt steering Britan-nia in a state of alarm through

turbulent straits flowing between the Rock of Democracy on the one hand - a fearsome crag topped by the Liberty cap of the French Revolutionaries - and the Whirlpool of Arbitrary Power on the other. Ibid., pp. 168-9.

30. Wardroper, p. 83.

31. The monument to the Duke of Argyll (1748) shows Britannia helmeted and plumed, with Athena's aegis and the Gorgon's head; on Sir Peter Warren's (1753) she is closer to a goddess of abundance, except that the British flag appears on her shield. Britannia also appears on John Bacon the Elder's monument to Sir George Pococke (c. 1792) (a sketch model in VA); Field Marshal Lord Clyde's memorial, in Waterloo Place, London, SW1, by one of Queen Victoria's favourite artists, Baron Marochetti (1867), shows Britannia riding a lion.

32. Trachtenburg, p. 92.

33. *Britannia* was first used in the Royal Navy for a 100-gun ship of 1682. I am indebted to D.A. Tull of the Department of Ships and Antiquities at the Royal Maritime Museum, Greenwich, for his detailed research.

34. See *Stamps of the British Empire*.

35. Ibid.

36. Read, p. 59.

37. Cowper, 'Boadicea, An Ode' in *The Poems of William Cowper*, John D. Baird and Charles Ryskamp eds. (Oxford, 1980), I, pp. 431-2.

38. V.G. Kiernan, LRB, 15 October 1981.

39. Tacitus, *The Annals*, XIV, vol. I, 31-7, pp. 370-7; *The Life of Agricola*, XV-XVI, pp. 360-1.

40. Dio Cassius, *Roman History*, 42, vol. 8, pp. 84-105.

41. Kightly, p. 39.

42. Milton, *History of Britain*, in *The Complete Prose Works* (New Haven, 1971), 5, pp. 76 ff.

43. Tennyson, 'Boadicea', lines 3-7, 47-52; Ricks ed., pp. 1118-23.

44. See *Nos ancêtres les Gaulois*, esp. Pingeot, pp. 255-75, and pls. ff.; for Arthurianism in Britain, see Girouard.

45. Gavin Ewart ed., *Other People's Clerihews* (Oxford, 1983), p. 11.

46. *Sunday Times*, 23 January 1983.

47. *Mail on Sunday*, 12 June 1983, photograph by Herbie Knott.

48. I am grateful to Mandy Merck for giving me various cuttings which illustrated the perceptions of Mrs Thatcher in the press, including a speech by Christopher Brocklebank-Fowler, MP, calling her a nanny, and a cartoon by Scarfe showing her doling out medicine.

49. *Observer*, 12 June 1983.

50. Barnett, pp. 71-2.

51. *Observer*, 5 June 1983.

52. Read, pp. 371-9.

53. Read, pp. 382-6; Beattie, pp. 222-4, 379-87.

54. Beattie, pp. 2-8; Physick, pp. 76-9.

55. See Geertz (1977), p. 171.

56. For Greenham, see Blackwood; Harford and Hopkins; Cook and Kirk; and Lynne Jones, 'On Common Ground: The Women's Peace Camp at Greenham Common', in Lynne Jones.

57. Author's visit, March 1983; see also 'Women for Peace', special issue of *Feminist Art News* (FAN), vol. 2, no. 1.

58. See Daly (1979), pp. 400-3, for development of weaving and spinning metaphors as fundamental to an essentialist feminism; and Daly (1984), passim, for her revival of 'webster' as a counterpart to 'spinster' as a positive name for a woman.

59. Cf. Geertz (1977), p. 168.

60. Scene in *Carry Greenham Home*, 1984.

61. *The Times*, 13 August 1984.

62. Compare the dread expressed in women's testimonies in Cook and Kirk, e.g. Wendy's statement pp. 20-1,

with the 1649 confession of Abiezer Coppe, a Ranter, quoted in Cohn, p. 320. See also Christopher Hill, *The*

World Turned Upside Down; Radical Ideas during the English Revolution (New York, 1972).

PART TWO

1. Barthes, 'Myth Today' (1972), pp. 155-6 (translation slightly adapted).

CHAPTER FOUR

1. Addison, p. 36. I am grateful to Nicholas Penny for pointing out this discussion to me.
2. Plato, *Timaeus*, 10.42, p. 57.
3. Ibid., p. 58.
4. Methodius, p. 113.
5. See Aristotle: 'A woman is as it were an infertile male; the female, in fact, is female on account of inability of a sort, viz. it lacks the power to concoct semen ... because of the coldness of its nature'. *On the Generation of Animals* (trans. A. L. Peck), quoted Lefkowitz and Fant, pp. 83-4; also 'We should look upon the female state as being as it were a deformity', ibid., 4.6, quoted O'Faolain and Martines, pp. 119-20. On Greek law and women see Lefkowitz and Fant, pp. 35-50; O'Faolain and Martines, pp. 9-32; and Gould, passim (an excellent article).
6. Philo Judaeus, *On Flight and Finding*, 51; quoted Meyer.
7. Isidore, *Etymologiae*, XI, ii, 17-19 (W. M. Lindsay ed.), quoted Ferrante, p. 6.
8. Ripa (1602), pp. 90-3.
9. On gender and language see Ritchie Key, passim; also Yaguello, Houdebine, Spender address the subject with partisan feeling.
10. See 'Le Mec' (the guy) and 'La Nana' (the bird) in Anne Corbett, 'Cherchez

la métaphore', *Guardian*, 18 February 1983.
11. Meillet, p. 202.
12. Ibid., p. 13.
13. Tom Disch, 'On the Use of the Masculine-Preferred', TLS, 23 January 1981.
14. Dionysius Thrax, p. 24. For the ensuing discussion of gender see Meillet, pp. 199-229, and Fodor, passim. I am most grateful to Simon Canelle for his valuable researches on my behalf on this topic.
15. Aristotle, *On The Generation of Animals*, I, 103, 109 (trans. Peck), 'The male provides the "form" and the "principle of movement", the female provides the body, in other words the material. Compare the coagulation of milk. Here, the milk is the body, and the fig-juice or rennet contains the principle which causes it to set. Quoted O'Faolain and Martines, p. 119. Aristotle's views on biology were given approval by Thomas Aquinas and were profoundly accepted, surprising as it may seem, even by later empiricists like William Harvey, who could not ascertain the material presence of male semen in the formation of the embryo and described its function as 'formative power'. See Martin Pollock, 'Pre-

formationists and Epigenesists', TLS, 11 June 1982.

16. Meillet, p. 210.

17. Throughout the discussion of Hesiod I have used West's edition and commentary on *Theogony*, and Wender's translation in the Penguin Classics. *Theogony*, 337-70, 389-403, 768ff., pp. 34, 35, 36, 48-9. See also Baladié, in *Mythe et personnification*, pp. 17-24.

18. *Theogony* (West ed.), pp. 45ff.

19. Ibid., 116, Wender, p. 27.

20. Ibid. (West ed.), pp. 192-3.

21. Ibid., 116-130 (West ed.), pp. 193-7.

22. Ibid., p. 33.

23. Ibid., 226-32, Wender, pp. 29-30.

24. Fletcher, p. 32.

25. Onians, pp. 399ff., esp. 404, for relationship of *ker* and *moira* to *daimon*.

26. Fletcher, pp. 42-3, quoting E. Schneweis, *Angels and Demons According to Lactantius* (Washington, 1944), pp. 82-3. See also Fletcher, pp. 25-69, for a general, perceptive analysis of 'The Daimonic Agent'; Webster, passim, on personification; Dietrich, Appendix VIII, on personification.

27. Fletcher, p. 40; Dietrich, op. cit., writes, 'The formation of abstracts occurred from the earliest history of the Greek *Grundsprache* onward ... as nomina agentis they expressed daemonic forces or daemons that were believed to possess direct influence over the most important aspects of a man's life: his strength to give birth and to live, his subjection to external forces that could deprive him of life.' It is possible that when an Olympian possesses a title, like Zeus Eleutherios (Zeus the Deliverer) or Athena Hygeia (Health-giving Athena), the god has absorbed the earlier daimon, of liberty, or of health.

28. *Iliad*, 4, 440, p. 88.

29. Ibid, 11, 73, p. 197.

30. *Theogony*, 881-1020, Wender, p. 52; West, pp. 397ff.

31. Vernant (1974), pp. 1ff., 231.

32. *Theogony*, 924ff., Wender, p. 53; West, pp. 412-3.

33. 'Homeric Hymn to Athena', 1, quoted Farnell, 1, p. 272.

34. Pindar, *Olympian* VII, trans. Bowra, p. 165.

35. See Onians, pp. 111, 178ff. for head as a source of generation.

36. See Vernant (1974), pp. 1-2; West, pp. 415ff.

37. *Theogony*, 66ff.; West, pp. 180-1.

38. Ibid., 245-64, West, pp. 240ff.

39. Ibid. (Brown ed.), p. 40.

40. Ibid., 910-11; Wender, p. 52.

41. Ibid. (Brown ed.), p. 25.

42. Ibid., 129; West, p. 199.

43. *Odyssey*, XI, 249-50, p. 178.

44. *Iliad*, 5, 739; 11, 37 (Agamemnon's shield as well).

45. *Iliad*, 4, 440.

46. Dodds, p. 5.

47. *Iliad*, 3, 420; 4, 31.

48. Ibid., 6, 343-58, p. 126.

49. *Odyssey*, 4, 261-4, p. 71.

50. *Iliad*, 19, 91ff., pp. 356-7. See also Dodds, pp. 1-27.

51. Dodds, p. 5.

52. *Iliad*, 19, 91ff., pp. 356-7.

53. *Works and Days*, 16-18, Wender, p. 59.

54. G.E.M. de Ste Croix, *The Origins of the Peloponnesian War* (London, 1972), p. 37.

55. Pheme: Webster, quoting *Scholiast to Aeschines*, 1, 128; Pausanias, I, XVII, 1, Vol. 1 p. 47; Limos: West, p. 231.

56. Fürtwangler, pp. 295-6; Haynes, p. 79.

57. Plato, *Timaeus*, 8.40-1, pp. 54-5.

58. Sextus Empiricus, Fr. 11, *Adv. Math.*, IX. 193, in Kirk, Raven and Schofield, pp. 168-9.

59. *Theogony*, 799-80, Wender, p. 49.

60. See 'The Reason of Myth', in Vernant (1982), p. 193.

61. See S.G. Pembroke, 'Myth', in Finley (1984), pp. 301-24, for a lucid account of different approaches; also Kirk (1974); Seznec; Weitzmann.

62. Ferrante, pp. 155-6, quoting MS. of Guillaume de Conches's commentary on the *Timaeus*.

63. Augustine, *City of God*, VII. 9; p. 207.

64. See Wind (1967), pp. 128ff., 141ff.

65. Following Wisdom 8:7, Ambrose designated the Cardinal Virtues; developing ideas in Plato, *Republic*, 435ff., pp. 208-24, on Justice, and Cicero (*De Natura Deorum*, III, 15, and *De Officiis*, I, XLIII ff). Augustine named them again and developed their interconnectedness; Gregory the Great gave faith, hope and charity, the three theological virtues, their pre-eminent place. See Tuve (1966), passim; Bloomfield (1952), pp. 66-7.

66. Jacob Burckhardt, referring to temples of Pavor and Pallor (Fear and Pallor) of Honor and Valor, in 'Die Allegorie in den Kunsten', in *J.B. Vorträge*, Durr ed. (Stuttgart, 1933), pp. 430-1, quoted Dronke (1980), p. 31.

67. Grant (1958), pls. 8, 9, 18, 19.

68. Plato, *Timaeus*, 7. 38-9, pp. 50-54.

69. *English Romanesque Art*, pp. 224-6.

70. Webster, passim; see also J. Bompaire, 'Quelques personnifications littéraires chez Lucien et dans la littérature impériale', in *Mythe et personnification*, pp. 77-82.

71. See 'A Grammatical Approach to Personification Allegory', in Bloomfield (1970), pp. 243ff.; also Fletcher, pp. 15ff.

72. See: 'C'est l'Ennui! - l'œil chargé d'un pleur involontaire,/Il rêve d'échafauds en fumant son houka.' 'Au Lecteur', in Baudelaire, p. 43; and 'La Beauté': 'Je suis belle, ô mortels! Comme un rêve de pierre', ibid., p. 54; and the sonnet 'Recueillement': 'Sois sage, ô ma Douleur, et tiens-toi plus tranquille'. The diction of that opening line's command must cut into the numbest of readers.

73. J. Hall, passim, is .the best brief handbook in print to the attributes and other distinguishing marks of Christian allegories; otherwise see Tuve (1966); Mâle (all works cited); Katzenellenbogen (1939); Marle.

74. See Lewis; Chew; Tuve (1966).

75. Dante, *Purgatorio*, XXXI, 107.

76. For Sainte Foy, see Réau I, 5-36; Farmer, pp. 146-7; André, passim; for Hroswitha's play, *The Passion of the Holy Maidens*, see PL 137, cols. 1045-62; Dronke (1984), pp. 54, 294.

77. Tuve (1963) discusses the 'New Iconography' developed *c.*1450, which conferred complex attributes on allegorical figures, and was used for instance in Brueghel's series of Virtues, engraved *c.*1550.

78. The mosaicist interpreted Matt. 5:3-10: Humilitas (poor in spirit), Compunctio - Contrition (Mourners), Benignitas (the Meek), Abstinentia (Those who Hunger and Thirst after Righteousness), Misericordia - Mercy (the Merciful), Castitas (the Pure in Heart), Patientia (the Peacemakers), Modestia and Constantia (the Persecuted). See Demus, pp. 131, 160; Bettini, passim; Toesca and Forlati, p. 21, figs. 7, pl. 34. Otto Demus' magnificent new publication on the mosaics of San Marco, in 4 vols. (Chicago, 1984) had not been received by the British Library in time for me to consult it.

79. Hecht, p. 80.

80. Jean Froissart, *Les Œuvres* (Brussels, 1867-77), vol. II, *Poésies*, lines 2173-4, p. 204.

81. Young, passim. The tapestry may have been woven to praise a living individual, the Queen, Isabeau of Bavaria, or perhaps Anne, Duchess of Bedford.

82. In the Milan, 1602 edition, Ripa depicted Virtù Eroica as an old man; he must have decided this was inappropriate, as he changed him into a Hercules figure in the Padua, 1611 edition;

in the Amsterdam, 1644 version, Valore appears as a man with a lion.

83. See Enea Vico's engraving of an old man, naked, seated on another, with the gloomy inscription, 'Ille sapit quisquis rerum videt undique finem' (He is wise who sees everywhere the end of things). (B.XV. 311.70, in MMA.)

84. E. Henderson, p. 327; *L'Art de l'estampe et la Révolution française*, no. 316, p. 62.

85. *Le Téléphone*, by E. Duez, in *Hôtel de Ville*, p. 64; *Le Gaz*, by Adolphe Itasse, ibid., fig. 158, p. 65.

86. *La Vapeur*, by Itasse, ibid., fig. 167; on the front Lobau of the Hôtel de Ville; *La Photographie* and *L'Electricité*, by E.-A. Soldi, on the same side, figs. 191–2; *Le Suffrage universel*, a caryatid in the Salle St-Jean, is by C. Gauthier, and makes a pair with *L'Education*, figs. 275–6; M. Moreau's group of mother and two children, *L'Assistance publique*, is on the Escalier d'Honneur, and forms a pair with P.-A. Schoenewerck's *L'Instruction*, figs. 299–300.

87. In the Ecole d'Agriculture, Montpellier. Jacques Villeneuve (1865-1933) was an occasional Salon exhibitor. See his dossier in the Musée d'Orsay archives.

88. The Gare de Lyon's bas-reliefs represent *La Vapeur* and *La Navigation* by Félix Charpentier, *La Mécanique* by Louis Baralis, and *L'Electricité* by Paul Gasq. Compare the last with the advertisement for 'Electricité rouge et blanche', showing a Pierrette holding a brilliantly lit lamp, by Lucien Lefèvre, in *French Fin-de-Siècle Posters*, pp. 36-7.

89. Mark Jones, of the BM Coins and Medals Department, showed me this example, as well as others celebrating the century's innovations – cars, dirigibles, aeroplanes – direct prototypes of advertising iconography. See catalogue, *La Médaille en France de Ponscarme à la fin de la Belle Epoque*, June-September 1967, Hôtel de la Monnaie, Paris. See also Trachtenburg, fig. 52, pp. 104-5, for photograph of Mrs Cornelius Vanderbilt as 'The Electric Light', a costume for a ball in 1883; and Mary Cable, *Top Drawer* (New York, 1984), pp. 204-7, for the co-operation of society girls in the twenties with advertisements, just as, in the eighties and nineties, they had posed as allegorical figures in *tableaux vivants*. (See Chapter 10).

CHAPTER FIVE

1. Empedocles, Fr. 134, Ammonius, *De Interpretatione*, 249, Kirk, Raven and Schofield, p. 312. (I've changed 'the divine ... *him*' to 'it', in order not to leave out goddesses!)

2. *Iliad*, 24 100, pp. 339-400; ibid., 14, 352-3; *Theogony*, 790ff., Wender, p. 49.

3. *Odyssey*, 10, 573-4, p. 170.

4. *Iliad*, 14, 271-9, p. 264.

5. Ibid., 4, 443, p. 88.

6. Ibid., 20, 144-50, p. 370.

7. *Odyssey*, 11, 249, p. 178.

8. Onians, p. 306; Lorimer, p. 20. He suggests that the flesh of the gods may even have been composed of ivory, since when they replaced Pelops' shoulder after it was mistakenly eaten by Demeter, they made him one of ivory instead of flesh. Ibid., p. 33. See Graves, 2, pp. 25-7; Pindar, *Olympian* 1, Bowra, pp. 65-6.

9. *Iliad*, 5, 334-417, pp. 101-3.

10. Ibid., 900-5, pp. 115-16.

11. Ibid., 22, 470, p. 409.

12. *Odyssey*, 1, 267, p. 32.

13. See Pindar, *Nemean* X, 11, for Athena's blonde hair; for the gods' knees,

see *Iliad*, 1, 500, p. 36; ibid., 24, 479, p. 450; Onians, pp. 174ff.; cf. Catherine Thompson, 'Women, Fertility and the Worship of Gods in a Hindu Village', in Pat Holden, ed., *Women's Religious Experience* (Beckenham, 1983), pp. 113-31, esp. p. 118 on symbolism of laps in Hindu ritual.

14. *Iliad*, 5, 835-9, pp. 114-15.
15. Ibid., 3, 395-9, p. 74.
16. Ibid., 1, 199-200, p. 28.
17. Ibid., 5, 859-60, p. 115.
18. Ibid., 5, 127, p. 95.
19. Ibid., 5, 815, p. 114.
20. *Odyssey*, 12, 449, p. 201.
21. *Iliad*, 21, 285-6, p. 387.
22. Graves, 2, pp. 85-6; see Pindar, *Isthmian* VII, Bowra, p. 224; *Nemean* X, 16, ibid., p. 177.
23. Ovid, II, pp. 61-2.
24. Pindar, *Olympian* XIII, 61-73, Bowra p. 173; see Detienne and Vernant, 'The Live Bit', in R. L. Gordon, pp. 187ff.
25. Finley (1977), p. 27.
26. *Iliad*, 23, 783, p. 433.
27. *Odyssey*, 6, 328-31, p. 111.
28. Ibid., 1, 44-323, pp. 26-33.
29. Ibid, 2, 267ff., 401ff., pp. 44-9; 3, 12ff., 372ff., pp. 50-60.
30. Ibid., 24, 503ff., p. 364.
31. Ibid., 2, 382-92, pp. 47-8.
32. Ibid., 2, 12-13, p. 37.
33. Ibid., 19, 137-57, pp. 291-3.
34. Farnell, 1, pp. 294ff; Fougères, passim.
35. Hesiod, *Works and Days*, 64, Wender, p. 61.
36. Ibid., 72, p. 61; cf. *Theogony*, 573, Wender, p. 42.
37. *Odyssey*, 7, 110-11, trans. Murray, 1, p. 241.
38. *Iliad*, 6, 269-311, pp. 124-5.
39. Ibid.
40. Lefkowitz and Fant, pp. 117-18.
41. *Iliad*, 6, 299-300, p. 324.
42. *Odyssey*, 2, 118, p. 40.
43. Ibid., 1, 364, p. 47; 4, 793-4, p. 85.
44. Ibid., 4, 795-829, pp. 85-6.
45. Ibid., 18, 192-6, p. 28.

46. Ibid., 18, 346-8, p. 285.
47. Ibid., 22, 297-301, p. 335.
48. Ibid., 16, 212, p. 250.
49. Ibid., 6, 20-40, pp. 102-3.
50. Ibid., 6, 110ff., pp. 105-8.
51. Ibid., 6, 229-37, p. 108.
52. Ibid., 8, 186ff., p. 127.
53. Ibid., 8, 521ff., p. 136; 9, 19, p. 139.
54. Ibid., 9, passim, pp. 139-54.
55. Ibid., 11, 153, p. 175.
56. Ibid., 9, 366-414, pp. 149-50.
57. Ibid., 13, 188-93, p. 206; see Vernant (1974), esp. pp. 25ff.
58. *Odyssey*, 13, 221-6, p. 208.
59. Ibid., 13, 250ff., pp. 208-9.
60. Ibid., 13, 287-9, p. 209.
61. Ibid., 13, 291-301, pp. 209-10.
62. Ibid., 13, 312-13, p. 210.
63. Ibid., 16, 160-3, p. 249.
64. See *Odyssey*, trans. Murray, II, p. 394: Aristophanes and Aristarchus considered 23, 296, the end of the epic, according to the scholia.
65. *Iliad*, 19, 479, p. 300.
66. *Odyssey*, 23, 1-110, pp. 341-3.
67. Ibid., 23, 156-63, p. 345.
68. The word Odysseus uses, translated as 'secret' by Rieu is *sema*, 'sign'. Ibid., 23, 184-9, p. 345.
69. Ibid., 190-9, pp. 345-6.
70. Ibid., 205-9, trans. Murray, p. 389.
71. Ibid., 232, p. 346.
72. Butler, p. 270.
73. *Odyssey*, 11, 427-39, pp. 182-3; see also Vidal-Naquet in R.L. Gordon, pp. 187-200.
74. *Odyssey*, 11, 441-6, pp. 182-3; see Foley (1978) for an excellent examination of attitudes to gender in Homer's *Odyssey*.
75. Alexander Pope, 'Essay on the Life, Writings, and Learning of Homer', quoted Murrin, p. 58.
76. *Iliad*, 1, 197-8, p. 28; Dodds, pp. 14-15.
77. William Gladstone, *Studies in Homer* (3 vols. Oxford, 1858), II, p. 43, see Lloyd-Jones (1982), p. 120.

CHAPTER SIX

1. H.D., *Tribute to Freud*, quoted by Barbara Taylor, in *Fathers*, Ursula Owen ed. (London, 1983), p. 113.

2. *Iliad*, 16, 130-6, p. 295; ibid., 278-83, p. 299.

3. Ibid., 790ff., p. 313.

4. Ibid., 801-15, p. 313.

5. Ibid., 820-1, p. 315.

6. Ibid., 17, 389-99, p. 326.

7. Ibid., 18, 478ff., pp. 349-53.

8. Ibid., 203-27, pp. 342-3; see 'The Eye of Bronze', in Vernant and Detienne (1978).

9. Herodotus, iv. 189, claims that Athena's dress was modelled on Libyan women's ordinary dress, 'except that the latter is of leather and has fringes of leather thongs instead of snakes', p. 334.

10. There is a Roman copy in the Salle des Caryatides of the Louvre.

11. Phidias' Athena Parthenos, made of gold and ivory, only survives in copies, see Brommer, pp. 59-60. Pausanias, 1.24.5, pp. 69-70, gives a description of the statue. (See front of jacket.)

12. Brommer, pp. 59-61.

13. *Iliad*, 2, 447-9, p. 52.

14. Ibid., 23, 702-5, p. 431.

15. Ibid., 4, 167, p. 81.

16. Ibid., 21, 401, p. 390.

17. Ibid., 15, 308-10, p. 279.

18. Hesiod, Frag. 343, Vernant and Detienne (1978), p. 182.

19. Lucian, *The Thirteenth Dialogue of the Gods*, quoted Farnell, 1, p. 306.

20. *Odyssey*, 22, 297, p. 335.

21. *Theogony*, 270ff, Wender, p. 32; Ovid, 4, 772-803, p. 115.

22. Pindar, *Pythian* XII, Bowra, p. 29.

23. Notes by Ida Tamburello, available at Museo Archeologico, Palermo; see Ettore Gabrici, 'Per la storia dell'architettura dorica in Sicilia' in *Monumenti Antichi dei Lincei*, XXV, 1935.

24. Barone and Elia, fig. 21, pp. 92-5.

25. BM, kylix B380, for instance.

26. Pindar, *Pythian* XII, 11-12, 18-21, Bowra, pp. 29-30.

27. *Iliad*, 5, 738-42, p. 112.

28. Ibid., 8, 349, p. 154.

29. Detienne and Vernant, in R.L. Gordon, p. 182.

30. *Iliad*, 6, 492-3, p. 130.

31. Ibid., 5, 909, p. 116.

32. Ibid., 24, 44, p. 438.

33. Ibid., 23, 76, p. 417.

34. 'Medusa's Head', in Freud, *Posthumous Writings*, Vol. XVIII (1955), pp. 273-4.

35. 'The Ringstrasse, its Critics, and the Birth of Urban Modernism', in Schorske, pp. 24-115.

36. Ibid., pp. 42-3.

37. Ibid., pp. 217-19.

38. An owl appeared with Athena on Athenian coins, and for a long time it was traditional to translate the Homeric epithet *glaukopis* as 'owl-eyed', though this is no longer considered correct.

39. Freud, 'Medusa's Head', see note 34 above.

40. Quoted by Oswyn Murray in 'The Archetype of Conflict', review of George Steiner's *Antigones*, TLS, 24 August 1984.

41. Catherine Gallagher, 'More about Medusa's Head', *Representations*, 4, Fall 1983, pp. 55-7, in reply to Hertz.

42. Graves, 1, p. 244.

43. *Odyssey*, 11, 623-40, p. 188.

44. Jung and Kerényi, pp. 126-8.

45. See Loraux, ch. 1. 'L'Imaginaire des autochtones'.

46. See note 24.

47. *Theogony*, 276-81, p. 32.

48. BM, B380.

49. BM, 619; Birchall and Corbett, pl. 50.

50. Euripides, *Ion*, 1001-15, trans. Vellacott, p. 71.

51. Ovid, 4, 617-20, p. 110.

52. Ibid., 627-62, p. 111.

53. Ibid., 664-752, pp. 113-14; Apollo-

dorus, III.10.3, tells how Asclepius, god of healing, was also given drops of Gorgon blood with wonder-working powers.

54. Graves, I, pp. 174-5.

55. Pindar, *Pythian* XII, Bowra, pp. 29-30; trans. Sandys, pp. 308-11. Danae herself had given birth to Perseus after Zeus visited her as a shower of gold, one of the least anthropomorphic of his metamorphoses. This rendered Danae a type of virgin mother, and even, in the works of some Christian classicists, a precursor of the Virgin Mary. See Graves, I, p. 238.

56. Pindar, *Pythian* XII; Apollodorus, II, IV, 1-2.

57. Pausanias, I, 4, p. 80, points out the spring of water near the Acropolis' 'formal entrance' where the encounter between Creusa and Apollo took place.

58. Euripides, *Ion*, 1404ff., trans. Vellacott, p. 82. Aristophanes' *Thesmophoriazousae* (*The Poet and the Women*) in fact shows women taking issue with Euripides for traducing the female sex with his portraits of women like Phaedra and Medea. See Zeitlin (1981).

59. Euripides, op. cit., 1048-60, p. 72.

60. Ibid., p. 78.

61. Ibid., 1478, p. 84.

62. Ibid., p. 87.

63. See Aeschylus, *Agamemnon*, 13; '[Clytemnestra] manoeuvres like a man', says the Watchman, in the opening speech. See Winnington-Ingram (1983), pp. 101-31.

64. Aeschylus, *Eumenides*, 658-67, trans. Fagles, pp. 260-1.

65. Ibid., 735-8, p. 264.

66. Ibid., 855, p. 269.

67. See Vidal-Naquet, 'Slavery and the Rule of Women'; Lefkowitz and Fant include a revealing fourth-century BC case of a woman tried for adultery, pp. 50-7.

68. Gould, pp. 43-6.

69. See also Loraux, p. 129.

70. Gould, p. 46.

71. *Iliad*, 2, 546-8, p. 54; Fowler quotes the Scholiast, who says that Erechtheus 'is also called Erichthonius', p. 28; Loraux pp. 28-9.

72. Apollodorus, III. 14.1; Hyginus, *Fabula* 274, quoted Graves, I, pp. 96-7.

73. Harrison (1896); Graves, I, p. 97; Kerényi, pp. 125-6; Pausanias, 1.18.2, p. 50.

74. Graves, I, p. 98

75. Pausanias, 1.24.7, p. 70.

76. *Iliad*, 2, 547, p. 54.

77. Brommer, p. 48, pls. 114-15. Cf. Plato, *Menexenus*, 237b-c, trans. Jowett: 'And first as to their birth – their ancestors were not strangers, nor are their descendants sojourners only, whose fathers have come from another country; but they are the children of the soil, dwelling and living in their own land. And the country which brought them up is not like other countries, a stepmother to her children, but their own true mother; she bore them and nourished them and received them, and in her bosom they now repose.' Plato's intention was satirical, to parody the commonplaces of a funeral oration, but the satire none the less reveals that the analogy between the motherland and the maternal body existed in his day. (I am grateful to Simon Canelle for bringing this quotation to my attention.)

78. Varro, in Augustine, *City of God*, 18.9; Pembroke, pp. 26-7; Vidal-Naquet, in R.L. Gordon, pp. 198-9.

79. Pembroke, pp. 27, 30-1.

80. Vidal-Naquet, op. cit.

81. See Graves, I, pp. 103-6; Kerényi, pp. 250-74.

82. Ovid, 3, 298-309, p. 82.

83. Euripides, *Bacchae*, p. 194.

84. Apollonius Rhodius, IV, 1137, quoted Graves, I, p. 56.

85. It was recently discovered that the whiptail lizard (genus Cnemidophorus), of south-west US and north Mexico, is able to reproduce parthenogenetically, producing only daughters, which are in fact clones. *Scientific American*, January 1984, *The Times*, 17 January 1984.

86. *Theogony*, 927-8, p. 53.

87. *Odyssey*, 8, 295-366, pp. 131-2.

88. Gould, p. 43.

89. *Theogony*, p. 52.

90. Gould, p. 44.

91. Agnello, pp. 3-12.

92. See Warner (1976), pp. 47-8.

93. It is interesting in this regard that Spenser chose the name Una - One - for the figure of the True Church in Book I of *The Faerie Queene*, and Duessa - Two - to represent duplicity and 'departures from a primal integrity'. See Kermode, pp. 263-4.

94. Ruskin, p. 48.

95. Farnell, I, pp. 318-19.

96. See Lee Holcombe, *Wives and Property. Reform of the Married Women's Property Law in Nineteenth-Century England* (Oxford, 1984). It unfortunately came out too late for me to consult; also Margaret Forster, *Significant Sisters* (London, 1984), pp. 47-8.

CHAPTER SEVEN

1. Blake, Notebooks MS, 1793, p. 105.

2. Fourcaud, p. 217: 'Les statuaires font parler l'Histoire du siècle; mais Rude seul la fait rugir.'

3. The image became very familiar through reproduction, e.g. on the one-franc stamp issued in 1917 to aid the orphans of the war, and in a poster showing the army of 1914-18 answering her call. Darracott and Loftus, p. 62.

4. Compare for instance Auguste Préault's powerful image of war and its horrors, *Tuerie* of 1834, in Honour (1979), p. 142, where the woman screams in grief, and with Rubens' allegory of Peace and War in the Pitti, Florence. I am indebted to Nicholas Penny for this insight into Rude's transformation of the imagery of Eris.

5. Graillot, p. 830.

6. Meletzis and Papadakis, pls. 111-12, p. 29; Haynes, pp. 70-2; Finley (1977), pl. 14.

7. For Nike, see Graillot, passim; Ellinger.

8. Ellinger, pp. 1185-90.

9. *c.* 430-410 BC. BM 1183, 1910. 6-15. 1.

10. Hesiod, *Theogony*, 384, p. 35; Kerényi, p. 34; Herodotus 8, 77, p. 549, where he is quoting a prophecy of Bacis: '... all-seeing Zeus/And gracious Victory shall bring to Greece the day of freedom'.

11. Graillot, pp. 832-4.

12. Brommer, pp. 47-8. For Carrey's drawing of 1674 showing Athena's horses and charioteer, possibly Nike, fig. 23, p. 49. The carving itself is now lost.

13. K. Jenkins, figs. 9, 10, pp. 16-20.

14. Ibid., fig. 32, from Catana, 430-420 BC, a streamlined horizontal Nike; figs 37, 39, also from Catana, by Euainetos, *c.* 415-410 BC, in which Nike holds a wreath for the victor *and* a tablet bearing the artist's name, pp. 36-7; fig. 46, showing her in vertical flight, fluttering, by Kimon for Syracuse, late fifth century BC, over a chariot wheeling towards us, as if round a bend, pp. 40-3.

15. Graillot, pp. 833-5; Farnell, I, pp. 312ff.

16. Graillot, pp. 836-9, 850ff.

17. See BM/c/GR/024 for an exquisite pair of Hellenistic Victory earrings, 300-200 BC, from near Bolsena.

18. *Odyssey*, 3, 371-21, p. 60. For *phene* Lattimore gives vulture, but the associations are perhaps too predatory in English, though, as we shall see, Nike's relationship to fate does make her something of a raptor.

19. Coffin, BM 24794, *c.* 1050 BC, Thebes.

20. Plutarch, *On Isis and Osiris*, 12. 355ff., p. 137. Trans and ed. J. Gwynn Griffith, Cardiff, 1970.

21. Plato, *Phaedrus*, 9.24d, R. Hackforth ed. (Cambridge, 1952), p. 70.

22. Brommer, p. 48, pl. 123 shows sockets in the back of Iris where her wings would have fitted, and her tunic tied between her shoulder-blades to make room for them (!); see also vase, BM E523, *c.* 440 BC, in which Iris or Nike with huge wings pours a libation for Hera.

23. See Birchall and Corbett, fig. 8: BM E199, an Attic hydria showing Eos and Cephalos (460-450 BC), Nola; Reinach, I, p. 112, from Vulci.

24. *Theogony*, 297ff., 308, pp. 32-3; Kerényi, pp. 51-3.

25. *Odyssey*, 12, 39ff.; see the famous stamnos painting, BM E440, pl. 72, in Birchall and Corbett; Virgil, *Aeneid*, 3, 222ff., p. 82.

26. Alison Packer, Stella Beddoe and Lianne Jarrett, *Fairies in Legend and the Arts* (Brighton, 1980), pp. 15, 18, 28-9, 116-17, 128; on the meaning and cult of fairies in general, see Maureen Duffy's original study, *The Erotic World of Faery*, London, 1972.

27. Sleep and Death appear, carrying off the body of Sarpedon, on BM E12, and on another by the painter Euphronios in MMA, illustrating *Iliad*, 16, 450-7, p. 304. See Robertson, 2, pls. 73a, 73b.

28. Reinach, II, p. 330.

29. Ibid, II, p. 9.

30. Aeschylus, *Oresteia, Eumenides*, 54-5, p. 233.

31. Aristophanes, *Birds*, 574ff., p. 173.

32. See for instance the bronze mirror, BM 544, Etruscan, fifth century BC, showing Heracles and the Hydra with a winged Athena standing by, Birchall and Corbett, pl. 22; cf. Artemis, as Mistress of Animals, ibid., pl. 7, BM 1128, seventh century BC.

33. Andrew Marvell, 'To His Coy Mistress', *New Oxford Book of English Verse*, pp. 334-5; Horace, *Odes*, 2, 14, 1-2, p. 118.

34. Lakoff and Johnson, pp. 41-4.

35. *Troilus and Cressida*, III, iii, 165-9.

36. W.H. Auden, 'As I Walked Out One Evening', in *Selected Poems* (London, 1968), p. 19.

37. 'La sculpture, la vraie, solennise tout, même le mouvement; elle donne à tout ce qui est humain quelque chose d'éternel et qui participe de la dureté de la matière employée.' Baudelaire, *Salon de 1859*, p. 419.

38. Horace, *Odes*, I, 35ff., pp. 98-9; see Dumézil (1975), pp. 238-49; Grant (1973), p. 177; Marle, pp. 182ff.

39. See for instance a seated Fortuna, with cornucopia, rudder, and the *polos* or tall headdress of a goddess on her head, in the Townley Collection at the British Museum (1701), *c.* AD 150-200. See Panofsky (1939), pp. 110-28 on the blindfold of Cupid. He writes that the appearance of Fortune's blindfold in imagery cannot be precisely dated. See Wither, pp. 4, 174 and R. Wittkower, 'Chance, Time, and Virtue', JWCI, I, 1938, for the iconography of Occasio or Opportunity.

40. For coins see *Wealth of the Roman World*, no. 484, p. 171; 569, p. 175.

41. *Theogony*, 343ff., 361, p. 34; *Olympian* XII, p. 129; see also *Olympian* VIII, 67; 'Tycha ... daimonos', trans. Sandys p. 90, trans. Bowra as 'God favoured him', p. 212.

42. De Rossi, *Bulletin d'archéologie chrétienne* (1879), p. 45; Graillot, p. 853.
43. *Wealth of the Roman World*, 502, p. 172.
44. Ibid., 674, p. 179.
45. For Angels, see articles by T.L. Fallon, S. Tsuji, A.A. Bialas, J. Michl, NCE; Ellinger; Berefelt, Wilson, PL.
46. Haskell and Penny, p. 333.
47. *Theogony*, 265-9, p. 31; *Iliad*, 4, 442-3.
48. Virgil, *Aeneid*, 4, pp. 102-3; see Hesiod, *Works and Days*, 760-4, p. 84.
49. Ovid, *Metamorphoses*, 12, p. 269; Simone Viarre, 'La Personnification de la Renommée - Fama - dans quelques récits mythiques ovidiens', in *Mythe et personnification*, 1980, pp. 69-75.
50. Cartari, p. 291.
51. Champoiseau; Jacquet, pp. 17-19; Haskell and Penny, p. 333.
52. In the Archaeological Museum, Olympia, reproduced in Rex Warner, facing p. 144.
53. Other Nikai influential on the classical revival are the Pompeii statuette, poised on a sphere, in the Museo Archeologico, Naples; and another, from Cassel, also poised on a globe (of which Sir John Soane had a cast in his breakfast parlour) (see Summerson, p. 45), which Flaxman had brought back from Rome.
54. 'Sonnets Cisalpins', XII, in D'Annunzio (1946), p. 315:
 I see all of a sudden your vehement flight spring upwards,
 O Victory, I see your marble where the blood courses
 Take off from the plinth all of a sudden and unfurl,
 Like the dawn of a star in the bosom of the heavens ...

The Soul gives voice to the lofty chorus of Euripides:
'Nike most venerated, on the swift path of life,
Stay by my side! And at the end, give me the victor's crown!'

Marinetti singled out the statue as the symbol of the past 'beauty of speed', superseded in the new world by racing cars. See 'The Manifesto of Futurism', 4, in R.W. Flint, ed., *Marinetti; Selected Writings* (London, 1972), p. 41.

55. Panofsky (1963).
56. Read, pp. 370-9.
57. Byron, pp. 265-6.
58. Richard Pankhurst, *Sylvia Pankhurst, Artist and Crusader* (London, 1979), p. 103; see also pp. 114-23 for other female figures she painted for the Women's Exhibition.
59. Schorske, pp. 87, 92-3.
60. *WPA Guide to New York*, p. 235.
61. Saint Victoria (feast 23 December), is a rather unhistorical Roman virgin martyr, one of the many exemplary young women who refused to marry her pagan betrothed and sacrifice to his gods, and was put to death during the persecutions of Decius. See Farmer, pp. 390-1.
62. See Werckmeister.
63. Walter Benjamin, 'Agesilaus Santander' (1933), quoted from Gershom Scholem, 'Walter Benjamin und sein Engel', in Werckmeister, p. 116.
64. 'Theses on the Philosophy of History', in Benjamin (1982), pp. 259-60.

CHAPTER EIGHT

1. Baudelaire, p. 54:

 Viens-tu du ciel profond ou sors-tu de l'abîme,

 O Beauté? Ton regard, infernal et divin,
 Verse confusément le bienfait et le crime....

Tu marches sur les morts, Beauté,
dont tu te moques;
De tes bijoux l'Horreur n'est pas le
moins charmant,
Et le Meurtre, parmi tes plus chères
breloques,
Sur ton ventre orgueilleux danse
amoureusement.

Trans. Richard Howard (Brighton,
1982), pp. 28-9.

2. Herodotus, 4, 180, p. 331; see King,
pp. 109-27.
3. Herodotus, op. cit.
4. Pembroke, passim: Vidal-Naquet, passim.
5. Dronke (1984), p. 4; see also *La Passion
des Saintes Perpétue et Félicité*, trans. and
ed. Ad. Levin-Duplouy (Paris, 1972).
6. Tertullian, pp. 294-7.
7. Pindar, *Pythian* IX, trans. Sandys,
pp. 272-85, 18-70; Bowra, pp. 87-9.
8. Prudentius, *Psychomachia*, trans.
Thomson (1949); see also Raby,
pp. 61-3; Ferrante, pp. 43-6; Katzenellenbogen (1939), pp. 1-14; Bloomfield
(1952), pp. 63ff., 81ff.
9. Katzenellenbogen (1939), pp. 14-21;
Mâle (1908), pp. 365ff.; Mâle (1913),
pp. 98ff.; Mâle (1925), pp. 100-6.
10. Herrad of Hohenburg, fols. 199v-
204r, I, pp. 190-6; II, pls. 110-19.
11. Hildegard (1927); Dronke (1970),
pp. 168-91; recorded by Harmonia
Mundi 20395/96, 1982, director Klaus
L. Neumann.
12. *English Romanesque Art*, pp. 287-8.
13. Marle, vol. 2, p. 13.
14. Keen, p. 98.
15. Prudentius, 420-31:

casus agit saxum, medii spiramen ut
oris
frangeret, et recavo misceret labra
palato.
dentibus introrsum resolutis lingua
resectam
dilaniata gulam frustis cum sanguinis inplet.

insolitis dapibus crudescit guttur, et
ossa
conliquefata voraris revomit quas
hauserat offas.
'Ebibe iam proprum post pocula
multa cruorem,'
virgo ait increpitans, 'sint haec tibi
fercula ...'

16. Caroline Elam, 'Mantegna at Mantua',
from *Splendours of the Gonzaga*, pp. 22-
3; Seznec, p. 109.
17. See Bloomfield (1952), pp. 60ff.
18. Freud, *The Interpretation of Dreams*,
vol. 4 Pelican Freud Library, p. 473;
also pp. 470, 476, 506, 519.
19. By the firm of Farmer and Brindley,
architectural stonemasons. In 'An Architectural and General Description of
the Town Hall Manchester', William
E. A. Axon ed. (Manchester, 1878),
p. 21.
20. Prudentius, 49-52.
21. See Tuve (1966), pp. 57ff.
22. Rubinstein; reproduced in Carli, pp.
40ff.; Tuve (1966), p. 69.
23. Rubinstein, p. 182.
24. Cf. Domenico Morone's circular
painting, NGL.
25. Tuve (1963), p. 295.
26. Chew, pp. 39-40.
27. Ibid., p. 44.
28. Marillier, pl. 11, pp. 13-15.
29. Klein, p. 233, pl. 51. Original drawing
in the Royal Library, Brussels.
30. Ibid., p. 231.
31. Fiera, p. 35; see Chew, pp. 92ff. for
variations in the depiction of Justice.
32. For Saints Margaret and Catherine, see
Réau, 3.1, pp. 262-72; 3.2, pp. 877-82;
Voragine, 4, pp. 66-72; 5, pp. 238-40,
7, 1-30; also Warner (1981), pp. 132-
4, and n. 58, p. 302.
33. Jerusalem Bible, pp. 601-4.
34. Jdt. 15:10; ibid., p. 637.
35. *Speculum Humanae Salvationis*, M.R.
James ed., p. 29, ch. XXX, pls. 1-4.
36. *Miroure of Mans Salvacionne*, p. 105.

An English verse translation, written before 1324, of the *Speculum*, as above, describes the link:

> And als crist ouercome the feende/ be his seint compassione
> So dide eke blissid marie/be modrefulle compassionne
> With armes of hire sonnes passionne/armed hire blissed marie
> When sho shuld azeinst the feende/ to bataille make hire redy
> Be Judith yt holofern withstode/ prefigured this was fulle wele
> Ffor marye putte hire azeinst/the feende prince infernele.

37. Ibid., p. 107; Herodotus, 1, p. 127.
38. *Miroure of Mans Salvacionne*, p. 108:

> And after in a fulle potte/of mannes blode she putte itte
> And saide drink nowe manes blode/ whare of thowe hadde swilk thrist
> Yt neuer there of lyving/hadde thowe ynogh to thi list
> Right so the feende mansleere/fro the werlde begynnyng
> Might neuer zit be fulfillid/of mans kynde perysshing
> Bot the qwene of heven hym matid [defeated])/with hire sons passionne
> And fillid hym with his ordeyned/ for us dampnacionne.

39. Christine de Pizan, *Ditié*, XXVIII, p. 33:

> Qui furent dames de grant pris,
> Par lesqueles Dieu restora
> Son pueple, qui fort estoit pris,
> Et d'autres plusers ay apris
> Qui furent Preuses . . .
> Plus a fait par ceste Pucelle.

40. BN f.fr. 12476, see Warner (1981), p. 233, fig. 22.
41. *Somme-le-roy*, fol. 145r. Hanover, Provinzial-Bibliothek, I, 82.

42. 'Donatello's Judith', Wind (1983), pp. 37-8.
43. *The Quattro Cento*, Stokes, I, p. 122; Seymour, pp. 142-5.
44. Rubens, *The Feast of Herod*, in National Gallery of Scotland, Edinburgh, see *Painting in Naples*, pp. 239-40; Caravaggio, *Salome Receives the Head of John the Baptist*, NGL, ibid., pp. 133-4; Titian, *Salome*, Galleria Doria-Pamphilj, Rome, see *The Genius of Venice*, pp. 219-20.
45. For Salome's love of John the Baptist see Panofsky (1969), pp. 42-7.
46. For cushions and voluptuaries, see Friedman, pp. 41-56.
47. Stokes, 1, p. 122. There were other versions of nude, or nearly nude Judiths: Bartholomew Spranger (d. 1611), who worked in Antwerp, like Meit, painted the heroine holding up Holofernes' head, in a version that was also, like Meit's, engraved and therefore distributed.
48. Mary D. Garrard, 'Artemisia and Susannah', in Broude and Garrard, pp. 146-71; Greer, pp. 189-207.
49. Greer, ibid., p. 193.
50. Meisel, pp. 74-7.
51. Physick, pp. 51-104; Beattie, pp. 1-3.
52. 'Gustav Klimt: Painting and the Crisis of the Liberal Ego', in Schorske, pp. 208-78.
53. In the Galleria d'Arte Moderna, Venice.
54. Schorske, pp. 246-54.
55. Ibid., p. 251.
56. By the Atelier Manassé, exhibited in 'Geschichte der Fotografie in Österreich', Museum of the Twentieth Century, Vienna, December 1983-February 1984.
57. Harry, p. 56.
58. Ibid., p. 100.
59. 'Women on Top', in Davis (1975), pp. 124-51.
60. Freud, 'Some Psychical Consequences of the Anatomical Distinction between

the Sexes' (1925), Standard Edition, XIX, pp. 243-58; 'Female Sexuality' (1931), XXI, pp. 223-43; 'Femininity', Lecture XXXIII, xxii, pp. 112-35.

61. Jacques Lacan, 'The Phallic Phase and the Subjective Import of the Castration Complex', in Mitchell and Rose, p. 113; see also Rose's Intro., p. 42. Cf. Hélène Cixous, 'The Laugh of the Medusa': 'For phallologocentric continuity is still there, and it is militant, reproducing the old patterns, anchored in the dogma of castration. They haven't changed anything: they have theorized their desire as reality. Let them tremble, the priests, we are going to show them our sexts. Too bad if they fall apart upon discovering that women aren't men, or that the mother doesn't have one.' Quoted by Nancy Spero on her painting, Let the Priests Tremble, seen at her exhibition at Riverside Centre, London, 1984.

62. For Lisa Lyon's icons, with weapons and other strong-arm attributes, see Robert Mapplethorpe's photographs in Lady Lisa Lyon (London, 1983); for rock singers, see Peter Nash, Women in Rock (London, 1984), and a thoughtful essay, Sue Steward and Sheryl Garratt, Signed, Sealed and Delivered (London, 1985).

CHAPTER NINE

1. Jacques Lacan, Seminar XX, Encore. 'God and the Jouissance of T̸h̸é̸ [sic] Woman. A Love Letter' (1972-3), in Mitchell and Rose, p. 147.

2. See the Jerusalem Bible, Introduction to Wisdom Books, pp. 1034-5.

3. Daniélou, pp. 293-313 on early theology about the Church as the Bride of Christ; see also Roland Batey, New Testament Nuptial Imagery (Leiden, 1971); Musurillo, pp. 18-19; Encyclopaedia Judaica (Jerusalem, 1971) for Shekinah, 14, cols. 1349-54; Warner (1976), pp. 123-31; Phyllis Bond, 'Images of Women in the Old Testament', in Ruether (1974), pp. 41-88.

4. The dedication of Hagia Sophia in Constantinople was to the Second Person of the Trinity, not the Holy Ghost, as a western European might assume. See Anselm, 'Prayer to St Paul', esp. pp. 153-6:

And you, Jesus, are you not also a mother ...
Fathers by your authority, mothers by your kindness.
Fathers by your teaching, mothers by your mercy.

See Julian passim, esp. p. 170:

'He needs to feed us ... it is an obligation of his dear, motherly, love. The human mother will suckle her child with her own milk, but our beloved Mother, Jesus, feeds us with himself.... The human mother may put her child tenderly to her breast, but our tender Mother Jesus simply leads us into his blessed breast through his open side, and there gives us a glimpse of the Godhead and heavenly joy....

This fine and lovely word Mother is so sweet and so much its own that it cannot properly be used of any but him, and of her who is his own true Mother - and ours.'

The metaphor of God's motherhood is warranted by several passages of the Bible. See Isa. 66:13; 31:5; Ps. 27:9-10; Luke 13:34-5; Matt. 23:37. Meditations and studies on this subject include Bynum; and Margaret

Hebblethwaite, *The Motherhood of God* (London, 1984). I have also benefited from correspondence on this subject with Dom Sylvester Houédard, to whom much thanks. In April 1984, the sculptor Edwina Sandys interpreted the scriptural passages in visual terms, to create a *Christa*, a crucified Jesus with breasts, for the cathedral of St John the Divine in New York - a good example of the flexibility of language compared to the dismaying literalness of image. *The Times*, 26 April 1984.

Feminine gender was sometimes attributed to the Third Person of the Trinity also; see Pagels, pp. 61-2; R.H. Grant, *After the New Testament*, pp. 185-8 and Warner (1976), pp. 38-9; Meyer, on the Gospel of Philip, II, 55, 25-6 (see Chapter 4, n. 6).

5. Musurillo, pp. 81-3; Warner (1976), pp. 128-9, pp. 197-8.
6. See Catta, passim. In the second-century *Shepherd of Hermas*, the visionary sees the Church 'full of days', like the figure of Wisdom.
7. Peter Damian, PL 144, cols. 736-40; see Schiller, I, pp. 23-4.
8. Katzenellenbogen (1959), p. 15, pl. 9. Mary was also represented as a type of Wisdom herself, not only as her throne. See the beautiful Jesse tree in the Lambeth Bible, *c.* 1150, in *English Romanesque Art*, pp. 114-15.
9. Two early examples of the high incidence of female personification in works either made or commissioned by women: the cross of Lady Gunhild, daughter of the King of Denmark, commissioned by her in *c.* 1075 (in the Danish National Museum, Copenhagen), shows Ecclesia and Synagoga, Life and Death, in the roundels on the arms. Life and the Church are robed as Gunhild herself might have been. *Ivory Carvings in Early Medieval England 700-1200*

(catalogue), VA, 8 May-7 July, 1974. The tapestry of the abbey of Quedlinburg, worked by the nuns in the twelfth century, tells the story of the *Marriage of Mercury and Philology*, based on the popular allegory by Martianus Capella of the fifth century. The surviving fragments represent such scenes as the embrace of Mercy and Justice.

10. Guillaume de Conches, MS. Paris BN Lat. 14380, trans. and quoted Ferrante, p. 43.
11. Alcuin, *De Grammatica*, Migne, PL 101, cols. 849-54, quoted Adams, p. 93.
12. See Incipit in Alcuin's revised Vulgate, BM Add. MS. 10546, fol. 262b; and another, opening Ecclesiasticus, in the Bible of St Martial de Limoges, BN Lat. 811, fol. 74v, in d'Alverny, pl. II, between pp. 262-3.
13. Katzenellenbogen (1959), p. 16, figs. 9, 24.
14. Hroswitha, PL 137, cols. 972-3; see Dronke (1984), pp. 55-83 for his characteristically perceptive account of her writings.
15. Hroswitha, PL 137, cols. 1045-62; trans. St John, p. 137.
16. PL 137, col. 993; trans. St John, p. 35.
17. See Dronke (1984), pp. 72-3, 77-9.
18. Baudri de Bourgueil, Poem CXCVI, lines 103-4. The whole poem (1365 lines): pp. 196-331.
19. Ibid., lines 949-1342.
20. Herrad, fol. 32r., vol. I, p. 104, vol. II, pl. 18. See Witkowski, I, p. 195, and Neumann, pl. 175, for examples of Wisdom nursing.
21. Goethe, *Faust*, Part I, 'Faust's Study', ii, trans. Philip Wayne (1949), PC, 1984, vol. I, pp. 93-4.
22. Vat. Lib. MS., PL 1066, Neumann, pl. 174.
23. Hildegard, Migne, PL 197, col. 338, trans. Dronke (1984), pp. 165-6,

slightly adapted by me. For Hildegard in general, see Dronke (1970), 'Hildegard of Bingen as Poetess and Dramatist', pp. 150-92; Dronke (1984), pp. 144-201, 231-64; Baillet, passim.

24. For Alain de Lille: Musurillo, pp. 150-1; Lewis, pp. 98-111.

25. 'Sequences and Hymns by Hildegard of Bingen', recording by Gothic Voices, directed by Christopher Page. (A 66039). My thanks to Patricia Morison for communicating her love of this music to me. See Dronke (1970), pp. 161-3.

26. Dronke, ibid., pp. 163-5.

27. This famous example of what seemed to the Reformers the fallaciousness of Catholic cult was the result of a copyist's error. He understood XI MV to mean 11,000 Virgins (XIM V) rather than eleven Virgin Martyrs.

28. PL 197, cols. 216-8; Dronke (1984), p. 149. See Eckenstein pp. 256ff., 274ff.

29. Page recording; Dronke (1970), p. 162.

30. PL 197, col. 383; Scivias, vol 1, pp. 3-4.

31. Baillet, p. 56.

32. Page recording; Dronke (1970), p. 162.

33. Dronke, ibid., gives 'For in these pearls/Of the substance of God's word/The throat of the serpent of old/lies strangled.' Latin text, pp. 202ff.

34. Dronke (1984), p. 201.

35. Scivias, vol. 1, p. 4.

36. Bernard to Hildegard, PL 197, cols. 189-90.

37. Recording by Harmonia Mundi directed by Klaus L. Neumann. St Michel de Provence, 1982. See Dronke (1970), pp. 169ff., pp. 180-92.

38. Dronke (1984), pp. 171-83, 241-50 for edited passages. See Hildegard's

39. Migne, PL 197, cols. 216-8; Dronke (1984), p. 149.

40. Ibid., col. 352; see also Page's record sleeve notes, which first brought this letter to my attention.

41. Dronke (1984), pp. 168, 250-4.

42. Vita, ibid., pp. 236-7.

43. PL 197, cols. 371-3. Letter to community of nuns at Zwiefalten, near Württemberg. Cf. her vision, quoted Dronke (1984), pp. 164, 239, of a 'pulcherrimus et amantissimus vir'.

44. Dronke (1984), p. 169.

45. Scivias, vol. 2, pp. 386, 452, 505.

46. Ibid., vol. 2, p. 386.

47. Ibid., vol. 2, p. 377.

48. Letter to Abbot Adam of Ebra, PL 197, cols. 192-3, Dronke (1984), p. 170.

49. Dronke, ibid., p. 145. He gives the text of Hildegard's Vita, pp. 231-64.

50. Dronke (1984), p. 170.

51. Letter to Bernard, PL 197, cols. 189-90.

52. PL 197, cols. 325-6.

53. Letter to Bernard, ibid., cols. 189-90.

54. Scivias, vol. 1, p. 3; cf. passages from Vita, Dronke (1984), p. 231.

55. Bernard, Sermo XXXVIII, iii, 4, In Cantica Canticarum, quoted Ferrante, p. 28.

56. Scivias, vol. 1, p. 142; PL 197, col. 453.

57. The illuminated MS. of Scivias, one of the great treasures of the twelfth century, was lost in Dresden, where it had been taken for safe keeping, during the last war. But Baillet, passim, reproduces many of the illuminations, some in colour.

58. Baillet, pls. V, VII; Scivias, vol. 1, pp. 92, 174.

59. Scivias, vol. 1, p. 93; PL 197, col. 433. See Singer.

60. Baillet, pl. VII; see also Scivias, vol. 1, pp. 174-81.

61. Farmer, p. 193.
62. For Hadewijch, see Mother Columba Hart's translation, pp. 1-42; Ria Wanderauwera, 'The Brabant Mystic Hadewijch', in K. Wilson, pp. 186-203; also edition and translation into French by Frère J.-B.P (orion), pp. 7-56; Dronke (1984), p. 325 for bibliography; Lilar, pp. 90-100; and Guest (a principally technical study).
63. Hart, pp. 1-2.
64. Vision 7, in Hart, pp. 281-2.
65. Lilar, p. 99.
66. See Bonaventure, *Meditations on the Life of Christ*, trans. Isa Ragusa, ed. Isa Ragusa and Rosalie B. Green (Princeton, 1961).
67. 'The Strongest of All Things', Hart ed., 25, p. 319.
68. Ibid., 46, p. 320.
69. Ibid., 48-51.
70. Ibid., 62-74.
71. Ibid., 75-6.
72. Ibid., 77.
73. Ibid., 85-8, Hart, p. 321.
74. Ibid., 4-5, p. 319.
75. Ibid., 93-5, p. 321.
76. Ibid., 97-100, p. 321.
77. Ferrante, p. 40.
78. In NGL, part of a pair showing Music and Rhetoric, in *The Rival of Nature*, p. 47, nos. 251, 252 pl. 36. The rest of the cycle has disappeared. Naamah or Noemi, credited with the invention of weaving, sometimes appears alongside her brother Tubal-Cain (Gen. 4: 22), the originator of metallurgy and musical instruments as a protagonist of the *ars tecnica* of clothworking, as in a miniature of *c.* 1435, in the Bodleian, Oxford. See M. Evans, p. 327.
79. Homer, *Odyssey*, Prologue, 1-10; *Iliad*, 1; Hesiod, *Theogony*, 1-25, *Works and Days*, 1ff.
80. *Theogony*, 56ff. Hesiod's Muses are Clio, Euterpe, Melpomene, Thalia, Erato, Terpsichore, Polyhymnia, Urania, and Calliope, and the spheres they were later allotted are respectively: History, Elegy, Tragedy, Comedy, Lyric, Dance, Music, Astronomy and Epic, though definitions do vary. Hesiod gives two different accounts of their origins: first daughters to Kronos, they later reappear, engendered on Mnemosyne (Memory) by Zeus. See Hall, p. 217, for their attributes.
81. See Argan, pp. 101-7; the fresco forms a pair with another, showing Lorenzo Tornabuoni's bride Giovanna degli Albizzi being led to meet the Virtues or the Graces.
82. There is a sarcophagus in the Glyptothek, Munich, showing Minerva and Apollo together, with the Muses between them. Another, in Woburn Abbey, shows Apollo and Minerva together in the centre, with seven Muses.
83. Ovid, 5, 250ff, p. 123. See Poussin's drawing of this event (Windsor 11946).
84. Cicero's letter to Atticus, 1.4,3, saying that a statue of Athena is especially appropriate for his study, was interpreted to warrant her patronage of the intellectual life.
85. For Christine de Pizan, see Earl Jeffrey Richards; intro., *Book of the City of Ladies*, pp. xix-xlvi, Sarah Lawson, intro., *Treasure of the City of Ladies*, pp. 15-27.
86. Pizan (1977).
87. Ibid., p. 44, see Warner (1981), pp. 220, 63, 25.
88. There are also reminiscences of *The Shepherd of Hermas*, in which the Church appears as a woman, and then unfolds a series of visions in which various personifications, maidens all, build the Church on earth.
89. Pizan (1982), pp. 3-5.
90. Ibid., p. 218.
91. Ibid., pp. 73-5.

92. Ibid.
93. Pizan (1932), pp. 7-8.
94. See Warner (1981), pl. 11.
95. Giraldus, pp. 464ff.
96. Mosaic by Elihu Vedder, illus. Small, pp. 84-5, pl. xi.
97. There are sixteenth- and seventeenth-century examples of paintings depicting the scene *Minerva Presenting Painting to the Liberal Arts*, e.g. by Hans van Aachen showing the Muses greeting the new member of their company (private collection), another by Elsheimer (in the Fitzwilliam), by Lebrun (in the Louvre), by Pietro da Cortona (in the Uffizi).
98. Rose Garrard's reinterpretation of Artemisia's self-portrait has been an inspiration to me here. See *Flaccid Guns, Cutting Edge* and *Models Triptich*, in Rose Garrard, pp. 26-7. Exhibited Birmingham Ikon Gallery, 1984.
99. See Greer's comments, p. 201. Cf. *Annibale Caracci Raises Painting*, by P. Aquila, after C. Maratti, Levey (1981), p. 39.
100. Bjurstrom, pp. 18-19.
101. Ibid., p. 134.
102. For Angelica Kauffmann, see *Kauffmann* (catalogue); also Greer, pp. 80-2, 90-5; Hedges and Wendt, pp. 172. 221-2; Petersen and Wilson, pp. 43-6.
103. In National Portrait Gallery, London.
104. Oil sketches are in VA. Greer, p. 81, reproduces *Design*.
105. Ibid., p. 81, pl. 10. Collection Lord St

Oswald, Nostell Priory. Kauffmann's great friend, Reynolds, painted *Garrick between Tragedy and Comedy*, reproduced Meisel, p. 325; see also Hagstrum, pp. 190-7; Paulson, pp. 30ff., 80. Samuel Johnson commented à propos such paintings, 'I had rather see the portrait of a dog that I know than all the allegorical painting in the world.' Meisel, p. 28.

106. *Twenty Paintings*, pp. 20-1.
107. T. Matthews, *The Life of John Gibson* (London, 1911), p. 175.
108. Contemporary Christian feminism has returned to the feminine scriptural imagery, to work new meanings. In 1984, Rosemary Radford Ruether issued a call:

> As Woman-Church we cry out. ... We are not in exile but the Church is in exodus with us. God's Shekinah, Holy Wisdom, the Mother-face of God has fled from the high thrones of patriarchy and has gone into exodus with us. She is with us as we flee from the smoking altars where women's bodies are sacrificed, as we cover our ears to blot out the inhuman voice that comes forth from the idol of patriarchy. As Woman-Church we are not left to starve for the words of Wisdom; we are not left without the bread of life. Ministry goes with us too into exodus. Ruether, 1984, p. 3.

PART THREE

1. Ruth Padel 'The Market Place', in *Alibi* (London, 1985).

CHAPTER TEN

1. Lionel Bart, 'Living Doll', from the film *Serious Charge*, sung by Cliff Richard, 1959.

2. *Iliad*, 18, 417-20, pp. 347-8. Compare these golden girls to the gold and silver dogs that mount guard as sentries for the Phaeacians, also made by Hephaestus, in *Odyssey*, 7, 91-4, p. 114.

3. Hesiod, *Theogony*, 513-14, p. 40. (Page references are to Wender's translations.)

4. Ibid., 572, p. 42.

5. Ibid.

6. *Works and Days*, 81, Wender, p. 61.

7. Ibid., 60ff., p. 61.

8. Ibid., 72, p. 61; see Schmitt, passim.

9. *Theogony*, 573-7, p. 42.

10. Ibid., 578-84, p. 42; see *Iliad*, 18, 481ff.

11. *Works and Days*, 73-5, p. 61; see Loraux, p. 86.

12. *Iliad*, 18, 382, p. 347.

13. *Works and Days*, 63, p. 61.

14. Ibid., 64, p. 61.

15. *Theogony*, 511-12, p. 39.

16. Ibid., 585, p. 42.

17. *Works and Days*, 90ff., p. 62.

18. Ibid., 96ff., p. 62; in Aeschylus' *Prometheus Bound*, it is Prometheus who brings to humanity hope as well as fire, lines 248-51. See also Vernant, 'The Myth of Prometheus', in R. L. Gordon, pp. 184-5.

19. See Harrison (1900), pp. 99-106.

20. Smith, passim; Harrison (1900), pp. 106-7. For Zeus's jars: *Iliad*, 24, 525-39.

21. *Works and Days*, 82, p. 61.

22. Ibid., 67-8, 83, p. 61. See Vernant (1982), p. 178.

23. *Odyssey*, 8, 276ff., pp. 129-31.

24. Ibid., 8, 493ff., p. 135.

25. Zeitlin (1981), p. 154.

26. *Theogony*, 602-7, p. 43; Vernant (1982), pp. 178-9.

27. *Works and Days*, 703, p. 82.

28. *Theogony*, 590-3, p. 42.

29. *Works and Days*, 106ff., p. 62-3; Vernant (1982), p. 176.

30. Giraldus, *Syntagma* XIII, p. 571; Harrison (1900), p. 100.

31. Kerényi, p. 213; Loraux, pp. 14ff. In Plato's *Timaeus*, humanity is made out of clay male and female, as we saw in Ch. 4.

32. Pausanias, 1. 24.7; Pliny, *Natural History*, 36, 5, 19; see Smith, passim.

33. Ovid 1, pp. 39-40.

34. See also Isa. 29:16; Jer. 18:6; Isa. 45:9; Rom. 9:20.

35. Tertullian, *De Corona Militis*, VII, quoted D. and E. Panofsky, p. 12.

36. Origen, *Contra Celsum* IV, ibid., p. 12.

37. Phillips, fig. 3A, p. 26.

38. 'Numeri Rabba, a Midrash', ed. R. Graves and R. Pata, in *Hebrew Myths*, p. 65, quoted Figes, p. 26.

39. Scholem, 'Lilith', *Encyclopaedia Judaica*, pp. 246-9.

40. Milton, *Paradise Lost*, IV, 708ff., quoted D. and E. Panofsky, pp. 62-7, 71.

41. *Iliad*, 6, 354ff., p. 126.

42. Ibid., 3, 125-8, p. 67.

43. *Odyssey*, 4, 220ff., pp. 70.

44. Ibid., 4, 235ff., pp. 70-1.

45. Ibid., 4, 274ff., pp. 71-2.

46. See Zeitlin (1981), for an acute account of Helen esp. pp. 153-4.

47. Euripides, *Helen*, trans. Vellacott, p. 136. The story of her innocence is widespread, cf. Plato, *Phaedrus*, 243a-b; Herodotus, II, pp. 170-4.

48. *Helen*, p. 152.

49. Ibid., p. 153.

50. *Iliad*, 5, 499.

51. See *The Times*, 8 September 1983: report of the 12th International Congress of Classical Archaeology, Athens; also John Barron, *An Introduction to Greek Sculpture* (London, 1981).

52. Pindar, *Olympian* VII, Bowra, pp. 164-9; trans. Sandys, pp. 70-81.

53. Ibid., 33-4, Bowra, p. 165.

54. Ibid., 33-7, p. 165.

55. Ibid., 51-3, p. 166.

56. *Zoogoneo*, to make living creatures (out of inanimate substances) is used once of Zeus giving birth to Athena by Lucian; *zooplasteo* means to mould to the life, to make into statues; *zooglyphos* is a word for sculptor; in one instance the creator himself is called *zooplastes*.

57. Graves, I, pp. 188-9.

58. See Harrison (1900), p. 107, where she says that if Sophocles' lost satyr play, *Pandora* or *The Hammerers* had come down to us, we might know more about the Greeks' view of the relationship between the making of art and the making of woman.

59. Pindar, *Olympian* VII, 54, p. 166.

60. See Hagstrum, p. 24.

61. Pliny, *Natural History*, 35, 64-5, quoted Bryson (1983), p. 1.

62. Ovid, 10, pp. 231-2.

63. For the transmission of Hesiod, see *Theogony* (ed. West), pp. 48-61.

64. Ovid, op. cit.

65. *Anthologie poétique française*, 2, pp. 58-60.

66. See Thompson, 2, p. 41; 3, pp. 261, 346; 5, p. 333.

67. Ibid., 3, p. 436.

68. Carlo Collodi, *Pinocchio*, trans. E. Harden (London, 1984).

69. Shelley, passim.

70. Pliny, *Natural History*, 36, 4.

71. Gautier de Coincy, 'De l'enfant qui mist l'anel au doit l'ymage', from 'Miracles de Notre Dame', in *Vierge et merveille*, lines 44-9, p. 88.

72. Ibid., lines 154-62, pp. 92-4.

73. *Twelfth Night*, Act I, Sc. iv.

74. Cicero, *Second Treatise on Rhetorical Invention*, II, I. Trans. C.D. Yonge (London 1894), quoted Hagstrum, p. 14.

75. See Alpers, pp. 106ff, 119ff, 166ff, 223ff. for a sensitive and inspiring discussion of this painting.

76. Herrad of Hohenburg, fol. 31r., I, p. 103. Clio's name derives from *cleo*, to make famous, and *cleos*, rumour or fame.

77. Alpers. pp. 166ff.

78. Ibid., p. 106.

79. Ibid., p. 167.

80. Levey (1981), p. 14.

81. See William L. Pressly, *The Life and Art of James Barry* (Yale, 1982).

82. Beattie, fig. 163, p. 167.

83. Wood, p. 233.

84. Mérimée, pp. 87-118; the source is William of Malmesbury, *De Gestibus Regum Anglorum*, Stubbs ed., I, 256-8; see Mérimée, pp. 79-80, for its many later versions.

85. D'Annunzio, in the Prologue of *La Pisanella*, also turns to the theme with relish.

86. Jenkyns, p. 141.

87. Ibid., pp. 141-2.

88. Not all collectables are invariably Venuses. See Lorenzo Lotto, *Portrait of Andrea Odoni*, in which he holds a Diana of Ephesus. In the Queen's Collection. See *The Genius of Venice*, pl. 92, 1778.

89. Meisel, pp. 47-8.

90. Wharton, *The House of Mirth* (Harmondsworth, 1979), pp. 153-4.

91. Garrard, pp. 1, 12-15, and in conversation with the author. She has focused principally on Bates's sculpture.

92. Edwin Muir, 'Adam's Dream', quoted in David Daiches, *God and the Poets* (Oxford, 1984), p. 180.

CHAPTER ELEVEN

1. Plato, *Republic*, p. 110.

2. *Moroni*, pp. 21-3, fig. 30.

3. Pliny, 28, 2, 12; Valerius Maximus, VIII, 1.5; also in Dionysius of Halicar-

nassus, II, 69. 1ff. Stories about virgins' magical powers are quite frequent in the literature of all societies; see F. J. Child, *English and Scottish Popular Ballads* (Boston, 1882-98, rep. New York, 1957) 1, pp. 270-1 for examples; Warner (1976), p. 72, (1981), pp. 148ff; Bugge, passim. Another Vestal, Claudia Quinta, proved her chastity by miraculously freeing a stranded boat on which a sacred statue was being transported. See the painting c. 1494, by Neroccio de' Landi and the Master of the Griselda Legend, in the National Gallery of Art, Washington.

4. Tuve (1966), pp. 71-2, fig. 14, reproduces Bodleian MS. Laud misc. 570, f. 9v, from John of Wales on the Cardinal Virtues, adapted by Christine de Pizan (?); also *Brueghel*, Klein ed., pl. 52; Whitney, p. 68, shows a sieve on its own, as the emblem of prudence with the motto: 'Sic discerne/The prudent sorte . . ./And sifte the good, and to discerne their deedes,/And weye the bad, noe better than the weedes.'

5. Augustine, *City of God*, X, 16.

6. Petrarch, *Trionfi*, lines 23ff. The cycle describes Chastity prevailing against Love; then Death against Chastity; Fame against Death; Time against Fame. The first two, with their clear appeal to lovers and spouses, were the most popular, but the poems inspired a wealth of artefacts, in all media.

7. Marle, 2. pp. 111-31.

8. Petrarch, lines 148-51.

9. In the Paul Getty Museum. Fredericksen, figs. 8-10, pp. 18-19.

10. In the Richmond Museum of Art, Virginia; Fredericksen, pp. 39-40, fig. 26.

11. Museo Bandini, Fiesole; reproduced in Yates (1975), fig. 15.

12. In the Albertina, Vienna.

13. Compare with Rubens' drawing, in the Louvre.

14. In the Pitti Palace, Florence.

15. In Ugbrooke Park, Chudleigh, Devon.

16. Yates, p. 115; see also pp. 114-20; Strong, pp. 66ff., pl. xx.

17. Camden (1605), p. 373.

18. For Aeschylus' *Suppliants*, see Garvie; Johansen and Whittle, esp. vol. 1; Winnington-Ingram (1961-2, 1983); Zeitlin (1978). References to the text are given in Vellacott's translation.

19. Aeschylus, *Suppliants*, 332, p. 64.

20. Ibid., 1013, p. 84.

21. Ibid, 1047-51, p. 85.

22. *Prometheus Bound*, 862-4, p. 45.

23. Ibid., 867-8.

24. See Johansen and Whittle, 1, pp. 50ff; Garvie, pp. 176-7, 234-5. The earliest images that may be of the Danaids are most uncertain. Carcopino, pp. 280-91 argues that the fate of the uninitiated in Pythagoreanism was transferred to the Danaids during the first century AD.; in the Metaponto Museum, a fourth-century BC Hydria, showing women pouring water, has however been tentatively identified as an image of the Danaids. *I Musei Archeologici della Provincia di Matera*, p. 22.

25. Winnington-Ingram (1961-2) argues very persuasively that Aeschylus' third play might have ended with the Danaids' ritual purification and acceptance of marriage, another triumph for moderation over excess, as dramatized in *The Oresteia*, where Orestes, a protagonist who has also committed a great pollution, is saved. See also Johansen and Whittle, 1, pp. 46-9. Early stories about the sisters certainly relate their subsequent re-marriage. (See Pindar, *Pythian* IX, Bowra, pp. 86ff.; Pausanias, 3,12.2) However, if it were the case that the Danaids had been purified of their crime by Aphrodite in Aeschylus' trilogy, another, vigorous, part of their myth which Aeschylus either ignored or did not know, denied them

redemption, and placed them in Hades all the same.

26. Horace, III, xi, 25-44 (1914), p. 218.
27. Ibid., trans. W. G. Shepherd, pp. 144-5.
28. Aeschylus, *Suppliant Women* trans. Murray, p. 23.
29. Ibid., p. 12. See also Harrison (1900), pp. 110-1; also Graves, 1, pp. 204-5.
30. Pindar, *Nemean* X, Bowra, p. 176.
31. Horace III, xi, ibid.
32. Aeschylus, *Suppliants*, 798-99; *Prometheus Bound*, 863.
33. Hyginus, *Fabula* 168; Apollodorus ii, 1.5; Graves, 1, p. 201. 203. Hesiod, fr. 128; Johansen and Whittle, 1, p.44.
34. Winnington-Ingram (1961-2), pp. 151-2.
35. From Photius Lexicographus, ninth century, quoted Pembroke, p. 32.
36. Plato, *Gorgias* 493B, (1971), pp. 92-3; Dodds ed., pp. 296-7; see also Plato, *Republic*, p. 110 (see note 1).
37. By the Maestro delle Vele, part of the spandrel cycle of the Virtues which includes Francis' marriage to Lady Poverty (see Chapter 13).
38. See Ch. 4, n. 79.
39. Tuve (1966), p. 119ff.
40. Ripa (1602), *Virginità*, pp. 288-9; (1611), pp. 534-6.
41. Three children, approximately the same age, are very common in images of Charity; cf. the school of Raphael drawing in the Albertina, Vienna; Andrea del Sarto's painting in the Louvre; Ripa (1602), p. 64; (1644). p. 292; and Bouguereau's *Alma Parens* in which a host of children clambering over the mother figure of Charity reveal how multiplication of offspring in the nineteenth century assured Charity's allegorical status in imagery. (See E. Wind, 'Charity: The Case History of a Pattern', JWCI, 1, 4, pp. 322-30.
42. In nineteenth-century holy pictures, the image of the bodily vessel was a widespread visual trope: cf. 'Le Vase

d'argile s'est brisé, et l'âme fidèle s'élève au ciel' - sheet of emblems, 1832, in BN, Paris, exhibited in *Un siècle d'images de piété*, Musée Galerie de la Seita, Paris, 1984; see Catherine Rosenbaum-Dondaine. The heart too, both Jesus and Mary's and the ordinary human heart, inspires variations both sentimental and grisly on the equation between a container and identity. Ibid., pp. 74-5, a sheet of engravings showing hearts like perfume bottles; pp. 120-1, 'Le cœur malade, le cœur vivant, le cœur guéri', showing the heart as a jar/lamp, filled, growing, burning with the love of God.

For the feminine gender of ships, see Rodgers (1983) and Rodgers, 'Feminine power at Sea', in RAIN, October 1984, pp. 2-4.

43. Musurillo, pp. 65-6.
44. *Conferences*, 2, quoted Musurillo, p. 140.
45. Fortunatus, *Opera Poetica*, C. Nisard ed. (Paris, 1887), Bk. 8.3, quoted O'Faolain and Martines, p. 138.
46. *Hali Meidenhad*, p. 49.
47. Boxer, p. 99.
48. Christian (1972), pp. 151-3.
49. Ibid., p. 159.
50. Methodius, *Logos* 11, Musurillo ed., p. 150.
51. *Hali Meidenhad*, p. 13; Bugge, p. 127.
52. The earliest litany invoking Mary under biblical names was composed around 1200. The Litany of Loreto was established by St Peter Canisius, SJ (d. 1597) from a version in use at the shrine of the Holy House, Loreto. He published the first printed copy at Dillingen in Germany in 1558.
53. Ex. 3: 1-10; there is a magnificent painting of the Madonna and Child seated in the burning bush by Nicolas Froment (d. c. 1484), in the central panel of a triptych in the cathedral, Aix-en-Provence.
54. See Mâle (1972), p. 198.

55. This is a development of northern European sixteenth- and seventeenth-century art, which showed the Foolish Virgins in contemporary dress, idling at cards, at banquets, at self-adornment, at making music and making merry, while the Wise ones sew, spin and study. E.g. Peeter Lisaert's painting in Seville. The iconography was borrowed for paintings of the Five Senses: the Foolish Virgins' tippling became emblematic of taste, their musical instruments of hearing, and so forth. Cf. Frans Floris' painting in the National Gallery of Canada, Ottawa.

56. *Aucassin and Nicolette*, quoted Adams p. 233:

'En paradis qu'ai je a faire? Je n'i quier entrer mais que j'aie Nicolete, ma tres douce amie, que j'aim tant. C'en paradis ne vont fors tex gens con je vous dirai. Il i vont ci viel prestre . . . en infer voil jou aler. Car en infer vont li bel clerc et li bel cevalier. . . . Et si vont les beles dames cortoises. . . . Avec ciax voil jou aler mais que j'aie Nicolete, ma tres douce amie, aveuc moi.'

'In Paradise what have I to do? I do not care to go there unless I may have Nicolette, my very sweet friend, whom I love so much. For to Paradise goes no one but such people as I will tell you of. . . . There go old priests. . . . To Hell go the fine scholars and the fair knights . . . and the fair courteous ladies. . . . With these will I go, if only I may have Nicolette, my very sweet friend, with me.'

57. *Schongauer,* pp. v–x, xiv, pls. 79–88, 103.

58. Réau, 3, 2, pp. 846–59.

59. Luke 7: 39–47. See Saxer passim for the cult of Mary Magdalen.

60. Réau, ibid.

61. Voragine, 4, p. 73. Even this cave, called after the precious ointment, seems to continue the symbolism.

62. See Kirsten Hastrup, 'The Semantics of Biology: Virginity', in S. Ardener (1978), pp. 49–65; also King, p. 111.

63. Lakoff and Johnson, p. 92. Mary Douglas' work is fundamental to the argument here about containers.

64. The overlap (between the two dominant metaphors for argument – the container and the journey –) 'is the progressive creation of a surface. As the argument covers more ground (via the Journey surface) it gets more content (via the Container surface).' Lakoff and Johnson, pp. 92–6.

65. Léopold Morice (1846–1920) produced little else of note. Kjellberg, p. 104. See dossier on him in the Musée d'Orsay, Paris.

66. See for instance Rome and Constantinople, in the Kunsthistorisches Museum, Vienna, reproduced in Carrà, p. 71.

67. Addison, pp. 87–8.

68. *Hôtel de Ville*, pp. 157–65.

69. Beattie, pp. 222–4, pls. 224–5.

70. Barry Flanagan, in conversation with the author.

71. See Rosen and Zerner, 'The Ideology of the Licked Surface', pp. 205–32, for an amusing and perceptive discussion of the alignment of official *pompier* art and varnished smoothness, '*le fini*', whose function is to hold the real world of experience at a very great distance.

72. Aristophanes, *The Poet and the Women*, trans. D. Barrett, pp. 107–8; Zeitlin (1981), p. 134.

73. Francesco di Valdambrino, (active 1402, d. before 1435). Crucifix exhibited in Siena, Pinacoteca, July 1984. David Freedberg's Slade Lectures, given autumn 1984, inspired much of what I say here about simulacra.

74. Weekes, p. 169, quoted Read, p. 199.

75. See for instance Frampton's *Lamia* (1899-1900) and *Mysteriarch* (1902), in Beattie, pp. 150, 158, pl. 1, fig. 152.
76. Read, p. 25, pl. 43.
77. Matthews, p. 230; quoted Read, p. 25.
78. *The Times*, 23 November 1982.
79. *Carpeaux à Matisse*, pp. 128-9.
80. Ibid., pp. 113, 120.
81. Ibid., pp. 129-38; there is a model for this group in Manchester City Art Gallery.
82. Cf. Baudelaire, Ch. 7, n. 37.
83. See Carole Vance, 'Pleasure and Danger: Towards a Politics of Sexuality', in Vance, p. 15.
84. Herrera, pls. XIV, XXVIII, XXIX, pp. 76-7, 277-9, 282-3, 347-8.
85. Griffin (1984), pp. 190-1.
86. Daly, esp. (1984), is one of the chief voices of this philosophical movement, though much more demagogic in character than Griffin; see also Rich (1977, 1980).
87. Chicago (1979, 1980, 1982), passim.
88. Chicago (1979), p. 22; see also Ardener (1983), p. 15.
89. Chicago (1982), pp. 143-4; Ardener (1983), p. 16; see also Pollock and Parker (1981), p. 32.
90. *The Dinner Party* was exhibited during the Edinburgh Festival, 1984, where the author saw it.
91. Herrera, pl. XXXI, pp. 356-8.
92. Susan Hiller, in conversation with the author; see also Van Den Bosch.
93. 'Notes IV', Hiller (1979).

CHAPTER TWELVE

1. Hugo, *Chants du crépuscule*, I, 'Your mother is indeed this fecund France. ... Oh! the future is magnificent! Youth of France, young friends, a pure and peaceful century opens before your ever steadier steps.... Every day will have its victory. We shall see, like a sea rising on the shore, majestically rising from level to level, from the base to the summit, Liberty, irresistible!' Hugo, 3, pp. 13-24.
2. For Dalou, see Dreyfous; Hunisak; Mosse; Agulhon (1973); Beattie, pp. 114-16, and passim; Read, pp. 333-5.
3. Dalou is a pivotal figure in English sculpture. As an exile in London, he taught the generation who have emerged as the most sensitive and imaginative of the New Sculpture school, first at the National Art Training College in South Kensington (later the Royal College of Art), and then at the South London Technical Art School at Kennington too. His craftsman's immediacy of model-

ling freed sculptors like Alfred Gilbert and Frederick Pomeroy from neoclassicism's stiffness. Alfred Drury, one of the finest late-Victorian sculptors, returned with Dalou to Paris and assisted him on *The Triumph of the Republic* from 1881 to 1885.
4. Read, pp. 376-8.
5. Dreyfous, pp. 104ff.
6. Cf. Dalou's effigy of Victor Noir, a republican journalist who was shot in 1870 by Prince Pierre Napoleon, a cousin of the emperor, and who thus became a martyr to the cause. The tomb, in Père Lachaise, shows Victor Noir as he fell dead on the ground; it is a masterpiece of radical realism, breaking with the tradition of dignifying the body of the deceased in death. The observation of Dalou was so unsparingly exact that he rendered the bulge in the crotch of his breeches; this has today become a fertility fetish, and has been rubbed shiny by visitors, who also leave

flowers on the grave in order to have better luck with their wives! Author's visit May 1984, *Connoisseur*, July 1985; see also Penny, 'Stroking'.

7. The Victoria and Albert has a fine large Dalou, *The Rocking Chair*, and others; examples of his work can be seen in the Musée d'Orsay, Paris, Manchester City Art Gallery, Castle Howard, Yorkshire, the Detroit Art Institute and the Toledo Museum.

8. Hunisak, p. 217.

9. Compare Dalou's *Bacchanale*, for the Jardins Fleuristes in Paris, (version in VA) with Clodion's *Satyr* with two bacchantes in the Frick, New York, for instance.

10. Hunisak, p. 229.

11. The architect Alavoine designed it, from 1831 to 1840, in memory of the dead of the Trois Glorieuses. Barye and Marneuf worked on the column, Augustin Dumont sculpted the 4m high 'Génie de la Liberté' on the top. Agulhon (1979), pp. 46-7; Kjellberg, p. 47.

12. Agulhon (1979), p. 6.

13. For a broad-ranging and inspiring view of undress, see Hollander, pp. 157-236.

14. For Delacroix's *Liberty Guiding the People*, see Hobsbawm (1978); Hadjinicolaou; Toussaint (1982); Hollander, pp. 199-202; Honour (1979), pp. 235-6. For Delacroix's *œuvre*, see Rossi-Bortolatto.

15. Letter to Félix Guillemardet, 15 February 1831, quoted Toussaint, ibid., pp. 6-7.

16. Hadjinicolaou, pp. 23-5.

17. T. J. Clark (1973), p. 17.

18. Toussaint (1982), pp. 36-8.

19. Ibid., pp. 18-19.

20. Ibid., p. 19: *Les Femmes Souliotes*, pp. 20-1; *Etudes de guerrière* and *Projet pour une composition célébrant la Grèce*, pp. 21-6.

21. Saxl (1931), passim.

22. Ibid., *San Clemente* (guidebook), Rome, 1973, fig. 38.

23. Saxl (1931), pl. 133; BM 1720.

24. See the Jenkins vase, in the National Museum of Wales, Cardiff: a beautiful relief carving of the *Marriage of Paris and Helen*; J. L. David also painted Paris in a scarlet cap, in his *Paris and Helen* of 1788, see Brookner, pp. 87-8, fig. 41.

25. The Magi also appear wearing Phrygian caps on the sarcophagus of Valerius and Adelphis (fourth-century) in the Archaeological Museum, Syracuse, and in the fifth-century mosaics of Santa Maria Maggiore, Rome.

26. For the obelisk of Theodosius I, see Grabar, pl. 120.

27. For an early Carolingian representation of the Magi as kings, see Beckwith (1964), p. 110: *The Gospel Book of Otto III, c. 1000*.

28. Red-figured *pelike*, BM E390, Birchall and Corbett, fig. 54.

29. Onians, pp. 144ff.

30. Gombrich (1979), p. 196, fig. 8.

31. Ibid., figs. 8, 9, p. 196.

32. Cartari, fig. 308, engraved by Bolognino Zaltieri.

33. Ripa (1602), pp. 292-3; Gombrich, (1979), fig. 10; Ripa (1611), pp. 312-13.

34. Menestrier, pl. CXI.

35. I am grateful to Mark Jones for showing me these medals (1689, 1714) in the BM Coins and Medals Department.

36. Gombrich (1979), pp. 198-9.

37. E. F. Henderson, p. 59; Philippe, p. 122.

38. *La Révolution française*, p. 98.

39. Harris, pp. 283-313.

40. Kathryn C. Buhler, *Paul Revere, Goldsmith 1735-1818* (catalogue, n.d.), Museum of Fine Arts, Boston, pl. 21.

41. In the National Numismatic Collection, National Museum of American

History, exhibited in 'Treasures from the Smithsonian Institution', Royal Scottish Museum, Edinburgh, 1984.

42. Agulhon (1979), pp. 139-61 describes fluctuations in the cap's acceptability.

43. Agulhon, ibid., pp. 154-6.

44. I am grateful to all those who took part in the discussion of this chapter at a meeting of the History Workshop, 1984, for analysis of these inversions.

45. Hollander, p. 202.

46. Keen, p. 149, on the association of the Franks, the knight crusaders, with the French and their *franchise*, or frankness.

47. *Odyssey*, 5, 298, p. 96; Garnier (1982), p. 184, says that the hand indicating the breast is a sign of sincerity, generosity and acceptance, and present in images of Christ as intercessor.

48. I am grateful to Susannah Clapp for reminding me of Keats's 'Ode to Autumn': 'Close bosom-friend of the maturing sun ...' does not tell us whether Autumn is male or female. Though traditionally - following Latin - he is male, Keats suggests a Ceres-like goddess of the harvest:
 Thy hair soft-lifted by the winnowing wind ...
 while thy hook
 Spares the next swath and all its twined flowers.

49. Red-figured amphora, BM E256, found at Vulci, 510-500 BC, Birchell and Corbett, pl. 6. See also BM 21 55, mid-fourth century BC. Compare two celebrated Dianas of antiquity, much reproduced later: the *Diane de Versailles*, which shows her as a huntress in short tunic (but not slipped) in the Louvre, and the *Diane de Gabies* (also Louvre) in which she is either fastening or unfastening her long robe (Haskell and Penny, pp. 196-9).

50. Euripides, *Hippolytus*, trans. R. Warner, pp. 78-9, for Aphrodite's rage against the hero for worshipping Artemis 'the virgin goddess'. For Actaon's sad tale, see Ovid, 3, pp. 77-8.

51. Ibid., 2, pp. 61-2.

52. Robertson, 1, p. 378.

53. In Kunsthistorisches Museum, Vienna.

54. Euripides, *Bacchae*, pp. 215-16. The herdsman describes their ecstatic disarray:

 I have seen the holy Bacchae, who like a flight of spears
 Went streaming bare-limbed, frantic, out of the city gate ...
 First they let their hair fall free
 Over their shoulders; some tied up the fastenings
 Of fawnskins they had loosened; round the dappled fur
 Curled snakes that licked their cheeks. Some would have in their arms
 A young gazelle, or wild wolf-cubs, to which they gave
 Their own white milk ...

55. In BM.

56. The battle of the Lapiths and Centaurs is the probable subject of the Parthenon metopes in the British Museum, reproduced Brommer pp. 23-30; see Graves, i, pp. 360-2 for the myth.

57. For Amazons, see Warner (1981), pp. 203-5, n. 29, p. 314. It is a late accretion to their myth, found in Diodorus Siculus, III, 52ff., trans. C.H. Oldfather (London, 1935), that they severed a breast in order to draw the bow. The mutilation is not shown in Greek art.

58. See Merck, pp. 99-106.

59. Cf. silver multiple of Priscus Attalus (c.409-410) in *Wealth of the Roman World*, pl. 569.

60. Vermeule, passim.

61. King, pp. 111-13.

62. E. Ardener, pp. 14-15.

63. Ibid., p. 14.

64. Ibid.

65. *Iliad*, 22, 79-89, p. 399. Hecuba uses the word *mastos*, a sex-specific word for the breast.

66. Aeschylus, *Oresteia, Libation Bearers*, 883-9, pp. 216-17.

67. Zeitlin (1978), p. 158.

68. One of the Twelve Tables of the Republic, in Lefkowitz and Fant, p. 175.

69. See Warner (1976), pp. 192-205.

70. *Dürer*, p. 219: title page of *The Life of the Virgin*, 1511, *The Virgin in Glory*.

71. Warner (1976), pp. 181-3.

72. Arnaud de Chartres (d. 1156) used Hecuba's gesture to illuminate Mary's powers of intercession as the Mother of Jesus in a sermon. See Warner, ibid., pp. 199-200, and fig. 26 for an anonymous painting of *c.* 1402 showing Mary interceding with God the Father and showing her breast like Christ showing his wounds. (In the Cloisters Museum, New York).

73. In A. Cirici Pellier, *El Arte Modernista Catalan* (Barcelona, 1951), p. 155. My thanks to Temma Kaplan, who brought this carving to my attention.

74. Reproduced in Marle, 2, p. 177.

75. See Warner (1976), p. 197 for St Bernard's indignation at the custom; see Sussman for an account of wet-nursing practices from 1700 to 1900.

76. The Melun Diptych, *c.* 1450. The Virgin panel is in the Antwerp Museum.

77. Heilbrunn, passim; cf. *Minerva protects Pax from Mars*, in NGL, and the *Consequences of War*, in the Pitti Palace, Florence.

78. Princess Charlotte, the beloved daughter of George IV, whose death in childbirth in 1817 eventually led to Princess Victoria's accession, is commemorated in St George's Chapel, Windsor, by a remarkable monument by Matthew Wyatt, showing her soul ascending to heaven attended by angels, while draped mourners weep around her shrouded corpse. The Princess' ascending figure is wearing a slipped chiton.

79. In the Philadelphia Museum of Art. A similar composition was later adapted to represent the higher love of the Patria, as in a vignette by J. Chéreau.

80. Beaulieu (1981), p. 4. In the Louvre.

81. Also in the Louvre, see Beaulieu, ibid., p. 3. *Iconology* (London, 1832) prescribes that Friendship should be 'the figure of a woman, simply dressed in white, with flowing hair, and crowned with a garland of myrtle and pomegranate flowers; her breast is uncovered and her feet bare. She points to her heart ... the simple dress of white, and flowing hair, indicate that true friendship is natural, and an enemy to fiction or flattery.' p. 17.

82. Rudofsky, pp. 42-3; two drawings in the British Museum, *Iphigenia* (1749) and *Miss Ch-dly* (1749), the latter exhibited in *Masquerade*, Museum of London, July-October 1983.

83. Gravelot and Cochin, 1768. There is an early instance of Natura depicted as a nursing mother, usually the activity of Wisdom in Christian allegory, on the *champlevé* enamel Liberal Arts casket, *c.* 1180-1200, VA. See *English Romanesque Art*, pp. 270-1. Dronke (1980), passim, on the development of the idea of Natura as a mother giving milk.

84. Sussman, pp. 109-10 gives figures for babies put out to nurse from Paris; see also pp. 27-9.

85. 'Lettre à d'Alembert', 1758, in Rousseau (1820), pp. 86-7, 187-96; Mosse, p. 170. For David's *Fêtes*, see Dowd, passim; Ozouf, passim; E. F. Henderson, pp. 356ff; Brookner, pp. 100-7, 119-20.

86. Agulhon (1979), p. 88.
87. Gombrich (1979), pp. 188ff; Starobinski (1979), p. 102; Ozouf, pp. 119ff., 135ff.
88. Gombrich, (1979), pp. 188-9, quoting M. A. Thiers, *Histoire de la Révolution française* (Brussels, 1845), I, p. 449.
89. Gombrich, p. 189, quoting Aulard (1982), p. 83; see also Starobinski (1979), p. 102, who adds that Hébert perceived the irony in attempting to portray Liberty incarnate by actresses who were 'free' in another sense of the word: 'Elle (la Raison) était entourée de toutes les jolies damnées de l'Opéra', p. 102.
90. E. Burke, p. 69.
91. Hunt (1980), p. 14.
92. Article VI, Declaration of the Rights of Women and Citizens, 1790, in Riemer and Fout, pp. 63-7; for the role of women in the Revolution, see R. B. Rose, *The Making of the Sans-Culottes. Democratic Ideas and Institutions in Paris 1789-92* (Manchester, 1984).
93. Rousseau, 'De l'Inégalité parmi les hommes', in *Du contrat social*, e.g. p. 55: 'La plupart de nos maux sont notre propre ouvrage, et [que] nous les aurions presque tous évités en conservant la manière de vivre ... qui nous étoit présentée par la nature.' Or p. 84: '... dons essentiels de la nature, tels que la vie et la liberté'. See too, the famous ringing opening of *Du contrat social*: 'L'homme est né libre, et partout il est dans les fers', ibid., p. 236.
94. Paulson, p. 14; the revolutionary year began at the autumn equinox, on 22 September, and the months were called Vendémiaire, Brumaire, Frimaire, Nivôse, Pluviôse, Ventôse, Germinal, Floréal, Prairial, Messidor, Thermidor, Fructidor. In a pack of cards of 1793 in the Musée Carnavalet, they are all represented as 'gracieuses jeunes femmes'. See *L'Art de l'estampe ...*, nos. 325ff.
95. Ozouf, p. 135.
96. Gravelot and Cochin, 1767.
97. Harris, pp. 283-313.
98. *La Révolution française*, pp. 36-7, reproduces his male designs. Interestingly these fashions were not taken up like the women's. See *Les Fêtes de la Révolution*, no. 97, p. 43, for P.-E. Le Sueur's designs for women.
99. In NGW, reproduced Hollander, p. 65.
100. Agulhon (1979), p. 29.
101. Balzac, *Les Paysans*, p. 392:

> Catherine, grande et forte, en tout point semblable aux filles que les sculpteurs et les peintres prennent, comme jadis la République, pour modèle de la Liberté, charmait la jeunesse de la vallée d'Avonne par ce même sein volumineux, ces mêmes jambes musculeuses, cette même taille à la fois robuste et flexible, ces bras charnus, cet œil allumé d'une paillette de feu; par l'air fier, les cheveux tordus à grosses poignées, le front masculin, la bouche rouge, aux lèvres retroussées par un sourire quasi féroce qu'Eugène Delacroix et David (d'Angers) ont tous deux admirablement saisi et représenté. Image du peuple, l'ardente et brune Catherine vomissait des insurrections par ses yeux d'un jaune clair, pénétrants et d'une insolence soldatesque.

102. Ibid., p. 233.
103. Flaubert, p. 291.
104. Daumier, *La République*, now in the Louvre. See Boime, pp. 76-7; T. J. Clark (1973), pp. 107-8, reproduced on the cover of the 1982 edition.
105. 'L'Œuvre et la vie d'Eugène Delacroix', in Baudelaire, p. 531.
106. Ibid.

107. 'La belle Dorothée', in *Petits Poèmes en prose*, Baudelaire, p. 165.

> Meanwhile Dorothée, strong and proud as the sun, goes up the deserted street, the only living thing at this hour beneath the immense blue heaven, and casting a stain against the light like a burst of blackness.
>
> On she goes, softly swinging her torso, so thin, on her hips, so wide. Her clinging silk dress, of a clear pink colour cuts vividly across the shadows of her skin and moulds the exact shape of her long waist, her hollow back and her pointed breasts. . . .
>
> Now and then the sea breeze lifts the corner of her floating skirt and reveals her leg, gleaming and splendid; and her foot, like the feet of those marble goddesses which Europe keeps closed up in its museums, prints its form faithfully on the fine sand. For Dorothée is so prodigiously flirtatious that her pleasure at being admired surpasses the pride of the freed slave, and even though she is free, she walks without shoes. . . . At the hour when even dogs groan in pain under the sun which bites them, what powerful motive moves her to make her way like this, indolent Dorothée, beautiful and cold as bronze?

108. Bruce Chatwin, 'The Banks of the Volga', *Observer Magazine*, 10 June 1984.

109. I'm most grateful to Philip French for bringing this grisly example to my attention.

110. See Sanday for an illuminating general study of different societies' views of women and nature, and the corresponding higher or more equal position of women among people who do not depreciate what they consider to be 'nature'.

111. See Daly (1984), for a radical acceptance of women's closeness to the wild and nature and Otherness.

CHAPTER THIRTEEN

1. From 'The Songs We Know Best', Ashbery, p. 3, reproduced with kind permission of Carcanet Press, Manchester.

2. See also Rev. 3:17-18; Hebrews 4:13.

3. Bercheur, vol. 2, pp. 332-3; Panofsky (1939), p. 156.

4. Ortalli, pl. III.

5. See *The Garden of Earthly Delights*, in the Prado, Madrid, reproduced in Martin, pls. 17, 22.

6. Knight falling: see M.D. Anderson, fig. 10; Mâle (1913), pp. 120ff. and fig. 63 (Amiens), fig. 51 (Chartres); startled by rabbit, Mâle, ibid., figs. 65, 70 (Cowardice from the Virtues and Vices cycle, Notre-Dame, Paris, and a rose window in the same); also at Reims, and Chartres (where the rabbit has been effaced); see also fig. 67 for an example in BN MS. Lat. 14284, delightfully painted; For Luxuria, Lust, see Mâle (1913), p. 116, fig. 57 (Amiens); also Katzenellenbogen (1939), pp. 75-81, pls. XLVI-XLVIII (Amiens and Notre-Dame, Paris).

7. Witkowski, vol. 1, p. 242; Katzenellenbogen (1939), pp. 58-9; Mâle (1924), pp. 375-6.

8. Heinrich Krämer and Jakob Sprenger, *Malleus Maleficarum*, trans. Montague Summers (London, 1951), quoted Phillips, p. 70. To put the *Malleus* in

NOTES

perspective, see Cohn; Douglas (ed.) (1970) and Larner (1981, 1984).

9. Peter Comestor, PL 198, col. 1072, quoted Phillips, p. 62.

10. See Phillips, pp. 59-69 for an interesting idiosyncratic discussion of Eve's resemblance to the serpent Satan, and for remarkable images, including Max Klinger's of 1880, in which Eve looks at herself appreciatively in a mirror held up by the serpent.

11. Now in the Cloisters Museum, New York.

12. On attitudes to death, see Ariès, pp. 95-201; on smells, Warner (1976), pp. 99-100.

13. On the fashion for Vanities, see Ariès, pp. 327-32.

14. *Ballade de la belle heaulmière*, in Villon, *Le Testament*, 501-8, p. 28. Author's translation; see Robert Lowell, *Imitations* (London, 1961), p. 19 for another, very free, version.

15. Villon, 517-24, p. 28.

16. John Gower, *Le Mirour de l'omme*, lines 17889-94, in *The Complete Works*, ed. G.C. Macaulay (Oxford, 1899), vol. 1, p. 208.

17. Blunt, p. 78, pl. 57.

18. Sculpted before 1583. Blunt, pp. 99-102, pl. 65. Cf. Pilon's effigy of Henri II, pl. 64, ibid; see Beaulieu (1979), pp. 12-13, for a drawing of the tomb as it was before it was mutilated during the French Revolution.

19. Ovid, II, lines 775ff., pp. 70-1.

20. *Italian Renaissance Drawings*, pl. 24.

21. Painted in 1507. In the Kunsthistorisches Museum, Vienna. Repro. Heinzl, pl. 49.

22. For an excellent study of perceptions of witches, focusing on Scotland, but with wide implications, see Larner (1981).

23. The Master of Niederrhein, *The Lovespell*, repro. K. Clark, *Feminine Beauty* (London, 1980), fig. 43. Compare with Frans Francken II (d. 1642),

Witches' Sabbath (VA), and, much later, Francisco Goya, *Pretty Teacher! Caprichos*, pl. 68, Bareau, p. 35.

24. Beaulieu (1981), p. 9.

25. Rembrandt, pls. B199 *Seated Naked Woman with a Hat beside her*, and B200, *Woman Bathing her Feet at a Brook*; see also Clark (1956), pp. 325ff., and (1966), pp. 11-12, 82-3. Adrian Stokes, III, pp. 325-6, wrote a famous passage, deserving re-quotation, about Rembrandt's attitude to the naked female body:

'[He] painted the female nude as the sagging repository of jewels and dirt, of fabulous babies and magical faeces despoiled, yet later repaired and restored, a body often flaccid and creased yet still the desirable source of a scarred bounty: not the bounty of the perfected, stable breast housed in the temple of the integrated psyche that we possess in the rounded forms of classical art, but riches and drabness joined by the infant's interfering envy, sometimes with the character of an oppressive weight or listlessness left by his thefts. There supervenes, none the less, a noble acceptance of ambivalence in which love shines.'

26. Letter written May 1911, quoted in Ede, pp. 52-3.

Interestingly the Hindu pantheon includes a goddess who resembles in many respects the hags of classical culture, though the points of convergence are beyond the scope of this book. Kali, in her aspect as Camunda, the devourer, has starting eyes, flat, withered breasts and desiccated limbs, and her ravening belly is hollow and open as she feeds on the entrails of a dying man whom she straddles, as in a stone relief in the British Museum. But in Hinduism, Kali is only one aspect of Parvati, the beautiful and nourishing goddess, consort of Shiva,

and her destructiveness mirrors one aspect of the creative energy of nature. See Zimmer, p. 213, pl. 68.

27. Onuphrius, wearing a hula skirt of leaves, appears in a Venetian painting attributed to G. F. Caroto (d. 1555) in the Philadelphia Museum of Art; St Macarius and St Anthony Abbot were painted as a pair of hairy hermits by Bartolo di Fredi (act. 1353–d. 1410) in the Pinacoteca of Siena. See Réau, 3, 1, pp. 101-15; 3, 2, pp. 845, 1007-10.

28. Réau, 3, 2, pp. 740-50.

29. *Encyclopaedia of Catholic Saints* (Philadelphia and New York, 1966), p. 19; Voragine 3, pp. 106-10 (Mary of Egypt) and 4, 73-89 (Mary Magdalen); Farmer, p. 271.

30. Réau, 3, 2, pp. 846-59, 884-8.

31. C. M. Kauffmann (1968), pl. 7.

32. *Dürer*, no. 199, *The Ecstasy of Saint Mary Magdalene*.

33. Known as *La Belle Allemande*, in the Louvre.

34. For Donatello in general, see Levey (1967); for excellent repro. of Judith, see MacCarthy, p. 4, f.p. 11.

35. BN MS.fr. 379 fol. 33, reproduced in Panofsky (1939), fig. 111.

36. For David's *Judgement of Cambyses*, see Max Friedlander, vɪb, pls. 224-5, p. 77.

37. Repro. C.M. Kauffmann (1970), pp. 78-9, figs. 11, 12.

38. Voragine, 2, pp. 151-2; Bonnet, vol. 2, pp. 103ff.; cf. the Celtic Sheela-na-gig representation of woman, in Lippard, pp. 218-19.

39. *Renaissance Drawings and Manuscripts*, exhibition, 25 May–September 1984, BM

40. Cf. the mosaics on the *ambo* in the Duomo, Ravello (twelfth century).

41. Mâle (1913), p. 382.

42. See also *English Romanesque Art*, p. 96 for Harrowing of Hell on a coffin lid, *c.* 1050 Anglo-Saxon.

43. Steinberg, pp. 47-8.

44. *c.* 1450, in Berne, Kunstmuseum, ibid., p. 92.

45. Ibid., pp. 140-1.

46. Boas, pp. 22ff.

47. *The Quattro Cento*, Stokes, I, p. 119.

48. 'The Body as Hierarchy', Steinberg, pp. 143-4: see Charles Hope, 'Ostentatio Genitalium', L R B 15 November-6 December 1984, pp. 19-20, for a severe criticism of Steinberg's argument.

49. *Sermo VI, In Cantica Canticarum*, quoted Steinberg, p. 143.

50. 'Praise of the Virtues', in Francis (ed. Mattesini and Franceschino):

> O Queen Wisdom, may God save you and your sister,
> pure Simplicity.
> Holy Lady Poverty, may God save you and your sister,
> holy Humility.
> Holy Lady Charity, may God save you and your sister,
> holy Obedience.
> Most holy virtues all, may God from whom you proceed and come, save you. There is hardly a man in the world who by himself can have one of you unless he die first.

> Sassetta's painting is in the Musée Condé, Chantilly.

51. See Warner (1976), pp. 179-81.

52. Steinberg, p. 34.

53. On Godiva, see Hafele; Newbold; Burbidge; Aquilla-Clarke and Day.

54. Wilkins, p. 25.

55. Roger of Wendover, *Flores Historiarum*, ed. H.O. Coxe (London, 1841-4), pp. 314-15.

56. Ibid., p. 314.

57. Ibid.

58. 'Lady Godiva', in Tennyson, *Poems* (London, 1893), pp. 281-4.

59. Aquilla-Clarke and Day, p. 8.

60. Ibid., pp. 8-10.

61. Ibid., p. 16.

62. In the Herbert Art Gallery, Coventry.

63. See Aquilla-Clarke and Day, pls. 4B, 5A and 6A. Maurice Maeterlinck, in *Monna Vanna*, a play first produced in 1902, set a Godiva-type tale in fifteenth-century Tuscany: the leader of the Florentine forces, Prinzivalle, is about to bring his bloody siege of Pisa to its bloody conclusion, but agrees to raise it if Giovanna, a Pisan noblewoman, will come to his tent naked that night. The heroine is so self-sacrificing she agrees; he is so overwhelmed by her beauty and virtue he cannot do the foul deed, but only protest an undying love dating back to a childhood glimpse. Maeterlinck's play then takes a *fin-de-siècle* turn, and Giovanna takes Prinzivalle back to Pisa and decides to die with him.

Colette had a *succès de scandale* in a play which took this morbid theme further, and indeed turned it into a version of Judith and Holofernes: in 1907 she performed on tour a mime written by Georges Wague called *La Chair*, in which an unfaithful wife, assaulted by a murderous husband, disrobes to show herself to him for the first time. The sight proves too much for him – he kills himself instead. Joanna Richardson, *Colette* (London, 1984), p. 40.

64. Ardener (1983).

65. Aylmer Maude, *The Doukhobors* (1904), quoted Ardener (1983), p. 16.

66. The words of Alexey Makhortov, ibid., p. 248.

67. See T. J. Clark (1980); Hollander, pp. 177-8.

68. 'Imogen Cunningham and Twinka', Yosemite, 1974, taken by Judy Dater, in Dater, p. 126. (Pl. 98.)

69. *WPA Guide to New York*, pp. 325-6. The fountain is a memorial to Joseph Pulitzer.

70. Ibid., p. 230.

71. Kjellberg, p. 125. The sculptures are gilded bronze, and the work of Felix Desruelle, Paul Niclausse, Robert Couturier, Lucien Brasseur, Paul Cornet, Pryas, Marcel Gimond, Alexandre Descatoire.

72. Byron, p. 408.

73. K. Clark (1956), pp. 68ff.; Haynes, pp. 82-3; for an inspiring general discussion see Hollander, pp. 83-157; Finley (1963), p. 163; Peter Kidson, 'The Figural Arts', in Finley (1981), pp. 401-28.

74. Pliny, *Historia Naturalis*, XXXVI, 20; quoted Haynes, p. 83.

75. *Odyssey*, 6, 127ff., pp. 105-6.

76. Hope, pp. 34-7, where he argues convincingly that both figures portray the bride of Niccolò Aurelio, who commissioned the painting, and who was getting married in May 1514, the approximate date of the work.

77. *English Romanesque Art*, p. 114, fig. 53; for a discussion of the representation of Truth in literature and art inspired by Psalm 85, see Chew, pp. 69-100. Cf. also the appearance of Veritie in *Ane Satyre of the Thrie Estaits* by Sir David Lindsay (1540), which the author saw performed in the 1984 Edinburgh Festival, under the direction of Tom Fleming.

78. Panofsky (1939), p. 157, fig. 114, from Cod. Pal. Lat. 1693 (1350-1).

79. K. Clark (1956), pp. 89-90, fig. 74.

80. A. P. D. Mourelatos, *The Route of Parmenides* (New Haven, 1970), pp. 63-7; Horace, *Carmina*, I.24.7; quoted Panofsky (1939), p. 155.

81. Petronius, *Satyricon*, 88, Panofsky (1939).

82. Panofsky, ibid., pp. 158-9.

83. Drawings of *The Calumny of Apelles* exist by Raphael (Louvre), Perino del Vaga (BM), Dürer (Albertina) – where Truth is fashionably dressed in contemporary style – Caron (Louvre), and Mantegna (BM).

84. See Canaday, pp. 292–4.

85. Saxl (1936).

86. Ripa (1602), pp. 285–6; he gives four alternative representations of Truth.

87. Hibbard, pp. 185ff.; Lavin, 1, pp. 70–4.

88. Chew, p. 70; Bergeron, pp. 20–1.

89. Saxl (1936), passim.

90. Heilbrunn, p. 17.

91. Gravelot and Cochin, 1767.

92. Gombrich (1979), p. 194.

93. NGL, *Allegory of Venus and Time*; Museum of Fine Arts, Boston, *Time Unveils Truth*. See R. Wittkower (1977), passim.

94. See Elisabeth Vigée-Lebrun, *Peace Bringing Back Abundance*, in the Louvre, Nanine Vallain's *La Liberté*, also in the Louvre, and Käthe Koll-witz, *Uprising*, in *Käthe Kollwitz* (1981), pp. 30–1.

95. *Apollo and Daphne*, in the Villa Borghese, Rome.

96. *Woman after a Bath*, or *Bathsheba*, in the Louvre.

97. *Noli me tangere*, NGL.

98. *French Fin-de-Siècle Posters*, Sotheby's, 14 May 1969; T. R. Nevett, *Advertising in Britain* (London, 1982) esp. pp. 121, 158–9; also Marshall McLuhan, *The Mechanical Bride Folklore of Industrial Man* (1951) (London, 1967), pp. 93–101.

99. *La Vérité assise*, by Decam, printed by P. Lemenil of Asnières, for *Le Vélo-Caténol* (Pl. 96). Bicycling belles were a favourite topos of early advertising.

See *French Fin-de-Siècle Posters*, passim.

100. For Eakins see Goodrich; Johns: and *Thomas Eakins*, passim.

101. William H. Gerdts, 'William Rush: Sculptural Genius or Inspired Artisan?' in *William Rush*, pp. 57–75. See also Linda Bantel, 'William Rush, Esq.', ibid., pp. 9–30.

102. See Toussaint (1978).

103. *Thomas Eakins*, p. 47.

104. Goodrich, 1, pp. 282–4.

105. Goodrich, 2, p. 295.

106. Goodrich, 2, p. 305. The painting is in the Honolulu Academy of Arts.

107. Hollander, p. 142.

108. *William Rush*, p. 116.

109. Adorno, pp. 95–6.

110. Barbara Kruger, 'No Progress in Pleasure', in Vance, p. 215. Also exhibited at the Institute of Contemporary Arts, London, 4 November-11 December 1983.

111. *The Epic of Gilgamesh*, trans. Sandars.

112. Ibid., p. 62.

113. Ibid., pp. 62–3.

114. Ibid., p. 63.

115. Ibid., p. 62.

116. Ibid., p. 64.

117. Ibid., p. 65.

118. Ibid., p. 63.

119. Ibid., p. 67.

120. Ibid., p. 66.

121. Ibid., pp. 68–9.

122. Ibid., pp. 64–5.

123. Schiller, *Thalia*, 398–9, quoted Phillips, p. 80.

EPILOGUE

1. Quoted Barthes (1954), p. 1.

2. *Odyssey*, 10, 488–95, p. 168.

3. Ibid., 11, 90ff., p. 173.

4. Pindar, *Nemean* I, 62, Bowra, p. 74.

5. Sophocles, *Oedipus Rex*, *King of Thebes*, see 358: 'Thou art thyself the unclean thing', p. 21.

6. Ovid, 3, 320, pp. 82–3; Apollodorus,

III.6.7; Hyginus, *Fabula* 75. There was another story told about Tiresias' change into a woman, a variation on the judgement of Paris: when Tiresias gave the Grace Cale the prize as the most beautiful of the three Graces, Aphrodite, the goddess, was so angry she changed Tiresias into an old

woman. But Cale gave him a magnificent head of hair to make up for it.

7. T. S. Eliot, 'The Waste Land', in *The Faber Book of Modern Verse, 1936*, ed. Michael Roberts (London, 1956), p. 116.

8. Graves, 2, p. 11. There was another myth too about Tiresias' blindness, that he had accidentally come upon Athena bathing, and she had covered his eyes and robbed him of his sight. In this case, his compensation was the gift of inner vision. *The Bath of Pallas*, in *Callimachus: The Fifth Hymn,* ed. A.W. Bulloch (Cambridge, 1985).

9. *Reflections on the Nude*, Stokes, III, pp. 303-42.

10. Ibid., p. 304.

11. Kundera (1967), pp. 73-4.

12. Perry, pp. 54-6, pl. XIV; Ludwig-Roselius Sammlung, Bremen.

13. Hélène Cixous, 'The Laugh of the Medusa', quoted by Nancy Spero, in 'Let the Priests Tremble', exhibited Riverside Studios, London, 1984.

14. 'Looking at Life with the Eyes of a Child' (1953), Flam. p. 148.

BIBLIOGRAPHY AND REFERENCES

Abel, Elizabeth (ed.). *Writing and Sexual Difference*. Brighton, 1983.

Adams, Henry. *Mont-Saint-Michel and Chartres*. Princeton, 1981.

Addison, Joseph. *Dialogue upon the Usefulness of Ancient Medals*. London, 1726.

Adorno, Theodor. *Minima Moralia*. Trans. E. F. N. Jephcott. London, 1978.

Aeschylus, *Suppliant Maidens, Persians, Prometheus, Seven Against Thebes; Agamemnon, The Libation Bearers, Eumenides, Fragments*. Ed. Herbert Weir Smith. Rev. ed. Hugh Lloyd-Jones. 2 vols. London, New York, 1922, 1963.

Aeschylus. *Prometheus Bound and Other Plays* (including *The Suppliants*). Trans. Philip Vellacott (1961). PC, 1983.

Aeschylus. *The Suppliant Women*. Trans. and ed. Gilbert Murray. London, 1930.

Aeschylus. *The Suppliants*. Ed. H. Friis Johansen and Edward W. Whittle. 3 vols. Copenhagen, 1980.

Aeschylus. *The Oresteia*. Trans. Robert Fagles. PC, 1979.

Age of Spirituality, The. Intro. Kurt Weitzmann. MMA, 1977.

Agnello, G. *Guida del Duomo di Siracusa*. Syracuse, 1964.

Agulhon, Maurice. 'Esquisse pour une archéologie de la République: l'allégorie civique féminine.' Annales ESC, 28, 1973, pp. 5-34.

Agulhon, Maurice. 'A reply to Eric Hobsbawm'. HWJ, 8, 1979, pp. 167-73.

Agulhon, Maurice. 'La "Statuomanie" et l'histoire'. *Ethnologie française*, 1978, 8, 2-3, pp. 145-73.

Agulhon, Maurice. *Marianne into Battle* (1979). Trans. Janet Lloyd. Cambridge, 1981.

Agulhon, Maurice. 'Le Langage des façades'. In *Hôtel de Ville*.

Alain de Lille. *Anticlaudianus*. Ed. R. Bossuat. Paris, 1955.

Alexander, Sally, Davin, Anna and Hostettler, Eve. 'Labouring Women: a Reply to Eric Hobsbawm'. HWJ, 8, 1979, pp. 174-82.

Alexander, Sally. *Women's Work in Nineteenth-Century London*. London, New York, 1983.

Alpers, Svetlana. *The Art of Describing*. London, 1983.

Alsop, J. *The Rare Art Traditions*. London, 1982.

d'Alverny, Marie-Thérèse. *La Sagesse et ses sept filles*. Paris, 1946.

L'Amateur de plein air, no. 2, 'L'Ange, mon désir'. Paris, 1983.

d'Ancona, P. 'Le rappresentazioni allegoriche delle arti liberali'. *Arte*, V, 1902, pp. 211-28, 137-55, 269-89, 370-85.

Anderson, Benedict. *Imagined Communities. Reflections on the Origin and Spread of Nationalism*. London, 1983.

Anderson, M. D. *The Choir Stalls of Lincoln Minster*. Lincoln, 1967.

André, Joseph. *Histoire de Sainte-Foy*. Aveyron, 1957.

d'Anjou, René. *Le Livre du cuer d'amours espris*. Ed. Susan Wharton. Paris, 1980.

D'Annunzio, Gabriele. *La Pisanella*. Milan, 1919.

D'Annunzio, Gabriele. *Correspondance à Georges Hérelle*. Ed. Guy Tosi. Paris, 1946.

Anselm. *The Prayers and Meditations of Saint Anselm*. Trans. and intro. Sister Benedicta Ward, PC, 1973.

Anthologie poétique française du moyen-âge. Ed. A. Mary. 2 vols. Paris, 1967.

The Apocalypse. (Catalogue by Kathryn Henkel). University of Maryland, 22 March-29 April 1973. Maryland, 1973.

Apollodorus, *The Library*. Trans. J. G. Frazer. 2 vols. London, 1921.

Apuleius. *The Golden Ass*. Trans. Robert Graves. PC, 1950.

Aquilla-Clarke, Ronald and Day, Patrick A. E. *Lady Godiva, Images of a Legend in Art and Society*. Coventry, 1982.

Ardener, Edwin. 'Belief and the Problem of Women'. (1972, 1975). In Shirley Ardener, 1975.

Ardener, Shirley (ed.). *Perceiving Women*. London, 1975.

Ardener, Shirley (ed.). *Defining Females. The Nature of Women in Society*. London, 1978.

Ardener, Shirley (ed.). *Women and Space: Ground Rules and Social Maps*. London, 1981.

Ardener, Shirley. 'A note on Gender Ikonography: The Vagina'. Draft paper for ASA. Decennial Conference, Cambridge, July 1983. Kindly lent by the author.

Ardener, Shirley. 'Arson, Nudity and Bombs among the Canadian Doukhobors: A Question of Identity'. In Glynis M. Breakwell (ed.), *Threatened Identities*. Chichester, 1983, pp. 239–66.

Arethusa, XI, 1–2 (1978). 'Women in Antiquity'.

Argan, Giulio Carlo. *Botticelli*. Trans. James Emmons. Lausanne, 1957.

Ariès, Philippe. *The Hour of Our Death*. Trans. Helen Wearle. London, 1981.

Aristophanes. *The Wasps, The Poet and the Women, The Frogs*. Trans. and intro. David Barrett. PC, 1964.

Aristophanes. *The Knights, Peace, The Birds, The Assemblywomen, Wealth*. Trans. David Barrett. PC, 1978.

Aristotle. *On the Art of Fiction*. An English Translation of *The Poetics*. L. J. Potts. Cambridge, 1959.

L'Art de l'estampe et la Révolution française. Musée Carnavalet, Paris, 27 June–20 November 1977.

L'Art en France sous le Second Empire. Grand Palais, Paris, 11 May–13 August 1979.

Ashbery, John. *A Wave*. Manchester, 1984.

Atkinson, Clarissa W. *Mystic and Pilgrim: The Book and the World of Margery Kempe*. New York, 1983.

Auerbach, Erich. *Mimesis*. Trans. Willard Trask. New York, 1957.

Auerbach, Erich. 'Figura', in *Scenes from the Drama of European Literature* (1959). Manchester, 1984, pp. 11–76.

Augustine, St. *The City of God*. Trans. John Healey. 2 vols. 1610, reprinted London, 1909.

Aulard, Alphonse. *Christianity and the French Revolution* (1925). New York, 1966.

Aulard, Alphonse. *Le Culte de la raison et le culte de l'Etre suprême* (1892). Aalen, 1975.

Autenrieth, Georg. *An Homeric Dictionary*. Trans. Robert P. Keep. London, 1908.

Avery, Charles. *The Rood-Loft from Hertogenbosch*. VA, 1969.

Baillet, Dom Louis. 'Les Miniatures du "Scivias" de Sainte Hildegarde conservé à la bibliothèque de Wiesbaden'. In *Monuments et mémoires. Académie des inscriptions et belles lettres*. Ed. George Perrot and Robert de Lasteyrie, vol. XIX (Fondation Eugène Piot). Paris, 1911.

Baker, Derek (ed.). *Medieval Women*. Studies in Church History. Subsidia I. Oxford, 1978.

Baladié, R. 'Le Styx, site et personnification'. In *Mythe et personnification*.

Balzac, Honoré de. *Œuvres complètes*. Paris, 1870.

Bann, Stephen. *The Clothing of Clio*. Cambridge, 1984.

Bareau, Juliet Wilson. *Goya's Prints*. London, 1981.

Barker, D. L. and Allen, S. *Sexual Divisions and Society*. London, 1976.

Barnett, Anthony. *Iron Britannia*. London, 1982.

Barone, Vito and Elia, Sebastiano. *Selinunte*. Palermo, 1979.

Barthes, Roland. *Michelet*. Paris, 1954.

Barthes, Roland. *Le Plaisir du texte*. Paris, 1970.

Barthes, Roland. *L'Empire des signes*. Geneva, 1970.

Barthes, Roland. *Mythologies*. Sel. and trans. Annette Lavers. New York, 1972.

Barthes, Roland. *Sade Fourier Loyola*. Trans. Richard Miller. London, 1977.

Barthes, Roland. *A Barthes Reader*. Ed. and intro. Susan Sontag. London, 1982.

Barthes, Roland. *Camera Lucida*. Trans. Richard Howard. London 1982.

Bass, K.J. 'The Britannia Reverse'. In *Seaby's Coin and Medal Bulletin*, July–December 1963, nos. 542-7.

Baudelaire, Charles. *Œuvres complètes*. Ed. Marcel A. Ruff. Paris, 1968.

Baudri de Bourgueil. *Les Œuvres poétiques*. Ed. Phyllis Abrahams. Paris, 1926.

Baudrillard, Jean. 'La Précession des simulacres'. *Traverses*, 10, February 1978, Paris.

Bayley, Stephen. *The Albert Memorial. The monument in its social and architectural context*. London, 1983.

Beattie, Susan. *The New Sculpture*. New Haven, 1983.

Beaulieu, Michèle. *La Sculpture française du XVIᵉ siècle*. PGGM, 51. Paris, 1979.

Beaulieu, Michèle. *Les Sculptures du parc de Marly au musée du Louvre et aux Tuileries*. PGGM, 63. Paris, 1980.

Beaulieu, Michèle. *Le Portrait sculpté au XVIIIᵉ siècle*. PGGM, 85. Paris, 1981.

Beauvoir, Simone de. *The Second Sex*. Trans. and ed. H.M. Parshley. New York, 1961.

Beazley, J.D. *Attic Black-figure Vase-painters*. Oxford, 1956.

Beazley, J.D. *Attic Red-figure Vase-painters*. Oxford, 1963.

Beckwith, John. *Early Medieval Art*. London, 1964.

Beckwith, John. *Ivory Carvings in Early Medieval England*. London, 1972.

Bellasi, Pietro. 'Gulliver e Noi'. *Prometeo*, 1, 2, May-July 1983, pp. 30-41. Milan, 1983.

Benjamin, Walter. *Charles Baudelaire: A Lyric Poet in the Era of High Capitalism*. Trans. Harry Zohn. London, 1973.

Benjamin, Walter. *One-Way Street*. Trans. H. Jephcott and K. Shorter. London, 1979.

Benjamin, Walter. *Illuminations*. Trans. Harry Zohn. Ed. and intro. Hannah Arendt. London, 1982.

Benthall, Jonathan. *The Body Electric. Patterns of Western Industrial Culture*. London, 1976.

Benthall, Jonathan and Polhemus, Ted (eds.). *The Body as Medium of Expression*. New York, 1975.

Benveniste, Emile. *Indo-European Language and Society*. Trans. Elizabeth Palmer. London, 1973.

Beny, Roloff and‧ Gunn, Peter. *The Churches of Rome*. London, 1981.

Bercheur, Pierre. *Tabula Alphabetica in Dictionarium Petri Bercharii*. 2 vols. Venice, 1516.

Berefelt, Gunnar. *A Study on the Winged Angel*. Trans. Patricia Hort. Stockholm, 1968.

Berenson, Bernard. *The Italian Painters of the Renaissance*. London, 1960.

Berger, John. *Ways of Seeing*. London, 1972.

Bergeron, David M. *English Civic Pageantry 1558-1642*. London, 1971.

Bettelheim, Bruno. *Symbolic Wounds, Puberty Rites and the Envious Male*. London, 1955.

Bettelheim, Bruno. *The Uses of Enchantment*. London, 1978.

Bettini, Sergio. *Mosaici di San Marco*. Milan, 1968.

Birchall, Ann and Corbett, P.E. *Greek Gods and Heroes*. London, 1974.

Biver, Marie-Louise. *Le Paris de Napoléon III*. Paris, 1963.

Bjurstrom, Per. *Feast and Theatre in Queen Christina's Rome*. Stockholm, 1966.

Blackwood, Caroline. *On the Perimeter*. London, 1984.

Bloomfield, Morton W. *The Seven Deadly Sins*. Michigan, 1952.

Bloomfield, Morton W. *Essays and Explorations. Studies in Ideas, Language and Literature*. Harvard, 1970.

Blunt, Anthony. *Art and Architecture in France, 1500-1700*. London, 1953.

Boas, George. *The Cult of Childhood*. Leiden, 1966.

Boccaccio. *De Claris Mulieribus. Volgarizzamento di Maestro Donato di Casentino dell'Opera de Messer Boccaccio*. Ed. Luigi Tosti. Milan, 1841.

Bogin, Meg. *The Women Troubadours*. London, 1976.

Boime, Albert. 'The Second Republic's Contest for the Figure of the Republic'. AB, 53, March 1971.

Bompaire, Jean. 'Quelques personnifications littéraires chez Lucien et dans la littérature impériale'. In *Mythe et personnification*, 1980, pp. 77-82.

Bonnet, Gérard. *Voir Etre Vu*. 2 vols. Paris, 1981.

The Book of Saints. A Dictionary of the servants of God canonized by the Catholic Church. Ed. Benedictine Monks of St Augustine's, Ramsgate. London, 1966.

Boppe, A. *Les Vignettes emblématiques sous la Révolution*. Paris, 1911.

Bornstein, Diane (ed.). *Ideals for Women in the Works of Christine de Pizan*. Michigan, 1981.

Borzello, Frances. *The Artist's Model*. London, 1982.

Bothmer, D. Van. *Amazons in Greek Art*. Oxford, 1957.

Bowra, Maurice. See Pindar.

Boxer, C. R. *Mary and Misogyny*. London, 1975.

Bradley, Howard W. *A Handbook of the Coins of the British Isles*. London, 1978.

Braun, Adolphe Armand. *Hieroglyphic or Greek Method*. London, 1916.

Brèreton, Georgine E. and Ferrier, Janet M. (eds.). *Le Ménagier de Paris*. Oxford, 1981.

Bresc-Bautier, Geneviève. *Sculpture française du XVIIIᵉ siècle*. LNHA, Paris, 1980.

Briffault, Robert. *The Mothers*. 3 vols. New York, 1927.

Brisson, Luc. *Le Mythe de Tirésias*. Leiden, 1976.

Bristow, Edward J. *Vice and Vigilance*. Dublin, 1977.

Brommer, Frank. *The Sculptures of the Parthenon*. London, 1979.

Brooke-Rose, Christine. *A Grammar of Metaphor*. London, 1965.

Brookner, Anita. *Jacques-Louis David*. London, 1980.

Broude, Norma and Garrard, Mary D. (eds.). *Feminism and Art History*. New York, 1982.

Brown, Norman O. *Life against Death, The Psychoanalytical Meaning of History*. London, 1959.

Brownmiller, Susan. *Femininity*. New York, 1984.

Peter Brueghel the Elder: The Graphic Works. Ed. H. Arthur Klein. New York, 1963.

Brueghel: Une dynastie de peintres. (Catalogue). Palais des Beaux-Arts, Brussels, exhibition 18 September-18 November 1980.

Bruyn, Lucy De. *Woman and the Devil in Sixteenth-Century Literature*. Salisbury, 1979.

Bryson, Norman. *Word and Image*. Cambridge, 1981.

Bryson, Norman. *Vision and Painting*. London, 1983.

Bucher, Bernadette. *Icon and Conquest: A Structural Analysis of the Illustrations of de Bry's Great Voyages*. Chicago, 1981.

Bugge, John. *Virginitas. An Essay in the history of the medieval ideal*. The Hague, 1975.

Burbidge, F. Bliss. *Old Coventry and Lady Godiva*. Birmingham, 1952.

Burckhardt, Jacob. *The Civilisation of the Renaissance in Italy*. Trans. S. G. C. Middlemore. 2 vols. New York, 1958.

Burke, Edmund. *Reflections on the Revolution in France* (1790). London, 1912.

Burke, Kenneth. *Language as Symbolic Action*. Berkeley, 1966.

Burke Leacock, Eleanor. *Myths of Male Dominance*. London, New York, 1981.

Burton, R. B. *Pindar's Pythian Odes. Essays in Interpretation*. Oxford, 1962.

Bury, J. P. T. *France 1814-1940. A History*. London, 1949.

Butler, Samuel. *The Authoress of the Odyssey*. Intro. David Grene. Chicago, 1967.

Buxton, R. G. A. *Persuasion in Greek Tragedy: A Study of Peitho*. Cambridge, 1982.

Bynum, Caroline Walker. *Jesus as Mother: Studies in the Spirituality of the High Middle Ages*. Berkeley, 1983.

Byron, Anthony. *London Statues: A guide to London's outdoor statues and sculpture*. London, 1981.

Cahier, C. du. *Caractéristiques des saints dans l'art populaire*. 2 vols. Brussels, 1966.

Camden, William. *Remains Concerning Britain* (1605). London, 1870.

Camden, William. *Britannia or a Chorographical Description of the Flourishing Kingdoms of England, Scotland and Ireland* (1607). Trans. and rev. Richard Gough. 3 vols. London, 1789, 1806.

Cameron, Averil and Kuhrt, Amélie (eds.). *Images of Women in Antiquity*. Beckenham, Kent, 1983.

Julia Margaret Cameron 1815-1879. (Catalogue by Mike Weaver). John Hansard Gallery, Southampton, 7 March-28 April 1984.

Canaday, John. *What is Art?* New York, 1980.

Cannadine, David. 'The Context, Performance and Meaning of Ritual: The British Monarchy and the "Invention of Tradition", *c.* 1820-1977'. In Hobsbawm and Ranger.

Carcopino, Jérôme. *Etudes romaines: La Basilique Pythagoricienne de la Porte Majeure*. Paris, 1926.

Carli, Enzo. *La Pittura Senese*. Florence, 1982.

De Carpeaux à Matisse. La Sculpture française de 1859 à 1914 dans les musées et les collections publiques du Nord de la France. Lille, 1982.

Carrà, Massimo. *Ivories of the West*. London, 1970.

Cartari, Vincenzo. *Le Imagini* [sic] *dei dei e gli antichi* (Venice, 1556). New York, 1976.

Cast, David. *The Calumny of Apelles*. New Haven, 1981.

Catherine of Genoa, St. *Treatise on Purgatory, the Dialogue*. Trans. Charlotte Balfour and Helen Douglas Irvine. London, 1946.

Catta, Etienne. 'Sedes Sapientiae'. In *Maria*. Ed. Hubert du Manoir de Juaye, S J. 8 vols. Paris, 1949-71, vol. VI.

Champoiseau, Charles. 'La Victoire de Samothrace'. *Revue archéologique*, 1880, 39, pp. 11-7.

Chantraine, P. *Morphologie historique du grec*. Paris, 1967.

Chapman, J. M. and Brian. *The Life and Times of Baron Haussmann*. London, 1957.

Chew, Samuel C. *The Virtues Reconciled. An Iconographic Study*. Toronto, 1947.

Chicago, Judy. *The Dinner Party, a symbol of our heritage*. New York, 1979.

Chicago, Judy. *Embroidering our Heritage. The Dinner Party Needlework*. New York, 1980.

Chicago, Judy. *Through the Flower*. London, 1982.

Chierichetti, Sandro. *The Cathedral of Monreale*. Trans. Donald Mills. Palermo, 1981.

Christian, William A., Jr. *Person and God in a Spanish Valley*. New York, London, 1972.

Christian, William A., Jr. *Apparitions in late Medieval and Renaissance Spain*. Princeton, 1981.

Cixous, Hélène. *Souffles*. Paris, 1975.

Cixous, Hélène. *Vivre l'orange*. (*To Live the*

Orange). Trans. A. Liddle and S. Cornell. Paris, 1979.

Clark, Kenneth. *The Nude. A Study of Ideal Art*. Harmondsworth, 1956.

Clark, Kenneth. *Leonardo da Vinci*. London, 1959.

Clark, Kenneth. *Rembrandt and the Italian Renaissance*. London, 1966.

Clark, T. J. 'Preliminaries to a Possible Treatment of Manet's *Olympia* in 1865'. *Screen*, 21, 1, 1980, pp. 18–41.

Clark, T. J. *The Absolute Bourgeois. Artists and Politics in France 1848-1851* (1973). London, 1982.

Clarke, Jennifer. *In Our Grandmothers' Footsteps*. London, 1984.

Clément, Catherine. *L'Opéra ou la défaite des femmes*. Paris, 1979.

Cochrane, Charles Norris. *Christianity and Classical Culture* (1940). Oxford, 1980.

Cohn, Norman. *Europe's Inner Demons*. London, 1975.

Colledge, Edmund and Marler, J. C. ' "Mystical" pictures in the Suso "Exemplar" – Ms Strasbourg 2929'. *Archivum Fratrum Praedicatorum*, 54 (1984), pp. 293–354.

Colley, Linda. 'The Apotheosis of George III: Loyalty, Royalty and the British Nation 1760-1820'. *Past and Present* 102, February 1984, pp. 94–129.

Collis, Louise. *Memoirs of a Medieval Woman*. New York, 1964.

Colvin, H. M. *The Sheldonian Theatre and the Divinity School*. Oxford, 1981.

Conti, Natale. *Mythologiae sive Explicationis Fabularum*. Geneva, 1651.

Cook, Alice and Kirk, Gwyn. *Greenham Women Everywhere*. London, 1983.

Cook, B. F. *Greek and Roman Art in the British Museum*. London, 1976.

Cook, B. F. *The Elgin Marbles*. London, 1984.

Cope, Gilbert. *Symbolism in the Bible and the Church*. London, 1959.

Cosman, Carol, Keefe, Joan and Weaver, Kathleen (eds.). *The Penguin Book of Women Poets*. Harmondsworth, 1979.

Gustave Courbet. (Catalogue). RA, 19 January-19 March 1978.

Coward, Rosalind. *Female Desire*. London, 1984.

The Crystal Palace Exhibition Illustrated Catalogue London 1851. New intro. John Gloag. New York, 1970.

Curtius, Ernst. *European Literature and the Latin Middle Ages*. Trans. Willard R. Trask. New York, 1953.

Dain, Phyllis. *The New York Public Library*. New York, 1972.

Daly, Mary. *The Church and the Second Sex*. New York, 1968.

Daly, Mary. *Beyond God the Father*. Boston, 1973.

Daly, Mary. *Gyn/Ecology*. London, 1979.

Daly, Mary. *Pure Lust. Elemental Feminist Philosophy*. London, 1984.

Damian, Peter. 'Sermo in Nativitate Beatae Mariae Virginis'. PL 144, cols. 735-40.

Daniélou, Jean. 'The Church'. In *A History of Early Christian Doctrine before the Council of Trent*. Trans. and ed. John A. Baker. London, 1964, pp. 293–313.

Dante Alighieri. *La Vita Nuova*. Trans. and intro. Barbara Reynolds. PC, 1961.

Dante Alighieri. *The Divine Comedy*. Trans. and commentary John D. Sinclair. 3 vols. London, 1958.

Darracott, Joseph and Loftus, Belinda (eds.). *First World War Posters*. London, 1981.

Dater, Judy. *Imogen Cunningham. A Portrait*. London, 1979.

Honoré Daumier 1808-1879. (Catalogue). The Armand Hammer Daumier Collection, Los Angeles, 1981.

Daumier, Honoré. *Daumier on War*. Intro. Hans Rothe. New York, 1977.

Davis, Natalie Zemon. *Society and Culture in Early Modern France*. London, 1975.

Davis, Natalie Zemon, ' "Women's History" in Transition: The European Case.' *Feminist Studies*, III, Spring-Summer 1976, pp. 83–103.

Delacroix, Eugène. *The Journal of Eugène Delacroix*. Ed. Hubert Wellington. Oxford, 1980.

Demus, Otto. *Byzantine Art and the West*. London, 1970.

Detienne, Marcel. *Dionysos Slain*. Trans. Mireille and Leonard Muellner. Baltimore, 1979.

Detienne, Marcel. 'Between Beasts and Gods'. In R. L. Gordon, 1981.

Detienne, Marcel. 'Potagerie des femmes ou comment engendrer seule'. *Traverses*, 5-6, October 1976, Paris.

Detienne, Marcel and Vernant, Jean-Pierre. See R. L. Gordon, 1981.

Devereux, G. *Femme et mythe*. Paris, 1982.

Dietrich, B. C. *Death, Fate and the Gods*. London, 1965.

Dio Cassius. *Roman History*. Trans. Ernest Cary. 9 vols. London, 1961.

Dionysius Thrax. *Ars Grammatica*. Ed. Gustav Uhlig. Leipzig, 1883.

Documents of the Christian Church. Ed. Henry Bettenson. Oxford, 1963.

Dodds, E. R. *The Greeks and the Irrational*. Berkeley, 1951.

Doni. *Pitture del Doni, nelle quali si mostra di nuova intentione Amore, Fortuna, Tempo, Castità, Religione, Sdegno, Riforma, Morte e Sogno, Huomo, Reppublica e Magnanimità*. Padua, 1564.

Douglas, Mary. *Purity and Danger*. Harmondsworth, 1970.

Douglas, Mary (ed.). *Witchcraft: Confessions and Accusations*. London, 1970.

Douglas, Mary. *Natural Symbols*. London, 1973.

Dowd, David Lloyd. *Pageant-Master of the Republic: J. L. David and the French Revolution*. Lincoln, Nebraska, 1948.

Dreyfous, Maurice. *Dalou. Sa vie et son œuvre*. Paris, 1903.

Dronke, Peter. *Medieval Latin and the Rise of the European Love Lyric*. 2 vols. Oxford, 1965.

Dronke, Peter. *Poetic Individuality in the Middle Ages*. Oxford, 1970.

Dronke, Peter. *Fabula. Exploration into the Uses of Myth in Medieval Platonism*. Leiden, 1974.

Dronke, Peter. 'Bernard Silvestris, Natura and Personification'. JWCI, XLIII, 1980, pp. 16-31.

Dronke, Peter. *Women Writers of the Middle Ages*. Cambridge, 1984.

Dryfhout, John. *The Work of Augustus Saint-Gaudens*. London, 1982.

Duby, Georges. *Le Temps des cathédrales. L'Art et la société 980-1420*. Paris, 1976.

Duby, Georges. *The Knight, the Lady and the Priest*. Trans. Barbara Bray. London, 1983.

Dumézil, Georges, *Fêtes romaines d'eté et d'automne*. Paris, 1975.

Albrecht Dürer. The Complete Woodcuts. Ed. Willi Kurth. New York, 1963.

Thomas Eakins, Artist of Philadelphia. (Catalogue ed. Darrell Sewell). Philadelphia Museum of Art, 29 May-1 August 1982. Philadelphia, 1982.

Early Italian Engravings at the National Gallery of Art. Ed. Jay A. Levenson, Konrad Oberhuber and Jacquelyn L. Sheehan. Washington, 1973.

Eckenstein, Lina. *Women under Monasticism*. Cambridge, 1896.

Ede, H. S. *Savage Messiah*. London, 1971.

Eisler, George. *From Naked to Nude: Life Drawing in the Twentieth Century*. London, 1977.

Eliade, Mircea. *The Sacred and the Profane*. New York, 1961.

Eliade, Mircea. *Patterns in Comparative Religion*. New York, 1963.

Eliade, Mircea. *Images and Symbols*. New York, 1969.

Ellinger, Ilona E. 'Winged Figures'. In *Studies Presented to D. M. Robinson II*. Ed. George E. Mylonas and Doris Raymond. St Louis, 1953, pp. 1185-90.

English Romanesque Art 1066-1200. (Catalogue ed. George Zarnecki). Hayward Gallery, 5 April-8 July 1984. London, 1984.

Epic of Gilgamesh, The. Trans. and intro. N. K. Sandars (1960). PC, 1972.

Erim, Kenan T. 'A New Relief showing Claudius and Britannia from Aphrodisias'. *Britannia*, XIII, 1982, pp. 277-81.

Etex, Antoine. *Les Souvenirs d'un artiste*. Paris, 1877.

Euripides. *The Bacchae and Other Plays (Ion, The Women of Troy, Helen)*. Trans. Philip Vellacott (1954). PC, 1984.

Euripides. *Medea. Hippolytus. Helen*. Trans. Rex Warner (1944, 1950, 1951). New York, 1958.

Evans, Michael. 'Allegorical Women and Practical Men: The Iconography of the *Artes* Reconsidered'. In Baker, 1978, pp. 305-28.

Evans, Richard J. *The Feminists*. London, 1977.

Every, George. *Christian Mythology*. London, 1970.

Farmer, David Hugh. *The Oxford Dictionary of Saints*. Oxford, 1978.

Farnell, Lewis Richard. *The Cults of the Greek States*. 3 vols. Oxford, 1896.

Fell, Christine. *Women in Anglo-Saxon England*. London, 1985.

Ferguson, George. *Signs and Symbols in Christian Art*. New York, 1961.

Ferrante, Joan M. *Woman as Image in Mediaeval Literature*. New York, London, 1975.

Ferro, Mark. *Comment on raconte l'histoire aux enfants*. Paris, 1981.

Les Fêtes de la Révolution. (Catalogue). Musée Bargoin, Clermont-Ferrand, 15 June-15 September 1974.

Fiera, Battista. *De Iusticia Pingenda. A dialogue between Mantegna and Momus (1515)*. Trans. James Wardrop. London, 1957.

Fifteenth-Century Engravings of Northern Europe. (Catalogue ed. Richard Shestack). NGW, 3 December 1967-7 January 1968.

Fifteenth-Century Woodcuts and Metalcuts. (Catalogue ed. Richard S. Field). NGW, n.d.

Figes, Eva. *Patriarchal Attitudes*. London, 1972.

Finley, M. I. *The Ancient Greeks*. Harmondsworth, 1977.

Finley, M. I. (ed.). *The Legacy of Greece*. Oxford, 1984.

Flam, Jack D. *Matisse on Art*. Oxford, 1973.

Flanagan, Barry. (Catalogue). Whitechapel Gallery, 7 January-20 February 1982.

Flaubert, Gustave. *L'Education sentimentale*. Paris, 1964.

Fletcher, Angus. *Allegory. The Theory of a Symbolic Mode*. Cornell, 1964.

Fodor, Istvań. 'The Origin of Grammatical Gender'. *Lingua*, 8, 1959, pp. 1-214.

Foley, Helene B. 'Reverse Similes and Sex Roles in the *Odyssey*'. *Arethusa*, II, 1-2, Spring and Fall 1978 pp. 7-27.

Foley, Helene B. (ed.). *Reflections of Women in Antiquity*. London, 1981.

Forster, Kurt W. (ed.). See *Oppositions*.

Forsyth, Ilene H. *The Throne of Wisdom*. Princeton, 1972.

Fougères, G. 'Athéna'. DAGM, vol. 3.

Fourcaud, Louis de. *François Rude, sculpteur. Ses oeuvres et son temps 1784-1855*. Paris, 1904.

Fowler, M. 'The Myth of Erichthonius'. *Classical Philology*, 38, 1943, pp. 28-32.

Francis, of Assisi, St. *Scritti di San Francesco d'Assisi*. Trans. Francesco Mattesini. Intro. Ezio Franceschini. Milan, 1976.

Fredericksen, Burton B. *The Cassone Paintings of Francesco di Giorgio*. PGMP, 4. Los Angeles, 1969.

French Fin-de-Siècle Posters. (Catalogue). Sotheby's, London, 14 May 1969.

French Popular Imagery. (Catalogue). Hayward Gallery exhibition, 26 March-27 May 1974.

Freud, Sigmund. *Complete Psychological Works*. Standard edition, trans. and ed. James Strachey. 24 vols. London, 1953-74.

Friedlander, Max. *Early Netherlandish Painting*. vol. 3: 'Dieric Bouts and Joos van Ghent'. Trans. H. Norden. Leiden, 1968.

Friedlander, Walter. *Caravaggio Studies*. Princeton, 1974.

Friedman, John B. 'Pandarus' Cushion and the "Pluma Sardanapalli"'. JEGP, LXXV, 1-2, January-April 1976, pp. 41-56.

Fürtwangler, Adolf. *Masterpieces of Greek Sculpture*. London, 1895.

Gallagher, Catherine, Fineman, Joel and Hertz, Neil. 'More about Medusa's Head'. *Representations*, 14, Fall 1983, pp. 55-72.

Garnier, François. *Le Langage de l'image au moyen-âge: signification et symbolique*. Paris, 1982.

Garnier, J.-L.-C. *Le Théâtre*. Paris, 1871.

Garrard, Rose. *Between Ourselves*. (Catalogue). Ikon Gallery, Birmingham, January-February 1984. Birmingham, 1984.

Garvie, A. F. *Aeschylus' Supplices: Play and Trilogy*. Cambridge, 1969.

Gass, William. *On Being Blue*. Manchester, 1979.

Gass, William. 'Monument/Mentality'. *Oppositions*, pp. 127-44.

Gautier, Théophile. 'L'Art en 1848', 'Symbolisme de la République'. *L'Artiste*, 15 May 1848, pp. 173-5, pp. 160-1.

Geertz, Clifford. *The Interpretation of Cultures*. New York, 1973.

Geertz, Clifford. 'Centers, Kings and Charisma: Reflections on the Symbolics of Power'. In J. Ben-David and T. N. Clark (eds.), *Culture and its Creators: Essays in Honor of E. Shils*. Chicago, London, 1977, pp. 150-71.

The Genius of Venice. (Catalogue ed. Jane Martineau and Charles Hope). RA, 25 November-11 March 1984. London, 1983.

Gennep, A. Van. 'Le Sexe des Mots'. *Religions*, 1908, pp. 265-75.

Gernsheim, Helmut and Alison. *A Concise History of Photography*. London, 1971.

Giarda, Cristoforo. *Bibliothecae Alexandrinae*

Icones Symbolicae (1628). New York, 1979.

Gilson, Etienne. *The Mystical Theology of St Bernard*. Trans. A. H. C. Downes. London, 1940.

Gimpel, Jean. *Les Bâtisseurs des cathédrales*. Paris, 1973.

Giordano, Stefano (ed.). *The Palatine Chapel in the Norman Palace*. Trans. Arthur Oliver. Palermo, 1977.

Giraldus, Lilius. *De Deis Gentium. The Renaissance and the Gods* (Basel, 1548). New York, 1976.

Girouard, Mark. *The Return to Camelot. Chivalry and the English Gentleman*. New Haven, 1981.

Goethe, J. W. *Italian Journey 1786-88*. Trans. W. H. Auden and Elizabeth Mayer. London, 1962.

Gombrich, E. H. *Meditations on a Hobby Horse*. London, 1963.

Gombrich, E. H. 'The Use of Art for the Study of Symbols'. *American Psychologist*, 20, January 1965, pp. 34-50.

Gombrich, E. H. *Norm and Form*. London, 1966.

Gombrich, E. H. *Personification*. In R. Bolgar (ed.), *Classical Influences on European Culture AD 500-1500*. Cambridge, 1971.

Gombrich, E. H. *Symbolic Images*. Oxford, New York, 1972.

Gombrich, E. H. *Means and Ends*. London, 1976.

Gombrich, E. H. 'The Dream of Reason: Symbolism in the French Revolution'. BJES, 2, 3. Autumn 1979, pp. 187-204.

Goodrich, Lloyd. *Thomas Eakins*. 2 vols. London, 1982.

Gordon, Donald. ' "Veritas Filia Temporis". Hadrianus Junius and Geoffrey Whitney'. JWCI, III, 1939-40.

Gordon, R. L. (ed.). *Myth, Religion and Society*. Cambridge, 1981.

Gould, John. 'Law, Custom and Myth: Aspects of the Social Position of Women in Classical Athens'. JHS, 100, 1980, pp. 38-59.

Gouliano, Joan (ed.). *By a Woman Writt*. New York, 1974.

Gowing, Lawrence. *Lucian Freud*. London, 1982.

Grabar, André. *Christian Iconography. A Study of its Origins*. London, 1969.

Graillot, Henri. 'Victoria'. DAGM, vol. 9, pp. 830-54.

Grant, Michael. *Roman History from Coins*. Cambridge, 1958.

Grant, Michael. *Roman Myths*. Harmondsworth, 1973.

Gravelot, H. and Cochin, N. *Almanach Iconologique*. Paris, 1766 (Des Sciences); 1767 (Des Vertus); 1768 (Etres métaphysiques); 1772 (L'Homme); 1773 (Etres moraux); 1774 (Des Sciences); 1775 (Les Vertus et les Vices).

Graves, Robert. *The Greek Myths*. 2 vols. Harmondsworth, 1955, rev. 1966.

Greek Arms and Armour. (Catalogue ed. Patricia Hester). Greek Museum, University of Newcastle-upon-Tyne. Newcastle, 1978.

The Greenham Factor. (Anon). London, 1983.

Greer, Germaine. *The Obstacle Race. The Fortunes of Women Painters and their Work*. New York, 1979.

Grego, Joseph. *Rowlandson the Caricaturist. A Selection of His Works*. 2 vols. London, 1980.

Griffin, Susan. *Pornography and Silence*. London, 1981.

Griffin, Susan. *Woman and Nature*. London, 1984.

Griffin, Susan. 'The Way of all Ideology'. In Keohane, Rosaldo and Gelpi, *Feminist Theory*, pp. 273-92.

Grigson, Geoffrey. *The Goddess of Love*. London, 1976.

Guest, Tanis Margaret. *Some Aspects of Hadewijch's Poetic Form in the 'Strofische Gedichten'*. The Hague, 1975.

Guide de Paris, Le. By 'Les principaux ecrivains et artistes de la France'. Intro. Victor Hugo. Brussels, Leipzig and Livorno, 1867.

Guillemot, Gabriel. 'Les Arcs de Triomphe'. In *Guide de Paris*.

Hadewijch. *Hadewijch d'Anvers. Ecrits mystiques des béguines*. Trans. J.-B. Porion. Paris, 1954.

Hadewijch. *The Complete Works*. Trans. Mother Columba Hart OSB. London, 1981.

Hadjinicolaou, Nicos. '*La Liberté guidant le peuple* de Delacroix devant son premier public'. ARSC, 28, June 1979.

Hafele, Karl. *Die Godivasage*. Heidelberg, 1928.

Hagstrum, Jean H. *The Sister Arts: The Tradition of Literary Pictorialism and English Poetry from Dryden to Gray*. Chicago, 1958.

Hale, J. R. *Renaissance Europe 1480-1520*. London, 1971.

Hale, J. R. *Florence and the Medici*. London, 1977.

Hale, J. R. *Italian Renaissance Painting*. Oxford, 1977.

Hale, J. R. (ed.). *A Concise Encyclopedia of the Italian Renaissance*. London, 1981.

Hali Meidenhad. An alliterative homily of the thirteenth century. Ed. O. Cockayne, rev. F. J. Furnivall. New York, 1969.

Hall, James. *Hall's Dictionary of Subjects and Symbols in Art* (1974). London, 1984.

Hall, Stuart and Jacques, Martin (eds.). *The Politics of Thatcherism*. London, 1983.

Happold, F. C. *Mysticism*. Harmondsworth, 1970.

Hardison, O. B. *Christian Rite and Christian Drama in the Middle Ages*. Baltimore, 1965.

Harford, Barbara and Hopkins, Sarah (eds.). *Greenham Common: Women at the Wire*. London, 1984.

Harksen, Sybille. *Women in the Middle Ages*. New York, 1975.

Harris, Jennifer. 'The Red Cap of Liberty'. BJES, 14, 1981, pp. 283-313.

Harrison, Jane E. 'Mythological Studies I: The Three Daughters of Cecrops'. JHS, 12, 1896, pp. 350-5.

Harrison, Jane E. 'Pandora's Box'. JHS, 20, 1900, pp. 99–114.

Harry, Bill. Heroes of the Spaceways. London, New York, 1981.

Hart, Mother Columba. See Hadewijch.

Haskell, Francis and Penny, Nicholas. Taste and the Antique. New Haven, 1981.

Hawkes, Terence. Metaphor. London, 1972.

Haworth, Kenneth. Deified Virtues, Demonic Vices and Descriptive Allegory in Prudentius' Psychomachia. Amsterdam, 1980.

Haynes, Denys. Greek Art and the Idea of Freedom. London, 1981.

Hays, H. R. The Dangerous Sex. New York, 1966.

Hebdige, Dick. Subculture. The Meaning of Style. London, 1979.

Hecht, Anthony. The Venetian Vespers. Oxford, 1980.

Hedges, Elaine and Wendt, Ingrid. In Her Own Image. New York, 1980.

Heilbrunn, Françoise. Galerie Médicis de Rubens. PGGM, 34. Paris, 1977.

Heine, Heinrich. 'The Gods in Exile'. In The Works of Heinrich Heine. Trans. Charles Godfrey Leland. London, 1892. vol. VI (1836).

Heinzl, Brigitte. Dürer. New York, 1968.

Henderson, Ernest F. Symbol and Satire in the French Revolution. New York, 1912.

Henderson, George. Chartres. Harmondsworth, 1968.

Hendy, Philip. Piero della Francesca and the Early Renaissance. London, 1968.

Herodotus. The Histories. Trans. Aubrey de Selincourt. Rev. ed. A. R. Burn (1954). PC, 1975.

Herrad of Hohenburg. Hortus Deliciarum. Ed. Rosalie Green, Michael Evans, Christine Bischoff and Michael Curshmann. 2 vols. London, 1979.

Herrera, Hayden. Frida. A Biography of Frida Kahlo. New York, 1983.

Hertz, Neil. 'Medusa's Head: Male Hysteria under Political Pressure'. Representations, 4, Fall 1983, pp. 27–54.

Hesiod. Works and Days. Ed. T. A. Sinclair. London, 1932.

Hesiod. Theogony. Trans. and intro. Norman O. Brown. Indianapolis, 1953.

Hesiod. Theogony. Ed. M. L. West. Oxford, 1966.

Hesiod. Theogony, Works and Days; Theognis. Elegies. Trans. Dorothea Wender. PC, 1973.

Hibbard, Howard. Bernini. Harmondsworth, 1965.

Higgins, R. A. Greek Terracotta Figures. London, 1969.

Hildegard of Bingen. Reigen der Tugenden: Ordo Virtutum. Ein Singspiel. Ed. M. Bockeler and P. Barth. Berlin, 1927.

Hildegard of Bingen. Scivias. See Abbreviations list.

Hildegard of Bingen. Opera Omnia. PL, 197.

Hillairet, Jacques. Evocation du vieux Paris. 2 vols. Paris, 1952–3.

Hiller, Susan. Sisters of Menon. London, 1979.

Hiller, Susan. The Muse My Sister. (Catalogue). Exhibition, Gimpel Fils, London, March–April 1983. London, 1983.

Hiller, Susan and Coxhead, David. Dreams. Visions of the Night. London, 1981.

Hobsbawm, Eric. 'Man and Woman in Socialist Iconography'. HWJ, 6, 1978, pp. 121–38.

Hobsbawm, Eric and Ranger, Terence (eds.). The Invention of Tradition. Cambridge, 1983.

Hobsbawm, Eric. 'Mass-Producing Traditions: Europe 1890-1914'. In Hobsbawm and Ranger, 1983.

Hollander, Anne. Seeing Through Clothes. New York, 1975.

Homer. The Odyssey. Trans. A. T. Murray (1919). 2 vols. London, 1976, 1980.

Homer. The Odyssey. Trans. E. V. Rieu (1946). PC, 1982.

Homer. The Odyssey. Trans. Richmond Lattimore. London, 1967.

Homer. The Iliad. Trans. E. V. Rieu (1950). PC, 1976.

Homer. *The Iliad*. Trans. Richmond Lat-timore. London, 1961.

The Homeric Hymns. Trans. Charles Boer. Ann Arbor, 1970.

Honig, Edwin. *Dark Conceit: The Making of Allegory*. London, 1960.

Honour, Hugh. *The New Golden Land. European Images of America from the Dis-coveries to the Present Time*. London, 1975.

Honour, Hugh. *Romanticism*. London, 1979.

Honour, Hugh and Fleming, John. *A World History of Art*. London, 1982.

Hope, Charles. *Titian*. London, 1980.

Horace. *The Odes and Epodes*. Trans. C. E. Bennett. London, 1914.

Horace. *The Complete Odes and Epodes*. Trans. W. G. Shepherd. PC, 1983.

Horton, Adey. *The Child Jesus*. London, 1975.

Hôtel de Ville. *Exposition du centenaire de la réconstruction de l'Hôtel de Ville, 1882–1982*. Paris, 1982.

Houdebine, Anne-Marie. 'Les Femmes et la langue'. *Tel Quel*, 74, Winter 1977, pp. 84–95.

Hroswitha of Gandersheim. *The Non-Dramatic Works*. Trans. Sister M. Gon-salva Wiegand. St Louis, Missouri, 1936.

Hroswitha of Gandersheim. *Opera*. PL 137.

Hroswitha. *The Plays*. Trans. Christopher St John. New York, 1923.

Hudson, Liam. *Bodies of Knowledge. The Psychological Significance of the Nude in Art*. London, 1982.

Huet, J. B. *Le Trésor des artistes*. Paris, 1810.

Hugo, Victor. *Œuvres complètes*. Paris, 1880–9.

Huizinga, J. *The Waning of the Middle Ages*. Trans. F. Hopman (1924). Har-mondsworth, 1972.

Huizinga J. *Homo Ludens*. Haarlem, 1938.

Hunisak, John M. *The Sculptor Jules Dalou. Studies in his style and imagery*. Thesis, University of New York, 1975. New York, 1977.

Hunt, Lynn. 'Engraving the Republic: Prints and Propaganda in the French Revolution'. *History Today*, October 1980, pp. 11–17.

Hunt, Lynn. 'Hercules and the Radical Image in the French Revolution'. *Re-presentations*, 1, 2, 15, 1983, pp. 95–117.

Hunt, Lynn. 'The Rhetoric of Revolution in France'. HWJ, 1983, pp. 78–91.

Hunt, Lynn. *Politics, Culture and Class in the French Revolution*. Berkeley, 1984.

Husband, Timothy. *The Wild Man. Medi-eval Myth and Symbolism*. New York, 1981.

Iconology: A Collection of Emblematical Figures, Moral and Instructive. London, 1832.

Ignatieff, Michael. 'Homo Sexualis'. LRB, 4–17 March 1982.

Il y a cent cinquante ans ... Juillet 1930. (Catalogue). Musée Carnavalet, Paris, 8 July–2 November 1980.

Irigaray, Luce. *Speculum, de l'autre femme*. Paris, 1974.

Irigaray, Luce. *Ce Sexe qui n'en est pas un*. Paris, 1977.

Italian Renaissance Drawings from the Musée du Louvre, Paris 1500–1575. (Catalogue). MMA, 11 October 1974–5 January 1975. New York, 1974.

Ivory Carving in Early Medieval England. (Catalogue). VA, 8 May–7 July 1974.

Jacobs, Lea. 'Now Voyager: Some Prob-lems of Enunciation and Sexual Differ-ence'. *Camera Obscura*, 7. Berkeley, 1981, pp. 89–104.

Jacobs, Michael. *Mythological Painting*. Ox-ford, 1979.

Jacquet, George. *La Victoire de Samothrace*. Paris, 1976.

James, E. O. *The Cult of the Mother God-dess*. New York, 1959.

James, William. *The Varieties of Religious Experience*. London, 1960.

Jenkins, Kenneth. *Coins of Greek Sicily*. London, 1966.

Jenkyns, Richard. *The Victorians and Ancient Greece*. Oxford, 1980.

Johns, Elizabeth. *Thomas Eakins. The Heroism of Modern Life*. Princeton, 1983.

Johnson, Ellen H. *Claes Oldenburg*. Harmondsworth, 1971.

Jones, Lynne (ed.). *Keeping the Peace*. London, 1985.

Jones, Mark. *Medals of the Sun King*. London, 1979.

Jones, Mark. *The Art of the Medal*. London, 1979.

Jones, Mark. *The Dance of Death: Medallic Art of the First World War*. London, 1979.

Jones, Mark. 'The Medal as an Instrument of Propaganda in late Seventeenth and early Eighteenth Century Europe. Part I'. *The Numismatic Chronicle*, 142, 1982, pp. 117-26.

Julian of Norwich. *Revelations of Divine Love*. Trans. and intro. Clifton Wolters. PC, 1966.

Jung, C. G. *Aspects of the Feminine*. Trans. R. F. C. Hull. London, 1982.

Jung, C. G. and Kerényi, C. *Essays on a Science of Mythology*. Trans. R. F. C. Hull. Princeton, 1969.

Kafka, Franz. *America* (1927). Trans. Edwin and Willa Muir (1938). Harmondsworth, 1981.

Katzenellenbogen, Adolf. *Allegories of the Virtues and Vices in Medieval Art. From early Christian times to the thirteenth century* (1939). London, 1968.

Katzenellenbogen, Adolf. *The Sculptural Programmes of Chartres Cathedral*. Baltimore, 1959.

Angelika Kauffmann und ihre Zeitgenossen. (Catalogue). Bregenz Vorarlberger Landesmuseum, 23 July-13 October 1968.

Kauffmann, C. M. *An Altar-piece of the Apocalypse*. VA, 1968.

Kauffmann, C. M. *The Altar-piece of St George from Valencia*. VA, 1970.

Keen, Maurice. *Chivalry*. New Haven, 1984.

Keohane, Nannerl O., Rosaldo, Michelle Z. and Gelpi, Barbara C. (eds.). *Feminist Theory: A Critique of Ideology*. Brighton, 1982.

Kerényi, C. *The Gods of the Greeks*. Trans. Norman Cameron. London, 1979.

Kermode, Frank. 'Spenser and the Allegorists'. *Proceedings of the British Academy*, 1962, 48 (1963).

Kiernan, V. G. *Lords of Human Kind*. London, 1969.

Kightly, Charles. *Folk Heroes of Britain*. London, 1982.

King, Helen. 'Bound to Bleed, Artemis and Greek Women'. In Cameron and Kuhrt, pp. 109-27.

Kingsley Porter, A. *Romanesque Sculpture of the Pilgrimage Roads*. Boston, 1923.

Kirk, G. S. *The Nature of the Greek Myths*. Harmondsworth, 1974.

Kirk, G. S., Raven, J. E. and Schofield, M. (eds.). *The Presocratic Philosophers*. Cambridge, 1983.

Kjellberg, Pierre. *Le Guide des statues de Paris*. Paris, 1973.

Kloek, Wouter. *Just Looking at Girls or Boys*. (Catalogue). Rijksmuseum, Amsterdam, 1977-8.

Knight, A. E. *Aspects of Genre in Late Medieval French Drama*. Manchester, 1983.

Knoepflmacher, U. C. and Tennyson, G. B. *Nature and the Victorian Imagination*. Los Angeles, 1978. Esp: Frederick Kirchhoff, 'A Science against Sciences: Ruskin's Floral Mythology', pp. 246-58; Martin Meisel, ' "Half-Sick of Shadows": The Aesthetic Dialogue in Pre-Raphaelite Painting', pp. 309-40.

Käthe Kollwitz. Graphics, Posters, Drawings. Ed. Renate Hinz. Trans. Rita and Robert Kimber. London, 1981.

Käthe Kollwitz: Engravings, Drawings, Sculptures. (Catalogue). Trans. Eileen Martin. Stuttgart, 1982.

Kristeva, Julia. *Desire in Language*. Ed. Leon S. Roudiez. Trans. T. Gora, A. Jardine, L. S. Roudiez. Columbia, 1980.

Kristeva, Julia. 'Women's Time'. Trans.

Alice Jardine and Harry Blake. In Keohane, Rosaldo and Gelpi, 1982, pp. 31-53.

Kundera, Milan. *The Book of Laughter and Forgetting*. Trans. Michael Henry Heim. London, 1982.

Kundera, Milan. *The Joke* (1967). Trans. Michael Henry Heim. London, 1983.

Labalme, Patricia (ed.). *Beyond Their Sex: Learned Women of the European Past*. New York, 1984.

Lagorio, Valerie. 'The Medieval Continental Women Mystics: An Introduction'. In Paul Szarmach (ed.), *An Introduction to the Medieval Mystics of Europe*. Albany, 1984.

Lakoff, George and Johnson, Mark. *Metaphors We Live By*. Chicago, London, 1980.

Lami, Stanislas. *Dictionnaire des sculpteurs de l'Ecole Française au dix-huitième siècle*, 2 vols. Paris, 1910-11.

Lami, Stanislas. *Dictionnaire des sculpteurs de l'Ecole Française au dix-neuvième siècle*, 4 vols. Paris, 1914-21.

Lane, Michael (ed. and intro.). *Introduction to Structuralism*. New York, 1970.

Langland, W. *Piers the Ploughman*. Trans. J. F. Goodridge. PC, 1966.

Larner, Christina. *Enemies of God. The Witch-Hunt in Scotland*. Oxford, 1981.

Larner, Christina. *Witchcraft and Religion*. Oxford, 1984.

Larousse Dictionary of Painters. Intro. Alistair Smith. London, 1981.

Larousse Encyclopedia of Mythology, The New. Intro. Robert Graves. London, 1968.

Larson, Gerald James, Pal, Pratapaditya and Gowen, Rebecca P. *In Her Image*. Santa Barbara, 1980.

Late Gothic Art from Cologne. NGL, 5 April-1 June 1977. London, 1977.

Lavin, Irving. *Bernini and the Unity of the Visual Arts*. 2 vols. New York, 1980.

Lawrence, A. W. *Greek Architecture*. Harmondsworth, 1957.

Leach, E. R. 'Magical Hair'. *Journal of the Royal Anthropological Institute*, 88, 1958, pp. 147-64.

Leach, Edmund. *Genesis as Myth and Other Essays*. London, 1969.

Lee, Patrick C. and Sussman Stewart, Robert (eds.). *Sex Differences*. New York, 1970.

Lefkowitz, Mary R. 'Princess Ida, The Amazons and a women's college curriculum'. TLS, 27 November 1981.

Lefkowitz, Mary R. and Fant, Maureen B. *Women's Life in Greece and Rome*. London, 1982.

Leith, James A. *The Idea of Art as Propaganda in France*. Toronto, 1965.

Lerner, Robert E. *The Heresy of the Free Spirit in the Later Middle Ages*. Berkeley, 1972.

Levey, Michael. *Early Renaissance*. London, 1967.

Levey, Michael. *The Painter Depicted*. London, 1981.

Lévi-Strauss, Claude. *Totemism*. Trans. Rodney Needham. Boston, 1963.

Lévi-Strauss, Claude. 'The Sex of the Heavenly Bodies'. In Michael Lane, pp. 330-9.

Lévi-Strauss, Claude. *The Scope of Anthropology*. Trans. Sherry Ortner Paul and Robert A. Paul. London, 1971.

Lewis, C. S. *The Allegory of Love*. Cambridge, 1936.

Lilar, Suzanne. *Aspects of Love in Western Society*. London, 1965.

Lippard, Lucy R. *Overlay*. New York, 1983.

Llewelyn Davies, Margaret. *Maternity: Letters from Working Women*. London, 1978.

Lloyd-Jones, Hugh. *The Justice of Zeus*. Berkeley, 1971.

Lloyd-Jones, Hugh (trans. and ed.). *Females of the Species. Simonides on Women*. London, 1975.

Lloyd-Jones, Hugh J. *Blood for the Ghosts: Classical Influences in the Nineteenth and Twentieth Centuries*. London, 1982.

Looz, Pierre de. *Sociologie et Canonisations*. Liège, 1969.

Loraux, Nicole. *Les Enfants d'Athéna: idées athéniennes sur la citoyenneté et la division des sexes.* Paris, 1981.

Lorimer, H. L. 'Gold and Ivory in Greek Mythology'. In *Greek Poetry and Life: Essays Presented to Gilbert Murray.* Oxford, 1936, pp. 14-34.

Lorris, Guillaume de, and Meung, Jean de. *Le Roman de la rose.* Ed. Ernest Langlois. 5 vols. Paris, 1914-24.

Louth, Andrew. *Discerning the Mystery.* Oxford, 1983.

Lucas, E. V. *A Wanderer in Paris.* London, 1952.

Lucie-Smith, Edward. *Eroticism in Western Art.* London, 1972.

Lucie-Smith, Edward. *The Body.* London, 1981.

Lullies, R. and Hirmer, M. *Greek Sculpture.* London, 1957.

Lurie, Alison. *The Language of Clothes.* London, 1983.

MacCarthy, Mary. *The Stones of Florence.* London, 1965.

MacCormack, Carol P. and Strathern, Marilyn (eds.). *Nature, Culture and Gender.* Cambridge, 1980.

MacCormack, Sabine G. *Art and Ceremony in Late Antiquity.* Berkeley, 1981.

MacDonald, Sharon. 'Boadicea, Warrior Queen: A Study in Sexual Anomaly and Nationalism'. Paper kindly lent by author. Oxford, 1985.

Maclean, Ian. *The Renaissance Idea of Woman: A study in the fortunes of scholasticism and medical science in European intellectual life.* Cambridge, 1980.

Maeterlinck, Maurice. *Monna Vanna.* Paris, 1911.

Malaxecheverria, Ignacio. *Le bestiaire médiéval et l'archétype de la fémininité.* Paris, 1982.

Malcolm, Janet. *Diana and Nikon: Essays on the Aesthetic of Photography.* Boston, 1980.

Mâle, Emile. *L'Art en France à la fin du moyen-âge.* Paris, 1908.

Mâle, Emile. *L'Art du douzième siècle en France.* Paris, 1924.

Mâle, Emile. *L'Art du treizième siècle en France.* Paris, 1925.

Mâle, Emile. *L'Art religieux de la fin du XVIe siècle, du XVIIe siècle et du VIIIe siècle* (1932). Paris, 1951.

Mâle, Emile. *Religious Art.* New York, 1958.

Mâle, Emile. *The Early Churches of Rome* (1942). Trans. David Buxton. London, 1960.

Mâle, Emile. *The Gothic Image* (1913). Trans. Dora Nussey. New York, 1972.

Marillier, H. C. *The Tapestries of Hampton Court Palace.* London, 1962.

Markale, J. *Women of the Celts.* Trans. A. Mygind, C. Hauch and P. Henry. London, 1980.

Marle, Raymond Van. *Iconographie de l'art profane.* 2 vols. The Hague, 1932.

Martin, Gregory. *Hieronymus Bosch.* London, 1978.

Marwick, Arthur. *Women at War 1914-1918.* London, 1977.

Marwick, Max (ed.). *Witchcraft and Sorcery.* Harmondsworth, 1970.

Masson, Georgina. *The Companion Guide to Rome.* London, 1972.

Mauss, Marcel. *Sociologie et anthropologie.* Paris, 1950.

Mead, Margaret. *Male and Female.* London, 1962.

Medieval and Early Renaissance Treasures in the North West. (Catalogue). Whitworth Art Gallery, Manchester, 15 January-28 February 1976.

Meillet, A. *Linguistique historique et linguistique générale.* Paris, 1921.

Meisel, Martin. *Realizations. Narrative Pictorial and Theatrical Arts in Nineteenth-Century England.* Princeton, 1983.

Meletzis, Spyros and Papadakis, Helen. *Acropolis and Museum.* Munich, Zurich, 1967.

Menestrier, Claude François. *Histoire du roi Louis le Grand par les médailles.* Paris, 1693.

Merck, Mandy. 'The Patriotic Amazono-machy and ancient Athens'. In *Tearing the Veil*. Ed. Susan Lipshitz. London, 1978.

Merimée, Prosper. *La Vénus d'Ille* (1837). In *Romans et nouvelles*. Ed. Maurice Parturier, vol. II. Paris, 1967.

Methodius of Olympus, *The Symposium. A Treatise on Chastity*. Ed. Herbert Musurillo. Maryland, 1958.

Meung, Jean de. See Lorris.

Meyer, Martin W. 'Making Mary Male: the Categories "Male" and "Female" in the Gospel of Thomas'. Paper kindly lent by the author. Forthcoming in *Journal of Theological Studies*.

Middleton, Robin (ed.). 'The Beaux-Arts'. AD Profiles 17. London, 1975.

Middleton, Robin. 'The Use and Abuse of Tradition in Architecture'. JRSA, 5328, November 1983, pp. 729-37.

Mill, Harriet Taylor. *Enfranchisement of Women*, and Mill, John Stuart. *The Subjection of Women*. London, 1983.

Miller, Jonathan and Pelham, David. *The Human Body*. London, 1983.

Miroure of Mans Salvacionne, The. London, 1888.

Mitchell, Juliet and Rose, Jacqueline (eds.). *Jacques Lacan and the Ecole Freudienne: Feminine Sexuality*. London, 1982.

Mitchell, Juliet. *Women: The Longest Revolution*. London, 1984.

Mockler, Anthony. *Francis of Assisi*. Oxford, 1976.

Morand, François C. *L'Arc de Triomphe*. Paris, 1961.

Moreau-Vauthier, Charles. *Gérôme, peintre et sculpteur: l'homme et l'artiste*. Paris, 1906.

Giovanni Battista Moroni. (Catalogue ed. Allan Braham). NGL, 1978.

Morris, Joan. *The Lady was a Bishop*. New York, 1973.

Mosse, David, 'Caesarism, Circuses and Monuments'. JCH, VI, 2, 1971, pp. 167-82.

Alphonse Mucha. Figures décoratives. New York, 1981.

Murrell, William. *A History of American Graphic Humour*. 2 vols. New York, 1933.

Murrin, Michael. *The Allegorical Epic*. Chicago, 1979.

I Musei Archeologici della Provincia di Matera. (Catalogue). Matera, 1975.

Musil, Robert. 'Denkmale'. In *Nachlass zu Lebzeiten*. Zurich, 1936, pp. 87-93.

Musurillo, Herbert. *Symbolism and the Christian Imagination*. Baltimore, Dublin, 1962.

Mythe et personnification. Actes du colloque au Grand Palais. 7-8 May 1977. Paris, 1980.

The Nag Hammadi Library in English. Trans. members of the Coptic Gnostic Library Project of the Institute for Antiquity and Christianity. Directed James M. Robinson. Leiden, 1977.

Nash, Peter. *Women in Rock*. London, 1983.

Navaretta, Cynthia (ed.). *Voices of Women*. New York, 1980.

Neumann, Erich. *The Great Mother*. Trans. Ralph Manheim. London, 1955.

Newbold, E. B. *Portrait of Coventry*. London, 1982.

Newton, Judith L., Ryan, Mary P. and Walkowitz, Judith R. (eds.). *Sex and Class in Women's History*. London, 1983.

Nicholson, John. *Men and Women. How Different are They?* Oxford, 1984.

Nickel, Helmut. *The Art of Chivalry*. MMA, n. d.

Nos ancêtres les Gaulois. Actes du colloque international de Clermont-Ferrand, recueillis et présentés par Paul Viallaneix et Jean Enfard. Clermont-Ferrand, 1982.

O'Faolain, Julia and Martines, Lauro (eds.). *Not in God's Image*. London, 1973.

O'Flaherty, Wendy Doniger. *Women, Androgynes, and other Mythical Beasts*. Chicago, 1980.

Oakley, Anne. *Subject Women*. Oxford, 1981.

Oldenburg, Claes. *Notes in Hand*. London, 1971.

Onians, Richard B. *The Origins of European Thought*. Cambridge, 1951.

Opie, Iona and Peter. *The Classic Fairy Tales*. London, 1974.

Opie, Iona and Peter (eds.). *The Oxford Dictionary of Nursery Rhymes*. Oxford, 1977.

Opie, Iona and Peter (eds.). *A Nursery Companion*. Oxford, 1980.

Oppositions. 'Monument/Memory'. Ed. Kurt W. Forster. Fall 1982, New York.

Ortalli, Gherardo. *La Pittura Infamante nei Secoli XIV-XVI*. Rome, 1979.

Ovid. *Metamorphoses*. Trans. Mary M. Innes. PC, 1955.

Ozouf, Mona. *La Fête révolutionnaire*. Paris, 1981.

Pagels, Elaine. *The Gnostic Gospels*. New York, 1981.

Painting in Naples 1606-1705; from Caravaggio to Giordano. (Catalogue ed. Clovis Whitfield and Jane Martineau). RA, 2 October-12 December 1982. London, 1982.

Palmer, Robert E. A. 'Roman Shrines of Female Chastity from the Caste Struggle to the Papacy of Innocent I'. *Rivista Storica dell'Antichità*, 4, 1974, pp. 294-309.

Pandora's Box. Women's Images. (Catalogue ed. Gill Calvert, Jill Morgan and Mouse Katz). London, 1984.

Panofsky, Erwin. *Problems in Titian - Mainly Iconographic*. London, 1969.

Panofsky, D. and E. *Pandora's Box*. London, 1956.

Panofsky, Erwin. 'The Ideological Antecedents of the Rolls-Royce Radiator'. *Proceedings of the American Philosophical Society*, 107, 1963.

Panofsky, Erwin. *Meaning in the Visual Arts*. New York, 1955.

Panofsky, Erwin. *Studies in Iconology* (1939). New York, 1972.

Parker, Roszika. *The Subversive Stitch*. London, 1984.

Pater, Walter. *The Renaissance*. New York, 1959.

Paulson, Ronald. *Representations of Revolution 1789-1820*. New Haven, 1983.

Pausanias. *Guide to Greece*. Trans. Peter Levi (1971). PC, 1984.

Péju, Pierre. *La Petite Fille dans la forêt des contes*. Paris, 1981.

Pember Reeves, Maud. *Round about a Pound a Week*. London, 1979.

Pembroke, Simon. 'Women in Charge: The function of alternatives in early Greek tradition and the ancient idea of matriarchy'. JWCI, XXX, 1967, pp. 1-36.

Penley, Constance. 'Introduction to "Metaphor/Metonymy" of the Imaginary Referent'. *Camera Obscura*, 7. Berkeley, 1981, pp. 7-28.

Penny, Nicholas. *Church Monuments in Romantic England*. New Haven and London, 1977.

Penny, Nicholas. *Mourning*. London, 1981.

Penny, Nicholas. 'Stroking'. LRB, IV, 15 July-4 August 1982, pp. 16-17.

Penny, Nicholas. 'Goddesses and Girls'. LRB, IV, 2-29 December 1982, pp. 20-1.

Perniôla, Mario. 'Icônes, visions, simulacres'. *Traverses*, 10, February 1978, Paris.

Perry, Gillian. *Paula Modersohn-Becker*. London, 1979.

Petersen, Karen and Wilson, J. J. *Women Artists*. London, 1978.

Petrarch. *Rime, Trionfi e Poesie Latine*. Ed. F. Neir, G. Martellotti, E. Bianchi, N. Sapegno. Milan, 1951.

Pevsner, Nikolaus. *The Buildings of England. The Cities of London and Westminster*. London, 1952.

Philippe, Robert. *Political Graphics. Art as a Weapon*. Trans. J. Ramsay. Oxford, 1982.

Phillips, J. A. *Eve: The History of an Idea*. New York, 1984.

Physick, John. *The Wellington Monument*. VA, 1970.

Picasso's Picassos. (Catalogue). Hayward

Gallery, London, 17 July-11 October 1981. Intro. Timothy Hilton.

Pindar. *The Odes*. Trans. C. M. Bowra. PC, 1969.

Pindar. *The Odes*. Trans. Sir J. E. Sandys (1915). London, 1978.

Pingeot, Anne. *De Carpeaux à Rodin*. PGGM, 48. Paris, 1979.

Pingeot, Anne. 'Le Rôle de la sculpture dans l'architecture. A propos de l'Opéra de Paris'. *Revue Suisse de l'art et d'archéologie*, 1981, pp. 119-35.

Pingeot, Anne, Le Normand-Romaine, Antoinette and Lemaistre, Isabelle. *Sculpture française du XIX^e siècle*. LNHA, Paris, 1982.

Pingeot, Anne. 'Les Gaulois sculptés'. In *Nos ancêtres les Gaulois*, pp. 250-69.

Pinkney, David H. *Napoleon III and the Rebuilding of Paris*. Princeton, 1958.

Pizan, Christine de. *Le Ditié de Jehanne d'Arc*. Ed. A. J. Kennedy and Kenneth Varty. Oxford, 1977.

Pizan, Christine de. *Œuvres Poétiques*. Ed. M. Roy. Paris, 1886-96.

Pizan, Christine de. *The Book of Fayttes of Armes and Chyvalrye*. Trans. W. Caxton (1489). Ed. A. T. P. Byles. London, 1932.

Pizan, Christine de. *The Book of the City of Ladies*. Trans. and intro. Earl Jeffrey Richards. New York, 1982.

Pizan, Christine de. *The Treasure of the City of Ladies* or *The Book of the Three Virtues*. Trans. and intro. Sarah Lawson. London, 1985.

Plato. *Gorgias*. Ed. E. R. Dodds. Oxford, 1959.

Plato. *Gorgias*. Trans. and intro. Walter Hamilton. PC, 1971.

Plato. *The Republic*. Trans. and intro. Desmond Lee. PC, 1974.

Plato. *The Symposium*. Trans. Walter Hamilton. PC, 1951.

Plato. *Timaeus and Critias*. Trans. and intro. H. D. P. Lee. PC, 1971.

Pliny the Elder. *Natural History*. Trans. H. Rackham, W. H. S. Jones et al. 9 vols. London, 1966-9.

Plommer, Hugh. 'Vitruvius and the Origin of Caryatids'. JHS, 94, 1979, pp. 97-102.

Plumb, J. H. and Wheldon, Huw. *Royal Heritage – the Story of Britain's Royal Builders and Collectors*. London, 1977.

Poèmes de la mort de Turold à Villon. Ed. Jean Marcel Paquette. Paris, 1979.

Poems of Heaven and Hell from Ancient Mesopotamia. Trans. and intro. N. K. Sandars. PC, 1971.

Politics of Matriarchy. Matriarchy Study Group. London, n.d.

Pollock, Griselda. 'Artists, Mythologies and Media: Genius, Madness and Art History'. *Screen*, 21, 3, 1980.

Pollock, Griselda and Parker, Roszika. *Old Mistresses*. London, 1981.

Pomeroy, Sarah B. *Goddesses, Whores, Wives and Slaves*. New York, 1975.

Pope-Hennessy, John. *Italian Gothic Sculpture*. VA, 1952.

Porteous, John. *Coins in History*. London, 1969.

Power, Eileen. *Medieval Women*. Cambridge, 1975.

Pradel, Pierre. *Le Palais*. PGGM, 5. Paris, 1979.

Pradel, Pierre. *Musée du Louvre: son histoire*. PGGM, 4. Paris, 1981.

Praz, Mario. *The Romantic Agony*. Trans. Angus Davidson. London, 1960.

Prints of the Italian Renaissance. (Catalogue by Jay A. Levenson). NGW, 24 June-7 October 1973. Washington, DC, 1973.

Pritchard, James B. (ed.). *Ancient Near Eastern Texts Relating to the Old Testament*. Princeton, 1969.

Prudentius. *Psychomachia*. Trans. H. J. Thomson. 2 vols. London, 1949.

Quiguier, Claude. *Femmes et machines de 1900*. Paris, 1979.

Quilligan, Maureen. *The Language of Allegory*. Ithaca, 1979.

Quintavalle, Carlo. *Bellini*. Milan, 1964.

Rabson, Carolyn (ed.). *Songbooks of the American Revolution*. Maine, 1974.

Raby, F. J. E. *A History of Christian-Latin Poetry* (1927). Oxford, 1953.

Radcliffe, Anthony. *Monti's Allegory of the Risorgimento*. VA, 1970.

Radice, Betty. *Who's Who in the Ancient World*. Harmondsworth, 1973.

Read, Benedict. *Victorian Sculpture*. London, New Haven, 1982.

Rearick, Charles. 'Festivals in Modern France: The Experience of the Third Republic'. JCH, 12, 1977, pp. 435–60.

Réau, Louis. *L'Iconographie de l'art chrétien*. 3 vols. Paris, 1958.

Reinach, Salomon. *Répertoire des vases peints grecs et etrusques*. 2 vols. Paris, 1899–1900.

Rembrandt. All the Etchings. Ed. Garry Schwartz. London, 1977.

Renouvier, J. *Histoire de l'art pendant la Révolution*. Paris, 1863.

La Révolution française/Le Premier Empire. Dessins du Musée Carnavalet. Musée Carnavalet, Paris, 22 February–22 May 1982.

Rich, Adrienne. *Of Woman Born*. London, 1977.

Rich, Adrienne. *On Lies, Secrets and Silence*. London, 1980.

Riegl, Alois. 'The Modern Cult of Monuments: Its Character and Its Origin'. Trans. Kurt W. Forster and Diane Ghirardo. In *Oppositions*.

Riemer, Eleanor S. and Fout, John C. (eds.). *European Women. A Documentary History 1789–1945*. Brighton, 1983.

Ripa, Cesare. *Iconologia overo Descrittione delle Imagini Universali, cavate dalle statue, e Medaglie antiche, e da buonissimi Auttori Greci e Latini di Cesare Ripa Perugino*. Milan, 1602.

Ritchie Key, Mary. *Male/Female Language*. New Jersey, 1975.

The Rival of Nature. (Catalogue). NGL, June 1975. London, 1975.

Robertson, M. *A History of Greek Art*. 2 vols. Cambridge, 1975.

Rodgers, Sylvia. 'The Symbolism of Ship Launching in the British Navy'. D. Phil. Thesis, Oxford, 1983.

Rogers, Katherine M. *The Troublesome Helpmate. A History of Misogyny in Literature*. Washington, 1966.

Rollinson, Philip. *Classical Theories of Allegory and Christian Culture*. Pittsburgh, 1981.

The Romantics to Rodin. French Nineteenth-Century Sculpture from North American Collections. (Catalogue ed. Peter Fusco and H. W. Janson). Los Angeles County Museum, 1980.

Roots of Bitterness: Documents of the social history of American women. Ed. and intro. Nancy F. Cott. New York, 1972.

Rosaldo, Michelle Zimbalist and Lamphere, Louise (eds.). *Woman, Culture and Society*. Stanford, 1974.

Rosen, Charles and Zerner, Henri. *Romanticism and Realism. The Mythology of Nineteenth-Century Art*. London, 1984.

Rosena, Helen. *Woman in Art from Type to Personality*. London, 1944.

Rosenbaum-Dondaine, Catherine. *L' Image de pieté en France* (Catalogue). Musée de la Seita. Paris, 1984.

Rossi-Bortolatto, Luigina. *L'Opera Pittorica Completa di Delacroix*. Milan, 1972.

Rossiter, Stuart (ed.). *Blue Guide to Rome and its Environs*. London, 1971.

Roszak, Betty and Theodore. *Masculine/Feminine*. New York, 1969.

Rousseau, Jean-Jacques. 'Lettre à d'Alembert'. In *Œuvres de J.-J. Rousseau*, vol. 2, Paris, 1820.

Rousseau, Jean-Jacques. *Du contrat social ou principes du droit politique*. Paris, 1962.

Roussel, Nelly. *L'Eternelle sacrifiée*. Paris, 1979.

Rubinstein, Nikolai. 'Political Ideas in Sienese Art: The Frescoes by Ambrogio Lorenzetti and Taddeo di Bartolo in the Palazzo Pubblico'. JWCI, XXI, 1958, pp. 179–89.

Rudofsky, Bernard. *The Unfashionable Human Body*. New York, 1971.

Ruether, Rosemary Radford (ed.). *Religion and Sexism*. New York, 1974.

Ruether, Rosemary Radford. 'Reflection on Woman-Church'. *Probe*, XII, 2, February/March 1984.

William Rush, American Sculptor. (Catalogue). Pennsylvania Academy of Arts. Foreword by Richard J. Boyle. Pennsylvania, 1982.

Ruskin, John. *The Queen of the Air* (1869). London, 1907.

Rycroft, Charles. *The Innocence of Dreams*. London, 1979.

Rykwert, Joseph. *The Necessity of Artifice*. London, 1982.

Saintyves, P. (Emile Nourry). *Essais de mythologie chrétienne. Les Saints successeurs des dieux*. Paris, 1907.

Samuel, Pierre. *Amazones, guerrières et gaillardes*. Grenoble, 1975.

Samuel, Raphael and Stedman-Jones, Gareth (eds.). *Culture, Ideology and Politics*. London, 1982.

Sanday, Peggy Reeves. *Female Power and Male Dominance. On the Origins of Sexual Inequality*. Cambridge, 1981.

Saxer, Victor. *Le Culte de Marie-Madeleine en occident des origines à la fin du moyen-âge*. 2 vols. Paris, 1959.

Saxl, Fritz. 'Veritas Filia Temporis'. In *Philosophy and History, Essays Presented to Paul Cassirer*. Ed. Raymond Klibansky and Herbert J. Paton. 1936, pp. 213ff.

Saxl, Fritz. *Mithras*. Berlin, 1931.

Schiller, Gertrud. *Iconography of Christian Art*. Trans. J. Seligman. 2 vols. London, 1971-2.

Schmitt, Pauline. 'Athéna Apatouria et la ceinture. Les aspects féminins des Apatouries à Athènes'. *Annales ESC*, 1977, pp. 1059-73.

Scholem, Gershom. 'Lilith'. *Encyclopedia Judaica*, II, pp. 246-9. Jerusalem, 1971.

Martin Schongauer. The Complete Engravings. Ed. Alan Shestack. New York, 1969.

Schorsch, Anita. *Images of Childhood*. New York, 1979.

Schorske, Carl E. *Fin-de-Siècle Vienna: Politics and Culture*. London, 1980.

Seabrook, Jeremy and Blackwell, Trevor. 'Mrs Thatcher's Religious Pilgrimage'. *Granta 6, A Literature for Politics*. Cambridge, 1983.

Seymour, Charles, Jr. *Michelangelo's David*. Pittsburgh, 1967.

Seznec, Jean. *The Survival of the Pagan Gods*. Trans. Barbara F. Sessions. Princeton, 1953.

Shahar, Shulamith. *The Fourth Estate: A History of Women in the Middle Ages*. London, 1983.

Shelley, Mary. *Frankenstein* (1816). New York, 1965.

The Shepherd of Hermas. Hermas le Pasteur. Trans. and ed. Robert Joly. Paris, 1968.

Singer, C. 'An Allegorical Representation of the Synagogue in a twelfth-century illuminated manuscript of Hildegard of Bingen'. London, 1915.

Slater, Philip. *The Glory of Hera*. Boston, 1968.

Small, Herbert. *The Library of Congress. Its Architecture and Decoration*. New York, London, 1982.

Smith, A. H. 'The Making of Pandora'. *JHS*, 11, 1911. pp. 278-83.

Snitow, Ann, Stansell, Christine and Thompson, Sharon (eds.). *Desire. The Politics of Sexuality*. London, 1984.

Sontag, Susan. *Illness as Metaphor*. London, 1979.

Sontag, Susan. *On Photography*. Harmondsworth, 1981.

Sophocles. *Electra and Other Plays*. Trans. E. F. Watling. PC, 1953.

Sophocles. *The Theban Plays*. Trans. E. F. Watling. PC, 1947.

Sowerine, Charles. *Sisters or Citizens?* Cambridge, 1982.

Speculum Humanae Salvationis. Reproduction of an Italian MS. of the 14th century, BN. MS. Lat. 9584. Described by M. R. James. Oxford, 1926.

Spencer, Isobel. *Walter Crane*. London, 1975.

Spender, Dale. *Man Made Language*. London, 1980.

Splendours of the Gonzaga. (Catalogue ed. David Chambers and Jane Martineau). VA, 4 November 1981-31 January 1982. London, 1981.

Stafford, Pauline. *Queens, Concubines and Dowagers*. London, 1983.

Stamps of Foreign Countries. (Stanley Gibbons Catalogue). 2 vols. London, 1928.

Stamps of the British Empire. (Stanley Gibbons Catalogue). vol. 1. London, 1928.

Starobinski, Jean. *L'Invention de la Liberté*. Geneva, 1964.

Starobinski, Jean. *1789: les emblèmes de la Raison*. Paris, 1979.

Steinberg, Leo. *The Sexuality of Christ in Renaissance Art and in Modern Oblivion*. London, 1984.

Stokes, Adrian. *The Critical Writings of Adrian Stokes*. Ed. Lawrence Gowing. 3 vols. London, 1978. Especially: *The Quattro Cento* (1932); *Michelangelo* (1955); *Reflections on the Nude* (1967).

Strong, Roy. *Portraits of Queen Elizabeth I*. Oxford, 1963.

Summerson, John (ed.). *A New Description of Sir John Soane's Museum*. London, 1955.

Surel, Jeannine. 'La première image de John Bull, bourgeois radical, Anglais loyaliste, 1779-1815'. *Mouvement social*, 106, 1979, pp. 5-84.

Sussman, George D. *Selling Mothers' Milk*. London, 1982.

Sweet, Frederick A. *Miss Mary Cassatt. Impressionist from Pennsylvania*. Oklahoma, 1966.

Taft, Lorado. *The History of American Sculpture*. New York, 1930.

Taylor, Barbara. *Eve and the New Jerusalem*. London, 1983.

Temko, Allan. *Notre-Dame of Paris*. New York, 1952.

Tennyson, Alfred, Lord. *The Poems*. Ed. Christopher Ricks. London, 1969.

Tertullian. *De Spectaculis*. Trans. T. R. Glover. London, 1931.

Tervarent, Guy de. 'Veritas and Iustitia Triumphant'. JWCI, VII, 1944, pp. 95-101.

Thomas, Edith. *The Women Incendiaries*. Trans. James and Starr Atkinson. London, 1967.

Thompson, Stith. *Motif-Index of Folk Literature*. 6 vols. Bloomington, Indiana, 1932-6.

Thomson, James. *The Poetical Works*. 2 vols. London, 1860.

Thomson, James. *Britannia, A Poem 1729*. Oxford, 1925.

Thucydides. *The Peloponnesian War*. Trans. and intro. Rex Warner. PC, 1954.

Toesca, Pietro and Forlati, Ferdinando. *The Mosaics in the Church of St Mark in Venice*. London, 1968.

Torriti, Marco. *La Pinacoteca Nazionale di Siena*. Genoa, 1982.

Toussaint, Hélène. 'The dossier on "The Studio" by Courbet' (1978). In *Courbet* (Catalogue), pp. 249ff.

Toussaint, Hélène (ed.). *'La Liberté guidant le peuple' de Delacroix*. (Catalogue). Paris, 1982.

Trachtenburg, Marvin. *The Statue of Liberty*. London, 1977.

Treasures from the Burrell Collection. (Catalogue). Hayward Gallery, London, 18 March-4 May 1975. London, 1975.

Trevor-Roper, H. R. *The European Witch-Craze of the Sixteenth and Seventeenth Centuries and other essays*. New York, 1969.

Turner, Frank M. *The Greek Heritage in Victorian Britain*. New Haven, 1981.

Tuve, Rosemund. 'Notes on the Virtues and Vices'. JWCI, XXVI, 1963, pp. 264-303.

Tuve, Rosemund. *Allegorical Imagery*. Princeton, 1966.

Twenty Paintings from the Collection of the Manchester City Art Gallery. Intro. Julian Treuherz. Manchester, 1977.

Valerius Maximus. *Detti e Fatti Memorabili.* Ed. Rino Faranda. Turin, 1971.

Vance, Carole S. (ed.). *Pleasure and Danger. Exploring Female Sexuality.* London, 1984.

Van Den Bosch, Annette. 'Susan Hiller: Resisting Representation'. *Artscribe*, 46, May–July 1984, pp. 44–8.

Vaughan, William. *German Romantic Painting.* New Haven, 1980.

Vermeule, Cornelius C. *The Goddess Roma in the Art of the Roman Empire.* Cambridge, Mass., 1959.

Vernant, Jean-Pierre. 'The Union with Metis and the Sovereignty of Heaven' (1974). In R. L. Gordon, 1981, pp. 1 ff.

Vernant, Jean-Pierre and Detienne, Marcel. *Cunning Intelligence in Greek Culture and Society.* Trans. Janet Lloyd. London, 1978.

Vernant, Jean-Pierre. *Religions, histoires, raisons.* Paris, 1979.

Vernant, Jean-Pierre. *Myth and Society in Ancient Greece.* Trans. Janet Lloyd. London, 1982.

Vickers, Michael. *Greek Vases in the Ashmolean Museum.* Oxford, 1982.

Vidal-Naquet, Pierre. 'Slavery and the Rule of Women in Tradition, Myth and Utopia' (1970, 1979). In R.L. Gordon, 1981.

Vienna Secession: Art Nouveau to 1970. (Catalogue). RA, 9 January–7 March 1971.

Vierge et merveille. Les miracles de Notre Dame narratifs au moyen-âge. Ed. Pierre Kunstmann. Paris, 1981.

Villon, François. *Œuvres.* Ed. Auguste Longnon and Lucien Foulet. Paris, 1964.

Virgil. *The Aeneid.* Trans. and intro. W. F. Jackson Knight. PC, 1969.

Voragine, Jacopus de. *The Golden Legend.* Trans. William Caxton. Ed. F. S. Ellis. 8 vols. London, 1900.

The WPA Guide to New York City. Intro. William H. Wyte. New York, 1982.

The WPA Guide to Washington DC. The

Federal Writers' Project Guide to 1930s Washington. New York, 1983.

Walker, D. P. *The Decline of Hell.* London, 1964.

Walker, D. P. *Unclean Spirits.* London, 1981.

Walkowitz, Judith R. *Prostitution and Victorian Society.* Cambridge, 1980.

Wallace, James D. *Virtues and Vices.* Ithaca, 1978.

Walters, Margaret. *The Nude Male.* Harmondsworth, 1979.

Walzer, Michael. *Just and Unjust Wars.* London, 1978.

Wardroper, John. *The Caricatures of George Cruikshank.* London, 1977.

Warner, Marina. *Alone of all her Sex: The Myth and Cult of the Virgin Mary.* London, 1976.

Warner, Marina. *Joan of Arc. The Image of Female Heroism.* London, 1981.

Warner, Rex. *Eternal Greece.* London, 1953.

We, the People: The Story of the United States Capitol. The United States Capitol Historical Society in co-operation with the National Geographic Society, Washington, 1981.

Wealth of the Roman World: Gold and Silver AD 300–700. (Catalogue by J.P.C. Kent and K. S. Painter). BM, 1977.

Webb, Peter. *The Erotic Arts.* London, 1975.

Weber, Max. *From Max Weber: Essays in Sociology.* Trans., ed. and intro. H. H. Gerth and C. Wright Mills (1948). London, 1967.

Webster, T. B. L. 'Personification as a Mode of Greek Thought'. JWCI, XVII, 1954, pp. 10–21.

Weekes, Henry. *Lectures on Art.* London, 1880.

Weil, Simone. *Lectures on Philosophy.* Trans. Hugh Price. Intro. Peter Winch. Cambridge, 1978.

Weil, Simone. 'L'Iliade – poème de la force' ('The Iliad, Poem of Might'). In *Intimations of Christianity among the Ancient*

Greeks. Ed. E. C. Geissbuhler. London, 1957.

Weitzmann, Kurt. 'The Survival of Mythological Representations in Early Christian and Byzantine Art and their impact on Christian Iconography'. *Dumbarton Oaks Papers*, 14, 1960, pp. 45-68.

Wenzel, Siegfried. 'The Seven Deadly Sins: Some Problems of Research'. *Speculum*, XLIII, January 1968, 1, pp. 1-22.

Werckmeister, O. K. 'Walter Benjamin, Paul Klee and the Angel of History'. In *Oppositions*, pp. 102-25.

Wharton, Edith. *The House of Mirth* (1905). Harmondsworth, 1979.

Wheelwright, Philip. 'Semantics and Ontology'. In L. C. Knights and Basil Cottle (eds.), *Metaphor and Symbol*. London, 1960, pp. 1-9.

Whitney, Geffrey. *Whitney's Choice of Emblemes*. A facsimile edition by Henry Green. London, 1866.

Wilkins, Eithne. *The Rose Garden Game*. London, 1969.

Williams, Caroline. *Saints, their Cults and Origins*. London, 1980.

Williams, Raymond. *Culture and Society 1790-1950*. Harmondsworth, 1963.

Williams, Roger L. *The World of Napoleon III, 1851-1870*. New York, 1957.

Williamson, Judith. *Decoding Advertisements. Ideology and Meaning in Advertising*. London, 1978.

Wilson, Elizabeth. 'All the Rage'. *New Socialist*, November-December 1983, pp. 22-6.

Wilson, Katharina M. (ed.). *Mediaeval Women Writers*. Manchester, 1984.

Wilson, Peter Lamborn. *Angels*. London, 1980.

Wilson, Stephen (ed.). *Saints and their Cults. Studies in Religious Sociology, Folklore and History*. Cambridge, 1983.

Wind, Edgar. *Pagan Mysteries in the Renaissance*. Harmondsworth, 1967.

Wind, Edgar. *The Eloquence of Symbols*. Ed. Jaynie Anderson. Oxford, 1983.

Winnington-Ingram, R. P. 'The Danaid Trilogy of Aeschylus'. JHS, 81-82, 1961-2, pp. 141-52.

Winnington-Ingram, R. P. *Studies in Aeschylus*. Cambridge, 1983.

Wither, George. *A Collection of Emblemes, Ancient and Moderne* (1635). Intro. Rosemary Freeman. Columbia, South Carolina, 1975.

Witkowski, G. J. *L'Art profane à l'eglise*. 3 vols. Paris, 1908-12.

Wittkower, Rudolf. *Allegory and the Migration of Symbols*. London, 1977.

Wittkower, Rudolf. 'Chance, Time and Virtue'. JWCI, I, 4, pp. 313-21.

Wolff, Jetta S. *Historic Paris*. London, New York, 1921.

Wollheim, Richard. *Freud*. London, 1971.

Women Painters of the World. Ed. W. Shaw Sparrow. London, 1905.

Women's Art Show 1550-1970. (Catalogue). Nottingham Castle Museum. 1982.

Wood, Christopher. *Olympian Dreamers*. London, 1983.

Woolf, Virginia. *The London Scene. Five Essays*. London, 1982.

Works of Art in the House of Lords. Ed. Maurice Bond. London, 1980.

Wright, Thomas and Evans, R. H. *History and Descriptive Account of the Caricatures of James Gillray*. London, 1851.

Wynn-Jones, Michael. *A Cartoon History of the Monarchy*. London, 1978.

Yaguello, Marina. *Les Mots et les femmes*. Paris, 1978.

Yates, Frances. *The Valois Tapestries*. London, 1959.

Yates, Frances. *Astraea: The Imperial Theme in the Sixteenth Century*. London, 1975.

Young, Bonnie. 'The "Lady Honor and her Children" '. *Bulletin of the Metropolitan Museum of Art*, June 1963, pp. 340-8.

Zeitlin, Froma I. 'The Dynamics of Misogyny: Myth and Mythmaking in *The*

Oresteia'. Arethusa, 11, 1-2, Spring and Fall 1978.

Zeitlin, Froma I. 'Travesties of Gender and Genre in Aristophanes' *Thesmophoriazousae'*. In Foley, 1981, pp. 169-217; also in Abel, pp. 131-57.

Zeldin, Theodore (ed.). *Conflicts in French Society*. London, 1970.

Zeldin, Theodore. *France 1848-1945: Intellect, Taste and Anxiety*. Oxford, 1977.

Zeldin, Theodore. *France 1848-1945: Ambition and Love*. Oxford, 1979.

Zimmer, Heinrich. *Myths and Symbols in Indian Art and Civilization*. Ed. Joseph Campbell. Princeton, 1972.

Index